# The Emergence *of the* Modern Museum

# THE EMERGENCE
## *of the*
# MODERN MUSEUM

## An Anthology of Nineteenth-Century Sources

*Edited by*

## JONAH SIEGEL

## OXFORD
### UNIVERSITY PRESS
2008

# OXFORD

UNIVERSITY PRESS

Oxford University Press, Inc., publishes works that
further Oxford University's objective of excellence
in research, scholarship, and education.

Oxford    New York
Auckland   Bangkok   Bogotá   Buenos Aires   Cape Town   Chennai
Dar es Salaam   Delhi   Hong Kong   Istanbul   Karachi   Kolkata
Kuala Lumpur   Madrid   Melbourne   Mexico City   Mumbai   Nairobi
São Paulo   Shanghai   Singapore   Taipei   Tokyo   Toronto

Published by Oxford University Press, Inc.
198 Madison Avenue, New York, New York, 10016
www.oup.com

Library of Congress Cataloging-in-Publication Data
The emergence of the modern museum: an anthology of
nineteenth-century sources / edited by Jonah Siegel.
p. cm.
Includes index.
ISBN 978-0-19-533113-4

1. Museums—Great Britain—History—19th century—
Sources. 2. Museums—Collection management—Great
Britain—History—19th century—Sources. 3. Museum
exhibits—Great Britain—History—19th century—Sources.
4. Museum attendance—Great Britain—History—19th
Century—Sources. I. Siegel, Jonah, 1963–
AM41.E44   2007
069.0941'09034—dc22   2007006153

1 3 5 7 9 8 6 4 2
Printed in the United States of America
on acid-free paper

*For my parents*

# PREFACE

In 1820 fewer than a handful of museums existed on the British Isles, and both their form and function were far from what a visitor today would expect. By the beginning of the First World War, not only had over 400 museums been founded in Great Britain but their place in culture was recognizably close and often identical to the modern one—whether considered in terms of content, forms of display, or modes of access. Although there has never been a single and uncontested account of the character and function of the museum, it is to this period of inception that we may turn for the most urgent and compelling debates as to the nature of institutions that were set up with such effort and expense in England and all over the world. The goal of this anthology is to allow the reader access to primary sources indicative of the history and development of the museum in the nineteenth century, which is to say, at the moment the modern concept took institutional form in response to varied social and cultural debates.

While the nature of a private collection is limited only by the resources, aspirations, and opportunities of an individual who may acquire, sell, or rearrange holdings at will, the public museum is always of necessity a compromise shaped by competing interests as well as by practical constraints including the characteristics of objects acquired through gift or purchase, the architecture of structures built or redesigned to accommodate particular collections, and competition for funding from other quarters. The various and sometimes countervailing tendencies shaping the institutions we have come to call museums are repeatedly illustrated by the material included in this book. Protecting precious objects or identifying the value of items not self-evidently important, making objects available for advanced study or introducing them to unprepared visitors, supporting disinterested culture or offering practical instruction: each of these goals depends on its own set of assumptions and calls for particular responses to practical challenges.

Nineteenth-century writings on any one of the institutions mentioned in this anthology to follow could fill several volumes, and it would be entirely reasonable to focus on one particular kind of museum—of science or art, for example—or on one issue, such as architecture, display, location, the role of empire, and so forth. As the selections to follow will demonstrate, however, the material itself does not naturally divide into such straightforward categories. In testimony before parliamentary committees, for example, questioning can move from developments in art history to speculations on the effect of weather on paintings to the appropriate pay scale for guards. Because the emergence of the institution involves aspirations that may never

be realized, plans that may or may not be put into effect, and practical concerns ranging from the vicissitudes of public commitment to culture to the effects of coal dust on pigment or varnish, useful sources on the nineteenth-century museum are notably heterogeneous.

I have arranged the entries in this anthology thematically, but it is in the nature of the material to challenge categorization. While the story of the emergence of the modern museum is a tale of ever-greater specialization, it is difficult to understand the significance of paths taken without some sense of the options historically present, of the elements needing to be distinguished in order to shape specialized institutions. For example, the vision of pedagogy and display that led to the formation of the South Kensington Museum in the 1860s (eventually the Victoria and Albert) is vividly manifested in debates on the role of government support of the arts at least as early as the 1830s. Similarly, an intervention in the long-running controversies that led to the emergence of a Museum of Natural History in the 1880s might be folded into a discussion of the antiquities at the British Museum in the 1850s. And so this collection attempts to illustrate a broad cross-section of the elements that may be said to be part of the museum phenomenon, not because it aspires to cover the topic fully in such a brief space, but in order to indicate the wealth and complexity of its manifestation in the nineteenth century.

An important motivation for this anthology has been the wish to give new life to voices the general reader or student rarely has the opportunity to hear. For this reason I have tried to include items that are not widely available. A number of very fine writers—some well known, some anonymous—weigh in on the topic of museums and collections. The powerful instrument that is nonfiction prose in the nineteenth century, be it manifested in formal essays or journalism, is at the heart of this anthology, accompanied by a number of instances in which actual voices are transcribed from parliamentary or other debate or testimony.

Among the many elements this anthology does not have the space to cover are some important related institutions that developed in tandem with the museum, such as libraries, zoos, botanic gardens, and sales galleries, as well as that important nineteenth-century phenomenon, the international exhibition. I regret not only the absence of sustained treatment of particular provincial and imperial museums but also my inability to do justice to the crucial influence of the reconstructed Crystal Palace that opened at Sydenham in 1854. My hope has been that the presentation of the museum phenomenon in much of its variety will compensate for the inability of this modest collection to pursue the stories of individual institutions. The selections themselves, as well as the suggestions for further reading at the end of the book, are only a beginning on the rich sources available for the student.

Although it is in the nature of texts dealing with museums to mention rarities and curiosities, I have annotated lightly and focused on identifying terms or individuals significant in the history of the museum or collection. Thus, I do not generally annotate the names of explorers, artists, or exotic locations unless the absence of such information would make the reading difficult. For similar reasons of space and readability, I have also generally edited out extended discussion of individual objects unless their treatment was particularly telling in reference to the nature of the collection as a whole. Material from parliamentary papers, whether debate or committee

report or transcription of testimony, is all of necessity presented in excerpts. In all cases, brief or immaterial excisions are made silently; more significant cuts are indicated in the text by the following symbol: —◦❯ ❮◦—. Cuts at the beginnings and ends of sections have not been marked. Corrections of obvious typographical errors have been made silently. The very few more substantial emendations have been placed in square brackets. Otherwise, the texts have not been changed. To preserve as much as possible the original character of the material, no attempt has been made to modernize or standardize spelling or punctuation. While the extracts are self-sufficient, it is my hope that readers will be encouraged to seek out the fascinating material still waiting in those texts only partly reproduced in this volume.

# ACKNOWLEDGMENTS

This book benefited greatly from the assistance of a number of current and former graduate students at Rutgers. I am grateful for the research help of Nellickal Jacob and Cale Scheinbaum, and most especially for the committed and imaginative collaboration of Jason Rudy, now a member of the faculty at the University of Maryland.

I am happy to acknowledge the support of the Rutgers University Research Council and of the American Council of Learned Societies and The American Academy in Rome. This book is one fruit from the ACLS Frederick Burkhardt and Rome Prize Fellowships it was my good fortune to be able to take up at the Academy in 2003–2004. Conversations with the community of scholars and artists gathered on the Janiculum helped shape the project from its earliest stages.

I am grateful to Mary Poovey for the original impetus to take on this anthology, and to Barry Qualls, at Rutgers University, who has been a source of unstinting encouragement throughout its development.

Coming to the topic of museums from literary studies, I have a debt of long standing to many of the scholars cited in the bibliography at the end of the book. I am glad to acknowledge a more recent obligation: figure 3.1 came to my attention as the cover of David Wayne Thomas's excellent *Cultivating Victorians: Liberal Culture and the Aesthetic* (Philadelphia: University of Philadelphia Press, 2004).

This book is dedicated to my parents, who first introduced me to the mysteries of museums and galleries.

# CONTENTS

# Two

— ◦≫ ≪◦ —

## Rationalizing The National Collections

# CHRONOLOGY

Where no location is indicated, the event took place in London. Unless otherwise specified, dates indicate foundation or opening to the public. A small number of representative events away from the British Isles are included and distinguished with italics.

1683    Oxford, Ashmolean Museum
1734    *Rome, Capitoline Museum*
1753    British Museum Act, founding British Museum
1759    British Museum
1768    Royal Academy (first annual exhibition, 1769)
1769    *Florence, Uffizi*
1771    *Vatican, Museo Pio-Clementino*
1793    *Paris, Louvre*
1801    *Bordeaux, Museum of Fine Arts*
1802    Arrival of Rosetta Stone
1803    *Lyon, Museum of Fine Arts*
1807    British Museum, Department of Antiquities
       Elgin Marbles first displayed in Piccadilly
       Glasgow, Hunterian Museum
       *Venice, Galleria dell' Accademia*
1809    *Milan, Pinacoteca di Brera*
1812    Edinburgh, Royal Museum of the University (later, Museum
       of Science and Art)
1813    Dulwich Picture Gallery (John Soane, architect)
       Hunterian Museum of the Royal College of Surgeons (renovated 1837)
1814    *Calcutta, the Oriental Museum of the Asiatic Society (later,*
       *the Indian Museum)*
1815    British Museum, acquisition of antiquities from Bassae ("Phigaleian
       Marbles")
1816    British Museum, acquisition of Elgin Marbles
       Cambridge, Fitzwilliam Museum
       *Denmark, National Museum*
1817    British Museum, temporary building for Elgin Marbles (demolished 1831)
1819    *Madrid, Royal Museum of Art and Sculpture (later, the Prado)*

1823   British Museum redesigned by Robert Smirke (work completed 1852)
       *Brooklyn Museum*
1824   National Gallery
1830   *Berlin, Altes Museum*
1832   British Museum, New Elgin gallery
1835   Royal Manchester Institution for the Promotion of Literature, Science and
       the Arts (later the Manchester Art Gallery)
1837   Government School of Design (Somerset House)
       First holiday opening of British Museum: Easter Monday (23,895 visitors)
1838   National Gallery opens on Trafalgar Square (accompanied by Royal
       Academy)
1841   Museum of Economic Geology
1844   *Hartford, Connecticut, Wadsworth Atheneum*
       *Paris, Musêe de Cluny*
1845   Museums Act (allowing town councils to levy rates to pay for local
       museums)
1847   British Museum, arrival of first Assyrian statues
1848   Cambridge, Fitzwilliam Museum, Founder's Building
1851   Great Exhibition
       Museum of Practical Geology
       *Karachi, Victoria Museum*
1852   Museum of Manufactures
1854   Crystal Palace at Sydenham
       Edinburgh, Industrial Museum of Scotland (later, the Royal Scottish
       Museum)
1855   *Lahore, District Museum (later, Jubilee Museum; currently, Lahore*
       *Museum)*
1856   National Portrait Gallery
1857   South Kensington Museum (renamed Victoria & Albert by Queen Victoria
       in 1899)
       Completion of British Museum Reading Room
       Manchester, Art-Treasures Exhibition
1859   Edinburgh, National Gallery of Scotland
       National Portrait Gallery
1860   Oxford, University Museum
1861   *Melbourne, National Gallery of Victoria*
1863   *Cairo, Bulaq Museum (predecessor, Museum of Egyptian Antiquities)*
1865   British Museum, first restaurant
1866   British Museum, Department of British and Medieval Antiquities and
       Ethnography
       Edinburgh, Museum of Science and Art
1869   Royal Academy Exhibitions begin at Burlington House
1870   *Boston, Museum of Fine Arts*
       *New York, Metropolitan Museum of Art*
1872   Bethnal Green Museum

British Museum acquires antiquities and sculptures of the East India
    Company
*Tokyo, National Museum*
1876    *Philadelphia, Museum of Art*
1879    *Chicago, Academy of Fine Arts (later, the Art Institute)*
1880    *Ottawa, National Gallery of Canada*
    *Paris, Carnavalet Museum*
1881    Natural History Museum
1884    Cambridge, Museum of Classical and General Archeology
    Oxford, Pitt Rivers Museum
1886    Guildhall Art Gallery
1889    Museums Association
1890    British Museum, electric lighting fully installed
    Dublin, Museum of Science and Art
1896    National Portrait Gallery moved to separate building
1897    National Gallery of British Art (Tate)
1900    Wallace Collection
1902    *Cairo, Museum of Egyptian Antiquities*
1907    Cardiff, National Museum of Wales
1912    British Museum, counter for sale of museum publications and post cards
    London Museum
1916    All museums and public galleries closed as a wartime economic measure
      (British Museum Reading Room and Manuscript Students' Room
      remain open)
1929    *New York, Museum of Modern Art*
1937    *Washington, National Gallery of Art*
    *New York, Solomon R. Guggenheim Museum*
1991    National Gallery, Sainsbury Wing
2000    Tate Britain
    Tate Modern
    British Museum, Queen Elizabeth II Great Court

# THE EMERGENCE *of the* MODERN MUSEUM

# INTRODUCTION

## The Age of the Museum

"Museum," meaning "seat of the muses," is a classical name for a modern invention. The archaic nature of the term is, of course, part of its charm. The effect to which the institution so often seems to aspire is to give the impression of permanence, of being always already necessary and therefore established. In fact, the muses themselves, those immortal sisters who presided over the arts and sciences, typically gathered outside—on Mounts Parnassus or Helicon, somewhere near the spring of Hippocrene—to carry out their activities under the aegis of musical Apollo. Ancient worship of the muses took place in structures that were no more characterized by display or collection than other ancient temples. It is a particularly *modern* hope, then, that the divinities that stand for inspiration will be summoned by the practice of gathering together and contemplating prized objects.

To describe the nineteenth century as the Age of the Museum as Germaine Bazin did in his important book of that title is not simply to say that the period from 1789 to 1900 saw the foundation or fundamental reorganization of the museums that have helped shape the imagination of later periods. Oscar Wilde identified the museal qualities of the era itself when he noted in "The Critic as Artist" (1891) that "to realise the nineteenth century, one must realise every century that has preceded it."[1] As Wilde's remark suggests, historicism is more than a matter of style, it represents a widespread cultural commitment to the inescapable value of the past, whether used as evidence of modern achievement or as a conceptual yardstick by which to identify contemporary shortcomings. To *realize* the nineteenth century, as Wilde puts it—meaning to understand, but also suggesting the process of bringing about, or making *real*—is to find that the historicizing aspirations evident in museum design of the period are themselves part of a phenomenon manifested as much in the drives to collect as in the historical eccleticism of nineteenth-century architecture.

If the museal nature of the nineteenth century is demonstrated by its thoroughgoing historicism, however, the other quality that makes the museum so characteristic an institution of the era is its relation to the public imagination. The pressing political claims that manifested themselves not only violently in the course of the French

---

1. Germain Bazin, *The Museum Age*, trans. Jane van Nuis Cahill (New York: Universe Books, 1967). Oscar Wilde, "The Critic as Artist," *The Complete Works of Oscar Wilde* (London: Collins, 1986), 1040.

Revolution and in threatened and actual uprisings throughout the century that fol-
lowed but also in important legislative changes in Great Britain and elsewhere were
unmistakeable evidence of the emerging social and political force of an ever more
powerful mass public. A new level of general culture was called for, whether to ac-
company and mollify the effects of enfranchisement or to shape the taste of the artisan
involved in mass production. The fear of the crowd and the resulting desire to edu-
cate it into a grouping of responsible and productive political subjects free from the
dangerous passions of the mob are central influences on nineteenth-century social
institutions. As the development of suitable subjects for a democratizing nation and
of skilled artisans for an ever-more competitive international market of goods were
both goals the museum was expected to further, debates ranging from the location
of museums to their opening hours, the nature and organization of their collections,
and even the presence or absence of toilets are so many reflections of an anxious and
never-resolved relationship to the public.

The challenges facing the museum, then, were not simply those to be expected
from the practical project of the acquisition and preservation of things but also
those attendant on bringing people together and managing their desires. As a so-
cially sanctioned gathering place, the museum shares characteristics not only with
such emergent structures as the newly reformed schools and universities but also
with more popular venues, such as the pleasure ground, the park, even the public
house—indeed, with the modern city itself. In the case of England, the period lead-
ing up to the first Reform Bill of 1832 marks the forceful beginning of a national
debate about the place of the people in the museum, and the role of the museum in
shaping the people. Decades later, among the most noteworthy effects of the Great
Exhibition of 1851 was its clear demonstration not only of the new possibility of
organizing so much material and manpower for public display but also its revelation
of the generally tractable character of the lower classes who came in massive num-
bers. We may take the anxiety that attended the planning and development of the
Great Exhibition as typical, but it is important to recognize the long-term effects of
an event that both raised the funds necessary to support ventures such as the South
Kensington Museum (later the Victoria and Albert) and reassured the governing
classes as to the behavior of the population.

## Revolution and Empire

The home, the workplace, the temple, the town square—these are the sites at
which admired objects might be expected to reside as a matter of course. The museum
will in turn share something with all of these locations, but it will never be any of
them. As critics of the museum—and some of its most sophisticated supporters—
consistently point out, the existence of the whole that is a museum requires a great
many things to be broken.[2] With the recent exception of modern art, the museum can

2. For two influential accounts of the losses implied in the exhibition of works of art, see Martin
Heidegger, "The Origin of the Work of Art" (1936), in *Poetry, Language, Thought*, trans. Albert
Hofstatdter (New York: Harper and Row, 1975), 17–87, and Walter Benjamin, "The Work of

never be understood to be the natural home of any of the material it displays. Objects tend to enter the museum when their world has been destroyed, and so they are relics and witnesses of a loss. The collapse of older political and cultural arrangements was an important contributing factor in the emergence of the modern museum; not only was the Louvre collection transformed from the king's property to the patrimony of a nation by a revolution but also the dispersal of objects caused by the political turmoil that shook Europe immediately after that political cataclysm led to fundamental shifts in the ownership and location of important works of art.

In England itself, the dispersal of the collection of Charles I under Cromwell in the seventeenth century is an indication of the force that historical events will have on the disposition of precious objects. Though some significant collections remained in the country and were developed in the intervening years, when the paintings of the Duke D'Orleans were put on the market in London in 1798–99, art lovers understood the display and sale as epochal events in the life of taste in England.[3] The sale of the duke's artworks in order to raise funds for his ill-fated political intrigues in response to the French Revolution was just one particularly notable manifestation of a widespread phenomenon. The opportunity for a prosperous and newly interested England to enrich its collections was due to a new instability in the location of artworks traceable not only to the carefully planned expropriations carried out by Napoleon's troops but also to the never-completed restitutions that took place after the emperor's fall. It was not only the institutions of the conquerors that were shaped by plunder in this era, however; important museums in Milan, Venice, and elsewhere in Italy trace their very existence to this period. But their gains required a number of losses—canvases removed from churches for which they had been painted, sculptures displaced from collections with which they had been long associated.

That an important impetus to the formation of the earliest museum devoted to medieval art was the revolutionary despoliation of French churches during the Revolution is a good indication of the characteristic link between the loss of natural context and the rise of the museum, of the disruption and profound dislocation that underlies every museum. Very little is whole in a museum. Nothing is at home. Something must be broken in order for fragments to come into existence. The museum creates wholes that speak of fragmentation; it houses hostages or refugees that can never really be sent home because their native land has ceased to exist in a way that can welcome them back as they were. For this reason, it is the cultural institution par excellence of a period of revolution and imperial expansion. The triumphal arch raised in Rome in the first century to celebrate the victory of Titus over the Jews does not feature images of battle; instead it shows the Romans carrying booty from the sacking of the Temple in Jerusalem. The possession of fragments from another people's history indicates not only the destruction or disappearance of an earlier political dispensation but the triumph of a new one. Empires gather trophies whose possession marks the disparity of power between the imperial center and areas of conquest or contestation. That

---

Art in the Age of Mechanical Reproduction," in *Illuminations*, trans. Harry Zohn (New York: Schoken, 1969), 217–51.

3. See Francis Haskell, *Rediscoveries in Art: Some Aspects of Taste, Fashion and Collecting in England and France* (Oxford: Phaidon, 1980), 39–84.

objects in British museums were not generally acquired by the kind of bloody battle involved in Titus's appropriation of the Menorah of the Temple is not only an indication of the complex and historically bound nature of cultural property but of the new forms of empire that characterized the nineteenth century.

The development of museums requires not simply the acquisition of material, however, but also the will to make that material available to the public. A number of political crises contributed to the importance of public display in the nineteenth century. The Revolutionary period, and especially the Napoleonic campaigns of artistic plunder, loosened important pieces from their historic moorings, while adding a new force to traditional ideas of war booty by identifying the possession and public display of important antiquities as an important modern symbol of political power. The acquisition of the Elgin Marbles by the British Museum may be placed in this context, as well as in relation to the complex negotiations between the emergent British Empire and the declining Ottoman Empire that would be an important subtext in international politics for the century to follow and beyond.

Imperial glory was not the justification generally given for the expansion of the British museums, however. More typical were the claims that accompanied the acquisition of the Elgin Marbles: that to own them was bound to improve British art, and eventually to provide an advantage to the nation's manufacturing design. This argument for the expansion and improvement of museums was sometimes accompanied by a more direct political claim—such as that made by Robert Peel (see pp. 62–63) that the museum could become a place in which intellectual pursuits and aesthetic contemplation might mitigate the class schisms that characterized the nineteenth century. Peel's argument, which he offers in the immediate context of the passing of the Reform Bill, is made in support of the construction of a new building for the National Gallery, but both the practical and political justifications are available throughout the period—be it for the support of an Indian Museum to replace the one that became homeless with the decline and eventual dissolution of the East India Company, or the opening of the South Kensington Museum as a site of design instruction for British artisans.

## The Lessons of the Object

The eighteenth century saw the formation or opening to the public of a number of influential museums on the continent, among them the Capitoline in Rome (1734) and the Uffizi in Florence (1769), the Pio-Clementino at the Vatican (1771), and the Louvre in Paris (1793). Though each of these developments was motivated and shaped by distinct cultural and social pressures, the process in every case can be described as a top-down decision to make a noble collection regularly available to a wider public. British foundations tend to have a less exalted—not to say more bourgeois—pedigree, a fact that is crucial in shaping the history of the institutions of the United Kingdom from the outset.

The first national public collection in England, and the one that would continue to have the most important hold on the popular imagination, was the British Museum, founded in 1753 when the collection of curiosities and objects of natural

history acquired from Sir Hans Sloane's estate was combined with the Harley Collection of manuscripts and the Cottonian library acquired by the nation earlier in the century. In 1754 the museum moved to Montague House, a seventeenth-century mansion in Bloomsbury, and in 1757 King George II donated not only the Royal Library but the privilege of copyright deposit, a gift that would have assured even if nothing else had done so the constant overcrowding that came to characterize the institution. The museum opened to the public in 1759, but its form and content, shaped early on by accidents of acquisition rather than any plan, would be a topic of debate and reform for the century to come, even as individual collections expanded at a rate unforeseeable by its founders and early supporters.

Along with the British Museum, a small number of collections existed in England prior to the great period of museum foundation of the nineteenth century, including privately founded and university institutions such as the Ashmolean Museum at Oxford (1683) and the Dulwich Picture Gallery (1813). The institution in Dulwich, the first purpose-built art gallery in the nation, was designed by Sir John Soane, and was influential on art lovers including William Hazlitt and John Ruskin from its early days. The venerable Ashmolean Museum, on the other hand, with its collection of carved fruit stones, coins, seashells, sculptures, and native American artifacts, as well as objects associated with British history, shared many characteristics with the cabinets of curiosity with which its foundation was contemporary while anticipating the ever-greater public accessibility that would come to characterize nineteenth-century institutions.

In addition to these establishments, stately homes could be visited by travelers who had the resources and time to find their way to country seats and make themselves acceptable to custodians or housekeepers left in charge. Generally, however, before museums were well established, the experience of displays was constrained and episodic in nature—the annual exhibition of the Royal Academy, for instance, or displays of Old Masters at the British Institute or by auction houses prior to sale, or even visits to Bullock's Museum, the extensive and varied private collection available to paying customers in London in the early years of the nineteenth century. The British Museum itself was difficult to visit, particularly by any member of the working classes, due to the hours it kept and the mode in which its collections could be viewed—the notoriously rushed tour that followed on the required prior reservation.

However, making the collections more easily available and rationalizing the management of visitors were not ultimately to prove the most fundamental tasks for museum reformers. The material on display itself presented constant and proliferating challenges that were at once practical and conceptual. The story of the development of the British Museum collections, to cite the central example, is from the outset one of inexorable accumulation leading to competition for resources and viewer attention. The passion for art that emerged with force in late eighteenth-century English intellectual circles, along with the opportunities for acquisition presented by international exploration, conflict, and expansion, resulted in the constant augmentation of museum holdings throughout the century that followed. For decades the collection of much-restored, largely Hellenistic works assembled by the connoisseur Charles Townley had been the principal source of what was taken to be direct knowledge of

classical art in England. Though new forms of discrimination and connoisseurship meant that their fame would soon go into uncheckable decline, at the time of their accession in 1805 they formed an important holding at the British Museum, joining the more heterogeneous set of objects of natural history and art assembled by Sir Hans Sloane, as well as such disparate material as the Egyptian collection that was acquired in 1801, a trophy of Napoleonic struggle.

The Elgin Marbles, purchased with much controversy in 1816, quickly overcame the Townley collection in the estimation of the cultured elite, and eventually in the popular imagination. But they themselves were subject to competition from the phenomenal Assyrian finds of Henry Layard and others at mid-century. Alongside the development of a large and diverse collection of antiquities and objects of natural history, however, the museum-goer and administrator also had to confront the effects of the emergence and expansion of other categories, ranging from medieval British history to what came to be known as anthropology. The natural history collection itself was an object of constant popular interest, even as its development was fostered by a great period in British science. Whales, giraffes, shells, bones, and the feet of dodos vied with cuneiform tablets, winged monsters carved in stone, and acknowledged artistic masterpieces for the interest of the viewer and the funds of the institution.

Even though the instruction hoped for from a display is always meant to be an object lesson, the challenges presented by the development of British museums demonstrate an important lesson of the nineteenth-century institution: objects do not generally speak for themselves, and even when they appear to do so they do not necessarily say what their collectors intended. While the accumulation of objects provokes the desire to organize into hierarchies of meaning and value, those hierarchies are unavoidably subjected to revisions that themselves indicate the difficulty of making sense of so much material. Prized material calls out for ideas that might identify the quantity and kind of attention required from the viewer: look to Greek sculpture for formal ideals that reflect a time of greater political freedom, suggests the neoclassical theorist; contemplate a medieval cloister to see the lessons of a time of simple faith and social coherence, advises the Gothic revivalist; study an Egyptian sphinx to learn the limits of hieratic art, proposes the art historian—but do not become fascinated with the formal achievement it represents, or with the sublime character of a massive Assyrian winged bull that a religious man has put on display as a moving demonstration of the truth of scripture; look to the symmetries of a shell or the length of a giraffe's neck for signs of God's wisdom, to fossils for evidence of the flood, or perhaps for confirmation of the workings of evolution.

The lessons of an object may be more or less than what is hoped for when it is put on display not only for practical reasons but because the imagination of the viewer is the most difficult element for the museum planner to control, though it is precisely what validates the existence of the institution. Objects consistently bring to mind visions beyond the ideas proposed to contain them. The museum-goer may be moved by the poignancy of an actual fragment more than by the imagined perfection of the whole. Or, on the contrary, wonder may be evoked by the massive presence of a complete object from a period or culture that is not sanctioned by the canons

of taste. Indeed, the space of the museum itself, the opportunity it presents to gather and see, may foster modes of sociability that are far from edifying: encounter, flirtation, even assignation, or simply rest and shelter.

It would be a matter of debate throughout the nineteenth century what kind of objects and what form of organization were best suited to inspire, and even what kinds of inspiration were most necessary for the British public, or the various subsets of that abstraction that preoccupied culture at different moments—artists, artisans, scientists, working people, the population as a whole, and so on. Was the aim to disseminate general culture or guidance on practical design, to provide an introduction to the ingenuity of modern designers, or to inspire wonder at the work of the deity? Each answer to these questions called for new decisions on quite practical topics such as the nature of future acquisitions, proper opening hours, effective modes of display, and pedagogical amenities, whether didactic labels and lectures addressed to a general public or access to specialized research libraries.

## Wonders Taken for Signs

The urge to acquire things is old enough to have earned Mosaic proscription. And indeed, the history of collection, like that of display, is far longer than that of museums, and in some measure easier to understand. Given the range of things people come to own and hoard, collecting is self-evidently driven by psychological as much as by social or cultural pressures. The display of property as a means of acquiring or ensuring social distinction is also a practice of long standing. While the drive to gather together prized objects, though never free of cultural influences, has deeply personal sources, the effects of display always necessarily involve others. Early collections, with a few rare exceptions, were generally expected to strike the viewer with admiration and wonder. Indeed, *Wunderkammer*—"Chamber of wonders"—and "Cabinet of Curiosities" were typical terms for the institutions that anticipated the modern museum. Although wonder and curiosity have not disappeared from the list of emotions still liable to be provoked by the institution, and important scientific work was carried out in these early predecessors, an important characteristic of the *modern* museum is the tendency to wish to establish a significance beyond the suspension of the understanding suggested by these terms.

The writings included in this book are selected to demonstrate the rich complexity that accompanied the emergence of the modern museum. What they make clear, for all their variety, is both the contested nature of institutions that can seem always already old-fashioned and the moving uncertainty that drives the creation of the most apparently staid cultural structures. The essays, reports, articles, and reviews in the pages that follow demonstrate that every part of the museum, from structure to content, from aim to audience, is a matter of debate in the nineteenth century. The shift from *Wunderkammer* to museum, from wonder to sign, is ultimately a change in aspiration; it does not clearly indicate what the signs collectors gathered together so eagerly may signify and for whom their meaning is intended. The attempt to give voice to the significance of objects, to create a structure that will

make meaning clear—that is the unresolved challenge of the modern institution. As the selections of material to follow will amply demonstrate, it is in the interplay of aspiration and disappointment, of plans and unintended consequences, of admired objects and disturbing subjects, that the interest of the nineteenth-century museum resides.

# One

# From Collection to Museum

# Chapter One
# PRIVATE COLLECTIONS

The development of cultural institutions in England has typically taken place in the uncertain interplay of private enterprise, individual aspiration, and an often hesitant and even suspicious government. Without the tradition of centralized control characteristic of the nations of the continent, the establishment of such institutions has consistently been a laborious bottom-up, rather than top-down, process. And so it is that the emergence of the museum in the nineteenth century required not only the existence of collections that could form the nucleus of new foundations but the development of the kind of social consensus that would make the acquisition, protection, and display of such collections a matter of national interest.

The emergence of ideas of taste and culture that had to precede and that would always outpace the actual existence of museums is suggested by the selections in this section describing the experience of early collections at a time when access to the material they contained could not be taken for granted.

William Bullock displayed his collection of natural history, curiosities, and works of art to paying customers in rented rooms in Sheffield in the early 1790s before moving to Liverpool and ultimately to London in 1809, where in 1812 he installed his wonders at the Egyptian Hall constructed for the purpose in Piccadilly. Bullock's enterprise shares many characteristics with the emergent public museums (contemporary sources sometimes refer to it as "the London Museum") while bearing as clearly the traces of that older model, the cabinet of curiosity. His holdings, carefully described in a catalogue that went through many editions, are typical not only in content but in organization: that is, the museum's widely disparate items are arranged by category rather than by source culture. The display gave a new home to material acquired in the explorations of Captain Cook and his crew that had originally been on display at the defunct Leverian Museum. It brought together not only shoes fabricated by Pacific Islanders and Africans, however, but the footwear of a Chinese lady and of a celebrated Polish dwarf. Various paintings were included, but they were exhibited alongside curiosities of representation such as a picture of

birds made out of feathers and another of "A Jew Rabbi, done with a hot iron, on wood." Bullock's museum also included a large number of stuffed animals, some set in a large diorama or "Artificial Forest" designed with little concern for the quite distinct natural environments of the creatures on display.

Like many museums throughout the century, including the British Museum, Bullock's was a repository of natural wonders as well as man-made ones, of objects that were taken to be important because typical, as well as those that were understood to be noteworthy because rare. With its Egyptian mummies, skeletons of ostriches and other birds, and its piece of fossilized oak from Coventry, it represents a model of collection and display that would be challenged and reformed throughout the century as the era became ever more committed to specialization and to more focused forms of instruction. Nevertheless, the legacy of institutions such as this one was never fully overcome. Indeed, the British Museum itself came to be the final repository of a number of objects once displayed in the Egyptian Hall.

In 1837 Gustav Friedrich Waagen, the German art historian and director of the newly founded Berlin Museum, a man who was to play a long-lasting role in the development of art-culture in England, set out on a voyage to explore the holdings of a nation with no great public museum but many important works in private hands. The English version of Waagen's book of observations, *Treasures of Art in Great Britain*, was extremely influential in bringing wider attention to the wealth of British holdings (1838; revised 1854; supplement 1857). As such it provides a useful sense of the transition from collection to museum, as well as a resource on the history of taste as viewed in the nineteenth century. Waagen's account of British collecting emphasizes the remarkable increase in the practice starting in the eighteenth century. Also included in the selection are extracts from the art historian's visits to important collections, not only to Panshanger and Blenheim but also to the more idiosyncratic Sir John Soane's Museum—an institution combining the love of the fine arts with qualities of wonder and strangeness associated with the very earliest collections.

As Waagen's text makes clear, before the museum became a dominant cultural institution, the experience of important art collections often required visits to haunts of individual wealth and privilege, not infrequently at locations quite distant from London. William Hazlitt's *Sketches of the Principal Picture-Galleries in England* (1824) vividly illustrates the experience of art-loving individuals dependent on seeing art sporadically, whether in the context of display for sale or in the course of visits to stately homes. "Mr Angerstein's Collection" not only memorializes the critic's return to a London collection that would soon become the core holding of the National Gallery at its founding, it also evokes the passion for the fine arts that was typical of

literary circles in the early nineteenth century and that would contribute toward the development of broader cultural support for the emergence of the museum.

## WILLIAM BULLOCK
—◦❧ ☙◦—
### A Companion to Mr. Bullock's Museum

*The full value given for rare and uncommon Quadrupeds, Birds, Fishes, Reptiles, Shells, Old Paintings, Carvings on Wood or Ivory, Stained Glass, ancient and foreign Arms and Armour, or any uncommon Production of Art or Nature.*

*The Visitor is requested to commence with the first Case on the Left Hand at the Entrance.*

*The Number at the Corner of each Case refers to the Page of this Catalogue, in which it is described.*

### Sandwich Islands.—CASE No. 1*

LETTER A.—A superb *Cloak*, made of the black feathers of the Powhee bird, ornamented with a broad checquered border of red and yellow. This Cloak is so long as to touch the feet of the wearer, and is considered of the greatest value. It is worn by none except the Chiefs, and by them only on particular occasions; as they never appeared in them but three times during Captain Cook's stay at Owhyhee, viz. at the procession of the King and his people to the ships, on their first arrival; in the tumult when the unfortunate commander fell a victim to their fury and mistaken resentment; and when two of the Chiefs brought *his* bones to Captain Clarke.

B.—Red feathered *Cloak*, decorated with yellow, from ditto. The ground of these elegant and singularly beautiful Cloaks is network wrought by the hand, upon which the feathers are so closely fixed, that the surface resembles the thickest and richest velvet, both in delicate softness and glossy appearance.

C.—A *Helmet*, composed of wicker-work, covered with red feathers.

From *A Companion to Mr. Bullock's Museum, Containing a brief Description of upward of Seven Thousand Natural and Foreign Curiosities, Antiquities, and productions of the fine arts, Collected principally at Liverpool, during several Years of arduous research, and at an Expence of upwards of Twenty-two Thousand Pounds and now open for public inspection, in the Great Room, No. 22, Piccadilly, London, which has been fitted up for the Purpose in a Manner entirely new.* London: Henry Reynell and Son, 1810 (excerpt).

---

* Several of the Articles in this Case were once the property of the celebrated Captain Cook.

D.—Another *Helmet* of a different construction, covered with black feathers. These Helmets, with the Dresses, form the principal riches of the Chiefs of the South-Sea Islands.

E.—A large *Hat*, made of red, yellow, and black feathers; remarkable for its resemblance in form to those of Europe.

F.—Two *Neck Ornaments*, made of different coloured feathers, from the Sandwich Islands.

G.—*Breast Plate, or Gorget*, from Otaheite, made of wicker, covered with feathers, and ornamented with rows of shark's teeth.

H.—Small *Idol*, of black wood, from ditto.

I.—*War Club*, from the Sandwich Islands. This Club, which belonged to a Chief of Owhyhee, is armed with a very hard, sharp, polished stone, which makes it somewhat like a Battle-axe; the other end is pointed for the purpose of a Pahoo or Dagger.

K.—A *Basket*, from the Friendly Islands. That the untutored Indians of the South-Seas exceed the artists of every civilized nation in this kind of work, the above basket is a proof, for it is of so close a texture, as to hold any liquid. It was used by the gentleman (who brought it from the South Seas, and presented it to this Museum) as a punch bowl.

L.—*Fish Hook*, from the N. W. coast of America.

M.—A *Necklace*, made of the teeth of the Peccary.

N.—*Head Ornament*, made of mother-of-pearl and tortoiseshell. New Caledonia.

O.—A beautiful *Fly-flap*, purchased at the sale of the late Leverian Museum.[1] In the first part of the Reference Catalogue to this once celebrated repository of curiosities, an account is given in a note of the manner in which it came into the possession of Mr. Samwell, the late surgeon of the ship Discovery, who published a Narrative of the Death of Capt. Cook, he informs us, he brought this Fly-flap home with him, of which he gives the following account:— "The Natives of the Sandwich Islands always endeavour to carry off the dead bodies of their slain friends in battle, even at the hazard of their own lives. This custom is probably owing to the barbarity with which they treat the body of an enemy, and the trophies they make of his bones; a remarkable instance of which I met with at Atowai. Tomataherei, the Queen of that island, one day paid us a visit on board the Discovery, accompanied by her husband, Taeoh, and one of her daughters by a former husband, whose name was Oteeha. The young Princess, who was called Orereemo horanee, carried in her hand a very elegant Fly-flap, of a curious construction. The upper part of it was variegated with alternate rings of tortoiseshell and human bone, and the handle, which was polished, consisted of the greater part of the *os humeri* (bone of the upper arm) of a Chief, called Mahowra; he had belonged to the neighbouring island of Oahoo, and in an

1. The Leverian Museum, established by Ashton Lever (1729–88) in 1773 in Leicester Square, had displayed curiosities and objects of natural history and art to paying customers. It was an important repository for material acquired during the explorations of James Cook—some of which was subsequently on display at Bullock's museum after the collection was sold at auction in 1806. [Ed.]

hostile descent he made upon this coast, had been killed by Oteeha, who was then King of Otowai. His bones were in this manner carried about by Orereemo-horanee, as trophies of her father's victory. The mother and daughter set a great value upon it, and were not willing to part with it for any of our iron; but Tomataherei happening to cast her eye upon a wash-hand bason of mine, which was of Queen's ware, it struck her fancy, and she offered to exchange. I accepted of her proposal, and the bones of the unfortunate Mahowra came at last into my possession."

## Glass Case, A

### *On the Staircase*

A pair of ponderous *Ear-Rings*, made of white shells, from Christian's Island.

A *Necklace*, of Human Bone, from New Zealand.

Beautiful *Feather Necklaces*, from the Sandwich Isles.

*Gaiters*, worn by the dancers of the Sandwich Isles. The ground work is a strong close netting, on which are fastened several hundred small shells, which, when put in motion, produce a rattling sound, to the music of which the dancers keep time.

In this Case is also a variety of the *Fishing Tackle* of the Sandwich and Friendly Islands. The books are made of mother-of-pearl, bone, or wood, pointed or barbed with small bones or tortoiseshell. They are of various sizes and forms; that marked A is the most common; it is between two and three inches long, and made in the shape of a fish, which serves as a bait. B is of a tortoiseshell.

The lines are made of different degrees of strength and fineness. That marked C is the finest kind, and is of human hair platted together, and is used chiefly for things of ornament. D is a specimen of the common kind, made of the bark of the cloth tree, neatly and evenly twisted in the same manner as our common twine. E is a softer kind, made of the bark of a small shrub, called *Areemah*, platted together, and is flat. That marked F is of great strength, being made of the platted sinews of some sea animal.

The *Combs* marked G are from the Friendly Islands, and are specimens of their exquisite wicker-work.

A quantity of *Fishing-Lines*, made from human hair, brought from the South-Seas.

A *Net Mesh* from the South-Seas.

A *Shoe* of a Chinese Lady.

A *Shoe* of Count Borulaski, the Polish Dwarf.

*Afzelia Speciosa*, from Sierra Leone.

New Zealand *Flax*, Phormium Tenax, of which the natives make their cloaks, twine, &c.

Strings of Beads made of Aromatic Berries, from South America.

Pod of a very large *Bean*.—Cotton in the Pod and in Flower.

## Works of Art

Beautiful Equestrian *Model* of *Edward the Black Prince* in Armour, finely executed by Mr. G. Bullock of Liverpool.

*Portrait* of *Mrs. Siddons* in Queen Catherine, and *Mr. Kemble* in Cato, by ditto.

Capital *Group of Figures*, representing the progress of inebriety;

A *Blind Beggar*, led by a Child;

*Frederick the Great* in his last illness;

And a *Dead Christ*.

[The four last pieces are all modelled by Mr. Piercy, in coloured wax, and are universally admired by every lover of the arts, for the correct and spirited manner in which they are executed.]

A small Anatomical Figure, from the original of *Dr. Hunter*, done in Rice Paste of its natural colour.

An exquisite *Model*, in Rice Paste, of the *Death of Voltaire*; by Mons. Oudon, of Paris.

Gothic *Model* of an *Ancient Armoury*, on a scale of an inch to a foot. It contains accurate models and representations of every kind of Armour and Warlike Weapon used in the British Armies, from the Norman Conquest to the Restoration of Charles II.

*Bust* in Carrara Marble, size of life, of Master *H. W. Betty* (the Young Roscius) at the age of 14; by Mr. L. Gahagan.

*Group of Flowers*, wonderfully cut in white Marble.

Bacchanalian *Group* of 12 Figures, cut in high relief, in statuary Marble; by Lege.

*Model* of a *Chinese Pagoda*, made of Mother-of-pearl, ornamented with carving and gilding.

Complete *Model* of a *Man of War*, only six inches long.

A ditto, entirely of Ivory.

View of the Lake and City of *Geneva* most inimitably carved in Ivory.

The City of *Messina*, taken from the Sea; the shipping, &c. executed with astonishing minuteness; some of the vessels, though not more than half an inch in length, have the sails, rigging, men, &c. perfectly distinct.

*Windsor Castle*, with the Thames.

*Greenwich Hospital*, with Shipping, &c.

Two Pieces with Stags in a Forest.

[The above 6 are all in *Ivory*, carved in the most exquisite manner by Messrs. Stephany and Dresh.]

Pair of *Beggars*, carved in Ivory, the drapery of Rose-wood.

Sixteen hollow *Balls* of *Ivory*, cut within each other out of one solid piece by the Chinese, in the most wonderful manner, every ball being pierced of a different pattern almost as fine as lace.

Another ditto with only eight balls.

Several beautiful Turnings in Ivory, by Mr. Perry, of London.

*Picture* of a *Saint*, sailing on his cloak, in marble, of its natural colours.

Beautiful Imitations of *Flowers*, made entirely of *Shells*, by Miss Humphreys, of Leicester-square.

Case of *Flowers*, made of Butterfly's Wings.

Large Picture of *Vulture* and *Snake*, finely done in coloured sand.

*Holy Family*, from Carlo Maratti, done in wool, at Rome.

Picture of *Birds*, executed with Feathers.

*Picture*, which being viewed in various directions, produces three different subjects.

*A* Dutch *Merry-Making*, from Teniers, in coloured Straw.

*A Jew Rabbi*, done with a hot iron, on wood.

Several Copies of Engravings with pen and ink, by Mons. Mongenot.

*Model* of a *Man of War*, of sixty guns, entirely of Crystal Glass.

Complete *Model* of a seventy-four gun *Ship* at anchor, only six inches long.

*Profile Heads* of the following celebrated Painters: Titian, Raphael, M. Angelo, Corregio, Carracchi, and Carlo Marati.

## Natural History

### Quadrupeds

*These are thy glorious works, Parent of Good,*

........................

*Thou sitt'st above those heavens*

*To us invisible, or dimly seen*
*In these thy lowest works; yet these declare*
*Thy goodness beyond thought, and power divine.*

Milton.[2]

*Variegated, Tufted,* or *Ursine Baboon* (Simia Mormon.)

This Baboon is very numerous about the Cape of Good Hope, and is one of the largest of this tribe of animals, measuring, when full grown, nearly five feet in height. It is very strong, fierce, and libidinous, yet at the same time is capable of attachment and gratitude. One that was sent to the Proprietor of this Museum, in the year 1803, had two deep wounds in his loins, owing to the pressure of a heavy chain by which it was confined; on appearing anxious to examine the wounds, it presented the lacerated part to inspection, and after one side was dressed with a very sharp mixture (though at the same time it was agonized with pain) it opened the other wound for the same application, which it continued to do until such time the excoriated places were healed. It remained at the Museum some time afterwards, and although mischievous to the family, yet on the least motion of the hand, or on uttering an angry word, it was all attention and submission. These baboons in their native country do considerable damage to the gardens and plantations, carrying on their depredations in large troops, with such boldness and resolution, as excite astonishment.

*Dog-faced Baboon* (Simia Hamadryas.)

A very large and fierce species, remarkable for the long grey hair with which it is covered; it is rarely brought to Europe, is a native of the hottest parts of Africa, where it is said to be found in vast troops, and to be very fierce and dangerous.

### Artificial Forest

The center of the Apartment, which is 40 feet high, is fitted up with Artificial Trees, copied from nature so as to represent the interior of a Tropical Forest, in appropriate situation of which are placed the larger Quadrupeds, Birds and Reptiles. At the upper end of the Wood facing the entrance, is displayed on a large Tree, a specimen of that immense Serpent the Boa Constrictor measuring 22 feet in length, in the act of preparing to seize the Wood Baboon, (*Simia Silvatica*) which is represented so petrified with fear as to be incapable of sufficient exertion to escape the extended jaws of its powerful adversary. Under the above is the huge Rhinoceros, (*Rhinocerous Unicornis*), which, next to the Elephant, may be considered as one of the most powerful of animals; in strength indeed he is inferior to none, and his bulk (says Bontius) equals the elephant, but is lower only on account of the shortness of his legs. The length of the Rhinoceros from head to tail is usually twelve feet; and the circumference of the body nearly equals that length. Its nose is armed with so hard and formidable a horn that the Tiger will rather attack the Elephant, whose

---

2. John Milton, *Paradise Lost*, v., 11. 153–154. [Ed.]

proboscis he can lay hold of, than the Rhinoceros, which he cannot face without danger of having his bowels torn out by the defensive weapon of his adversary. The body and limbs of the Rhinoceros are covered with a skin so hard and impenetrable, that he fears neither the claws of the Tiger, nor the trunk of the Elephant. It is said to turn the edge of a scymetar, and to resist even the force of a musket-ball. His sense of smelling is so acute, that his pursuers are obliged to avoid being to windward of him. They follow him at a distance, and watch till he lies down to sleep. They then approach and discharge their muskets into the lower part of his belly.

On the left of this, issuing from a Den, is seen the *Panther*, which is an untameable animal, and next in size to the tiger. It inhabits Africa, Barbary, the remotest parts of Guinea, and the interior of South America; is extremely fierce, and attacks every living creature without distinction, but happily prefers the flesh of brutes to that of mankind. The ancients were well acquainted with these animals. The Romans drew prodigious numbers from Africa, for their public shews. Scarus exhibited 150 of them at one time; Pompey 410; and Augustus 420. They probably thinned the coast of Mauritania of these animals; but they still swarm in the southern parts of Guinea. The skin of the Panther was presented by Mr. Polito.

Near the foot of the Rhinoceros is the *Persian Lynx* (Felis Caracal) an inhabitant of Persia, India, and Africa; it is an animal of much ferocity, although capable of being sometimes so far tamed as to be used for the purpose of taking game. In front of the Rhynoceros lies a species of the St. Domingo Crocodile; and close to the Bamboo-rail on the right side of the room, is the American Aligator, 12 feet long; near this, under the American Aloe in blossom, is, perhaps, the largest specimen of the Land Tortoise ever brought to this country, the shell alone measuring 3 feet 2 inches in length, and near six feet in circumference; it is the *Testuda Indica* of Linnæus: opposite the head of this, is the Emeu of New Holland (*Struthio Novæ Hollandia*); this stupendous bird, equalled in size only by the African Ostrich, was lately living in the valuable and extensive Menagerie of Mr. S. Polito: near this is the Arctic, or White Fox (*Canis Lagopus*); it is an inhabitant of the Northern parts of America, and in winter is perfectly white; between this and the rail on the left side is the Capibara (*Cavia Capibara*); it is the largest of the Cavias, and the only one known to have been brought to this country; it lived two years in the possession of Mr. Kendrick of Piccadilly, it was extremely gentle and fed on vegetables, though in a state of nature they are said to dive and catch fish with great dexterity; a singularity in the animal which has not been noticed by writers is, that on the outside of each hind foot, it has a large horny projection four inches long and two broad, probably intended to assist it in swimming.

Nearer the door on the same side is the Zebra (*Equus Zebra*).—This extremely beautiful animal is a native of the hotter parts of Africa, and is frequently seen in herds in the neighbourhood of the Cape of Good Hope; they are however so extremely wild and cautious as rarely to be taken, and are of a disposition so vicious and untameable as seldom to submit to the bridle, even when taken quite young. In size the Zebra is superior to the ass; in its form it is much more elegant: the ground colour is white, or cream colour, and the whole animal is decorated with very numerous black or dark brown stripes, disposed with the utmost symmetry in a manner not easy to be described.

To the right of this is the Three-toed Ostrich of America (*Struthio Rhea*); this Bird, which till lately was very little known to European Naturalists, is a native of South America, and attains the height of a man; the one in this Collection was brought alive, and in its food and manners was similar to the common or African Ostrich.

At the left hand corner on the entrance is the White or Greenland Bear (*Ursus Maritimus*). This is a far larger species than the common Bear, and is said to have been sometimes found of the length of twelve feet. The head and neck are of a more lengthened form than in the common Bear, and the body itself is longer in proportion. The whole animal is white, the ears round and small; the eyes little, and the teeth of extraordinary magnitude: the hair is of great length, and the limbs are extremely large and strong. It seems confined to the coldest part of the globe; being found within eighty degrees of north latitude, as far as any navigators have yet penetrated. The shores of Hudson's Bay, Greenland, and Spitsbergen, are its principal places of residence; but it is said to be carried sometimes on the floating ice as far south as Newfoundland. The Polar Bear is an animal of tremendous strength and fierceness. Barentz, in his voyage in search of a North-east passage to China, had proofs of the ferocity of these animals, in the island of Nova Zembla, where they attacked the seamen, seizing them in their months, carrying them off with the greatest ease, and devouring them in the sight of their comrades. It is said that they sometimes will attempt to board armed vessels at a distance from shore, and have been repelled with difficulty. Presented by S. Staniforth, Esq. of Liverpool.

In the front is a pair of those remarkable animals, the Kangaroo, (*Didelphis Gigantea*). The Kangaroo may be considered in some degree as naturalized in England, several having been kept for many years in the Royal domains at Richmond, which have during their residence there produced young, and promise to render this most elegant animal a permanent acquisition to our country.

In the right hand corner is the Black Swan (*Anas Atrata*) of New Holland, from whence they are frequently brought alive.

Close to the rail at the entrance, is a pair of those immense Shells, the Chama Gigas of Linnæus. They are the largest of all known shell fish, being 3 feet across, and weighing upwards of 300lb. This is the Cockle mentioned by voyagers as capable of dining a whole ship's company. The fish is said to weigh 40lb. It is black, but not ill tasted, and is generally cut into steaks and broiled.

The various Trees have all their names on them.

## Miscellaneous Articles

Numerous extraordinary and stupendous remains of non-descript animals, found in the vicinity of the rivers Ohio, Wabash, Illinois, Mississippi, Osage, Missouri, &c. brought to England by a gentleman who passed several years on a mineralogical tour in unfrequented parts of North-America. They consist of different parts of animals, such as heads, vertebræ, ribs, grinders, and horns; among which, the most worthy of remark is the foot of a clawed animal of the *fera* genus, or tiger species. This paw, clothed with flesh, skin, and hair, filled with muscles, flexors, and cartilages, must,

when dilated on its prey, have covered a space of ground four feet by three. Did the animal to whom it appertained partake of a strength of body proportionate to the size of this foot, and at the same time add the agility and ferocity of the tiger to his unequalled magnitude, he must have been the terror of the forests, and of mankind. That such an animal did exist, this specimen is a sufficient proof; nor did it alone inhabit America, for we have reason to believe that an animal, similar in some respects to the above, once had possession of our island; for various remains of non-descript animals have been frequently dug up of late in different counties. The thigh-bone marked A. which is nearly four feet in length, was found in digging the Ellesmere Canal in the year 1803, near the village of Wrenbury, in Cheshire. B. is one toe of the clawed foot. C. several joints of the tail, which must in the living animal have been as thick as an ordinary oak tree. D. one of the vertebræ of the back; the passage for the spinal marrow is so large, that a man's arm may with ease pass through it. E. is a section of a spiral tusk, thirteen feet in length. F. a carnivorous grinder, nine pounds weight, being one hundred and forty-four times as heavy as that of a horse. G. a large grinder of another species of these stupendous non-descripts, evidently an herbivorous animal. On the subject however of these Incognita, but a few words are necessary: they have been on the whole, the surprise of the enlightened naturalist, and the admiration of the classical scholar; we therefore refer those, who wish to be more particularly informed respecting these remains, to a pamphlet, entitled "*Memoirs of Mammoth, and other extraordinary and stupendous bones,*" written by the gentleman who brought them to England, and sold them to the Proprietor of this Museum. It may be had at the Rooms, price 1s. 6d.[3]

Glass Case, containing an *Egyptian Mummy*.

The Mummy in this collection was brought from Egypt by the French, and taken from them by an English privateer, and was remarkable for containing only the head, and part of the thigh and leg bones, which were enveloped in folds of fine linen, nearly three inches thick. The linen in some parts was as white and perfect as when first done, and on the legs there was some of the flesh still remaining, although, from a moderate calculation, it must have been embalmed upwards of two thousand years.

> The *Hand of a Lady*, with the Blood-vessels finely injected, to shew the situation of the veins, &c. Presented by Allan Burn, esq. Lecturer of Anatomy, Glasgow.
>
> A *Mummy* of the *White Ibis*. The White Ibis, though now unknown to the Egyptians, was formerly worshipped by them as a deity, in consequence of the great service it did them in destroying the vast quantities of serpents and reptiles with which that country was infested. The veneration for them extended even after their death; for whenever the body

3.  Thomas Ashe (1770–1835), *Memoirs of Mammoth, and various other Extraordinary and Stupendous Bones of Incognita, or Non-Descript Animals, Found in the Vicinity of the Ohio, Wabash, Illinois, Mississippi, Missouri, Osage, and Red Rivers* (London: G. F. Harris, 1806). [Ed.]

of a dead Ibis could be found, it was carefully embalmed after the manner of the mummies.

—◦❧ ☙◦—

The Horn of the Ibex.

Horns of the Roe-buck.

Egg and Thigh-bone of an Ostrich.

Leg of a Cassowary.

Three Noses of the Saw Fish. The largest of these is three feet seven inches long, eight inches broad at the base, and four at the point; it is armed at the sides with thirty-eight strong teeth, about an inch and a half long, and two inches from each other.

The Jaws of an enormous Shark, which measures six feet six inches in circumference.

The Fossil Tooth of a Shark, nearly four times as large as those in the above jaws.

The Cavity of a Whale's Ear.

The Jaws of a Porpoise.

Shells of the Nine and Three-banded Armadillos.

Part of the Hide of a Rhinoceros, remarkable for its thickness, being pistol proof.

Skull of the Walrus. This animal inhabits the Northern Seas, and grows to an amazing size; the tusks are sometimes upwards of two feet in length.

Horns of the White Antelope. The horns of this animal are very long and slender, of a black colour, and sharp-pointed. The animal is of a milk-white colour, and inhabits the island of Gow Bahrein, in the Gulf of Bassora.

Teeth of the Hippopotamus, which are of vast strength and size, particularly the tusks, or canine teeth of the lower jaw; they sometimes measure more than two feet, and weigh upwards of six pounds.

Glass Case, containing four different Beaks and Heads of the Calao, or Hornbill Bird; remarkable for the singular appendages on the upper mandibles. No. 1. Helmet Hornbill. No. 2. Pied Hornbill. No. 3. Rhinoceros Hornbill. No. 4. Philippa Hornbill.

An Elephant's Tail.

Wasp's Nest from South America, on the branch of an oak, on which it was formed. The hole in the side is cut to shew the

structure of the combs. The entrance to it is at the bottom, and is contrived in such a manner that no rain can enter.

Skeleton of an Ostrich.—Skeletons of Birds, viz. the Creeper, Snipe, Oyster Catcher, Lark, Starling, Green Linnet, Field-fare, and Moor Game.

Vertebræ of the Spermaceti Whale.

Specimen of Fossil Oak, found in a quarry near Coventry.

# GUSTAV FRIEDRICH WAAGEN

—◦❧ ❦◦—

## *Treasures of Art in Great Britain*

## Collecting in England

The taste for collecting works of art in England originated with the court. King Henry VIII., a friend of the fine arts, and a great patron of Holbein, was the first who formed a collection of pictures. It was, however, of moderate extent, since, including miniatures, it contained no more than 150 works. The glory of first forming a gallery of paintings on a large scale belongs to King Charles I., who lived a century later. As this prince united an extraordinary love for works of art with the most refined taste, and spared neither pains nor expense, he succeeded in forming a collection of paintings, which was not only the richest of that age in masterpieces of the time of Raphael, but is perhaps scarcely to be equalled even in our days. The king began to collect before he ascended the throne. After the death of his elder brother, Prince Henry, who was likewise a lover of the arts, the gallery was increased by the addition of his cabinet.

—◦❧ ❦◦—

The example set by the king and the first men in the kingdom, amongst the nobility and other wealthy individuals, could not fail to find imitators; so that the English were then in a fair way of acquiring an elevated and pure taste in the fine arts, by the more general diffusion of works of the finest periods. The political events, however, which led to the death of Charles I. and the Protectorship of Cromwell, put an end for a considerable time to this fair prospect. For in July, 1650, it was resolved by the Parliament to sell by public auction all the pictures and statues, valued at 49,903*l.* 2*s.* 6*d.*, with the rest of the king's private property. The sale took place in that year and in the year 1653, and attracted vast numbers of agents from foreign princes, and amateurs from all parts of Europe.

—◦❧ ❦◦—

The joyless spirit of the Puritans, hostile to all art and poetry, which prevailed in England, was not favourable to the collecting of works of art, and if the succeeding Kings, Charles II. and James II., took some pleasure in such works, they did not possess their father's refined taste. The endeavours of the first, however, to recover the dispersed pictures of the collection of Charles I. merits the most honourable commendation.

—◦❧ ❦◦—

When the taste for collecting pictures revived after the commencement of the eighteenth century, it was not encouraged either by the Crown or by Parliament, but

From Gustav Friedrich Waagen, *Treasures of Art in Great Britain: Being an Account of the Chief Collections of Painting, Drawings, Sculptures, Illuminated Mss., &c. &c.* Originally published as *Works of Art and Artists in England*, 1838; revised edition, London: John Murray, 1854 (excerpts).

solely by private individuals, who, at the same time, introduced the custom of plac-
ing their collections for the most part at their country seats.

These collections, which were formed by the end of the eighteenth century, are,
however, of a very different character from those of the time of Charles I. They
betray a far less pure and elevated taste, and in many parts show a less profound
knowledge of art. We, indeed, often find the names of Raphael, Correggio, and
Andrea del Sarto, but very seldom their works. The Venetian school is better repre-
sented, so that there are often fine pictures by Titian, Paul Veronese, Tintoretto, and
the Bassanos. Still more frequent are the pictures of the Carracci and their school, of
Domenichino, Guido, Guercino, Albano; but there are among them but few works
of the first rank. Unhappily the masters of the period of the decline of art in Italy
are particularly numerous; for instance, Castiglione, Pietro Francesco Mola, Filippo
Lauri, Carlo Cignani, Andrea Sacchi, Pietro da Cortona, Carlo Maratti, Luca Gior-
dano. At this time also a particular predilection for the works of certain masters
appears. Among these are, of the Italian school, Carlo Dolce, Sasso Ferrato, Salvator
Rosa, Claude Lorraine, and Gaspar Poussin, pictures by the two latter being fre-
quently the brightest gems of these galleries. Of the French school, Nicholas Poussin
and Bourguignon are esteemed beyond all others. Of the Flemish school, Rubens
and Vandyck and, though not in an equal degree, Rembrandt. Of all these favou-
rite masters we see the most admirable specimens. Here and there are found fine
sea-pieces by William Van de Velde, choice landscapes by Ruysdael and Hobbema,
and pretty pictures by Teniers. On the other hand, we seldom meet with a genuine
Holbein, still more rarely with a Jan Van Eyck, or with any other masters of the old
Flemish and German schools. As the only collection which forms an honourable
exception, and was made in the elevated taste of Charles I., I must here mention that
of the Earl of Cowper, at his country seat, Panshanger, in Hertfordshire.[1] This col-
lection, which was formed towards the close of the century, contains chiefly pictures
by Raphael, Andrea del Sarto, and Fra Bartolommeo.

The amateurs of the eighteenth century were likewise very ardent in collecting
drawings. Among the numerous cabinets thus obtained the most distinguished were
those of the Dukes of Devonshire, the Earls of Pembroke, and of George III., which
still exist; and those of the two Richardsons and Sir Joshua Reynolds, which have
been broken up.[2]

1.  George Nassau Clavering, third Earl Cowper (1738–1789): long-time resident of Florence and
    important patron of the arts and sciences. [Ed.]
2.  George III (r. 1760–1820) made a number of additions to the royal drawing collection, includ-
    ing the work of both Italian and Northern European artists. The earls of Pembroke assembled
    a notable art collection at Wilton House in Wiltshire. Thomas Herbert, the eighth Earl of Pem-
    broke (1656–1733): noted collector. Over the course of the eighteenth century, the dukes of
    Devonshire, particularly William Cavendish, the second duke (1673–1729), assembled what is
    still one of the major collections of Renaissance and Baroque drawings at Chatsworth House in
    Derbyshire. Jonathan Richardson, the elder (1667–1745): leading portraitist and author on art,
    established, along with his son, Jonathan Richardson, the younger (1694–1771), an important
    collection, which was sold in 1747. Sir Joshua Reynolds (1723–1792): painter and influential
    neoclassical art theorist, the first president of the Royal Academy and author of the *Discourses*
    delivered annually from 1769 to 1772 and published in 1778. [Ed.]

Private collections of ancient sculpture, some of them very numerous, arose at this period. But here the first glance is sufficient to show that the refined critical knowledge of art possessed in our times did not preside in the formation of them. We accordingly find works of superior merit more or less mixed with the restorations of Roman workers in marble.

— ◦❧ ❦◦ —

The most important of all, that of Mr. Charles Townley, now forms a portion of the British Museum.[3] Lastly, other articles of ancient art, such as small bronzes, painted vases, terra cottas, household furniture, ornaments—in a word, all that is comprehended in the name of antiquities;—also medals and engraved gems were eagerly sought for.

— ◦❧ ❦◦ —

But England was destined to sustain another grievous loss of works of art. In the year 1780 the gallery of paintings belonging to Sir Robert Walpole at Houghton Hall, which was very considerable both in extent and value, was sold for 30,000l. to the Empress Catherine of Russia, and is now one of the most important parts of the imperial gallery in the Hermitage. A number of capital works by Rubens and Vandyck were thus lost to England. A collection, too, of eighty antique works of sculpture belonging to Mr. Lyde Brown, mostly collected at Rome by the well-known English banker Jenkins from the Barberini Palace and from recent excavations, went in the same manner to St. Petersburg.[4]

The time, however, soon came when the consequences of the French Revolution brought a full indemnification to this country for all its preceding losses in works of art.

Of all the collections imported into England during this period the most important was the first, namely, the gallery of the Duke of Orleans.[5] In order that you may be able to form some idea of it, I send you some particulars respecting its origin and subsequent fortunes. Philip Duke of Orleans, known by the name of the Regent, founded it in the first half of the eighteenth century with much taste and at very great expense.

— ◦❧ ❦◦ —

The gallery, which at his death consisted of 485 pictures, contained the most costly treasures of the most flourishing periods of the Italian, Flemish, and French schools, but was especially rich in Italian pictures of the age of Raphael and the Carracci. Many of the pictures, it is true, will not bear the test of the more strict critical knowledge of modern times. The twelve to which the name of Raphael is given are reduced to five, the twelve Correggios to at most the half of that number. But which of the present galleries in Europe can boast of so many undoubted pictures by those

3. Charles Townley: see glossary. [Ed.]

4. The Hermitage Museum: founded by Catherine the Great in St. Petersburg in 1764. The collection of Robert Walpole (1676–1745) was sold by George Walpole (1730–1791) in 1779. Thomas Jenkins (1722–1798): notorious art dealer, painter, and banker in Rome. Lyde Browne (d. 1787): antiquary collector and banker, had one of the largest collections of classical objects in the eighteenth century. [Ed.]

5. Orleans: see glossary. [Ed.]

masters? In the works of other masters the proportion is far more favourable. Thus, of the twenty-seven assigned to Titian, the sixth part at the most, and of the thirty-three by the Carracci a very small number, are liable to any well-founded objection. Though the pictures of the Flemish school were not so numerous, the gallery contained, however, nineteen by Rubens, twelve by Vandyck, seven by Rembrandt, ten by Teniers, four by Gerard Dow, three by Franz Mieris the elder, seven by Netscher, four by Wouvermans, and many other valuable works. Among the pictures of the French school were the celebrated Seven Sacraments by Nicholas Poussin. Louis Duke of Orleans, the son of the Regent, nearly did the gallery an irreparable injury. In a fit of blind fanaticism he cut the heads of Leda and Io out of the pictures of Correggio, and burned them. Those pictures were purchased afterwards at the public sale of a Mr. Pasquier for Frederic the Great, and are now in the Royal Museum at Berlin.

If the unhappy fanaticism of Duke Louis of Orleans had thus already deprived the gallery of some of its greatest ornaments, it was entirely broken up by the lamentable ambition of Philip, known by the name of Egalité: in order to procure money for the attainment of his political objects, he sold the whole collection in the year 1792 for a mere trifle. For all the pictures of the Italian and French schools, which amounted to 295, he received from Mr. Walkners, a banker of Brussels, the sum of 750,000 livres; and for the pictures of the Flemish, Dutch, and German schools the sum of 350,000 francs from Mr. Thomas Moor Slade, an Englishman.[6] With the laudable view of preserving these treasures for his country, M. Laborde de Mereville, a wealthy nobleman, bought the first division of Mr. Walkners for 900,000 francs. But when, like so many other nobles, he was compelled to leave France during the Revolution, he caused his pictures to be brought to England, where, having no resources to support himself, he sold them for 40,000l. to the house of Jeremiah Harmann in London.

Thus matters stood till the year 1798, when Mr. Bryan, an ardent friend of the arts, prevailed on the late Duke of Bridgewater, the Earl of Gower, afterwards Marquis of Stafford, and the Earl of Carlisle, to purchase this splendid collection for the sum of 43,000l., and thus to secure it for ever to England.[7] These noblemen then employed Mr. Bryan to value each picture separately, the result of which amounted to the sum of 72,000l.; and they then exhibited them for public sale from the 26th of December, 1798, to the end of August, 1799. After they had selected for themselves ninety-four pictures, of the value, according to Bryan's estimate, of 39,000 guineas, there were disposed of by private sale pictures to the amount of 31,000 guineas. Lastly, the sixty-six pictures which still remained were sold by auction in the following year, and, with the large sum received for the exhibition, produced nearly 10,000l. In this manner the three noblemen obtained the ninety-four pictures, which they had for the most part selected as the finest, for little or nothing.

6. Thomas Moore Slade: wealthy art collector and dealer. [Ed.]

7. Michael Bryan (1757–1821): art historian and dealer, Bryan was involved in the purchase of important French collections in the 1790s. He was author of the influential *Biographical and Critical Dictionary of Painters and Engravers* (1813–1816). Duke of Bridgewater: Francis Egerton, third Duke of Bridgewater (1736–1803), canal promoter, colliery owner, and collector. Gower: Granville Leveson-Gower, first Marquess of Stafford (1721–1803), politician and landowner. Carlisle: Frederick Howard, fifth Earl of Carlisle (1748–1825): politician, diplomat, author, and guardian of Lord Byron. [Ed.]

The greater portion of the other division of the Orleans gallery, containing the pictures of the Flemish, Dutch, and German schools, was purchased by Mr. Slade in conjunction with some other gentlemen, namely, Lord Kinnaird and Messrs. Moreland and Hammersley, and conveyed in the year 1792 to Mr. Slade's house at Chatham, where it remained for some months.[8] But in 1793 it was brought to London, exhibited, and sold by auction.

The Orleans collection was next succeeded by that of the French minister M. Calonne, consisting of 359 pictures, which he had formed at a great expense during a series of years.[9] It contained a number of the finest chefs-d'œuvre of the Dutch school of the seventeenth century, as well as some admirable works of French and Spanish painters. The prices which were paid at the auction in the year 1795 may, on the whole, be called very moderate for England.

By the dispersion of these two collections in England a taste for fine pictures was astonishingly increased, and succeeding years afforded the most various and rare opportunities of gratifying it in a worthy manner. For when the storm of the French Revolution burst over the different countries of Europe, and shook the foundations of the property of states, as well as of individuals, the general distress, and the insecurity of property, brought an immense number of works of art into the market, which had for centuries adorned the altars of the churches as inviolably sacred, or ornamented the palaces of the great, as memorials of ancient wealth and splendour. Of these works of art England has found means to obtain the greater number and the best. For no sooner was a country overrun by the French than Englishmen skilled in the arts were at hand with their guineas.

In proportion as the number of capital pictures thus imported gradually increased, the more did a taste for them spread, so that with the greater demand the prices continued to rise. The natural consequence was, that whoever in Europe wished to sell pictures of great value endeavoured to dispose of them in England. Accordingly, an immense number of pictures were consigned over to England.

## Blenheim Palace

The celebrated country-seat of the Dukes of Marlborough, situated about eight miles from Oxford. If nothing were to be seen in England but this seat, with its park and treasures of art, there would be no reason to repent the journey to this country. The whole is on so grand a scale that any prince in the world might be satisfied with it for his summer residence; and, at the same time, it is a noble monument of the gratitude of the English nation to the great Duke of Marlborough.[10] Much as

---

8. George Kinnaird, seventh Lord Kinnaird of Inchture, Thomas Hammersley, and William Moreland were bankers in London's West End. [Ed.]

9. Charles Alexandre, Vicomte de Calonne (1734–1802): French statesman and collector. [Ed.]

10. Queen Anne presented John, Duke of Marlborough, with the land and resources to build Blenheim in gratitude for his military accomplishments. It was constructed between 1705 and 1722, and named for Marlborough's victory at the Battle of Blenheim in 1704. [Ed.]

the architect of this palace has sinned against the principles of his art, by breaking the masses and main lines, and by the heaviness and overlading of the ornamental parts, yet it affords at a distance very picturesque views, and the interior is very striking for the size of the apartments, the beauty of the materials, and the richness and splendour of the decorations. The most attractive decorations, however, are the paintings, which, arranged in a series of apartments, form one of the most considerable galleries in England. The great Duke of Marlborough was a great admirer of Rubens. The Emperor, and the great cities of the Netherlands,—Brussels, Antwerp, Ghent,—therefore vied with each other in presenting him with the finest works of that master; he purchased others himself, and thus formed the most considerable collection of pictures by Rubens in the possession of any private person, and with which no royal gallery even can be compared, except those of Munich, Vienna, and Paris. It is the more important, because the pictures are almost throughout by the hand of Rubens alone, and are chiefly of his earlier and middle periods. My admiration of this rich and ardent genius was, therefore, only increased here. There are also admirable portraits by Vandyck, and some of the pictures justly bear the names of some of the greatest Italian masters. I enjoyed the very rare favour of being allowed to remain alone, and as long as I pleased, in the different rooms; indeed the hurrying through, as is practised here almost daily, would have been of little use to me. Nay, the late Duke, happening to find me at my studies, conversed with me in a very friendly manner, desired me not to let his coming and going interrupt me, and presented me, as a remembrance of Blenheim, with the latest edition of the Guide to it, which is adorned with a plan of the park and with the chief views, engraved on steel and wood. I will now give some particulars of the most important original pictures in the order they occupy in the rooms.

## Bow-Window Room

VANDYCK.—1. Queen Henrietta Maria, whole-length, in a blue silk dress; this picture hangs too high, and in too dark a situation, to decide whether it be an original or one of the many old repetitions.

Boltraffio.—The Virgin and Child, a small oval picture. The expression of melancholy in the Virgin is very noble. This delicate picture, which is here called a Leonardo da Vinci, has unfortunately suffered much damage.

## The Duke's Study

VANDYCK.—2. Saturn, with wings, holding Cupid on his knee, and cutting his wings. A rather insipid allegory, to the effect that love decreases with time. On canvas, 4 ft. 10 in. high, 3 ft. 8 in. wide. Of the latter period of the master.

SIR GODFREY KNELLER.—Sarah, wife of the great Duke of Marlborough. Far more natural, careful, and delicate than the majority of pictures by this artificial artist. The ambitious, proud, and violent character by which this lady acted so important a part in the affairs of her own family, of England, and even of Europe, is clearly expressed in her features.

TITIAN.—1. St. Sebastian, whole-length, the size of life. The figure is fine and slender, the expression noble, the tone of the flesh warm and clear. A landscape in the background. The picture unfortunately hangs in a very bad light.

## Sir John Soane's Museum

I cannot leave unmentioned one of the most remarkable curiosities of London, the museum of Sir John Soane the architect, bequeathed by him to the nation.[11] The house, built in 1812, is situated in Lincoln's-inn Fields; the rooms are small, and such an immense number of objects are crowded together in three different stories, that it is the work of some hours to gain even a superficial view of them. The greater part consists of a rich collection of architectonic ornaments, partly original, partly plaster of Paris casts. East Indian specimens here alternate with Greek; Roman with Gothic; Egyptian, with ornaments of the fifteenth and sixteenth centuries. There is also as great a variety of works in sculpture; for instance, an injured and indifferently wrought marble sarcophagus, with the Rape of Proserpine, a highly spirited composition, and plaster-casts of many other subjects. The principal part of this strange collection may be compared to a mine with numerous veins, in which, instead of metallic ore, you find works of art. Also in most of the apartments a partial light falls from above, which heightens the feeling of the subterranean and mysterious, and this is further increased by an Egyptian sarcophagus, the finest ever found, which adorns the middle of the most considerable apartment. This sarcophagus, measuring 9 ft. 4 in. in length by 3 ft. 8 in. in width and 2 ft. 8 in. in depth, consists of a single block of what is called Oriental alabaster, or rather, from the recent examination of mineralogists, of what is properly called aragonite. The sides are about 2½ inches thick. At the bottom a full-length figure, in profile, representing Isis as guardian of the dead, is very carefully engraved, the outlines of which, as well as the hieroglyphics with which it is covered entirely, are filled with a black substance. The stone is so transparent, that, when a candle is put into the sarcophagus, it appears of a beautiful red. This splendid relic, which was discovered by Belzoni, October 19th, 1816, in a tomb in the valley of Beban el Malook, near Gournou, was brought by him to Alexandria, and subsequently offered in vain by Mr. Salt to the British Museum for 2000*l.* In 1824 it was bought by Sir John Soane. Sir Gardner Wilkinson considers the name inscribed to be that of Osiris, father of Rhamses the Great. Another very small apartment contains pictures, hung on a series of screens one before the other. The most important are the four pictures of scenes in an election, and the eight of the Rake's Progress, by HOGARTH. These pictures are, however, much coarser, more approaching to caricature, and of less merit, than the Mariage à la Mode. Next to them is a large view of the Canal Grande, by CANALETTO, which has a degree of

---

11. Sir John Soane (1753–1837): The most important British architect of his day and professor at the Royal Academy. Soane's work included not only the Bank of England but also the design of the Dulwich Picture Gallery and the idiosyncratic museum he established in his own home. [Ed.]

delicacy and detail very rare with him. A large water-scene, by CALCOTT, is also very pleasing. Lastly, there are several architectural designs by Sir J. Soane, which, by their extent and style, produce the impression of enchanted castles. Passing over the curiosities which fill the other apartments, I observe that the whole, notwithstanding the picturesque, fantastic charm, which cannot be denied, has, in consequence of this arbitrary mixture of heterogeneous objects, something of the unpleasant effect of a feverish dream. As a splendid example of English eccentricity, which can be realised only by the union of English wealth and English modes of thinking, it is very remarkable; and there is therefore reason to rejoice that, by the liberality of the owner, its permanent existence has been secured. In this, as in so many other things, England gives a noble example to the rest of the world.

## Panshanger, Seat of Earl Cowper

In July, 1835, I arrived at Hertford on my way to Panshanger. Being favoured by the finest weather, I set out on foot, with a guide, for this seat of the Earl of Cowper, who has a very choice collection, consisting chiefly of Italian pictures, most of which were purchased by the grandfather of the present Earl, when ambassador at Florence. The rather hilly ground, richly wooded, affords an agreeable diversity of views. The town of Hertford lies very picturesquely between hills of agreeable forms; and here and there I saw, at a distance, beautiful country-seats, situated on eminences, to which my attendant drew my attention, telling me the names of the owners. After walking through a part of the fine park, I reached the mansion, and being provided, by the kind intervention of the Duke of Sutherland, with a letter from Lady Cowper to the housekeeper, all the rooms containing pictures were opened to me, and I was then left to myself.

The coolness of these fine apartments, in which the pictures are arranged with much taste, was very refreshing after my hot walk. The drawing-room, especially, is one of those apartments which not only give great pleasure by their size and elegance, but also afford the most elevated gratification to the mind by works of art of the noblest kind. This splendid apartment receives light from three skylights, and from large windows at one of the ends; while the paintings of the Italian school are well relieved by the crimson silk hangings. I cannot refrain from again praising the refined taste of the English for thus adorning the rooms they daily occupy, by which means they enjoy, from their youth upward, the silent and slow but sure influence of works of art. I passed here six happy hours in quiet solitude. The silence was interrupted only by the humming of innumerable bees round the flowers which grew in the greatest luxuriance beneath the windows. It is only when thus left alone that such works of art gradually unfold all their peculiar beauties. But when, as I have too often experienced in England, an impatient housekeeper is perpetually sounding the note of departure by the rattle of her keys, no work of art can be viewed with that tranquillity of mind which alone ensures its thorough appreciation.

# WILLIAM HAZLITT

—◦❧ ❦◦—

## *Sketches of the Principal Picture-Galleries in England*

### Mr. Angerstein's Collection[1]

Oh! Art, lovely Art! "Balm of hurt minds, chief nourisher in life's feast, great Nature's second course!"[2] Time's treasurer, the unsullied mirror of the mind of man! Thee we invoke, and not in vain, for we find thee here retired in thy plenitude and thy power! The walls are dark with beauty; they frown severest grace. The eye is not caught by glitter and varnish; we see the pictures by their own internal light. This is not a bazaar, a raree-show of art, a Noah's ark of all the Schools, marching out in endless procession; but a sanctuary, a holy of holies, collected by taste, sacred to fame, enriched by the rarest products of genius. For the number of pictures, Mr. Angerstein's is the finest gallery, perhaps, in the world. We feel no sense of littleness: the attention is never distracted for a moment, but concentrated on a few pictures of first-rate excellence. Many of these *chefs-d'œuvre* might occupy the spectator for a whole morning; yet they do not interfere with the pleasure derived from each other—so much consistency of style is there in the midst of variety!

We know of no greater treat than to be admitted freely to a Collection of this sort, where the mind reposes with full confidence in its feelings of admiration, and finds that idea and love of conceivable beauty, which it has cherished perhaps for a whole life, reflected from every object around it. It is a cure (for the time at least) for low-thoughted cares and uneasy passions. We are abstracted to another sphere: we breathe empyrean air; we enter into the minds of Raphael, of Titian, of Poussin, of the Caracci, and look at nature with their eyes; we live in time past, and seem identified with the permanent forms of things. The business of the world at large, and its pleasures, appear like a vanity and an impertinence. What signify the hubbub, the shifting scenery, the fantoccini figures, the folly, the idle fashions without, when compared with the solitude, the silence, the speaking looks, the unfading forms within?—Here is the mind's true home. The contemplation of truth and beauty is the proper object for which we were created, which calls forth the most intense desires of the soul, and of which it never tires. A capital print-shop (Molteno's or Colnaghi's) is a point to aim at in a morning's walk—a relief and

From *William Hazlitt, Sketches of the Principal Picture-Galleries in England* (1824), in William Hazlitt, *Criticisms on Art and Sketches of the Picture Galleries of England*. London: John Templeman, 1864 (excerpt).

1. Angerstein: see glossary. [Ed.]
2. *Macbeth*, 2.2.36. [Ed.]

satisfaction in the motley confusion, the littleness, the vulgarity of common life: but a print-shop has but a mean, cold, meagre, petty appearance, after coming out of a fine Collection of Pictures.[3] We want the size of life, the marble flesh, the rich tones of nature, the diviner expanded expression. Good prints are, no doubt, better than bad pictures; or prints, generally speaking are better than pictures; for we have more prints of good pictures than of bad ones: yet they are for the most part but hints, loose memorandums, outlines in little of what the painter has done. How often, in turning over a number of choice engravings, do we tantalise ourselves by thinking "what a head *that* must be,"—in wondering what colour a piece of drapery is of, green or black,—in wishing, in vain, to know the exact tone of the sky in a particular corner of the picture! Throw open the folding-doors of a fine Collection, and you see all you have desired realised at a blow—the bright originals starting up in their own proper shape, clad with flesh and blood, and teeming with the first conception of the painter's mind! The disadvantage of pictures is that they cannot be multiplied to any extent, like books or prints; but this, in another point of view, operates probably as an advantage, by making the sight of a fine original picture an event so much the more memorable, and the impression so much the deeper. A visit to a genuine Collection is like going a pilgrimage—it is an act of devotion performed at the shrine of Art! It is as if there were but one copy of a book in the world, locked up in some curious casket, which, by special favour, we had been permitted to open, and peruse (as we must) with unaccustomed relish. The words would, in that case, leave stings in the mind of the reader, and every letter appear of gold. The ancients, before the invention of printing, were nearly in the same situation, with respect to books, that we are with regard to pictures; and at the revival of letters, we find the same unmingled satisfaction, or fervid enthusiasm, manifested in the pursuit or the discovery of an old manuscript, that connoisseurs still feel in the purchase and possession of an antique cameo, or a fine specimen of the Italian school of painting. Literature was not then cheap and vulgar, nor was there what is called a *reading public*; and the pride of intellect, like the pride of art, or the pride of birth, was confined to the privileged few!

We sometimes, in viewing a celebrated Collection, meet with an old favourite, a *first love* in such matters, that we have not seen for many years, which greatly enhances the delight. We have, perhaps, pampered our imaginations with it all that time; its charms have sunk deep into our minds; we wish to see it once more, that we may confirm our judgment, and renew our vows. The *Susannah and the Elders* at Mr. Angerstein's was one of those that came upon us under these circumstances. We had seen it formerly, among other visions of our youth, in the Orleans Collection,—where we used to go and look at it by the hour together, till our hearts thrilled with its beauty, and our eyes were filled with tears. How often had we thought of it since, how often spoken of it!—There it was still, the same lovely phantom as ever—not as when Rousseau met Madame de Warens, after a lapse of twenty years,

3.  Paul Colnaghi and Anthony Molteno founded distinguished commercial art galleries specializing in prints in London in the eighteenth century. [Ed.]

who was grown old and wrinkled—but as if the young Jewish Beauty had been just surprised in that unguarded spot—crouching down in one corner of the picture, the face turned back with a mingled expression of terror, shame, and unconquerable sweetness, and the whole figure (with the arms crossed) shrinking into itself with bewitching grace and modesty![4]

4. Ludovico Carracci, *Susannah and the Elders* (1616): now in the National Gallery. Orleans collection: see glossary and 28–30. Madame de Warens: see Rousseau's *Confessions* (1782). [Ed.]

# Chapter Two

# TOWARD A PUBLIC ART COLLECTION

The move from private collection to public is the crucial development in the nineteenth-century history of museums, but it is not one that took place without controversy. This section includes extracts demonstrating the contested nature of public collections in England from their earliest days and the interplay of politics, taste, and ideas of display that would continue to affect the development of institutions throughout the nineteenth century and beyond.

*The Report from the Select Committee on the Earl of Elgin's Collection* of 1816 is not simply an important record of the deliberations leading to the acquisition of what is still the keystone of the collection of the British Museum, it is also a significant document in the history of European taste. Although the purchase of the marbles Elgin had had removed from the Parthenon while serving as ambassador to Constantinople was controversial from the outset, it was also immediately recognized as a crucially important event: the acquisition by the nation of works of the most impressive classical pedigree at a time when the emergent fields of art history and archeology had put into question the merits of objects that had been prized by art lovers of an earlier era. The marred and unrestored condition of many of the objects Elgin brought back from Athens also speaks to the consolidation of an aesthetics of ruin and fragmentation in which the museum played a vital part.

While many artists associated with the neoclassical revival of the eighteenth century spoke in support of the acquisition, the skeptical testimony of a connoisseur such as Richard Payne Knight, like the anxious questioning of the commissioners themselves about the status of the Apollo Belvedere as a point of comparison, suggests the challenge presented to earlier canons of taste by the Parthenon Marbles. The dilemma of arriving at a fair financial appraisal of material that might be considered either priceless or of little value speaks to the museum's role in itself imparting worth. The parliamentary debate included in this selection demonstrates that the controversy involved not only the actual cost of the objects but also the moral and political questions raised by their means of acquisition. Even more clearly than

the *Report*, the debate places the accession in the context of international cultural politics of the Napoleonic era. The members of Parliament were well aware that it was only six months earlier—and with a great deal of English help—that the looted masterpieces of Roman sculpture that had filled the Musée Napoleon had finally been restored to the Vatican.

Capacious and heterogeneous as it was, it soon became evident that the British Museum could not be the only repository of the nation's aesthetic aspirations, and a modest National Gallery was founded with the purchase of the collection of John Julius Angerstein, a set of works put on display at the collector's home in Pall Mall in 1824. Although the question of the worth of the Elgin Marbles had been referred to artists and connoisseurs, the terms of the parliamentary debate on building a more suitable home for the collection make clear that the validation for public support of the museum had to move beyond the concerns of specialists. While international affairs were a clear subtext of the debate on the Elgin Marbles, support for the development of a creditable gallery of art in the nation's capital was profoundly affected by a pressing crisis in national politics. Robert Peel's 1832 interventions on funding a new building for the Gallery touch on some of the key social arguments for support of the arts, not only the perennial topic of the poor quality of British design as opposed to the excellence of British technology, but the more general hope that the museum might provide a site in which it would be possible to ameliorate relations among classes divided by the political crises that characterized the era of the first Reform Bill.

The creation and development of museums and the culture needed to support them evidently required more than political commitments. The popular press—made newly effective by the development of cheaper forms of illustration and reproduction, and eventually by the reduction of the paper tax—was intimately connected with the emergence of museums in the nineteenth century. Groups such as the Society for the Diffusion of Useful Knowledge recognized in the public museums the manifestation of drives close to those motivating their own publications. The typical interplay among press, politicians, and cultural institutions is evident in a set of four articles on the British Museum in the Society's organ, *The Penny Magazine*. The series, itself inspired by recent parliamentary investigations (1836), is just one instance of the *Magazine*'s characteristic attempts to impart not only information but a new level of comfort with high culture. Thus, along with a history of the institution and its founders, it features instruction for the intimidated visitor on how to respond to the material on view.

The National Gallery was regarded as unsuccessful and even as something of an embarrassment for the first several decades of its existence. The tone and emphases of Anna Jameson's *Handbook to the Public Galleries of Art in and near London*

(1842) anticipate debates that would come to shape the great period of museum reform at mid-century. Jameson's frustrations would be typical of British art lovers for some decades to come, ever imagining plans for rational display, but constrained by the mismanagement and parsimony typical of the few public collections and the indifference and idiosyncrasy of the great private ones.

—◦❦ ❧◦—

## Report from the Select Committee of the House of Commons on the Earl of Elgin's Collection

### Testimony: Lunæ, 4° die Martii, 1816, Henry Bankes,[1] Esquire, in the Chair

#### Joseph Nollekins, Esquire, R. A. Called in, and Examined

ARE you well acquainted with the collection of Marbles brought to England by Lord Elgin?—I am.

What is your opinion of those Marbles, as to the excellency of the work?—They are very fine; the finest things that ever came to this country.

In what class do you place them, as compared with the finest Marbles which you have seen formerly in Italy?—I compare them to the finest of Italy.

Which of those of my Lord Elgin's do you hold in the highest estimation?—I hold the Theseus and the Neptune two of the finest things; finer than any thing in this country.[2]

In what class do you place the bas reliefs?—They are very fine, among the first class of bas relief work.

Do you think that the bas reliefs of the Centaurs are in the first class of art?—I do think so.

Do you think the bas relief of the frieze, representing the Procession, also in the first class of the art?—In the first class of the art.

Do you conceive those two sets to be of or about the same date?—I cannot determine upon that.

From House of Commons, *Report from the Select Committee of the House of Commons on the Earl of Elgin's Collection* (London: John Murray, 1816), 1–17; 67–104 (excerpts).

1. Henry Bankes: see authors and speakers. [Ed.]
2. The fragments from the Acropolis include a bas relief frieze showing a religious procession, metopes (or decorated panels) carved in deeper relief representing scenes from a battle between centaurs and Lapiths, and a set of extremely damaged pedimental statues identified at the time as Theseus, Neptune, and other gods. [Ed.]

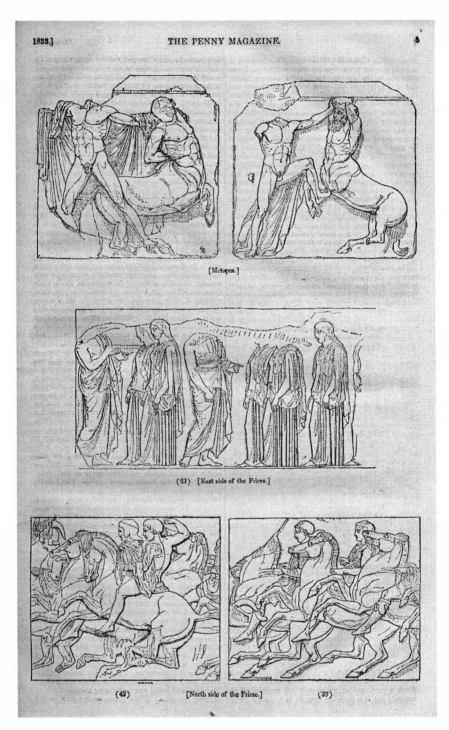

[Metope.]

(23) [East side of the Frieze.]

(42)     [North side of the Frieze.]     (39)

FIGURE 2.1 Elgin Marbles, Metope and Frieze. Henry Ellis, *Elgin and Phigaleian Marbles*, vol. 2. London: Charles Knight, 1833.

Have you ever looked at this Collection, with a view to the value of it?—No, I have not.

Can you form any sort of estimate of the value of it?—I cannot say any thing about the value.

Do you think it very desirable, as a National object, that this Collection should become public property?—Undoubtedly.

Can you form any judgment as to the date of those works, comparing them with other works that you have seen in Italy?—I suppose they are about as old; but they may be older or later.

To which of the works you have seen in Italy do you think the Theseus bears the greatest resemblance? I compare that to the Apollo Belvidere and Laocoon.[3]

Do you think the Theseus of as fine sculpture as the Apollo?—I do.

Do you think it is more or less of ideal beauty than the Apollo?—I cannot say it is more than the Apollo.

Is it as much?—I think it is as much.

Do you think that the Theseus is a closer copy of fine nature than the Apollo?—No; I do not say it is a finer copy of nature than the Apollo.

Is there not a distinction amongst artists, between a close imitation of nature, and ideal beauty?—I look upon them as ideal beauty and closeness of study from nature.

You were asked just now, if you could form any estimate of the value of this Collection; can you put any value upon them comparatively with the Townley Marbles?[4]—I reckon them very much higher than the Townley Marbles for beauty.

Suppose the Townley Marbles to be valued at £ 20,000., what might you estimate these at?—They are quite a different thing; I think the one is all completely finished and mended up, and these are real fragments as they have been found, and it would cost a great deal of time and expense to put them in order.

For the use of artists, will they not answer every purpose in their present state?—Yes, perfectly; I would not have them touched.

Have you seen the Greek Marbles lately brought to the Museum?—I have.[5]

How do you rank those in comparison with these?—Those are very clever, but not like those of Lord Elgin's.

Then you consider them very inferior?—No; I consider them inferior to Lord Elgin's, not very inferior, though they may be called inferior.

Were you ever in Greece yourself?—No, never further than Rome and Naples.

When you studied in Italy, had you many opportunities of seeing remains of Grecian art?—I saw all the fine things that were to be seen at Rome, in both painting and sculpture.

---

3. The Apollo Belvedere was on display at the Vatican by 1511. The Laocoon, discovered in 1506, was immediately purchased by Pope Julius II and also placed in the Belvedere. Although they were identified as touchstones of ideal beauty and as original productions of the best period of classical art throughout the eighteenth century, by the early years of the nineteenth century the preeminence of these works had been challenged among connoisseurs. Both are now recognized as Hellenistic productions, the Apollo possibly based on an earlier model. [Ed.]

4. Townley: see glossary. [Ed.]

5. Phigaleian marbles: sculptures from the Temple of Apollo at Bassae, Greece, acquired in 1815. [Ed.]

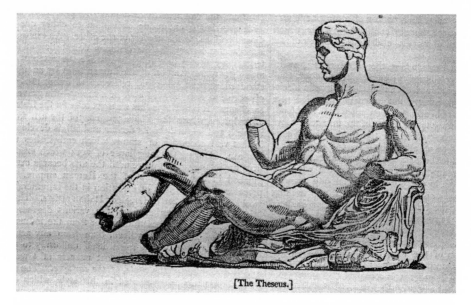

[The Theseus.]

FIGURE 2.2  Elgin Marbles, "The Theseus." Henry Ellis, *Elgin and Phigaleian Marbles,* vol. 2. London: Charles Knight, 1833.

Do you remember a piece of bas relief representing Bacchus and Icarus in the Townley collection?—I recollect all those things; I used to spend my Sundays there with Mr. Townley.

Do you happen to recollect particularly that piece?—No, I do not recollect it among the great quantity of things.

Have you formed any idea of the value of these objects in the light of acquisitions to individuals, as objects of decoration, if sold individually?—I cannot put a value upon them; they are by far the finest things that ever came to this country.

Do you mean by that, that you consider them so valuable, that you cannot put a value upon them?—No, I do not know; as to fine things, they are not to be got every day.

Do you consider part of the value of the Townley Collection to have depended upon the cost and labour incurred in restoring them?—As for restoring them, that must have cost a great deal of money; I know Mr. Townley was there for years about them.

Have the Elgin Collection gained in general estimation and utility since they have been more known and studied?—Yes.

## John Flaxman, *Esquire, R. A. Called in, and Examined*

ARE you well acquainted with the Elgin collection of marbles?—Yes, I have seen them frequently, and I have drawn from them; and I have made such enquiries as I thought necessary concerning them respecting my art.

In what class do you hold them, as compared with the first works of art which you have seen before?—The Elgin Marbles are mostly basso-relievos, and the finest works

of art I have seen. Those in the Pope's Museum, and the other galleries of Italy, were the Laocoon, the Apollo Belvidere; and the other most celebrated works of antiquity were groups and statues. These differ in the respect that they are chiefly basso-relievos, and fragments of statuary. With respect to their excellence, they are the most excellent of their kind that I have seen; and I have every reason to believe that they were executed by Phidias, and those employed under him, or the general design of them given by him at the time the Temple was built; as we are informed he was the artist principally employed by Pericles and his principal scholars, mentioned by Pliny, Alcamenes, and about four others immediately under him; to which he adds a catalogue of seven or eight others, who followed in order; and he mentions their succeeding Phidias, in the course of twenty years.[6] I believe they are the works of those artists; and in this respect they are superior almost to any of the works of antiquity, excepting the Laocoon and Toro Farnese; because they are known to have been executed by the artists whose names are recorded by the ancient authors.[7] With respect to the beauty of the basso-relievos, they are as perfect nature as it is possible to put into the compass of the marble in which they are executed, and that of the most elegant kind. There is one statue also which is called a Hercules or Theseus, of the first order of merit. The fragments are finely executed; but I do not, in my own estimation, think their merit is as great.

What fragments do you speak of?—Several fragments of women; the groups without their heads.

You do not mean the Metopes?—No; those statues which were in the east and west pediments originally.

In what estimation do you hold the Theseus, as compared with the Apollo Belvidere and the Laocoon?—If you would permit me to compare it with a fragment I will mention, I should estimate it before the Torso Belvidere.[8]

As compared with the Apollo Belvidere, in what rank do you hold the Theseus?— For two reasons, I cannot at this moment very correctly compare them in my own mind. In the first place, the Apollo Belvidere is a divinity of a higher order than the Hercules; and therefore I cannot so well compare the two. I compared the Hercules with a Hercules before, to make the comparison more just. In the next place, the Theseus is not only on the surface corroded by the weather; but the head is in that impaired state that I can scarcely give an opinion upon it; and the limbs are mutilated. To answer the question, I should prefer the Apollo Belvidere certainly, though I believe it is only a copy.

6. Phidias, said to have been the greatest of all the Greek sculptors of the great age of Classical art, oversaw the design and construction of the Parthenon, which had been commissioned by Pericles (c. 490–429 B.C.), the most important statesman of a Democratic Athens. Pliny the Elder (A.D. 23–79) is a principal source on the history of Greek art. The sculptor Alcamenes was a younger contemporary of Phidias, said to have been his pupil (or "scholar"). [Ed.]

7. The Toro Farnese, or "Farnese Bull," was a sculptural work excavated in the Baths of Caracalla in Rome in 1545 and subsequently placed on display at the Palazzo Farnese. In the late eighteenth century it was taken to Naples, where it remains. It was originally associated with a large marble group described by Pliny, and so it is another work originally ascribed to early Greek masters but ultimately identified as a later Roman production. [Ed.]

8. The Belvedere Torso, a highly admired fragment of classical sculpture, was at the Vatican by early in the sixteenth century. Closely identified with Michelangelo, who adapted it in important works, it was ceded to the French in 1797, but returned to the Vatican with other works of art in 1816. [Ed.]

Does the Apollo Belvidere partake more of ideal beauty than the Theseus?—In my mind it does decidedly: I have not the least question of it.

Do you think that increases its value?—Yes, very highly. The highest efforts of art in that class have always been the most difficult to succeed in, both among ancients and moderns, if they have succeeded in it.

Supposing the state of the Theseus to be perfect, would you value it more as a work of art than the Apollo?—No; I should value the Apollo for the ideal beauty before any male statue I know.

Although you think it is a copy?—I am sure it is a copy; the other is an original, and by a first rate artist.

The Committee is very anxious to know the reason you have for stating so decidedly your opinion, that the Apollo is a copy?—There are many reasons; and I am afraid it would be troublesome to the Committee to go through them. The general appearance of the hair, and the mantle of the Apollo Belvidere, is in the style more of bronze than of marble; and there is mentioned in the Pope's Museum (Pio Clementino) by the Chevalier Visconti, who illustrated that museum, that there was a statue in Athens, I do not know whether it was in the city or some particular temple, or whether the place is mentioned, an Apollo Alexicacos, a driver away of evil, in bronze by Calamis, erected on account of a plague that had been in Athens; from the representations of this statue in basso-relievos with a bow, it is believed that this figure might be a copy of that.[9] One reason I have given is, that the execution of the hair and cloak resembles bronze. But another thing convinces me of its being a copy; I had a conversation with Visconti and Canova, on the spot;[10] and my particular reason is this, a cloak hangs over the left arm, which in bronze it was easy to execute, so that the folds on one side should answer to the folds on the other; the cloak is single, and therefore it is requisite, that the folds on one side should answer to the folds on the other; there is no duplication of drapery; in bronze that was easy to execute, but in marble it was not; therefore I presume, the copyist preferred copying the folds in front, but the folds did not answer to each other on one side and the other; those on the back appear to have been calculated for strength in the marble, and those in front to represent the bronze, from which I apprehend they were copied. There is another reason, which is, that the most celebrated figure of antiquity is mentioned by Pliny and its sculptor, the Venus of Cnidus by Praxiteles; and he mentions it in a remarkable manner, for he says the works of Praxiteles in the Ceramicus, not only excel those of all other sculptors, but his own; and this Venus excels all that he ever did.[11] Now it seems inconceivable, that so fine a statue as the Apollo could have been executed without its name being brought down to us, either by Pliny or Pausanias, if it had been esteemed the first statue in the world.

9.  Giovanni Battista Antonio Visconti (1722–1784): the prefect of antiquities at Rome from 1768, he organized the Museo Pio-Clementino at the Vatican and produced the first volume of its catalogue. Calamis was a noted sculptor of the first half of the fifth century B.C. [Ed.]

10.  Antonio Canova (1757–1822): the principal sculptor of the neoclassical era, Canova also served as art curator to Pope Pius VII. In 1815 he was sent to Paris to participate in the recovery of art looted by Napoleonic troops. [Ed.]

11.  The renowned Venus of Cnidus, carved by Praxiteles in the fourth century B.C., was a much-imitated model for the representation of the goddess. See Pliny, *Natural History* 36.20-1. Ceramicus: ancient graveyard of Athens. [Ed.]

Do you think it of great consequence to the progress of art in Britain, that this Collection should become the property of the Public?—Of the greatest importance, I think; and I always have thought so as an individual.

Do you conceive practically, that any improvement has taken place in the state of the arts in this country, since this Collection has been open to the Public?—Within these last twenty years, I think sculpture has improved in a very great degree, and I believe my opinion is not singular; but unless I was to take time to reflect upon the several causes, of which that has been the consequence, I cannot pretend to answer the question: I think works of such prime importance could not remain in the country without improving the public taste and the taste of the artists.

— ⚬❦ ❦⚬ —

In what rate do you class these Marbles, as compared with Mr. Townley's collection?—I should value them more, as being the ascertained works of the first artists of that celebrated age; the greater part of Mr. Townley's Marbles, with some few exceptions, are perhaps copies or only acknowledged inferior works.

Do you reckon Lord Elgin's Marbles of greater value, as never having being touched by any modern hand?—Yes.

### Richard Payne Knight, Esquire, Called in, and Examined

ARE you acquainted with the Elgin Collection—Yes: I have looked them over, not only formerly, but I have looked them over on this occasion, with reference to their value.

In what class of art do you place the finest works in this Collection?—I think of things extant, I should put them in the second rank—some of them; they are very unequal; the finest I should put in the second rank.

Do you think that none of them rank in the first class of art?—Not with the Laocoon and the Apollo, and these which have been placed in the first class of art; at the same time I must observe, that their state of preservation is such I cannot form a very accurate notion; their surface is gone mostly.

Do you consider them to be of a very high antiquity?—We know from the authority of Plutarch, that those of the Temple of Minerva, which are the principal, were executed by Callicrates and Ictinus, and their assistants and scholars; and I think some were added in the time of Hadrian, from the style of them.[12]

Do you consider what is called the Theseus and the River God, as works of that age?—The River God I should think, certainly—of the Theseus I have doubts whether it was in that age or added by Hadrian; there is very little surface about it, therefore I cannot tell: the River God is very fine.

Do you consider the River God as the finest figure in the collection?—Yes, I do.

---

12.  Callicrates and Ictinus: fifth-century architects credited with the design of the Parthenon. See Plutarch, *Lives of the Noble Greeks and Romans*, "Pericles" (75 A.D.), 13.4. Hadrian (76–138 A.D.), great art lover and connoisseur, was proclaimed Roman emperor in 117 A.D. [Ed.]

In what class do you rank the fragments of the draped female figures?—They are so mutilated I can hardly tell, but I should think most of them were added by Hadrian: they are so mutilated I cannot say much about them: they are but of little value except from their local interest, from having been part of the Temple.

In what class of art do you consider the metopes?—The metopes I consider of the first class of relief: I think there is nothing finer: but they are very much corroded: there are some of them very poor: but the best of them I consider as the best works of high relief.

Do you consider them as of high antiquity?—I consider most of them as executed at the time of the original building; the others might have been finished since.

What proportion of them do you think are of the first class?—I should think a half at least.

In what class of art do you reckon the frieze of the Procession?—I think it is of the first class of low relief: I know nothing finer than what remains of it: there is very little of it.

Do you consider that as of the same high antiquity?—Certainly; all of it I think has been executed at the first building of the Temple, as far as I can judge: they are very much mutilated.

Can you form any judgment as to what may be the money value of that collection or of the parts?—I have gone over them to make an estimate, and I will state the grounds on which I have done it: I have been over them three times, to form the value. I valued that statue of Venus, which Lord Lansdowne paid £700, for, at £1,400.: and I valued Lord Elgin's accordingly; and I put on fifty per cent in consideration of their local interest. I valued the draped figures, which I think would be worth very little if it were not for their local interest, at £2,000. I do not know the value of the drawings.

[The Witness delivered in a paper, which was read as follows.]

"Such of the Sculptures of the Temple of Minerva at Athens, as are of the time of Pericles, are the work of Callicrates and Ictinus, or their assistants and scholars, to which the testimony of Plutarch, the only ancient authority, is precise—Phidias only made the statue of the Goddess, and presided over the works of Pericles in general."

"The Prices which have been paid to Roman dealers, within my knowledge, for important articles in this country, are as follows:—

By Mr. Townley, to Jenkins, for the Discobolus    £700

By the Marquis of Lansdowne, to D°, for a Hercules.... 600

By Mr. Townley, to D°, for the Relief of the Feast of
Icarus ................................................................. 400

By D°, to Gavin Hamilton, for a large Venus ............... 700
(I learn since that Mr. Townley paid about £350 more
in fees to have the Venus exported.)

By the Marquis of Lansdowne, to D°, for a Mercury ....700[13]

13. William Petty Fitzmaurice, second Earl of Shelburne, first Marquess of Lansdowne (1737–1805): English statesman, formed an important collection of antiquities in the late eighteenth century. On Jenkins, see above (28). Townley: see glossary. Gavin Hamilton (1723–1798):

"The two last articles were, however, unreasonably cheap even at that time (forty years ago)—Hamilton not having been allowed a fair competition; and the last having been clandestinely brought from Rome. I think each of them worth more than any two articles in Lord Elgin's collection, especially the latter, which is, in my judgment, of better sculpture; and both are a thousand per cent. better in preservation, which has always been considered as of the utmost importance.

| | |
|---|---|
| Recumbent statue of Hercules, as on the coins of Croto, with little of the surface remaining | £1,500 |
| Trunk of a male statue recumbent | 1,500 |
| Back and shoulders of a trunk, on which the head of Hadrian appears to have been | 200 |
| Fragment of the head of a horse, very fine | 250 |
| Fragments of about ten draped trunks, from the pediments of the Parthenon, most of which appear to be the age of Hadrian | 2,000 |
| Fourteen metopes, of various degrees of merit, all corroded, and mostly much mutilated | 7,000 |
| Twelve pieces of frieze of the cell, with parts entire | 3,600 |
| About thirty-five more, completely ruined | 1,400 |
| Three capitals, and part of a column, from the same temple | 500 |
| Plaster casts, from d° and other temples | 2,500 |
| A granite scarabous | 300 |
| A white marble soros complete and entire, but coarse | 500 |
| Various shafts and blocks of marble | 350 |
| D° of porphyry | 350 |
| Various fragments of statuary and relief | 500 |
| Various d° of architecture | 300 |
| Caryates from the Propylæa, much injured | 200 |
| Nine broken marble urns | 450 |
| One wrought brass d° | 150 |
| One inscribed earthen d° | 150 |

influential neoclassical painter and archeologist, Hamilton was also an important dealer in antiquities to English and Roman collectors, often in partnership with Jenkins, and James Byres, with whom he undertook excavations at Hadrian's villa. The Marquess of Lansdowne made substantial purchases from their finds at this site between 1770 and 1780. [Ed.]


Inscriptions, &c. ..........................................................  300
Medals...................................................................  1,000
                                                                        _____
                                                                        £25,000
Drawings ...............................................................       ”


Do you conceive that if this Collection were to be publicly sold, it would produce the prices that are named here?—No, not near half, if sold in detail; what any of the Sovereigns of Europe might give for them collectively, I cannot pretend to say.

Do you conceive that the medals, if sold in England, would produce as much as they are valued at?—Yes, certainly; and I think the cameo would.

Upon what authority do you state, that a great part of these marbles belong to the time of Hadrian?—From no other authority than Spon and Wheler having thought one of the heads to be of that Emporor, and later travellers having found no symbols of any deity upon it; also from the draped trunks, which seem to be of that complicated and stringy kind of work which was then in fashion; that is mere matter of opinion; there is no authority as to the time when particular articles were made.[14]

Upon which of the figures is it that you understand Spon and Wheler to have recognized the head of Hadrian?—I can give no opinion on this point, having misunderstood Lord Aberdeen, from whose conversation I had formed an opinion.[15]

Have you ever seen Nointel's drawing of that pediment, as it was at the time when Spon and Wheler saw it?—I have seen a copy of it, but it is so long since that I do not recollect.[16]

Do not you recollect that Spon and Wheler's observations were exceedingly loose, and in some cases wholly inaccurate?—Very loose, certainly.

And in some cases wholly inaccurate?—It is a long while ago since I have adverted to them.

What do you think of the value of the River God, compared with the Torso of Belvidere?—I really can hardly speak to that; I have not perfect recollection enough of the surface of the Torso, and I never considered it in a pecuniary view; I cannot speak to the execution, not having a recollection of the surface; but as a part of a statue, I think the River God inferior. I cannot speak to the value, but I should not put the River God at so much under as fifty per cent.

Do you consider the River God as considerably superior to the Theseus?—Yes, I do.

14.  *A Journey into Greece by George Wheler, Esq., in Company of Dr. Spon of Lyons* (1682) provided illustrations and an important, if not always accurate, account of the Parthenon before it had suffered significant later damage. [Ed.]

15.  George Hamilton Gordon, fourth Earl of Aberdeen (1784–1860): scholar, politician, and eventually prime minister, visited Athens and studied the Parthenon in 1803. [Ed.]

16.  In 1674, C.F. Olier, Marquis de Nointel, French ambassador to Constantinople, visited Athens in the company of Jacques Carrey, who produced remarkably accurate drawings of the Parthenon sculptures. [Ed.]

Then do you consider the Theseus as vastly inferior to the Torso of Belvidere?—I consider it considerably inferior, not vastly inferior; it is difficult to speak to the degrees of things of that kind, especially when the surface is so much corroded.

Do you consider the Torso of Belvidere as having any value whatsoever, but as a model or school for art?—Yes; I think it has value in every respect to collectors as well as students.

It has no furniture value?—No; a corroded, dirty surface people do not like.

Do you think the corrosion of the surface of the Torso of Belvidere renders it, in any considerable degree, less valuable as a model or school for art?—If it is corroded, it certainly does; but I do not recollect whether it is or not; it is very much stained I know.

Do you recollect in what degree the River God is corroded?—The upper parts that have been exposed to the weather are corroded; the under parts are entire, and very perfect. I think it is not so much corroded as the Theseus; but I think there is more than half of it corroded; the back and the side, which are very fine, are not corroded.

Have you formed any estimate of the value of these Marbles, wholly unconnected with their value as furniture, and merely in the view of forming a national school for art?—The value I have stated, has been entirely upon that consideration of a school of art; they would not sell as furniture; they would produce nothing at all. I think, my Lord Elgin, in bringing them away, is entitled to the gratitude of the Country; because, otherwise, they would have been all broken by the Turks, or carried away by individuals, and dispersed in piece-meal. I think therefore the Government ought to make him a remuneration beyond the amount of my estimate.

The Committee observe, that in the paper you have given in of your estimate of the value, you lead to that value, by an enumeration of the prices of five different pieces of sculpture; the Committee beg to know, whether all those pieces are not fit for what may be called furniture?—Certainly.

Do you consider our own Artists as proper judges of the execution of ancient works of art?—Those I am acquainted with, Mr. Nollekens and Mr. Westmacott, are very good judges.

Do you happen to be acquainted with Mr. Flaxman?—Yes; they are all good judges.

They are competent judges?—Yes.

Have you reason to think that the art of Sculpture has advanced in this Country since this Collections has been brought into England?—No, certainly not; the best thing that has ever been done in this country, in my judgment, is the monument of Mrs. Howard, by Mr. Nollekens, many years ago.[17]

Do not you conceive that the purchase of my Lord Elgin's collection by the Nation, for the purpose of forming a great National school of art, would contribute very much eventually to the improvement of the arts in this Country?—A general Museum of Art is very desirable, certainly. I dare say it will contribute to the improvement of the Arts; and I think it will be a valuable addition to the Museum.

---

17.  Joseph Nollekens (1737–1823): the most successful British neoclassical sculptor. His monument to Mrs. Howard of Corby was widely admired in his day. [Ed.]

—◦❧ ❦◦—

## House of Commons: *Parliamentary Debate on Purchasing the Elgin Marbles*

ELGIN MARBLES.] The House having resolved itself into a committee of supply,

Mr. *Bankes*, in calling the attention of the committee to this subject, expressed his regret that it had not been decided when under consideration five years ago. On the present occasion he should not take up much of the time of the committee, as he anticipated some objections to his proposition. Where the reputation of his country was concerned, as in cases where opportunities had occurred of purchasing valuable collections in science or art, calculated to enlighten and improve the taste of the people, even under the pressure of war, the House had never shown an unwillingness to listen to any applications made to them on that account. What large additions had been made to the public stock of valuable monuments of this description in the late French war. He need only refer to the Lansdown manuscripts; and what was more analogous to the present case, the Townleian collection of marbles purchased in 1795, when the war was but recently begun, and there was no prospect of its being soon finished.[1] He wished to remind the House what a large vote had been given in the last session for a national monument to commemorate the glorious battle of Waterloo. In the present session, the House had also voted a monument in commemoration of the victory of Trafalgar, though long since past. He made these preliminary observations, in order to meet the objections of economy, which, he conceived, did not apply in this case. By declining to purchase the Elgin marbles, the public must renounce all right in the thing, and leave my lord Elgin at liberty to deal with any person who offers to purchase. The sort of mixed claims which the public had on lord Elgin, was, he conceived, of this description—they had not a right to take his collection from him by force; but they had a right of preemption at a fair price and to say that it should not be taken out of this country. If he had not heard from gentlemen that it was their intention to oppose the present grant, he should not have thought it necessary—supposing the things good in themselves—to press upon the House, of what great consequence it was to every country, to promote public taste, and public refinement. How could these be better promoted than by making the greatest examples of excellence their own, for the benefit of the public? With respect to the manner in which the Elgin marbles had been acquired, the objects certainly could not have been attained, had lord Elgin not been a British ambassador; but it was not solely as a British ambassador that he obtained them. No objection had ever been made to the operations of lord Elgin, either by the government, at Constantinople, or the local

From *Hansard Parliamentary Debates*, 1st ser. Vol. 34 (1816), cols. 1027–1040.

1. The Lansdowne Collection, comprising more than 1,200 volumes of manuscripts acquired by Lord Lansdowne, first Earl of Shelbourne, was purchased for the British Museum by vote of Parliament in 1807. Townley: see glossary. [Ed.]

authorities; nor did it appear that any person had ever been disgraced or superseded on that account. Not only the local authorities of Athens were favourable, but the natives both Turks and Greeks, assisted as labourers. He had to state confidently that in all the examinations before the committee, of persons who had been at Athens, either at the period of lord Elgin's operations, or shortly afterwards, the uniform tenour of the evidence was, that the natives were not only instrumental in carrying the firmaun[2] into execution, but even pleased with it as the means of bringing money among them. He could therefore say, that there was nothing like spoliation in the case, and that it bore not resemblance to those undue and tyrannical means by which the French had obtained possession of so many treasures of art, which he rejoiced to see again in the possession of their rightful owners.[3] A notion prevailed among some gentlemen, that these treasures also should be restored to their original owners. But how was this to be done? Were they to be taken as public property? Though we had a right of pre-emption, we had no right to take them away from lord Elgin without compensation. Did they mean that they should be purchased from lord Elgin, for the purpose of being shipped back to those who set no value on them? Were not these works in a state of constant dilapidation and danger before their removal? The climate was no doubt less severe than our northern one; but still they were then making rapid strides towards decay, and the natives displayed such wanton indifference as to fire at them as marks. They had also been continually suffering, from the parts carried off by enlightened travelers. The greatest desire, too, had been evinced by the government of France to become possessed of them. We found them however here. The public had a right to bargain for them; and it would be a strange neglect of the policy pursued by the House of Commons in all the times, and especially during the late war, if they neglected to become possessed of them. With respect of the price, in all works of art, the value might be said to depend on caprice. The most eminent artists had been consulted by the committee; by many they were classed above, and by others little below the highest works obtained since the restoration of art; and for forming a school of art they were considered as absolutely invaluable. The House had some actual data to guide them in the price given for the Townley collection. In point of number, the age to which they belonged, the place from which they were brought and the authenticity of the collection, there could be no doubt that they ranked considerably higher than the Townleian collection. If the Townleian collection was worth 20,000*l.* this was worth at least the 15,000*l.* additional proposed to be given. There was at least one foreign prince extremely desirous of purchasing this collection. The opportunity would not again recur. In no time had so large, so magnificent, and so well authenticated a collection of works of art of the best time, been produced, either in this or in any other country. In Italy the works of ancient art were found in excavations at different places and different times. But here we had at once the whole of the ornaments of the most celebrated temple of Athens. There

2. Athens was under the control of the Ottoman Empire. Elgin and his supporters based the legal justification for the removal of the Parthenon marbles on a firmaun, or official permission, granted by the Porte, or government, in Constantinople. [Ed.]

3. With significant British support, the major works of art looted by Napoleon for display at the Louvre had been returned to Italy early in 1816. [Ed.]

was another mode of valuing the collection, the expense incurred in making it. He had no doubt that the sum proposed to be given fell considerably within the expense actually incurred by lord Elgin, exclusive of interest. In 1811, 30,000*l.* had been offered by Mr. Perceval, provided lord Elgin could make it appear that his expense amounted to that sum.[4] But considerable additions had been made since 1811, no fewer than eighty cases, containing some of the best works had been since received, and persons who were judges had no doubt that such additions greatly exceeded in value 5,000*l.* Under all these circumstances, he should move, "That 35,000*l.* be granted to his majesty, for the purchase of the Elgin marbles, and that the said sum be issued and paid without any fee or other deduction whatsoever."

Mr. *Curwen* opposed the grant. He cordially joined the hon. gentleman in his sentiments respecting the importance of works of art. The hon. gentleman had referred to the monuments voted for the victims of Waterloo and Trafalgar. He hoped, however, in the present situation of the country, that the House would retrace their steps. No monument could add to the transcendant glory of those victories, or of the heroes engaged in them. A statement had been made the other night, that the expenses of the country exceeded the revenue by nearly 17,000,000*l.* He wished it were possible to controvert this statement. In such a state was it fit to make purchases of this description, however gratifying to a few individuals, at the expense of the nation? He was afraid that we were fast approaching to that course of extravagance with respect to the public money, which had brought to decay the countries where these works of art were produced. Whatever imputations of want of taste and feeling might be thrown out against him, he would say that the House were bound, however much they admired this collection, and it was admired by every man in the House, to refrain from making the purchase at the present moment. Retrenchments of a very different magnitude from any yet witnessed must necessarily be made.

Mr. *J. W. Ward* was as adverse to idle expenditure as the hon. gentleman himself could be, and thought we should not seek occasions for it; yet he considered the present an opportunity of benefiting the public that could not occur again: and it was precisely because it was not against the principle of economy that he voted for the measure. As to the spoliation of Greece that had been so much complained of, no one could be more unwilling than he was that these sacred relics should be taken from that consecrated spot, where they had excited the enthusiasm of ages; no one could have a greater respect than himself for the feelings of nations; but these objects were lying in their own country in a course of destruction: and he wished to consult the feelings of that country by any means short of the actual destruction of specimens so precious. As to the price that had been proposed, it was pretty clear that foreign princes would go to it, if we did not; and it certainly did not exceed the value of the articles.

Mr. *Hammersley* said, he should oppose the resolution on the ground of the dishonesty of the transaction by which the collection was obtained. As to the value of the statues, he was inclined to go as far as the hon. mover, but he was not so

4. Spencer Perceval (1762–1812): prime minister 1809–1812.

enamoured of those headless ladies as to forget another lady, which was justice. If a restitution of these marbles was demanded from this country, was it supposed that our title to them could be supported on the vague words of the firmaun, which only gave authority to remove some small pieces of stone? It was well known that the empress Catharine had entertained the idea of establishing the Archduke Constantine in Greece.[5] If the project of that extraordinary woman should ever be accomplished, and Greece ranked among independent nations with what feelings, would she contemplate the people who had stripped her most celebrated temple of its noblest ornaments? The evidence taken before the committee disproved the assertion that the Turkish government attached no value to these statues. Lord Elgin himself had not been able to gain access to them for his artists, for less than five guineas a day. The member for Northallerton (Mr. Morris) had stated before the committee, that when he had inquired of the governor of Athens whether he would suffer them to be taken away, he had said, that for his own part he preferred the money which was offered him to the statues: but it would be more than his head was worth to part with them. He had also stated, that the pieces thrown down were certainly liable to injury, but that the others were only subject to the waste of time. The Turks (the same witness said) were not in the habit of shooting at them, nor had he heard any instance of that kind. But whether the Turks set any value on them or no, the question would not be altered, as his objection was founded on the unbecoming manner in which they had been obtained. It was in the evidence of the noble earl himself, that at the time when he had demanded permission to remove these statues, the Turkish government was in a situation to grant any thing which this country might ask, on account of the efforts which we had made against the French in Egypt.[6] It thus appeared that a British ambassador had taken advantage of our success over the French to plunder the city of Athens. The earl of Aberdeen had stated that no private traveller would have been able to have obtained leave to remove them. But the most material evidence respecting the manner in which these statues had been obtained, was that of Dr. Hunt, who stated, that when the firmaun was delivered to the waywode, presents were also given him.[7] It thus appeared that bribery had been employed, and he lamented that the clergyman alluded to should have made himself an agent in the transaction. It was his opinion that we should restore what we had taken away. It had been computed that lord Elgin's expenses had been 74,000*l.*, of which, however, 24,000*l.* was interest of the money expended. A part of the loss of this sum should be suffered to fall on lord Elgin, and a part on the country. It was to be regretted that the government had not restrained this act of spoliation; but, as it had been committed, we should exert ourselves to wipe off the stain, and not place in our museum a monument of our disgrace, but at once return the bribe which our ambassador had received, to his own dishonour and that of the country. He should

5. Constantine Pavlovich (1779–1839), grand-duke and czarevich of Russia, was part of Catherine the Great's aspirations for influence over Greece. [Ed.]

6. In 1801 the British had driven the French out of Egypt, at the time a province of the Ottoman Empire conquered by Napoleon in 1798. [Ed.]

7. Philip Hunt, Chaplain to the British Embassy in Constantinople, was an active promoter of the removal of the Parthenon marbles. Waywode: official of the Ottoman Empire. [Ed.]

propose as an amendment, a resolution, which stated—" That this committee having taken into its consideration the manner in which the earl of Elgin became possessed of certain ancient sculptured marbles from Athens, laments that this ambassador did not keep in rememberance that the high and dignified station of representing his sovereign should have made him forbear from availing himself of that character in order to obtain valuable possessions belonging to the government to which he was accredited; and that such forbearance was peculiarly necessary at a moment when that government was expressing high obligations to Great Britain. This committee, however, imputes to the noble earl no venal motive whatever of pecuniary advantage to himself, but on the contrary, believes that he was actuated by a desire to benefit his country, by acquiring for it, at great risk and labour to himself, some of the most valuable specimens in existence of ancient sculpture. This committee, therefore, feels justified, under the particular circumstances of the case, in recommending that 25,000*l.* be offered to the earl of Elgin for the collection in order to recover and keep it together for that government from which it has been improperly taken, and to which this committee is of opinion that a communication should be immediately made, stating, that Great Britain holds these marbles only in trust till they are demanded by the present, or any future, possessors of the city of Athens; and upon such demand, engages, without question or negociation, to restore them, as far as can be effected, to the places from whence they were taken, and that they shall be in the mean time carefully preserved in the British Museum."

Mr. *Croker* was desirous not to take up the time of the committee by entering into the discussion, but he could not help remarking upon one or two of the statements which the last speaker had drawn from the evidence, by reading one part of it, and omitting others which should have been taken in connexion. He had never heard a speech filled with so much tragic pomp and circumstance, concluded with so farcical a resolution. After speaking of the glories of Athens, after haranguing us on the injustice of spoliation, it was rather too much to expect to interest our feelings for the future conqueror of those classic regions, and to contemplate his rights to treasures which we reckoned it flagitious to retain. It did seem extraordinary that we should be required to send back these monuments of art, not for the benefit of those by whom they were formerly possessed, but for the behoof of the descendants of the empress Catherine, who were viewed by the hon. gentleman as the future conquerors of Greece. Spoliation must precede the attainment of them by Russia: and yet, from a horror at spoliation, we were to send them, that they might tempt and reward it! Nay, we were to hold them in trust for the future invader, and to restore them to the possession of the conqueror, when his rapacious and bloody work was executed. Our museum, then, was to be the repository of these monuments for Russia, and our money was to purchase them in order that we might hold them in deposit till she made her demand. The proposition, he would venture to say, was one of the most absurd ever heard in that House. Considerations of economy had been much mixed up with the question of the purchase; and the House had been warned in the present circumstances of the country, not to incur a heavy expense merely to acquire the possession of works of ornament. But who was to pay this expense, and for whose use was the purchase intended? The bargain was for the benefit of the public, for the honour of the nation, for the promotion of national arts, for the use of the national

artists, and even for the advantage of our manufactures, the excellence of which depended on the progress of the arts in the country. It was singular that when 2,500 years ago, Pericles was adorning Athens with those very works, some of which we are now about to acquire, the same cry of economy was raised against him, and the same answer that he then gave might be repeated now, that it was money spent for the use of the people, for the encouragement of arts, the increase of manufactures, the prosperity of trades, and the encouragement of industry; not merely to please the eye of the man of taste, but to create, to stimulate, to guide the exertions of the artist, the mechanic, and even the labourer, and to spread through all the branches of society a spirit of improvement, and the means of a sober and industrious affluence. But he would go the length of saying, that the possession of these precious remains of ancient genius and taste would conduce not only to the perfection of the arts, but to the elevation of our national character, to our opulence, to our substantial greatness. The conduct of the noble earl, who by his meritorious exertions, had given us an opportunity of considering whether we should retain in the country what, if retained, would constitute one of its greatest ornaments, had been made the subject of severe and undeserved censure. No blame had, however, been shown to attach to it after the fullest examination. One of the objects, and the most important object, for which he wished the institution of a committee was, that the transactions by which those works of art were obtained, and imported into this country, might stand clear of all suspicion, and be completely justified in the eyes of the world, and that the conduct of the noble lord implicated might be fully investigated. He (Mr. C.) was entirely [un]acquainted with the noble lord before he became a member of the committee, and could, of course, have no partialities to indulge. What he said for himself, he believed he might say for the other members with whom he acted. They were all perfectly unprejudiced before the inquiry commenced, and all perfectly satisfied before its conclusion. They had come to a unanimous opinion in favour of the noble lord's conduct and claims, and that opinion was unequivocally expressed in the report which was the result of their impartial examination. With regard to the spoliation, the sacrilegious rapacity, on which the last speaker had descanted so freely, he would say a few words in favour of the noble lord, in which he would be borne out by the evidence in the report The noble lord had shown no principle of rapacity. He laid his hand on nothing that could have been preserved in any state of repair: he touched nothing that was not previously in ruins. He went into Greece with no design to commit ravages on her works of art, to carry off her ornaments, to despoil her temples. His first intention was to take drawings of her celebrated architectural monuments, or models of her works of sculpture. This part of his design he had to a certain extent executed, and many drawings and models were found in his collection. Nothing else entered into his contemplation, till he saw that many of the pieces of which his predecessors in this pursuit had taken drawings had entirely disappeared, that some of them were buried in ruins, and others converted into the materials of building. No less than 18 pieces of statuary from the western pediment had been entirely destroyed since the time when M. de Nointel, the French ambassador, had procured his interesting drawings to be made; and when his lordship purchased a house in the ruins of which he expected to find some of them, and had proceeded to dig under its foundation with such a hope, the malicious Turk to whom he had given the purchase-money

observed, "The statues you are digging for are pounded into mortar, and I could have told you so before you began your fruitless labour." [Hear, hear!]—Ought not the hon. gentleman who had spoken so much about spoliation to have mentioned this fact? Ought he not to have stated that it was then, and not till then, that lord Elgin resolved to endeavour to save what still remained from such wanton barbarity? Had he read the report, and did he know the circumstances without allowing any apology for the noble earl? Did he not know that many of the articles taken from the Parthenon, were found among its ruins? More than one-third of that noble building was rubbish before he touched it. The hon. member (Mr. Hammersley) had referred to the evidence of the member for Northallerton (Mr. Morrit); but while he quoted one part of it, he had forgotten another, by which that quotation would have been explained and qualified. He had visited Athens in 1796; and when he returned five years afterwards, he found the greatest dilapidations. In his first visit he stated, that there were 8 or ten fragments on the pediment, with a car and horses not entire, but distinguishable: but when he returned, neither car nor horses were to be seen, and all the figures were destroyed but two. If the hon. member, whose statement he was combating, had read the evidence carefully, he would have seen that lord Elgin interfered with nothing that was not already in ruins, or that was threatened with immediate destruction. The temple of Theseus was in a state of great preservation, and, therefore, proceeding on this principle, he had left it as he found it, and only enriched this country with models and drawings taken from it. Much had been said of the manner in which lord Elgin had prostituted his ambassadorial character to obtain possession of the monuments in question. There was no ground for such an imputation. Not a piece had been removed from Athens till lord Elgin had returned, and of course till his official influence ceased. Signor Lucieri was even now employed there under his lordship's orders; and was he still prostituting the ambassadorial character? When his lordship was a prisoner in France, the work was still going on; and was he then prostituting the ambassadorial character? His lordship had remained after his return at his seat in Scotland; and was the character of ambassador injured in his person during his retirement? He (Mr. Croker) might have shown some warmth in defending the opinion of the committee, and removing the imputation thrown upon the noble person whose character had been attacked by the hon. member: but he hoped he would be excused, when the nature of the charges which had excited him were considered.—He could not sit in his place, and hear such terms as dishonesty, plunder, spoliation, bribery, and others of the same kind, applied to the conduct of a British nobleman, who was so far from deserving them that he merited the greatest praise, and to the nature of transactions by which so great a benefit was conferred upon the country, without any ground for a charge of rapacity or spoliation. But if the charges of improper conduct on lord Elgin's part were groundless, the idea of sending them back to the Turks was chimerical and ridiculous. This would be awarding those admirable works the doom of destruction. The work of plunder and dilapidation was proceeding with rapid strides, and we were required again to subject the monuments that we had rescued to its influence. Of 20 statues that decorated the western pediments of the Parthenon, only seven miserable fragments were preserved: yet this part of the building was almost perfect at the beginning of last century; now only a few worthless pieces of marble were preserved—he called them worthless, not

as compared with the productions of art in other countries, but in comparison with what had been lost. They would, however, remain to animate the genius and improve the arts of this country, and to constitute in after times a sufficient answer to the speech of the hon. member, or of any one else who should use his arguments, if indeed such arguments could be supposed to be repeated, or to be heard beyond the bottle hour in which they were made.

Mr. Serjeant *Best* conceived that lord Elgin had not acted as he ought to have done, whatever opinion might be entertained of the works of art which he had been the means of importing into this country. He regarded the improvement of national taste much, but he valued the preservation of national honour still more. He could not approve of a representative of his majesty laying himself under obligations to a foreign court, to which he was sent to watch the interests and maintain the honour of the country. Such an officer should be independent, as by his independence alone he could perform his duty. He had obtained the firmaun out of favour, and had used it contrary to the intention with which it was granted. What would be thought of an ambassador at an European court, who should lay himself under obligations by receiving a sum to the amount of 35,000*l.*? But even the firmaun lord Elgin had obtained did not warrant him to do as he had done. The firmaun could do nothing without bribery. Could the words in which it was written admit the construction that was put upon them? It merely gave a power to view, to contemplate and design them. Did this mean that these works were to be viewed and contemplated with the design of being pulled down and removed? Lord Elgin himself did not say that he had authority to carry off any thing by means of the firmaun. His lordship was himself the best interpreter of the instrument by which he acted, and he was here an interpreter against himself. If he erred, he erred therefore knowingly, though his design might be excusable or praiseworthy. Dr. Hunt's evidence had been quoted, to show that his lordship had authority from the waywode of Athens for what he had done, but his words would not bear such an interpretation. Dr. Hunt said only that the waywode was induced to allow the construction put upon the instrument by lord Elgin. The powerful argument by which the waywode was induced to allow the construction alluded to, consisted in a present of a brilliant lustre, fire-arms, and other articles of English manufacture. But were these the arguments that ought to have been used by a British ambassador? Was he to be permitted to corrupt the fidelity of a subject of another state—the servant of a government in alliance with our own, and under obligations to us? But it had been said that if the works of art had not been brought here, they would have been destroyed by the Turks. This would not have been the alternative. The Turks would have been taught to value these monuments, had they seen strangers admiring them, and travellers coming from distant countries to do them homage. They could not but now learn their value, after they were deprived of them, by hearing that 35,000*l.* had been paid for them to the person who imported them to England. It had been said that lord Elgin would advance the arts by lodging those remains of antiquity in a country where eminence in arts was studiously attempted. This he denied, or at least thought doubtful. Such works always appeared best in the places to which they were originally fitted. Besides, with this example of plunder before their eyes, the Turks would be a little more cautious in future whom they admitted to see their ornaments. These marbles

had been brought to this country in breach of good faith. He therefore could not consent to their purchase, lest by so doing he should render himself a partaker in the guilt of spoliation. He did not object to the bargain on the ground of economy, but of justice.

Mr. *Wynn* was not aware of the transaction being so flagitious as it was said to be. He equally disliked the idea being entertained that we had got them by bribery. Every person who knew the Turkish character must be sensible that when they gave any thing away it was with the view of receiving an equivalent. He could not condemn the transaction on the ground of the marbles being a gift from a foreign government, and therefore affording a bad precedent; for he did not think that a gift of 35,000*l.* purchased at an expense of 64,000*l.* was a precedent likely to be much followed. On the principle of economy he knew it was the duty of the House to act, but economy was often ill-judged, and very much misapplied. Considering them a valuable accession in every point of view, and that the same opportunity might never recur, he had no objection to the grant.

Sir *J. Newport* would vote against the motion, even if the country were in affluent circumstances, on account of the unjustifiable nature of the transaction by which the marbles in question were acquired.

Mr. *C. Long* said, he was ready to agree in all the objections founded upon the unfitness of the time for any acts of lavish expenditure; but the present was an occasion, which could not again present itself, of acquiring for the country these exquisite specimens of art. It was fair to say that the purchase of these precious remains of antiquity was for the grantification of the few, at the expense of the many. The amendment of the hon. gentleman was somewhat inconsistent with his professions of economy, for he proposed to give 25,000*l.* to lord Elgin, for obtaining these marbles dishonestly, and then to send them back to those who would not thank them for their trouble.

Lord *Milton* was aware that an apology might be expected from all those who objected to a grant that was to put the country in possession of these invaluable monuments of ancient art. He could not, however, agree that they had been acquired consistently with the strict rules of morality. They appeared to him to have been obtained by lord Elgin through his influence as ambassador from this country, and it was not unnatural that the Turkish government should view with suspicion a national purchase arising out of such circumstances. The objection to the purchase he should deem niggardly and ill-advised at any other time; but the present was one of peculiar distress, and one in which the want of subsistence was the cause of riot and disturbances in many parts of the country.

Mr. *P. Moure* said, the hon. gentleman who had talked of this being the last opportunity, reminded him of the auctioneer's cry of "going, going, gone." He desired to know whether any offer had been made for these marbles by a foreign power; and whether they were not in fact under sequestration at present by government for a debt due to the Crown by lord Elgin.

Mr. *Brougham* considered that there was no doubt as to the desirableness of our possessing these interesting monuments, from their general tendency to improve the arts. The only question upon which he hesitated was, whether we could afford to buy them. The purchase-money, they were told, was but 35,000*l.*; but he

apprehended that, when purchased, it would be necessary to build a proper recep-
tacle for them, and the whole expense might be estimated at 70 or 80,000*l*. Had we,
then, this money at present in our pockets, with which to gratify ourselves by so
desirable a possession? The stronger the temptation was to this purchase, the greater
satisfaction he felt in redeeming his share of the pledge given to the country, that no
unnecessary expenditure should be incurred.

Mr. *J. P. Grant* declared in favour of the original motion, observing, that that
would be a mistaken economy, as well as bad taste, which would deprive this coun-
try of such valuable works of art as lord Elgin had collected.

The House divided; For the original Motion, 82; Against it, 30.

## House of Commons: *Parliamentary Debate on Building the National Gallery* (April 1832)

Sir *Robert Peel* wished that a definite sum should be especially appropriated to raise a new and suitable building for the National Gallery. This was, truly, a national consideration. The noble collection of pictures which it contained was visited, not only by the inhabitants of the metropolis, but by persons from the most distant corners of the empire, to whom it was a source of the highest gratification. The number of such visitants was upwards of 100,000 in the year, and their convenience deserved the attention of the House. Independently of this consideration, the collection was in itself so fine and so valuable as to deserve an exhibition-room of the choicest construction. It had cost, at least, 150,000*l.*, of which Mr. Holwell Carr's munificent gift alone was valued at 25,000*l.*[1] But motives of public gratification were not the only ones which appealed to the House on this matter; the interest of our manufactures was also involved in every encouragement being held out to the fine arts in this country. It was well known that our manufacturers were, in all matters connected with machinery, superior to all their foreign competitors; but, in the pictorial designs, which were so important in recommending the productions of industry to the taste of the consumer, they were, unfortunately, not equally successful; and hence they had found themselves unequal to cope with their rivals. This deserved the serious consideration of the House in its patronage of the fine arts. For his part, although fully aware of the importance of economy, and most anxious to observe it, he thought this was an occasion for liberality, and, that the House would do well to grant freely a sum of 30,000*l.* for the construction of a suitable edifice for the reception of our noble national collection of pictures. He thought the country would be amply repaid if it devoted a sum of 30,000*l.* for the purpose of erecting a suitable gallery for the reception of the valuable collection of national paintings.

Lord *Althorp* agreed with the right hon. Baronet that it was right and fit that a place should be provided for the reception of the pictures, which would be convenient to the public, but he was not prepared to go to any architectural expense for that purpose.

Sir *Robert Peel* repeated, that he thought it of importance that immediate measures should be taken for providing a gallery; he did not wish to erect an expensive building, the architectural magnificence of which would be attended with great expense, but merely a plain and suitable gallery, with a proper light to view the paintings with advantage.

From *Hansard Parliamentary Debates*, 3rd ser. Vol. 12 (1832), cols. 467–469

1. William Holwell Carr (1758–1830): left his paintings to the nation, with the proviso that a more appropriate structure be found to house the collection. [Ed.]

Mr. *Warburton* concurred in the opinion expressed by the hon. Baronet. He had no doubt it would tend materially to an improvement in our manufactures; and he thought that the expense incurred would be paid over and over again by the advantages derived by the country. He would have no old house selected, but a plain gallery built expressly for the purpose.

Lord *Ashley* observed, that the patronage of works of science and art, such as the calculating machine of Mr. Babbage, had collateral advantages.[2] Some improvements in machinery had lately taken place in Glasgow from the contemplation of that machine. He considered that the erection of a gallery would be extremely beneficial for artists and mechanics to resort to, and he had reason for believing that it would be frequented by the industrious classes, instead of resorting to alehouses, as at present.

2. Charles Babbage (1791–1871): mathematician, scientist, and inventor. Development of his calculating engines, noted precursors to the computer, was supported, if fitfully, by funds from the Treasury. [Ed.]

—◦❧ ❦◦—

## House of Commons: *Parliamentary Debate on Building the National Gallery* (July 1832)

SUPPLY—NATIONAL GALLERY.] House went into a Committee of Supply.

Mr. *Spring Rice* intended to move for a grant of 15,000*l.* as the first instalment towards the expense of building a National Gallery. This vote had not been originally included in the annual estimates; but so great a desire had been expressed on all sides, that such a vote should be submitted, that Ministers, after certain preliminary inquiries, had directed the estimate should be made of the expense of the building. The Commission of Inquiry had recommended that it should be erected partly of brick, and partly of stone; but, when it was found that the building it entirely of stone would add only 3,000*l.* to the expense, it was determined to erect it entirely of that material. He conceived that such a structure ought to be expressive of the progress which architecture had made in this country, and it ought to correspond with the general encouragement that had been given to the arts. The Government would receive in exchange the rooms at present occupied by the Royal Academy in Somerset-place, and they could be most advantageously converted into public offices. The 50,000*l.* for which Government meant, on the whole, to ask, would likewise include the expense of a place of deposit for the public records, and the whole sum would be spread over a period of three years, which was the shortest term in which it could be built with propriety. The present vote was for 15,000*l.*

Sir *Robert Peel* felt the greatest satisfaction in declaring that the vote in every respect met with his most cordial approbation. It had been prepared, most properly by his Majesty's Ministers, in deference to the unanimous sense which had been expressed by the House when the subject had been discussed. After his Majesty's Ministers had ascertained what were the strong and general sentiments upon the subject of encouraging the fine arts, in this country, they had taken the course best adapted to accomplish that most desirable object. He was happy to say, that they had entirely divested the question of all party feeling, and had consulted every class of persons most likely to promote the object in view. He conceived, that it would be very false and pernicious economy that prevented such a building being ornamental, and, of the whole sum demanded, 10,000*l.* might be considered as spent for the security of the public records. It was impossible to reflect upon how the public records had been treated, without admitting the necessity of providing for their security; and no detached building could be erected for that purpose for anything like the sum of 10,000*l.* With reference to the Royal Academy, the value of the rooms which they would give up to the public upon receiving this accommodation would be at least 30,000*l.*, or 2,000*l.* a-year; and the public would also gain very much in obtaining these rooms, as they would contribute greatly to the convenience of the Government

From *Hansard Parliamentary Debates*, 3rd ser. Vol. 14 (1832), cols. 643–648

business. When all these points were considered, together with the saving for the rooms which now contained his Majesty's pictures, he could not but say that in providing a National Gallery for 50,000*l*. Ministers had made an arrangement most favourable and advantageous to the public. When he considered how great and important was the object of having a place in which to exhibit the works of the ancient masters, and the productions of modern artists, he could not but feel that both the Parliament and his Majesty's Ministers did themselves honour by voting this sum. In the present times of political excitement, the exacerbation of angry and unsocial feelings might be much softened by the effects which the fine arts had ever produced upon the minds of men. Of all expenditure, that like the present, was the most adequate to confer advantage on those classes which had but little leisure to enjoy the most refined species of pleasure. The rich might have their own pictures, but those who had to obtain their bread by their labour, could not hope for such an enjoyment. With respect to the situation of the building, it was as well selected as possible, close to Charing Cross, where, as Dr. Johnson said, "the great tide of human existence is fullest in its stream;" and consequently, where all classes of the community would be equally accommodated.[1] He therefore, trusted that the erection of the edifice would not only contribute to the cultivation of the arts, but also to the cementing of those bonds of union between the richer and the poorer orders of the State, which no man was more anxious to see joined in mutual intercourse and good understanding than he was.

Mr. *Ridley Colborne* supported the vote most cordially. As soon as the building was completed he was convinced that valuable works of art would be contributed to it from all quarters, and which had hitherto been withheld merely because there had not been any place to put them in, appropriated by the country.

1. "I think the full tide of human existence is at Charing-Cross." Boswell, *Life of Johnson* (1791) vol. II. [Ed.]

ANONYMOUS

—∘❧ ❦∘—

The British Museum *[History and Description]*

## The British Museum—No. I

The term "Museum" appears to have been first applied to a public institution in Alexandria in Egypt. This was the college or retreat of learned men attached to the celebrated Alexandrian Library. It was called the Museum [μουσετογ] as signifying a place where the arts and sciences were studied, typified by the mythological personages the Muses. The word has passed into general use, to express a collection or repository of rare and curious things in nature and art, arranged for the purposes of study.

No collection, such as we would now term a museum, could well be formed in England, while the country was in an unsettled state. The monasteries were the repositories of books and MSS., and the castles or strongholds of the nobility contained family muniments and records, such as title-deeds, marriage-settlements, &c., but these were frequently scattered by war and confiscation. The Tower of London alone contained anything approaching to what may be termed a national collection. In the latter part of the sixteenth century, and during the seventeenth, a taste or desire for collecting books, manuscripts, coins, and curiosities, began to spread amongst such as had the means to gratify it; but the taste, except with a few, was quite unformed, and delighted more in accumulating what was valueless or absurd, if it were rare or singular, than in gathering stores which would contribute to the advancement of knowledge.

Probably the earliest collector in England of such objects as are now held necessary to constitute a museum, was John Tradescant, who was gardener to Charles I.[1] This individual had travelled over a large part of Europe, and is conjectured to have visited Egypt and other oriental countries. In his travels he collected plants and seeds, and curiosities of every kind. He had a botanical garden at South Lambeth, where he had also a house, in which his curiosities were deposited. This was called Tradescant's Ark; it contained specimens of minerals, birds, fishes, insects, and plants, as well as coins and medals, and a variety of things then considered uncommon rarities. Tradescant's Museum was much celebrated in its day, and was favoured not only by the visits of the nobility and gentry, but by many benefactions from them, a list of which latter is given in a work which he published, entitled 'Museum Tradescantianum, or a Collection of Rarities preserved at South Lambeth, near London, 1656.' From this book it would appear that the Tradescants (father and son) had used great

Anonymous, "The British Museum," *The Penny Magazine* 5 (1836), 350–396 (excerpts).

1. Tradescant: see glossary [Ed.]

64

industry and activity in bringing together a large and valuable collection, though, from the state of knowledge at the time, there were a number of absurdities admitted into it. "Zoology," says Mr. Pennant. "was in their time in a low state, and credulity far from being extinguished; among the eggs was one supposed to have been the egg of the dragon, and another of the griffin. You might have found here two feathers of the tail of the phenix, and the claw of a ruck, a bird able to truss an elephant."[2] The Museum of the Tradescants passed into the hands of Elias Ashmole, the founder of the Ashmolean Museum at Oxford.

To Sir John Cotton, the grandson of the founder of the Cottonian Library, may be fairly attributed the merit of commencing what is now the British Museum. He certainly has the credit of setting the example of establishing a national institution. His grandfather, Sir Robert Cotton, was born in 1570. During his lifetime he was in high repute as an antiquary, and was much esteemed in the courts of Elizabeth and James I. His favourite study and pursuit was the collecting of ancient records, charters, and other valuable manuscripts, in which he displayed considerable judgment. The library which he formed was preserved and augmented by his son and grandson, the latter of whom offered it to the government for the public use, reserving to the Cotton family an interest in it. This offer was accepted, and an act (the 12th and 13th Will III. c. 7) was passed, providing for its care. The preamble of the act states that "Sir Robert Cotton, late of Connington, in the county of Huntingdon, Baronet, did, at his own great charge and expense, and by the assistance of the most learned antiquaries of his time, collect and purchase the most useful manuscripts, written books, papers, parchments [records], and other memorials in most languages, of great use and service for the knowledge and preservation of our constitution, both in church and state, which manuscripts and other writings were procured as well from parts beyond the seas as from several private collections of such antiquities within this realm, and are generally esteemed the best collection of its kind now any where extant." The act, after mentioning the augmentation of the library by the son and grandson of Sir Robert, vests the MSS., "together with all coins, medals, and other rarities and curiosities in the said library," in trustees, who were to "nominate and appoint a good and sufficient person, well read in antiquities and records," as librarian. Six years afterwards another act was passed, (the 6th Anne, c.30,) in which it is stated that since the passing of the previous act "very little hath been done in pursuance thereof to make the said library useful to the public, except what has been done lately at her Majesty's charge." The reason of this is explained to be that the library was kept in the family mansion of the Cottons, and that there were difficulties in the way of rendering it generally accessible. Cotton House was therefore vested in the crown, (a consideration being made to the family,) in order that "it may be in her Majesty's power to make this most valuable collection useful to her own subjects, and all learned strangers."

Sir Hans Sloane was born in Ireland in the year 1660. He went out, when a young man, to Jamaica, as physician to the Duke of Albemarle, who had been appointed governor. The premature death of the duke deprived him of his situation: but during

2. Thomas Pennant (1726–1798): British naturalist and travel writer. [Ed.]

a brief residence in the West Indies he formed a collection of plants, valuable at the time, for the botany of these islands was then unknown. This was the commencement of his museum. In the course of a very long life, chiefly spent in London, he rose to great eminence in his profession, was created a baronet by George I., and succeeded Sir Isaac Newton in the chair of the Royal Society. His successful professional career brought him an ample fortune, by which he was enabled to gratify on an extensive scale his taste for collecting. Before his death, the idea of preserving his museum entire, and of purchasing it for the nation, was frequently discussed, and it was known that by his will he intended to make the offer. Accordingly, on his death, in the beginning of 1753, in the 92nd year of his age, little difficulty was experienced in procuring an act of Parliament, sanctioning the purchase of the museum for 20,000*l.*, which passed the legislature towards the end of that year. The same act directed that the collection of manuscripts made by Robert Harley, Esq., afterwards Earl of Oxford, and his son, (now known as the Harleian collection,) which was then offered for sale, should be bought for the sum of 10,000*l.*; that the Cottonian collection should be added to the Sloanean and the Harleian, the whole to be placed in a suitable depository, and to be called the British Museum.

The manner in which the money was proposed to be raised by the act of 1753, for the purpose of purchasing Sir Hans Sloane's museum, the Harleian collection, and for defraying necessary expenses, was most objectionable. "The act directed that 100,000*l.* should be raised by way of lottery, the net produce of which, together with the several collections, was to be vested in an incorporated body of persons, selected from the first characters in the kingdom for rank, station, and literary attainments, upon whom it conferred ample powers for the disposal, preservation, and management of the institution*." How little could the true interests or dignity of science have been then understood, when, instead of voting the required sum from the public purse, it was resolved to raise it "by way of lottery!" The natural consequences followed; there was management and jobbing and dishonesty in the transaction, which required and received a parliamentary investigation.

Thus a measure having for its object the improvement of the national taste was accompanied by another which tended to degrade the national character. The lottery, however, produced a large sum of money. After deducting various expenses of management, the net amount was 95,194*l.* 8*s.* 2*d.* The trustees of the Museum bought Montague House, in Great Russell Street, Bloomsbury, which had been erected by the Duke of Montague, for which they paid 10,250*l.*; and here the different collections were brought. The Museum was opened for study and public inspection on Jan. 15, 1759, about six years after the passing of the act.

Up to the close of the eighteenth century, the British Museum was but little known, except to literary and scientific individuals. The great bulk of the people had yet to be interested in it, as indeed they had to be interested in anything relating generally to their intellectual improvement. Yet this period, during which the Museum may be said to have been in its infancy and youth, was marked by extraordinary accessions to our knowledge. It was the period when Cook, Solander, and Banks explored the southern seas;—when Black, Priestley, Cavendish, and Watt made and

*'Penny Cyclopædia,' article British Museum, No. 328.

applied their discoveries;—and when the Hamiltons, Charles Townley, and others, made those collections which have tended so much to the advancement of the fine arts. The war retarded the progress of the Museum in the earlier part of the present century, but it could not check the impulse which had been communicated to the public mind. From the year 1807 we find a steady progressive increase in the interest taken in the Museum by the public, as evinced by the number of visits paid. The parliamentary return for that year gives the number of visiters at 13,046; in 1814 we find it stated at 33,074; in 1818 it was 63,253; it fell below that number till 1821, when it is stated at 91,151; in 1825 and 1826 the numbers are 127,643 and 123,302: but the commercial distress of that period appears to have reduced the numbers in 1827 to 79,131. In 1830, previous to the impulsion given by cheap literature, the numbers were 71,336; in 1832 it rose to 147,896; and the numbers each year since are—1833, 210,495; 1834, 237,366; 1835, 289,104.

One of the witnesses examined before the recent Parliamentary Committee says, "There is one important feature with respect to the British Museum in the mind of the public that I am much pleased with—the general good feeling exhibited by them on all occasions. * * * There is also, I may observe, no scribbling about the Museum; and the only instance in which I found any remark made, was by some ignorant man who wrote with a piece of red chalk on the bannisters leading to the King's Library, 'Museaum.'" The same witness, on being asked for information as to the comparative behaviour of the public of the present and of a former day, replied—" The British Museum has only become very popular within the last few years—time was when we had not more than 200 visiters a day; we have now 2000, 3000, 4000, 5000, and sometimes 6000 visiters a day."

The government of the Museum is vested in forty-eight trustees, by different Acts of Parliament. Of these ten are family trustees, representing the different families whose ancestors have left to it large bequests. There are two Cottonian trustees, two Sloane trustees, two Harleian trustees, the Earl of Elgin is trustee for the Elgin family, and the Townley and Knight families have each a representative. The tenth family trustee is appointed by the king. There are twenty-three official trustees, who become so by virtue of their offices. These trustees are the Archbishop of Canterbury, the Bishop of London, the Speaker of the House of Commons, various Members of the Government, the Chief Justices of King's Bench and Common Pleas, the Master of the Rolls, and the Presidents of the Royal Society, Royal Academy, College of Physicians, and Society of Antiquaries. The remaining fifteen trustees are elected by the others.

Respecting this constitution, the Parliamentary Committee say, in the Resolutions which they have lately laid before the House of Commons, that they "do not recommend any interference with the family trustees, who hold their offices under Acts of Parliament, being of the nature of national compacts;" and with respect to the others, that "though the number of official trustees may appear unnecessarily large, and though practically most of them rarely, if ever, attend, yet no inconvenience has been alleged to have arisen from the number." But they add, "If any act of the Legislature should ultimately be found necessary, a reduction in the number of this class of trustees might not be unadvisable." As to the elective trustees, they suggest the propriety of the other trustees, when vacancies occur, occasionally conferring "a mark of distinction upon men of eminence in science, literature, and art," by associating them in the trusteeship.

## The British Museum—No. II

ON the institution of the British Museum its objects were divided into three departments—those of printed books, manuscripts, and natural history. The antiquities and artificial curiosities were made appendages of the department of natural history; the coins, medals, and drawings were connected with the MSS.; and the prints and engravings with the library of printed books. The rapid increase of knowledge, as well as the acquisition of numerous objects connected with the subject of antiquities and the Fine Arts, have rendered necessary various subdivisions in the department of natural history, and the creation of a new department—that of antiquities. The great preponderance of the library departments of the Museum still keeps up the term of librarian, which is applied to the different officers who have the charge of departments; which, so far as a name may be thought of any importance, is an inapplicable designation when given to those who are over the departments of botany, entomology, mineralogy, antiquities, &c.

The visiter of the Museum will do well, if he can afford it, to purchase the official catalogue, which is termed, 'A Synopsis of the Contents of the British Museum.' It is an octavo pamphlet of 240 pages, the price of which has been lately, and very properly, reduced from 2s. to 1s. 6d. It is certainly capable of considerable improvement in its details; it might be made both more interesting and cheaper than it is; might be printed in a more compact and less expensive manner; point out to the attention of the visiter the objects more particularly worthy of attention; and supply information where at present it is deficient. It might thus become a book which the visiter could carry away with him, and read afterwards with instruction and pleasure. The additional sale would amply repay the trouble and expense, and the public would receive more benefit from the Museum. The improvement of the 'Synopsis' forms one of the recent recommendations of the Parliamentary Committee, which will, doubtless, be acted on; and the propriety of selling it in portions or departments is also suggested, which would be another judicious improvement. He whose taste lies towards zoology or entomology might thus purchase for study those departments, without being under the necessity of taking the descriptions of mineralogy or antiquities; and each department could be given more in detail. There are several large and expensive official works, illustrative of portions of the Museum contents; but their prices put them out of the reach of the ordinary visiter. To supply this deficiency in the department of antiquities, the Society for the Diffusion of Useful Knowledge have published two cheap volumes on the 'Egyptian Antiquities,' and two on the 'Elgin Marbles;'—two on the 'Townley Marbles' are in the press.[3] These works have been executed at a very heavy expense for wood-cuts, and they are calculated to interest the scholar as well as the general reader.

---

3. The Society for the Diffusion of Useful Knowledge (1827–1848) aimed to promote learning among a working- and middle-class readership. Its many publications included the *Penny Magazine* and *Penny Cyclopaedia*, as well as inexpensive guides to museums and collections and other works published as part of the Library of Entertaining Knowledge or the Library or Useful Knowledge. [Ed.]

Suppose, then, the visitor standing in the entrance-hall of the Museum, with his 'Synopsis' in his hand. The first thing that will strike his attention will probably be the words "Ground Floor," under which is the following paragraph:—

"This floor, consisting of sixteen rooms, contains the old library of printed books. Strangers are not admitted into these apartments, as the mere sight of the outside of books cannot convey either instruction or amusement."

This information is more official than pleasing. If the visitor does not cavil at the objectionable phrase "strangers," he may, perhaps, think that the reason for his exclusion is not cogent. There are many things less worthy of being looked at than an extensive library. The noble room which contains the King's Library is open to the visiter, as he will afterwards ascertain. One of the library rooms on the ground-floor is also open to the public; it contains an original of Magna Charta, which is damaged by fire: alongside of it is a fac-simile engraving. A partial view of the suite of library-rooms may be obtained through the upper part of a door in the Gallery of Antiquities.

There are reasons more valid for the non-admission of the general visitor into these library-rooms than the one given in the 'Synopsis.' The chief reason is, that the passage of a crowd would interrupt not only the students in the Reading Room, but distract the assistant-librarians, whose duty it is to supply the students with every book they require.

The entrance-hall, and the staircase leading to the rooms containing the collections of curiosities and objects of natural history, exhibit various things worthy of attention. Here is a statue of Sir Joseph Banks, so great a benefactor to science and the British Museum. "It represents the great naturalist," says the 'Synopsis,' "not as he was in his latter days, feeble and lame, but hale and vigorous; he is seated in an arm-chair, holding a scroll in his right hand. The figure is raised upon a marble pedestal." There is also a statue of the Hon. Anne Seymour Damer, the celebrated sculptress; one of Shakspeare by Roubilliac, bequeathed by Garrick; and a gilt figure of Gaudma, a Burmese idol, presented by Captain Marryat. There are also several preserved animals; a hippopotamus, a llama, a musk ox, a polar bear, an antelope, a Siberian elk, and three giraffes. The latter beautiful animals were, until very lately, only known to us in this country from an engraving or a description—one of the three in the Museum was the first, of which even a stuffed specimen was ever seen in England. The arrival of living individuals in the two Zoological Gardens of London, detracts, of course, from the interest with which preserved specimens are regarded. Indeed, the rapid improvements now making in zoological science will gradually diminish the value of collections of dead animals. Where we have an opportunity of watching the habits and dispositions of living creatures, however modified by confinement, we shall not, of course, care so much for that which only enables us to consider their forms.

In passing from the staircase into the first room of the upper floor, the visitor will find himself surrounded by what are termed, "a series of artificial curiosities from the less civilized parts of the world." These consist of dresses, weapons, fishing implements, articles of ornament and domestic use, from the Arctic regions, the interior of South America, the South Sea Islands, &c. The second, third, and fourth rooms are devoted to Sir Joseph Banks's, together with Sir Hans Sloane's and other collections of dried plants. The second also holds temporarily Mr. William Smith's collection

of English fossils, arranged according to the strata in which they are found. The Sloanean herbaria are contained in 336 volumes, bound in 262, and consist of Sir Hans Sloane's collections made by himself in the West Indies, and of various others presented to, or purchased by, him. The herbarium of Sir Joseph Banks, of which the larger and arranged portion is contained in cabinets, comprises upwards of 24,000 species, the materials in progress of arrangement being estimated to contain 5000 more. The Banksian collection formed at one time the most valuable assemblage of dried plants in Europe, and is still a very important one.

## The British Museum—No. III

SCARCELY one half of the visiters of the British Museum enter the Gallery of Antiquities. Two reasons are given for this. The greater portion of the visiters come late, and proceeding up-stairs to the general collections, the hour of closing has arrived before they have time to examine the antiquities*. The second reason is, that the entrance to the Gallery, under the principal staircase, is obscure, and escapes the observation of many. It has been announced that the Museum is to be open till seven in the evening during summer, to commence next year. This will probably bring a still greater number of visiters. A great proportion of the working-classes of the metropolis, instead of devoting *Saint* Monday to dissipation, as was too frequently the case formerly, now occasionally take a half holiday—generally Monday afternoon— bringing out with them their wives and families to enjoy it. It is of great importance that such places as the Museum should be open to them on these occasions. The general behaviour of the public has been hitherto excellent—but as under the new regulation the Gallery of Antiquities may count on its full share of visiters, it will require both patience and vigilance on the part of the officers to prevent mischief being done to some of those glorious works of art which adorn it. The general body of the public have not yet got rid of what they consider to be the good old English privilege of touching and meddling with what attracts their attention. It is fast disappearing, however, and the period may soon arrive when it can be no longer scornfully said with truth that the English people are excluded from indiscriminate admission to parks, palaces, and collections, owing to their propensity to commit mischief.

## The British Museum—No. IV

A PLAIN man may walk round the collections in the Gallery of Antiquities, and though admiring the intrinsic beauty of much that it contains, may ask, What is

---

*It appears from the statements of the officers that the number of visiters during the present year (1836) has greatly exceeded all former years—so many as 9000 having been within the walls during the six hours, viz., from ten till four, that the Museum is open. Monday is generally the busiest day; and sometimes one-half-of-the day's visiters will arrive after two o'clock. The writer has occasionally remarked the number, especially on fine days—the average was about fifty every five minutes during the last two hours of the Museum being open.

the utility of collecting, and so carefully preserving so many mutilated statues and broken fragments of works of art? Let him not be told with a sneer that he has no taste. It is better he should confess that he does not understand the matter, than that he should unthinkingly admire because he hears other people admiring. Taste in the great body of a people is as much a thing of acquisition as the ability to read or write. It is based on knowledge; and, like knowledge, it may be both acquired and lost. If it were not so, we should not now have to deplore the dilapidated state of many of the finest monuments and works of art in the Gallery—they have suffered more from the hand of man than from time. The Gallery of Antiquities has been formed, as one of its objects, to create and promote the growth of taste; and this also is one of the intentions of such publications as the 'Penny Magazine,' in giving pictorial illustrations of remains of antiquity, and subjects belonging to the fine arts.

Another individual might ask, What is the moral value of these collections? He might object that there is no necessary connexion between a people's happiness and their possessing a fine and polished taste; and that these works of art but perpetuate the recollection of the human intellect having been laboriously devoted to the service of absurd, fantastic, or grovelling superstitions. But if there is no necessary connexion between taste and happiness, neither is there between taste and vice; and if we can render taste subservient to the improvement of a people's manners without injuring their morals, we make a high advance in civilization. Besides, do we learn nothing from these collections which is valuable? "The religious sentiment which led the Egyptians to bestow so much pains on the preservation of their dead, has been the means of transmitting to the present day nearly all that we know of their skill in the useful and ornamental arts. Their temples and their tombs were, in their origin, perhaps closely connected; and when their temples and palaces had received all the splendour and decoration which Egyptian art could bestow on them, the tombs, which they appropriately called eternal habitations, were not left without a corresponding degree of magnificence and ornament. From the tombs we learn not only what was the mode of disposing of the dead—a subject of the highest interest in every nation, as being one of the outward signs of its social state and its religious character—but here we see also the daily occupations of life, an enduring and almost living picture of one of the oldest states of social existence of which we have any record.*"

These observations, when adapted to circumstances, may be found to answer to any objections which may be urged against the collections in the Gallery of Antiquities. They are, apart from other considerations, valuable as historical documents. They reveal much to us concerning the modes of thought, habits, manners, and customs of generations long since swept away; they tell us what man has *been,* and we may compare it with what man *is;* and from the comparison we may draw, not merely humiliation for our pride, but much that may exalt our nature as rational and intelligent creatures.

*'Egyptian Antiquities,' vol. ii., p. 96, 'Library of Entertaining Knowledge.'

# ANNA JAMESON

## The National Gallery

## Introduction

IT has been a subject of astonishment to intelligent foreigners that, in a country like England, possessed of such vast resources both in wealth and power, no National Gallery of art belonging, or at least accessible, to the public at large, should have existed till within the last twenty years. If, on the death of Charles I., his magnificent collection, instead of being sold for some paltry thousands, had been retained as the property of the Commonwealth, we should now rival the most celebrated foreign galleries in the possession of grand works of art. After the purchase of the gallery of the Duke of Mantua, King Charles's collection included about 387 pictures of value, among which were 9 by Raphael, 16 by Giulio Romano, 11 by Correggio, 28 by Titian, 20 by Vandyck, &c.; and persons conversant with the history of the arts in England, who meet, in the galleries of foreign Princes, chef-d'œuvres once in our possession, obtained at great cost and afterwards sold beneath their value, may be pardoned if on such occasions, they do not feel like citizens of the world, but rather indulge in some private and patriotic regrets for a loss now irretrievable. Something of this coarseness of taste and ill-understood economy might have been imputed to the republican and utilitarian spirit of those times, had we not seen that the English Government, one hundred and fifty years after the dispersion of King Charles's pictures, and when directed by principles diametrically opposite, did not display more wisdom, taste, or foresight, than the stern puritanical republicans of 1649. During the French invasion of Italy in 1797–8 the nobles of that country, impoverished by the heavy contributions exacted from them, found themselves under the necessity of disposing of the works of art long accumulated in their families. These were, according to the Italian custom, in all cases so strictly entailed, that nothing but such a convulsion as then shook the whole frame of civilised society to its very basis could have effected their alienation. The Princes Borghese, Colonna, Barberini, Chigi, Corsini, Falconieri, Spada, Lancellotti, and others, parted with their pictures, reluctantly indeed, and at prices far beneath their real value. At this period the outlay of about £20,000 would have secured to this country the possession of some of the grandest works of art now existing, and a representation to this effect was made to the Government, but remained unnoticed. What were Titians and Correggios to us in those days,

From Anna Jameson, *A Handbook to the Public Galleries of Art in and near London with Catalogues of the Pictures, Accompanied by Critical, Historical, and Biographical Notices, and Copious Indexes to Facilitate Reference* (London: John Murray, 1842), 2–16; 282–289 (excerpts).

*"When rumour of oppression and deceit,*
*Of unsuccessful or successful war,"*[1]

filled all ears, occupied all minds? A lieutenant in the navy was then a greater man than Raphael: and it must be allowed that, had Pitt and his ministry take up the matter seriously, though thanks and deathless praise would have been their meed to all later times, the national feeling would *then* have been against them.[2] The opportunity passed away, never to be recalled. The public spirit of England, so magnificently displayed in the building of hospitals and bridges, and fighting, at her own cost, the battles of all Europe, has not till lately been directed to the fine arts: not till lately has a feeling been awakened in the public mind, that, in the endeavour to humanise and educate the heart of a nation for all noble and all gentle purposes, art, if not the most important, is no despicable means towards that greatest end.

It appears that, between the years 1804 and 1823, the idea of forming a National Gallery of art had several times been suggested to the Government, but in vain. Sir Francis Bourgeois, who in 1811 left his fine collection to Dulwich College, wished to have appropriated it to the nation at large, provided a suitable building were prepared to receive it. This offer was not accepted.[3]

In the year 1823 John Julius Angerstein, a wealthy banker and merchant of London, died and left to his heirs a gallery of 38 pictures, many of which were considered first-rate in point of beauty and value. Mr. Angerstein had acquired them by a judicious outlay of ready money during the war, and had been assisted in the selection by his two friends, Benjamin West and Sir Thomas Lawrence. There were, notwithstanding, some copies, since detected, and some indifferent pictures, in the number. The expediency of purchasing this collection was urgently pressed on the Government by Mr. Agar Ellis (afterwards Lord Dover) and Sir George Beaumont.[4] Meantime the King of Bavaria, the Prince of Orange, and others, sent to treat with the heirs of the property. A sensation, amounting to apprehension, was excited among those who felt the importance of the crisis. They were few, but they were influential. Still Lord Liverpool hesitated. He and the other ministers were absolutely intimidated by the fierce attacks of the economists, and scarcely dared to propose such a measure themselves, dreading the apathy of some and the animosity of others. Lord Dover acknowledged that he should have wanted courage to bring the subject before the House of Commons, had it not been for the stimulating zeal of Sir George Beaumont. This accomplished and enthusiastic man was indefatigable in his exertions and representations. One of his letters to Lord Dover at this time is very striking:—

"You have proved yourself so sincere a friend to the arts, that I am sure you must have heard the report that Lord Hertford is in treaty for and likely to purchase

1. William Cowper, "The Task" (1784). [Ed.]
2. Prime minister from 1783 to 1801, and again from 1804 to 1806, William Pitt the Younger (1759–1806) was in office during the French Revolution and subsequent military conflicts. [Ed.]
3. Dulwich: see glossary. [Ed.]
4. George James Welbore Agar-Ellis, first Baron Dover (1797–1833): politician and patron of art, was an early supporter of the National Gallery, notably of the purchase of the Angerstein collection. On Angerstein and Beaumont, see glossary [Ed.]

Angerstein's pictures; but that, if he finds the nation will buy them, he will give up his claim. I hope the latter part of the report is true, and that the country will purchase. You manifested such sincere and laudable zeal to bring this about, that I have great hopes you will carry your point: certainly I would rather see them in the hands of his Lordship than have them lost to the country; but I would rather see them in the Museum than in the possession of any individual, however respectable in rank or taste; because taste is not inherited, and there are few families in which it succeeds for three generations. My idea, therefore, is, that the few examples which remain perfect can never be so safe as under the guardianship of a body which never dies; and I see every year such proofs of the carelessness with which people suffer these inestimable relics to be rubbed, scraped, and polished, as if they were their family plate, that I verily believe, if they do not find some safe asylum, in another half-century little more will be left than the bare canvases."

At last Lord Liverpool took courage, and proposed to Parliament to purchase the Angerstein collection as it stood, at a just valuation, and make it the nucleus of a National Gallery. "Buy this collection of pictures for the nation," said Sir George Beaumont, "and I will add mine;" and the offer—the bribe shall we call it?—was accepted. In the November following Sir George thus writes to Lord Dover:—"Our friend Knight has informed me that Parliament has resolved upon the purchase of the Angerstein collection; and as I shall always consider the public greatly indebted to your exertions, I hope you will pardon my troubling you with my congratulations. By easy access to such works of art the public taste must improve, which I think the grand desideratum; for when the time shall come when bad pictures, or even works of mediocrity, shall be neglected, and excellence never passed over, my opinion is, we shall have fewer painters and better pictures. I think the public already begin to feel works of art are not merely toys for connoisseurs, but solid objects of concern to the nation; and those who consider it in the narrowest point of view will perceive that works of high excellence pay ample interest for the money they cost. My belief is, that the Apollo, the Venus, the Laocoon, &c., are worth thousands a-year to the country which possesses them."

The sum at which the whole of the Angerstein pictures were valued by competent judges was 57,000l.; to defray other incidental expenses Parliament granted the farther sum of 3000l., in all 60,000l.* The pictures remained for several years in the house of Mr. Angerstein in Pall-mall, where they were first opened to the public on the 10th of May, 1824. They were placed in the edifice they now occupy in 1838, and it was opened to the public on the 9th of April in that year.

In the mean time, the original collection had been materially increased by purchases and bequests. In 1825 three fine pictures, viz. the Bacchus and Ariadne of

*The prices given for the three great collections sold in England within the last century may perhaps be interesting as data. The Houghton pictures, 232 in number, collected by Sir Robert Walpole, were sold to the Empress Catherine of Russia for 43,500l. The pictures were overvalued, even in the estimation of Horace Walpole, and the Empress never paid more than 36,000l. of the money, and, in the extremity of her imperial indignation, she refused to look at them, or to allow them to be taken out of the packing-cases in which they arrived at St. Petersburg. Her disgust at being, as she thought, overreached, was stronger than her love for fine pictures. The Orleans collections, consisting of 296 pictures, was sold, in 1798, for 43,555l.; and the Angerstein collection of 38 pictures was valued and sold at 57,000l.

Titian (No. 35), the Dance of Bacchanals by Nicolo Poussin (No. 62), and, sub-sequently, Annibal Carracci's "Christ and St. Peter" (No. 9), were purchased of Mr. Hamlet the jeweller, for 8000*l*. In the same year the exquisite little Correggio (No. 23) was bought from Mr. Nieuwenhuys for 3800 guineas.

In 1826 Sir George Beaumont (dear be his memory therefore to every lover of art and of his country!) made a formal gift of his pictures, valued at 7500 guineas, to the nation. This was the first example given of private munificence. Sir George, besides being a passionate lover of art, was himself a fine artist. The pictures he had collected round him were not mere objects of pride or taste, but the loved companions of his leisure—the reverenced models of his art: we are told he used to gaze upon them by the hour; he could scarcely bear to be absent from them. Yet, endowed with a truly poetical and elevated mind, he appears to have felt and understood one of the high-est, truest sources of delight, when, "with ambition, modest yet sublime," he made of this rich sacrifice a *gift*, and not a *bequest*, and had the gratification while he yet ex-isted of seeing his pictures, by him not only valued but loved, hung up in public view to bestow on thousands "unreproved pleasure."[5] And, as this was most nobly done, so there was something affecting in his request to be allowed to retain till his death one little picture, a favourite Claude, which had long been in his possession. For several years he had never moved from one residence to another without it; but car-ried it about with him like a household god. This picture (No. 61) will henceforth be consecrated by these grateful and tender recollections in the mind of every spectator.

—◦❧ ❦◦—

The number of pictures is at present 177, of which 118 have been either presented or bequeathed by individuals. We possess one of the finest pictures of the Florentine school in the Raising of Lazarus;* but the school of Raphael is most inadequately represented in the Saint Catherine, beautiful as it is. We may esteem ourselves rich in Correggios (we have three among his finest productions, and he is the rarest of the first-rate masters, Michael Angelo excepted); also in pictures of Claude, and of Nicolò and Gaspar Poussin, and of Annibal Carracci and his school. We are poor in fine specimens of some of the best of the early Italian masters; of Gian Bellini, of Francia, of Perugino, the master of Raphael, of Fra Bartolomeo, of Frate Angelico—

> "The limner cowl'd, who never raised his hand
> Till he had steep'd his inmost soul in prayer," —

and others who flourished in the latter half of the 15th century, we have as yet nothing:[†] of Titian we have only one very good picture,—not one of his wondrous

---

*I call it *Florentine*, because, though painted by the Venetian, Sebastian del Piombo, the composi-tion is by Michael Angelo, and bears the stamp of his school of design.

†See Mr. Solly's Evidence before the Arts Committee in 1836:—" I should say that painting was at its greatest state of perfection from 1510 to 1530; but even of that period there are a great num-ber of painters whose works are not known in this country, as Gaudenzio Ferrari, Bernardino Luino, Cesare da Sesto, and Salaino (Milan); Andrea da Salerno (the Raphael of Naples); and painters of Bergamo, Padua, Verona, Treviso, whose works are all extremely fine, and would be desirable for a National Gallery (No. 1845)."

5. See William Wordsworth, "Upon Sight of a Beautiful Picture Painted by Sir G. H. Beaumont" (1811), and John Milton, "L'Allegro" (1632). [Ed.]

portraits; the only Giorgione is doubtful. Of the gorgeous Paul Veronese and the fiery Tintoretto there is nothing of consequence.* Of the power and splendour of Rubens we have some fair examples; but for the great pictures at Whitehall, which he painted for Charles I., and which lie there out of sight and out of mind, there is absolutely no space in our National Gallery. They exceed in dimensions (both in breadth and height) any room in it. Of Salvator Rosa, whose great works are so often met with in England, we have but one picture—a noble one, it must be allowed. There are two fine Murillos, but of Velasquez nothing,—for the picture which bears his name is certainly not his: and of the other great masters of the Spanish school—Alonzo Cano, Zurbaran, Coello, el Mudo, el Greco—not one picture. We are as yet most poor in the fine masters of the Dutch school. There is not a single specimen of Hobbema or Ruysdael. The specimens of Vandervelde are insignificant; and of the beautiful conversation-pieces of Terburg, Gerard Douw, Netscher, Metzu, Ostade, Franz Mieris, and their compeers, not one. But what is most extraordinary, and almost melancholy, is, our poverty in the works of Van Dyck, a painter almost naturalised among us; whose best years were spent in England, whose best works belong to us and our history. The only very good picture of his here—the portrait styled Gevartius—as a specimen of what his pencil could do, is invaluable; but otherwise not interesting. How would it keep alive in the mind of the people all the chivalrous, and patriotic, and historical associations connected with the families of our old nobility, to see from these walls the effigies of our Stanleys, Howards, Cecils, Percies, Russells, Cavendishes, Whartons, Villierses, with their noble dames and daughters, the Lady Margarets and Lady Dorotheas, looking down magnificent and gracious, as they have been immortalised by the pencil of Van Dyck! Will no one bestow on us an Arundel, or a Derby, or a Hamilton—a Lady Carlisle, a Lady Wharton, a Lady Rich, a Sacharissa, or a Mrs. Hutchinson? Most willingly would we dispense with some of the pictures now occupying the walls of the gallery, to make room for them:—but until we are thus gloriously enriched, those who worship Van Dyck, and those who would study him, must seek him at Windsor, or at Chatsworth, or at Wilton. Let it be allowed also to wish for a few more, and more distinguished, pictures of our own Sir Joshua Reynolds. The difficulties which must stand in the way of any government patronage of living artists will be understood at once; but what individual spirit and generosity has begun in the case of Hilton's noble picture—"Sir Calepine rescuing Serena"—may, and it is to be hoped *will*, be carried much further; guided, however, by elevated taste and genuine public spirit, and love of art for art's sake:—shameful would it be, and most pitiful, if the spirit of *jobbing*, which finds its way into most of our public undertakings, could be suffered to intrude into such a sanctuary as this. Under the present direction we may feel assured that it could not happen,—and that whatever is done will be done at least conscientiously.

The utter want of all arrangement and classification has been publicly and severely noticed; but is not the number and choice of the pictures much too confined

---

*The consecration of St. Nicholas is undoubtedly a fine picture; but when we speak of important works of Paul Veronese, we allude to such as are to be seen at Venice, Dresden, and in the Louvre. In the latter collection is the "Marriage at Cana," which no room in our National Gallery is large enough to contain.

at present to admit of that systematic arrangement we admire in the foreign galleries of art? It appears to me that the number of pictures should be at least doubled before any such arrangement could be either improving or satisfactory, though undoubtedly the purposes for which the *National* Gallery has been instituted demand that it should be taken into consideration as soon as possible. In the present state of the gallery, still in its very infancy, any comparison with some of the celebrated foreign galleries would be invidious and absurd. I will only observe that in the collection at Berlin, which was begun about the same time with our National Gallery, there are now about 900 pictures admirably arranged; in the glorious Pinacothek at Munich there are 1600 pictures, the arrangement of which appears to me perfect. The Florentine Gallery containing about 1500 pictures, that of the Louvre containing about 1350, that of Dresden about 1200, that of the city of Frankfort (of recent date, and owing its existence to an individual) about 340 pictures, all afford facilities in the study of art which we look for in vain, as yet, in our own.

A gallery like this—a national gallery—is not merely for the pleasure and civilization of our people, but also for their instruction in the value and significance of art. How far the history of the progress of painting is connected with the history of the manners, morals, and government, and, above all, with the history of our religion, might be exemplified visibly by a collection of specimens in painting, from the earliest times of its revival, tracing the pictorial representations of sacred subjects from the ancient Byzantine types of the heads of Madonnas and Apostles, through the gradual development of taste in design and sensibility to colour, aided by the progress in science, which at length burst out in fullest splendour when Leonardo da Vinci, Michael Angelo, Raphael, Correggio, Titian, were living at the same time. (What an era of light! it dazzles one's mental vision to think of it.) They effected much, but how much did they owe to their predecessors? As to the effect which would be produced here by the exhibition of an old Greek or Siennese Madonna, I can imagine it all;—the sneering wonder, the aversion, the contempt; for as yet we are far from that intelligence which would give to such objects their due relative value as historic monuments. But we are making progress: in the fine arts, as in many other things, knowledge comes after love. Let us not despair of possessing at some future period a series of pictures so arranged, with regard to school and chronology, as to lead the inquiring mind to a study of comparative style in art; to a knowledge of the gradual steps by which it advanced and declined; and thence to a consideration of the causes, lying deep in the history of nations and of our species, which led to both.

Meantime the very confined precincts assigned to the National Gallery have excited some well-founded misgivings, and people ask very naturally—"Suppose that another munificent spirit were to rise up among us, emulous of Sir George Beaumont, Mr. Carr, or Lord Farnborough, and bequeath or present a gallery of pictures to the nation: where are they to be hung?"[6] There is indeed a room (a sort of cellar)

---

6. Like Beaumont, Reverend William Holwell Carr (1758–1830) left his collection of paintings to the National Gallery provided a suitable building was constructed to house it. Charles Long, First Baron Farnborough (1760–1838), paymaster-general and connoisseur, was an important supporter of the arts. He advocated for the establishment of the National Gallery, to which, on his death, he left paintings by Rubens, Vandyck, Canaletto, Teniers, Mola, and Cuyp, among others. [Ed.]

beneath, where the few pictures not exhibited are for the present incarcerated, and which is intended, I believe, to receive those for which there is no room above stairs; but the arrangement of space and light is as bad as possible. We may for the present comfort ourselves in the reflection that some twenty or thirty pictures, which now *adorn* the walls of these rooms, might be turned out without any great loss to the public, or any essential diminution of the value and attraction of our National Gallery. But this comfort can only last a certain time, and then——? I suppose we must have what the Scotch call a *flitting*, and seek house-room elsewhere.

The annual expenses of the establishment have varied little since the opening, and have never amounted to 1000*l.*, every charge, taxes, salaries, &c., included.

Referring to the evidence taken before the Committee of the House of Commons in 1836, it there appears that no funds are set apart or available for the purchase of pictures, and that the degree of responsibility resting with the trustees, keepers, and other officials, is not exactly defined, and by no means clear to themselves or to the public.

The number of rooms now open to the public is six, four large and two small. In the latter, which I suppose to be planned for cabinet pictures, are placed for the present some of the largest pictures we possess, to their great disadvantage: while the grand drawings by Annibal Carracci, presented by Lord Francis Egerton, and the drawing of Baldassar Peruzzi, presented by Lord Vernon, are hung in the passage.

All persons are admitted to the Gallery without fee or distinction during the first four days of the week; the other two days are appropriated to students, who have permission to copy pictures. This permission is obtained by application to Mr. Seguier, the keeper, sending at the same time a drawing or picture as a specimen of the ability of the applicant.

The fears once entertained that the indiscriminate admission of the public would be attended with danger to the pictures, or would prove otherwise inexpedient, have fortunately long since vanished; no complaint has ever been made. The deportment of those who are seen wandering through the rooms (on a holiday particularly), with faces of curiosity, pleasure, and astonishment, has hitherto been exemplary; and to listen to their remarks, and to the questions they put to the attendants (always replied to with intelligence and civility), is sometimes highly interesting and amusing.

On Whit-Monday, 1840, the number of persons admitted was 14,000. The number during the whole week was 24,980.

The number of persons admitted during the year 1835 was 130,000. The number admitted from October, 1839, to October, 1840, was 768,244.

The average number admitted daily is therefore about 2830.

These numbers are given on the authority of the under-keeper.

# Chapter Three
## THE PUBLIC IN THE MUSEUM

While the most compelling justification of the museum as a state institution was its effect on the public, the nature of this effect and of the public itself were far from simple questions. The ever-increasing numbers walking through the galleries of England—the British Museum in particular, but also the much-criticized National Gallery—called for reflection on what the goals of the museum in fact were, and how those goals were being met or failed by the institution. The impact of the collection on the public conscience was a central concern, but no more so than the impact of the public on prized objects. The risk of vandalism is one way to talk about the threat of the modern public, but the more subtle dangers posed to oil paint by the accumulation of bodily effluvia generated by individuals moving through galleries or by the coal smoke produced in the process of heating and feeding the bodies of the metropolis may be understood as related concerns.

The contention that art museums were necessary for the creation of great artists was supported by contemporary notions of art and education, but further argument was required to make this claim compelling for a nation of manufacturers and merchants. Driving attempts to improve the taste of the public was the widely recognized weakness of British design, especially when compared to the strength of British technology. The desire to bring the quality of objects produced in the nation's factories to a level approaching that of continental competition makes the improvement of taste a practical as much as an ideal matter. And yet, it was clear to commentators throughout the century that certain objects were deeply impressive to visitors without appearing to offer the improvements in taste that were desired.

Debate about the form of the museum became particularly pressing around the middle of the century, following the success of the Great Exhibition. But the nature of the institution was a recurring concern throughout the period, provoking not only government inquiries and public polemics but sustained journalistic interventions. Given the aspiration to spread knowledge to an ever-wider audience common to

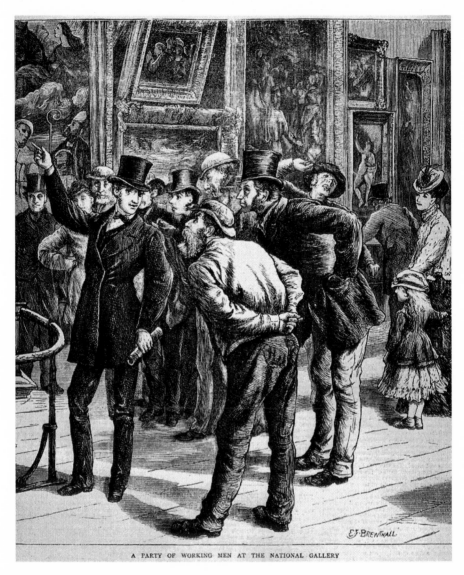

A PARTY OF WORKING MEN AT THE NATIONAL GALLERY

FIGURE 3.1  "A Party of Working Men at the National Gallery." *The Graphic*, August 6, 1870.

newspapers, magazines, and public collections, it is little wonder that the press of the nineteenth century was closely attuned to the development, establishment, and management of museums. Nevertheless, during the course of the century, emerging forms of specialized knowledge also came to affect public debate as to what the museum could be. While the connoisseurs and amateurs of an earlier era were never entirely superseded, the increasingly systematized ideas of art historians, curators, critics, and scientists further shaped the response to the museum.

The selections in this chapter are all characterized by the interplay of government report, popular press, and expert testimony that would come to determine the cultural force of the institution. The Society for the Diffusion of Useful Knowledge produced a number of the earliest guides to the collections at the British Museum, but more than information about objects was necessary to make museums truly public. Thus, in its very first year of publication, *The Penny Magazine*, the organ of the Society, featured an article at once defending the behavior of the British public from imputations of a tendency toward vandalism and providing instruction designed to encourage inhibited members of the lower classes to make use of the new (or newly available) institutions (1832).

The behavior of the public was still at issue when the committee on Arts and Manufactures met in 1835 and published an important report a year later citing the *Penny Magazine* and related publications as indications of popular interest and as sources of evidence for the conduct of the lower classes. The general conclusions of the committee give official form to issues that were to recur in debates on British museums for decades to come: the financial benefits of a tasteful artisan class, the weakness of British institutions in comparison to Continental counterparts, and the great interest of the working people in increasing access to culture.

The excerpts from the 1841 *Report from the Select Committee on National Monuments and Works of Art* include not only the summary conclusions but also a selection of representative exchanges between politicians and staff of the National Gallery and British Museum. The latter are of interest as much for the questions that preoccupy the commissioners as for the responses their inquiries elicit. Both illustrate the serious concern with the behavior of the public driving the imagination of the museum in the period. Vandalism and its absence, Sunday opening as a breach of the Sabbath or as an alternative to the public house, the appropriate form and price of a written catalogue, even the existence or lack of public toilets—such preoccupations clearly demonstrate the inexorable pressure of the public in the development of the modern museum.

Some of the fears motivating reform are suggested by the *Report of the Select Committee to Consider the Present Accommodation Afforded by the National Gallery* of 1850. While this testimony from a period in which serious consideration was being given to moving the Gallery in order to protect its holdings from the air of central London illuminates the ambivalence of museum administration toward the public, it also illustrates a function the museum would continue to have throughout the century, as an educational resource for artists perfecting their craft through copying. The fear that the lower classes might be using the museum for purposes other than art

appreciation while their bodies contributed to the decay of its collection is paralleled by the concern that artists given special access in order to hone their craft might be copying with the intent of selling their works, not with the aim of improving their technique.

This section concludes with a reflection on the Victorian institution from the perspective provided by the First World War. Henry Mayo Bateman's 1914 "The Boy Who Breathed on the Glass in the British Museum," a cartoon for *Punch,* is one popular response to the anxieties that motivated commissioners and administrators throughout the century. Bateman's "Ante-Bellum Tragedy" identifies the museum, the court room, and the prison as related sites, at least for an anarchic spirit that seems to be provoked rather than mollified by the structures of high culture.

# ANONYMOUS

—∘❥ ❦∘—

## The British Museum

"THE characteristic of the English populace,—perhaps we ought to say people, for it extends to the middle classes,—is their propensity to mischief. The people of most other countries may safely be admitted into parks, gardens, public buildings, and galleries of pictures and statues; but in England it is necessary to exclude them, as much as possible, from all such places."

This is a sentence from the last published number of the 'Quarterly Review.' Severe as it is, there is much truth in it. The fault is not entirely on the side of the people (we will not use the offensive term populace); but still they are in fault. The writer adds, speaking of this love of mischief, which he calls "a disgraceful part of the English character," that "anything tends to correct it that contributes to give the people a taste for intellectual pleasures,—anything that contributes to their innocent enjoyment,—anything that excites them to wholesome and pleasurable activity of body and mind." This is quite true. We hope to do something, speaking generally, to excite and gratify a taste for intellectual pleasure; but we wish to do more in this particular case. We wish to point out many unexpensive pleasures, of the very highest order, which all those who reside in London have within their reach; and how the education of themselves and of their children may be advanced by using their opportunities of enjoying some of the purest gratifications which an instructed mind is capable of receiving. Having learnt to enjoy them, they will naturally feel an honest pride in the possession, by the Nation, of many of the most valuable treasures of Art and of Science; and they will hold that person a baby in mind—a spoiled, wilful, mischievous baby—who dares to attempt the slightest injury to the public

Anonymous, "The British Museum." *The Penny Magazine* 1 (1832), 13–14.

property, which has been collected together, at an immense expense, for the public advantage.

Well, then, that we may waste no time in general discussion, let us begin with the BRITISH MUSEUM. We will suppose ourselves addressing an artisan or trades- man, who can sometimes afford to take a holiday, and who knows there are better modes of spending a working-day, which he some half-dozen times a year devotes to pleasure, than amidst the smoke of a taproom, or the din of a skittle-ground. He is a family man; he enjoys a pleasure doubly if it is shared by his wife and children. Well, then, in Great Russell-street, Bloomsbury, is the British Museum; and here, from ten o'clock till four, on Mondays, Wednesdays, and Fridays, he may see many of the choicest productions of ancient art—Egyptian, Grecian, and Roman monu- ments; and what will probably please the young people most, in the first instance, a splendid collection of natural history—quadrupeds, birds, insects, shells—all classed and beautifully disposed in an immense gallery, lately built by the Government for the more convenient exhibition of these curiosities. "But hold," says the working man, "I have passed by the British Museum: there are two sentinels at the gateway, and the large gates are always closed. Will they let me in? Is there nothing to pay?" That is a very natural question about the payment; for there is too much of paying in England by the people for admission to what they ought to see for nothing. But *here* there *is* nothing to pay. Knock boldly at the gate; the porter will open it. You are in a large square court-yard, with an old-fashioned house occupying three sides. A flight of steps leads up to the principal entrance. Go on. Do not fear any surly looks or impertinent glances from any person in attendance. You are upon safe ground here. You are come to see your own property. You have as much right to see it, and you are as welcome therefore to see it, as the highest in the land. There is no favour in showing it you. You assist in paying for the purchase, and the maintenance of it; and one of the very best effects that could result from that expense would be to teach every Englishman to set a proper value upon the enjoyments which such public property is capable of affording. Go boldly forward, then. The officers of the Mu- seum, who are obliging to all strangers, will be glad to see you. Your garb is homely, you think, as you see gaily-dressed persons going in and out. No matter; you and your wife, and your children, are clean, if not smart. By the way, it will be well to mention that very young children (those under eight years old) are not admitted; and that for a very sufficient reason: in most cases they would disturb the other visitors.

You are now in the great Hall—a lofty room, with a fine staircase. In an adjoin- ing room a book is presented to you, in which one of a party has to write his name and address, with the number of persons accompanying him. That is the only form you have to go through; and it is a necessary form, if it were only to preserve a record of the number of persons admitted. In each year this number amounts to about seventy thousand: so you see that the British Museum has afforded pleasure and im- provement to a great many people. We hope the number of visitors will be doubled and trebled; for exhibitions such as these do a very great deal for the advance of a people in knowledge and virtue. What reasonable man would abandon himself to low gratifications—to drinking or gambling—when he may, whenever he pleases, and as often as he pleases at no cost but that of his time, enjoy the sight of some of the most curious and valuable things in the world, with as much ease as a prince

walking about in his own private gallery. But that he may enjoy these treasures, and that every body else may enjoy them at the same time, it will be necessary to observe a few simple rules.

1st. *Touch nothing.* The statues, and other curious things, which are in the Museum, are to be seen, not to be handled. If visitors were to be allowed to touch them, to try whether they were hard or soft, to scratch them, to write upon them with their pencils, they would be soon worth very little. You will see some mutilated remains of two or three of the finest figures that ever were executed in the world: they form part of the collection called the Elgin Marbles, and were brought from the Temple of Minerva, at Athens, which city at the time of the sculpture of these statues, about two thousand three hundred years ago, was one of the cities of Greece most renowned for art and learning. Time has, of course, greatly worn these statues: but it is said that the Turkish soldiers, who kept the modern Greeks under subjection, used to take a brutal pleasure in the injury of these remains of ancient art; as if they were glad to destroy what their ignorance made them incapable of valuing. Is it not as great ignorance for a stupid fellow of our own day slily to write his own paltry name upon one of these glorious monuments? Is not such an act the most severe reproach upon the writer? Is it not, as if the scribbler should say, "Here am I, in the presence of some of the great masterpieces of art, whose antiquity ought to produce reverence, if I cannot comprehend their beauty; and I derive a pleasure from putting my own obscure, perishable name upon works whose fame will endure for ever." What a satire upon such vanity. Doubtless, these fellows, who are so pleased with their own weak selves, as to poke their names into every face, are nothing but grown babies, and want a fool's cap most exceedingly.

2dly. *Do not talk loud.* Talk, of course, you must; or you would lose much of the enjoyment we wish you to have—for pleasure is only half pleasure, unless it be shared with those we love. But do not disturb others with your talk. Do not call loudly from one end of a long gallery to the other, or you will distract the attention of those who derive great enjoyment from an undisturbed contemplation of the wonders in these rooms. You will excuse this hint.

3rdly. *Be not obtrusive.* You will see many things in the Museum that you do not understand. It will be well to make a memorandum of these, to be inquired into at your leisure; and in these inquiries we shall endeavour to assist you from time to time. But do not trouble other visitors with your questions; and, above all, do not trouble the young artists, some of whom you will see making drawings for their improvement. Their time is precious to them; and it is a real inconvenience to be obliged to give their attention to anything but their work, or to have their attention disturbed by an overcurious person peeping at what they are doing. If you want to make any inquiry, go to one of the attendants, who walks about in each room. He will answer you as far as he knows. You must not expect to understand what you see all at once: you must go again and again if you wish to obtain real knowledge, beyond the gratification of passing curiosity.

—o❧ ❦o—

# Report of the Select Committee on Arts and Their Connexion with Manufactures (1836)

In taking a general view of the subject before them, the Committee advert with regret to the inference they are obliged to draw from the testimony they have received; that, from the highest branches of poetical design down to the lowest connexion between design and manufactures, the Arts have received little encouragement in this country. The want of instruction in design among our industrious population, the absence of public and freely open galleries containing approved specimens of art, the fact that only recently a National Gallery has even been commenced among us, have all combined strongly to impress this conviction on the minds of the Members of the Committee. In many despotic countries far more development has been given to genius, and greater encouragement to industry, by a more liberal diffusion of the enlightening influence of the Arts. Yet, to us, a peculiarly manufacturing nation, the connexion between art and manufactures is most important;—and for this merely economical reason (were there no higher motive), it equally imports us to encourage art in its loftier attributes; since it is admitted that the cultivation of the more exalted branches of design tends to advance the humblest pursuits of industry, while the connexion of art with manufacture has often developed the genius of the greatest masters in design.

The want of instruction experienced by our workmen in the Arts is strongly adverted to by many witnesses. This deficiency is said to be particularly manifest in that branch of our industry which is commonly called the fancy trade; more especially in the silk trade; and most of all, probably, in the ribbon manufacture. Mr. Martin (the celebrated painter) complains of the want of correct design in the china trade; Mr. Papworth (an eminent architect) of its absence in the interior decorative architecture of our houses, and in furniture. Hence the adoption of the designs of the era of Louis XV. (commonly dignified with the name of Louis XIV.), a style inferior in taste and easy of execution. To a similar want of enlightened information in art, Mr. Cockerell attributes the prevailing fashion for what is called Elizabethan Architecture; a style which (whatever may be the occasional excellencies of its execution) is undoubtedly of spurious origin.[1]

From House of Commons, *Report of the Select Committee appointed to inquire into the best means of extending a knowledge of the Arts and of the Principles of Design among the People (especially the Manufacturing Population) of the Country; and also to inquire into the Constitution, Management and Effects of Institutions connected with the Arts* (1836), iii–xi (excerpts).

1. John Martin (1789–1854): celebrated painter and printmaker. John Buonarotti Papworth (1775–1847): influential designer, architect, and writer. Charles Robert Cockerell (1788–1863): architect and professor at the Royal Academy (1841–1856). [Ed.]

This scanty supply of instruction is the more to be lamented, because it appears that there exists among the enterprizing and laborious classes of our country an earnest desire for information in the Arts. To this fact, Mr. Howell, one of the Factory-Inspectors, has borne ample testimony. Mr. Morrison, a Member of the House of Commons, has given evidence to the same effect.[2]

The ardour for information is apparent in Birmingham, Sheffield and in London; and the manufacturing workmen in the neighbourhood of Coventry have (to their great honour) specifically petitioned the House of Commons for instruction in design.

It has too frequently, if not uniformly occurred, that the witnesses consulted by the Committee have felt themselves compelled to draw a comparison more favourable (in the matter of design) to our foreign rivals, and especially to the French, than could have been desired, either by the Committee or the witnesses.

The Committee were anxious to investigate the pervading cause which seemed to justify this conclusion. It appears that the great advantage which foreign manufacturing-artists possess over those of Great Britain consists in the greater extension of art throughout the mass of society abroad. Art is comparatively dear in England. In France it is cheap, because it is generally diffused.

In nothing have foreign countries possessed a greater advantage over Great Britain than in their numerous public galleries devoted to the Arts, and open gratuitously to the people. The larger towns of France are generally adorned by such institutions. In this country we can scarcely boast of any. Our exhibitions (where they exist) are usually periodical. A fee is demanded for admission, and modern works only are exhibited. From such exhibitions the poor are necessarily excluded. Even those who can afford to pay seldom enjoy the advantage of contemplating perfect specimens of beauty, or of imbibing the pure principles of art. If the recommendation of the Committee were adopted,—that the opening of public galleries for the people should, as much as possible, be encouraged,—casts of the best specimens of Sculpture might be advantageously transmitted from the metropolis to the different towns. Casts are cheaply supplied in Paris under the superintendence of an artist; and a *tarif*, indicating their several prices, is issued for the benefit of the public. This example is worthy of imitation. But, besides casts and paintings, copies of the Arabesques of Raphael, the designs at Pompeii, specimens from the era of the revival of the Arts, every thing, in short, which exhibits in combination the efforts of the artist and the workman, should be sought for in the formation of such institutions. They should also contain the most approved modern specimens, foreign as well as domestic, which our extensive commerce would readily convey to us from the most distant quarters of the globe.

It appears that among our workmen a great desire exists for such public exhibitions. Wherever it be possible, they should be accessible after working hours; and admission should be gratuitous and general. A small obstruction is frequently a virtual prohibition. The vexatious fees exacted at Westminster Abbey, St. Paul's and other public buildings are discreditable to the nation. In the Abbey at Westminster,

---

2. Thomas Jones Howell (1793–1858): legal writer, judge, and inspector of factories. James Morrison (1789–1857): merchant, politician, and art collector. [Ed.]

not only is a fee demanded at the door, but supplementary fees are extorted in different portions of the building.

—◦❧ ❦◦—

Among the advantages possessed by the manufacturing artists of foreign countries, the attention of Your Committee has been directed to the BOOKS ON ART published by the Governments for the instruction of their workmen. Among these the works issued by M. Beuth, director of the *Gewerb-Institut* at Berlin, particularly deserve to be mentioned. These works, printed at the expense of the Prussian Government, with copper-plate engravings, make known to the manufacturing artist the most beautiful models of antiquity and the era of the *Renaissance*, as well as Oriental and Moresque designs. Architectural illustrations, both for the exterior and interior of buildings, vases, tripods, pateræ, patterns for various species of manufacture, form one of these volumes. The other is devoted to plans and illustrations of the construction of the public works of Prussia.

The chief excellence of these works appears to consist in their general correctness and classical purity of taste. It is gratifying to observe, that British capital and intelligence, unaided by the Government, have been turned in the same direction. Cheap publications upon art are studied with interest by our workmen. The "Mechanics' Magazine" has, in this point of view, as well as in its more scientific character, conferred lasting advantages on the manufactures of the country. The immensely-extended publication of specimens of art by means of the steam-printing machine is justly commemorated in the Evidence of Mr. Cowper. The "Penny" and "Saturday" Magazines, the "Magasin-Pittoresque," the "Magasin-Universel," and other cheap works issued in France and Germany, are mainly indebted for their success to this great instrument of knowledge. Nothing is more cheering than to find public instruction, and consequently public happiness, thus extending with the increase of national capital, and conveying intelligence and civilization in so cheap a form to the remotest cottage in the kingdom. Such instruments may be said to form the paper-circulation of knowledge; and, while the friends of education lament that the people are yet most insufficiently provided with places of instruction, they are somewhat consoled by the reflection that these works convey instruction to the very dwellings of the people.

—◦❧ ❦◦—

The subject of a CATALOGUE, or description of the paintings, is an important element in a national collection. Besides a *catalogue raisonné*, Mr. Waagen, in the Berlin Gallery, and Baron Von Klenze, in the Gallery at Munich, have placed in each compartment of the gallery a descriptive map of the walls, by reference to which the spectator derives some brief information respecting the several pictures and their painters. It appears to the Committee that the most ready and compendious information would be given to the public by fixing its name over every separate school, and, under every picture, the name, with the time of the birth and death, of the painter; the name also of the master, or the most celebrated pupil, of the artist, might in certain cases be added. This ready (though limited) information is important to those whose time is much absorbed by mental or bodily labour. For their sakes, also,

it is essential that the Gallery be opened, in summer, after the usual hours of labour. It is far better for the nation to pay a few additional attendants in the rooms, than to close the doors on the laborious classes, to whose recreation and refinement a national collection ought to be principally devoted.

It appears to Your Committee, that some portion of the Gallery should be dedicated to the perpetuation and extension of the British School of Art. Pictures by living British artists of acknowledged merit might, after they have stood the test of time and criticism, be purchased for the national collection; especially such paintings as are more adapted, by their style and subject, to a gallery than a cabinet. A room might also be devoted to such engravings as have undergone a similar probation of public criticism. This encouragement appears to be due to the higher branches of engraving.

It would be a great public benefit if the celebrated Cartoons from Hampton Court could be deposited in the National Gallery. That they could be preserved there with safety is the opinion of several eminent artists.

Your Committee observe with regret, that the great picture of Sebastian del Piombo has been exposed to the hazard (from the incursions of insects) detailed in the Evidence.

With respect to the future extension of the national collection, it has been suggested that individuals might be encouraged to bequeath to it money as well as paintings, by inscribing over the works purchased with their bequests the names of the donors.

It has been recommended by more than one experienced witness, that the pictures particularly sought for in our national collection should be those of the era of Raphael, or of the times just antecedent to it; such works being of a purer and more elevated style than the eminent works of the Caracci. Paintings of the Raphael era form the best nucleus of a gallery; they have been sought for on this account as the basis of the new National Gallery at Berlin.

The capability of the persons appointed to make purchases for the National Gallery is a very important question. It would seem that the majority of Trustees ordinarily selected for such purposes in this country are chosen rather on account of their elevated rank and their possession of pictures than for any peculiar professional ability. A private collector may be an excellent judge of cabinet-paintings; but he may not have the comprehensive knowledge required in the choice of a national collection. In the Committees appointed to purchase paintings for the National Galleries of France and Prussia, there is a greater admixture of artists and of *experts*, or persons who have devoted themselves to the study of the value of pictures. A similar admission of practical and professional critics is, in the opinion of the Committee, desirable in this country.

—◦❧ ❦◦—

It has already been submitted by the Committee that an occasional outlay of public money on British works of art of acknowledged excellence, and in the highest style and purest taste, would be a national advantage. It has also been suggested that, in the completion of great public buildings, the arts of Sculpture and Painting might be called in for the embellishment of Architecture to the advancement of the Arts and the refinement of the people. The habitual contemplation of

noble works in Fresco and in Sculpture is worthy of the intelligence of a great and civilized nation.

It will give Your Committee the sincerest gratification if the result of their inquiry (in which they have been liberally assisted by the artists of this country) tend in any degree to raise the character of a profession which is said to stand much higher among foreign nations than, in our own; to infuse, even remotely, into an industrious and enterprizing people, a love of art, and to teach them to respect and venerate the name of "Artist."

—◦❧ ❦◦—

## Report of the Select Committee on National Monuments and Works of Art (1841)

### British Museum

At the British Museum, notwithstanding the fears of some of the principal officers, the great experiment has been made of admitting the public on the annual holidays; and the result has been very satisfactory. From 16,000 to upwards of 32,000 persons have passed through the rooms of that institution in one day, without any accident or mischief; and, it is gratifying to report, that in the course of the three or four years that this liberal system has continued, not a single case has required the interference of the police, although the displacement from the old, and the re-arrangement of the collections in the new rooms, consequent to the rebuilding of the premises, have been very unfavourable to the free passage of large numbers of visitors. The exclusion of children under eight years of age, though under the care of their parents, has caused considerable inconvenience and disappointment, and prevented many persons from visiting the Museum; and that exclusion is more complained of, as children are admitted to Hampton Court Palace and to the National Gallery without any inconvenience. The days open to the public are Mondays, Wednesdays and Fridays, from ten to five in winter, and until seven in summer; and on Tuesdays and Thursdays the Museum is visited by parties on private admission;—it may be a question, whether granting one or both of those days to the public would, in any great degree, increase the trouble to the attendants, whilst, it would be a great convenience and advantage to the public, especially in avoiding the disappointment of visitors from the country. It is also a matter worthy of the consideration of the Trustees, whether there be any necessity to require visitors, when they proceed in parties, to write their names in a book, whilst, entering separately, they are not required so to do. Delay is the consequence of that rule, and no advantage whatever seems to be derived from it. Your Committee consider that it is most desirable that all obstacles should be removed consistently with the safety of the collection. Your Committee call attention to the small number of visitors who enter the Museum between the hours of six and seven o'clock, and how far it may be advisable, consistent with public convenience, to close the admission at six o'clock.

From House of Commons, *Report of the Select Committee appointed to inquire into the present State of the National Monuments and Works of Art in Westminster Abbey, in St. Paul's Cathedral, and in other Public Edifices; to consider the best means for their Protection, and for affording Facilities to the Public for their Inspection as a means of moral and intellectual Improvement for the People* (1841), iii–iv; 133–174 (excerpts).

## The National Gallery

Affords a still more gratifying instance of success from free admission. The public are admitted on four days a week; viz., Monday, Tuesday, Wednesday and Thursday, from ten o'clock to five in winter, and to six in summer; and men, women and children are admitted without distinction. If Friday and Saturday be really required for the convenience of students, the only additional time that could be afforded would be on Sunday, after the time of divine service. The number of visitors has increased from 125,000 in 1837, to 397,649 in 1838; and in 1840 to upwards of 500,000. The greatest propriety has been observed in the demeanour of the visitors, and no instance of misconduct, requiring the interference of the police authority, has occurred. Children of every age have been admitted, with, or without their parents; and not one accident has occurred, or any inconvenience been experienced.

*Minutes of Evidence: Lieutenant-Colonel Thwaites,*
*Called in; and Examined*

2576. *Chairman.*][1] ARE you assistant-keeper and secretary to the National Gallery?—I am.

2577. How long have you been appointed?—Since the first formation of the gallery, 17 years.

2578. Can you state what number of persons have visited the gallery in the last year?—For the year ending the 31st December 1840, 503,011.

2579. What were the numbers in the preceding year?—Four hundred and sixty-six thousand eight hundred and fifty.

2580. Will you prepare a statement of the number that have attended in each year, in order to show the gradual increase from the time for which you have kept an account?—Certainly.

2581. What number have visited the gallery in this year, up to this period?—Up to the 27th day of May, 227,885.

2582. Do you attend daily?—I do.

2583. Have you had an opportunity of seeing what the conduct and behaviour of the parties attending is?—When I am not engaged with my duties as secretary, or when I am not employed upon the books or correspondence, I am always in the gallery, and have an opportunity of observing the conduct of the public; their conduct has been, as far as relates to the safety of the pictures, quite unexceptionable, and in other respects it has been quite as satisfactory as we could have wished and expected.

2584. Have they shown much interest in the pictures?—A considerable interest is shown by a few individuals, but I do not think that the mass of the people who attend, particularly on holidays, take any particular interest in them; they come and go without paying very much attention to the pictures.

1. Chairman: Joseph Hume (1777–1855); radical politician and reformer. [Ed.]

2585. Conducting themselves quietly?—Yes, conducting themselves peaceably and orderly.

2586. What is the greatest number that have ever been in the gallery on one day?—The greatest number, except, I think, once, would touch upon 10,000, but there was one day last year, if I recollect right it was Whit-Monday, when we had reason to believe that there were more than that; I think nearly 14,000 people.

2587. Did the usual attendants suffice to maintain order?—Order was maintained certainly, but it was with considerable difficulty; the rooms are small, and the crowd was very great.

2588. They are obliged to enter at one door and come out at the same door?—Yes.

2589. If there was a place for entering at one end and a door to go out at another, would not that prevent the inconvenience which is found where a great crowd assemble?—I do not think it would, because the crowd is in the rooms themselves, not in the avenues. I am not aware that there is any inconvenience there; I would add, that it would do away with one of the greatest safeguards of the pictures, that of visitors leaving their sticks, umbrellas, &c., in the entrance hall.

2590. How many should you suppose at one time could be present in the rooms?—We were originally instructed not to admit more than 200, but that was in the old gallery; we have not any instructions upon that head at present; at that time we were allowed, in case there was a great pressure of people, to close the door till part had left, but we have never had occasion to act upon that.

2591. You were aware that at Hampton Court the public are admitted on Sunday alone?—I have heard that they are.

2592. Do you see any objection to the National Gallery opening at nine o'clock in the summer instead of ten?—I am not aware of any objection, further than its being, I should think, of little use, for there is scarcely any body for the first hour, and it would make the duty of the attendants so very onerous that I think it would require additional attendants. As it is now, I assure the Committee the watching in those crowded rooms for seven and eight hours at a time, is as much as the physical powers of a man is well equal to, to do his duty.

2593. Do you and all the attendants attend during the two days when the artists are admitted?—Certainly; all except the police-officer, who is not paid for attendance for those days.

2594. You have a policeman who stands at the door to take the sticks and canes?—He assists the porter in taking the sticks and canes; but he was originally brought there as a police-officer to keep the peace.

2595. Does he belong to the police establishment?—Not to the present police establishment; he belonged to Bow-street.

2596. He now belongs to your establishment?—Yes.

2597. The number of visitors at Pall Mall was limited to 200 at a time?—Yes; and we had instructions, if they exceeded that number, so as to become inconvenient, to close the door for a time.

2598. What is the greatest number that you suppose have ever been in the present gallery at one time?—I should think about 700 or 800.

2599. How many rooms have you in the present gallery?—Three large rooms and two small ones.

2600. Are you aware of the number of rooms in Hampton Court Palace?—No, I am not; I never took a note of them, but I know they are numerous.

2601. Are the attendants in the National Gallery competent to give information to any of the visitors if they ask for it?—On most points they are.

2602. Do you observe questions occasionally put to the attendants?—Constantly.

2603. And you think that they are sufficiently competent to give information?—Decidedly so, upon general points; in short, upon all the points that it would be at all necessary for the public to know.

2604. Have you charge of the catalogues, as secretary?—Yes, I have.

2605. Can you give the Committee an account of the expense of printing the catalogue and of the proceeds of the sale for a certain number of years?—A return can be furnished.

2606. Will you have the goodness to prepare a return showing the expense of printing and the profit derived from the same?—I will.

2607. The price of the catalogues is a shilling?—Yes.

2608. What number were sold last year?—For the last half year, from the 1st of April to the 30th of September, 4,751 catalogues were sold; and 2,070 catalogues were sold from the 1st of October to the 31st of March; the two make the year.

2626. Are you able to give an opinion as to how far a catalogue different from the present one might be made out, classed according to the schools, and sold at a lower price than the present catalogue?—If the pictures were so hung, then I think the catalogue could be so made out, but not otherwise.

2627. As they are now mixed, you think the present catalogue is the best?—I think it is the best, for this simple reason, the catalogue is always available as far as it goes to the purchasers; we never change the number of the pictures, and therefore the catalogue is always serviceable; every new addition has a new number added.

2628. As they are now mingled, Italian, Flemish, English and Spanish, you think the present catalogue is the best?—I do; but I beg to mention one thing, that the pictures are not quite mingled in the way the question suggests; they are arranged as nearly as possible according to the schools, that is, the Great-room is entirely filled with Italian pictures; the next largest room is all Flemish, with a few of the superfluity of Italian pictures; the third room is filled again with some of the inferior Italian pictures and some new acquisitions of Italian pictures and English pictures.

2629. Then an attempt has been made to classify the pictures by the schools?—As far as circumstances would permit, we were instructed to do it.

2630. Do you consider that the walls are nearly covered; is there room for any more pictures?—Not in the best possible positions; there is room for a considerable number, because we can remove some of the inferior pictures to a large hall that there is beneath, which may eventually be opened to the public, if thought desirable.

2631. From your experience, are there any suggestions, in addition to the present regulation for admitting the public, which you can offer with a view to afford facility to the public in viewing the pictures?—I am not aware of any; I should, if I were asked the question, say that the public have the greatest possible facility, consistently with the benefit to be derived from the pictures by artists and students.

2632. You think that the two days in the week occupied by them are necessary for that purpose?—I should think quite so; I should say that one day would be hardly worth their attention for permanent study.

2633. If the National Gallery was opened on the Sunday afternoon, as Hampton Court Palace is, what additional attendants, and what arrangement could you make?—I should think if it were considered necessary that the gallery should be open to the public for any particular time on the Sunday, that there ought to be an entire change of attendants; with the arduous attendance in the gallery on six days in the week, I think they require the relaxation of the Sunday.

2634. If additional attendants could be procured, you are not afraid of any injury to the pictures on that day more than on any other day?—I am not; I think all depends upon the degree of surveillance; if we had equally careful men, no injury would arise.

### Mr. John Peter Wildsmith, Called in; and Examined

2635. *Chairman.*] How long have you been an attendant in the National Gallery?—Since May 1824.

2636. What hours do you attend?—From 10 till 5 in the winter, and from 10 till 6 in the summer.

2637. Are you one of the attendants who receive two guineas a week?—Yes.

2638. You have never received any increase?—In the old gallery we had two guineas a week; but we were not paid for the six weeks that the gallery was not open; but we have been paid two guineas a week all the year round, since we have been moved to the new gallery.

2639. Your attendance, in fact, is for all the year round?—We can do nothing else in the holiday.

2640. What has been the conduct of the visitors in the gallery? Nothing could be more orderly.

2641. If any of the visitors require information, do they apply to you and other attendants?—Very frequently; and any information we have we give with pleasure.

2642. Have you heard any remarks made upon the pictures?—I have heard remarks; I have been told that three-fourths of our pictures are not good enough; but no remarks of any consequence; I think some of our worst pictures are most liked.

2643. Are there any particular pictures you have heard remarks on?—I think Murillo is the greatest favourite with the public generally.

2644. Have you heard any objections to any of Poussin's paintings?—Occasionally; some people think they are a little too broad; but they are very fine; and you scarcely know where to draw the line in works of art; some of the finest statues might be objected to because they are naked.

2645. During the last year, the Committee have been informed that upwards of 500,000 visitors attended the gallery; did you find, at any time of the year, the crowd inconvenient?—Occasionally, at holiday times we have been very crowded; but when the people were tired they went away; they had an opportunity of staying as long or short a period as they liked; but we have felt it very much.

2646. You leave them to their own discretion; you never urge them to leave?—No.

2647. Colonel *Salwey*.][2] Are children admitted?—Yes.

2648. At what ages?—Infants in arms, and as soon as they can walk.

2649. Are they counted?—That I am not prepared to say; but it is possible they may be; I am in the room, and I have nothing to do with taking the numbers.

2650. *Chairman*.] Have you seen any inconvenience from children attending with their parents?—Very trifling; nothing worth remarking.

2651. Are you aware that in the British Museum they do not admit children?— Yes; but there it is of serious consequence; for they might injure things by touching them; there are many things within reach that are not so with us.

2652. And as far as you have yet gone you have found no inconvenience?—Not the least.

2653. Do you hear observations respecting the catalogue; do you believe that if the catalogue was sold at 6 *d*. instead of 1*s*. there would be a larger number purchased?—There would be a larger number purchased; people ask the price, and seem surprised when they are told 1*s*.; it occurred to-day that a party would not have one because it cost 1*s*.; but that does not occur 20 times in the year.

2654. Are those who ask questions people who have catalogues, or those who have not bought them?—Both, and as much almost the one as the other.

2655. Do you think that the interest in the pictures is increasing on the part of the visitors?—I think it is increasing every day; I notice mechanics that come, and they appear to come in order to see the pictures, and not to see the company.

2656. Then the taste for the pictures is increasing?—I think so.

2657. If a stranger applies to you for information respecting any picture in the catalogue, have you any catalogues connected with European collections to which you can refer?—No, I have not; I have never seen any collections but of the English pictures; but I know the prices that most of them have cost, and the pictures that are considered the finest of the different masters, and that information I give willingly to any body who asks me a question; I feel a pleasure in telling them, as it gives gratification to visitors.

2658. Do you consider the present hours convenient?—I assure the Committee that I feel them quite long enough, particularly in the summer; many people when they come in say, "I do not know how you bear it;" the place is wretchedly ventilated.

2659. Has not an alteration been made in the ventilation?—Very little; it is certainly better, but still it is very bad; it was almost impossible for any body to live in the rooms; it has been altered through your interference, but it is not what it ought to be.

2660. During the days in the summer when the crowds are great, you find the heat extremely oppressive?—Yes, and when they pull the windows down it causes such a draft that it is enough to give every body cold; we have almost always colds in the summer time.

2661. Then, in your opinion, the comfort of the visitors and of the attendants would be much increased by a better system of ventilation?—I think so.

2662. Is there any other suggestion you would make?—With regard to our opening at an earlier hour, I would observe, that you would be surprised at the few we have before eleven, and even twelve, and also after five o'clock; we have not one

2. Henry Salwey (1794–1874): member of Parliament. [Ed.]

after five of the lower orders, for it is their hour for tea, and those of the higher class are at that time going home to dress for dinner.

2663. Then you think the present hours are sufficient for the public?—I think quite sufficient.

2664. In case of opening the gallery on Sunday, could that be accomplished by having half the attendants, and probably a number of police officers equal to the attendants that might be on leave?—I think it might be done; but still I really think that the public having four days a week it is amply sufficient; and I think for mechanics that are shut up all day after they have been to church in the morning a walk in the fields would be much better; but that is of course a question for them.

2665. But as to the mode of providing attendance you see no difficulty?—If it was left to myself I should like Sunday to myself; but if it is altered I must submit to any regulation that is proposed.

2666. Would it not be satisfactory to you to have an alternate Sunday, or one in three?—I think that if we had visitors on Sunday we must have quite as many attendants as we have at present, because we have only one in each room, and if there was not one in every room the pictures might be damaged, and whoever was in the other room could not be accountable for it.

2667. Would there be any difficulty in finding attendants?—No; there are plenty of people to be found.

2668. What do you consider would be a fair remuneration for a man attending?—I dare say there are many who would be glad to attend at the same pay in proportion as we receive.

2669. Have you any other suggestion to offer with a view to render the gallery comfortable and useful?—If the ventilation could be made a little more equal it would be a great benefit, for it is too close without the windows down, and when they are down there is such a draft that many people leave in consequence.

2670. Colonel *Salwey*.] Could that easily be obviated?—I am not aware whether it could be done at a moderate expense; it was done in the two little rooms, but it was not sufficient.

### Sir Henry Ellis, Called in; and Examined, as Follows

2864. *Chairman*.] ARE you the principal librarian in the British Museum?—I am.

2865. Does that title properly indicate the duties of your office as librarian?—I have nothing to do with books individually; I am the superintendent of the whole institution, and the Act of Parliament names me as principal librarian.

2869. In the evidence before the Select Committee on the British Museum, in 1835–6, you expressed fears with respect to the conduct of the public if admitted to the Museum during the great holidays of Easter and Whitsuntide; will you now state, from the experience you have had since, what is your opinion of the conduct of the populace?—My fears have not been realised; on Easter Monday and on Whit-Monday the numbers are very great; on one Whit-Monday they amounted to 32,000 visitors.

2870. In what year was that?—I believe it was in 1837; between nine in the morning and seven in the evening.

2871. During that day in which the numbers were so great, was there any difficulty in maintaining order, or was the conduct of the people perfectly correct?—There might have been some few irregularities, but nothing of consequence, nor have I ever had occasion on the crowded days, or on other days, to give any single individual into custody for misconduct.

2872. Has not the popularity of the British Museum much increased of late years, as shown by the anxiety and the number of visitors that attend?—Yes, it has.

2873. What arrangements in the Museum have been made for the convenience of visitors since 1836?—The recommendations of the Committee of the House of Commons have been carried out, but I do not know that I can specify them at this moment.

2874. Have you provided any convenience for the public in the Museum, such as seats or other conveniences?—Yes, there are benches in some parts, and chairs in others.

2875. Have those been erected lately?—No; there has always been that sort of accommodation in every part of the Museum.

2876. Have any complaints reached you of want of a sufficient number of seats during the circuit in the rooms?—There have been two or three complaints, I think; an anonymous letter was written to the Bishop of London, who sent me the letter, and in consequence I ordered a number of additional seats to be provided; I think two dozen chairs immediately were ordered.

2877. Can you suggest any improvement in the arrangements made for the better accommodation of the public or the convenience of the household?—No, I have none to suggest; because the moment any fresh convenience is discovered the public are accommodated. If we find any convenience necessary we supply it [at] once.

2878. Are there any water-closets provided for the visitors in any part of the Museum?—No, there are not; there are one or two privies on the outside of the house, in the garden, and people are directed there if they make inquiry for them; but there is nothing of that kind regularly provided for the public visitors.

2879. Do not you think that provision might be made without the walls of the building, to which individuals, if necessary, might have reference?—The arrangement might be made by the architect.

2880. Do not you think in the concourse of 20,000 or 30,000 people passing in one day through the rooms, instances may occur when great inconvenience arises from want of such places?—No doubt.

2881. Mr. *Goulburn*.][3] How long, upon the average, do the people remain in the Museum?—Some an hour, some two hours, some four or five hours, and some only come to see particular branches of the institution, or single objects.

2882. *Chairman*.] Visitors are allowed to go from room to room without hindrance, and stay as long as they please?—Yes; and they return back to the same room if they please.

2883. Are there any persons in the rooms who can answer questions, if any are put by visitors?—The Synopsis is so complete as to what is publicly exhibited, that there is very little necessity for visitors to ask questions.

3. Henry Goulburn (1784–1856): Tory politician whose positions included chancellor of the exchequer, chief secretary for Ireland, and home secretary. [Ed.]

2884. And yet questions are asked, are they not?—No doubt they may be asked as regards the number of the room, or the number of the case; but the book gives the best information.

2885. What number of attendants have you for the whole establishment, excluding the library?—Exclusive of those employed in the libraries of printed books and manuscripts, the number of attendants is 24.

2886. How many attendants are there in the public rooms to which visitors are admitted?—Eighteen upon the public days.

2887. On those holidays when a great concourse is expected, do you not obtain the assistance of some of the police?—In the Easter, Whitsun and Christmas weeks we have for two or three days generally a number of police, 12 or 14.

2888. Who are stationed round the different rooms?—Who walk about the different rooms, and are in addition to the regular attendants.

2889. That is in case any thing should occur to require their interference?—Yes.

2890. But during the whole time since you were examined last in 1836, in no instance has any irregularity occurred which has required you to place any of the visitors under the police?—Certainly not; I speak of the visitors only; I do not speak of the readers.

2891. Do you still require when parties visit the Museum that one of the party should write his name and address in a book kept in the entrance-hall?—The name of one person is put down, and then perhaps 14, 16 or 20 others are counted, and the number attached against that name.

2892. If a person goes in singly he is not required to write his name down?—He is added to the number of the next party.

2893. But is not an individual coming in allowed to go at once up the stairs?—Yes.

2894. Whereas, if a party come together they are detained till one of that party writes his name in the book?—They are not detained for a moment, but one of the party writes his name and follows the rest.

2895. What advantage do you derive from having the name of one individual in a party, and not taking the names of the others?—I cannot say that I know of any particular advantage, but it insures the performance of his duty by the person who takes the numbers.

2896. Does it not create occasionally a crowd in the entrance-room?—I have never seen that; it is taken in the great hall, and the parties are counted without a word being said to them.

2897. Might they not be counted and pass on without entering their names at all, and thus prevent the possibility of interruption?—I think the servant who takes the numbers might not be so faithful in taking them down as when the name is written and the number added afterwards.

2898. You consider it merely a means of numbering?—I think it the quickest ordinary mode of numbering.

2899. Is not a portion of his time taken up in seeing that the name is written down in the book, which might be occupied in counting the different parties?—No; he says, "Sir, please to write your name;" and I do not suppose he sees what the name is; it is of no importance to him.

2900. Have you seen the National Gallery and Hampton Court?—Occasionally; I have not visited Hampton Court since the new arrangements.

2901. Are you aware of any inconvenience at the National Gallery where parties are counted without their names being taken down?—I presume that the number of visitors may be less at the National Gallery.

2902. Have you any list of the number of visitors in the several years since 1836?—I have a return of the number of persons admitted to view the British Museum between 26th March 1820 and Christmas 1840.

*[The Witness delivered in the Table, which is as follows:]*

RETURN of the Number of Persons admitted to view the British Museum, from 26th March 1820, to Christmas 1840.

| | | | |
|---|---|---|---:|
| March 26th | 1820, to March 25th | 1821 - - - - - - - - | 62,543 |
| March 26th | 1821, to March 25th | 1822 - - - - - - - - | 91,151 |
| March 26th | 1822, to March 25th | 1823 - - - - - - - - | 98,801 |
| March 26th | 1823, to Christmas | 1823 - - - - - - - - | 89,825 |
| Christmas | 1823, to Christmas | 1824 - - - - - - - - | 112,840 |
| Christmas | 1824, to Christmas | 1825 - - - - - - - - | 127,643 |
| Christmas | 1825, to Christmas | 1826 - - - - - - - - | 123,302 |
| Christmas | 1826, to Christmas | 1827 - - - - - - - - | 79,131 |
| Christmas | 1827, to Christmas | 1828 - - - - - - - - | 81,228 |
| Christmas | 1828, to Christmas | 1829 - - - - - - - - | 68,101 |
| Christmas | 1829, to Christmas | 1830 - - - - - - - - | 71,336 |
| Christmas | 1830, to Christmas | 1831 - - - - - - - - | 99,712 |
| Christmas | 1831, to Christmas | 1832 - - - - - - - - | 147,896 |
| Christmas | 1832, to Christmas | 1833 - - - - - - - - | 210,495 |
| Christmas | 1833, to Christmas | 1834 - - - - - - - - | 237,366 |
| Christmas | 1834, to Christmas | 1835 - - - - - - - - | 289,104 |
| Christmas | 1835, to Christmas | 1836 - - - - - - - - | 383,147 |
| Christmas | 1836, to Christmas | 1837 - - - - - - - - | 321,151 |
| Christmas | 1837, to Christmas | 1838 - - - - - - - - | 266,008 |
| Christmas | 1838, to Christmas | 1839 - - - - - - - - | 280,850 |
| Christmas | 1839, to Christmas | 1840 - - - - - - - - | 247,929 |

2903. Are the Committee to understand that the greatest number at any time was in 1835–6, when 383,147 persons were admitted?—Yes.

2904. Is it your opinion that the numbers have fallen off, as, from this table, they appear in 1840 to have been only 247,929?—They have fallen off certainly.

2905. Mr. *Ewart*.][4] To what do you attribute that?—I hardly know. On Whit-Monday last we had not many more than 9,000 persons; but the reason for that was evident, that Hampton Court was open, and the river was open, and the railways were open, and a variety of exhibitions were also open.

2906. But, as Hampton Court was open last year, that would not account for the falling off this year?—The weather this year was fine; there were many other attractions to divide the multitude.

2907. *Chairman*.] Are the public excluded from the King's Library at the British Museum?—Yes, at present.

2908. Why?—The operations which are carrying on for the formation of a new catalogue require all the tables to be used, and it would be a great inconvenience

4. William Ewart (1798–1869): Liberal politician and noted supporter of public access to museums and libraries. See authors and speakers. [Ed.]

to admit the public; in addition to which, the immense quantity of dust raised by them in the room has done evident injury to the books. I think that is the universal opinion; the mischief has arisen from the quantity of dirt shuffled up.

2909. Do not you think that that exclusion from the King's Library may be the reason why the number of people visiting the Museum has decreased?—I doubt it very much; the outsides of the books could not have formed any great gratification. I beg to say that parties occasionally ask on the public days to see the King's Library, and if they apply to me, I always contrive to have it shown to them.

2910. When were the public excluded from the King's Library?—I think about two years ago.

2911. Is not the library itself an object of great attraction to visitors?—The King's Library is only one room, and it would be impossible to let them go through the whole library.

2912. Is the chief objection to the public seeing the King's Library the dust that would be raised?—It is not the only objection; an objection equally great arises from the necessity of having quantities of books lying about in the room, for the use of those who are making the catalogues.

2913. How long will that take; when do you contemplate the library being opened as before?—I do not know that the trustees have at all considered that subject at present.

2914. What is the rule respecting the admission of children when accompanying their parents?—The rule is, that no children apparently under eight years of age shall be admitted.

2915. On what ground is that?—The regulation was made in consequence of a representation from several of the officers at the heads of the departments.

2916. What was the nature of the representation, and what was the date?—It was in 1836; the rule has existed for several years.

2917. Are you aware that at Hampton Court and the National Gallery no exclusion of that kind takes place?—No; I was not aware of the regulation adopted there.

2918. Have you had any complaints made, or has it been represented to you that parents have turned back from the doors and not entered the Museum when their children were refused admission?—Yes; at one time I ordered the porter to keep a list for me of the number of grown persons who went away with children, and I found that they were nearly equal in number, that is, that the refusal of a child always carried away a grown person as well, and sometimes more than one.

2919. Do not you think that that is an exclusion which ought to be removed, seeing that in other institutions children behave with great correctness?—The trustees, upon consideration of the report made to them by the heads of the departments, in which I did not join, ordered it in consequence of their representation, and it is my duty to obey it.

2920. Was there any written representation drawn up at that time against children being admitted?—There was; Mr. Hawkins was one of the parties, and he can state to the Committee his reasons for joining in it.

2921. How many days in the week are for public admission?—Three; Mondays, Wednesdays and Fridays.

2922. On the other days, what are called private days, are not parties admitted to visit the Museum?—Yes.

2923. Are not children allowed to enter with private parties?—I never make inquiry about the children who come on those days; the parties being specially attended.

2924. There is no exclusion of children on private days?—No; they come, as I have mentioned; I never take any notice of their introduction.

2925. Do not you think that one great object of the Museum is defeated by refusing to admit children under eight years of age?—I consider that a child of fourteen is as likely to be mischievous as a child of eight.

2926. Then on that score you do not see any objection to their admission?—I see no objection except the rule which the trustees have laid down, and which of course I am bound to enforce as long as it lasts.

2927. Mr. *Goulburn*.] Which do you think is more likely to profit from the Museum, a child of fourteen, or a child of eight years of age?—A child of fourteen undoubtedly; but we have had children of eight drawing in the gallery.

2928. *Chairman*.] Have you not been informed that parents have left their children at a neighbouring public-house, and have come themselves to see the Museum?—No; I have never been informed of that; but I have had at my house a succession of people to reason with me upon the propriety of letting them take their children in on the public days, and I have usually pacified them by saying, "Bring your children to-morrow, or on another day to the Museum." I have sometimes had a dozen people in the course of the day at my house, begging me to take off the restriction, which of course I could not do then.

2929. Have you made any representation to the trustees of the applications from parties with a view to be admitted with their children?—I stated my opinion at the time the rule was proposed by the heads of the departments, and having done that, and the trustees having made the rule, I have not troubled myself with it further, except to enforce it.

2930. From the representations made to you by parents, are you not aware that sometimes one parent goes through the Museum, leaving the other parent and the children outside, and that when he returns the other parent goes through?—No; I recollect, upon one occasion, Mr. Caldecot, the upholsterer, who lives opposite the Museum, stating that our rule was a great inconvenience to him; that sometimes he had six or eight people at his shop at one time begging to be allowed to sit down with their children till their friends came out.

2931. In fact, then, if the restriction was rescinded, all those inconveniences and disappointments would be removed?—I do not see the necessity for very young children coming into the Museum; they are apt to commit little indiscretions.

2932. You have had no experience of that?—Yes, we had at a former time, and I believe that was one reason why the officers made their representation to the trustees.

2933. But looking at the general effect on visitors, is not the inconvenience on the one side much greater than any that can possibly occur on the other?—It is frequently a great disappointment to parents who have brought their children from a distance, having no one at home to leave them with, to find they cannot be admitted.

2934. During private days, on whose authority are visitors admitted?—Generally on mine; or the officer who is applied to will tell the messenger to let that party go round; but we are limited in the number of attendants who can go with them; on those days all foreigners who apply are admitted.

2935. On private days what number of attendants remain in the rooms?—They do not remain in the rooms on those days; there is generally an attendant who will take half a dozen, or 12 or more visitors round the rooms; but we cannot spare the attendants to be stationed in the rooms on those days, they are engaged in the labours of the departments.

2936. But you say that a party is attended by some one of the attendants?—Yes, I generally contrive to have three or four attendants who can take parties round, and frequently the officers take parties themselves.

2937. Do you keep any list of the number of visitors who visit on private days?—Yes.

2938. Are they part of those in the list that you have given in?—Yes.

2939. What is the greatest number of visitors on that day?—Perhaps 20 or 30; I never refuse any party that comes if they are respectable, and make application; I immediately send them over.

2940. Do not you think that one of those three days might be appropriated to the public?—No, I think not.

2941. On what ground?—Because artists and scientific men make great use of those days.

2942. Do you keep any list of the number of artists or scientific men who attend?—Yes, every artist that comes to the gallery puts his name down every day.

2943. Are they numerous, so that they would be interfered with if visitors were freely admitted?—They usually make their drawings on the private days, and a great number do not come on the public days, because the inconvenience is so great; no female artist could come on a public day.

2944. Are any of the present arrangements as to the time of admission of the public susceptible of improvement?—I do not think they are at all susceptible of improvement; my own opinion is, that the Museum is open too long in the summer time, because from six to seven o'clock we rarely find that more than four or five people come in, and then if a small number of persons are distributed through the whole house there is great chance that you may some day or other be robbed; our servants cannot watch them so well when a few persons are distributed over a large space; when there are many, one visitor, to a certain extent, may be said to watch another.

2945. Then is it your opinion that the public should not be admitted after six o'clock?—I would not say that; you have opened it till seven, and, therefore, let it remain so; no inconvenience has arisen; but I only observe that the numbers are very small indeed after six.

—•◈ ◈•—

2954. Have you considered whether it might be possible to open the Museum in the afternoons of Sundays; have you directed your attention at all to that point?—No; and I hope never to direct my attention to that point.

2955. What objections do you see to it?—I do not see any advantage that could arise to people from visiting the Museum on the Sunday.

2956. Are there no advantages derived from visiting it on the week days?—Yes.

2957. Are there not many persons who cannot on the week days find time to visit the Museum, and who might be able to find time on the afternoon of Sundays?—I do not see any necessity for it at all, or any advantage that they would obtain; and I think that the servants of the Museum are as much entitled to the quiet of the Sabbath as any others of Her Majesty's subjects.

2958. Are you aware that there are many others of Her Majesty's subjects who are obliged to do duty on the Sabbath?—Probably where necessity is the plea; in catholic countries it is different. I remember hearing the coppersmiths at work on a Sunday at Calais.

2959. Is then your principal objection to any portion of the Sabbath being so appropriated on behalf of the servants of the establishment?—No, not my principal objection; because I think that it is profaning the Sabbath to open places of amusement on that day.

2960. Do you consider the British Museum a place of amusement?—It would be merely a place of amusement on the Sunday; unless you opened the library. It would be only for people to look at statues and natural history.

2961. Is not Sunday afternoon a time of which thousands in London avail themselves for amusement, and would it not be better that those persons should have an opportunity of going into the Museum, as they can now go into the palace at Hampton Court, instead of going to public-houses?—I do not think that the Museum would be an attraction to any party who might be inclined to go into a public-house on the Sunday.

2962. You consider the Museum a mere show, without affording any instruction to the visitors?—On the Sunday it would be a mere show.

2963. Why should it be a mere show on the Sundays and instructive on the week days?—Because I consider the most useful part of the Museum is the library, which, of course, you would not open on the Sunday.

2964. I am speaking of the other part of the Museum; if there are thousands in London who have not time on the week days, but who are desirous of seeing the Museum, do not you consider that great loss occurs to the community by their being deprived of that opportunity?—I cannot see that.

2965. If you were yourself desirous to see those objects of curiosity, and were confined for six days in the week to business, would you not think it a loss not to be able to see them on the Sunday?—No, it is a thing I should never look for.

2966. Mr. *Ewart*.] Are you aware that Hampton Court Palace is open on the Sundays?—I was not aware of it till I heard it in this room; it is a thing I did not expect.

2967. Mr. *Goulburn*.] When you see the numbers that visit the Museum on the week days, do you apprehend that there can be any large portion of the population debarred from seeing the Museum?—No.

2968. Mr. *Ewart*.] Must there not be a great portion of the population constantly employed in the three days during which the Museum is open to the public?—I think they all have holidays at some time or other.

2969. *Chairman.*] Your opinion is, that it would be a profanation to admit them on Sundays?—Yes.

2970. Mr. *Goulburn.*] By "profanation," you mean interfering with the discharge of the religious duties which ought to be observed on that day?—Yes, I do.

2971. *Chairman.*] Are you aware that on Sunday afternoon the public-houses in the neighbourhood of London are fuller than on any other day of the week?—I cannot give an answer to that question, for I go very little about London on the Sunday.

2972. Then, in fact, you are not acquainted with the habits of the population of London?—Not as relates to public-houses.

2973. You are not aware how they spend their time on Sundays?—No; if I accidentally pass a public-house, I may see people in it, but I have never given it a thought as to the great number that attend the public-houses.

2974. Do you consider it preferable that any portion of the working classes should pass their time in the Museum rather than in the public-house?—I do not think that the people who attend the public-houses would come to the Museum on the Sunday.

2975. Mr. *Goulburn.*] Are you not aware that a great part of the population can only attend church service in the afternoon?—A large proportion, I conceive.

2976. Have not of late afternoon services become almost universal throughout London in the churches?—Yes, in many parishes.

2977. Mr. *Ewart.*] Would your objection equally apply if the Museum was to be opened at hours on the Sunday on which service is not to be performed?—I think it would.

2978. Do you think that it is more injurious to the public to walk in the Museum than to walk in the park?—I hardly know how to answer the question.

2979. You would not restrict them from walking in the parks?—No, for that is good for the health.

2980. And you think it is more injurious and more immoral for persons to walk in the Museum than to walk in the park on the Sunday?—No, I do not know that it would be positively more immoral.

2981. *Chairman.*] Is there not a botanical department in the Museum?—There is.

2982. Of what particular advantage is that botanical department?—For scientific use.

2983. Can you state the annual number of visitors to that department?—I cannot, because none but scientific persons, or persons who have collections of botany, or who are desirous of making such come; and it would destroy the botanical specimens to open the collection to visitors generally.

2984. Do you keep any register of the persons who are admitted?—I have no doubt Mr. Brown does.

2985. Will you endeavour to obtain the number that have visited in the last few years?—I will obtain that information of Mr. Brown.

2986. Speaking of opportunities of doing mischief, do you not think that some of the attendants between the hours of five and seven have the opportunity, if they were so disposed, of interfering with any of the collections?—No, for there is an officer always superintending.

2987. Then, although it might take place, you say no injury has ever arisen?—No.

2988. Mr. *Goulburn.*] Do not you previously assure yourselves of the character of those whom you employ to attend the Museum?—Most assuredly.

2989. You do not take them without being well certified that they are persons of honesty?—They are appointed by the three principal trustees, who take care to investigate their character sufficiently.

2990. *Chairman.*] What is the amount of wages of the lowest attendant?—Eighteen shillings a week is the lowest sum; you have that in the Return and all the gradations upward.

2991. Is there any great responsibility placed in those officers?—No; there are no keys of the collections put into their hands.

2992. Then their duty is to see that the visitors do not interfere?—Yes, and to perform such duties as the officer of the department in which they are shall require of them in the cleansing or re-arranging of the collections.

2993. Have you directed your attention to the possibility of having catalogues for each department in the Museum properly arranged, and sold at a small price, instead of the single catalogue you now have?—I have turned my attention to that several times, but I think at present it is much better to have the Synopsis as a whole.

2994. But suppose a visitor goes to the Museum desirous to be informed in one department, do not you think that it is hard that he should be obliged to buy the whole of a large book, nine-tenths of which he pays little attention to?—The book is sold for 1s.; and it is the largest book for 1s. that is sold in London.

2995. Suppose a party who was directing his attention to one branch, were able to get one-twelfth for a penny, would you not be more likely to sell thousands than you are now, and would not the public be benefited?—The changes which our different departments undergo would render such catalogues incomplete in a month or two.

2996. Do not those changes render your large catalogue equally imperfect?—No; we correct the large catalogue as often as we can; but in the case of our having what we call a synopsis of natural history, and a synopsis of antiquities separately, you would print a certain number of each, and you would find, perhaps, that 200 of one or 200 of the other would be sold, leaving thousands upon your hands. The greater part of the people who come want a synopsis of the whole, they would not thank you for portions.

2997. Do you mean to say that a party who came to the Museum in order to examine the specimens of natural history, which was his particular study, would not take the single list relating to that branch?—The people who would want the single list would be very few indeed.

2998. Mr. *Goulburn.*] The great portion of those who come to the Museum are general visitors, who see all they can?—Yes; and sometimes families will take two or three copies of the Synopsis.

2999. To them it would be extremely inconvenient to have a dozen books instead of one?—Yes; and a confusion would arise.

3000. *Chairman.*] Do not you consider that there would be less confusion by having a catalogue for each department, than in the present case where there is trouble

in finding out the department from the bulk, and so on?—There is no objection that I see, to having such catalogues as you refer to, if they pay the expense. At one particular time we divided natural history and antiquities, it was at a very early period of the publication of the Synopsis, and we found the separate books did not sell.

3001. Do you require the head of every department to make an annual report to you of the state of the department?—They make an annual report to the trustees, which goes through my hands.

3002. What becomes of these reports?—The trustees have them.

3003. Are they ever printed, or merely kept for reference?—They are kept for reference; they are for the satisfaction of the trustees, that they may know what duties are performed.

3004. Are there any suggestions which occur to you that would be beneficial to the public?—Not that I am aware; for whenever any suggestion arises which I think will be serviceable to the Museum, I communicate it to the trustees, who either adopt it or reject it as they please.

## *Edward Hawkins, Esq., Called in; and Examined*

3005. *Chairman.*] You are keeper of the antiquities and coins in the British Museum?—Yes.

3006. Have you the care of the statues, bronzes, medals and various other articles of antiquity in the Museum?—Yes.

3007. Is not your collection rapidly increasing in interest with all classes of persons?—Certainly.

3008. Do you think that it assists in forming the taste of the public, as well as in conveying historical knowledge?—Certainly.

3009. What measures have the trustees taken in consequence of the recommendation of the Select Committee respecting the preparation of casts from statues, bronzes and medals?—There is a regular establishment; a moulder is appointed, who upon the application of any individual, receives direction to make moulds and to supply casts of any objects in the department, be they statues, or medals, or any thing else.

3010. Are copies kept ready of the different statues and bronzes?—Not of all; of some of the smaller objects there are, but the space that would be required to keep specimens of the larger objects would be more than we have the power of providing.

3011. Are they given to any party who may apply?—Yes.

3012. What has been the rule observed with respect to the rate of charge?—The rule is to calculate the price of the mould, to add to that the price of as many casts as we think it probable would be sold while the mould is in good condition, and then to divide the amount by the number of casts made, and add some trifle to cover extra expenses; but, generally speaking, the cost to the public, I should say, is very little more than the prime cost.

3013. Do you keep an account of the expenses attending the establishment, and also of the receipts from the sale to the public?—Yes; there is a separate account of the casting establishment, and of the receipts and payments.

3014. Have any copies of medals been taken and sold to the public?—There are casts existing of the most remarkable medals, which may be had by application.

3015. Have any of them been sold?—Several, chiefly the ancient medals.

3016. Can any institution or any individual, upon applying to the trustees or to you, obtain copies of any particular coin or any particular object in your charge?—Yes, certainly.

3017. Have you prepared and presented any to institutions free of expense?—I do not know that we have; but that would not fall at all in my department, it would go through the hands of the secretary.

3018. Can a return be prepared of the public institutions to which presents have been made?—No doubt the secretary could supply the Committee with an account of the disposal of every cast that has been made.

3019. Under the new discovery of electrotype, has any attempt been made to exchange copies with any other museums or collections in Europe?—No, nothing of the kind.

3020. Does not that discovery afford great facility for improving the collections in each country?—Yes, certainly; it has very great advantages, in giving you the most perfect representation of the type of any medal.

3021. Have you in the British Museum many coins and medals which are not to be found in other parts of the world?—Yes.

3022. And in many parts of Europe they have medals and coins which you have not?—Yes.

3023. Have the trustees made any applications for the interchange of those rarities, so that the collections in each country might be complete?—I am not aware that they have.

3024. Are you acquainted with the process of electrotype?—Yes, perfectly.

3025. It is attended with very little expense?—With very little expense, and with very little trouble.

3026. Does the medal suffer any injury from the operation, if properly conducted?—No, none that I am aware of; but the medal itself is not subjected to the process; a careful cast of a medal is quite sufficient for the purpose.

3027. But, in taking the cast of the medal preparatory to the process, the medal does not suffer any injury?—In taking a single cast, I should say none; but in the operation of cleaning the medal, both before and after the cast is taken, it is subjected to a certain degree of rubbing, which would in time injure the surface; but one mould will do for a thousand casts.

3028. Have not we an opportunity now of making a collection of all those objects at a trifling expense which heretofore has not existed?—We have, inasmuch as a metal representation of a medal is much better than the one we used to have of plaster or sulphur.

3029. Do you make a report to the trustees of the proceedings of your department annually?—Monthly.

3030. Have you in any report which you have made suggested to the trustees that interchange and addition to the collection to which I have now alluded?—No, I have not made any recommendation of the kind.

3031. Do not you think that ought to be done?—I do not know; the benefits are not so great as they appear; this process gives only the surface; it might be useful, but still in no very great degree; not commensurate with the trouble of establishing a system of exchanges.

3032. Is there any ready explanation of the different objects of antiquity under your care for the information of that portion of the public who are unable to purchase the Synopsis?—That is not carried out at present to the extent to which it ought to be, in consequence of our want of strength in the department.

3033. Would it not be advantageous to have the name of every object, and its history attached to it, in addition to the number referring to the Synopsis?—Yes; and it has only not been done, because the department has not been of sufficient strength to do it; the name only is sufficient, and practicable.

3034. Would not a catalogue of each room or of each department be preferable to one synopsis?—Not of each separate room, but a division of the Synopsis into departments would be certainly desirable.

3035. Would it not be desirable in the catalogues or description, along with the classical and technical, to give the English explanation of the different objects?—Certainly.

3036. During what hours do the principal keepers of the Museum attend in their several departments?—From ten o'clock till four; and in that part of the year when the Museum is kept open till seven, one officer is always in attendance.

3037. The Museum opens at ten?—Yes, and continues open till four the greater part of the year, but part of the year it continues open till seven.

3038. During that time, after the principal officers go away, in whose charge are the principal collections?—In the charge of the attendants.

3039. Are there not under their charge objects of great value?—Yes.

3040. Under whose responsibility, after the principal officer goes away, are those objects?—One officer is always in residence between four and seven, when the Museum is kept open till that later hour.

3041. One officer in each department?—No, one officer for the whole Museum.

3042. After the officer at the head of the department goes away, with whom does the responsibility rest?—With the attendants.

3043. Is your attendant, for instance, appointed by you or by the trustees?—By the trustees.

3044. What security is taken in your department that no abstraction or injury takes place?—Every thing that is portable is under lock and key, to which the attendant has not access; he could only get at any objects of value by breaking open the cases in which they are contained, and care is taken that we get only persons of respectable and approved character as attendants.

3045. Then the Committee are to understand that all small objects which might be removed are under the lock and key of the principal officer, and that the attendants have only the care of the rooms?—Yes; and that is the case during the whole day; the officers are occupied in their own rooms, occasionally inspecting their departments, and within call if their presence is any where required.

3046. Have you considered how far any alteration might be made in the hours of closing the Museum?—I do not think that there is any great object attained by keeping it open later that five; few people remain, and very few indeed come, after five.

3047. If there was any disposition to pilfer or injure, that time would be selected; you would be more open to injury during those hours?—I do not see that; for the attendants are in the room, whether there are more or fewer people; when there are

considerable numbers in the room, they might screen a pilferer from the sight of the attendants, but then every one is a sort of watch over his neighbour; the number of attendants is the same whether there are few visitors or many.

3051. During what you have called private days, have you observed any inconvenience arise from the admission of children along with their parents?—No, not at all.

3052. Children under the age of eight are admitted on those days with their parents, are they not?—Yes, I think they are; I do not think that there is any notice taken of them.

3053. Do you see any reason for excluding them on ordinary days?—No, none worth mentioning.

3054. You once made a representation on that subject, did you not?—I do not recollect it if we did; I heard Sir Henry Ellis mention that the officers had done so; but I really do not recollect any thing about it; I know that I never had any feeling myself about excluding them; I never thought that there was much advantage in admitting them, or in excluding them.

3055. Is there any account kept of the number of visitors on Tuesdays, Thursdays and Saturdays, which are private days?—Not in my department.

3056. Does the door-keeper attend to count the visitors?—No; I do not think any account is taken of the parties on private days.

3057. Does not the admission of parties on those days increase the labour of the attendants, and is not the risk as great when few are present?—No; our visitors are few on the private days, and an attendant goes round with them; so that there is very little chance of any damage being done by that means; then again, the parties that come in on those days come in by special recommendation; so that they are a description of persons not likely to commit depredations.

3058. If a party of 15 or 20 come, one attendant attends them?—Yes.

3059. Mr. *Goulburn*.] Have you ever sustained any loss on private days?—No, nor on public days either.

3060. *Chairman.* Are the new rooms well lighted and well suited for the purposes for which they are intended?—Those in my department certainly are.

3061. Do the lights in the Elgin room possess the distinctness required for statuary?—The light in the Elgin room is exceedingly good, but I do not think we make the best use of it; the statues are arranged on a line immediately under the light; I do not think that a good disposition of the statues; if the light came upon them diagonally, that would be better. Then, again, the floors are white; that causes a reflection which confuses the light and shadows, and prevents the objects from being viewed with advantage.

3062. With whom does the arrangement of that rest?—With the trustees.

3063. Are not the heads of the department consulted?—Yes, they are consulted.

3064. Is their advice followed?—Not always.

3065. Are the Egyptian rooms in a style consistent with the objects they contain?—The style of architecture is not Egyptian, but I do not think the style interferes much with the display of such objects.

3066. Is there any thing in the light of that room and the arrangements objectionable?—I do not quite like the light, but it is not very material with Egyptian objects that are not works of high art; I do not think it would be a good light for Roman or Greek sculpture.

3067. Can you suggest any alterations in any part of the building calculated to improve the exhibition and increase the convenience of the public?—No, I am not aware that I can; the lights are generally, I think, very good in my department.

—◦❧ ❦◦—

3073. Is the number of visitors now as great as it was three or four years ago?—No, it is not.

3074. Can you inform the Committee on what ground the decrease has taken place?—In the first place, the novelty has in some degree passed over; there is also a vast increase of attractions in various directions in and about London, and there are great facilities for getting at those objects of curiosity and attraction by rail-roads and steam-vessels which draw people from London more than they used to do.

3075. Have you attended to the practice of taking down the names of visitors in the hall of the British Museum, and do you consider that to be of any use?—No, I am not aware that it is of any use.

3076. Is it attended with any inconvenience; does it produce a crowd in getting the names?—No, I do not think it does; people are not required to put down their names; they are requested to do so, and one in five, or one in twenty or one in thirty does so; I see no great inconvenience, and no great advantage.

3077. Have you not seen parties stopped while the names were being put down?—Yes; but the numbers coming to the Museum are so few at a time that it does not create any stoppage or obstruction worth noticing.

3078. You are not aware of any advantage from that process?—No.

3079. Has not the shutting up of the King's Library tended in some degree to lessen the attraction to the public?—No, I should think not; in former times the number who visited the King's Library were comparatively few, and yet it was sufficient to create an obstruction in the transaction of the business of the library; a considerable obstruction to the passage of books and manuscripts for the accommodation of persons in the reading-room; at present, too, the King's Library is the working-room used for the formation of the catalogue, so that there are a great number of loose books lying about, and it would not be safe to admit visitors.

3080. Might not the preparation of the catalogue be going on in other rooms, and the public be allowed to go in during the three days?—That room is now required for a working-room for the making of the catalogue; but that would not get rid of the inconvenience in the way of the readers being supplied with books; and the dust that is created by the public is beyond all imagination; I think the King's Library has materially suffered from the dirt.

3081. With so many people passing through the room, is it not impossible to prevent the dust arising?—It is quite impossible to prevent it arising and settling upon the books if you have a great number of people.

3082. If the room was shut up, would it not suffer equally from dust?—No, certainly not.

3083. Mr. *Goulburn.* At what date was the King's Library rendered inaccessible to the public?—About two years ago.

3084. *Chairman*. Are not visitors allowed in the private days to go into the King's Library?—Either on public or private days small parties go in if introduced by a friend, or any special recommendation.

—•※ ※•—

3088. *Chairman*. Have you directed your attention to the possibility of opening the Museum on Sunday afternoons with the present establishment?—Yes; and if you consider the profanation of the Sabbath, and the temptation it would hold out to people to profane it, as a subject of discussion at all, there are other decided objections to its being done.

3089. But setting the profanation of the Sabbath aside; speaking to the establishment and the situation in which it now is, what is your opinion?—We could not do it with the present establishment; men who are occupied there every day in the week for 11 months in the year would not like to give up their Sundays to such occupations; if they did, it must be with a great increase of expense; but I do not apprehend they would like to do it at all; and if you were to get occasional attendants, I do not think that it would be safe.

3090. Do not you at present call in on holidays a number of police officers to attend in the Museum?—Upon Easter and Whit-Monday we do, but they are in addition to our own force; and if they were called in constantly the expense would be the same to the public, though it would be charged in one case under the head of police, and in the other to the British Museum.

3091. Do you consider that any arrangement might be made by which half the number of attendants now retained might be assisted by an equal number of police, alternating the Sundays?—That would take away from the attendants half their Sundays, and I am sure that a great number of officers and servants would object to it.

3092. Mr. *Goulburn*.] Do not you think you would have persons of inferior character, if you required that they should dedicate the whole of their Sundays to the British Museum?—Certainly; I should have less confidence in a man who would be willing to have his Sunday occupied in that way than in one who had scruples upon the subject.

3093. *Chairman*.] It is only, you will observe, in the afternoon of the Sunday?— Yes, but in the parish in which I live the service is going on the whole day; it begins at eleven in the morning, then again at three in the afternoon; and there is service again in the evening. But, after all, Sunday duties are not limited to attendance upon the church services; the whole day is appointed to be kept holy.

3094. You consider that persons could not be found to do the duty during the afternoon of the day?—I should not be disposed to trust them; at least I should trust them with great hesitation.

3095. Do you think that persons who allow themselves to be employed on the Sunday are not to be trusted?—Not except in cases of necessity; I should have less confidence in a person who allowed himself to be employed on the Sunday than in those who were not so employed.

3096. Then your opinion is, that the difficulty in finding attendants would be such, that it would not be advisable to adopt it?—I should think, certainly, that it would not be advisable.

3097. Are there not many thousands of individuals in London who cannot spare an hour in the week-day who would be glad to avail themselves of an hour in the afternoon of Sunday in visiting the Museum?—There may be, but I should say they had much better employ themselves in other ways; in the first place, those persons who are employed so closely as that on the week days had better go out on the Sunday afternoon in the country and get a little fresh air.

3098. Supposing it is a rainy day, and they are obliged to go either to the public house or the British Museum?—I do not admit the alternative.

3099. Do not you consider that relaxation is required by the artisan as well as by other individuals?—Certainly; but I do not consider that relaxation is at all incompatible with the duties of the day; I do not think that he is to be at church the whole day through, but there is a proper tone of mind to be cultivated the whole day, which he may do while he is enjoying his relaxation.

3100. Your objection is on the score of religious duties, which every man ought to perform?—That I think is the paramount objection; but I think there are other objections connected with the establishment, even if we put the other aside.

3101. What are the other objections?—The difficulty of finding proper attendants to take care of the Museum.

3102. Are there any observations which you have to make respecting greater facilities being afforded to the public, in connection with your department?—Yes; I should say that we occasionally suffer inconveniences for want of a cloak-room, or retiring-rooms; that such accommodation is a mere matter of arrangement and of expense, and that it ought to be provided.

3103. Do you mean to say that there are none for the servants of the Museum?—There are, but I am alluding to visitors.

3104. Have you witnessed any inconvenience in consequence of that?—Yes, occasionally we do witness inconvenience, because there are not those accommodations provided.

3105. Do you see any objection to that provision being made with perfect satisfaction to yourselves?—None; it is a mere matter of arrangement and expense, and one that ought to be provided for.

3106. With regard to seats in the Museum; are there sufficient facilities to enable visitors to take time in examining the curiosities?—In my department there are seats provided in those rooms where the space admits of any accommodation of that kind; some of the rooms are so crowded that there is not room to put any seat, but where there is room seats are provided.

3107. And with great satisfaction to visitors?—Yes.

3108. Are there any other suggestions that you would make?—I do not recollect any at the present moment.

3109. With regard to catalogues for your department, have you considered in what way the collections could be made more valuable?—Yes; I consider that the Catalogue, or Synopsis, might be very much improved, and it would have been improved before this time but for the reason I have mentioned, that we have not had strength enough in the department to do it, but the trustees have attended to the representation I made to them, to give me additional strength, and I do hope at some time or other we shall be able to put before the public a synopsis much more satisfactory than that which we have now.

3110. A synopsis of your department?—Yes.

3111. Will that be done by you?—In the department, by the officers of the department.

3112. I presume that you intend it should be sold at the lowest possible charge?—Of course; I believe it is the wish of the trustees to sell it at the lowest possible charge to cover the expenses of it.

3113. Have you any idea when it will be prepared?—No, I cannot tell; the strength of the department has been only lately increased, and we have a great arrear to work up; it requires a great deal of arrangement before the thing can be got into such a state as to lay it before the public.

3114. Mr. *Goulburn.*] Do you happen to know the regulations of museums abroad?—Not minutely.

3115. Do you know whether the facilities given to the public in the British Museum are greater or less than those afforded in the museums abroad?—I can speak of Paris; I should say the facilities here are greater than there.

3116. The Louvre is open only one day in the week?—Yes; but three days in the week our museum is as open as the streets; people walk in and out and backwards and forwards as they please.

3117. *Chairman.*] You have not witnessed any inconvenience or any ill-behaviour on the part of the public?—No inconvenience but want of retiring rooms, and that constant habit that young people have of touching every thing, which dirties some of the objects.

## *John Edward Gray, Esq., Called in; and Examined*

3118. *Chairman.*] WHAT situation do you fill in the British Museum?—Keeper of the zoological collection.

3119. Has your collection been increased of late?—Very rapidly indeed; within these last 12 years it has almost grown up; it was a very small collection 10 or 12 years ago.

3120. Is it now completely arranged?—Not completely, because we are on the point of moving it from the old house to the new building, and there is no part of our collection, except the birds, corals and sea-eggs, permanently arranged; the shells are disposed in the places which they are intended to occupy; the rest of the collection is not yet removed.

3121. Have you visited the museums and collections in different parts of Europe?—I have seen most of the collections in the northern parts of Europe, as far south as Vienna, but I have not seen the collections of Italy.

3122. You have been in Munich, and Vienna and Paris?—Yes.

3123. And Frankfort?—Yes.

3124. And Leyden?—Yes.

3125. Comparing the collection in the British Museum with those, what is its extent and value?—I should say that our collection takes a fair place among the collections of Europe; I would not say that it was the first, but it would come within the first two or three.

3126. Which collection do you reckon the best?—It depends upon certain points; the only collection you can compare it with is the collection at Paris, because there

you have a general collection; almost all the other collections in Europe are in a great degree local; such is the collection at Leyden; that is chiefly a collection of the animals of the Dutch colonies; the collections of Frankfort are collections chiefly made in Abyssinia and in North Africa; the collections of Vienna are confined almost to European and Brazilian specimens; but the collections of France and England are general collections, and they range pretty nearly on a par; in some respects, I should say ours was superior, and in others theirs; the collection of fish in France is far superior to our collection here. Most of the foreign collections are the appendages to colleges, and not intended for the institution, but the mass of the people.

3127. We understand that your collection in the British Museum is rapidly increasing in value and interest?—Undoubtedly.

3128. Are the number of visitors to it increasing also?—The number of students who come to use the Museum for scientific purposes, I think, is increasing; the number of general visitors I am not capable of speaking to; I can only judge from the return and the number I see in the rooms; I do not think the numbers in my own department have fallen off so much as the return would make it appear they have in the last year or two. The rooms appear to be nearly as full as in former days when the return was larger.

3129. Mr. *Goulburn.*] People may stay longer?—Yes, that may be the case; on the days on which a very large number come, it is quite delightful to see the interest that the people take; on the holiday days I go round often to notice what they are about, and I am delighted to see the manner in which they are examining the collection. The mechanics themselves appear much interested in the specimens; and you frequently see one who knows more than the others demonstrating the collection to the rest of the party.

3130. What is the conduct of the people in the Museum as compared with the conduct of the people in foreign collections?—I should say that the behaviour of the visitors to the Museum is very good, and my own opinion is, that they are better behaved than persons who visit the foreign museums, because the people here are not under any fear; but in foreign museums they seem to be under the idea that they are closely watched and guarded; and I know that the persons who are in charge of foreign collections are much more strict than our attendants ever find it necessary to be. For example, in Paris I have seen a man reprimanded for putting his finger on a glass, in order to point out a bird: I was myself arrested, in company with my wife, because I had a small parcel of paper in my hand, and I was conducted through the rooms by three soldiers; I had been making notes, and had carried the paper in my hand on which I had made my notes, and this was against the regulation; they would allow nothing to be carried by visitors to the collection. The lower class of visitors in our Museum are always well behaved, they appear to consider it as a privilege. In speaking of the behaviour of the English visitors, we should recollect, that in our large towns the people are scarcely known to each other, and our police regulations do not force every person as they do on the continent to carry with them an authentic account of himself if he is a resident, and a passport if he is a visitor, and he is not in every place liable to have these certificates of his character called for and examined.

3131. Are we to understand that visitors in the British Museum are freely permitted to examine the objects, and are more at liberty during the time they are in the

Museum?—Undoubtedly more so than in any museum in Europe. There is another difference; the English collections are the only place where I have observed any attention paid to the comfort of the great part of the visitors.

3132. You speak of those museums which you have visited in Paris, Munich and Vienna and other places?—Yes; in Vienna there is a person going round with every party, the same as in the Tower and some other places here: in Munich, in going through the picture gallery and the sculpture gallery, you are allowed to go only in one course; you enter on one side and follow that course; if you wish to see the sculpture on the further side, you must go through the galleries and see the whole of the rooms, and if you wish to return to the other end of the room you must go round the other side and enter again; it is all a matter of regulation, enforced by a strong police body. In some cases, in Vienna for instance, there are police in the rooms; in other places, in Paris for instance, there is the Invalid corps. In the Museum at Paris I think there is an officer who would be very useful in our museums and galleries; he is the guardian of the collection, and has no other duties than that of seeing that the attendants do their duty, the collection is in safety, and that during the time that visitors are in the rooms, it is his duty to be going constantly about; he is well known, and if any thing is wrong, the person in fault is taken before this guardian, who has the entire responsibility of the collection during the time that the collection is open to the public. When I was arrested in the Paris Museum, I was taken before Mr. Dufresne, who then held this office, and he immediately said, "I know Mr. Gray," and I was set at liberty directly. It would be the duty of the guardian to report any irregularity to the keeper of the collections, who is generally occupied in his study in the performance of his duties, and consequently cannot himself see that the attendants are constantly in their duty, or watch over the behaviour of the visitors.

3133. Are the Committee to understand that the present mode of visiting the British Museum, by which parties are permitted to go from room to room, and take what time they please in examining the different objects, is better than that which you experienced abroad?—Yes, and far more advantageous to them, as it allows every person to pay attention to that which interests him most.

3134. You disapprove of the plan by which the attendant accompanies a party of five or six or more round, and hurries them through the collection without allowing them time to examine the peculiar objects which they wish to examine?—Undoubtedly; and so far do I disapprove of the system, that I do not myself adopt it, even in regard to the visitors on private days in the Museum; the attendants who have charge of the rooms during the public days are also in charge of them during the private days, it being their duty to clean those rooms and keep them in order; and if a party comes to me on the private days, and asks me, "Will you allow us to go into the Museum?" I say, "You can go into my rooms, there are attendants in them, and you can look about them as you like."

3135. How many attendants have you in your rooms?—I have seven attendants; six of whom are employed in the public rooms.

3136. Do they attend on private and public days to see that all is right?—Their duty is to act as warders, to see to the conduct of the public on the public days; and it is also their duty to keep the rooms in good order, and attend to any visitors that come on the private days.

3137. Then the attendants are employed both on the public and private days?—Yes; on the public days in looking after the public solely, and on the private days in keeping the rooms clean and getting them in order for the next public day, or to answer any questions from the persons who come to study or to look at the collection in a private manner, or for scientific purposes.

3138. Are not all your rooms cleaned early in the day?—No, it occupies the attendants nearly the whole day to clean them. My attendants have many thousand square feet of glass to clean; it is as much as two men can do to keep the glass clean in the bird gallery alone; there are two men in the bird gallery, and it requires their constant exertion to keep it in a fit state to be seen.

3139. All your objects are under glass?—Almost all, except a few very large beasts, and a few specimens not liable to be injured by exposure, but almost every thing is under glass, and under lock and key.

3140. Have you found any injury done to those articles not under glass by visitors?—None at all.

3141. Abroad are the collections railed off or protected in a different manner from what ours are?—All the collections that are open to the public are protected pretty nearly the same as our own, that is to say, the animals are railed off. In Leyden they are not so, but they have perhaps only 10 visitors a day, perhaps not 10 a week; the case is therefore very different; you can only compare the collections in large towns, and there is no town so large as London.

3142. You have visited the cathedrals and chapels generally abroad; are you able to state what is the conduct of the people there as compared with the conduct of the people in England?—I should say that the conduct of the people in Catholic countries, was not better than the conduct of the people in England. In all those chapels the parts which contain the works of art are locked up even during the service time, and there is usually "the Swiss," whose business it is to look after the behaviour of the congregation, and the people that may be walking about looking at the various curiosities. In many parts of the Tyrol, where a man would not think of going past a crucifix without putting up his hand to his hat, I have frequently seen by the roadside pictures pelted and injured. I believe that the English people are better behaved than the continental people in such cases.

3143. In your museum have you any police?—We have one policeman, who attends in the hall on the public days; and others to assist the attendants in preserving order on great holidays.

3144. What is your opinion as to the advantages derived to the public from the perusal of your collection?—I must say that my opinion is that great advantages are derived from it; it gives the mass of the people a general taste for the study of nature, which cannot but be highly advantageous to their morals; it also offers great advantages to scientific people, and I am inclined to consider that the Museum is one of the greatest educational institutions of the country. I have always felt great interest in it on that account, as one of those places where people may gain real and sound knowledge.

3145. Have you made any observations upon the effect of fees being paid for admission to the public collections either here or elsewhere?—My feeling is, that it is a most injurious custom, because it induces those who are interested in the receipt

of them, to spread the report that the public are not to be trusted. I think those who receive fees have a vast interest in keeping the people out, for fear of losing their emoluments, and I found it just the same on the continent; if you wish to see the collections in many places you must pay for it, and by way of excuse they tell you the same stories as you are told here, that the people at large are not to be trusted.

3146. Where you have had experience of people being trusted, either here or abroad, do you find the same results?—I cannot say that my experience on this head has been great abroad, because abroad, the people are but little trusted; in the cathedrals and buildings of that kind, they rail the people off; you find in every chapel a high railing wherever there are pictures or sculpture; and not only for sculpture, but absolutely even for such a thing as an obelisk. There is a bronze obelisk in one of the squares at Munich, which nobody could injure, but there is a soldier whose duty it is to take care of it; the soldier has to walk backwards and forwards to prevent people coming near the obelisk; and I believe this arises only from the feeling that the people might be inclined to injure it. In the English garden (or park) at Munich, there are boards desiring the people not to write on the temples, &c.; it is the same thing with regard to the statue of Theseus, by Canova, in the Volks Garden, at Vienna, where a small temple has been built to contain it; I have never been in it without seeing a policeman in uniform in the vestibule where it is placed.

3147. Is it your opinion that a museum of natural history, being an educational establishment, ought therefore to be as free as possible?—Yes; and not only natural history, but I would regard galleries of works of art in the same light.

—◦❧ ❦◦—

3150. Did you find museums abroad open on Sundays as well as weekdays?—I do not know any natural history museum that is open on Sunday; the Museum of painting, sculpture and naval affairs, at the Louvre, and the paintings of the Luxembourg, Versailles, and the Palais Royal, are open on Sundays; the Museum of sculpture and painting at Munich, and the Museum of the Academy of Paintings at Antwerp are also open on Sundays. Botanic gardens are almost universally open on the continent on a Sunday. I was asked when I last returned from the continent for some remarks upon the subject, and I made a few notes, of which I have brought a copy, and as they were made at the time, they may be more interesting.

3151. Do they apply to opening the museums on Sundays, or to what do they apply?—To the opening of museums on Sundays.

3152. Have you directed your attention to that subject particularly, as proposed or talked of in England?—As it was proposed and talked of in England, when I was abroad I took the opportunity of inquiring what museums were open on the Sunday.

3153. What is the result of your observation and opinion?—The result is, that it seems to be the custom for people on the continent to go to see pictures and sculptures on the Sunday on the continent; for instance, the exhibition of paintings belonging to the Art-Union in Munich, and the Gallery of Sculpture and Pictures in the Great Place in Francfort was open on the Sunday, and it was almost the only day on which people went to see the pictures. The exhibition of arts and manufactures in Dresden was open on the Sunday; but the armory and the green vaults of the

Museum were not open on the Sunday; but the valet de place, however, told me that if I could make up three parties who wished to go, or paid the fees generally paid by three parties, I could obtain admission. The Zoological Garden in Paris, the collection of animals, and the garden of the Palace of Schoenbrun, near Vienna, were open on the Sunday.

3154. Mr. *Goulburn*.] Are you speaking of museums being open in Protestant or Catholic countries?—Dresden is in a Protestant country; the others are Catholic. It is the custom of the people generally in Germany, Belgium and Holland to go out and spend the Sunday afternoon at what they call a "harmony," a place where they drink and have music; that is almost universally the custom with all classes.

3155. The German bands generally play on the Sunday?—Yes, in these gardens.

3156. *Chairman*.] Have you directed your attention to the possibility of the advantage that would be derived from opening the British Museum on the Sunday?—I can see no objection to it; and I think that there may be advantage in it, confining it to the afternoon, after service. I certainly do think that much moral instruction might be gained by visiting the Museum of Natural History and Fine Arts instead of people being confined at home in close rooms, or frequenting public-houses and similar places. I would much rather have attractions in the country than in town, because I would wish to induce the people in a large town like this to go into the country; but there are times at which the opening of the Museum might be advantageous, for example, on a rainy afternoon.

3157. Mr. *Goulburn*.] On what ground do you found the opinion that persons excluded from the museums go to public-houses?—Having formerly practised as a medical man in one of the large districts of Spitalfields, I am well aware that there is a mass of the population who have no opportunity of visiting museums or galleries of art but on the Sunday, and many of whom would rather spend their Sunday afternoons in that manner than in the manner they have been accustomed to do.

3158. There is a great want of church accommodation in that particular neighbourhood, is there not?—When I lived there, there was a greater want than now; but I believe that many of those who would go to church in the morning might be inclined to come and see the Museum instead of going to public-houses in the afternoon. I know that, in that neighbourhood especially, they are very fond of works of natural history. If you go into that part of the town early on the Sunday morning, you will see many hundreds working in their little gardens for their own amusement, and evidently taking great delight in that occupation; and you will also find that a large number of them go out into the country to collect objects of natural history; if you are in search of a rare British insect or bird you will probably find it among these men.

3159. Those weavers of Spitalfields are in the habit of going into the country on the Sunday?—Yes, many of them; but I think we should have many of the Spitalfields weavers with their families visiting the Museum if it were open in the afternoon of Sunday.

3160. *Chairman*.] Are you aware that a number of the Spitalfields weavers do go to Hampton Court on Sunday?—I believe so; when I was acquainted with that neighbourhood, Hampton Court was not open.

3161. From your knowledge of the Museum establishment, can you state what arrangements could be made to admit the public in the afternoons of Sundays consistently with that recreation and attention to other duties which the attendants ought to have?—I do not anticipate any difficulty in making arrangements for opening on the Sunday afternoon; if the trustees came to the determination, I think they would readily find the means of doing it; at the present time one officer is required to be within the walls of the establishment, between the hours of four and seven, on the days when the public are admitted. The same regulation might apply to Sundays; but this would not be necessary if a guardian or superintendent of the attendants were appointed.

3162. One officer out of how many?—Out of the five heads of departments that are in residence, there are, however, only four: being the junior of the five, I receive a less salary than the rest, and I am not called upon to be in the Museum at seven o'clock.

3163. What arrangement would you make for proper attendance in the rooms?—I will not take upon myself to propose a plan, but I think the trustees would readily find the means if they were to determine upon carrying it into effect; I do not think that there would be any difficulty in its being carried out, because the same system might be adopted with regard to the assistance of the police as on the great holidays.

3164. You mean that, as on the days when there are great crowds, you have additional assistance from the police, you might on Sundays have the same assistance from them, and permit a portion of the attendants to have the day to themselves?—I should think there would not be any difficulty in it; it would of course be for the trustees to make the necessary regulations; but I do not think that there would be any difficulty.

3165. Would there be any difficulty in hiring individuals at the same rate of allowance as the attendants receive?—I think not; I do not see why there should be more difficulty in obtaining attendants to attend the Museum on the Sunday than in obtaining the assistance of police-officers, or in finding coachmen, gamekeepers or domestic servants to do their duties on a Sunday; the men employed should of course receive an adequate addition to their salaries.

3166. Mr. *Goulburn*.] Are you not aware that a large portion of the community feel a religious objection to the opening of the exhibition on the Sunday?—I should myself feel an objection to opening it during the morning service; but I do not see that there is any religious objection to giving a rational employment to people on Sunday.

3167. Do not you apprehend that a great proportion of the population have no other opportunity of attending service but in the evening and afternoon?—I had no idea of opening the Museum in the evening; the evening service begins at six or seven, and we should scarcely keep the Museum open till that time; there are many churches that have afternoon service, but the generality of servants and that class of people attend in the evening; the morning and evening are the two great services, judging from my experience of what I have seen of the churches in London; and those services would not be interfered with by opening the Museum and the picture galleries in the afternoon.

3168. But would not the same reason which prevents you from opening the Museum in the morning service apply to your not opening it in the afternoon

service?—No, because I would wish to give persons the opportunity of attending divine worship. The gardens of the Zoological Society are open during the whole of Sunday, but very few people attend them during the morning service; so that there is no necessity for all the attendants to attend until two o'clock. The same thing has taken place with regard to Mr. Cross's Surrey Zoological Gardens; he is living in a neighbourhood where the people are strict in regard to religious observances, and he has therefore thought it right to close his gardens till two o'clock; and as this is a private speculation, he doubtless found this arrangement to be most consistent with the feelings of the neighbourhood from which he derives his chief support.

3169. Have you not heard great objections stated to that?—I have not heard any objections to the plan adopted by Mr. Cross; it has given, as he informs me, great satisfaction.

3170. *Chairman.*] During rainy weather, would not the Museum on Sunday afternoon afford rational amusement to parties who have not time in the week to visit it, and who otherwise would be during that period probably driven to a public-house?—I think so.

3171. Mr. *Goulburn.*] What proportion of people would come within that category?—I should say a very considerable portion; a number of persons, especially with families, who cannot afford to take their children into the country: a single man may afford to travel by railroad or in a steam-boat, but a man with a family cannot afford to take his family to Hampton Court, although he would find the means of bringing his family to the Museum; such facilities not being given, many a man, I am inclined to think, leaves his family and gets intoxicated instead of taking rational pleasure with them.

3172. *Chairman.*] If the Museum was open, it would not prevent any person having a desire to attend public service from attending?—No.

3173. You mean the Museum to be the resort of those who in bad weather have no resort but to go to the public-house or to stop at home?—Certainly.

3174. Mr. *Goulburn.*] Opening the theatres would not interfere with the discharge of the duties of religion by those who were desirous of discharging them?—I should not be an advocate myself for the theatres being open on the Sunday, but it must depend entirely upon the feeling of the country. I must say, that I do not think the feeling of this country would be against this way of opening the Museum or similar establishments; I will give the Committee an instance: A requisition, signed by the Bishop of London and a great number of the clergy of Marylebone, was presented to the council of the Zoological Society, some little time ago, strongly urging them to close their gardens on the Sunday; the council would not take upon themselves to decide the question; they called a public meeting of the members for the purpose of considering it, and at the meeting a considerable number attended, and out of more than 200, there were 17 only who voted for closing the gardens on the Sunday.

3175. The Zoological Garden is not open generally on the Sunday?—It is open to the subscribers, each of whom may take two friends with him.

3176. That does not extend to the whole mass of the population who may have difficulty in arranging their time so as to go to any public service on the Sunday?—I should expect from the people who can afford to be subscribers to the gardens, more decorous conduct than from the lower class of the population, and therefore we may

take their conduct as a good indication of the feeling of the people, whose guides they should be.

3177. But have not the lower class of persons greater difficulty in arranging their time for the discharge of their proper religious duties on the Sunday than those who are in more easy circumstances?—I am not able to give an opinion upon that matter; I believe the attendants upon evening service are generally made up of domestic servants and the poorer classes; the masters and mistresses go to church in the morning, and the servants go to church in the evening.

3178. That is with respect to the families of the higher class, but the question refers to the inferior classes of society who have no servants; is not it generally the case with those, that it is not possible for many of them to attend the morning service, and that those persons attend the afternoon service?—I believe in that case the only persons kept at home are the wife and the younger children, and she may go to church in the evening; I believe the husband goes to church in the morning, and the children; and if the wife has not been in the morning, and is inclined to go to church, the husband takes care of the children, and the wife goes. The fact is, that people must eat and drink, and the wife is kept at home in the morning to prepare the food.

3179. But in their case necessity prevents them from going to the morning service, and in the afternoon you see no objection to offering them a recreation which is in itself a temptation not to attend the afternoon service?—I believe you will find that those same people generally go out walking, or to the public-house, in the afternoon; I am only judging from the number who attend the churches; I believe in the generality of afternoon services the attendance is very small; it may be larger in the country, but I have seen several churches in the city and the neighbourhood of London where the afternoon attendance is very small; the evening and morning service are the two great services; and the opening of the Museum in the middle of the day could not interfere with those.

3180. Have you attended many of the parish churches in the afternoon?—I have been in several; in many there is even no sermon in the afternoon.

3181. *Chairman.*] Do I understand you to state, that if the British Museum was open on the Sunday afternoon, many men who now go to the country for a trip alone would be disposed to accompany their wives and children to pass an hour or two in the Museum, if they had the opportunity free of expense?—Certainly; I can state, from having spoken to some mechanics on the subject, that I have heard them express such a desire; and I believe, from my knowledge of them, that they would be inclined to do so. Judging from the attention shown by them in the holiday time, when the husband and the wife come together, there evidently seems a great desire on their part to avail themselves of the instruction which the Museum affords. With respect to the regulation excluding young children from the Museum, I may state that I have often seen the husband stand in the court-yard to take care of such children while the wife has gone in to see the Museum, and then she has returned and stayed with them while he went in to look at it.

3182. Do you see any objection to children being allowed to go in with their parents?—I do not.

3183. You are aware that they are admitted to Hampton Court Palace along with their parents?—I am aware of it; and, such is my feeling, that when parties

have asked me on a public day to allow them to bring their children, I have said, "I cannot give you permission to-day, but there is no law to prevent you bringing them on a private day, and if you bring them I will then give them admission."

3184. Does not the present rule tend to keep away the fathers and mothers of families, who would be desirous of bringing their children?—Yes, certainly.

3185. You think that restriction ought to be removed?—Yes, I see no use in the restriction.

3186. Mr. *Milnes*.][5] You would not have any restriction of age?—I do not see any use in it; a child in arms may be an obstruction, but it can do no mischief; but its being prevented coming prevents the mother also from coming. As to young children, the remarks I have heard young children make, even under eight years of age, strongly incline me to recommend their admission.

3187. *Chairman*.] Do you make a report from your department to the trustees annually or monthly?—I make a report every month of what has been done during the month.

3188. What is the nature of it?—It includes an account of the occupation of the persons employed in the department during the month; and every year we are called upon to make a report of what has been our occupation, and what increase has taken place in the collection during the preceding year, an abstract of which report is printed in the return that is made to the House of Commons.

3189. Within the last two years?—Yes; the report is very short; I think it might be advantageously made longer. It is the regulation, that we should make a report of that kind, and I apprehend the making the report is advantageous.

3190. Do you mean that a longer report might be useful to the public, by affording information which they have not now?—Yes.

3191. With regard to the catalogues, is the present general catalogue, which is sold at the door for 1*s*., prepared in the most convenient mode for visitors generally of the Museum?—On that subject I would wish to refer the Committee to my evidence given before the British Museum Committee on a former occasion, in which I expressed a wish that there should be two works; viz., a cheap "Guide" for the general visitors, and a "Synopsis" similar to the present one for students, but of which there should be a separate one for each department; one would be very useful to persons who use the reading-rooms. I there recommended a smaller "Guide" adapted for the visitors; the Synopsis we have is a large book, and the general visitor does not want all the details, but wants a short account that he can look through while walking through the Museum.

3192. Do you consider that that should be made for the use of visitors only, or for students, or that there should be one for each?—I think there should be one for each. I said that I thought this smaller "Guide" ought to be sold for 4*d*., but if you could reduce it to 2*d*. it would be better,—merely a sheet or two, which should state what is in each room, and the more remarkable things in each room; but for the purpose of students you require a larger catalogue.

3193. Have you attended to the publications in Mr. Knight's works respecting the Museum, and considered how far the publication of cheap Penny Magazines has been productive of benefit?—Mr. Knight has not only published some account of the Museum in the Penny Magazine, but he has published three or four volumes, two

5. Richard Monckton Milnes (1809–1885): author, politician, bibliophile, biographer of Keats. [Ed.]

of which were written by Sir Henry Ellis, illustrated by figures of the works of art in the British Museum.[6]

3194. Do you consider that that cheap publication has tended to direct the attention of the public and visitors to those works of art?—I think so, very considerably; far more than any of the large works of the same kind; I think they have had a very good effect, and I wish that an account of the natural history collection was published in somewhat of the same manner.

3195. If advantage has followed the publication with respect to that department, it is your opinion that a similar publication with respect to each department would add to the value of the Museum?—I think so; but I have often thought that it would be better that it should be undertaken by a private individual than by the trustees, and I think that the trustees might at the same time give facilities for such publications being sold on or near the premises. The trustees have not the means of bringing their works before the public, or I am quite sure that there would not have been the loss that has been incurred in publishing the works on the ancient marbles; the sale of that work has been exceedingly small, as we see from the returns. Those works are scarcely known on the continent, and very little in England. There are some guides published by private booksellers, but they are very bad.

3196. Have any instances of inconvenience to the public from want of proper accommodation, such as retiring places, existed in your department?—Very considerable, arising from the want of a ladies' cloak-room; and I am very glad to say that, from some conversation which I have had with the clerk of the works, I believe one is about being formed in the Museum. I have been called upon, as having been a medical man, to wait upon women fainting in the institution; and I have found that the real cause of illness was the want of accommodation, and the best mode of cure to send them to an out-of-door's closet, the only one accessible, and very inconveniently placed.

3197. You see no difficulty in that convenience being provided?—I can see no difficulty whatever; and, judging from experience, I should say, that no inconvenience arises from having such a thing in the Zoological Society's Gardens; there is what is called a cloak-room at the back of the cages on the lawn; it is merely an open room for the ladies to go to, and there is no attendant in it; but I conceive that there would be no difficulty, as we have four housemaids in the Museum, in one of them being called upon to attend constantly in the room.

3198. Are there any other suggestions which you can offer to the Committee to increase the facilities of visitors in visiting the Museum?—I do not know of any. I may just mention, that I think it very desirable that some means should be adopted to prevent people from entering the Museum with their shoes loaded with dust and dirt. I think this might be readily accomplished by having part of the steps or of the hall over which they walk in entering the building, furnished with iron gratings like those at the entrance of the House of Commons, and the remainder covered with mats which would suffer the dust to fall through the interstices. In Dresden people with dust on their shoes are not permitted to enter the galleries; and shoe-blacks attend by the steps at the entrance to perform their function for such as need it. Direction calling people's attention to the evil should also be put up at the door.

6. Charles Knight (1791–1866): author and publisher for the Society for the Diffusion of Useful Knowledge. [Ed.]

— ◦❧ ❦◦ —

# Report of the Select Committee on the National Gallery (1850)

## Lord Seymour IN THE CHAIR

### Thomas Uwins, Esq. R. A., Keeper of the National Gallery; and Colonel George Saunders Thwaites; Examined

71. *Chairman*[1].] (To Mr. *Uwins*.) YOU are Keeper of the National Gallery?—I am.

72. Since what time have you held that appointment?—Since November 1847.

73. Previously to your having that appointment, the pictures were under the charge of Mr. Eastlake?—Yes, they were.

74. (To Colonel *Thwaites*.) You are Assistant Keeper of the National Gallery?— Yes, I am Assistant Keeper and Secretary to the Trustees.

75. Since what time have you held that appointment?—Since 1824; from the original formation of the Gallery.

76. Mr. *Disraeli*.][2] (To Mr. *Uwins*.) Did you give evidence before the Committee in 1848?—Not before the Committee; I gave evidence before another Committee connected with the Fine Arts.

77. *Chairman*.] Have you read the Report of the Commission appointed to inquire into the state of the pictures in the National Gallery?—I have read it this morning.

78. Do you concur in the statements made in that Report as to the injury done to the pictures by the atmosphere of the rooms in which they are kept?—Yes, my experience compels me to concur in it; I have observed it so attentively and so accurately, that I cannot doubt the fact.

79. Are you a member of the Royal Academy?—Yes.

80. In the Exhibition of the Royal Academy, have there been equal complaints respecting the state of the pictures from the effect of the atmosphere?—I apprehend, from the short time that the pictures are there, only a few weeks comparatively, the same results would not be observable.

81. But, practically, you have not heard the complaint?—No, I have not.

House of Commons, *Report of the Select Committee to Consider the Present Accommodation Afforded by the National Gallery; and the Best Mode of Preserving and Exhibiting to the Public the Works of Art Given to the Nation or Purchased by Parliamentary Grants Commissioners on the Fine Arts* (1850), 5–13 (excerpts).

1. Edward Adolphus Seymour, twelfth Duke of Somerset (1805–1885): Whig aristocrat and politician. [Ed.]

2. Benjamin Disraeli, Earl of Beaconsfield (1804–1881): Conservative politician and novelist, prime minister (1868, 1874–80). [Ed.]

82. The evils arising to the pictures from the atmosphere, appear to arise from the crowds who go there in cases of bad weather, and who go there without any regard for the pictures; have you observed that many persons, out of the 3,000 a day that are said to go into the Gallery, do go there without reference to seeing pictures of high art?—I must imagine that to be the case, from many things that I have myself observed take place in the Gallery. I have seen that many persons use it as a place to eat luncheons in, and for refreshment, and for appointments. There are room-keepers, who are very vigilant and attentive to everything that goes forward, and who check any improprieties. Scarcely a day passes that I do not visit the Gallery myself, and I have observed a great many things which show that many persons who come, do not come really to see the pictures. On one occasion, I saw a school of boys, imagine 20, taking their satchels from their backs with their bread and cheese, sitting down and making themselves very comfortable, and eating their luncheon. I saw the impropriety of the thing, and the room-keeper would have observed it, if I had not. I asked whether they had any superintendent or master; they pointed out a person to me, to whom I addressed myself; and I must say that, with great civility and great attention, he immediately ordered the ceremony to be put an end to, and it was stopped accordingly; but it required that interference on my part to stop it; it was supposed to be a place where such a thing could, without impropriety, be done. On another occasion, I saw some people, who seemed to be country people, who had a basket of provisions, and who drew their chairs round and sat down, and seemed to make themselves very comfortable; they had meat and drink; and when I suggested to them the impropriety of such a proceeding in such a place, they were very good-humoured, and a lady offered me a glass of gin, and wished me to partake of what they had provided; I represented to them that those things could not be tolerated. And on frequent occasions, I have perceived a quantity of orange-peel in different corners of the place, which proved that oranges, among other things, are eaten; and eating, no doubt, goes forward sometimes. On another occasion, I witnessed what appeared to me to evidence anything but a desire to see the pictures: a man and woman had got their child, teaching it its first steps; they were making it run from one place to another, backwards and forwards; on receiving it on one side, they made it run to the other side; it seemed to be just the place that was sought for for such an amusement.

83. Since you have been acquainted with the Gallery, have you observed any improvement in the character of the visitors, with regard to their looking at the pictures, or seeming to come more for study than they did at first?—I have not observed any difference in that respect; but there is a difference in the visitors on different days. Mondays, for instance, are days when a large number of the lower class of people assemble there, and men and women bring their families of children, children in arms, and a train of children around them and following them, and they are subject to all the little accidents that happen with children, and which are constantly visible upon the floors of the place; and on the days especially that the regiment which is quartered behind the National Gallery is mounting guard at Saint James's; the music attracts the multitude; an immense crowd follows the soldiers, and then they come into the National Gallery; as soon as the procession is over, the multitude come in, who certainly do not seem to be interested at all about the pictures.

84. Have you complaints, from the artists and others who come to study the pictures, of the inconvenience and annoyance that attend this crowding of people into the National Gallery?—There are two days in the week appropriated to the artists to study in the National Gallery; and they only come on those days when they can see the pictures without the disturbance of a multitude of people.

85. Then, in fact, upon four days of the week the artists are excluded by the multitudes that come to the National Gallery?—They are excluded, necessarily; they could not in the midst of crowds of visitors pursue their studies in the regular way, and therefore two days in the week, Fridays and Saturdays, are set apart for that purpose.

86. Mr. *Disraeli.*] Have not the Trustees power to make regulations to prevent persons taking refreshment in the National Gallery?—They have the power to make such regulations; I am not sure whether there are such regulations put up in the hall.

87. Have not they the power to make regulations to prevent the introduction of children under a certain age?—They have that power, but it has never been exercised; on the contrary, it was the wish especially of Lord Liverpool that children of all ages should be admitted.

88. That children in arms should be admitted?—Yes; Lord Liverpool's reason was, that by admitting children, the parents had the power of coming; and if the children did not come, the parents could not, but if my opinion were asked. I should say, it is very injudicious, because it must be a dangerous thing to admit children; they do mischief in various ways.

89. Do you know whether children are admitted into the different Galleries on the continent?—I think they are not, under a certain age; I have visited most of the continental Galleries, and I do not recollect in any instance seeing young children in those galleries.

90. You have been in the Louvre?—Frequently.

91. Did you ever see children in arms in the Louvre?—I never did.

92. Did you ever see people taking refreshment in the Louvre?—No.

93. *Chairman.*] In the British Museum children under 12 are not admitted?—Such a regulation might, with very great propriety, be made in the case of the National Gallery; but such has not been the case, and I have no power to act, except as the Trustees dictate.

94. Mr. *H. Hope.*][3] Are you aware that the public are not admitted to the Louvre on any day but on Sundays?—I am quite aware that there is no gallery in Europe where the admission is so general as it is in this country; in every other country it is only on Sundays and feast-days that the public are admitted.

95. Mr. *Baring Wall.*][4] That is to say, the French public; foreigners are admitted on all days by passports?—Yes, and that is the case here; I have never refused foreigners that came on private days, but to the Louvre the mass of the public are never admitted except on Sundays or feast-days.

---

3. Henry Thomas Hope (1808–1862): wealthy patron of the arts and Conservative member of Parliament. [Ed.]

4. Charles Baring Wall (1795–1853): Conservative member of Parliament. [Ed.]

96. Do not you imagine that the staff of the Louvre Gallery is much more numerous than the staff of our National Gallery in London?—I am not aware how that is.

97. Can you state how many we have in attendance at the National Gallery?—There is one for every room in the National Gallery, except for the two smaller rooms, there is one person in attendance; but the three large rooms have each one person in attendance; so that I think there are as many attendants in the National Gallery in proportion as in the Louvre, according to my observation.

98. Colonel *Rawdon*.] Do they attend all day, or are they relieved?—They attend all day; they are relieved when they take their dinners, but it is merely by exchanging with each other, so that for a short time there is a comparatively smaller attendance, but it is supplied as far as possible; every arrangement is made to secure the attendance of the men.

99. You have one man to each of the large rooms, and one man for the two smaller rooms?—Yes.

100. When one man goes away to dinner, one of the large rooms must be neglected?—In general a man is brought from the hall on that occasion to attend; there is a porter in the hall, and there are men who attend to take umbrellas, so that by means of their giving assistance the place is tolerably well supplied; it is for only a short time, and I am not aware of much evil arising from that cause.

101. Do the attendants who remain during the whole day complain of the atmosphere of the rooms being prejudicial to their health?—I have heard frequent complaints of the state of the atmosphere when the rooms are crowded, but I never heard from any of the attendants that their health was affected by it.

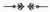

120. On the two days in the week that the artists have the Gallery to themselves, do many artists visit it?—A great many.

121. Have the number of artists increased since you knew the Gallery first, comparing the former with the latter period?—I think they go on constantly increasing; but there can only be a certain number admitted at a time, on account of the size of the rooms, and the inconvenience that there would be, with the space that the easels and other apparatus occupy, if there were a great number; so that there is always a quarterly list, and the students who are admitted must be confined to that list.

122. Is that list submitted to the trustees?—No, it is not submitted to them; it is my list entirely; it is kept by Colonel Thwaites, and it is for him to put down the names according to their priority of application.

123. Are they put down strictly according to priority of application?—They are.

124. Without reference to their knowledge of drawing, or any other circumstance, if they apply for admission as artists, they are admitted to copy?—If, from the examples they show me of their talents (for that is one necessary part of the system), I see that they can get no good from copying there, I recommend the applicants, as gently as I can, to study in some fitting school before they come there; because I tell them it is not a place to which they should come in perfect ignorance, and that they can get no good from coming in that state.

125. In applying to you, do they bring with them a specimen of their talents?—Always.

126. If you consider that specimen to show very great insufficiency of practice, you recommend them to study elsewhere; is that so?—I recommend them to study at schools suitable to their capability, if their studies show a great deficiency in drawing, or a great deficiency in the power of painting, because I think that they can get no good unless they come to the National Gallery possessed of a certain amount of information.

127. How many artists at one time can be accommodated in the Gallery?—I should make a distinction between those who paint in water-colours and those who paint in oil. The limit is only with reference to those who paint in oil; those who apply for admission, and who draw in water-colours or in chalk, take up so much less room, and are so much less incumbrance altogether, that I have been in the habit of giving tickets to whoever applied, provided there was talent sufficiently displayed in the artist, to show that good would be obtained from his attending the National Gallery.

128. With regard to those paintings in oil; to what number is it limited?— Colonel Thwaites can answer that question better than I can.—(Col. *Thwaites.*) The regular number admitted in each of the three monthly periods is 70; but the keeper is authorized by the Trustees to admit a few supernumeraries, which, upon an average, amount to about eight more, or perhaps we may say 10 more.

129. Do you mean that 70 have permission to enter the Gallery to paint in oil?—Yes; 50 general students, and 20 additional, who are students of the Royal Academy, making altogether 70.

130. So that, if an artist applied when the 50 were full, he could not be admitted unless he belonged to the Royal Academy; is that so?—He could not be admitted unless his name was on the Royal Academy list.——(Mr. *Uwins.*) That is, unless he were admitted as a stranger; it is usual to admit foreigners, and persons whose usual residence is at a distance from London, and who cannot take advantage of the regular list of the Royal Academy.

131. But 70 only can be accommodated at a time to copy?—There is never the whole number there at one time.

132. At one time, how many on an average can find room, or do find room, practically?—I should suppose that all of them who come could find room; but then they must only choose such a picture as they could find a place to copy; precedence gives them the choice of the picture; and if two or three artists are round a picture, it is obvious there cannot be many more round that particular picture.

133. How many in a day, practically, do come on the days reserved for artists to copy in oil?—I should suppose rather more than half the number.——(Colonel *Thwaites.*) I should think more than half, but not much more.

134. That would be between 30 and 40?—(Mr. *Uwins.*) Yes, and a great many copy in water colours and chalk.

135. Have you observed whether they come to copy pictures for sale, or whether they come as students?—I am sorry to say that it is a very common thing indeed for them to come to copy pictures for sale; I do everything I can to prevent it, and to discourage it in every way I can, because I consider it a very improper course.

136. Why do you consider it so improper a course that they should copy pictures for sale?—Because I think their object ought to be to study the pictures, and not to make a profit of them.

137. Have you not observed in the foreign galleries in France, and Italy and Germany, a great many artists seem to live by making copies of pictures for sale?—Certainly I have, and there are a great many who seem to do it here; but it does appear to me a very illegitimate course to pursue; speaking for myself, I am very sorry to see it.

138. Do not copies of good pictures tend to diffuse among the public generally a knowledge and love of art?—I doubt whether such copies as are sold have that tendency; I consider that, if really good copies were made, and diffused, some good might come of it, but the copies which are ordinarily made for sale, I imagine, have a tendency more to do harm than to do good. I believe they are like the witches in Macbeth, "they keep the promise to the ear, but break it to the hope;" they seem to be what in reality they are not; they deceive the eye, and do not satisfy the mind.

139. Mr. *H. Hope*.] Added to which, they are sometimes sold as originals?—Yes, and I think there is very great danger of that; we know the arts of picture-dealers in smoking pictures, and worm-eating them, and a thousand other tricks that are practised to make them appear originals.

140. Mr. *Sidney Herbert*.][5] Do you mean that there are so many copyists of pictures for sale as to exclude students?—They all come under the guise of students; they are considered as students, but those who make copies for sale are not the best artists who work there.

141. Mr. *Disraeli*.] With reference to those 50 that you mentioned, are we to understand that none of those are students of the Royal Academy?—Some may be.

142. Are those who copy pictures for sale confined to the 50?—I cannot say that; I would be happy to say it if I could, because I should be glad, for the credit of the students of the Royal Academy, that nothing of the kind should be said of them; and I do hope it is not the case, but I cannot say that it is not.

143. Mr. *Vernon Smith*.][6] Is it contrary to your regulations that there should be any copies made for sale; is that a stipulation with the students?—There is no regulation of that kind; nor have the Trustees made any regulation upon the subject.

144. Mr. *Disraeli*.] Has not the Royal Academy the power of making regulations, as regards the students making copies for sale?—In the School of Painting, the Royal Academy take every possible precaution that it shall not be the case. Every picture is signed by the keeper, and it is stated that it is a copy of such a picture, and by whom it is taken, and it is dated; all that is done on purpose to prevent, as far as possible, any attempt to sell it in any other shape than as a copy; and it is understood that pictures are not copied for that purpose, but for the purposes of the school; and when we remember that it is for such purposes that noblemen and other possessors of pictures that are sent there, contribute their works to the school, we have, I think, a right to expect that nothing of the kind shall be done. There is one strict law observed at the Royal Academy, which is, that nothing shall be copied without some alteration from the original. That is one means that is taken to prevent the picture being sold, and to ensure as much as possible that it shall bear the marks of a picture copied. There is

5. Sidney Herbert, first Baron Herbert of Lea (1810–1861): Conservative politician. [Ed.]
6. Robert Vernon Smith, first Baron Lyveden (1800–1873): Liberal politician. [Ed.]

every endeavour made in the school of the Royal Academy to prevent the possibility of the copies going abroad under a false name; and I may say, for the honour of the students of the Royal Academy, that, generally, I have seen hung up in their studies all those copies which they have made in the school, and that is the real object of their painting them; but still I cannot undertake to say that they do not sometimes make copies for sale.

145. But those observations do not extend, as far as your experience is concerned, to their copying pictures in the National Gallery?—I think the students of the Royal Academy, when they copy in the National Gallery, are likely to be bound by the same rule that we impose upon them at the Royal Academy, because it is only an extension of the same indulgence which they have in the School of Painting.

146. Generally speaking, the copyists of the pictures for sale would be found among the 50?—That I would not venture to say; I should say they would be among the 77.

147. Mr. *Sidney Herbert.*] I understood you to say that there were from 30 to 40 of the whole 70 who paint in oils?—That is the number who generally attend.

148. What proportion of the 30 or 40 students do you suppose are students of the Royal Academy?——I think a large proportion; but Colonel Thwaites can answer that question better than I can.—(Colonel *Thwaites.*) It fluctuates so much, that I should be at a loss to answer that question.

149. Mr. *Baring Wall.*] Supposing all the 70 were to come, what would happen?—(Mr. *Uwins.*) They must separate themselves to different pictures.

150. Should you tell any of them to go away?—No.

151. Did such a thing ever happen?—I do not suppose it ever did happen that the whole number came.

152. What is the greatest number, do you think, that ever attended?—I think the average generally is about half, as near as I can calculate.

153. *Colonel Rawdon.*][7] Do you reside at the National Gallery?—No.

154. When applications are made to you by students to copy, do you see the students yourself?—I see the works they present, and, generally, I see the students themselves.

155. Do you ascertain from the student what particular picture he wants to copy?—No; he is allowed, if I approve the specimen he sends, to enter the Gallery, and to take advantage of what pictures there may be in it.

156. What check is there upon many students going to the same picture?—The only check is the palpable inconvenience and impossibility of their all reaching the picture, so as to take any advantage of it.

157. Then they arrange that among themselves; you do not regulate it?—No; they arrange it in the best way they can.

158. Did you ever know an instance of their not being able to arrange it amicably?—Generally, they arrange it amicably among themselves.

159. Mr. *Baring Wall.*] What proof have you that the drawing brought to you is the production of the gentleman who applies for admission?—I must rely upon his honour; but, generally speaking, these things may be tolerably well ascertained.

7. John Dawson Rawdon (1804–1866): Irish Whig member of Parliament. [Ed.]

160. Colonel *Rawdon*.] Are you not aware that at the Louvre, and other picture galleries abroad, artists generally apply for permission to copy a particular picture, and they are only allowed to copy that picture?—I have applied, myself, for permission to copy, not in the Louvre, but in the Gallery of Florence and other public galleries, and it was always left for the artists to arrange it among themselves. If they found that the picture that they wished to copy was surrounded by a certain number of artists, as many as were able to get near the picture, others gave way. I am not aware that there was any positive law upon the subject.

161. Mr. *Baring Wall*.] What school is most in demand for copying?—The Flemish school is most in demand; the Vandyke Head, and the Works of Rubens, are the most frequently copied in the Gallery; and next to those, perhaps, the collection of children's heads by Sir Joshua Reynolds.

162. Are there any ladies amongst the copyists?—A great many; I should suppose nearly half are ladies.

163. Are many of the pictures that are copied, reduced in size and made miniatures of, or small recollections of the original pictures?—Yes, in many cases, that is so.

164. The artist may do as he or she thinks fit, in copying the pictures?—Yes, there is no restriction of any kind.

165. Colonel *Rawdon*.] You regard it as improper, on the part of a student, to copy a picture with a view to sell it?—I do regard it as an improper thing.

166. Therefore it would be improper on the part of any gentleman to give an artist a commission to copy a picture?—If an artist came to me, and said that he had a commission to copy a picture, and claimed any particular privilege in consequence of that, I certainly should avoid giving him any privilege on that account. I should bind him more strictly to the laws, and rather put it out of his way, than give him any facilities for doing it; that I should do on principle.

167. Mr. *Vernon Smith*.] You say that you would not give an artist, so applying, any privilege, but you would not refuse him power to do it?—No, I could not refuse him power to do it in his turn; but I should not wish to do anything to assist him in carrying out that object.

168. It is not an order given by the Trustees to yourself, that artists are not to be permitted to copy?—No, this is an opinion of my own; we never had the opinion of the Trustees on the subject, but I have the privilege of extending the limits of an artist's term on some occasions; an artist's term of three months has come to an end, and he asks permission to have that extended; and on examination of his picture, if I think he can accomplish his object in a short time without interfering with the next set of pupils, I allow him the privilege.

169. Are you aware whether the public generally know that it is not considered right that copies should be made for sale?—I am not aware of that.

170. Are you aware of the fact, that persons have given orders for copies to be made for them?—I hear occasionally of orders being given to copy pictures, and I have no means of preventing it. I merely give an opinion upon the subject.

171. Mr. *Disraeli*.] Do you think a man could make a good copy of a picture of an old master without studying that old master for some time?—I believe he could not make a good copy of a picture of an old master, not only without studying that master, but without a very general knowledge of art, obtained from a very long

course of study; no good copy of a picture can be made unless the person copying has attained such a point of art as to be able to paint an original analogous to that which he is copying.

172. Is not all copying, to a certain degree, the process of study?—Certainly, it is the process of study, and every artist must copy to a certain extent, in the course of his studies, to understand the different mode of proceeding of different artists and different schools; that seems to be the object of copying, and not to copy pictures for sale.

173. *Chairman.*] You say you have given admissions for about 70 artists to study in the Gallery, are you obliged to refuse any on account of want of space to accommodate them?—Not usually; I think generally it has arranged itself very well; the plan seems to work very well with those who are in the habit of coming.

174. As far as the extent of the Gallery goes, are the Committee to understand that the Gallery is large enough for the purpose of accommodating the artists?—Perhaps not; perhaps there are some pictures hung out of the way, which, if the Gallery were larger, might be brought down more, and made more available as objects of study; but it is clear that, however large the Gallery may be, only a certain number can copy one picture at one time; that must obviously be the case in the Louvre, and every Gallery.

175. The whole surface in the rooms which is adapted for pictures is occupied by pictures?—Nearly the whole surface is occupied by pictures; if any gentleman presented a very fine picture, I dare say we should find room for it.

176. If any collection of pictures were given to you, would you have room for it?—Not for a large collection.

# H. M. BATEMAN

—◦❧ ❦◦—

## *The Boy Who Breathed on the Glass at the British Museum*

# Two

# Rationalizing the National Collections

# Chapter Four
# ART AND THE NATIONAL GALLERY

The National Gallery was regularly faulted, not only for flaws in the design of the building it shared with the Royal Academy until 1868, but for gaps in its collection and errors in the accession and preservation of its holdings. The British Museum, while seldom subjected to the vitriol that characterized accounts of the Gallery, challenged administrators and visitors by the sheer size and heterogeneity of its collection. At once museum of antiquities, copyright library, and repository of collections of natural history, numismatics, and more—how was such a diverse accumulation of materials to be rationalized so that it carried out the function of a modern cultural institution, especially given the pressure on the space of the building bound to result from the inexorable increase in all holdings?

While the National Gallery contained a small number of important works, it was evidently a modest collection, and one whose growth was constrained by its cramped quarters. The British Museum, on the other hand, displayed objects of supreme artistic value—namely the Elgin Marbles. But it was an open question whether the appropriate home for those statues was with other antiquities—including many whose value was not understood to be aesthetic, but rather historical. Was the natural place for the work of Phidias among other archeological finds, or was it with the painted masterpieces on display in Trafalgar Square? If the decision were made to place the Elgin Marbles alongside other admired creations in a great reformed National Gallery, what would be the loss entailed in separating works of classical antiquity from the major research library in the country? More broadly, was the goal of a national museum to display its most worthy holdings in the most affecting manner, or was it to serve as a never-completable receptacle for objects of historic and cultural interest as they were identified?

The example of continental collections, the growing sophistication of the emerging field of art history and of science itself (along with great public interest in both), as well as the experience of decades of administration, all come into play in the repeated attempts to align practical concerns with ideal aspirations. The model of the

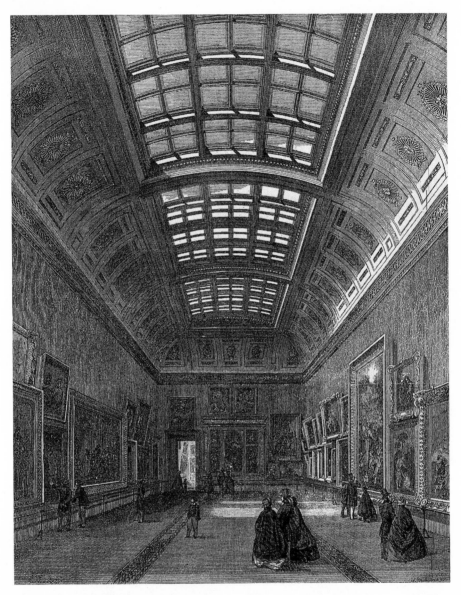

FIGURE 4.1  "New Room at the National Gallery." *Illustrated London News*, June 15, 1861.

Great Exhibition of 1851 evidently inspired those engaged in the arts to imagine a newly rationalized collection as well as to trust in the existence of a public liable to be responsive to the experience of its holdings, one ready to learn while engaged in rational amusement. Although most of the radical reforms recommended were not ultimately adopted—prized antiquities at the British Museum were not integrated

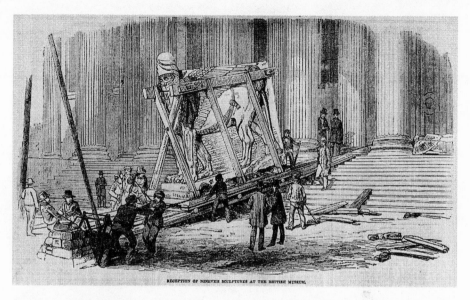

FIGURE 4.2 "Reception of Nineveh Sculptures at the British Museum." *Illustrated London News*, February 28, 1852.

with the paintings of the National Gallery, the National Gallery site in Trafalgar Square was not abandoned for healthier parkland—the debate at mid-century is an important source of insight into the emerging sense of what an art museum could aspire to be. The terms of the discussion not only shaped museal practice, but directly contributed to the emergence of important institutions in the second half of the century, such as the South Kensington and Natural History Museums.

The Gallery's perceived failings stood out in contrast to the apparent success of new developments such as the creation of the Department of Practical Art, the precursor of the South Kensington Museum that opened in Marlborough House in 1852. A number of significant texts were produced in the 1850s in response to the Gallery's shortcomings, including the important *Report of the Select Committee on the National Gallery* from 1853. Fundamental questions arose in the testimony of artists, scholars, critics, and curators when they were asked to consider which parts of the national collections ought to be placed into proximity and the appropriate form for the museum that might house such a new arrangement. In his testimony Charles Eastlake, who would be appointed director of the National Gallery a few years after the Committee finished its work, addresses what paintings from different schools and periods might mean to the public. Edmund Oldfield, curator of antiquities at the British Museum, makes a proposal for reform that reimagines the museum

as an infinitely expandable repository of culture. The sculptor, Richard Westmacott, speaks for the survival of the taste of an earlier day when he insists on the clear-cut distinctions separating artistic masterpieces from objects of archeological or historical interest. Such sentiments notwithstanding, the attention the public devoted to the immensely popular Assyrian statues found and publicized by Henry Layard raised unsettling questions about the difficult relationship between popular taste and the aspirations of the institution.

The appropriate location for the national collections would motivate discussion for years. This chapter includes an extensive extract from the testimony presented to the National Gallery Site Commission of 1857. Curators, art historians, artists, and others were interviewed by a group of legislators once again attempting to understand in what relationship the holdings at the British Museum and National Gallery should be displayed. Testimony develops around questions discussed in 1853, but now become even more pressing. What is the relationship between objects of archeological and those of aesthetic interest? What is the function of art history in public art appreciation? What should be done about objects considered less worthy of attention that nevertheless fascinate the public? How do the works of different nations and periods affect different kinds of audiences? How tenable are apparently straightforward period distinctions—such as the division of Christian art from Classical? Should masterpieces be shown together irrespective of period, or should the pursuit of completeness in the representation of art history motivate both acquisitions and forms of display? Given the heterogeneity of the British Museum collection in particular, the questions quickly ramified. For example, if the books were to be separated from the artworks, what would be the fate of engravings or illustrated manuscripts?

The chapter concludes with Gustav Friedrich Waagen's "Thoughts on the New Building to Be Erected for the National Gallery of England" (1853), a useful compendium of the most advanced and influential thinking on the arrangement and care of an art collection. Notable elements in Waagen's presentation include the emphasis on appropriate display over ostentatious decoration, and the importance of art history in providing principles for acquisition and exhibition.

—◦❧ ❦◦—

## Testimony before the Select Committee on
## the National Gallery (1853)

### Testimony of Sir Charles Eastlake

6520. *Chairman.*][1] I Suppose you have had your attention directed to the subject of combining the art collections belonging to the nation in one great repository?—Yes.

6521. Have you ever considered in your own mind what class of objects you would include under the head of collections of antiquity and fine art?—I am not aware that I can offer any suggestions which have not occurred to the Committee; it appears to me to be obvious that the contents of the British Museum divide themselves into books, works of art, and objects of natural history; and I think the department of art may be again subdivided into fine art and mechanical, or at most, ornamental art. With regard to objects of mechanical art, I think the new institution at Marlborough House, with its museum, offers at once a mode of disposing of a great part of the collection. Under the head of mechanical art I should even comprehend the Ethnographical collection in the British Museum, which there almost forms a separate department. I consider that all objects, of any age or place, which are the work of man, if not ranging under the class of fine art, may come under the class of mechanical art, and therefore belong to an Ethnographical Museum.

6522. Do you propose to make what is called ornamental or practical art a constituent part of the combined collections of antiquity and fine art, or do you merely propose to bring them, in their separate capacity, into a certain connexion with those combined collections?—I have said that art may be divided into fine art and mechanical or ornamental art; I have no knowledge of the ultimate intentions of Government with regard to the institution at Marlborough House; but whatever those intentions may be, I think that all objects of mechanical art should be placed in the museum belonging to that establishment.

6523. Would you propose under those circumstances to take a portion of the British Museum collection and bring it into connexion with the combined repository of works of fine art, and take another portion and allot it to the collection of practical art, as it is called, at Marlborough House?—Yes.

6524. You do not propose to bring the Marlborough House collections of practical or ornamental art into actual combination with objects of fine art or antiquity in the proper sense?—No, I see no necessity for that; but if one immense building were constructed which would hold all, I see no objection to their being near each

From House of Commons, *Report of the Select Committee on the National Gallery* (1853), 460–639 (excerpts).

1. Chairman: William Mure (1799–1860), classical scholar and Conservative politician. [Ed.]

other; as regards objects of antiquity, they would not all be disposed of, even when so divided, because there are many that belong strictly to literature; for instance, inscriptions might remain in the British Museum, or wherever books would be.

6525. How would you distinguish in the case of monuments, which, although representing very remarkable phases of art, such, for example, as the monuments at Nineveh, are almost entirely covered with inscriptions?—Whatever arrangement may be ultimately proposed, you will find that the departments are unavoidably dovetailed (if I may use such an expression), and it would be a matter of taste and judgment to subdivide them. I can imagine such a case as this; a philologist, looking at inscriptions with a view to ascertain the date from the form of the letters, and desiring to compare examples of a given form, might, in so doing, consult inscriptions on the bases of statues; if, for instance, it were a question of date from the form of the omega like our "W," he would find the name "Glycon" on the plinth of the Farnese Hercules, written with an omega of that form; and that is, perhaps, an early example. I mention that as one of a hundred instances that might be given to show the impossibility of arranging either art or inscriptions in strict subdivision; they must be mingled together, more or less.

6526. Considering how very much inscriptions are connected in the way you mention with works of fine art, and considering the number of inscriptions which would necessarily be embodied in a combined collection of fine art, would it not be more desirable, do you think, to keep the whole together than to separate the two, the different classes of inscriptions being essentially necessary to illustrate each other?—I do not think you could avoid that inconvenience; take another case, that of the department of mechanical art. I have assumed that there may be a museum devoted to that branch exclusively; supposing any manufacturer were turning his attention to the ceramic art, and the practice of the ancients in regard to earthenware, he could not complete his researches without consulting vases which would be in a department of fine art, and not in a department of practical art; when he came to the question of glazing terra cotta, he would consult the works of Luca della Robbia, which would not be in a department of practical art, but in a department of fine art. I do not see that by any arrangement you could entirely subdivide collections of the kind.

6527. What objection would you have to bringing all inscriptions into connexion with the fine art department, as is done in the Vatican, where you have a gallery of great length devoted entirely to the exhibition of inscriptions, many of which are engraved on very interesting works of art?—In the case of the Vatican, assuming that those inscriptions are most interesting to men of letters, the library is at hand, and that we may suppose would be the case here. Supposing the library to be in a different building, I think inscriptions should go with books rather than with works of art, when they can be separated.

6528. Would you have, in immediate connexion with the gallery of pictures, a library illustrative of art?—Yes, I have supposed that in the paper which I have had the honour to submit to the Committee; I think it essentially necessary, and that implies a further separation, and a departure, to a certain extent, from the general principle of subdivision.

6529. Would you have a library specially devoted to the picture gallery, or would you have books that are peculiarly interesting, as bearing on painting and its history,

in connexion with those on other works of art?—I would have it for the whole com-
bined establishment relating to art.

6530. Would you have a room for copies of paintings of interest, which do not
form part of the national collection?—I think that is well worthy of consideration.

6531. As to engravings, how would you dispose of them; would you have them
in connexion with the pictures?—Yes, I have also assumed that.

6532. Mr. *Stirling*.][2] Do you mean that you would have a separate collection
of engravings as connected with the National Gallery, or that you would have the
entire national collection which is now at the British Museum transferred to the
neighbourhood of the pictures?—I would have the entire collection transferred to
the neighbourhood of the pictures; I think that is their natural place.

6533. Do you not think a good deal of inconvenience would arise from that, in
consequence of people who are making researches in the library desiring to consult
certain engravings?—It may be so. I confess I can see no other mode of getting over
all the difficulties that present themselves; unless, indeed, you place everything that
could be placed in a museum under one roof. In that case, instead of moving works
of art now in the British Museum to a future national gallery, I should say, transfer
the National Gallery to the British Museum; if you separate them at all, you must
separate them on a principle.

6534. Mr. *Ewart*.][3] The objection suggested would go the length, would it not,
of preventing the removal of bas reliefs, and other works illustrative of history, in-
asmuch as a reader in the museum would require to have access to them, in order to
elucidate what he read?—No doubt; to a certain extent.

6535. *Chairman*.] How would you proceed in the case of important engravings
immediately connected, and in the same volumes, with equally important letter-
press?—Those are cases that would be difficult to decide; it would be necessary to
decide whether the work belonged to art or literature; if the claims literature pre-
ponderated, it would involve a certain inconvenience; but I do not imagine that you
could escape from such inconvenience by any arrangement.

6536. Mr. *Ewart*.] Would not the case of gems and medals involve the necessity
of some discrimination?—I think they should go with the works of art.

6537. Mr. *Stirling*.] I would give, as an instance, a book containing an account
of Brussels, printed about the year 1640, with a number of plates; the value of the
book is owing principally to the plates; what would you do with a work like that,
evidently a topographical work, relating to the history of the Low Countries?—It is
scarcely possible to establish any uniform principle, with reference to such details; if
the letter-press were worthless, I should then decide the question by putting the book
among the works of art.

6538. *Chairman*.] Would you consider it desirable to have a collection of
casts?—Yes; I suggested that in a printed letter which I addressed some years since
to Sir Robert Peel.

2. Sir William Stirling Maxwell, ninth baronet (1818–1878): art historian, historian, book collec-
   tor, pioneering writer on Spanish art, and Conservative politician. [Ed.]
3. William Ewart (1798–1869): Liberal politician and noted supporter of public access to museums
   and libraries. See contributors and witnesses. [Ed.]

6539. Would you have them attached to the Gallery of Sculpture?—Certainly.

6540. In many museums abroad, there is a collection of casts in connexion with the Academy of Art: you would not propose in that way to form any immediate connexion between the Royal Academy of Design and the Museum of Art, by means of a collection of casts?—By no means; because the collection of the academy, which it must always have for the purposes of study, is a private collection, and the public would not have easy access to it; it is very desirable that there should be casts of the finest antiques of every time, the originals of which we do not possess, in a public gallery. When the Elgin marbles were first exhibited in this country, comparisons were made between them and such statues as the Apollo and Laocoon; and it was felt at the time to be desirable that such works should be in the immediate neighbourhood of the Elgin marbles.

—◦❧ ❧◦—

## Testimony of Edmund Oldfield

8282. Your attention has been called to proposals which have lately been rife in respect of combining the art collections of the British Museum with those of the National Gallery?—Yes; I have heard of such suggestions having been made.

8283. What is your opinion as to the policy of so combining the art collection?—In my opinion it is incorrect to view the British Museum as a collection of works of art; it is, in its primary character, a collection of antiquities of the highest value as illustrative of history.

8284. I meant to include in my question the whole of the ancient sculpture collections; did you understand me as meaning to draw a distinction between those works which may be called objects of high art, and those works which may be called objects of barbaric art or archæology?—I have heard of such a distinction being drawn, which I think is, practically, very objectionable.

8285. Supposing that objection not to exist, what do you think would be the effect of combining the whole of those collections with which you are connected with the fine art collection in the National Gallery?—Taking the question by itself, I see no objection to that, provided care be taken that the building is sufficiently large, and sufficiently distinct in its two compartments to secure all the accommodation and means of arrangement we desire; there is always a little danger in the uniting of heterogeneous objects, lest one should a little interfere with the other.

8286. You would wish that collections of sculpture and bronzes, and those collections with which you are yourself connected, should not be mixed up with the collection of pictures?—Certainly; I should consider it indispensable that the collection should be kept distinct.

8287. Do drawings and engravings form part of the collection with which you are immediately concerned?—No; they are under a distinct superintendence

8288. Do you think there would be any difficulty in removing the monuments, if such a plan should be entertained?—I think it is merely a question of expense and time.

8289. If a monument has been removed from Thebes or Nineveh to the British Museum, it would not be impossible, I suppose, to remove it from the British Museum

to a situation a mile or two off?—I believe that engineers do not admit the word "impossible" in their vocabulary.

8290. Assuming that on various grounds, whether from the narrowness of the present locality of the British Museum, or from the disadvantages to which you have alluded on account of the atmosphere, a plan was entertained for a new site, what sort of site would you desire, to combine all the advantages?—I think it would be most desirable that it should be an entirely open site, so as to admit of an unlimited extension, as circumstances may require, and that there should be no danger of injury from smoke and dust in the neighbourhood.

8291. There should be no risk of buildings springing up in the immediate neighbourhood of the gallery and creating smoke?—I think that is a very important element of consideration.

8292. It would be requisite to have, if possible, a free open space of ground all round the building, would it not?—I think so.

8293. Is there any particular site to which you have had your attention called?—I should certainly prefer the site of Hyde Park, if the collection of antiquities is to be removed at all.

8294. Do you mean Hyde Park itself, or do you include also Kensington Gardens?—I should prefer Hyde Park itself to Kensington Gardens, simply because it is more accessible.

8295. Do you mean a site in a portion of that large open pleasure ground which comprises Kensington Gardens and Hyde Park, and which would possess the advantage of a free open airy space on all sides of the building?—Yes; and probably removed half a mile from any building.

8296. You would not propose to have a site in Hyde Park alongside of the road, where you would be liable to have a brewery or a distillery opposite to it, or in its immediate neighbourhood?—No; I think that would be very objectionable.

8297. *Lord Seymour.*][4] Do you seriously propose to put such a collection, with the power of unlimited extension, in Hyde Park?—I can hardly say I propose it; but when the neighbourhood of Hyde Park is suggested to me, I cannot but say I think it would have great recommendations. The principal recommendation would be, that it would give facilities for extending the Museum in any direction, and would furnish an opportunity for constructing a Museum better arranged for the purposes of classification than the present.

8298. Having been for some time acquainted with the public feeling in London, do you think that a proposal to take the middle of Hyde Park as the site for a collection of objects of art and antiquity would be listened to for a moment?—I have no doubt there would be great difficulty in it; but I can offer no opinion that would be of any special value on such a point.

8299. *Chairman.*] You mentioned Hyde Park to illustrate your view that it would be desirable to have an open space?—Yes, without reference to any social or political difficulties, of which the Committee can judge for themselves.

---

4. Edward Adolphus Seymour, twelfth Duke of Somerset (1805–1885): Whig aristocrat and politician. [Ed.]

8300. The Regent's Park, assuming there to be no other objection to it, would also meet your view of the case, would it not?—I think Hyde Park would be better, because the soil is drier.

8301. Mr. *B. Wall*.][5] Have you any notion how many acres of ground you would require?—I should be unwilling to specify the number of acres; I should not wish there to be any limit.

8302. What acreage does the present British Museum cover?—I do not exactly recollect; but I have a plan before me from which you could easily form an idea.

8303. Supposing this great Museum to be built in the middle of the Park, as you propose, with the whole of the collections centering there, how many acres of ground do you think would be required for the purpose?—I am not prepared to specify the quantity of acreage that would be required.

8304. Lord *Seymour*.] Can you tell us what amount of space the antiquities at present occupy in the British Museum?—Taking the galleries as if they were all extended in a right line, they would amount, probably, to about a third of a mile.

8305. The great lower gallery, for instance, is about 300 feet, is it not?—I should say, roughly speaking, that it is rather more than 300 feet.

8306. Above that you have another length, also of 300 feet, have you not?—Yes.

8307. Have you, parallel with that, the galleries for the Nineveh sculptures, which, with the central portion added to them, makes pretty nearly the same length?—Yes, rather more.

8308. That makes it above 900 feet?—Yes.

8309. You have then the Roman gallery, the Lycian gallery, and the Greek antiquities, the Elgin gallery?—Yes.

8310. What do you put that at?—The Elgin gallery 140 feet, the Lycian gallery 70, and the Roman gallery, I think, about 140.

8311. Then you have the length of the gallery up to about 1,200 feet?—Yes. There are besides that two new rooms, as yet incomplete, and two or three rooms in the basement which the trustees propose to use for the exhibition of a certain class of antiquities; and when these are added, I think that will bring it to nearly a third of a mile.

8312. And yet you feel that to be totally inadequate for the purpose of such a collection of antiquities as you consider desirable?—Yes.

8313. *Chairman*.] Do you consider it necessary on the new site to erect a building with one front, amounting in length to a third of a mile?—No, I do not.

8314. What is the greatest length of that part of the British Museum which is occupied by any of your collections?—Taken in the way in which the space was just now calculated, I think it would be about a third of a mile.

8315. Do you mean that there is about a third of a mile in any place, from the end of one range of galleries to another, in the British Museum?—No, but that all these galleries added together would amount to that.

8316. If those galleries were erected as part of a large public building, you would not consider it necessary that that part of the building should spread a third of a mile along the locality?—No, I think that would be a most undesirable arrangement; my view is that it should consist of a series of parallel galleries, each appropriated to one

5. Charles Baring Wall (1795–1853): Conservative politician. [Ed.]

particular class of objects, and each of those galleries capable of extension to any length that might be required at any future time.

8317. In point of fact, the space occupied by the collections of the British Museum with which you are connected, does not form a very unreasonable portion of the present building, and therefore would not require a very exorbitant amount of space if it were placed elsewhere?—No.

8318. Mr. *M. Milnes.*][6] You have a good deal to do with the department of Medals, have you not?—Yes, as a branch of the department of Antiquities.

8319. Supposing a division were to be made between works of art and works of archæology, to which class would you attribute the collection at medals?—I think the collection of medals would be more useful in the department of archaeology, but I should object to such a division.

8320. You may perhaps have heard that it has come before us in evidence in this Committee, that certain persons have recommended that the works that would be called purely works of art, that is, works of an æsthetical character, might be transferred to some new edifice which would be combined with the Great National Gallery, at the same time retaining at the British Museum works of an archæological character, and works connected with literature; do you think it would be possible to draw that distinction?—I think not in any way which would be consistent with the rules of science, nor which would practically be instructive to the people.

8321. Where would you see the difficulty of such a line being drawn?—Chiefly on this ground, that almost all even of the æsthetic productions of mankind in the earlier periods of the world are so inseparably connected with the history and modes of life of the people, that taken by themselves they tell only a part of a story, which is unintelligible without the remainder of it; the one is indispensable to the other; and as a matter of fact, many of them are physically so united that you cannot separate them. For instance, the inscriptions (which obviously belong to the department of Literature and Archæology) are found, in the case of Egyptian and Assyrian remains, upon the sculptures themselves; and even in the Greek remains they are frequently so united as practically to be inseparable, and could they be separated, their separation would destroy the greatest part of their instructiveness.

8322. Do you happen to be aware whether in the great collections on the Continent, medals are combined with works of art or with the establishment devoted to literature?—I think the practice differs in different institutions. At Paris they belong to what I suppose you would consider the department of Literature, though even there they are united with other antiquities, not with books, or MSS.

8323. Where?—At the Bibliothèque, in Paris.

8324. Can you give another instance?—At Florence they are united with the remains of antiquity in the Uffizii collection; but I am not able to state what is the case in the various German collections.

8325. To which department do you think they would more appropriately belong?—I should feel unable to attach them to either department satisfactorily. Medals unite the two characters inseparably. A medal is at certain periods the very

6. Richard Monckton Milnes, first Baron Houghton (1809–1885): author, politician, bibliophile, and biographer of Keats. [Ed.]

best specimen of the fine art of the time, but at the same time it bears upon it an inscription which is historically immediately connected with the department of archæology.

8326. It is because the question is a difficult one that I put it to you; and therefore I should like to know if it suggests itself to you whether, supposing the division to be necessary, you would in your own mind prefer these collections being placed in one building rather than in the other?—It would depend on what the other objects were in the two departments. I should consider any such division objectionable; but if made, I should ask what objects were included in one and what in the other, and assign the medals and coins accordingly.

8327. Chairman.] Is it not the case that when a man wants to consult medals, he generally in the first instance goes to some book in which he will find them all arranged to his eye, and then if he has any difficulty he may go as a numismatic question to the medals in the collection?—Yes; but it is more usual for a person, having referred to the books, and having seen the coins published, to come to the British Museum to see if we have any others still unpublished which may throw a light upon the subject.

8328. Does he do so in cases in which there is no doubt existing with regard to the correctness of the drawing?—Generally, I should think not.

8329. Lord Seymour.] You were occupied for some time in registering and classifying the coins, were you not?—Yes, and I am still.

8330. Practically, do people come to you occasionally for information?—Yes; they continually come.

8331. For purposes connected with literature?—Yes.

8332. And for that purpose, is it, or is it not an advantage that the coins should be in the neighbourhood of the library?—I think it is an advantage; but at the same time I think a first rate archæological library night supply most of the purposes for which medals are consulted.

8333. A first rate archæological library, if attached to the department of Antiquities, would go far to supersede the necessity of having the present library attached?—Yes.

8334. Chairman.] Upon the whole, do the greater number of persons who come to consult the coins in the way you mention, come for the purpose of illustrating numismatical researches in the archæological sense, or for the purpose of illustrating general historical questions?—I think they come for both purposes.

8335. Do you think they are about equal in number?—No; I should say the archæologists and numismatists come more frequently than the mere literary men.

8336. Lord W. Graham.][7] You have stated that some of the sculptures from Nineveh are of a very delicate nature?—Most of them.

8337. Should you not think it a subject of just animadversion if sculptures, which have been almost miraculously preserved for 3,000 years, should be allowed to perish in a few years after being brought to the British Museum?—Yes, if it were in our power to prevent it.

7. Lord William Graham (1807–1878): Conservative Scottish politician. [Ed.]

8338. Therefore you would be in favour of their removal to a place where there is a better atmosphere?—I think that would be a great recommendation.

8339. Mr. *B. Wall.*] Does not damp affect them more than smoke?—Damp does more injury to the substance, but smoke disfigures it more; so soft a material as alabaster is also liable to suffer from friction, if frequently cleaned.

8340. Therefore you consider that whenever such objects are removed they should be taken to a place where the soil is dry and unexceptionable?—I do.

8341. *Chairman.*] Do you suffer from damp in the Museum?—No, the situation, upon the whole, is a very dry one. We do sometimes suffer from damp as we should in any situation in England. I have certainly seen in the months of November and December some of our monuments literally streaming with wet, especially such materials as granite and the colder marbles, on which there is a great deposit from the damp in the atmosphere.

8342. Mr. *B. Wall.*] Do you not think that stove heat, which is so disagreeable in the passages in which many of the monuments are, has a great tendency to bring out the damp, and make the condition of the marbles and stones worse than it otherwise would be?—I do not think that the mode of warming by hot air, if that is what you refer to, is so good as that by means of open stoves, which are now generally adopted in the sculpture galleries at the British Museum.

8343. *Chairman.*] Do you know what the soil is on the site of the British Museum?—I believe it is a gravel soil.

8344. You see no objection to the removal of the site to the suburbs of London to the distance to which you have alluded, on the ground of its interfering with the convenience of the public having to go so far?—Yes, I think that would be an evil; but we must choose between conflicting considerations.

8345. Do you find any disadvantage in your present site from crowds of people, idlers, congregating there, as they are said to do in the National Gallery?—I think we do to a certain extent, but not so much so as at the National Gallery, because the building is much larger, and the different nature of our monuments prevents the same injury from taking place.

8346. I suppose few people go to the Museum who do not go for the mere purpose of seeing the collections?—But few, I think; undoubtedly, however, the great crowds we sometimes have are very injurious.

8347. What do you observe the effect of the crowd to be upon the monuments?—To deposit dirt on the surface.

8348. That is, by the dust they occasion?—Yes, and from the animal heat and moisture arising from great crowds; we perceive it much more after Easter Monday and Whit Monday.

8349. Mr. *B. Wall.*] From what data do you speak when you say you have observed that those who go to the British Museum go only for the purpose of admiring works of art and antiquities?—We have no data that enable us to speak positively; but judging generally, from observation, and from the apparent interest manifested, and the questions which we have been asked, I should say that the majority go to the Museum to see the monuments, and not for the purpose of making it a place of rendezvous or lounging.

8350. Should you say generally that the majority of people were likely to admire the works in the British Museum more than the pictures in the National Gallery?—I rather doubt that; it is a question rather difficult to determine.

8351. I understood you to say that the great majority who went to the British Museum went there to see the objects in the Museum?—Yes, as compared with the National Gallery, which stands in the greatest thoroughfare of London.

8352. Are not the numbers who frequent the British Museum much greater than the numbers who frequent the National Gallery?—Generally they are, because the objects of interest are much more numerous; but I should think the proportion of loungers and persons who merely go to it as a covered building for the purpose of a rendezvous is not so great in the British Museum as it is in the National Gallery, because Bloomsbury is not so convenient a place to rendezvous at as Trafalgar-square.

8353. Even if you thought they were not attracted there from motives of curiosity rather than from a desire for instruction and information, you would not be inclined to recommend any restriction being imposed upon their free admission?—I do not think it would be practicable to make any restriction in admission; after the public have once been admitted, and availed themselves of the privilege to the extent of millions, I think it practically impossible to restrain their access to it.

8354. *Chairman.*] Practically, there is no real inconvenience felt from the number of persons visiting the British Museum?—No other inconvenience than the amount of dust and heat they occasion.

8355. A great number of persons who go to see the natural history collections afterwards go and take a walk in the art collections, do they not, without having gone for that purpose, and *vice versá?* — Yes; but most of the objects of natural history are contained in glass cases, and therefore suffer less than the sculptures do.

8356. Mr. *B. Wall.*] When you say the only inconveniences experienced are dust and heat, those are inconveniences which are generally complained of, are they not, in places where masses of people are admitted?—Exactly.

8357. *Chairman.*] Have you any further observations of your own to make?— With reference to the question you put to me just now, as to whether in a new edifice, the whole of the galleries, to the extent of a third of a mile, would necessarily spread over such a distance, I have drawn a rough plan here (*producing it*) of the manner in which I think a museum of antiquities might be most advantageously arranged, supposing the situation to be entirely open and unconfined. I think the principle should be, that all the collections should run in parallel lines, any one of which might be extended indefinitely. I think the means of access to these should be by a distinct corridor, so that persons might enter one department without having to pass through others, and that the corridor itself might be extended in the event of further acquisitions; the same corridor would also furnish the means of uniting such a building with the National Gallery or any other similar institution.

8358. What is the proposed length of the front?—As I have there drawn it, it is about 1,000 feet; but it is a peculiarity of the plan that it may be made of any dimensions or on any scale whatever; and it is there drawn on a very large scale.

8359. What is the proportion of the length to the breadth?—The breadth, as drawn, is about 300 feet; but either way, it might run out indefinitely. I should think

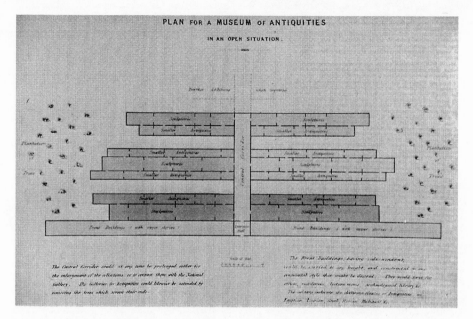

FIGURE 4.3   Edmund Oldfield, "Plan for a Museum of Antiquities in an Open Situation."
House of Commons, *Report of the Select Committee on the National Gallery* (1853).

the frontage might have rooms lighted by side windows, and therefore the building
might be carried to any height that was thought desirable with a view to architec-
tural effect; I consider it indispensable that all the collections of antiquities should
be on one floor, and that that floor should be the ground floor, so that the sculp-
ture should have sky-lights, which after many experiments, and much observation,
I should say are indispensable to a well arranged gallery of sculpture.

8360. Then you would make use of the lower floors for the economy of the
household?—Yes.

8361. Mr. *B. Wall.*] In the event of the erection of such a building as you pro-
pose, what would you do with the existing British Museum?—I believe that that part
which is now occupied by antiquities would be exceedingly valuable for the exten-
sion of the library or other collections which would remain there.

8362. *Chairman.*] One of the circumstances, in fact, which led to the proposal
being brought out of combining the collections was, that the removal of the antiq-
uities from the Museum, would give great additional space to the other branches
contained in the Museum?—Certainly.

8363. *Lord Seymour.*] I understand you to say you wish the whole of the antiqui-
ties to be upon the ground floor, and to be lit by means of skylights?—Yes.

8364. That would preclude the possibility of building over the antiquities, would
it not?—Yes; I look upon it as indispensable, that a building constructed as a mu-
seum of antiquities should be devoted to that one purpose only.

8365. You also prefer that antiquities should be disposed in galleries, that is, in
long narrow rooms, as I understand you?—Not necessarily narrow; long rooms, of a

suitable breadth; but what I consider as most desirable is, that the different classes of antiquities should be so arranged as to illustrate each other, which would be done if central galleries, like naves, were erected for sculpture, with side galleries, like aisles, for bronzes, gems, vases, &c., of the same class.

8366. If a scheme, which has been proposed, to inclose the whole central court of the Museum with a great glass dome, covering the whole quadrangle, were carried out, do you think that that would be a convenient place for putting antiquities?—No; it would confine us in every direction.

8367. You think it would be objectionable?—I do.

8368. That would not allow the scheme of arrangement which you think desirable?—No; nor would it admit of much extension.

8369. You require, I think you say, an almost unlimited extension for antiquities?—Yes; I think it would be most desirable.

8370. Observing the progress that antiquities have made at the British Museum during the last 25 years, do you think that if a museum for the purpose of antiquities is to be built, it would require to be on a much larger scale than anything we now have at the British Museum?—I think it ought to be.

8371. Mr. *B. Wall*.] How would you get the proper architectural effect?—I have drawn it in such a mode as to leave that question open; a frontage like that might be ornamented either like the present Houses of Parliament, the British Museum, or in any other style.

8372. *Chairman*.] You would not think it necessary, in the first instance, to build it of that size; about half that size would do, would it not, with the power of extending it if necessary?—Certainly; the galleries might be of any length, and I have drawn trees planted round the sides and back of the building, in order that the irregular ends of the galleries might not be a disfigurement externally.

8373. So that you might restrict the length, and add to the breadth if you wished it?—Yes.

8374. Lord *Seymour*.] As you have considered this subject so far as to have brought a scheme to the Committee, can you tell me in what way antiquities are to be restricted and limited, because I see you provide for Egyptian, Greek, Assyrian, Roman, and Mediæval; do you take in architectural antiquities of all times as well as other antiquities?—If they are on a sufficiently small scale to admit of going into a museum, they are very valuable; we have many architectural antiquities in the Elgin collection.

8375. Is it not difficult to know where to begin to exclude and to restrict?—It often is a difficulty. I think the most catholic principle is the best.

8376. I do not know what you call the most catholic principle in this case, except that of adopting and taking in everything?—I think anything that tends to illustrate the state of civilisation, and modes of life, amongst ancient races, is desirable in a museum of antiquities.

8377. Then, if we should find, as we have found, the palaces of some other ancient dynasties, we must build for them again?—Provided it be a new class of remains, and likely to instruct the public, I think we should.

8378. For instance, Mexican antiquities?—I do not find any sound principle laid down on which they should be excluded, unless the Museum of Antiquities were devoted

to the remains of that ancient civilisation which perished with the Roman empire, which would exclude all Mexican and American remains, and likewise all mediæval.

8379. As to those which they call ethnographical, belonging to all semicivilised races, should you admit them also?—No; I think it undesirable to annex them to a museum of antiquities, and I even think that in the present institution they are a great incumbrance.

8380. As regards mediæval antiquities, I understand you to be of opinion that they ought to be annexed?—I think there should be a national collection of mediæval antiquities, but it might admit of doubt whether that collection should be united with the collection of classical remains.

8381. It would grow to a very large size before long, would it not, if it were once to be commenced?—No doubt.

—◦❧ ❦◦—

## Testimony of Sir Richard Westmacott

9000. *Chairman.*] You have always taken an interest in the progress of art in this country; do you think it desirable that the art collections in the British Museum should be removed and combined in one building with the pictures?—Undoubtedly, if it were possible, and for this reason: a painter is taught in the same way that a sculptor is; he begins upon the plaster cast, because it is more easy to draw from than the marble, the marble being of different colours from its antiquity, and he is taught form from the plaster cast; he then goes to the statue. Now a painter has the same education that a sculptor has in being taught form; but when he comes to be a painter, he must forget the statue; but that is not so with the sculptor.

9001. Do I understand you to say you consider it desirable that students, whether of painting or of sculpture, should equally commence to study from casts?—From casts, certainly.

9002. I understand you to say it is in your opinion desirable that a student. who is a painter, should also study from the marble as well as from the cast?—Certainly.

9003. But do you think it of so much importance that he should have frequent access to the marbles as to make it desirable to put them in the same building with pictures?—Certainly; because it is the duty of the painter, as well as of the sculptor, to preserve form; it is very true that we have not in this country advanced so much in painting as they have on the Continent, and for this reason, that there artists have been employed, for it is employment that makes artists: you will find that we are very great in landscapes, and for the best reason in the world; there is a stronger inducement to the painter to become a landscape painter than to become a historical painter, because he will find employment in the one case when he will not in the other; it is from that cause that our deficiency in form in painting arises.

9004. Mr. *Hardinge.*][8] Is it not the case that a man who intends to be a figure painter must show his proficiency as a master of drawing from casts before he is

8. Charles Stewart Hardinge, second Viscount Hardinge of Lahore (1822–1894): Conservative politician and amateur artist, eventually trustee of the National Gallery and National Portrait Gallery. [Ed.]

allowed to paint in the Royal Academy?—Certainly; we do not allow them to paint till they have received either a silver medal, or shown that they are fully conversant with form; we never allow them to take a brush till they are fully conversant with form.

9005. Consequently it would be a great advantage to have the two branches of art combined under one roof?—Certainly. I have always considered that it would be a very desirable thing if the National Gallery of pictures and the sculpture were together.

9006. *Chairman.*] Supposing it were determined to remove the sculpture to the National Gallery of pictures, would you propose that with the sculpture the whole of the antiquity department should be removed also?—I certainly think that the bronzes belong to the sculpture.

9007. You would remove the sculpture and the bronzes?—Certainly.

9008. When you say the sculpture, does that include all the Egyptian sculpture?—Certainly.

9009. And the Nineveh sculptures?—And the Nineveh sculptures; because, supposing they were removed I then would propose that there should be a regular history as it were of the art; that you should begin with the Egyptian, go on to the Assyrian, and come down to the Grecian, Roman, and the lower ages; but you cannot do that in the British Museum.

9010. You would require a much larger space?—Yes, very much larger; before I came out I made a little sketch of the interior of the ground, which I will hand in to the Committee (*producing it*).

9011. You have given us a little sketch, supposing the central quadrangle of the British Museum to be covered over for the purpose of being devoted to antiquities?—Yes.

9012. Supposing that that expense were incurred, do you think that having so covered over the central quadrangle of the Museum, that would, independently of other considerations, afford a good means for exhibiting antiquities chronologically?—No, there would not be sufficient space; you will see if you look at the plan I have produced, how small a space there is left, and the marbles from Ephesus have not yet been thought of in the Museum; they are on the ground at this moment; we have no place in which we can put them; that is the only space that is left; I have taken that from a scale; the rooms in which the antiquities are at present occupy so much of that ground, that a space of only eight feet is left from the walls of the building, and that is really too small.

9013. Are the Committee right in understanding you to say, that if the present antiquities were removed into a building occupying the whole central quadrangle of the Museum, they would nearly fill that quadrangle?—They would nearly occupy the whole space; there is another reason why I think such a thing should not be adopted, which is this: you might say we will take the cellarage, but I should say, that I should think it would be very impolitic if a gentleman were to make a present to the British Museum of any antiquities, and there were not sufficient room within that space to exhibit them properly, to place those antiquities in the cellarage; I think no gentleman would be very well pleased to find his work placed in the cellars.

9014. You think it would not be an encouragement to the generosity of persons who might be disposed to give you presents?—Certainly not.

9015. Lord *W. Graham*.] The light in the cellars would be very defective, would it not?—Yes; you might judge for yourself if you were to go into the cellars of the Museum.

9016. Mr. *M. Milnes*.] Is it not the fact that large donations have been made to the Museum which, owing to the want of space, have been obliged to be deposited in the cellars and excluded from the public?—It is very true.

9017. *Chairman*.] You wish to combine together in the same building pictures, sculptures and bronzes?—Yes.

9018. Would you take the medals to the same building?—I cannot exactly say that; there are, no doubt, very historical and beautiful works among the medals, but I do not know that they are such works of art as should be combined with the others. I should say that everything, even the Egyptian antiquities, the mummies, and all the monuments of Egypt, should be brought together, with the marbles, if possible; but still that is not a thing that I should insist upon. I certainly think that sculpture and pictures should go together.

9019. Do you not see an objection to breaking up the collection, leaving the medals, vases, and other things in one building, and taking the sculpture and bronzes to another?—There is an objection to it, I confess. I think it would be desirable that everything belonging to archæology should be kept together.

9020. Mr. *M. Milnes*.] Are there not specimens of medals of the very finest order which may be regarded especially as works of art, and of which any duplicates that may exist in the British Museum might be very appropriately transferred to another building?—The Macedonian medals, and the Sicilian medals are works of art of the highest character, undoubtedly.

9021. *Chairman*.] But you would not break up the collection of medals and coins, sending part to one place, and leaving part in the Museum?—No; they must all go or none.

9022. Lord *W. Graham*.] Would you remove the Etruscan vases as well?—Certainly, because they are works of art, and very fine works too.

9023. *Chairman*.] Have you considered at all the expediency of removing the National Gallery from its present site to some other situation where room might be afforded for a combination of the collections?—Certainly.

9024. Have you considered it?—I have, and I think that not only with regard to the pictures, but even with reference to the sculpture, what with the smoke of London and the dirt from the flues, (for that is a thing that must be seriously looked into in any gallery that is built, because you may have as much dust from the flues as you have soot from smoke,) if the pictures are removed to a place, say a mile or half a mile, where you could be insured that they would not suffer from the influence of any smoke, it would be a vast advantage to them and a great advantage to sculpture.

9025. You think it would be an advantage to the pictures if they were removed to a place some distance from their present site?—Yes, some distance from their present site.

9026. Do you think that the effect of removing them would be to create an inconvenience to the persons who now go to the gallery for the purpose of study?—That is a very difficult question, for I believe that a large number of the young men who now

go to the gallery for the purpose of study, live on the other side of the river, and some at Hampstead; they come to the gallery for perhaps six hours. I do not think that the walk to and from the Museum does them any harm, and I think whether they go to the Museum or to Kensington, it would make very little difference.

9027. You think that the inconvenience to persons who frequent the gallery for the purpose of study, would not be great if the gallery were removed?—Certainly not.

9028. Have you talked the matter over with any persons, so as to be able to form anything like a confident opinion on that subject?—I believe there is a general opinion that the pictures should be removed; I think that is a pretty general opinion. I have not talked with them upon the subject of the removal of the sculptures.

9029. Do you consider that a gallery, for the purpose of the arrangement of the collection of pictures, requires a much larger space, in the same manner as you have said the sculptures require a larger space?—Certainly; whatever building is adopted should be upon the principle of a telescope, so that as you required more room you should be able to extend the building without injuring the effect of it; that will be the case with respect to sculpture, I have no doubt, because we must recollect that in Asia Minor very few cities have been examined, and those few which have been examined have been very beautifully given in the work of the Dilettante Society. I do not suppose there have been half-a-dozen cities examined in Asia Minor, and I have very little doubt that if you were to examine the mounds you would find a great deal of sculpture, and so in the Grecian Islands; there you would have a chance probably of getting a higher class of art than you have in Asia Minor, because it would be most probably the Roman art that you would get in Asia Minor; but I have no doubt, from what I have seen in the British Museum (and I speak from the last 20 years), that there must be, at least, between 400 and 500 feet more added to the capacity for the collection than there was, and that will go on I hope.

9030. Lord W. *Graham*.] Do you mean square feet or in length?—In length; an impetus has scarcely been given within the last 20 years; it is not more than 40 years, I think, since Mr. Townley's collection was purchased by the country, and you see what has been done in those 40 years; our taste has improved, our manufactures have advanced; everything has shown, as clearly as possible, the connexion of the arts with everything that is civilised.

9031. *Chairman*.] You think it has had a good effect, generally, upon the education of the people in works of art?—Certainly; just see how well the people behave who go to the British Museum; we never hear of any accident; yes, by the bye, there was one accident, but that was caused by a madman. I am very much at the British Museum, and I see there the strongest manifestation of a desire for information, and a great deal of good behaviour, from a very low class of people too.

9032. Mr. *Vernon*.][9] Have you ever made it an object to ascertain whereabouts many of these students reside?—I have; and I find that many of them reside at Hampstead and Highgate; some reside in the Borough, or the other side of Waterloo-bridge; perhaps their families live where it is more convenient to get house-room at a cheaper rate.

9. Granville Edward Harcourt Vernon (1816–1861): Liberal-Conservative politician. [Ed.]

9033. Do you not believe that many of them come from a distance to live in the neighbourhood of the Museum?—No; I do not believe that.

9034. With regard to those who come as students to the British Museum, have you at all followed them up to see what the subsequent career of a great number of them is?—Several of them became students of the Academy, and then there is no knowing what they do; they are put neck and neck with other young men, and strive for premiums, and very often obtain them.

9035. You are not aware whether many students come there who desire afterwards to be employed in furnishing designs for manufacturers?—Those persons who have talent enough to become artists, pursue their ways; the others that fail are often very useful to the manufacturers.

9036. You consider that those who fail, although they may not have genius enough to reach the higher walks of art, may yet attain such an accurate knowledge of form, as to be of great use for humbler purposes?—Yes; and they are employed for many purposes. We have now about 200 students in the Academy, and if 10 out of those 200 students turn out good artists, it is as much as we can expect; but the rest would be very useful.

9037. Is it much the practice for painters to study from the ancient classic models, or is it within your knowledge that they confine themselves more to living models?— As soon as they acquire a tolerable knowledge of form, we put them to the life.

9038. Do you believe that it is the practice now with painters to commence the education of their pupils by teaching them an accurate knowledge of form, through the medium of ancient sculpture?—Certainly; they first give them a knowledge of form by means of plaster casts, which is a much more easy thing to do, because there is a defined line which there is not in marble.

9039. You say they study from plaster casts; there is not the facility for doing that in the British Museum, is there?—No.

9040. Then you do not believe that the students, in their early stage, come to the British Museum at all?—I am afraid that a great many go there too early. I have thought that many a young man would have done much better if he had taken a plaster cast and worked from that.

9041. Then you would consider it highly advantageous, I presume, to have some place for the education of artists, where casts, in preference to originals, should be exhibited?—It would be a very desirable thing if there were casts taken from all the fine works of art, and if they were kept in a separate collection. I think that would be a very advantageous thing to young students.

9042. You think that, for the purpose of instruction in plastic art and in painting, that would be, practically, even more serviceable than having the statues themselves?—I think so.

9043. Mr. *B. Wall.*] You concur that casts are better for study than the original statues?—For a beginner, they are better. I should give any pupil I had a plaster cast in preference to the original. I should not allow him to go to the marbles until he had produced me a good drawing from plaster casts; he would see the shadows better in that.

9044. Is that owing to the surface of the cast being deader, and not reflecting light so much?—In marble it is dark and light, and difficult to see a form; it is

like looking at nature; if you do not know where to look for the form you do not see it.

9045. Mr. *Hardinge*.] You would recommend that he should study the marble before he studied the living model, would you not?—I do not think so at all; that is not at all necessary, because I should put the plaster cast and the marble together; when he can do from the still figure, then let him go to the life.

9046. He would go at once from the plaster cast to the living model?—Yes.

9047. Mr. *Vernon*.] In the British Museum is there not very defective accommodation, at present, for students in every way?—No, I see none; the only inconvenience I see is when there are public days.

9048. With regard to women who desire to study, is there not great inconvenience on the score of delicacy?—Upon my word it is a question I have often put to myself, but never to the officers of the British Museum, where women can accommodate themselves.

9049. Is it not the case that in the British Museum there is very defective accommodation for persons who have to spend the whole of the day in the study of works of art and whose residences are a great distance off?—There must be conveniences of the kind to which you allude, but I cannot answer the question. I know myself, being at the British Museum so often, that there are conveniences, but I cannot tell how the public are accommodated.

9050. Mr. *M. Milnes*.] Have you observed any change of feeling among the visitors at the British Museum with regard to the Elgin Marbles during the time you have been there?—No.

9051. Are the Elgin marbles as much the subject of interest and admiration now as they were in former years?—With all persons conversant with art they must be and will be always, because they are the finest things in the world; we shall never see anything like them again.

9052. Do you think the liberal introduction into the British Museum of works of earlier and oriental art, has had any effect upon the interest felt by the public with regard to the Elgin Marbles?—None whatever, I should say.

9053. Do you think there is no fear that by introducing freely into the institution objects of more occasional and peculiar interest, such for instance as the sculptures from Nineveh, may deteriorate the public taste, and less incline them than they otherwise would be to study works of great antiquity and great art?—I think it impossible that any artist can look at the Nineveh Marbles as works for study, for such they certainly are not; they are works of prescriptive art, like works of Egyptian art. No man would think of studying Egyptian art. The Nineveh Marbles are very curious, and it is very desirable to possess them, but I look upon it that the value of the Nineveh Marbles will be the history that their inscriptions, if ever they are translated, will produce; because, if we had one-tenth part of what we have of Nineveh art, it would be quite enough as specimens of the arts of the Chaldeans, for it is very bad art. In fact it is as I have said with respect to Egyptian art, an art which the hierarchy insisted on, and no man dare depart from; that is clear; but as monuments of a period eight hundred years before Christ, they are very curious things.

9054. Do you think that the great interest works of that kind excite, those works being much more objects of curiosity than of art, exercises an injurious effect upon

the public mind in matters of art?—I do not think they influence the public mind at all with respect to art.

9055. Do you think that as many persons attend and take an interest in the Elgin Marbles, when they are side by side with the Nineveh sculptures, as would take an interest in them if the Elgin Marbles were alone?—No; persons would look at the Nineveh Marbles and be thinking of their Bible at the time they were looking at them; they would consider them as very curious monuments of an age they feel highly interested in; but the interest in the Elgin Marbles arises from a distinct cause; from their excellence as works of art.

9056. Have not cases occurred in the intellectual history of many nations, in which the very free introduction of more barbarous specimens, such, for instance, as the Chinese, have had a very injurious effect upon taste in general?—I certainly think that the less people, as artists, look at objects of that kind the better.

9057. Do you not think that giving so very prominent a place, and drawing public attention so much to works of that character, will to a certain extent draw them away from models of pure beauty?—I have said I think we have quite sufficient specimens of Nineveh art.

9058. In the removal of such specimens to a building devoted to the purposes of art, would you think it quite sufficient if a few of the finer specimens were placed in such a building, and that others, which are merely of an archæological interest, were reserved for a building devoted to archæological purposes?—No; I think as they run, we should hope chronologically, from the plans which Mr. Layard took of the building, they should not be disturbed. What they are it is impossible to say, because we know nothing of the inscriptions yet; what has been done amounts to very little indeed. I think it would be dangerous to break the connexion; I should not think of doing that. We have them from one palace nearly perfect; and if ever men of eastern literature should be able to accomplish their object, we may probably find that they present something very interesting to us.

9059. You would therefore not fear that any corruption of the public taste would ensue from the juxtaposition of such works as the Elgin Marbles and such works as the sculptures from Nineveh?—No, I think not; I do not think that any consideration of the sculptures of Nineveh would affect a man who looked at the Elgin Marbles.

# Testimony before the National Gallery Site Commission (1857)

## Antonio Panizzi Esq., Examined

1491. *Chairman.*[1] You have been connected for a great many years with the British Museum?—I have.

1492. How many?—Very nearly twenty-six.

1493. In what capacity?—First of all I was Assistant-Keeper of the Printed Books, then Keeper, and then Principal Librarian.

—∘⧫ ⧫∘—

1503. Have you ever considered, with regard to this building, the feasibility of very much enlarging the Museum. so as to make it capable of containing whatever works of art are likely to be given to, or purchased by, the Trustees of the Museum?—No doubt, if you were to buy all the neighbourhood, you might find room for all the works of art that it would be desirable to place here for a long time. But I think there are other things to be considered besides; for instance, if you were to introduce the National Gallery here, then you would immediately have to alter the government of the Museum, and to have another instead: and that I am not prepared to recommend. I am the servant of the Trustees, and, as such, I wish the trust to remain as it is.

1504. Are there now, in your knowledge, lying in the repositories of the Museum, a great number of objects of art which at present there is no room to put in a proper position?—Yes, there are; and there are also objects of Natural History in the same condition.

1505. Have you ever considered the difficulty of removing any of the great objects of art which are in the possession of the British Museum?—Yes, I have. The Commissioners know better than I do the danger that there is in moving such objects. There is a special danger for those which are large, on account of their size. Then there is additional danger in removing from the walls those objects which are built up in them.

1506. Are you aware that an opposite opinion has been given in answer to Question 7790 in the examination of Mr. Hawkins?[2]—The question is as follows:—What

From House of Commons, *Report of the National Gallery Site Commission* (1857), 56–97 (excerpts).

1. Chairman: John Cam Hobhouse, Baron Broughton (1786–1869), politician, author, and friend of Byron. [Ed.]
2. Edward Hawkins (1780–1867): keeper of antiquities at the British Museum. See contributors and witnesses. [Ed.]

is your opinion about the possibility of safely moving large masses of marble to some distance?" and his answer is—"I do not apprehend that there is any difficulty at all in it; in the present state of engineering you can do anything?"—I am not engineer enough to give an opinion upon that question, but as a matter of common sense, I think that if you remove those things, there must be danger, whatever care is taken, just as there is danger in moving anything of a fragile or brittle nature—even furniture. However carefully you may do it, still there is danger that it may be injured or broken more or less. I do not see how you can be certain that no harm will be done. Very great care, no doubt, may prevent very great harm being done; but it is too much to say, that the state of engineering is such as to secure us from any.

1507. Are not you in the habit of going repeatedly through the rooms in which the archæological objects are?—Yes, I know them minutely.

1508. Have not you seen large crowds in the rooms occasionally?—Very large.

1509. Did you ever see any mischief done by any persons in those crowds before your own eyes?—Never. And what is more remarkable, not only have I not seen any damage done before my own eyes, but I never have known of any which was of any consequence. A boy was caught, about two months ago, writing his name on the great staircase. A policeman took him up, and he was sent to prison for six weeks, or fined, I do not know how much. That is the worst case I ever heard of.

1510. Has there been, since you have been connected with the Museum, any perceptible difference in the appearance of the sculptures and the other works in the Museum?—I have observed that those which have been moulded, and of which casts have been made were whiter after the moulding than they are now. I have observed that they have become darker since they were moulded.

1511. *Professor Faraday.*[3] Having become lighter they have since become darker?—Yes. But it seems to me that they are about the same colour as they were when I first saw them. I believe they have not altered in that respect from what they were then. The alteration which I have seen is this, that those which have been moulded have, I believe, become darker since.

1512. You do not mean to say that they are darker than they were originally, but that they have become darker since they have been moulded?—I think so. At the same time, seeing them every day, I am likely not to observe the shades of light so accurately as others would do.

1513. *Chairman.* Have you remarked any material, or indeed, any difference in the appearance, for example, of the surface of the Elgin marbles since they have been in the British Museum?—No; I was alluding to those particularly in my last answer. Those were exactly the marbles I had in my mind; they were in a shed when I first saw them, and were kept in it for some time after.

1514. *Dean of St. Paul's.*[4] Were not they for some time kept in a private house?— That was before I had seen them. As far as I can judge, their colour seems now what it was then, except that I must say again that in such as have been moulded there has

3. Michael Faraday (1791–1867): scientist, pioneer in the study of electricity, scientific advisor to various public ventures. [Ed.]

4. Dean of St. Paul's: Henry Hart Milman (1791–1868), author, historian, and dean (1849–1868). [Ed.]

been a perceptible difference, they being whiter immediately after being moulded, and then a little while after getting darker again.

1515. *Chairman.* Are you aware that Mr. Hamilton gave it as his opinion that the Elgin marbles are almost the only, if not the only, objects of art which have suffered, or are likely to suffer, from the crowds of persons and other influences to which they are exposed in their present condition?[5]—I was present when he gave that evidence.

1516. Do you agree with it?—No, I do not; but Mr. Hamilton is a much better judge than I am.

1517. *Dean of St. Paul's.* Putting aside the National Gallery Pictures, and supposing there were any considerable accessions to the works of art in the British Museum of objects kindred to those which they at present possess, have you any space at present unoccupied for their accommodation?—There is none quite ready, but I think that there is space that could be applied for their accommodation.

1518. Can you give the Commissioners any notion as to the extent of that space?—If you think of applying it to antiquities, for instance, the space that is now applied to Natural History might be applied to them, if you were to remove the Natural History to a suitable establishment.

1519. As things are at present, is there ground in the possession of the Trustees of the British Museum on which galleries might be built for the reception of any accessions that might be made to the National Gallery?—I think not much, but I believe there are rooms in the building already existing that might be applied to antiquities, without sending away any other collections.

1520. Has not a considerable accession of space, on the whole, been made by building a new Reading Room and Library?—Very considerable.

1521. And also considerable accommodation for books?—Yes, considerable accommodation for books.

1522. Does that set free any portion of the building, or is there any space uncovered in the building which might be applied to the accommodation of works of art?—That is exactly the part of the building that I had in contemplation in my answer. I think the Galleries of Antiquities may do very well in one locality and the Picture Galleries in another.

1523. Mr. *Cockerell.*[6] According to the system adopted at Munich, where they have Sculptured Antiquities and Painting Art separate?—Yes; I can only say that it seems to me that they may be put in separate buildings. It is all art, but it is quite another art. I think there is a great difference between the feelings which inspired the Greeks in their art and the feelings which inspired the Christian painters on the revival of art in Italy. I think that the two can be very well kept separate.

1524. *Chairman.* There is in this Museum a collection of original drawings of the greatest possible value and beauty; do you not think that such a collection ought to be with or near the collection of paintings, many of them representatives of the very originals which are to be found among those drawings?—It seems to me, that it is

5. William Richard Hamilton (1777–1859): antiquary and diplomat involved in the acquisition of the Elgin Marbles and of the Rosetta stone. Trustee of the British Museum (1838–1858). [Ed.]
6. Charles Robert Cockerell (1788–1863): architect and professor at the Royal Academy (1841–1856).

impossible to draw a line between them and the illuminated manuscripts, which are coloured drawings. Are we to break up the collections of manuscripts, in order to put the coloured drawings in those manuscripts with the pictures?

1525. Mr. *Cockerell*. Do you admit the distinction between what might be called archæological and historical objects, and what might be called artistical and æsthetical?—I do not see where we can draw the line between them.

1526. Is not there a marked distinction as respects fine art instruction, between those two classes?—They seem to me to run one into the other. I think there is a distinction between Christian art and Pagan art, which I can understand: but I cannot understand the distinction between archæological and artistical collections. I cannot see the demarcation, for instance, between the early Sicilian Sculptures and those which followed down to the time of Hadrian. I do not know where we are to say that art begins and archæology ends.

1527. *Chairman*. Are you decidedly of opinion that it would not be advisable to separate the Library from those archæological monuments of which the books in the Library serve as illustrations?—That is my opinion.

1528. Do not you think that it would be very easy in any repository of those monuments in the British Museum (supposing them to be moved), to have a collection of books referring specially to those objects; not of course in anything like the number, and, perhaps, not even in the same variety as the books in the British Museum, but still quite sufficient to serve as illustrations of those monuments?—I think not quite sufficient, because if you are to study the marbles in the Museum, you must enter into questions of the history, the language, the literature, the religion, the traditions, the laws, the customs of the people to whom they belong; and I do not know what books may not be wanted for that.

1529. *Dean of St. Paul's*. Might not a single passage in an obscure scholium or an obscure writer, be the precise passage which would illustrate a particular monument?—Precisely.

1530. *Chairman*. Do not you think that you yourself, from your very extensive knowledge of books, could make out such a catalogue for the collection to which I am alluding, as would be almost as much as any student of those monuments would require?—Not for a public and national collection like this. Such a catalogue might be sufficient for an artist or an academy; but not for a collection where the student ought to have every opportunity of illustrating monumental collections, as far as the literature of all countries and all ages can serve to illustrate them. It is often necessary, for instance, to collate manuscripts, in order to see whether a certain passage in an edition of a book is printed as the author wrote. And, further, the student must have all sorts of commentators and annotators, in order to get at the true text or meaning of an author, which may serve to clear up a point which would otherwise never be understood.

1531. Do you think that in order properly to illustrate, and to secure adequate study of a great national depository of marbles and other monuments, it is necessary to have a contiguous national library?—I think so; looking at those monuments, not as works of art only, but also as historical monuments.

1532. *Professor Faraday*. You spoke just now of the Natural History department. What is included under the term "Natural History?"—All that is not the work of man.

1533. That is to say every thing relating to the history of animals, and all geological specimens, and all the minerals?—Just so.

1534. Have you any idea how much space that department occupies in the galleries of the British Museum?—I cannot tell at this moment, but the plans will show; all that is here (*pointing to the plans*) marked in the plan with blue or a sort of drab, is devoted to the Natural History. There is also some in the basement.

1535. Is not nearly two-thirds of the first floor so occupied?—Yes.

1536. Mr. *Cockerell*. Is not some part of the basement also so occupied?—Yes.

1537. *Chairman*. Is there any on the ground-floor?—On the ground-floor you will see there is only the Insect Room.

1538. *Professor Faraday*. In what order do you consider the objects of the British Museum, taking times as they now are?—The Library and the Antiquities, in my opinion, would come first, and the Natural History after them.

1539. So that in case you wanted room for any new objects, if you are to throw out any thing, you would throw out the Natural History first?—I would not throw it out; but I believe it would be for the good of the Natural Sciences that there should be an appropriate building erected for them, with plenty of space and plenty of accommodation. It has been said that I do not attach importance enough to Natural History. I do attach great importance to it; it is because I attach great importance to it that I suggest, for the sake of science, that the Natural History Collections should be removed hence. At one time, I suggested the alternative that either the Library should go, or the Natural History. Now that a Reading room and a new Library has been built, it is out of the question to think of removing the Library. I am convinced that it would be for the good of the study of Natural History, that the Natural History Collections should be removed. At the present moment the officers of the Natural History Department have strongly represented to the Trustees that they cannot exhibit what they have, that they cannot increase the collection, that the collection which they have is not of the public use and of the advantage to Science of which it is capable of being, because they have no room. I can assure the Commissioners that want of room is pressed on the Trustees more by the naturalists than by anybody else; and the Trustees have at this moment referred to a Sub-Committee to inquire what should be done: this Sub-Committee have reported, and the report will go before the Trustees. It is recommended, as a sort of *pis aller*, that they should make such an arrangement as they can to put off for four or five years, but certainly not more, the pressing want of space for the Natural History Collections; but four or five years hence we shall just be in the same difficulty which we are now in. Depend upon it, neither the Antiquities, nor the Library, nor the Natural History, will thrive as they ought, so long as they are together.

1540. At the present moment the art and antiquity have not room?—No.

1541. Have you objects there that you cannot show?—We show them all. I was asked just now whether there were not things which were not shown so well as they ought to be—and I said, yes; but I believe that they are all shown. Whatever antiquities we have are shown.

1542. Is there not, in the large room below, a case that has not been opened?—There are very few things of any importance that are not shown. I do not believe

there is such a case as, is referred to in the question, but I will examine into the matter, and inform the Commissioners.

1543. Then again, as far as you know, is there not a like case of want of room, or even a stronger case, with regard to Natural History at the present moment?—certainly.

1544. What is the rate of increase which may be expected from this time forward in the objects of Art or of Natural History?—There is no proportion between the kingdom of nature and the works of the art of man. If we had to complete the collection, as far as such things can be completed, the Natural History collections undoubtedly would be much vaster than the antiquity collections.

1545. Are the occasions upon which new objects come forward frequent?—Yes. The officers of the department of Natural History state in their Report that the collection of Natural History ought to be double what it is; and that the present collection ought to have double the space which it has at present.

1546. Is it in fact within your knowledge that it is an impossibility either to accommodate at the present moment, or for the future, the objects which are brought to the British Museum?—As to the future, certainly it will soon be impossible to do so with our present building, except for books.

1547. With regard to the library, is there not provision made, by the addition of this great central room which has just been built, for the books which you have a right to look forward to for the next twenty or thirty years?—Yes, there is enough for fifty years.

1548. Can you really and practically spare room for the art exhibition from that space which has been library up to this time?—If it be necessary I think we can.

1549. Have you any observations to make upon any sort of special injury to sculptures or marbles, or the other things in the Museum arising from the smoky atmosphere of London?—Not at all. I have never looked at it with that view.

1550. Are you aware of the mode which is adopted for cleaning the Marbles in the British Museum?—No. I think they ought to be cleaned.

1551. Is there not some officer who has that under his particular charge?—Yes; but I have it under me, and if it is not well done I am answerable to the Trustees.

1552. Have you any special knowledge upon this subject?—I am afraid it is not done. I think it ought to be done, and I am glad that this question has been raised.

1553. Can you inform the Commissioners how the Elgin marbles are cleaned?—No, I cannot. I do not believe they are cleaned.

1554. *Chairman.* Do you know whether they are cleaned with soap or not?—I know they are not.

1555. Supposing that all the objects of Natural History were removed from the position in which they are now placed, would that removal afford sufficient or any thing like a sufficient room for such antiquities as you think might be added to your collection here?—Certainly. In that case the whole of the ground-floor ought to be applied to heavy antiquities, to great statues, or great monuments. For the library, we have plenty of room in the new building; and if more room was wanted, much of it might be put up stairs in the second floor; for there is no objection to having books there. Then all the small objects of antiquity, such, in fact, as there are now

already in the upper story, might be put upon that story. I would have the whole of the ground-floor reserved for heavy antiquities.

1556. Supposing that the collection of Natural History were removed, do you think that the collection of pictures, now called the National Gallery pictures, could, with propriety and advantage to the public for the preservation of the pictures, and for the objects for which the National Gallery is collected, be placed with any additions in the situation in which the Natural History collection is now found?—It seems to me that it could not; because we want the room for what we have already, or what we shall probably have. We want it for the antiquities and the works of art that are in the Museum now.

1557. Would any obvious and easy addition which might be made to the present building of the British Museum enable it to accommodate the pictures in the National Gallery?—Supposing it is desirable to have the works of ancient art and the pictures together, and supposing also that it is shown that after all pictures do not suffer by being in London, I think it could be done. I think you could easily add a story to all this building as it is. It is so strongly built that I understand there would be no difficulty in adding a story to it, and I think by adding another story you would have room.

1558. *Dean of St. Paul's.* Would not that change materially interfere with the light on the present second floor?—We should have to open windows wherever there are sky-lights now.

1559. Would not that deprive you of so large a surface of wall as to contract very much the present space devoted to works of art and archæology?—It seems to me that the space would be increased, but I cannot tell how much.

1560. Mr. *Richmond.*[7] Did I rightly understand you to state that you thought it desirable that Christian and Pagan art should be kept separate?—Yes.

1561. If you had specimens of Pagan painting (Greek painting for instance), would you have any objection to putting them in the same building with Greek sculptures?—None at all; but I know very well that they would not take up much room.

1562. But on principle you would not object?—Not at all.

1563. Then you have no objection on principle to Christian sculpture being united with Christian painting?—I have an objection on principle to putting modern sculpture in the British Museum, and considering the particular circumstances in which the Museum is placed with regard to the new Museum at Marlborough House. Ten or twelve years ago the Trustees of the British Museum never bought any but classical antiquities. It is only ten or twelve years ago that they have begun to buy mediæval antiquities, and to form a collection of mediæval renaissance art. The consequence is, that they have encroached still more on the already limited room for classical antiquities, and for natural objects in this institution. This has been at the very moment when another institution has been created by the Government, in which exactly the same sort of things are collected as are being collected here. For instance, at the sale of the Bernal collection, both the institutions bought. They

7. George Richmond (1809–1896): noted portrait painter and restorer.

bought with all due precautions, so as not to bid against each other (there has been the story spread that they bid against each other, but that is without any foundation), but they both bought things of the same nature; and in my humble opinion it would be better that all those things should be sent to Marlborough House, and none to the British Museum.

1564. Then in your opinion it would be better that the mediæval collection that is now in the British Museum should be sent out of the Museum?—Certainly; I should be very glad to see that done.

1565. Then, again, have you any objection, on principle, to the union of Christian sculpture with Christian painting?—It seems to me that it is quite a different inspiration which guided the Christian artist from that which influenced the Pagan artist. There is a clear division between the two. They are two branches of the same art, no doubt, but they seem to me totally distinct; and, as we cannot have everything, I think we ought to limit ourselves to that for which the museum was originally intended; other institutions in this great country should have other things.

1566. *Professor Faraday.* Would you divide painting into different periods?—With a few exceptions we have no paintings at the Museum of the time I am speaking of. We ought to have only ancient art. We have perhaps eight or ten fragments of old painting, but that is all.

1567. Mr. *Richmond.* It is quite possible that by the breaking up of old collections England may become possessed of many fragments of Greek paintings, or paintings by Greek artists of the classic time, in Italy or elsewhere. Would you exhibit them in connection with Greek sculpture in this museum, or would you say that they had better go with the other national pictures?—I am for putting them here.

1568. Then, I ask you, if by the same analogy you would object to putting sculptures wrought in the Christian time with pictures which are contemporary with them?—No; I would not object to that. I would not object to have the sculptures of Michael Angelo and the paintings of Raphael together.

1569. You have said, I think, in your former evidence, that engravings are intimately connected with printed books; do not you think that engravings are as intimately, or perhaps more intimately, connected with painted pictures, inasmuch as they may often represent the very pictures in a Gallery, or the drawings which formed the studies for such pictures, and may thus throw light upon the completed works?—That may be a reason for having a collection of engravings, both in the Gallery of Pictures and in the Library, but it seems to me that a great Library ought to have a collection of engravings.

1570. Who would go most frequently to the Print Room in the British Museum—students of art or students of letters?—It is very difficult to answer that question. The man who writes the life of a great artist, the man who writes the literary and artistic history of a country, and the man who writes a work on travels would have to consult engravings, but they could not write without going to the Library also.

1571. *Chairman.* Did I rightly understand you to say that you do not approve of objects of mediæval art, particularly of sculpture, being mixed up with ancient marbles?—Just so.

1572. Is there much mediæval sculpture in the British Museum? There is not much yet, because that collection has begun, as I said, only ten or twelve years ago,

but it takes up considerable space, and a considerable amount of the Museum funds, as the Trustees keep increasing it. As it has begun it goes on.

1573. In your opinion it is not desirable that those sculptures should be added to the ancient sculptures?—I think not. I think the Museum ought to be limited to the purposes to which it was limited until ten or twelve years ago.

1574.—*Professor Faraday.* That is to say you think they should be heathen antiquities?—That, and nothing else.

## Edward Hawkins, Esq., Examined

1585. *Chairman.* I believe you have charge of the Antiquities in the British Museum?—Yes, I have.

1586. Those antiquities, comprising "statuary, whether marble, terracotta, or bronze, also bronze vessels and miscellaneous objects, terracotta figures and vases, coins, medals and antiquities generally of any country," are under your charge?—Yes.

—◦❧ ☙◦—

1621. *Professor Faraday.* I think I understood you to state distinctly that under any circumstances you must have a new Museum of Antiquities?—I think so. The space that we have is much too small, and that space so inconveniently disposed that it is impossible to arrange all the monuments in an uninterrupted series, and therefore we cannot make the exhibition as instructive as it ought to be.

1622. Referring to any of the galleries of sculpture (either the Egyptian or the Assyrian, or any other), could you give the Commissioners an idea of how much room you would want to display what you have not displayed?—No. I could not. There are new objects to exhibit which are not exhibited at all; but those objects which we have now are so crowded that they cannot be seen to advantage; even in the very room which you first come into on entering the Museum two out of three of the objects at least ought to come away.

1623. Is that because they are too much crowded?—Yes.

1624. Is the influx of matters to the Museum at the present moment such as to make it probable that, for the next ten or twenty years, the additions will go on as they have been going on?—I have every reason to believe that they will. There is a ship-load at this moment coming.

1625. From where?—From Halicarnassus.

1626. May we expect that these objects will go on increasing?—Yes; and therefore you must have prospective means of enlarging the Museum.

1627. With regard to the Elgin marbles, have they suffered any deterioration since they have been in the Museum?—They are very much more dirty than they were formerly.

1628. Do you mean that the dirt sticks to them, or that they are discoloured?—They are discoloured, and in such a way that the discolouration cannot be removed.

1629. What are the means taken for the removal of the dirt from those marbles?—Once or twice the Elgin marbles have been covered with soap lees; it

was allowed to remain upon them for a certain time and it was washed off, for the purpose of cleaning them.

1630. By soap lees, you mean, I suppose, the alkali?—It is what Sir Richard Westmacott used to call soap lees.

1631. Was it left to soak upon them for two or three days, and then were they washed?—Yes.

1632. Was not that done under the idea that the soap lees would dissolve the organic matter, and then it could be washed away.—Yes.

1633. Could you give the Commissioners any idea whether the progress of change in the way of degradation was quicker or slower, after that process had been performed on them?—I cannot doubt that any operation of that kind would make the surface acted upon more susceptible of dirt than it was before, because it probably would soften the surface.

1634. As when paint is cleaned it is more liable to be discoloured, the same is the case here?—Yes; some portion of the surface is removed, and of course the dirt penetrates more deeply into the marble.

1635. Has it been within your observation that these soap lees did for a time remove the dirt from the marbles?—Yes; they were cleaner. But they had a raw look afterwards.

1636. It took off the surface?—It appeared to me to take off the surface.

1637. Did it remove the polish?—It took off the polish I think, and so far damaged the marbles.

1638. *Dean of St. Paul's.* Generally speaking, is not the polish of the ancient sculptures gone already?—Yes; the surface of almost all the old sculptures is to a great degree removed, still some portion remains.

1639. Is it within your knowledge whether it was pure soap lees which was used in this case, or soap lees and lime?—I do [not] know.

1640. Has soap, ever to your knowledge, been used upon the Elgin Marbles?— Yes.

1641. Have they been washed with soap?—Yes.

1642. Was it laid on?—No; it was merely rubbed on with a cloth, and washed off immediately.

1643. Was it laid on with a brush?—No; the soap was rubbed on with a flannel, and washed off immediately.

1644. Have you any impression upon your mind that washing these things with soap makes them liable to become dirty?—No.

1645. Have the alabaster slabs in the Assyrian Room undergone any change?— They are getting dirty of course, but I am not aware that they are damaged in any other respect. The material is such that any application of water must necessarily injure them.

1646. What means are taking for cleaning them?—They have never been otherwise cleaned than merely by being dusted with a feather, or something of that kind, they are not allowed to be touched with anything hard. We touch them as little as possible. There is a very curious thing which has happened to some of the slabs, which shows the effect of water upon them very strikingly. When they first arrived in England, they were packed in coarse matting, and in many places it was perfectly

clear that the water had percolated between the matting and the alabaster. Where the matting touched the slab, the surface was preserved, but between the interstices it was worn away. Where a great portion of the surface was worn away, there was the representation of the mat upon it, so that it was like a sculptured piece of matting. Where the mat had touched the alabaster, the alabaster was preserved, because no water could percolate between them; but in the interstices the matting had left its pattern. In fact, the slabs are made of such a material that I believe if you were to put a piece of it into a basin of water, and shake it about, you would have nothing left but the sand at the bottom.

1647. Are any of those slabs glazed?—I had a piece of glass put opposite to one of them; but it gave a very disagreeable appearance; and it was not thought right to proceed with the experiment. But the frames upon which the slabs rest, and which hold them in their places, are all grooved like windows, to receive glass, if at any time it should be thought advisable to put it there.

1648. Is not the work upon those slabs very fine?—Yes.

1649. Are there not fine inscriptions upon them?—The inscriptions are not very fine, but the workmanship is extremely fine.

1650. *Chairman.* Would there be any danger or difficulty in covering the Greek Antiquities and particularly the Elgin Marbles with glass?—It would be very difficult; it would be an enormous undertaking, which I should not like to recommend. Those Assyrian slabs being all even, it would be possible to put a frame of glass upon them, and the thing has occurred to me, whether by putting the glass at a distance, and admitting the light between the glass and the object, we might not destroy, to a great degree, the unpleasant reflection which there is when we put the glass close to the object.

1651. Mr. *Richmond.* Do you remember the Elgin Marbles in the old wooden room?—Yes.

1652. Since that time have they changed in colour very much?—They are getting worse every year. It must necessarily be so. It is hardly a thing that is perceptible to the eye from day to day: but those persons who recollect the Townley Marbles, particularly in the house of Mr. Townley, observe a marked difference between their original colour and their colour now. Those are mostly Roman sculptures.

1653. *Professor Faraday.* Do you apprehend that the Temple Collection will go on becoming dirtier from this time forward?—There is not much of the Temple Collection which will be much exposed to injury. It will suffer something, but the greater portion will be under glass. It consists of small things principally.

1654. Mr. *Richmond.* Does the dust find its way into a case, however well that case may be made?—I have tried every possible contrivance to keep dust out, and without success. We have metal cases, and the hinges move upon velvet, and they are closed with velvet; still the dust finds its way in.

1655. Mr. *Cockerell.* Do you consider this locality more or less charged with the sulphureous and smoky atmosphere of London than any other part of the metropolis?—There are some parts of London that are worse than this, but this is bad enough.

1656. How do you consider this locality, as compared with the Regent's Park?—I certainly think that it is less exempt from smoke and dirt than the Regent's Park; of course, there is less dust in the Regent's park than there is here.

1657. You are nearly equally subject to the smoke of the atmosphere here as in other parts of the Metropolis?—Yes; I think so.

1658. *Chairman*. Upon the whole, do you think it would be advisable to remove the Archæological objects in the British Museum to any other locality?—I really think it would, upon this ground, that we must have a new Museum of Antiquities, and we have no space for it here, unless we knock down all the buildings between here and Bedford-square; and they must be purchased at a very large cost; and afterwards we should still remain exposed to all the inconvenience of the London dirt to which we are now subject.

1659. *Dean of St. Paul's*. To what distance do you think you ought to go in order to be safe from the London dirt, which has caused the deteriorating effect of which you have spoken?—If I were allowed to fix upon the locality, I would fix upon the middle of Hyde Park. There you can put your arm out and say that the smoke shall not come near to you. I do not know anywhere else.

1660. *Chairman*. I find you say just the same now that you did when you were examined before the Committee in 1853. Your words then were, "One site that has been suggested I consider by far the best that I ever heard of, the middle of Hyde Park, because there you would be completely clear from all smoke, and free from a liability to intrusion." Is not that so?—Certainly; but it is not free from all smoke.

1661. Did you ever see the sheep in Hyde Park?—Yes.

1662. Are they not covered with smoke?—Yes, there is smoke even there. I do not know how far you must go to get clear of that; still Hyde Park is less exposed to smoke than any other place in the vicinity of London that I know of.

1663. Mr. *Richmond*. In the event of that removal would you associate the collection of drawings and prints, which is in the print-room of the British Museum, with the ancient sculptures or with the library?—With neither. I should put all the drawings and prints with the National Gallery of pictures. I think they would be better associated with them than with anything else.

1664. Do you think they would be better associated with the library or with the marbles?—I think they would be better with the National Gallery than with one or the other.

1665. That is they would be best associated with pictures that had been painted within the last five hundred years?—Yes.

1666. Mr. *Cockerell*. You are entirely attached to the department of Antiquities, and you, therefore, well understand the value of the Archæological and Historical Museum that we have here. Do you find that artists now frequent the Museum as they did in former days, when Greek Art was supreme?—Yes; I think quite as much so as formerly.

1667. Is it frequented by artists from the different schools of London?—Yes; we do not see so much of those who have actually attained to the rank of artists, because they come in without our knowing anything at all about it. I only know that they come here from the conversations I have with them afterwards; but the students who come are as numerous as they used to be.

1668. Are they more numerous than they used to be?—I think they are more numerous, particularly ladies.

1669. Does not that arise from the fact that the Institutions for the study of Art are more numerous than they used to be?—Yes.

1670. Would you make any distinction between the archæological and the historical value of these marbles, and the artistic and æsthetical value of them?—Our collections are available for both purposes. They are for the instruction of artists and for the gratification of men of taste, and they are also of great assistance to the historian.

1671. Do you find that the students study the Elgin Marbles, for instance, as they would study perfect works?—I think they do now more than they used; because formerly the Royal Academy had a rule which prevented their students ever working in the Elgin Room at all. They insisted upon the students bringing a copy of a perfect statue. Now the Elgin Marbles do not afford a perfect statue, and, therefore, though I think the Elgin Marbles are more valuable than all the sculptures in the world put together as a school of art, yet they were never much used by the students. It was quite dreadful to see a thing that they called a drunken Faun (though it was not really a drunken Faun) which was regularly wheeled into the room. Whenever I saw it, I knew that the admission to the Academy was approaching.

1672. *Dean of St. Paul's.* Do you think that it would be expedient to divide your collection of Elgin marbles and archæology?—It is impossible to divide them.

1673. Do you think that it would be inexpedient to take one part of it and leave the rest?—It would be far more than inexpedient; it would be impossible.

1674. *Professor Faraday.* Taking that as a settled matter, what is the first and highest use of your collection?—I do not know how to compare the uses. An artist would say that it is best for art; an historian would say it is best for history.

1675. Are the Commissioners to understand that every part of the collection except the Print Room and the Medal Room is overstocked?—Yes; the Medal Room is overstocked also. I should like to have the medal-cases tolerably near to the level of the eye, so that you should not be obliged to stoop down to the ground or to get upon steps to look at them. There is not space in the room to allow the cabinets to be arranged in that particular manner. But it is not worth while to complain of that.

1676. In the Print Room you have room to keep the things, but not to exhibit them?—They have no room to exhibit the things in the Print Room, but that is not my department. It was at one time attached to the Department of Antiquities, but is not so now.

[The Witness withdrew.]

## Edmund Oldfield, Esq., Examined

1677. *Chairman.* I believe that you are in Mr. Hawkins's Department in the British Museum?—Yes.

1678. Have you the sculpture generally under your care?—Yes, as a branch of the department of antiquities.

1679. And also the Assyrian and Egyptian monuments?—Yes; as portions of the department.

1680. Have you any other things under your care?—I have the whole of the sculpture, the Greek and Roman, as well as the Assyrian and Egyptian.

1681. Have the sculptures now in the British Museum sufficient room, or are they inconveniently crowded, or so placed as not to exhibit them to full advantage?—I think some portions of them are inconveniently crowded, but not all.

1682. Mr. *Cockerell*. You have said in your evidence before the Committee in 1853, in reply to question 8,314, that the actual galleries of sculpture would occupy one-third of a mile. Since then great additions have been made to the Museum, so that actually those galleries exceed half a mile in length; the length of the ground floor being 2,000 feet, and that of the basement floor 850 feet, making 2,850, which exceeds half a mile by something more than 200 feet. Is not that so?—I am not able to state the exact number of feet at present available: there has been some addition since the time when that Committee sat, but it consists merely in the rendering available for exhibition rooms which existed before, but which were then unoccupied, because they were either in an unfinished state, or considered unsuitable for displaying works of art. There has been no building whatever in our department entirely constructed since I gave that evidence. As well as I recollect, at the time that Committee was sitting, one gallery was in course of construction, with a basement room below it, and these have since been completed and opened. Two other rooms in the basement, which were previously unoccupied, or used only for the service of the Museum, have now also been made available for sculpture.

1683. *Chairman*. Do you include the room which is now in preparation for the additional exhibition of sculpture?—I think that can hardly be included amongst the existing buildings, as the works are scarcely begun.

1684. *Dean of St. Paul's*. If there has been some addition to the space, have there not also been very considerable accessions, in point of bulk, to the collections in the Museum since that time?—Yes, there have.

1685. *Chairman*. Let me repeat a question that was put to you in 1853. It is as follows, "Do you see any objection to the present site," (that is to say, the site in which the sculptures are placed,) "with reference to your own branch, except that arising from the confined nature of the ground?"—I think that is the chief objection to the site; but at the same time all sites in the center of London are necessarily a good deal exposed to smoke and dust.

1686. Have you observed, since you gave your evidence in 1853, any increased discolouration on any of the marbles in your department, particularly the Elgin marbles?—I think that discolouration is constantly in progress: but it is almost impossible for a person who sees the objects from day to day to recognize the amount of the change between any one period and any other.

1687. What is your opinion as to the proposal that has been made for combining the art collections of the British Museum with those in the National Gallery?—I think the advantages of that plan would in a great measure depend upon the manner in which the two collections were combined, whether it was simply a juxtaposition of the buildings, or whether it was a combination of their administration.

1688. Do you apply what you have just said to the whole of the sculpture collections in the British Museum?—In all that I have stated I intended to refer not merely to the collections of sculpture, but to the whole of the collections of antiquities.

1689. You apply it also to the marbles?—Not merely to the marbles, but to all other remains of ancient art.

1690. Mr. *Richmond*. Such as the vases and bronzes and inscribed monuments?—Yes.

1691. *Dean of St. Paul's*. What would be your judgment with regard to the expediency of separating the collections by removing one part and leaving the other behind?—I think it would be exceedingly injurious to the interests of archæology and the study of ancient art and would, in the judgment of most intelligent critics, be a great discredit to the country.

1692. *Professor Faraday*. You think that it might be advantageous to bring the National Gallery pictures to the art collection of the British Museum, but that it would not be advantageous to take a part of the collection of the British Museum from that building?—I suppose that there would be two objections to bringing the National Gallery pictures to the British Museum, namely, the effect of a London atmosphere upon the pictures, and also the unsuitability of our existing building for the arrangement of paintings. But at the same time I do not imagine that I am a competent judge upon that question.

1693. *Chairman*. Do you think, that supposing it were decided that the monuments and marbles generally, small and great, in the British Museum should be removed to another site, there would be any very great difficulty or danger in the removal of them?—I think there would be no other difficulty than the expense and the loss of time.

1694. *Dean of St. Paul's*. Do not you think that the moving of certain of the marbles would inevitably expose them to accident?—Undoubtedly it would expose them. But at the same time with the facilities which we have in the present state of engineering, and the great experience which those who are employed in these operations have, I do not think that the danger is worthy of consideration.

1695. *Professor Faraday*. You said you thought it might be inexpedient to bring the collection of pictures to the British Museum because of the dirtiness of the atmosphere, and the injury to pictures that would arise from it. Is the injury done to pictures by that cause greater than the injury done to sculptures?—I imagine that pictures are generally more delicate than sculptures.

1696. And therefore the injury which they suffer is greater?—They would be liable to receive greater injury.

1697. Do you think that pictures are more injured than sculptures by exposure to dirt?—Yes; and also by the variations of temperature which necessarily result in a crowded gallery.

1698. *Chairman*. I see that before the Committee in 1853 you gave your opinion rather in favour of the removal of the marbles and sculptures to a place where there was a better atmosphere than they have in their present site. Is that still your opinion?—I think undoubtedly it would be much better for the collection, if a convenient site could be found.

1699. Does the mischief done to the objects in the British Museum arise from the damp, or from the smoke, or from both?—Not I think much from the damp, but in a great measure from the smoke, and still more from the dust.

1700. *Professor Faraday.* Do you think that the dust would be in any way remarkably different in one situation as compared with another where there were equal crowds?—Not much I think; so long as the situation was in a populous neighbourhood.

1701. *Chairman.* I see that you said in your evidence before the Committee in 1853 that the situation of the British Museum was on the whole a very dry one. Do you remark that the things there suffer from damp at particular times of the year?—We certainly do suffer from damp, but not, I think, more than every other position in this climate.

1702. *Dean of St. Paul's.* During the assemblage of the great number of persons who visit the British Museum on very crowded days, does the exudation from their persons produce damp which in any way affects works of art?—I think it does injuriously affect them.

1703. *Professor Faraday.* Does it affect the sculptures?—It affects the sculptures because they are exposed. It would undoubtedly affect other works if they were not protected by glass.

1704. *Chairman.* You said in your former evidence, "I have seen in the months of November and December some of our monuments literally streaming with wet, especially such materials as granite and the colder marbles, on which there is a great deposit from the damp in the atmosphere." Have you remarked that effect generally since you gave that evidence?—Yes; certainly.

1705. *Professor Faraday.* Are you able to trace the effect of dampness to its source, either in the soil or in the changes of the temperature of the atmosphere which come on, not suddenly, but after three or four days?—I think it is caused by the changes in the temperature of the atmosphere.

1706. You think it is owing to an atmospheric condition, and not to the soil?—Yes.

1707. *Dean of St. Paul's.* Would not that be the same in any place in the neighbourhood of London?—I should think so.

1708. *Chairman.* You gave to the Select Committee of 1853 a plan for a Museum of Antiquities, which is contained in the Report of the Committee. Have you looked at that plan lately?—Yes; but at the same time, perhaps, I may be allowed to observe that that was hardly intended as a plan for practical adoption; but merely as a means of putting in the clearest point of view the principles upon which I think a Museum of Antiquities should be arranged.

1709. *Professor Faraday.* That plan goes upon the assumption of your having plenty of space at your command?—Yes; it was made principally for the purpose of illustrating what I think the most convenient adjustment of the galleries for the purpose of extension.

1710. *Chairman.* According to your plan you place certain galleries in an open space with trees about it. May we assume that you intended it to be in a park?—My plan was exclusively adapted for an open situation.

1711. *Dean of St. Paul's.* Was not your object in making that plan to shew the progress of the development of art in successive series?—Certainly; and to give each series facilities of expansion as circumstances might require, without interfering with any other series.

1712. So that you might immediately incorporate any accessions to any special department?—Certainly, without breaking the previous arrangements.

1713. Do you find that scarcely practicable according to the present allotments of the space available at the British Museum?—Certainly; it is not practicable to carry it out to an extent worthy of the value of such a collection as ours.

1714. *Chairman.* Do you personally superintend the cleaning of the marbles in the British Museum?—I generally point out the objects which it is proper to clean, and from time to time I visit and examine the operations: but I am not, of course, always present. My other occupations would not admit of it.

1715. Do you give directions as to the manner in which they are to be cleaned?— Not as to the details of the operation. Up to about six months since those details were under the direction of Sir Richard Westmacott. Since his death the trustees of the Museum have taken into their own direct employment the workmen whom he previously employed, and their instructions have simply been to follow that mode of cleaning and those recipes for the preservation of statues which he had recommended.

1716. *Professor Faraday.* Are they responsible to any head at present with regard to their cleaning proceedings?—They are responsible to Mr. Hawkins as head of the department.

1717. Are they responsible to him as to the principles of cleaning and the substances which they employ?—In those respects they act only upon the instructions which they received from Sir Richard Westmacott, but they are responsible for their mode of carrying them out.

1718. Is the intelligence which conducts their operations derived from Sir Richard Westmacott, although they are no longer, of course, under his guidance?—Yes.

1719. They do not go anywhere for instructions how they are to do the work?— No; certainly not.

1720. Are you aware what their operations are?—Yes; of course I refer chiefly to the marbles. Sir Richard Westmacott had been in the habit for many years of applying occasionally, and with caution, soap as well as lukewarm water. But a few years since, in consequence of the suggestions of various persons, he directed the workmen to desist from the application of soap; so that within the last few years the marbles have been washed with water alone.

1721. Are you clear, that by the word "soap" they meant soap, and not soap lees?—It was simply soap. I have enquired of the head workman who practically superintends these operations, and he tells me that white curd soap is that which Sir Richard Westmacott applied.

1722. Not yellow soap?—No; he always avoided yellow soap.

1723. Do they now use curd soap?—No; they do not use any soap at all.

1724. Are you aware that some years ago they used soap lees?—I have heard that Sir Richard Westmacott applied some many years since; but that was before I was connected with the Museum. I think that it must have been many years since that was done, for the workman of whom I enquired told me that soap lees had not been applied in his time: and he has been many years employed there.

1725. How many years do you know, of your own knowledge, that it has not been used,—for as much as seven years?—Certainly it has not been used for more than seven years.

1726. *Dean of St. Paul's*—Besides their cleaning are the objects in the British Museum regularly dusted?—Yes; generally speaking, every Saturday morning the attendant in charge of each gallery dusts the statues; and twice a year now (I speak of an arrangement that has been in existence for the last year or two) we devote a week to the washing of the statues.

1727. What is used for the dusting?—A clean duster chiefly.

1728. Do you use what is called a Turk's-head brush, or anything of that kind?—No.

1729. Can they reach the higher statues with a duster?—Not very easily. The very highest statues, and the bas-reliefs fixed in the walls, certainly are not dusted every week. That is only more rarely done. I was speaking only of those statues and busts which are placed upon an accessible level.

1730. *Professor Faraday.* They do not rub them I suppose?—No; they merely flap them with the duster. Perhaps I may here mention a circumstance that might be in some respects important, with reference to the effect of the dust which accumulates upon the statues, and which I also learned from the same workman to whom I was just now alluding, who has practical charge of the cleaning. He told me that he himself always takes care that the statues shall be washed from the bottom upwards instead of (what would at first appear the more natural process) from the top downwards. And the reason of that he stated to be, that if a statue is washed from the top downwards, and if any drops of water are allowed to run down it when it is coated with dust, the result is that a mark is left where the drop trickled down—and what is remarkable is, that the mark left is not a dark mark, which would be supposed to be the natural result of dirt, but it is a white mark, as though the surface of the marble had been attacked. This appears to me to shew that there is a certain acidity in the deposit upon the statues, resulting no doubt from the crowds who visit the gallery. In one or two instances statues may be seen now slightly streaked with those white marks, which have resulted from a little want of judgment in the mode of cleaning.

1731. *Chairman.* Is the man of whom you have been speaking a workman above the ordinary class of workmen?—He was a sculptor's assistant, who was many years employed by Sir Richard Westmacott, as his foreman at the Museum.

1732. *Dean of St. Paul's.* Is not it a temporary arrangement under which this workman is employed?—From information which I have this instant received, I believe all the arrangements with regard to the cleaning of the sculptures are at present provisional, as the whole subject is under the consideration of the trustees.

1733. *Professors Faraday.* Are not the processes now used the same as those employed by Sir Richard Westmacott?—Yes; and they are applied by his own workmen.

1734. *Chairman.* In your former examination you were asked, "Practically there is no real inconvenience felt from the number of persons visiting the British Museum?" and your answer is, "No other inconvenience than the amount of dust and heat they occasion." Do you think that the persons who frequent the British Museum however large the crowds may be do not do any mischief?—They are generally very well conducted indeed.

1735. *Professor Faraday.* Have you not many articles in your possession which are not yet displayed?—Yes.

1736. Have you any idea what proportion of room you want, to lay out the whole of what still remains to be displayed?—I think the amount of room that would be required simply to exhibit those objects in the same way as we exhibit what is now displayed, would not be very great. But I think it would be hardly advisable to make provision for the unexhibited objects, without at the same time making provision for a better display of what we are now exhibiting imperfectly.

1737. Taking into account the present display, and the future likelihood of display, what addition do you think should be made at this moment to the British Museum?—I think if provision were to be made not merely for the present, but for the future, in order to make it worthy of such a collection as we have, a very large amount of increase in required.

1738. What proportion should the increase bear to the present amount of space occupied by antiquities?—It is difficult to limit the increase to any exact proportion. Probably double the present space would be required.

1739. Are you aware whether there are any antiquities or sculptures on their way home, or likely to be sent home, in consequence of the investigations of gentlemen who have gone out for the purpose of collecting such things?—Yes, certainly.

1740. Is there apparently a considerable supply coming in?—Yes; a considerable collection is now on its way home. And besides this, we have reason to think it not improbable that before long another and very much larger addition may be made to our collection.

1741. Do you refer to the Halicarnassus Collection?[8]—That is now on its way home.

1742. *Dean of St. Paul's.* There are two ships freighted with that Collection?—I have no information which I can give the Commissioners on this subject.

1743. May we not expect considerable accessions to the collections generally?—Yes; beyond doubt.

1744. Mr. *Richmond.* If your antiquities were removed to a cleaner and more airy locality, have you reason to think that they would recover in any degree their original colour, or would the change only avert an increase of the evil which has already taken place?—I have no evidence which would enable me to form an opinion upon that subject; for I never heard of any case in which marbles, having been exposed like ours, have afterwards been subjected to the experiment of being placed in a clearer air.

1745. Mr. *Cockerell.* Are the Athenian and Halicarnassian fragments objects of practical study by artists of rank, especially by English artists?—I should think that artists in large practice have not much time for making studies from those monuments. But doubtless they have done so in early life; and the students at the Royal Academy frequently make them objects of study.

1746. Do they do so to a considerable extent?—Yes.

1747. Have you seen the whole of those marbles sketched or studied in the same way as artists sketch and study those that are found in foreign galleries?—There are constantly students in the British Museum studying from those collections of

---

8. In 1857–1858 Charles Newton carried out important excavations at Halicarnassus (now Bodrum, in modern Turkey) for the British Museum. [Ed.]

marbles; but, for the most part, they prefer the Roman, or what we call the Græco-Roman statues, which are generally restored.

1748. Are they preferred because they are restored?—Yes.

1749. For instance, you have in the British Museum a so-called drunken Faun, which is periodically a subject of study with the artists of the Royal Academy. Why is that monument so studied?—Because it appears perfect.

1750. *Dean of St Paul's.* Do you think that that is a sound system of study?—No. I think it would be infinitely more beneficial for them to study the finer monuments, though they are mutilated.

1751. Though those finer remains are only fragments?—Yes, certainly.

1752. Are there a considerable number of students who do study those finer fragmentary remains?—Yes; but not quite so many as I should like to see.

1753. Is there a fair proportion of students who do so?—A tolerable proportion; but I cannot exactly define their amount.

1754. Mr. *Richmond.* Is it in your power to ascertain how many artists study those works without copying them?—No, it is not.

1755. As students of art go to the National Gallery pictures and spend hours before them without copying a line, but are notwithstanding perhaps the sincerest students of the pictures, so many study the sculptures without making a line upon paper. Are you in a position to say who are studying them in that way?—In what I just now said, I was referring simply to those who make copies from the sculptures. That is the only means we have of judging about the matter.

1756. Do you allow modelling also in the British Museum?—Yes.

1757. Mr. *Cockerell.* Are you not yourself, more or less, practiced in the art of drawing and copying from antique sculpture?—Yes, a little.

1758. Do you consider that casts of perfect sculptures are better objects of elementary study than *fragmentary* sculptures?—I think casts are preferable for the purpose of drawing. The original statues are so much discoloured, that the student is not unfrequently deceived as to their form by this discolouration. The distinctions of the lights and shadows are not so clear generally on the original as they are on a cast.

1759. Mr. *Richmond.* Is not that because of the unequal dirtying of the marble, in consequence of which the light and shade are falsified?—I think it is.

1760. That which ought to be light is as dark as the true middle tint?—It is a little affected by the local colour.

1761. *Chairman.* In consequence of the discolouration the lights and shades are not accurate?—They are not distinct.

1762. Mr. *Cockerell.* Is it not the fact, that in foreign galleries, such, for instance, as Munich and Rome, it has been customary to restore fragmentary sculptures with a view to the education and advantage of those who are studying them, upon the ground that they will be infinitely better objects of study to students?—That has been very much the custom.

1763. They have even ventured to restore the Ægina Marbles?—They have: but they put them into the hands of the most eminent sculptor of the day. The experiment has not been very generally prosecuted of late years on the Continent; certainly it is not done at Paris, nor is it done in those galleries in Italy with which I am best

acquainted. I am not personally familiar with the German practice, but I am inclined to think that it is not now done in any museum in Germany.

1764. Is it not certainly profaning the works of art to attempt to restore them?—Yes. I believe the British Museum may claim the honour, if it be an honour, of being the first museum which took a great step towards putting an end to that practice.

1765. Could the marbles of Phidias have been entrusted for restoration to any hands in the world?—No.

1766. What is your opinion as to the best educational mode of presenting art to the public and to students? Do you consider that for such purpose fragmentary sculptures are at all to be compared with complete monuments or casts, or otherwise?—I think undoubtedly it would be better if the same statues which we now have in a fragmentary state had remained to us entire. They would then no doubt have been more instructive than they are in their mutilated state. But I think that even a mutilated statue of the very highest and best art is better than a restored statue of inferior art. It is more instructive both archæologically and artistically.

1767. Are not the fragmentary sculptures of which we have been speaking calculated for the study of the experienced artist, rather than of the student or the public?—No doubt the experienced artist is in least danger of misunderstanding their original treatment. At the same time I think that it is better to put thoroughly safe and sound models even before a student, than to put before him that which, under the appearance of giving him greater information, is in danger of giving him wrong information.

1768. Do you consider that the public is sufficiently cultivated to appreciate the admitted merit of the marbles of the Parthenon in their actual fragmentary state?—I am afraid not.

1769. Do not the public rather prefer complete monuments to fragments, however excellent those fragments may be?—Yes; no doubt they do. Of course I am speaking only of the majority, not of the cultivated portion of the public.

1770. *Dean of St. Paul's.* Would not it be rather a proof of want of cultivation to prefer the study of an inferior though complete statue to that of a fragment of the highest art?—Certainly.

1771. Mr. *Richmond.* Is not it the fact that the greatest teacher of art in our time, Mr. Haydon, who had an enthusiastic delight in those marbles, always sent his scholars to make drawings in the British Museum from those fragmentary monuments in preference to anything else?[9]—Yes, he did.

1772. Did not they often draw the Theseus the size of the original?—Yes; I believe they did. Besides, I think it is hardly possible to divest ourselves altogether of some consideration for what may be called the moral effect which the contemplation of such works produces, and for its tendency to strengthen and elevate the mind, quite irrespective of the knowledge which is acquired of mere external forms.

1773. Mr. *Cockerell.* Do you consider a complete gallery of casts of the most approved works in the museums of Rome and elsewhere, in their complete form, a great desideratum in London?—I think it is still a desideratum, though not so

9. Benjamin Robert Haydon (1786–1846): history painter and diarist was a fervent champion of the Elgin Marbles and of their acquisition by the British Museum. [Ed.]

much so as it formerly was, in consequence of the establishment of the Crystal Palace.

1774. Are you aware of any complete collection in London, or within any reasonable distance of London, of casts from fine works of antiquity, such as they have in more than one place at Paris, in more than one place at Rome, and in all the great Italian and continental Academies?—I know none equal to the collection at Paris, with the single exception of the collection at the Crystal Palace.

1775. Mr. *Richmond.* Is not that a great deal larger than the Paris collection?—Certainly.

1776. Mr. *Cockerell.* Is not that the first collection of the sort that has been made in England?—Yes; and I should think it is the finest collection of casts in the world.

1777. Is not a gallery of casts for the study of artists and the public taste a desideratum on every possible account?—It would be very desirable that there should be such a national collection, if there were means to form it, and space to exhibit it.

1778. Mr. *Richmond.* Do you think that plenty of light is essential to the preservation of the colour of marble, or have you observed when marble has been put in dark places that it has lost its brightness more than when there has been plenty of light upon it?—I have not perceived that effect, but at the same time I have never made any experiments which would illustrate that point.

1779. When in your former evidence you spoke of light as indispensable for larger sculptures, did you mean that it was indispensable in order to exhibit them thoroughly?—Yes.

1780. Mr. *Cockerell.* Are you acquainted with the collection of casts in the Academy at Edinburgh?—No.

1781. I am assured that there is a very complete and magnificent collection of casts, such as there is not in England—do you know whether it is so?—I am not acquainted with it.

1782. Are you well acquainted with the galleries of casts at Rome, at Florence, and at Paris?—I am, I believe, pretty well acquainted with the remains of antiquity in the museums of Rome and at Florence, but not with their casts, which I never had occasion to study. But I am acquainted with the casts in the Louvre, as well as with the other departments of the Paris Museum.

1783. Is not there rather a remarkable deficiency of this kind of study in this country?—Certainly.

1784. *Professor Faraday.* Which do you consider the first object of the British Museum, its library, or its natural history; or its sculptures and antiquities?—I am unable to determine the relative importance of those departments.

1785. Is it, as far as you know, an accident that these different objects have been brought together?—I think it is.

1786. Would you not think it very undesirable at present to separate the sculptures from the library?—I think, if the collection of antiquities had an adequate library of its own, no inconvenience would result from that separation.

1787. Would you say the same of Natural History, or does Natural History, in its various branches, cling closer to the general library than the antiquities do?—I do not feel myself competent to give an opinion as to Natural History: but I think decidedly that the Collection of Antiquities derives no advantage from its connection

with the library which might not easily be secured by a Departmental Library, if they were separated.

1788. *Dean of St. Paul's.* Would it not be very difficult in such a library to give a catalogue of books which would be satisfactory to the student of art?—I think not. I think that for a very moderate expense it might be done.

1789. Considering a collection of antiquities, not merely as an art collection, but as illustrative of history, could your library contain all the books which might be necessary for the purpose of applying the remains of ancient art to the illustration of history, manners, customs, and all that is included in the most comprehensive definition of history?—I think every book which any student directing himself to any one of the branches of study mentioned in the question would find necessary might be comprehended in a library of very moderate dimensions.

1790. *Chairman.* Have not you now a Departmental Library?—We have; but no doubt if we were separated from the great library, it would be indispensable to increase the Departmental Library very much. At present it consists perhaps of three or four thousand volumes, and no doubt it should be trebled or quadrupled in size, if we had not the general library near.

1791. Mr. *Richmond.* Do you find that your Departmental Library generally gives a sufficient assistance to those who consult books in connection with the antiquities which it is designed to illustrate?—Those who make use of the Departmental Library are merely the officers and assistants of the Museum. The public who wish to study any question connected with antiquities go to the general reading room, and not to our Departmental Library.

1792. In connection with any particular class of objects, would not you give to students of that particular class, access to your Departmental Library?—We do not do it in the present Institution; but, supposing we were separated from the general library, it might be very desirable to do it.

1793. *Professor Faraday.* Do not the uses of the sculpture and antiquity department for the purposes of art, and for the purposes of the study of antiquities, as they proceed, divide very far apart from each other, and require libraries of very different kinds for their ultimate use?—I should hardly be prepared to admit so great a distinction. I think that ancient art is almost inseparable from ancient history, especially in the case of such a people as the Greeks; and I do not think that the study of the one can be advantageously separated from the study of the other.

1794. Would not the study of art by artists for the purpose of making drawings be a different thing to the study of art historically in relation to former ages?—Yes; if the object be merely to prosecute professional study.

1795. The study of art at present is a very different thing from the study of ancient art?—Yes; but it must be borne in mind that ancient art is not studied exclusively by the professional student.

1796. Might not much of a great collection of art and archæology be thrown entirely aside as far as regards the purposes of art at the present day?—Yes; no doubt it might for the education of modern artists.

1797. Are not the two things very distinct in certain parts?—Certainly; but I should be very unwilling to admit that the Museum of Art was to be employed solely for the education of artistic students. I think it is also to be employed as a

branch of general education to the public. Without at all overlooking the importance of supplying a good technical education to professional artists, I should also wish to urge rather strongly the importance of supplying to the whole of the public an element of mental cultivation, such as I think the best works of art supply.

1798. Mr. *Cockerell*. In your acquaintance with artists, do not you find that their chief object is to attain a skilful hand, and that they embarrass themselves very little with archæological studies?—Yes; I think that is the case.

1799. Have not some of the men who were distinguished as men of genius in their profession been remarkable for the deficiency of their archæological learning?—I think that certainly they have devoted themselves principally to the other branch of study.

1800. Does not archæological study fetter and disturb that genius which applies itself particularly to the study of form, the cultivation of the hand, and of the imagination?—I am not quite sure that I should admit that; but it is a larger question than I am prepared to enter upon at present.

1801. When we form national galleries and collections for the cultivation of art, must we not separate art from archæology?—You may for convenience separate the consideration of the two branches of the subject.

[The Witness withdrew.]

## Richard Westmacott, Esq., R. A, Examined

2195. *Chairman*. I believe you are a sculptor?—I am.

2196. Have you ever considered the question of the union of the works of art at the National Gallery, that is to say, the pictures, with the sculptures at the British Museum?—Yes, generally I have considered it.

2197. Do you think such union desirable?—Putting it in that way, it is rather a large question. I think it is desirable, but there are so many contingent circumstances that I must hesitate before I give a decided answer.

2198. But you think generally that artistically it is desirable that painting and sculpture should be found under the same roof, or, at least, in a building where the collections are nearly contiguous?—Artistically I say yes to your Lordship's question. But sculpture is a very large subject. There is a great deal of sculpture that it is not desirable to have so placed for artistical purposes.

2199. The sculptures in the British Museum, for example, connected with Greek art?—You mean whether it is desirable to have exclusively Greek sculpture combined with painting under the same roof.

2200. Yes, if you do not think it desirable to have the large Assyrian marbles and other very fine specimens of ancient sculpture not Greek, such as are seen in the British Museum?—As applied to the British Museum, I must say no; I consider the Greek sculpture in the British Museum to be part of a great whole. If you consult me as an artist, I should say, that the union of Greek sculpture with any other subjects of artistic study might be exclusively given to any building in which studies are to be carried on; but I must look at the Greek sculpture in our National collection as only part of a great whole, and I should say that we could not spare any of it.

2201. My question has rather reference to the union of painting and sculpture of the highest order, namely, Greek sculpture, under the same roof.—I am obliged to say yes to that, of course; there can be no question about it. But I must be permitted to ask that that answer may have the modification which I have given to it, because I am greatly against dividing a collection of sculpture where so many objects are united as in the British Museum. If it were an academy, or an exhibition room I should say, yes; make the best of every thing you can, because it is the more gratifying to the eye, and it gives objects for study to artists. But I should say there are hundreds of objects in the British Museum which are not important for the study of artists: it is, I believe, the largest body of sculpture, as regards its series of historical art, in the world.

2202. *Dean of St. Paul's.* Then you would consider it of more importance to keep all the sculpture together than to associate the best works of sculpture with the best specimens of painting?—Certainly, if they are to be withdrawn from our national collection.

2203. *Professor Faraday.* The question is not altogether one of withdrawing them from the national collection; but if it is possible to unite the two without withdrawing any part, then you are for the combination?—Then I should not at all object; I can have no ground of objection then.

2204. *Dean of St. Paul's.* Do you think that there would be much advantage in sculpture on so large a scale being united with painting?—I cannot say that I think there would be any great advantage in it.

2205. Should you consider, with reference to ordinary persons, I will not say the ordinary students of art, that their judgment, or their taste for a picture gallery would be improved by passing first through a sculpture gallery; and, *vice versa,* do you think that they would judge well, or better, or worse, of a sculpture gallery by having previously habituated their eyes to a picture gallery?—No, I think not. I do not believe that there would be so great an advantage in that as might be supposed. I think if I were consulted upon the education of artists, or of anybody in art, I should say that it should be founded upon the knowledge of Greek sculpture, because it is the finest school of form; but I do not think that the enjoyment or appreciation of a gallery of paintings would be increased from merely passing through great halls of sculpture first. They have no connection with each other under the circumstances, and if there is no connection, your question is answered at once.

2206. *Chairman.* Would you have the objects of mediæval art mixed with the objects of ancient art?—Certainly. They are of very inferior value, archæologically and historically, I admit, but they are part and parcel of a great whole, after all. They come down very much after even those of the Romans, which I consider low in the valuable history of archæological art, but still they form a part of it. I have, perhaps, a prejudiced opinion upon the subject connected with the British Museum. I have been attached, as it were, all my life to the Museum. I was, when young, a student there, and I have watched with interest the growth of its collection; and I consider, taking it altogether, our bronzes, our coins, our vases, and other objects, that as a school of archæological study, the British Museum is, perhaps, the finest in the world.

2207. Are you acquainted with the collections in foreign museums?—Yes; pretty well. I was young when I was at Rome, but I endeavoured to use my opportunities,

and certainly the opinion which I formed then has been very much confirmed by further knowledge of our own collection. I think that any intelligent person who understands archæology and sculpture might, in the course of the morning of one day, for instance, even in three or four hours, give, with existing monuments before him in the British Museum, a history of the progress of art, and, therefore, of the progress of the human mind in civilization, which could not be equalled or illustrated in any other collection in the world.

2208. Then you are decidedly against the breaking up of that collection?—If it were broken up I should certainly feel much distressed.

2209. *Professor Faraday.* What would you say to the removal of the whole of the collection from the Museum—would you object to that?—I have no opinion about it: it is a mere question of site.

2210. Is it a mere question of site?—To me it is; because if I had any particular object in going to see a work, it would not matter whether it was half-a-mile one way or half-a-mile the other.

2211. With regard to the possible injury to the sculpture and the marbles at the Museum do you know anything for or against it in that point of view?—Nothing occurs to me.

2212. You do not think that they get more injured there than they would out of town, for instance?—I have a notion that a collection of art within the very heart of a city like this grows darker and blacker than it would in any other place, if you could insure a space round it, and the rooms not being warmed by coal fires; but I think that the objects of art in the collection in the British Museum might be kept cleaner than they are.

2213. You think that they do get blacker and dirtier?—Yes.

2214. But you think that that might be remedied by attention?—Yes, in a great degree.

2215. And that it does not require removal out of town, such as to a distant point at the west?—I cannot compare those two things very well. Those difficulties might be temporarily met; but London is growing so fast, that it could not be said, with certainty, that London would not be round the collection again in twenty-five years.

2216. *Dean of St. Paul's.* To effect that security, you must go a very considerable distance from London? Yes, and then there is great additional inconvenience.

2217. *Professor Faraday.* By the difficulty of access?—Yes.

2218. *Dean of St. Paul's.* Which inconvenience, of course, would increase with the distance from London?—Precisely.

2219. *Professor Faraday.* If it were possible to take the pictures to the British Museum, do you think it at all desirable on artistic grounds that they should go there, or is it a matter of indifference?—I should not be indifferent about it. For my own feelings, I should like all art to be located within one centre, if you could easily get at it; but I do not think that a point to be very much cared about.

2220. On the whole, would you rather concentrate art, or have it distributed over the town in several centres?—There are but two arts which you could divide; because, taking the view which I do of sculpture, I think that, although you might have some very beautiful works of art to please the public eye, you must associate

with sculpture very many things not pleasing to the eye, but which are very valuable for illustration.

2221. Mr. *Cockerell*. You make a distinction between archæology and fine art?—Yes.

2222. *Dean of St. Paul's*. Would you consider it of great advantage for the study of the art of sculpture, of ancient sculpture especially, and of archæology, that you should have a very fine library closely in connection with them?—All that I hesitate at is the word "fine," because it might involve a very extensive library. I think that a certain sort of library is very desirable. You must have books of a certain quality; but I do not think it need be a very extensive library.

2223. Would it not be necessary to have all books connected with ancient history for the real student of the fine arts and of ancient archæology?—I think that only certain books of reference would be necessary, because I imagine that the archæologist who was about to take the subject up seriously and carefully, would make his studies from his books, and then go and verify and illustrate from the works; but he need not necessarily sit with his books and the statues before him; or he might take the other course, and make his speculations from the works themselves, and then study what archæologists had said about them; because all archæological books are of course very subsequent to the works which have originated them—all the best books upon coins and so on are late books, comparatively.

2224. Mr. *Cockerell*. But one is a science, and the other is an art: the science of archæology is in itself a study and a business?—Yes; but the study of archæology might begin all over again to-morrow if every book that we have was destroyed. As long as you have the monuments to work upon, you have the groundwork which will always give you a new set of archæologists.

2225. *Dean of St. Paul's*. I do not allude so much to the works on archæology as other works from which you get all your facts on the history of art?—What I meant to say was, that I do not think a very extensive library is essential for the particular purpose referred to. I think that certain works of reference are useful, and therefore desirable.

2226. *Professor Faraday*. You say that you have used the British Museum very much; have you had occasion to refer much to the Departmental Library of Art and of Archæology?—At one time I did so.

2227. Did you find it sufficient for your purpose?—I am a very poor scholar, and ought to speak very carefully on that subject. At one time I was writing on art, for encyclopædias and similar works, and was obliged to study what I required for that purpose, and I found the works brought before me very useful and valuable to me.

2228. You had not occasion to go to the great library for the purpose?—Not precisely. I used to have occasion to go sometimes to the Medal Room, and Mr. Hawkins often allowed the books I required to be brought to me. At one time I was writing upon bronzes and coins, and knowing the precise works that I wanted, he was so good as to send for them. I have always found very great facilities afforded me, and I believe that every one who has had occasion to attend the Museum for any purpose of study would say the same with reference to the kindness and attention of the officers. For this reason I have not had to visit the great library myself.

2229. Mr. *Cockerell*. You say that you are a poor scholar; do you not consider that would be the confession of most artists?—Of course our art requires a whole life. I might have been a better artist or a better archæologist by dividing the two. I have only done as well as I could.

## John Ruskin Esq., Examined

2392. *Chairman*. Has your attention been turned to the desirableness of uniting sculpture with painting under the same roof?—Yes.

2393. What is your opinion on the subject?—I think it almost essential that they should be united, if a National Gallery is to be of service in teaching the course of art.

2394. Sculpture of all kinds, or only ancient sculpture?—Of all kinds.

2395. Do you think that the sculpture in the British Museum should be in the same building with the pictures in the National Gallery, that is to say, making an application of your principle to that particular case?—Yes, certainly; I think so for several reasons—chiefly because I think the taste of the nation can only be rightly directed by having always sculpture and painting visible together. Many of the highest and best points of painting, I think, can only be discerned after some discipline of the eye by sculpture. That is one very essential reason. I think that after looking at sculpture one feels the grace of composition infinitely more, and one also feels how that grace of composition was reached by the painter.

2396. Do you consider that if works of sculpture and works of painting were placed in the same gallery, the same light would be useful for both of them?—I understood your question only to refer to their collection under the same roof. I should be sorry to see them in the same room.

2397. You would not mix them up in the way in which they are mixed up in the Florentine Gallery, for instance?—Not at all. I think, on the contrary, that the one diverts the mind from the other, and that, although the one is an admirable discipline, you should take some time for the examination of sculpture, and pass afterwards into the painting room, and so on. You should not be disturbed while looking at paintings by the whiteness of the sculpture.

2398. You do not then approve, for example, of the way in which the famous room, the Tribune, at Florence is arranged?—No; I think it is merely arranged for show—for showing how many rich things can be got together.

2399. Mr. *Cockerell*. Then you do not regard sculpture as a proper decorative portion of the National Gallery of Pictures—you do not admit the term decoration?—No; I should not use that term of the sculpture which it was the object of the gallery to exhibit. It might be added, of course, supposing it became a part of the architecture, but not as independent—not as a thing to be contemplated separately in the room, and not as a part of the room. As a part of the room, of course, modern sculpture might be added; but I have never thought that it would be necessary.

2400. You do not consider that sculpture would be a repose after contemplating painting for some time?—I should not feel it so myself.

2401. *Dean of St. Paul's.* When you speak of removing the sculpture of the British Museum, and of uniting it with the pictures of the National Gallery, do you comprehend the whole range of the sculpture in the British Museum, commencing with the Egyptian, and going down through its regular series of gradation to the decline of the art?—Yes, because my great hope respecting the National Gallery is, that it may become a perfectly consecutive chronological arrangement, and it seems to me that it is one of the chief characteristics of a National Gallery that it should be so.

2402. Then you consider that one great excellence of the collection at the British Museum is, that it does present that sort of history of the art of sculpture?—I consider it rather its weakness that it does not.

2403. Then you would go down further?—I would.

2404. You are perhaps acquainted with the ivories which have been recently purchased there?—I am not.

2405. Supposing there were a fine collection of Byzantine ivories, you would consider that they were an important link in the general history?—Certainly.

2406. Would you unite the whole of that Pagan sculpture with what you call the later Christian art of Painting?—I should be glad to see it done—that is to say, I should be glad to see the galleries of painting and sculpture collaterally placed, and the gallery of sculpture, beginning with the Pagan art, and proceeding to the Christian art, but not necessarily associating the painting with the sculpture of each epoch; because the painting is so deficient in many of the periods where the sculpture is rich, that you could not carry them on collaterally—you must have your painting gallery and your sculpture gallery.

2407. You would be sorry to take any portion of the sculpture from the collection in the British Museum, and to associate it with any collection of painting?—Yes I should think it highly inexpedient. My whole object would be that it might be associated with a larger collection, a collection from other periods, and not be subdivided. And it seems to be one of the chief reasons advanced in order to justify removing that collection, that it cannot be much more enlarged—that you cannot at present put other sculpture with it.

2408. Supposing that the collection of ancient Pagan art could not be united with the National Gallery of pictures, with which would you associate the mediæval sculpture, supposing we were to retain any considerable amount of sculpture?—With the painting.

2409. The mediæval art you would associate with the painting, supposing you could not put the whole together?—Yes.

2410. *Chairman.* Do you approve of protecting pictures by glass?—Yes, in every case. I do not know of what size a pane of glass can be manufactured, but I have never seen a picture so large but that I should be glad to see it under glass. Even supposing it were possible, which I suppose it is not, the great Paul Veronese, in the gallery of the Louvre, I think would be more beautiful under glass.

2411. Independently of the preservation?—Independently of the preservation, I think it would be more beautiful. It gives an especial delicacy to light colours, and does little harm to dark colours—that is, it benefits delicate pictures most, and its injury is only to very dark pictures.

2412. Have you ever considered the propriety of covering the sculpture with glass?—I have never considered it. I did not know until a very few days ago that sculpture was injured by exposure to our climate and our smoke.

2413. *Professor Faraday.* But you would cover the pictures, independently of the preservation, you would cover them absolutely for the artistic effect, the improvement of the picture?—Not necessarily so, because to some persons there might be an objectionable character in having to avoid the reflection more scrupulously than otherwise. I should not press for it on that head only. The advantage gained is not a great one, it is only felt by very delicate eyes. As far as I know, many persons would not perceive that there was a difference, and that is caused by the very slight colour in the glass, which, perhaps, some persons might think it expedient to avoid altogether.

2414. Do you put it down to the absolute tint in the glass like a glazing, or do you put it down to a sort of reflection? Is the effect referable to the colour in the glass, or to some kind of optic action, which the most transparent glass might produce?—I do not know; but I suppose it to be referable to the very slight tint in the glass.

2415. *Dean of St. Paul's.* Is it not the case when ladies with very brilliant dresses look at pictures through glass, that the reflection of the colour of their dresses is so strong as greatly to disturb the enjoyment and the appreciation of the pictures?—Certainly; but I should ask the ladies to stand a little aside, and look at the pictures one by one. There is that disadvantage.

2416. I am supposing a crowded room—of course the object of a National Gallery is that it should be crowded—that as large a number of the public should have access to it as possible—there would of course be certain limited hours, and the gallery would be liable to get filled with the public in great numbers?— It would be disadvantageous certainly, but not so disadvantageous as to balance the much greater advantage of preservation. I imagine that, in fact, glass is essential; it is not merely an expedient thing, but an essential thing to the safety of the pictures for twenty or thirty years.

2417. Do you consider it essential, as regards the atmosphere of London, or of this country generally?—I speak of London only. I have no experience of other parts. But I have this experience in my own collection. I kept my pictures for some time without glass, and I found the deterioration definite within a very short period—a period of a couple of years.

2418. You mean at Denmark Hill?—Yes; that deterioration on pictures of the class I refer to is not to be afterwards remedied—the thing suffers for ever—you cannot get into the interstices.

2419. *Professor Faraday.* You consider that the picture is permanently injured by the dirt?—Yes.

2420. That no cleaning can restore it to what it was?—Nothing can restore it to what it was, I think, because the operation of cleaning must scrape away some of the grains of paint.

2421. Therefore, if you have two pictures, one in a dirtier place, and one in a cleaner place, no attention will put the one in the dirtier place on a level with that in the cleaner place?—I think never more.

2422. *Chairman.* I see that in your "Notes on the Turner Collection," you recommended that the large upright pictures would have great advantage in having a

room to themselves. Do you mean each of the large pictures or a whole collection of large pictures?—Supposing very beautiful pictures of a large size, (it would depend entirely on the value and size of the picture), supposing we ever acquired such large pictures as Titian's Assumption, or Raphael's Transfiguration, those pictures ought to have a room to themselves, and to have a gallery round them.

2423. Do you mean that each of them should have a room?—Yes.

2424. *Dean of St. Paul's*. Have you been recently at Dresden?—No, I have never been at Dresden.

2425. Then you do not know the position of the Great Holbein and of the Madonna de S. Sisto there, which have separate rooms?—No.

2426. *Mr. Cockerell*. Are you acquainted with the Munich Gallery?—No.

2427. Do you know the plans of it?—No.

2428. Then you have not seen, perhaps, the most recent arrangements adopted by that learned people, the Germans, with regard to the exhibition of pictures?—I have not been into Germany for 20 years.

2429. That subject has been handled by them in an original manner, and they have constructed galleries at Munich, at Dresden, and I believe at St. Petersburgh upon a new principle, and a very judicious principle. You have not had opportunities of considering that?—No, I have never considered that; because I always supposed that there was no difficulty in producing a beautiful gallery, or an efficient one. I never thought that there could be any question about the form which such a gallery should take, or that it was a matter of consideration. The only difficulty with me was this—the persuading, or hoping to persuade, a nation that if it, had pictures at all, it should have those pictures on the line of the eye; that it was not well to have a noble picture many feet above the eye, merely for the glory of the room. Then I think that as soon as you decide that a picture is to be seen, it is easy to find out the way of showing it; to say that it should have such and such a room, with such and such a light; not a raking light, as I heard Sir Charles Eastlake express it the other day, but rather an oblique and soft light, and not so near the picture as to catch the eye painfully. That may be easily obtained, and I think that all other questions after that are subordinate.

2430. *Dean of St. Paul's*. Your proposition would require a great extent of wall?—An immense extent of wall.

2431. *Chairman*. I see you state in the pamphlet to which I have before alluded, that it is of the highest importance that the works of each master should be kept together. Would not such an arrangement increase very much the size of the National Gallery?—I think not, because I have only supposed in my plan that, at the utmost, two lines of pictures should be admitted on the walls of the room; that being so, you would be always able to put all the works of any master together without any inconvenience or difficulty in fitting them to the size of the room. Supposing that you put the large pictures high on the walls, then it might be a question, of course, whether such and such a room or compartment of the Gallery would hold the works of a particular master; but supposing the pictures were all on a continuous line, you would only stop with A and begin with B.

2432. Then you would only have them on one level and one line?—In general; that seems to me the common-sense principle.

2433. Mr. *Richmond*. Then you disapprove of the whole of the European hanging of pictures in galleries?—I think it very beautiful sometimes, but not to be imitated. It produces most noble rooms. No one can but be impressed with the first room at the Louvre, where you have the most noble Venetian pictures one mass of fire on the four walls; but then none of the details of those pictures can be seen.

2434. *Dean of St. Paul's*. There you have a very fine general effect, but you lose the effect of the beauties of each individual picture?—You lose all the beauties; all the higher merits; you get merely your general idea. It is a perfectly splendid room, of which a great part of the impression depends upon the consciousness of the spectator that it is so costly.

2435. Would you have those galleries in themselves richly decoratéd?—Not richly, but pleasantly.

2436. Brilliantly, but not too brightly?—Not too brightly. I have not gone into that question, it being out of my way; but I think, generally, that great care should be taken to give a certain splendour—a certain gorgeous effect—so that the spectator may feel himself among splendid things; so that there shall be no discomfort or meagreness, or want of respect for the things which are being shown.

2437. Mr. *Richmond*. Then do you think that Art would be more worthily treated, and the public taste and artists better served, by having even a smaller collection of works so arranged, than by a much larger one merely housed and hung four or five deep, as in an auction-room?—Yes. But you put a difficult choice before me, because I do think it a very important thing that we should have many pictures. Totally new results might be obtained from a large gallery in which the chronological arrangement was perfect, and whose curators prepared for that chronological arrangement, by leaving gaps to be filled by future acquisition; taking the greatest pains in the selection of the examples, that they should be thoroughly characteristic; giving a greater price for a picture which was thoroughly characteristic and expressive of the habits of a nation; because it appears to me that one of the main uses of Art at present is not so much as Art, but as teaching us the feelings of nations. History only tells us what they did; Art tells us their feelings, and why they did it: whether they were energetic and fiery, or whether they were, as in the case of the Dutch, imitating minor things, quiet and cold. All those expressions of feeling cannot come out of History. Even the contemporary historian does not feel them; he does not feel what his nation is; but get the works of the same master together, the works of the same nation together, and the works of the same century together, and see how the thing will force itself upon every one's observation.

2438. Then you would not exclude the genuine work of inferior masters?—Not by any means.

2439. You would have the whole as far as you could obtain it?—Yes, as far as it was characteristic; but, I think, you can hardly call an inferior master one who does in the best possible way the thing he undertakes to do; and I would not take any master who did not in some way excel. For instance, I would not take a mere imitator of Cuyp among the Dutch; but Cuyp himself has done insuperable things in certain expressions of sunlight and repose. Vander Heyden and others may also be mentioned as first-rate in inferior lines.

2440. Taking from the rise of art to the time of Raphael, would you in the National Gallery include examples of all those masters whose names have come down to the most learned of us?—No.

2441. Where would you draw the line, and where would you begin to leave out?—I would only draw the line when I was purchasing a picture. I think that a person might always spend his money better by making an effort to get one noble picture than five or six second or third-rate pictures, provided only, that you had examples of the best kind of work produced at that time. I would not have second-rate pictures. Multitudes of masters among the disciples of Giotto might be named; you might have one or two pictures of Giotto, and one or two pictures of the disciples of Giotto.

2442. Then you would rather depend upon the beauty of the work itself; if the work were beautiful you would admit it?—Certainly.

2443. But if it were only historically interesting, would you then reject it?—Not in the least. I want it historically interesting, but I want as good an example as I can have of that particular manner.

2444. Would it not be historically interesting if it were the only picture known of that particular master, who was a follower of Giotto?—For instance, supposing a work of Cennino Cennini were brought to light, and had no real merit in it as a work of art, would it not be the duty of the authorities of a National Gallery to seize upon that picture, and pay perhaps rather a large price for it?—Certainly, all documentary art I should include.

2445. Then what would you exclude?—Merely that which is inferior, and not documentary; merely another example of the same kind of thing.

2446. Then you would not multiply examples of the same masters, if inferior men, but you would have one of each. There is no man, I suppose, whose memory has come down to us after three or four centuries, but has something worth preserving in his work—something peculiar to himself, which perhaps no other person has ever done, and you would retain one example of such, would you not?— I would, if it was in my power, but I would rather with given funds make an effort to get perfect examples.

2447. Then you think that the artistic element should govern the archæological in the selection?—Yes, and the archæological in the arrangement.

2448. *Dean of St. Paul's.* When you speak of arranging the works of one master consecutively, would you pay any regard or not to the subjects. You must be well aware that many painters, for instance, Correggio, and others, painted very incongruous subjects; would you rather keep them together than disperse the works of those painters to a certain degree according to their subjects?—I would most certainly keep them together. I think it an important feature of the master that he did paint incongruously, and very possibly the character of each picture would be better understood by seeing them together; the relations of each are sometimes essential to be seen.

2449. Mr. *Richmond.* Do you think that the preservation of these works is one of the first and most important things to be provided for?—It would be so with me in purchasing a picture. I would pay double the price for it if I thought it was likely to be destroyed where it was.

2450. In a note you wrote to me the other day, I find this passage: "The Art of a nation I think one of the most important points of its history, and a part, which,

if once destroyed, no history will ever supply the place of—and the first idea of a National Gallery is, that it should be a Library of Art, in which the rudest efforts are, in some cases, hardly less important than the noblest." Is that your opinion?—Perfectly. That seems somewhat inconsistent with what I have been saying, but I mean there, the noblest efforts of the time at which they are produced. I would take the greatest pains to get an example of 11th Century work, though the painting is perfectly barbarous at that time.

2451. You have much to do with the education of the working classes in Art. As far as you are able to tell us, what is your experience with regard to their liking and disliking in Art—do comparatively uneducated persons prefer the Art up to the time of Raphael, or down from the time of Raphael—we will take the Bolognese School, or the early Florentine School—which do you think a working man would feel the greatest interest in looking at?—I cannot tell you, because my working men would not be allowed to look at a Bolognese Picture; I teach them so much love of detail, that the moment they see a detail carefully drawn, they are caught by it. The main thing which has surprised me in dealing with these men is the exceeding refinement of their minds—so that in a moment I can get carpenters, and smiths, and ordinary workmen, and various classes to give me a refinement which I cannot get a young lady to give me, when I give her a lesson for the first time. Whether it is the habit of work which makes them go at it more intensely, or whether it is (as I rather think) that, as the feminine mind looks for strength, the masculine mind looks for delicacy, and when you take it simply, and give it its choice, it will go to the most refined thing, I do not know.

2452. *Dean of St. Paul's.* Can you see any perceptible improvement in the state of the public mind and taste in that respect, since these measures have been adopted?—There has not been time to judge of that.

2453. Do these persons who are taking an interest in Art come from different parts of London?—Yes.

2454. Of course the distance which they would have to come would be of very great importance?—Yes.

2455. Therefore one of the great recommendations of a Gallery, if you wish it to have an effect upon the public mind in that respect, would be its accessibility, both with regard to the time consumed in going there, and to the cheapness, as I may call it, of access?—Most certainly.

2456. You would therefore consider that the more central the situation, putting all other points out of consideration, the greater advantage it would be to the public?—Yes, there is this, however, to be said, that a central situation involves the crowding of the room with parties wholly uninterested in the matter—a situation more retired will generally be serviceable enough for the real student.

2457. Would not that very much depend upon its being in a thoroughfare? There might be a central situation which would not be so complete a thoroughfare as to tempt persons to go in who were not likely to derive advantage from it?—I think that if this gallery were made so large and so beautiful as we are proposing, it would be rather a resort, rather a lounge every day, and all day long, provided it were accessible.

2458. Would not that a good deal depend upon its being in a public thoroughfare? If it were in a thoroughfare, a great many persons might pass in who would

be driven in by accident, or driven in by caprice, if they passed it; but if it were at a little distance from a thoroughfare it would be less crowded with those persons who are not likely to derive much advantage from it?—Quite so; but there would always be an advantage in attracting a crowd; it would always extend its educational ability in its being crowded. But it would seem to me that all that is necessary for a noble Museum of the best art should be more or less removed, and that a collection, solely for the purpose of education, and for the purpose of interesting people who do not care much about art, should be provided in the very heart of the population, if possible, that pictures not of great value, but of sufficient value to interest the public, and of merit enough to form the basis of early education, and to give examples of all art, should be collected in the popular Gallery, but that all the precious things should be removed and put into the great Gallery, where they would be safest, irrespectively altogether of accessibility.

2459. *Chairman.* Then you would, in fact, have not one but two Galleries?—Two only.

2460. *Professor Faraday.* And you would seem to desire purposely the removal of the true and head Gallery to some distance, so as to prevent the great access of persons?—Yes.

2460*a.* Thinking that all those who could make a real use of a Gallery would go to that one?—Yes. My opinion in that respect has been altered within these few days from the fact having been brought to my knowledge of sculpture being much deteriorated by the atmosphere and the total impossibility of protecting sculpture. Pictures I do not care about, for I can protect them, but not sculpture.

2461. *Dean of St. Paul's.* Whence did you derive that knowledge?—I forget who told me; it was some authority I thought conclusive, and therefore took no special note of.

2462. *Chairman.* Do you not consider that it is rather prejudicial to art that there should be a gallery notoriously containing no first-rate works of art, but second-rate or third-rate works?—No; I think it rather valuable as an expression of the means of education, that there should be early lessons in art—that there should be this sort of art selected especially for first studies, and also that there should be a recognition of the exceeding preciousness of some other art. I think that portions of it should be set aside, as interesting, but not unreplaceable; but that other portions should be set aside, as being things as to which the function of the nation was, chiefly, to take care of those things, not for itself merely, but for all its descendants, and setting the example of taking care of them for ever.

2463. You do not think, then, that there would be any danger in the studying or the copying of works which notoriously were not the best works?—On the contrary, I think it would be better that works not altogether the best should be first submitted. I never should think of giving the best work myself to a student to copy—it is hopeless; he would not feel its beauties—he would merely blunder over it. I am perfectly certain that that cannot be serviceable in the particular branch of art which I profess, namely, Landscape-painting; I know that I must give more or less of bad examples.

2464. *Mr. Richmond.* But you would admit nothing into this second gallery which was not good or true of its kind?—Nothing which was not good or true of its kind, but only inferior in value to the others.

2465. And if there were any other works which might be deposited there with perfect safety, any precious drawings, which might be protected by glass, you would not object to exhibit those to the unselected multitude?—Not in the least; I should be very glad to do so, provided I could spare them from the grand chronological arrangement.

2466. Do you think that a very interesting supplementary exhibition might be got up, say at Trafalgar-Square, and retained there?—Yes; and all the more useful, because you would put few works, and you could make it complete in series—and because on a small scale, you would have the entire series. By selecting a few works, you would have an epitome of the Grand Gallery, the divisions of the Chronology being all within the compartment of a wall, which in the great Gallery would be in a separate division of the building.

2467. Mr. *Cockerell.* Do you contemplate the possibility of excellent copies being exhibited of the most excellent works both of Sculpture and of Painting?—I have not contemplated that possibility. I have a great horror of copies of any kind, except only of sculpture. I have great fear of copies of Painting; I think people generally catch the worst parts of the Painting and leave the best.

2468. But you would select the artist who should make the copy. There are persons whose whole talent is concentrated in the power of imitation of a given picture, and a great talent it is.—I have never in my life seen a good copy of a good picture.

2469. *Chairman.* Have you not seen any of the German copies of some of the great Italian masters, which are generally esteemed very admirable works?—I have not much studied the works of the copyists; I have not observed them much, never having yet found an exception to that rule which I have mentioned. When I came across a copyist in the Gallery of the Vatican, or in the Gallery at Florence, I had a horror of the mischief, and the scandal and the libel upon the Master, from the supposition that such a thing as that in any way resembled his work, and the harm that it would do to the populace among whom it was shown.

2470. Mr. *Richmond.* You look upon it as you would upon coining bad money and circulating it, doing mischief?—Yes, it is mischievous.

2471. Mr. *Cockerell.* But you admit engravings—you admit photographs of these works, which are imitations in another language?—Yes; in abstract terms, they are rather descriptions of the paintings than copies—they are rather measures and definitions of them—they are hints and tables of the pictures, rather than copies of them, they do not pretend to the same excellence in any way.

2472. You speak as a connoisseur; how would the common eye of the public agree with you in that opinion?—I think it would not agree with me. Nevertheless, if I were taking some of my workmen into the National Gallery, I should soon have some hope of making them understand in what excellence consisted, if I could point to a genuine work; but I should have no such hope if I had only copies of these pictures.

2473. Do you hold much to the archæological, chronological, and historical series and teaching of pictures?—Yes.

2474. Are you of opinion that that is essential to the creative teaching, with reference to our future schools?—No. I should think not essential at all. The teaching of the future Artist I should think might be accomplished by very few pictures of

the class which that particular Artist wished to study. I think that the chronological arrangement is in nowise connected with the general efficiency of the gallery as matter of study, for the Artist, but very much so as a means of study, not for persons interested in painting merely, but for those who wish to examine the general history of nations; and I think that painting should be considered by that class of persons as containing precious evidence. It would be part of the philosopher's work to examine the the art of a nation as well as its poetry.

2475. You consider that art speaks a language and tells a tale which no written document can effect?—Yes, and far more precious; the whole soul of a nation generally goes with its art. It may be urged by an ambitious king to become a warrior nation. It may be trained by a single leader to become a *great* warrior nation, and its character at that time may materially depend upon that one man, but in its art all the mind of the nation is more or less expressed: it can be said, that was what the peasant sought to, when he went into the city to the cathedral in the morning—that was the sort of book the poor person read or learned in—the sort of picture he prayed to. All which involves infinitely more important considerations than common history.

2476. *Dean of St. Paul's.* When you speak of your objections to copies of pictures, do you carry that objection to casts of sculpture?—Not at all.

2477. Supposing there could be no complete union of the great works of sculpture in a country with the great works of painting in that country, would you consider that a good selection of casts comprising the great remains of sculpture of all ages would be an important addition to a public gallery?—I should be very glad to see it.

2478. If you could not have it of originals you would wish very much to have a complete collection of casts, of course selected from all the finest sculpture in the world?—Certainly.

2479. Mr. *Richmond.* Would you do the same with Architecture—would you collect the remains of Architecture, as far as they are to be collected, and unite them with Sculpture and Painting?—I should think that Architecture consisted, as far as it was portable, very much in Sculpture. In saying that, I mean, that in the different branches of Sculpture Architecture is involved—that is to say, you would have the statues belonging to such and such a division of a building. Then if you had casts of those statues, you would necessarily have those casts placed exactly in the same position as the original statues—it involves the buildings surrounding them and the elevation—it involves the whole Architecture.

2480. In addition to that, would you have original drawings of architecture, and models of great buildings, and photographs, if they could be made permanent, of the great buildings as well as the mouldings and casts of the mouldings, and the members as far as you could obtain them?—Quite so.

2481. Would you also include, in the National Gallery, what may be called the handicraft of a nation—works for domestic use or ornament? For instance, we know that there were some salt-cellars designed for one of the Popes, would you have those if they came to us?—Everything, pots and pans, and salt-cellars, and knives.

2482. You would have everything that had an interesting art element in it?—Yes.

2483. *Dean of St. Paul's.* In short a modern Pompeian Gallery?—Yes; I know how much greater extent that involves, but I think that you should include all the

iron-work, and china, and pottery, and so on. I think that all works in metal, all works in clay, all works in carved wood, should be included. Of course, that involves much. It involves all the coins—it involves an immense extent.

2484. Supposing it were possible to concentre in one great museum the whole of these things, where should you prefer to draw the line? Would you draw the line between what I may call the ancient Pagan world and the modern Christian world, and so leave, to what may be called the ancient world, all the ancient sculpture, and any fragments of ancient painting which there might be—all the vases, all the ancient bronzes, and, in short, everything which comes down to a certain period? Do you think that that would be the best division, or should you prefer any division which takes special arts, and keeps those arts together?—I should like the Pagan and Christian division. I think it very essential that wherever the sculpture of a nation was there its iron work should be—that wherever its iron work was, there its pottery should be, and so on.

2485. And you would keep the mediæval works together, in whatever form those mediæval works existed?—Yes; I should not at all feel injured by having to take a cab-drive from one century to another century.

2486. Or from the ancient to the modern world?—No.

2487. Mr. *Richmond*. If it were found convenient, to keep separate the Pagan and the Christian art, with which would you associate the mediæval?—By "Christian and Pagan Art" I mean, before Christ, and after Christ.

2488. Then the mediæval would come with the paintings?—Yes; and also the Mahomedan, and all the Pagan art which was after Christ, I should associate as part, and a most essential part, because it seems to me that the history of Christianity is complicated perpetually with that which Christianity was affecting. Therefore, it is a matter of date, not of Christianity. Everything before Christ I should be glad to see separated, or you may take any other date that you like.

2489. But the inspiration of the two schools—the Pagan and the Christian— seems so different, that there would be no great violence done to the true theory of a national gallery in dividing those two, would there, if each were made complete in itself?—That is to say, taking the spirit of the world after Christianity was in it, and the spirit of the world before Christianity was in it.

2490. *Dean of St. Paul's*. The birth of Christ, you say, is the commencement of Christian art?—Yes.

2491. Then Christian influence began, and, of course, that would leave a small debateable ground, particularly among the ivories for instance, which we must settle according to circumstances?—Wide of any debateable ground, all the art of a nation which had never heard of Christianity, the Hindoo art and so on, would, I suppose, if of the Christian era, go into the Christian gallery.

2492. I was speaking rather of the transition period, which, of course, there must be?—Yes.

2493. Mr. *Cockerell*. There must be a distinction between the terms "museum" and "gallery." What are the distinctions which you would draw in the present case?—I should think "museum" was the right name of the whole building. A "gallery" is, I think, merely a room in a museum adapted for the exhibition of works in a series, whose effect depends upon their collateral showing forth.

2494. There are certainly persons who would derive their chief advantage from the historical and chronological arrangement which you propose, but there are others who look alone for the beautiful, and who say, "I have nothing to do with your pedantry. I desire to have the beautiful before me. Show me those complete and perfect works which are received and known as the works of Phidias and the great Greek masters as far as we possess them, and the works of the great Italian painters. I have not time, nor does my genius permit that I should trouble myself with those details." There is a large class who are guided by those feelings?—And I hope who always will be guided by them; but I should consult their feelings enough in the setting before them of the most beautiful works of art. All that I should beg of them to yield to me would be that they should look at Titian only, or at Raphael only, and not wish to have Titian and Raphael side by side; and I think I should be able to teach them, as a matter of beauty, that they did enjoy Titian and Raphael alone better than mingled. Then I would provide them beautiful galleries full of the most noble sculpture. Whenever we come as a country and a nation to provide beautiful sculpture, it seems to me that the greatest pains should be taken to set it off beautifully. You should have beautiful sculpture in the middle of the room, with dark walls round it to throw out its profile, and you should have all the arrangements made there so as to harmonize with it, and to set forth every line of it. So the painting gallery, I think, might be made a glorious thing, if the pictures were level, and the architecture above produced unity of impression from the beauty and glow of colour and the purity of form.

2495. Mr. *Richmond.* And you would not exclude a Crevelli because it was quaint, or an early master of any school—you would have the infancy, the youth, and the age, of each school, would you not?—Certainly.

2496. *Dean of St. Paul's.* Of the German as well as the Italian?—Yes.

2497. Mr. *Richmond.* Spanish, and all the schools?—Certainly.

2498. Mr. *Cockerell.* You are quite aware of the great liberality of the Government, as we learn from the papers, in a recent instance, namely, the purchase of a great Paul Veronese?—I am rejoiced to hear it. If it is confirmed, nothing will have given me such pleasure for a long time. I think it is the most precious Paul Veronese in the world, as far as the completion of the picture goes, and quite a priceless picture.

2499. Can you conceive a Government, or a people, who would countenance so expensive a purchase, condescending to take up with the occupation of the upper story of some public building, or with an expedient which should not be entirely worthy of such a noble Gallery of Pictures?—I do not think that they ought to do so: but I do not know how far they will be consistent. I certainly think they ought not to put up with any such expedient. I am not prepared to say what limits there are to consistency or inconsistency.

2500. Mr. *Richmond.* I understand you to have given in evidence that you think a National Collection should be illustrative of the whole art in all its branches?—Certainly.

2501. Not a cabinet of paintings, not a collection of sculptured works; but illustrative of the whole art?—Yes.

2502. Have you any further remark to offer to the Commissioners?—I wish to say one word respecting the question of the restoration of Statuary. It seems to me a

very simple question. Much harm is being at present done in Europe by restoration; more harm than was ever done, as far as I know, by revolutions or by wars. The French are now doing great harm to their cathedrals, under the idea that they are doing good, destroying more than all the good they are doing. And all this proceeds from the one great mistake of supposing that sculpture can be restored when it is injured. I am very much interested by the question which one of the Commissioners asked me in that respect; and I would suggest whether it does not seem easy to avoid all questions of that kind. If the Statue is injured, leave it so, but provide a perfect copy of the Statue in its restored form; offer, if you like, prizes to sculptors for conjectural restorations, and choose the most beautiful, but do not touch the original work.

2503. *Professor Faraday.* You said some time ago that in your own attempts to instruct the public there had not been time yet to see whether the course taken had produced improvement or not. You see no signs at all which lead you to suppose that it will not produce the improvement which you desire?—Far from it—I understood the Dean of St. Paul's to ask me whether any general effect had been produced upon the minds of the public. I have only been teaching a class of about forty workmen for a couple of years, after their work—they not always attending—and that forty being composed of people passing away and coming again; and I do not know what they are now doing; I only see a gradual succession of men in my own class. I rather take them in an elementary class, and pass them to a master in a higher class. But I have the greatest delight in the progress which these men have made, so far as I have seen it: and I have not the least doubt that great things will be done with respect to them.

2504. *Chairman.* Will you state precisely what position you hold?—I am master of the Elementary and Landscape School of drawing at the Working Men's College in Great Ormond Street.[10] My efforts are directed not to making carpenter an artist, but to making him happier as a carpenter.

[The Witness then withdrew.]

10. Working Men's College: founded in 1854 to educate the skilled artisan class. [Ed.]

# Gustav Friedrich Waagen

—◦❧ ❦◦—

## *Thoughts on the New Building to Be Erected for the National Gallery of England*

There is scarcely any lover of Art in England, I believe, who will have hailed with more lively joy than myself the proposition entertained by the Royal Commissioners, of devoting a portion of the surplus income derived from the Great Exhibition of 1851 to the purchase of ground for a new National Gallery, and the Parliamentary grant of a large sum for the same object. Many circumstances render the interest I feel quite natural. No other foreigner has, in recent times, to my knowledge, devoted his attention with such zealous interest to the works of Art in England, as I have done, in the thirteen months I passed in that country, during three visits in the years 1835, 1850, and 1851. The confidence with which I have been favoured by the Government,* as well as by private individuals of distinction, enabled me to acquire more information on these subjects than perhaps any other foreigner. In addition to this, I entertain a conviction that the Arts are destined in this country to fulfil, in an important degree, their high vocation, of influencing, educating, and ennobling mankind,—constituting as the English people do one main branch of the great Germanic race so alive to the influences of Art, and possessing a rare mental energy together with unlimited resources. Although far from presuming to imply, that England is deficient of men fully competent to execute this important work in a noble and satisfactory manner, yet I am induced, by several considerations, to commit to paper a few thoughts upon this subject. To this I am led partly by a feeling of gratitude for the confidence shown me in England,—partly, by the consciousness that I have acquired no ordinary experience in these studies, in the fulfillment of my duties in arranging the picture-gallery of the Museum at Berlin, aided by my intimate acquaintance with all the Museums of Europe, excepting those of Madrid and St. Petersburg,†—and, lastly, by the conviction that my opinion, as a foreigner, removed from many circumstances that might tend to narrow the views of an Englishman, is perhaps in some respects more free and unbiassed.†† I shall consider myself amply

Gustav Friedrich Waagen, "Thoughts on the New Building to Be Erected for the National Gallery of England, and on the Arrangement, Preservation, and Enlargement of the Collection," *The Art Journal* (1853), 101–125 (excerpts).

* In the years 1835 and 1850, at the desire of a Parliamentary Commission, I tendered my opinion on various matters of Art—in the last instance concerning the National Gallery.

† The causes of these exceptions, which I so much regret, have not arisen from indolence on my part, but from my inability to accomplish this object.

†† In order to maintain this independence intact, I have purposely refrained from corresponding with any of my artistic friends in England on this subject, and from submitting this Essay to their judgment before its appearance in print.

rewarded for my pains, if I may in any degree contribute toward the accomplishment of so important an object.

In the first place, it appears to me that the Government is called upon to respond to the confidence the Nation has manifested in the grant of so large a sum, by erecting a building which may fulfil all the objects in view, and correspond to the dignity of this country. And this duty is, in my view, the more imperative, as a similar proof of confidence on the part of the Nation, has in a former instance been grievously disappointed, in the erection of the building for the same purpose in Trafalgar Square. This disappointment can only in some degree be compensated, by assigning to the Royal Academy the apartment hitherto used for the exhibition of the National Gallery,—an arrangement urgently required for the purposes of this institution, for the uninterrupted prosecution of its studies (now suspended during four months in the year by the Annual Exhibition), for an appropriate exhibition of its casts from the antique, a befitting disposition of the few but precious original works which the Academy possesses, such as the cartoon of Lionardo da Vinci and the rilievo by Michael Angelo,* and, lastly, for a worthy exhibition of the works of modern sculpture in the annual exhibitions of the Academy.†

For the fulfilment of all the demands necessary in forming a public gallery of pictures worthy of the English nation, many things are required, which I shall proceed to consider.

## Selection of a Site for the Building

The site of the Gallery must lie beyond the London atmosphere and smoke; otherwise the pictures will suffer certain destruction at no very distant time, as is shown by the injured condition of the pictures in the National Gallery since its opening. It is, however, requisite that the spot should be easy of access, and therefore as near as possible to London; otherwise the principal object of the gallery—that of serving for the enjoyment and instruction of the community at large—will be lost. These two requirements have been admirably provided for by the Royal Commission, who have selected an eligible site in the vicinity of Kensington.

It is desirable that the building should stand on an open space, detached from any others, both for security against fire, and likewise to obtain a good light. It should be so placed, that the back, which is not restricted like the front by portico, entrance-hall, and staircase, and consequently offers the principal space for hanging the pictures, has a due north light, which is the most favourable for these works.

---

\*   During the Annual Exhibition, these works are stored away, so that I was unable to get a sight of them, either in 1850 or 1851.

†   The way in which these modern sculptures are crowded together in a cellar-like apartment, badly lighted, gives more the impression of their being stored away in a warehouse than an exhibition worthy of so great and opulent a nation.

## Exterior of the Building

As a very considerable outlay is required for the main object in view, it is desirable that the façade of the building should not be encumbered with columns and sculpture, which always entail considerable expense. Beauty of proportion, grandeur of form and outline in the single parts, are quite sufficient to give the appearance required. With a view to obtain a correct proportion between the elevation and length, in the necessarily large extent of the edifice, the latter might with advantage consist of an elevated ground-floor, with a story over it; the former containing the pictures of the English Schools, and the latter the works of Foreign Masters.

## Interior of the Building

If, in the erection of this National Gallery, the intention is that it should satisfy all the requirements that may arise during some centuries to come, as in the gallery of the Louvre at Paris, great attention must be paid to the superficies of wall, that it may comprise at least six times the space at present occupied by all the pictures in the National Gallery and those of the English schools in Marlborough House. No one can appreciate more highly than I do the treasures in the National Gallery; but, at the same time, no one acquainted with the galleries of Paris, Florence, and Dresden, can deny that the National Gallery of England is very far from competing with any one of them, or corresponding to the greatness and wealth of the English nation, in the same degree as the Gallery of the Louvre does with respect to the French nation. It is to be hoped that a Government which, by the support and assistance it has rendered to this new building, has recognized the great importance of such an institution, may endeavour, by making desirable purchases of pictures, as opportunities arise (a subject to which I shall presently revert), to bring the collection by degrees to that state of completeness which I shall indicate. It may, likewise, surely be anticipated, from the public spirit and patriotism to which the National Gallery is already so remarkably indebted, that it will hereafter be considerably enlarged by presents and bequests; unless, therefore, at the very outset, due attention be paid to these considerations, a similar dilemma as the present will probably recur after a few generations—namely, an insufficiency of space—and many a patriotic possessor of valuable pictures may thus be deterred from presenting them to the National Gallery. In speaking hereafter of the arrangement and exhibition of pictures, I shall allege another important reason for not being sparing of space.

As the large extent of surface-wall for the pictures requires a building of considerable size, it is most desirable that the entrance-hall and staircase should not occupy such a disproportionate waste of room as in the present National Gallery.

The apartments for hanging the pictures must be numerous, and should vary in height as well as size; small pictures lose extremely not only in a large, but likewise in too high a room; and from this circumstance they have the significant name of cabinet pictures. The rooms for large pictures should not be more spacious than to allow the spectator to contemplate a moderate number from the distance which the

artist's intention prescribes. In speaking of the arrangement of pictures, I shall assign other reasons for this.

The decoration of the rooms must be simple, and its effect always subordinate to the pictures; rich and heavy ceiling ornaments, in which gold is freely used, as in some of the saloons of the Louvre newly decorated in this manner, are especially to be avoided. A white ground tone, with light ornaments, in clear, broken colours, such as Schinkel has employed in the picture-galleries of the Royal Museum at Berlin, is especially recommended by the effect of lightness and elegance it imparts to the rooms.

## Lighting the Apartments

Among the various modes of introducing light, that from above is by far the most favourable for large pictures; a side light falls on the surface of the painting very unequally. This mode is, however, rarely employed so successfully as in the three large exhibition rooms of the Royal Academy in London. The lantern-skylight in the center is either too high, when only a subdued, cellar-like light reaches the pictures, (as in the apartment hung with pictures of the old German school in the Pinacothek at Munich, where the fine touches of these works are quite lost); or the light falls upon a corner, so that the direct front view of the pictures suffers from reflexion, and it is necessary to seek a side view, which is always unfavourable from the consequently contracted appearance of the forms depicted. This is the case with many paintings in the large room of the new gallery of the Earl of Ellesmere. To ensure correctness, therefore, in a matter of such importance, it would be advisable in the first instance, to build a slight wooden room of the size determined on, to hang in it the pictures for trial, and to shift them until a correct light is obtained.

In the case of small paintings, which are to be hung in small rooms, where the light reaches the end of the side walls in about equal strength, I should always prefer rather a high side light; and as painters invariably select this light in the execution of such pictures, it must, I think, be the most favourable one in which to view them. I do not remember, for instance, to have seen such pictures in a better light than the paintings hung next the two windows in the collection of the late Sir Robert Peel.

A front light—the most unfavourable—is either to be entirely avoided or only introduced with such pictures as have no claim to general effect, and are of inferior importance.

## Control of the Government over the
## Erection of the Building

To carry out the above arrangements satisfactorily and securely, it is indispensably necessary that the architect entrusted with the execution of the building should be placed under the strict control of a Commission, presided over by some nobleman of enlightened views on Art, and consisting of a small number of

artists and amateurs (not less than four, not exceeding six), whose judgment and love of the Fine Arts should admit of no question. Although I am far from asserting that there are not architects in England, who in the execution of a building keep its chief object steadily in view, treating everything as subordinate to this, yet experience shows that there are also architects who regard a building for the exhibition of works of Art merely as offering an opportunity to indulge every kind of caprice—such as the erection of magnificent halls, in which works of Art are introduced only as a decoration, sacrificing the principal object, of presenting an exhibition of Art under circumstances the most favourable for affording enjoyment and instruction. It would be unjustifiable, especially after the experience of the former Gallery, to expose so important an undertaking to the risk of such treatment. Fortunate would it be if H.R.H. Prince Albert were to put himself at the head of such a Commission! The rare degree in which His Royal Highness combines, with his elevated station in society, not only an ardent love of the Fine Arts, but likewise a refined insight into their study, would afford the greatest assurance of the success of the undertaking.

## Arrangement of the Pictures

Whoever regards works of sculpture and painting as the result of an advanced state of civilization among a highly gifted people—works intimately connected with all the circumstances of their national existence, religion, manners, geographical characteristics of country, climate, &c., and especially regulated and conditioned by architecture, for which they are calculated, and which serves to explain them—views a Museum containing the varied productions of all ages and countries, in relation to the places from which the works it contains have been derived, somewhat as a botanist looks at the hothouse, in which are collected the vegetable products of remote countries and climates. A Museum is simply a means of rescuing works of Art from otherwise certain destruction, or of exhibiting to general view those which would otherwise be seen by few, if any persons, who feel a want for such enjoyments. It is, therefore, the duty of those entrusted with the arrangement of Museums, to lessen as much as possible the contrast which must necessarily exist between works of Art in their original site, and in their position in a museum. But, to realise in some degree the impression produced by a temple, a church, a palace, or a cabinet, for which those works were originally intended, and where a certain general harmony reigned, such works alone (and in moderate number) ought to be collected in a room, which belong to the same period and school. This is the true æsthetical mode of proceeding; but the disadvantage incurred by removing the monuments of various nations and ages from their original locality, should at least be compensated in some degree, by the creation of an historical and scientific interest. This can only be accomplished by arranging the single groups of a similar character in chronological order, and according to the affinity of the Schools. In conformity with these principles, I have, in conjunction with my lamented friend the celebrated architect Schinkel, the sculptor Rauch, and other gentlemen, forming a Commission under the presidency of the late minister, William Von Humboldt, introduced this arrangement into the Picture

Gallery of the Royal Museum of Berlin; and I have had the satisfaction of receiving from various distinguished connoisseurs and artists of different nations, an expression of their approval of it. I mention these facts, not from any feeling of vanity, but only as they may serve to advance my present views and suggestions.

The justness of these views might perhaps be better shown, by contrasting them with well-known instances of the opposite system,—that of mingling works of different schools and periods, without regard to system or method. With this view, I shall select some examples from three apartments in the celebrated galleries of Dresden, Florence, and Paris, in which it has been intended to pay especial honour to the pictures of the great Masters, by this ill-judged arrangement, in a spacious and well-lighted apartment. In Dresden, pictures from the sixteenth to the eighteenth century have been hung in juxta-position, which belong especially to the Florentine, Roman, and Lombard schools. Passing over many other unpleasing contrasts, I will only cite the fact, that the famous Madonna di San Sisto, of Raphael, from being placed beside four large pictures by Correggio, distinguished by their splendid colouring and chiaro-oscuro, loses all its brilliancy; notwithstanding that it is in reality painted with such delicacy and harmony, that the pictures of Correggio, excepting the St. Francisco, are inferior in a still greater degree to Raphael's picture in loftiness of religious enthusiasm and pure beauty of form and motive, producing in comparison a worldly and mannered expression. In this way, these, the highest features of the Roman and Lombard schools, instead of mutually borrowing and imparting increased effect, by such immediate juxtaposition, are, on the contrary, materially injured by it.

In the second of the rooms I have mentioned, the famous 'Tribune' of Florence, this confused arrangement of the pictures, comprises works from the fifteenth to the seventeenth centuries, including the various Italian schools, as well as the Dutch and German. Among the pictures of the fifteenth and beginning of the sixteenth centuries, there is an altar-piece, by Andrea Mantegna, and an 'Adoration of the Kings,' by Albrecht Durer, both works of high intrinsic interest and meriting attentive study; but, placed as they are beside the celebrated 'Venus' of Titian, an altar-piece by Andrea del Sarto, and other pictures, combining the charm and truth of perfect artistic form, with a magic beauty of colouring, they are thrown into the shade, so as to be either quite overlooked by even observant amateurs, or at most to attract a merely cursory glance. This fact I have had repeated opportunities of witnessing, during my residence at Florence. In the Salon Quarré of the Louvre, where, in addition to the mixture of schools which is found in the 'Tribune,' pictures are introduced of the Spanish and French schools, the impression is most distasteful, nay painful, to any one who seeks in works of Art something more than a mere passing amusement. Such admirable works as the 'Coronation of the Virgin,' by Angelico da Fiesole, a large altar-piece by Fra Filippo Lippi, the beautiful round picture by Pietro Perugino, from the collection of the King of the Netherlands, a large altar-piece by Fra Bartolommeo, nay even the celebrated 'Belle Jardinière' of Raphael, appear in comparison with the other pictures, apart from the pure religious spirit which pervades them, and merely with reference to the medium of representation, hard and gaudy. The contrasts observable in an intellectual point of view, are still more harsh and offensive: to mention only one example,—close beside the 'Belle Jardinière,' hangs a picture by Terburg, representing a rough, burly

warrior, offering money to a courtesan. Now, much as I admire the distinguished talent of Terburg in his own sphere, as everyone acquainted with my writings on Art well knows, a picture by him appears to me very ill-placed in the immediate vicinity of a work, in which one of the most elevated subjects of Christian Art has been represented by the greatest painter of modern times, in the purest and noblest manner. It must be lamentable to every true lover of Art,* to witness this tasteless and capricious confusion, indicating as it does the wide chasm between the time in which these works were executed, and the present age, in which they have lost their significance and meaning; but the manner in which such errors of judgment and arrangement are lauded, by the large mass of the *soi-disant* educated classes, as proofs of intellectual and artistic taste, and success, is characteristic only of the level to which the cultivation of Art is lowered, and the present grade of criticism.

Again, this manner of bringing together the highest points of different schools and ages into one room, has another great objection; namely, that each school is exhibited to a great disadvantage, as is strikingly the case at Paris, in the pictures of the Spanish school in the long gallery of the Louvre, and in the Venetian school at Florence.

To effect such an arrangement, with reference to periods and schools, so as at the same time to fulfil the demands of the artist and connoisseur, and of the public, is attended with greater difficulties than might be imagined, and requires an accurate acquaintance with the various schools and their mutual relation, as likewise taste and the versatility of mind necessary to assume by turns the point of view of the artist, connoisseur, and of the public at large. There is no question that the two principal schools—the Italian and the Flemish-German—which may generally be regarded as representatives of the ideal and realistic tendencies, ought to be exhibited separately. It is therefore natural that, when the apartments in which these two tendencies approximate, are placed in immediate contact (as in the Museum at Berlin), the transition in the earlier forms from one to the other is best effected by the pictures of the brothers Van Eyck and their school, and those of the early Venetian school; since an Italian artist, Antonello da Messina, was a pupil of John Van Eyck, and establishing himself at Venice, contributed much, not only to introduce the system of oil-painting of the brothers Van Eyck, but to cultivate a realistic tendency which among all the Italian schools was most nearly allied to the Flemish. Lastly, it seems natural that the French and Spanish, as secondary schools, more or less influenced by the two former, and not attaining their perfection until the seventeenth century, should occupy a place among their later productions.

The next point for consideration is the arrangement of each particular School. Now the Italian School, as I have remarked, presents so many points of difference in its separate branches—among which I will only mention here the Florentine, Umbrio-Roman, Lombard, and Venetian—that a separation ought likewise to be made between these. There are two ways of effecting this: first, each School

---

* This is the more striking, since in the new arrangements of the Picture Gallery in the Louvre, in 1851, in the other rooms, the principles which I advanced in my work "Kunstwerke und Künstler in Paris," (published in 1839), in my criticism on this Gallery,—namely, that of bringing together those works which correspond according to schools and periods,—were followed with a remarkably favourable result; and the exhibition gained in consequence, extremely in comparison with former ones.

may be arranged in an uninterrupted series, from its commencement to its close—beginning, the Florentine, for instance, with Cimabue, in the thirteenth century, and terminating it with Zuccherelli, in the eighteenth; at the same time also arranging in each school the pictures chronologically, and thus introducing a second classification. But, in the second mode, the pictures of all the schools indiscriminately, belonging to the same period, may be brought together; thus in the fifteenth century the Masters of the Florentine school from Fiesole down to Domenico Ghirlandajo—in the Umbrian school, from Niccolo Alunno to Pietro Perugino—in the Venetian, from Antonio Vivarini to Giovanni Bellini—will follow in succession. In the first system of arrangement the Schools form the connecting principle; and in the second mode, the Epochs of the chief groups into which the whole Italian School is divided.

Each of these modes of arrangement has its advantages and disadvantages; in the first, the student of Art is enabled to follow each individual School in uninterrupted succession from its commencement to its climax, and again through its decline and decay. But, on the other hand, this has one serious disadvantage, that it exhibits the most opposed styles in the rise and decay of the different Schools in immediate juxta-position, presenting an abrupt and unpleasing contrast. For instance, when the Tuscan School closes with so pleasing a master as Zuccherelli, and the Umbrian School begins with Allegretto da Fabriano, an artist who followed the undeveloped and conventional forms of Giotto, the eye is little prepared to appreciate the intrinsic excellences of the latter. Such contrasts, of course, always recur where one School passes over to another. A want has been generally felt by the public for a standard for estimating the styles of Art of the fourteenth century; and as these are by this arrangement forced continually upon the spectator, he thus loses much of the enjoyment of a picture-gallery. This mode of exhibition adheres too strictly to the standing-point of the connoisseur of the history of Art.

When, on the other hand, according to the second mode of arrangement, the styles of all the Schools belonging to the same period are brought together, the spectator has the advantage of being able to pass over the entire groups comprised in the fourteenth and fifteenth centuries, and to begin his examination with those of the sixteenth century, as the epoch of the highest perfection. But even the student, who enjoys a more extensive acquaintance with Art, finds a great compensation for not being able to follow each School uninterruptedly through all its stages, in having the opportunity of comparing with advantage, and at once, the contemporaneous styles of the various Schools presenting nearly the same degree of development. This system offers one important advantage to the student as well as amateur, that it never presents the abrupt contrasts we have censured in the first mode; whilst the transitions from one School to another within an epoch, and from one period to another, are rendered easy and natural—the former by following a rule of affinity, and the latter by that of chronological succession, from their origin through their growth, perfection, decline, and decay.

—◦❥ ❦◦—

## Hanging the Pictures

The mode of hanging pictures is a point of great importance, for their general effect as well as the enjoyment of the works singly.

To avoid a tapestry-effect in hanging pictures, so opposed to the intention of their original exhibition—a point of the utmost importance—there must always be a certain space between the pictures, for which it is desirable to choose a paper of a warm and full red colour. Each painting becomes in this manner isolated and its effect heightened, and these intervals of space must be wider or narrower according to the artistic value and requirement of the pictures. The Pitti Palace at Florence may be mentioned as an exemplification of this, which, independent of the intrinsic excellence of the pictures, imparts, from the space allotted to them, a more favourable impression than any other gallery with which I am acquainted. Apart from these advantages, however, the dignity of the wealthiest nation in the world requires due attention to be paid to this subject, and that in a new National Gallery ample space should be devoted to the pictures.

Another important point is, that no picture should be hung higher than to allow its finest points and treatment to be within the correct view of an ordinary spectator. This requires that in large pictures their upper edge should not be further from the floor than fifteen feet, in medium-sized pictures not more than ten feet, and in those where small figures are introduced, not above six feet. If pictures are hung higher than this, they have a mere decorative value, as is the case with many of Rubens's paintings in the Pinacothek at Munich, where the imposing general effect in the apartment devoted to the works of this master fails to compensate the lover of Art for losing the enjoyment of each work singly. The lower edge of the pictures, on the other hand, should not be nearer to the floor than three feet. Lastly, on every wall care should be taken to distribute the pictures in a symmetrical manner at once natural and pleasing to the eye.

## Preservation of the Pictures

The chief sources of injury to pictures are damp, extreme dryness, dust and other particles in the air which settle upon them. The best means of preservation against these appears to me the following.

### Against Damp and Dryness

1. The pictures should always be hung upon wainscoat walls.
2. They should be fixed in such a manner as to admit a free current of air behind them.
3. An equable temperature is necessary; in winter the warmth being not less than 11 degrees (Reaumur); and in summer the pictures should be protected from the strong light by curtains before the windows, &c., so that the temperature is not higher than 18 degrees.
4. Whenever any bluish coating is perceived upon the pictures (always an indication of damp), this should be gently removed with a clean silk handkerchief, or otherwise it combines with the varnish, and makes it dulled, by the evaporation of the oil of turpentine.

5. If the varnish on a picture has, in the course of time, be-
come tarnished and partially destroyed, what remains of
the old varnish must be carefully removed, to prevent the
dryness of the colours that would ensue, to protect them
from the influence of the external air, and to restore the
pleasurable effect of the picture. A moderate covering of
mastic-varnish should then be equally applied, without
any other addition; but the use of purified oil of turpen-
tine must be avoided, as this becomes too thin in the pro-
cess of purifying, and resists insufficiently the effects of
external damp. From these considerations it will be evi-
dent that, however desirable it is to remove as speedily as
possible the treasures of the National Gallery from their
present destructive locality, they cannot be transferred to
the new building until it is thoroughly dry.

### Preservation against Dust, &c.

1. Ample accommodation should be provided at the entrance
of the Gallery for cleaning the shoes, &c., and every visi-
tor should be strictly enjoined to use this thoroughly, in
dry as well as wet weather.
2. A daily and careful cleaning of all the rooms with moist-
ened sawdust, immediately after the public have left the
Gallery.
3. A careful but complete dusting of the pictures and frames,
with soft feather brushes, at least once a week.

Although it is beyond my present purpose to enter on the extensive and difficult
subject of the restoration of pictures, I may urge, in connection with their preserva-
tion, the extreme importance, as soon as the least defect is perceived—for instance,
any colour peeling off or blistering—of immediately rectifying the mischief, as by
this means those serious restorations are avoided, most injurious to the pictures, but
which become necessary when such defects have spread generally over the surface.

## Use of the Gallery

### The Visit

As the Gallery is erected at the Nation's cost, it must of course be rendered as
generally useful as possible, every one being admitted capable of deriving from it en-
joyment or instruction. It should be open at least four days in the week, from about
ten o'clock till four. This principle is carried out so liberally in Berlin, that children
from ten years old and upwards (the earliest age at which they may be supposed
able to derive profit from such an institution) are admitted, when accompanied by

a grown-up person; and no one is excluded but those whose dress is so dirty as to create a smell obnoxious to the other visitors. In the National Gallery of London the freedom of admission is carried too far, infants in arms with their nurses, as well as persons in the dirtiest attire, being allowed entrance. I have at various times been in the National Gallery, when it had all the appearance of a large nursery, several wet-nurses having regularly encamped there with their babies for hours together; not to mention persons, whose filthy dress tainted the atmosphere with a most disagreeable smell. But independent of the offensiveness to other visitors from these two classes, (which I found so great that, in spite of all my love for the pictures, I have more than once been obliged to leave the building), it is highly important, for the mere preservation of the pictures, that such persons should in future be excluded from visiting the National Gallery. The exhalation produced by the congregation of any large number of persons, falling like vapour upon the pictures, tends to injure them; and this mischief is greatly increased in the case of the two classes of persons alluded to. I cannot but ascribe to this cause a considerable share of the present bad state of so many pictures in the National Gallery. It is self-evident that infants are incapable of deriving any advantage from such a Gallery; and it is scarcely too much to require, even from the working man, that, on entering a sanctuary of Art containing the masterpieces of every age and country, he should put on such decent attire as few are without.

## *Information relative to the Pictures*

Catalogues afford the chief means of imparting this, and it would be advantageous to issue two, of different kinds—one for the general reader, giving the necessary information respecting the schools, masters, and subjects, and sold at a price to bring it within the reach of the poorer classes; whilst a second catalogue should give a short sketch of the various epochs and chief schools of painting, each prefaced by a brief notice of the style of the masters at the head of the respective schools; and, lastly, an account of the life and works of the most important masters, sketched in a rapid and lucid manner. Both these wants have been admirably provided for in the National Gallery, with reference to the works it contained, by the small catalogue, sold for fourpence, and the larger one, written by Mr. Wornum and revised by Sir Charles Eastlake, an octavo volume of 216 pages, sold for a shilling. Introductory criticism, such as I have mentioned, is not required until the Gallery is more complete in the various Schools and epochs; and for the convenience of the spectator, it might be advisable that the numbers affixed to the pictures should as far as possible follow the succession in which they hang, the references in the catalogue corresponding to this arrangement.

The lovers of art in England are in no want of works of sound instruction;* nevertheless, with a view to impart more widely an understanding of the pictures in

---

\* For the Italian school, I may refer to the excellent translation of the "Handbook of Painting," by Kugler, edited by Sir C. Eastlake, and enriched with numerous illustrations; for the Dutch and German schools, there is the first edition of Kugler's Handbook, edited by Sir E. Head; for the French and Spanish schools, the excellent Handbook by Sir E. Head himself. Lastly detailed information on the Spanish school will be found in the "History of Painting in Spain," by Sterling, as well as in many parts of the works of Richard Ford on the same country.

the National Gallery, it would be very useful if the Government were to engage, at a fixed salary, some person well acquainted with the history of painting and competent to give instruction, to deliver popular lectures on the history of the art, principally directed to the pictures in the National Gallery, but likewise adverting to the treasures contained in the Royal and private collections in England. Admittance to these lectures might be fixed at a very small payment—say sixpence for the hour—few persons caring for any privilege offered them gratuitously.

## Enlargement of the National Gallery

In a former section, on the arrangement of the pictures, I have given the names of a large number of masters of the Italian Schools, partly because such classification may be regarded from many points of view, and I wished to state my own opinion, and partly from a desire to show clearly, in taking *one* school, the number of excellent masters of whose works the National Gallery is entirely deficient. I have refrained from citing many masters of a second and third rank. There is an almost total want of pictures of the first epoch in the thirteenth and fourteenth centuries; the works of the third epoch in the fifteenth century are represented only by a few pictures of Perugino, Francia, and Giovanni Bellini; whilst the flourishing period from 1500 to 1550 is very imperfectly exhibited; since of the works of its three great masters—Raphael, Correggio and Titian—the Gallery contains only masterpieces of the two last. Even the school of the Caracci, the best represented of all, is by no means complete. Of the Spanish and French Schools, the Gallery contains only the works of a few masters, although these are of unquestionable excellence. The German School is almost entirely passed over. The Dutch and Flemish Schools, great favourites in England, are represented it is true by a considerable number of masterpieces of the chief painters, but they are far from complete, and in this respect the Gallery is surpassed by numerous private collections in England. The English School is far the best and most complete, especially since the bequest of Mr. Vernon's gallery; yet even here much is still to be desired.

It is evident, from what has been said, how much is required to render the National Gallery in any degree comparable to the Gallery of the Louvre in point of extent and completeness. When, too, we consider how, up to a recent period, the masterpieces of the greatest artists have gradually fallen into the hands of those who will preserve and retain them—deposited either in churches, public galleries, or in families where they form an heirloom—the possibility of attaining this object might appear doubtful; nevertheless I am convinced that, if the course I propose be adopted, this may be accomplished in time.

The principal means of effecting this object are, of course, by purchase. Now if the system hitherto followed be adhered to, and a special Parliamentary grant be required before any valuable acquisition can be secured, it is easy to foresee that centuries must elapse before the object in view can at all be attained. On the contrary, it is absolutely necessary, in my opinion, that a considerable sum—certainly not less than 30,000*l.*—should be set apart in the yearly budget for this purpose, accompanied with an express understanding, that any portion of such grant remaining

unexpended one year, should be added to the grant of the following year. It might very probably happen that for several years no opportunity offered for making any desirable purchases; whilst, in a following year, extremely important ones might occur, requiring a far greater sum than the annual grant would defray; moreover such opportunities might happen at a time when Parliament was not assembled, and an application for any extraordinary grant would be impossible.

Another point I would urge is, that purchases of pictures should in future be made with a reference to more general and enlarged views than hitherto. I am well aware that the public taste has, in a certain degree, influenced the purchases made, and that, from this cause, there has been a hesitation in obtaining pictures of the fourteenth and fifteenth centuries, which are regarded as generally unintelligible and distasteful. Within the last ten years, however, a commencement has happily been made to overcome this prejudice, by the acquisition of the works of the fifteenth century by John Van Eyck, Pietro Perugino, Francesco Francia, and Giovanni Bellini: a feeling for these older forms of Art has recently been very generally awakened, and we may hope this will continue to increase, and that ere long public feeling and opinion may sanction enlarged purchases of such pictures. Nevertheless, although an ardent admirer of these works, I can quite understand the feeling of the public at large, who, from their present point of view, see in them only hardness, meagreness, dryness, and want of perspective, when compared with pictures which satisfy the demands of Art, in representing objects in nature, with a pleasing outline, completeness of form, and attention to perspective. I am therefore far from recommending, at present, the purchase of pictures by all these early Masters, even if they could be obtained at low prices, which is by no means the case. I am rather of opinion, that the means at disposal may be better expended in supplying the great blanks in the epochs of the highest style in Art.

## Chapter Five

# NATURAL HISTORY AND THE BRITISH MUSEUM

In his mid-century description of the British Museum W. I. Bicknell celebrates both the expansion of the collection and the ever-greater ease of public access to the treasures it contains. Nevertheless, he cannot avoid reflecting on the overwhelming nature of the institution, particularly given its heterogeneous display of antiquities alongside objects of natural history. The same point is vigorously emphasized a decade later by Elizabeth Eastlake in the first of two forceful pieces on the Museum she wrote for the *Quarterly Review*. Eastlake traces the institution's apparent incoherence to its very origins, thereby highlighting the inexorable expansion fated to shape its destiny.

While the new library constructed in 1857 had provided some relief to the problem of space for books, Eastlake argues for a more radical solution to the longstanding problem of crowding at the museum: the creation of a separate national institution devoted to the display of natural history. The practical and conceptual concerns driving the long process by which this new museum ultimately came into being in 1880 are evident not only in Eastlake's essay, but in the parliamentary debate of 1859, which is excerpted in this chapter. Deliberations over the place of natural history are shaped not by practical concerns alone, but also by the need to give an effective form to the experience of vast and diverse holdings. The congested situation of the museum vividly described by members of Parliament is only one part of the challenge; the other is to put into effect a newly rationalized concept of the institution.

Well before its foundation, the Museum of Natural History was closely identified with its chief champion, the paleontologist Richard Owen. The selection includes an excerpt from one of the distinguished naturalist's several proposals for the museum he labored to establish for decades. In his 1862 prospectus, Owen aims for a middle ground between the cabinet of curiosity and the scientific research museum. He describes a form of display that will provoke wonder and provide instruction for the general public while still offering serious resources for research to the advanced student. The chapter ends with a brief selection from a guide to the museum published

in 1893, indicating the achievement of Owen's vision as well as some of the practical challenges involved in its manifestation. An irony that Owen, a noted nemesis of Charles Darwin, could not have anticipated is the unavoidable impact of Darwinian concepts in shaping the museum Owen had worked so long to establish.

# W. I. BICKNELL

—◦❧ ☙◦—

## *The British Museum*

The Spectator somewhere speaks of an individual who was accustomed to thank God for making him *a Frenchman*. Without any desire to descry such a sentiment, we, on our part, are often disposed to render thanks to the great disposer of all events for making us *Englishmen*. And this feeling never becomes stronger than when reviewing some of those more recent alterations connected with our *mighty metropolis*. We remember the time when the BRITISH MUSEUM, of which we now propose to give a short notice, was regarded in no other light than a great *curiosity shop*, which might indeed be seen but not until after giving a long notice of such an intention; and then the visitors were conducted from room to room accompanied by a travelling guide as if to be the general expositor of a menagerie. The first time, for example, that we ever visited this national depôt of learning, we did so with an order which had six weeks to run. Access to the library was likewise nearly as difficult; so that the very purposes of a national institution became neutralized by the extraordinary manner in which it was conducted.

Our fathers have been borne away by the stream of time, and their successors have by a very tedious process removed, first one impediment then another, to the free inspection of the Museum generally; and every facility is now afforded to the student desirous of consulting this extensive and invaluable stock of books, whether printed or in manuscript; for these facilities every Englishman ought to rejoice, not merely for the personal gratification which he or even his countrymen, may derive from such an establishment; but also, for the advantages which foreigners visiting England, may possess of searching the hidden treasure of this inexhaustible *mine*. We repeat that there is a luxury in the recollection that we have *something*, amidst the everlasting *din* of trade and commerce, of which, as Englishmen we may boast, and to which we may direct a learned and enquiring brother, though he should have come from the very ends of the earth. In literature there must always be a general rivalry, but it is only one of brethren since he that happily arrives at any undiscovered goal, obtains a conquest not merely for himself, but for his compeers also. And

W. I. Bicknell, "The British Museum," in Bicknell, *Illustrated London; or, A Series of Views in the British Metropolis and Its Vicinity, Engraved by Albert Henry Payne* (London: E. T. Brain, 1847), 299–313.

since such facilities of access to this National Repository have been afforded, it is delightful to see what a moral renovation is being accomplished amongst the working classes of our community. Let our intelligent readers only walk through the rooms of the BRITISH MUSEUM during the holidays of Easter and Witsuntide to be convinced of this fact. Here husbands will be found pointing out to their wives the memorials of nature, of art worthy of their observation; fathers giving information to their children on subjects more than they themselves know; and young men talking over natural science with their *bonnes amies,* commonly called *sweet hearts*; All being decently clothed, and well conducted. If our national establishments do nothing more than this, the advantages thus obtained are of immense value.

The more popular parts of this grand depository of learning and art, are open to general inspection three days in every week, the holiday weeks not excepted. During this latter period, ten thousand persons have visited the Museum in the course of a single day. The days open to the public, are Monday, Wednesday, and Friday. No part of the library is seen by the general visitor; the mere sight of the backs of books would prove but a very uninteresting subject, and would likewise be a general hindrance to those engaged in looking out books for the use of students in the reading-rooms. The same remark is applicable to that part of the collection which requires individual inspection, such as coins, medals, drawings, prints, *herbanums,* &c. The rooms in which these are deposited, can be viewed only by a very few persons at a time, and by particular permission. Neither are the Reading rooms open to indiscriminate admission. This would be entirely incompatible with that quiet which must ever prevail where intellectual pursuits are carried on. Every facility, notwithstanding, is given to all classes of persons desirous of consulting the library, whether of printed books or manuscripts. For this purpose, the party must be introduced to the librarian of the Institution by a recommendation of a trustee, or at least of some person known at the Museum, when the applicant usually receives a ticket of admission for six months, renewable at the expiration of that time, unless something in the interim should have arisen which will not permit such a privilege to be continued. Such a step is seldom resorted to, except in extreme cases. That part of the building appropriated to the purpose of reading, consists chiefly of two large rooms, well warmed and ventilated, with the surrounding walls covered by about eight thousand volumes of books, principally books of reference, as dictionaries, encyclopœdias, &c., to which the reader has free access, the presses containing the books being always open. There is likewise every convenience for study, such as tables, book-stands, pens, ink, &c. A catalogue of the whole number of printed books is also here deposited, comprised in about eighty volumes folio, partly printed, partly in manuscript. The assistant librarians are very prompt in supplying the readers with such books as they may require, the titles, &c. of the books, being first looked out in the catalogue, copied upon a small piece of paper with a certain printed form, to which the student is required to affix his name. This paper, or papers, if he has more than one book, or one set of books, is returned to him on his delivering the books which he has had, to one of the librarians before leaving the room. No books being allowed, under certain circumstances, to be taken out of

the room. This is a delightful place for study, the utmost order being preserved, and every facility given to individuals in search of information on any particular subject. Modern books are more difficult of access than others, since some time is required before they can obtain a place in the catalogue.

The visitor to this grand depôt of science having passed the entrance, in Great Russel-street, is at present (1847) conducted by a temporary staircase to a landing, whence he can descend to the Gallery of Antiquities, presently to be more particularly mentioned, or ascend to the ETHNOGRAPHICAL ROOM, which contains various *miscellaneous articles*, chiefly of human art and superstition, in a state nearer to, or farther from, savageness. Such as various figures, idols, arms, &c., from China and Japan; baskets, and specimens of native cloth from Africa; Esquimaux dresses, &c., brought to England by Captain Sir Edward Parry in 1822, and various curiosities collected during Captain Beechay's voyage of discovery, in 1825–28; different articles of dress and war, from the west coast of North America, and the South Seas, by Captain Cook and others; numerous Mexican curiosities purchased at the sale of Mr. Bullock's museum; Arctic antiquities from the island of Sacrificios; implements and utensils from English and French Guiana; ornaments, and other manufactures of the ancient Peruvians; specimens of matting, cloth, mats, &c., from the Marquesas, Tahiti, New Zealand, Navigators' Islands, &c. Many of these specimens were, half a century ago, surveyed with more intense interest than at present, from their great novelty; now so many shiploads of such articles have been brought to England, and described by so many persons visiting the southern hemisphere, that the interest taken in such curiosities has greatly declined. These very articles, however, will shortly become more rare than ever, from the simple circumstance that the natives of the islands of the Pacific having improved in knowledge, cease to manufacture these articles: for example, articles which have a reference to warfare, which were formerly elaborated with great difficulty and perseverance, such as clubs, spears, &c., have been superseded by the more polite and Christian mode of committing murder by the musket, so as to be no longer made.

The collection of animals in the Museum is contained in two *galleries*, and arranged in two series. The student of natural history will find a list of the *genera* in a small work entitled, "A Guide to the Zoological Collection:" list of the specimens of mammalia, with their synonymes; parts 1 and 3 of a list of the birds; parts 1 and 2 of the reptiles; and part 1 of the specimens of lepidopterous insects and myriapades, are already printed, and may be had in the hall of the Museum. The beasts, birds, reptiles, fish, and smaller animals kept in spirits, are exhibited in wall-cases. The hard parts of the radiated, annulose and molluscous animals, as shells, corals, sea-eggs, starfish, crustacea, and insects, are arranged, as also are the skulls of the smaller beasts, and the eggs of birds, in the table cases of the several rooms. All these specimens are arranged according to the most approved modern classification, affording not only subjects of intense interest to the mere transient observer, but most extensive and ample information upon every branch of natural history, which the student can possibly desire. These immensely extended collections are placed in the *mammalia saloon*, and the *eastern and northern zoological galleries*. Suspended on the walls of the eastern zoological gallery, will be found a series of interesting and valuable portraits arranged in order, from the left hand of the mammalia saloon. They are *one*

*hundred and sixteen* in number, being divided into five compartments. Their present position possibly is designed to be only temporary, since many of them, being but of small dimensions, are very imperfectly seen from their great distance from the spectator. A few of the portraits have already, from their diminutive size, been transformed elsewhere.

The rooms on the north side of the north wing are appropriated to the *oryctosnotic*, or *mineralogical collection*, and to that of *palæontology*, or *organic remains*. These collections are of wonderful extent, and surpassing beauty and interest, exceeding, we presume, for extent and value, any others in Europe. The arrangement of the minerals, with slight deviations, is that of Berzelius, founded upon the electro-chemical theory, and the doctrine of definite proportions.[1] This part of the Museum though not quite complete, offers to the student who has formed for himself the most extensive plan of self-improvement, very ample materials. The sixty cases, with occasional duplicates, contain specimens of every variety of metallic substances, amounting in the whole, to not less than eight hundred and forty distinct families. Six rooms of the *north gallery* are devoted to the collection of *organic remains*, and are of magnificent extent. The fossil vegetables are arranged according to a botanical system, so far as these fossil remains, from their doubtful nature, appear to admit of classification. The wall-cases of rooms III. and IV. contain the osseous remains of the class *reptilæ*; amongst which will be found the order *enalsauria*, or *sea-lizards*, and the *ichthyosauri*, or *fishlizards*. In the centre of room V. is a complete skeleton of the large extinct elk, the bones of which are so frequently found in the bogs of Ireland. Room VI. is devoted to the osseous remains of the *pachydermata*, and *endentata*. Amongst the former may be mentioned the *American mastodon*, and the *elephas primigenius* or *mammoth* of earlier writers; and of the *megatherium*, brought from the neighbourhood of Buenos Ayres. In the same room is deposited the *fossil human skeleton* brought from Guadaloupe, and presented to the Museum by the Lords Commissioners of the Admiralty. The student surveys these *leaves* of the book of nature with wonder and surprise, and having anxiously gazed upon these *giant* remains of by-gone times, he retires from them, scarcely believing the *reality* of that of which he is *certain*.

Having conducted the reader through the labyrinth of natural productions, although in a very hurried manner, we return to the works of art, as exhibited in the *Gallery of Antiquities*. The noble collection of *Greek and Roman Sculptures* contained in this gallery, with few exceptions belonged to the late Charles Townley, Esq.[2] They bear the strongest impress upon them of that chaste and vigorous knowledge of sculpture, for which the Greeks and Romans were pre-eminently distinguished. The Greeks, who were the special models of the Romans, had the finest opportunity, from their earliest history, of studying the just proportions of the human figure. Living in a fine climate, with a dress removeable almost at pleasure, contented with a frugal and homely diet, inured from infancy to all kinds of manual labour, their

1. Jöns Berzelius (1779–1848): Pioneering Swedish chemist who introduced the classical system of chemical symbols, Berzelius also developed a system of classifying minerals by their chemical composition. [Ed.]
2. Townley: see glossary. [Ed.]

games and sports being for the most part, performed unencumbered with cloth-
ing. All these circumstances tended greatly to produce the most graceful forms as
to figure in the people themselves, and placed the finest human models, under the
constant inspection of the numerous sculptors, who at a very early period adorned
the classic country of Greece. The Greeks might have learned the first principles of
their art from the more ancient artists amongst the Egyptians; but the sculpture of
Greece attained to a degree of perfection which has since hardly ever been equalled,
and never excelled. Let even an inexperienced eye but compare some of the exqui-
sitely finished *busts* of the Greeks, as found in this invaluable collection, with any
from the chisel of a modern artist, whether foreign or British, and it will not long
remain a matter of doubt to whom the meed of praise most justly belongs. And if
from busts and statues, a comparison be instituted between the classical and highly
wrought buildings of ancient Greece, and the massy piles of *gingerbread* structures,
the productions of our own enlightened times and our artists, are not merely eclipsed
by such comparison, but disgraced also. For can it be forgotten, that with the models
of the Parthenon, Acropolis, and other buildings of Greece, our Metropolis, in the
middle of the nineteenth century, should be disfigured with such erections as the
*brick-dusty* Library and Hall of Lincoln's Inn, or the elaborate and ugly *filigree* of
the New Houses of Parliament.

In the centre of the IX. room stood *the celebrated Barberini Vase*, which for more
than two centuries was a principal ornament of the Barberini Palace. It was brought
to England by Sir William Hamilton, but purchased some years ago by the Duchess
of Portland. The material of which the vase is made, is glass: the figures on it are in
relief, of a beautiful opaque white, the ground being a dark transparent blue. This
superb and invaluable specimen of Greek art, was wantonly destroyed by a reckless
miscreant, (we hope for humanity's sake) a *maniac*. The treasures in the British Mu-
seum have, since that untoward event, been placed under the protection of a more
*stringent law*, calculated to restrain and punish any future *marauders*.

THE GRAND CENTRAL SALOON, AND ANTE ROOM next claim the attention of the
visitor, comprising many exquisite specimens of Greek and Roman Sculptures, Bas-
reliefs and Roman Sepulchral Antiquities.

Our readers are now to be introduced into a truly classical, not to say *holy
ground*, the PHIGALIAN SALOON.[3] The bas-reliefs in this Saloon claim special notice,
not only for their antiquity and exquisite elaboration, but also because the precise
time of their execution is known. Pausanias, in his description of the temple of
Apollo Epicurius (or the deliverer) built on mount Cotylion, at a little distance from
the ancient city of Phigalia in Arcadia, informs us expressly that this temple was
built by Ictinus an architect, contempory with Pericles who contemplated building
the Parthenon four hundred and thirty nine years before the Christian era.[4] These
bas-reliefs composed the frieze in the interior of the Ceila, and represent the battle of
the Centaurs and Lapitha, and the combat between the Greeks and Amazons. They

3.  The "Phigaleian marbles," sculptures from the Temple of Apollo at Bassae excavated by Charles
    Robert Cockerell, were purchased in 1814. They were at the Museum the following year. [Ed.]
4.  Pausanias: second century Greek travel writer. See his *Description of Greece*, 8.41.7 ff. [Ed.]

demonstrate, like other Grecian works of art, a perfect knowledge of the human fig-
ure in all its diversified positions and contortions. Various fragments from the same
temple will also greatly interest the intelligent observer of these wonders of ancient
art. The restored figures, &c. of the temple of Jupiter Parhellius, in the Island of
Egina, committed to the hands of Mr. Thorwalsden by Mr. Cockerell, no less claim
the notice of the visitor.[5]

All the articles in the ELGIN SALOON, with a few exceptions, were formerly the
property of the Earl of Elgin, and purchased of him. The specimens of ancient art
deposited in this room, are of a most magnificent description, being the *metopes*,
frieze, and other portions of the Parthenon. The figures are in *alto relievo*, and exe-
cuted with great spirit. We sincerely hope that our young artists will avail themselves
of these magnificent remains of the Greeks, that the statues and buildings hereafter
to be erected in London, may be imbued with a portion of that lofty spirit which
here reigns so triumphantly. The battle of the Centaurs and Lapidæ, even in their
present dilapidated state, exhibit that incomparable skill by which they were origi-
nally brought into existence.

The objects in the EGYPTIAN SALOON, though of a very different character from
the finished sculptures of the Greeks, and of a much earlier period, are notwithstand-
ing of immense importance in the history of art, pouring an astonishing flood of light
upon the history of a singularly interesting people. We owe them to the memorable
expedition of Napoleon Bonaparte to Egypt, where many of these remains were
collected by the French, but came into the possession of the English army at the ca-
pitulation of Alexandria, in September 1801, and being brought to England in 1820,
under the care of General Turner, were sent, by order of his MAJESTY, GEORGE III.,
to the British Museum. They form a collection of which an Englishman, under any
circumstances, may justly boast; but without wishing to encourage any unworthy
feelings towards our neighbours, and allies, the French, we cannot but remember
that these very *remains* were purchased by the blood of many of our poor fellows,
who perished in that memorable struggle, the result of which has so much changed
the general appearance of Europe. They are, however, chiefly valuable, not because
the trophies of victory, but from the important illustrations which they furnish of
ages long since passed away.

The *Etruscan room* contains a splendid collection of Græco-Italian vases, of
various epochs and styles. These specimens of art are arranged chronologically, and
according to the localities in which they were found.

The only remaining rooms necessary to mention are the medal and print room,
neither of which can be seen but by a few persons at a time, and by particular
permission. The medals consist of Greek, Roman, Anglo-Saxon, English, Anglo-
Gallic, Scotch, and Irish coins, with those of modern foreign nations. The print room
contains an extensive and valuable collection of prints and drawings.

A synopsis of the contents of the British Museum is published, and may be had
in the entrance hall of the Institution.

---

5. The British Museum displayed casts of the Aegina Marbles excavated by Cockerell and others
   and restored by the Danish neoclassical sculptor Bertel Thorvaldsen (1770–1844). The originals
   were at the Glypothek in Munich, where they remain. [Ed.]

# Elizabeth Eastlake

## The British Museum

THE British Museum is insufficient to accommodate a vast portion of its trea-
sures. Either this great national establishment must become a gigantic warehouse of
unpacked goods, or it must be enormously enlarged, or there must be some division
of its multifarious contents, and a single building be no longer made the receptacle
for almost everything which man has executed and nature produced from genera-
tion to generation and from one end of the earth to the other. Literature, art, and
science are each interested in the solution which may be given to the problem, and as
all persons are agreed upon the necessity of an immediate remedy, and as there is a
difference of opinion as to what that remedy should be, we shall endeavour to assist
the public in arriving at a decision.

Temporary expedients are out of the question, for the demands are too exten-
sive. Either permanent accommodation must be provided by the purchase of ground
contiguous to the present Museum, or a separation must take place and one or
more of the departments be removed elsewhere. In the discussion which took place
when the estimates for the British Museum were moved in the House of Commons,
Mr. Gladstone, Lord Elcho, and the Chancellor of the Exchequer pronounced a
decided opinion upon the impracticability of keeping the collections much longer
together. The naturalists, on the other hand, are desirous of maintaining the union,
and vehemently protest against the proposed divorce. To congregate under one roof
the productions of nature, art, science, and literature, might be proper at the com-
mencement of the institution, when the contributions in each department were few,
and the whole together only constituted a Museum of very moderate dimensions;
but the question is entirely different now that every collection is made as far as
possible complete, and has assumed colossal proportions. This development will
continue, and the inconveniences, which are already so manifold, must increase

Elizabeth Eastlake, Review of 1. *Report from the Select Committee on the British Museum; together
with the Minutes of Evidence*. London. 1835, 1836. Fol. 2. *Report of the Commissioners ap-
pointed to inquire into the Constitution and Management of the British Museum, with Minutes
of Evidence*. London. 1850. Fol. 3. *Acts and Votes of Parliament relating to the British Museum*.
4. *Synopsis and Contents of the British Museum*. 5. *Copy of all Communications made by the
Architect and Officers of the British Museum to the Trustees respecting the Enlargement of the
Building of that Institution, &c*. Ordered by the House of Commons to be printed, 30 June,
1852. 6. *Copies of all Communications made by the Officers and Architect of the British Mu-
seum to the Trustees respecting the want of space for exhibiting the Collections in that Institu-
tion, &c*. Ordered by the House of Commons to be printed, 1 July, 1858. *Quarterly Review* 104
(1858), 201–224 (excerpts).

so rapidly, that we must confess our surprise that the proposition for a separation should have met with opponents.

It is clear, in the first place, that while all the departments are united none will ever be properly accommodated. Each is requiring an extended space at the same moment, and the united demands are far too great to be satisfied. For this reason, when new buildings are sanctioned there will never be any considerable margin allowed for further accessions, and no sooner will fresh channels be opened, than the Museum will again be ready to burst its banks. The whole history of the establishment confirms this fact. In the second place the building must stop somewhere. It is impossible to go on expanding it indefinitely, for it will become too vast for superintendence. Already the functions of controlling the various departments are almost beyond the powers of a single man, and must soon outgrow the limits of human oversight. In the third place, no director can unite a supreme acquaintance with antiquities, with natural history, and with literature, conjoined with the qualities of a vigilant overseer, and he will always therefore be liable in some degree to be an object of jealousy to the heads of any department of which he has no special knowledge. However considerate he may be to their claims, they will always, in the contest for accommodation, believe themselves sacrificed to rival sections. In the fourth place, the trustees who are selected for their special acquirements, and who are the governing body of the institution, pronounce upon questions of which many of them are ignorant—the literary man voting upon subjects connected with natural history, the naturalist upon subjects connected with books. To some extent, this must prevail under any arrangement, but there is no need to aggravate the evil, and combine functions in the same person as incongruous as if the Speaker of the House of Commons was also to be appointed President of the Royal Academy. There is a plain and broad line to be drawn between the works of nature and the works of man, and in no other capital has the junction been attempted. In Paris, St. Petersburg, Berlin, Florence, the animals form a distinct museum, and the English naturalist is the only one who thinks that his science derives any advantage from the juxtaposition of Roman, Greek, and Assyrian remains. Everything which flies in the air, swims in the water, walks, creeps, and grows upon the earth, or is dug out of the bowels of the earth, is surely enough for one institution.

All branches of learning are fostered and improved by association. There must be a centre towards which the separate atoms may congregate. Men following the same pursuit naturally flock together, and the grandest results are produced from the information each member throws into the common stock. The necessity of unity of purpose is felt more strongly every year. The Royal Society, which in its constitution was the most catholic of all learned bodies, found it expedient to alter its statutes not long ago, with the view of limiting the number of Fellows and giving to the council the power of selection. As science advances, its cultivators necessarily divide themselves into groups, and the venerable parent has given birth to a numerous offspring in the shape of Chemical, Geological, and Linnean Societies. No reason has been assigned why the British Museum should be an exception to so wholesome a rule. At least when we turn to the protest of the eminent 'promoters and cultivators of natural knowledge' against the removal of the natural history collections from the British Museum, we look in vain for any arguments which

can outweigh the manifest advantage of a transference.[1] They commence with the statement, that the British Museum was founded by Sir Hans Sloane, and was essentially a natural history collection. Both these assertions are erroneous. The Museum was founded by Parliament, which, having purchased the Sloane Museum at the price named by the collector, did what it pleased with the property, and united it with other collections which had long been the property of the public. That it was not 'essentially a natural history collection' we have already shown. 'The British Museum,' said the great botanist, Robert Brown, before a Committee of the House of Commons, 'is and always has been more a literary than a scientific institution.' In fact, so little attention did the trustees pay to the latter department that for the first forty years only one purchase of natural history was made, that of a collection of birds. Let us see, on the other hand, what was going on in the way of destruction. Mr. König, in his evidence before the Committee of the House of Commons, states in answer to a question as to the condition of the entomological collection: 'When I came to the Museum most of those objects were in an advanced state of decomposition, and they were buried and committed to the flames one after another. Dr. Shaw had a burning every year; he called them his cremations.'[2] On his being asked, 'Is there one single insect remaining of the 5394 which were presented by Sir Hans Sloane?' he replies, 'I should think not.' Again the same witness stated that he did not think there was one specimen left of Sir Joseph Banks's collection of birds. He adds, 'I know there was a considerable number of bottles which contained birds, partly in spirits of wine, partly dry, consisting of skins merely. They were transferred with other objects, chiefly of comparative anatomy, to the College of Surgeons, and among those birds were certainly some which had no business at the College of Surgeons; *but they wished to have the bottles*, otherwise they would probably not have taken them; *the bottles were of some value to them*.' Such was the treatment which the natural history received in the early days of the British Museum, when this department is supposed by the memorialists to have been in the ascendant.

The next paragraph of the memorial asserts the excellence of the natural history collections, which is not denied. The sole question is how they can be made available to the public instead of being hidden in coal-cellars, where they are of little more use than if the creatures had remained in their native wilds or in the depths of the sea. The petitioners, however, proceed to urge that as the British Museum must at all events be extended to accommodate many massive specimens of art, which can only be placed on the basement, the natural history may occupy the galleries above. But they forget that numerous objects now below would be brought up stairs if there was space; that there are already extensive collections of antiquities

1. Eastlake addresses the claims made in a document signed by many prominent scientists, the "Memorial of the Promoters and Cultivators of Science on the Subject of the proposed Severance from the British Museum of its Natural History Collections, addressed to Her Majesty's Government" (1858).

2. George Shaw (1751–1813): natural historian and keeper of natural history, predecessor of Charles Dietrich Eberhard Konig (1774–1851), botanist and mineralogist, keeper of the department of natural history. [Ed.]

in the upper floor which will be constantly expanding; that rooms have long been required in which to exhibit the prints; and that if the birds, beasts, and fishes are to occupy any new area which might hereafter be provided, all the other purposes for which the Museum exists would be checked. This is precisely the reason for the separation, that one department can only now be accommodated at the expense of another. The memorialists propose to get over the difficulty by taking the lion's share to themselves, and even then they would not find anything like verge enough.

They proceed to argue against breaking up the natural history into several parts to be distributed among different societies, 'because its chief end and aim is to demonstrate the harmony which pervades the whole, and the unity of principle which bespeaks the unity of the creative Cause.' In this we agree with them. But with singular inconsistency they immediately depart from their own principle, and admit 'the possible expediency of transferring the botanical collections to the great national establishment at Kew.' How can they demonstrate the harmony and unity of principle for which they properly contend while they exclude the entire vegetable kingdom? Let the collection of natural history be kept together by all means, but let the union be complete.

The memorialists again object to remove from the British Museum because their specimens are now in the neighbourhood of the works on natural history in the library. Professor Owen was examined upon this point in 1848, when he stated that such a library as was attached to the *Jardin des Plantes* at Paris would answer every purpose. There is no difficulty whatever in procuring such a collection, just as the Museum of Geology in Jermyn Street have recently brought together a fine library of the same description. As far as this topic is an argument at all, it is in favour of the proposed separation. The library in the Museum is now made to answer every conceivable purpose. The same volume is often wanted by different persons; and, on observing in the returns of the expenditure of the British Museum a sum set down for books for several of the departments of natural history, and inquiring the reason, we were informed that they were needed by the officers because the general public monopolized many of the works in the library. Few things are more required than the formation of subsidiary collections, to divert the drain from the great central store, which could always be consulted in case of need.

The last reason which the memorialists urge against the removal is, that it 'would be viewed by the mass of the inhabitants with extreme disfavour, it being a well-known fact that by far the greater number of visitors to the Museum consist of those who frequent the halls containing the natural history collections.' If this be so, it is difficult to see why the inhabitants should view the removal with disfavour; for they will simply follow the natural history to its new destination, and desert the present Museum. But though the fact is said to be well known, we must beg to question it. In our visits to the Museum we have observed that the greatest number of persons were usually assembled round the illuminated missals and autographs; and if the prints could be exhibited, as they would be if the natural history was removed, they would attract greater crowds still. The visitors, we are satisfied, would in every way be the gainers. Once in the building, and they are anxious to make the circuit of the entire Museum. This has already, from its extent, become a weary pilgrimage, and if the building is to be increased till

it will accommodate all the collections which are now congregated beneath its roof, there will be so much of a good thing that it will be good for nothing. No doubt there is force in the demand of the naturalists that their department should be kept within the reach of the people; but it need not be fixed in the very heart of London. To sight-seers a little journey is often rather an incitement than a drawback, and if the new locality which may be chosen should be further from some, it will be nearer to others.

Notwithstanding the assertion of the naturalists, that their department is the most popular portion of the British Museum, we believe that all their arguments may be summed up into one which they have not expressed—the dread that the separation would diminish their importance. In our opinion, they are over modest, and underrate both themselves and their science. Apprehensions have been expressed that Parliament would be less liberal in its grants than now the natural history forms a part of one grand national institution. Of this we have no fear. The natural history, once allowed to have its proper development, which it never can have where it is, and it would become a matter of general admiration and pride, and would certainly not be grudged the sums which were essential for maintaining its supremacy.

There is another circumstance which we confess has considerable weight with us. We allude to the position of the great naturalist who is at present called the Superintendent of the Departments of Natural History in the British Museum. As an officer of the establishment, he is by the Act of Parliament subject to the immediate control of the principal librarian, and to such regulations as the trustees may think right to establish. He is bound to come at a certain hour and not to leave his post before a certain hour. He must superintend questions of detail, and look after the subordinate officers and servants in his department, and be answerable for the manner in which they and all others under him spend their time. He has to bear responsibilities which formerly rested upon the directors of the several sections into which the natural history is divided, and who have always discharged their duties in the most efficient manner. He is ordered to deliver twelve gratuitous lectures at Jermyn-street on certain days, which are attended by a crowd of ladies and gentlemen who are well able, and we dare say would be willing to pay for them, but for which the trustees are kind enough to pay on their behalf with public money; and should he desire to deliver any lectures elsewhere, he must ask permission of the trustees. Is this the way to popularize science? Is this the proper position for a man like Professor Owen, who has spent his life in forcing nature to give up her secrets? Is it right that learning so extensive and so accurate should be confined to so narrow a sphere, and that the exercise of such rare powers of communicating information should thus be impeded? Let the natural history be elevated to its rightful dignity. Let it form an independent institution, with Professor Owen at its head, and let him have a temple of his own instead of being a lodger. Let him have leisure for giving the world the benefit of his vast knowledge by his writings and his lectures, and let him enjoy all the honour and distinction he so richly deserves by conferring on him an independent post, where he will be no longer trammelled by the obligations of an inferior office in what the Act of Parliament calls a 'general repository.'

Having disposed of the point of expediency, the question yet remains as to the power of the trustees to dispossess themselves of any portion of the objects committed to their charge. But this need not detain us a moment. The separation of the

natural history collections cannot take place without a grant from Parliament; and if any difficulty arose under the present Act, a single sentence would enable the Legislature to decree a divorce. But the memorialists ask, 'where are we to go?' To this we answer, either to Kensington Gore or Burlington House. Nothing can be better than the situation of the latter. It is healthy and central; it has a large garden behind and a large court in front; and here a building might be erected at a much less cost than would be required for the necessary enlargement of the British Museum, and far more commodious. The Museum is constructed in an expensive style of architecture and with a massive solidity which would not be necessary for specimens of natural history. Provision could then be made for the development of the several collections to an almost indefinite extent. It is our conviction that natural science has no greater enemies than those who oppose the separation. Who will venture to calculate the injury it has already sustained by want of space? Who can say how much has been lost by the necessity of abstaining, more or less, for upwards of thirty years, from purchasing specimens or displaying those already in the institution? And surely the visitors who have recourse to the departments of literature, art, and antiquities in the British Museum, have also a right to complain that they look in vain for what they seek, because the space it would occupy is wanted for the collections of natural history. Each, in a word, is a detriment to the other, and the only effectual remedy is that one should go.

—◦❧ ❦◦—
# House of Commons: *The British Museum.*
## *Committee Moved For* (1859)

MR. GREGORY said, he rose to move for the appointment of a Select Committee to inquire into the re-organization of the British Museum. As, however, the right hon. Gentleman the Chancellor of the Exchequer had consented to grant this Committee, he did not consider it necessary to enter into any elaborate statement of the motives which had induced him to make the Motion. He must, however, ask the attention of the House for a short time while he endeavoured to show that he was not going unnecessarily to occupy the time of those hon. Gentlemen who might consent to serve on the Committee, or to defeat the laudable intention of the Government to remedy the defective state of the Museum. That the British Museum was at present in a lamentable state of congestion must be apparent to any one who had either visited it or read the reports of the heads of departments. So far back as the year 1854, Dr. Gray, the keeper of the zoological department, reported that the zoological collection, which had cost between £14,000 and £15,000, besides the specimens presented, was almost entirely useless to the public from its inaccessibility, and that, if it were not shortly removed to a drier place, it would be utterly destroyed.[1] In November, 1857, Mr. Panizzi stated that no specimen in this department could be scientifically examined without displacing two or three others; that the osteological collection, as well as many of the specimens preserved in spirits, being placed in the basement, were altogether withdrawn from public exhibition, and were only studied by scientific men on special occasions, and at great personal inconvenience; and that the trustees could not exhibit the collection of prints and drawings for want of space.[2] Now, it was quite unnecessary for him to comment on the loss the public had sustained by the valuable collection of prints and drawings being withdrawn from them. They were the drawings of the great ancient masters, and of all things he should consider were most essential to form the tastes and direct the studies of artists. Perhaps, too, some of the architectural designs might be studied to advantage by future Chief Commissioners of Woods and Forests. Any person who had gone to the British Museum must be aware that the drawings that were exhibited were exhibited most imperfectly as regarded the place in which they were put, and as regarded light. Mr. Panizzi proceeded to show that the department of antiquities was in a more hopeless condition. But into these statements of Mr. Panizzi he would not enter. It was only necessary for any gentleman to make use of his eyes as he entered the precincts of the Museum. He would be astonished to see a series

From *Hansard Parliamentary Debates*, 3rd ser. Vol. 153 (1859), cols. 250–264.

1. Gray: see authors and speakers. [Ed.]
2. Panizzi: see authors and speakers. [Ed.]

of glass conservatories extending all round, and defacing the colonnade, in which were stored away some of the noblest treasures of ancient art, which had been sent to us by Mr. Newton from Halicarnassus.[3] If he asked to see the mosaics discovered at Carthage by Mr. Davis he would be taken down into the regions of Erebus and Orcus and eternal night, down mysterious cellars where these valuable relics slept quite as undisturbed, as when beneath the ruins of Carthage, covered with several feet of earth.[4] Last year a suggestion was made in that House by his noble Friend the Member for Haddington (Lord Elcho), which the Chancellor of the Exchequer seemed disposed to adopt—namely, that the natural history collections should be removed from the Museum; that the geological one should find refuge in Jermyn-street, and the botanical one at Kew, and that the zoological collection should be provided for by either the Zoological or Linnæan Society. The unanimity in favour of that scheme which prevailed in the House of Commons was not, however, shared by the public out of doors, for on the 19th of July a protest against it was presented to the Chancellor of the Exchequer, signed by 114 gentlemen, among whom were all the officers in the department of natural history, and some of the most eminent scientific men in the country, such, for instance, as Professor Owen, Sir Charles Lyell, Sir John Herschell, Professor Sedgwick, and Dr. Whewell. Their objection to this plan, as was clear from the undertone that pervaded the memorial, arose principally from an apprehension that if it were adopted, the natural history collections would be dispersed to the four winds of heaven; but he believed that many of them would modify these opinions if they had an understanding that those collections should be preserved unseparated, and in a condition worthy of their importance and of the reputation of the country. Indeed, he had the authority of Professor Owen for saying that he should be willing to withdraw his name from the protest referred to if he was satisfied that the natural history collection would be kept together and transferred to some suitable establishment. He (Mr. Gregory) thought there ought to be a Committee, in order to give the gentlemen who had signed the protest an opportunity of further explaining their views as to the general question of the removal of the collections, and also should that point be decided in the affirmative, upon that next question—namely, "where to" should they be removed? He understood that the Government had already determined to remove the natural history collections to Brompton; but he could well remember the storm of indignation brought to bear on a similar proposal with respect to the National Gallery by Lord Elcho. All experience proved that the collections of natural history were the most popular of all the collections in the British Museum, and therefore the question of their removal ought to receive the fullest investigation. Granting that they ought to be removed, the Government should consider, before sending them to Brompton, whether there were not other sites which would be more easy of access to the people, and which would give a greater amount of accommodation. He need not say that he alluded to the Regent's-park, which would have the additional

3. Sir Charles Thomas Newton (1816–1894): diplomat and archeologist noted for his excavations in Halicarnassus, named keeper of Greek and Roman antiquities in 1861. [Ed.]

4. Nathan Davis (1812–1882): American traveler and excavator who undertook excavations in Carthage and Utica for the British Museum. [Ed.]

advantage of bringing the zoological specimens in the British Museum into closer proximity to the Zoological-gardens.

—◦❧ ❦◦—

There were also one or two minor matters connected with the Museum which he thought should be rectified. He desired that the Government should be able to make some change in the Act of Parliament by which at present bequests were confined to the Museum. He thought it advisable that some latitude should be given to the Trustees, so that they might be enabled to remove duplicates and specimens which they did not require. According to the Act of Parliament the Trustees were unable to get rid of these specimens except by sale or exchange. There were, however, many articles, which could not be sold or exchanged, but which local museums would be happy to receive. With respect to duplicates of books, it was most advisable that there should be a power of removing them to district libraries, in case they should at any future period be established in London, and thereby the present excessive pressure which the deserved popularity of the Museum reading-room had brought on it would be relieved. A reference to the catalogue of the British Museum would show that there were some articles which it would be difficult either to sell or exchange; for instance, in the Sloane catalogue, one of the articles was the "breeches of a gentleman singed by thunder." Some years ago the Trustees adopted an excellent plan of getting rid of some of their surplus articles. They dug a hole under the Museum and buried in it all the rubbish. The workmen some time since engaged in opening a new foundation came upon these remains which were again exhumed. At present there was such an accumulation that they would have now to dig a much larger hole for burying still more rubbish. In some future time the excavator on the ruins of London (when the prophecies of Sir A. Alison came true)[5] will be like Virgil's tiller of the soil: he will turn up with his spade the mutilated heads and limbs of Greek and Roman statues, and marvel at the gigantic bones of monsters buried out of the way by Professor Owen. Another subject of inquiry eminently suited to a Committee of that House was the connection between the heads of departments and the Trustees. He was anxious to see the heads of departments brought into immediate communication with the Trustees, when the business of the respective departments was considered. He should also be anxious to ascertain how far greater latitude might be given to the heads of departments in the arrangement of the collections. Again, with respect to the constitution of the Board of Trustees, he could not help thinking that something might be done in the way of improvement. He hoped no Trustee would be offended at what he was about to say. It was not his intention to make a vulgar *ad captandum* speech, and say that great dukes and men of title were not the persons to superintend a great scientific institution of this kind. Quite the reverse. He conceived that it was important that men having their leisure, education, taste, and influence in both Houses of the Legislature, should occupy the position of Trustees, he hoped to see the Museum estimates always moved by some great statesman having the confidence of the House; but he should be glad to see the proposed

5. Sir Archibald Alison (1792–1867): author of an extremely popular and pessimistic history of modern Europe. [Ed.]

Committee pursue the investigation commenced in 1836, when Mr. Ridley Colborne proposed a Resolution to the effect that it was to be regretted that, without under-rating the value of rank, wealth, and high station, in the character of the Trustees, selections were not more frequently made from those men who were distinguished by their knowledge in science and literature, and that it was hoped that in future this consideration would have weight.[6] Lord Stanley, the present Prime Minister, moved an Amendment that in filling up vacancies in the trust it was desirable that the Trustees should not lose sight of the opportunity thus afforded of occasionally conferring a mark of distinction on men of eminence in literature and science. He confessed that the word "occasionally" grated on his ears, and it appeared also to have grated on the ears of the Committee; for, on a division taken upon a Motion to omit that word, the Motion was only defeated by a majority of one. Since then thirteen new Trustees had been elected, and he should indeed be hard to please if he found fault with any of them. Still he could not but think that the Board should contain a certain proportion of men whose sole claims to distinction arose from their literary or scientific achievements. The last point to which he would advert was the expediency of giving popular lectures in connection with the Museum. The principle had already been established, because Professor Owen had received his appointment on the understanding that he should deliver lectures on physical science in Jermyn Street, but he was debarred, owing to want of accommodation, from delivering them at the British Museum. Professor Owen, who was examined before the Commission of 1850, expressed a strong opinion in favour of the delivery of lectures in connec-tion with the British Museum, and had instanced the good which had been derived from the Hunterian course at the College of Surgeons; many persons having made bequests to the College, in acknowledgment of the benefit they had derived from these lectures. To quote the Professor's own words in his inaugural address last year to the British Association at Leeds,

> "To open the book of nature without providing means for explaining her language to the masses was akin to the system which kept the Book of God sealed to the multitude in a dead tongue."

Year after year treasures of art and science from every quarter of the globe were poured into that great institution, and this valuable collection ought not to be made a mere raree-show for the gaze of loungers who had no means of appreciating its meaning and its worth. The higher classes had the means of purchasing or bor-rowing books necessary for the prosecution of their particular studies, they could always obtain introductions to some of the assistants at the Museum, who would explain to them the various objects which it contained, and he contended that mea-sures should be taken for affording similar information to the middle classes and the more intelligent members of the working class. Some years ago he was introduced by a gentleman to several of the weavers of Coventry who were engaged in making collections illustrating the entomology of the neighbourhood. Instead of haunting

6. Ridley Colborne: see authors and speakers. [Ed.]

the public-house they went on Sundays into the fields, and they succeeded in finding many remarkable specimens, which they took great pleasure in showing to him. But their great want was instruction. They lamented their want of books and teaching. The most they could do was to acquire a certain amount of empirical information; but without proper books or oral instruction many a working man, who might under more favourable circumstances achieve distinction, must for ever forego pursuits on which he might have shed much honour. From the year 1823 up to the year 1850 upwards of £2,000,000 had been spent upon the collections and buildings of the Museum, and he contended that the persons who paid that amount had a perfect right to participate in the advantages of the expenditure. That this Committee might cause some delay in the action of the Government (if the Government really was ready for action) he was ready to acknowledge, but it would only be for a short period, for the inquiry would not be a protracted one, but even that delay was as nothing compared with the misfortune of a wrong decision. As the reorganization of the British Museum was determined on, it was upon that reorganization that the reputation of this country as a scientific country would in the estimation of foreign nations stand or fall.

RICHARD OWEN

—∘❧ ❦∘—

*On the Extent and Aims of a National Museum
of Natural History*

To descant on the abstract advantage of a knowledge of the works of Creation is neither requisite nor convenient to my present purpose. I may assume the general admission that collections of the several classes of such objects, duly prepared, named, and arranged, so as to give the utmost facility for inspection and comparison, are the indispensable instruments in the acquisition and advance of that knowledge. Not but that a vital part of Natural History requires the observation of rocks and mineral beds as they naturally appear on the earth's surface, of plants as they clothe and adorn that surface, of animals as they add life and motion to sea, earth, and air. And such knowledge must be gained abroad, in the field, in that grand Natural Museum which the world becomes to the loving eyes of the geological, botanical, and zoological observer, even such as was the Paradise in which Adam, as sung by our great poet,

> "Beheld each bird and beast
> Approaching two and two; these cowering low
> With blandishment, each bird stooped on his wing.
> He named them as they passed and understood
> Their nature; with such knowledge God endued
> His sudden apprehension."[1]

Under other and harder conditions we strive to regain that knowledge, needing, and urgently seeking for, every collateral aid in the struggle to acquire that most precious commodity—the truth as it is in Nature, and as manifested by the works of God.

ARISTOTLE received such aid from his great pupil ALEXANDER, in large subventions for the requisite subjects of his numerous observations on the external form and anatomy of animals, and for the employment of hunters and fishers and other observers of their living habits. He thus obtained the materials on which his strong intellect wrought in the composition of the remarkable 'History of Animals' of which we probably form but an inadequate idea from the nine books that have come down to us.[2] Had the Greeks, indeed, possessed and practised the arts of preserving and preparing animal bodies and structures, the science of the universal teacher might

Richard Owen, *On the Extent and Aims of a National Museum of Natural History* (London: Saunders and Otley, 1862), 1–126 (excerpts).

1. Owen adapts John Milton, *Paradise Lost* (1667), 8.349–354. [Ed.]
2. *Historia Animalum* (c. 343 B.C.). [Ed.]

have been retained, exemplified, and expanded by his pupils. But there is no record of any collection of the conservable parts of the animals having been made after the philosopher had used them for his observations and comparisons. To the absence of such museum may be attributed the singular and sudden arrest in the course of the zoological science, which had started by so rapid a growth, but which, wanting that condition of progress, degenerated; so that even Bacon failed to comprehend the zoological discoveries of the Stagyrite; and their due appreciation had to await the zootomical labours of HUNTER and CUVIER.[3] Not until their time, and by the aid of their vast collections of animals and animal structures, could the value and importance of Aristotle's zoological and physiological writings be fully comprehended.

The Romans, during the height of their Empire, expended enormous treasures in the capture and transport to Italy of the wild beasts of their conquered provinces, but they were solely for the service of the amphitheatre. The rhinoceros, the hippopotamus, the giraffe, the crocodile, the lion, the tiger, the European bison, with many other rare animals—some of which, as the gigantic wild ox of Hyrcania, are now extinct—were brought to Rome, and there publicly exhibited. They might be seen by the philosopher, the historian, the poet, and the satirist; but they were seen only to be baited and slaughtered in cruel games for the gratification of the depraved tastes of an enslaved and voluptuous people.

Many centuries elapsed ere the nations of Europe began again to be familiar with the forms of the rarer animals of remote regions; and we may regard it as one of the beneficial results of the great moral revolution which had been effected during that interval, that Natural History objects began to be collected through other and higher motives than those which stimulated the Pagans of ancient Rome to excel in the exhibitions of the circus.

The Sophists and Epicureans of the Empire had ample opportunities during more than 400 years of making observations on the form and organization of foreign animals; but it seems that these animals, after being slaughtered, were put to no further use.

We may justly rejoice that, in these later times, aims engendered and supported by Christian principles, under a sense of responsibility for the use of talents and opportunities, have stimulated states and communities to bring together collections of objects from the different kingdoms of Nature, and to arrange them in orderly series, with a view to minister to the advancement of science and to the instruction, elevation of thought, and innocent pleasures of the peoples.

Every European nation now possesses its National Museum of Natural History, aiming, or professing, to be a more or less complete epitome of the three kingdoms of Nature—Animals, Plants, and Minerals. Such is the extent and scope of the great Natural History Museum or establishment at the Jardin des Plantes in Paris; and such also, in its fundamentals, is the Natural History Division of the British Museum.

Here the Natural History Departments are four in number: one for Zoology, comprising the prepared specimens, skeletons, shells, &c., of existing species of

---

3. Stagyrite: native of Stagira in ancient Macedonia, i.e. Aristotle. Georges Cuvier (1769–1832): pioneering zoologist and paleontologist. John Hunter (1728–1793): physician, anatomist, and collector. Owen was Hunterian lecturer in comparative anatomy. [Ed.]

animals; one for Geology, at present restricted to the exhibition of the remains of extinct organised beings; a third for Botany, and a fourth for Mineralogy: so that there needs only a co-ordinate or consistently proportional display of the several classes of objects in the four great Departments of this comprehensive design, to realise our ideal of the scope of a National Museum of Natural History.

These several Departments of Natural History are so related to each other as to give and receive reciprocal illustration, and to make it requisite for the student of any one class of objects to have ready access to the rest: the Galleries of Zoology, Botany, Geology, and Mineralogy, should therefore form part of one building. The Department of Zoology in such a Museum should be so located, in reference to the Department of Palæontology, as to afford the easiest transit from the specimens of existing to those of extinct animals. The Geologist specially devoted to the study of the evidences of extinct vegetation, ought, in like manner, to have means of comparing his fossils with the collections of recent plants.

The Department of Zoology, considered in its ordinary restricted application to the present phase of living nature, should illustrate both the outward form and inward structure of its subjects. The art of Taxidermy preserves the integument, so as to give the shape and exemplify the diverse coverings of mammals, birds, reptiles, fishes, insects, crustaceans, and echinoderms. In a great proportion of the Molluscous classes, the external defensive shell is all that is commonly seen of the living animal; and consequently the shell itself represents in a great measure the outward form of such. Where the soft parts of the body are habitually protruded from the shell in the ordinary living actions, they can be closely imitated in coloured wax models. Such models, or the Mollusks themselves in transparent colourless antiseptic liquor, will complete the representation of the outward forms of the species in this great department of Invertebrate Animals.

Most of the Arachnida (spiders, mites), the larvæ of the Insecta (caterpillars, maggots), many Crustacea, some of the Cirripedia (soft-stalked barnacles), all the Annelida (sea centipedes, nereids, tubeworms, earthworms, leeches) and Entozoa (intestinal and other internally parasitic worms, flukes, and hydatids) can only be exhibited either preserved in liquor or by means of models.

In the Radiated classes the testa, with its appendages, serves to convey a sufficient idea of the external form of the animal in the Sea-urchin and Starfish orders. The corals, madrepores, and other hard parts of the Polypes, are the mere skeletons of the animals: these masses of carbonate of lime are generally internal, rarely visible in the living colony; and as the delicate flesh shrinks in most preserving liquors, and loses colour in all, a true idea of these beautiful composite marine animals, with the polype-mouths expanded like the petals of a flower, can only be given by coloured models. The art of the colourist and modeller is still more essential to show the external characters of the lovely hyaline medusæ, jelly-fish, and other forms of the floating Acalephes; for only the form, and that commonly contracted, can be studied in specimens preserved in liquor.

The adjustment of the exquisitely sculptured silicious shells of microscopic organisms to microscopes adapted to afford the casual visitor to a Public Museum the opportunity of contemplating them, must be restricted to a few of the most striking examples. Enlarged coloured drawings, with the degree of the magnifying power

234 PART II Rationalizing the National Collections

noted, may serve to exemplify the majority of the species. A special apartment, with an attendant accustomed to the use of the microscope, would be requisite in the Public Museum, in which the general view of living Nature was completed by a demonstration of the forms of the infusorial and other animalcules.

The most obvious and simple aim of the Zoological Department of a National Museum of Natural History is to exhibit the various outward forms and characters of the animal kingdom; and this, as we have just seen, requires the labours of skilled artists in various costly procedures. But the first principle in the arrangement and allocation of such objects is, that each class of animals should receive its due proportional amount of elucidation to the extent which the acquired specimens at the time may admit, and according to the degree in which the principle of variety is manifested in the class.

A museum of Nature does not aim, like one of Art, merely to charm the eye and gratify the sense of beauty and of grace. Many animal forms do indeed accord with our apprehension of the Beautiful; some classes more especially, as *e.g.* that of birds, also the pearly shells in which mollusks "attend soft nutriment," the diversely-ramified or delicately-sculptured corals—all these are strikingly beautiful, and accordingly are the exemplifications of animated Nature which are the first to be collected, and are usually the most extensively illustrated in museums. But there are forms of animals which excite wonder by their bulk and power, which surprise by their strangeness and oddity, which repel by their ugliness, or excite an instinctive feeling of horror and disgust. How soon the latter emotions subside, as the adaptation of form and structure to the habits and exigencies of the species become understood, the observant Naturalist can readily testify; and it would be difficult indeed to say what exceptional proportion of the animal kingdom may not possess that element of beauty which rests in the appreciation of the perfect fitness of the thing to its function. As, however, the purpose of a Museum of Natural History is to set forth the extent and variety of the Creative Power, with the sole rational aim of imparting and diffusing that knowledge which begets the right spirit in which all Nature should be viewed, there ought to be no partiality for any particular class merely on account of the quality which catches and pleases the passing gaze.

The first and great essential for a co-equal or justly proportional representation of all the classes of animals to the extent in which a nation may possess, or have opportunities to acquire, the specimens of them, is adequate exhibition-space. This is to be estimated—first, by the number of known species of the class; secondly, by the extent of exhibition-space occupied by the proportion of the class which may be properly exhibited in any existing museum; thirdly, by the proportion of examples obtained, but not exhibited in such museum; fourthly, by the ratio at which such specimens have accrued in a given number of years, and by the circumstances or conditions on which the ratio of future increase may be computed; finally, by the proportion of the specimens required to be exhibited in orderly series for a true idea of the group, and for the convenience of the student.

—◦❧ ☙◦—

Very different opinions of the aims or appliances of a National Natural History Museum have been propounded, and its extent estimated accordingly.

A Museum of Natural History destined solely for the amusement or amazement of the general public, need exhibit only such specimens as are peculiar for singularity of size or form, beauty of colour, or other catching quality. In short, to achieve this aim, the curator need only follow the system which the mercenary showman finds most successful with the public. I need hardly say, however, that the appliances of a National Museum of Natural History are of a wider and higher nature than to gratify the gaze or the love of the marvellous in the vacant traverser of its galleries.

Such a Museum should subserve the instruction of a people. And were the Collection to aim exclusively at the primary teaching of the uninformed in Natural History, those specimens only need be selected for public exhibition which exemplify the characters of the classes, orders, families, and principal genera. A small exhibition of this elementary nature would suffice for such educational end; and, especially if orally expounded at stated times, would be more instructive than a collection of species and varieties.

A third appliance of a National Museum of Natural History is to afford objects of study and comparison to professed or advanced Naturalists, and so to serve as an instrument in the progress of their respective science or branch of science. Such an application is consistent with modes of preservation and storage of specimens, as of dried unstuffed skins of small animals, in boxes; of shells, insects, minerals, smaller fossils, &c., in cabinet-drawers, involving comparatively a small amount of space, for the conservation of specimens for such exclusive use.

But there are other aims besides those of the public showman, the elementary school, and the scientist's study. The one Metropolitan Museum of Natural History of a great nation has appliances and obligations of a distinct and peculiar, if not superior, kind. The proportion of each class of Natural objects there to be seen should be such as will impart more than a mere elementary acquaintance with the class; it should give an adequate idea of its known extent and of the changes in or departure from the fundamental characters of the class; it should exemplify the gradations by which one genus and order merges into another; and how the type of the class may have risen from that of a lower, or may be mounting to that of a higher class. Such a comprehensive, philosophic, and connected view of the classes of animals, plants, or minerals, necessitates a Public Gallery of proportionate size.

To the Metropolitan Museum of Natural History the public, moreover, resort in quest of special information on some particular subject. The local collector of birds, bird-eggs, shells, insects, fossils, &c.,—the intelligent wageman, tradesman, or professional man, whose tastes may lead him to devote his modicum of leisure to the pursuit of a particular branch of Natural History,—expects or hopes to find, and ought to find, the help and information for which he visits the galleries of a Public Museum. He comes in the confidence of seeing the series of exhibited specimens so complete, and so displayed, as to enable him to identify his own specimen with one there ticketed with its proper name and locality. Such worthy visitors are not unfrequently averse to ask for, or intrude upon the time of, the officer in charge of the department, in order to obtain the piece of information which a mere elementary or otherwise restricted display of specimens would fail to impart.

The proportion of exhibited specimens for which galleries of the extent I have estimated are adapted, would, in the majority of instances, supply the kind of information

for which the last-named class of public visitors frequent them; the instances in which it would be requisite to make application to inspect the unexhibited stores would then be comparatively few. Thirty years' experience of the requirements of visitors to a public Museum has convinced me that this is a general expectation of the British public; and I believe it to be a reasonable one, and based on a well-grounded view of one of the uses of their National Collections. It would be unfulfilled, with much consequent disappointment, were the proportion of exhibited specimens to be below the scale which I have estimated to meet that and other above-defined aims.

In the fulfilment of such aims, however, the principle of selection would still guide the arranger of the several classes in the proportionate space which should be allotted to each.

But such space being provided for a consistent or equable display of every class,—a comprehensive view of the entire range of Natural History from Man to the Mineral once achieved,—the increase of exhibition-space would not need to keep pace with the increasing number of the added specimens and newly-discovered species of the several classes. The withdrawal of the more common specimens into store would proceed in a greater ratio.

In my original 'Plan and Estimates,' I had regard to the wishes of many Members of the House of Commons* as to our National Museum affording the public, and especially the wage-classes, the opportunity of visiting its collections in the evening. I conceived that in regard to Natural History, such visitors would be most interested in an exhibition of select specimens according to the elementary-instructive aim, and in the productions of their native land; and I proposed to combine with the British Collections such a selection of the more striking and instructive specimens of general Natural History as would be required to fulfil the first and second of the above-named appliances of a National Museum of Natural History. This combination of an "Elementary" with a "British" Collection might be arranged in a circular-domed apartment, so placed as to admit of the required arrangements for lighting and ventilation, and so insulated from the galleries of the main-building as to reduce to a minimum the extent and chances of damage by fire. It would be easy of access, without interference with any of the Normal galleries of the Natural History Collections.

Is there, then, anything inherently or patently extravagant in such an appreciation of the requirements of space as is exemplified in the subjoined Plans, in order to lodge samples of the Works of Creation of every class, of all time, and from the whole world! Indeed, the very vastness of the field whence such samples have to be culled, might seem to afford ground for evading or opposing the idea of attempting to provide the space required for such an epitome of Nature. "When you have got your five acres," it is said, "you will soon crowd them with specimens, and will then want more room for new discoveries."

It is to this fallacy that I would, next, address a few words. It is no new objection. The improvement of any state of things notoriously inadequate or bad has always been opposed, on the grounds, either, that the proposed improvement—at the time perhaps the sole practical one—will but effect a partial reform, not worth the

---

*Subsequently expressed in the 'Report from the Select Committee on Public Institutions,' &c., 27th March, 1860.

trouble to try to make; or, that a thorough reform being impossible, it is useless to try to make any amendment at all. So, in discussing this subject, I hear it said, "You may have space for properly exhibiting only two or three classes of Natural objects according to the evidences you now possess of such classes; and it may be true that to exhibit a corresponding or proportional series of the remaining score of classes of the objects of Natural History would require a building much less extensive than that which has been erected in one year for the temporary exhibition of the works of human industry. But as you never can exhibit all that future years may bring to light, in the several classes of Natural objects, it is useless to attempt to show a consistent and proportionable epitome of such classes, as they are represented by specimens actually acquired. It is enough that you show the people the most attractive and beautiful objects, such as Birds, Shells, Minerals; and sink the Mammoths and Whales."

To this I reply, that we are able to estimate the full extent of space which would be required to exhibit, in the same degree of completeness, all the other classes of Natural objects, and at the same time provide for a certain future prospective increase. That in each of the classes so exhibited, the principle of selection guides the arranger, whilst a certain proportion of the species, varying according to the class, is preserved in store. That, with the increasing numbers of species, the stored proportion of specimens would increase. That to a Museum consistently exhibiting every class, the argument for more space which is now founded upon the inability to exhibit more than a few classes, would not apply. The consistent display of every class, in equable proportion once being completed, any future requisition for space would have to be considered on the simple question of the proportion of specimens of each class to be displayed or to be stored. The arguments for and against such requisition would be easily weighed, and the ground of discussion narrowed. This, at least, is most certain, that such a necessity of increase of space as now presses would never recur.

But my estimate of that necessity transcends, it is averred by some, the physical powers of Museum-visitors.

One mile of galleries stored with examples of creative skill may leave the traverser somewhat wearied; but thousands gladly court the greater fatigue of six miles of galleries stored with the works of the industry of all nations. These, doubtless, come more immediately home to human wants and interests, and are more easily comprehended. Nor would I offer any invidious comparison between the aims of Art and Science.

Alimentary substances are good: and let those enjoy, who can, the purest and the choicest; let them dine off the finest specimens of ceramic and metal-chasing skill, supported by the most elegant and tasteful of the works of the cabinet-maker. Encourage every art and manufacture and invention that ministers to human enjoyment, ease, and luxury: ennoble the inventors of the machine of production which augments the wealth, and of the instrument of destruction that contributes to the safety and honour, of the nation: reward the foremost in each class, and raise a fitting edifice for the exhibition of their industrial products.

Only let it not be forgotten that truth is something more important, more valuable, more enduring. Above all, the truth as it is in organic Nature; which, as it is

slowly and surely evolved, seems, amongst other great ends, destined by Providence to be the instrument for the removal of those errors and misconceptions, which the blindness, pride, ignorance, and other infirmities of man have systematised and would sanctify, to the obscuration and distortion of the rays of divine and eternal truth which have been transmitted from Above for our guidance and support.

With the arguments which have been set forth under the advantage of an influential social position against the national acquisition of a Building for Natural History, on the scale here advocated, I might, from mere personal motives, be led to acquiesce. The larger the Museum, the greater the cares of the Curator. But the question rests on other grounds: and, in conclusion, I can only repeat that, practical acquaintance with the space required for the appropriate arrangement and display of a given number of specimens of each class of Natural objects—an approximate knowledge of the known species of each class and of the circumstances favouring or affecting future accessions to the several classes of objects—have afforded the data on which I have estimated the space required for a National Museum of Natural History. Save in the instance of the State Museum of Massachusetts, I have abstained from referring to the extent of such buildings abroad. It might seem invidious in the cases where the foreign museum approaches to my estimate for completeness. Neither do the instances in which National Museums in other countries fall short of such estimate afford any arguments to bar endeavours to realise it in this country.

England may well, in this matter, set the example rather than follow it. The greatest commercial and colonizing empire of the world can take her own befitting course for ennobling herself with that material symbol of advance in the march of civilisation which a Public Museum of Natural History embodies, and for effecting which her resources and command of the world give her peculiar advantages and facilities.

WILLIAM HENRY FLOWER

—◦❧ ❦◦—

*Topographical Description of the Museum and Its Contents,*
*British Museum (Natural History)*

## The Central Hall

In the centre of the entrance hall is placed a specimen of the bony framework of one of the most colossal of animals, for which space cannot at present be found in its proper locality—the Cetacean gallery. It is the skeleton of the Cachalot, or Sperm-whale (*Physeter macrocephalus*), prepared from an animal cast ashore near Thurso, on the north coast of Scotland, in July, 1863, on the estate of Capt. D. Macdonald, R.E., by whom it was presented to the Museum. The Sperm-whale is the principal source of supply of the sperm oil and spermaceti of commerce. The former is obtained by boiling the fat or blubber lying beneath the skin over the whole body; the latter, in a liquid state at the ordinary temperature of the living animal, is contained in cells which fill the immense cavity on the top of the skull. It feeds chiefly on Cephalopods (squid and cuttlefish), and also fish, and is widely distributed throughout the warm and temperate regions of both Atlantic and Pacific Oceans. The skeleton is that of a full-grown animal. It measures fifty feet one inch in length, but wants three of the vertebræ from the end of the tail.

In order to render this skeleton more instructive, and to bring it into relation with the elementary specimens of osteology in the adjoining bay (No. I., west side), the names of the principal parts have been attached to them. This will enable the anatomist to trace at a glance the extraordinary modifications in the form and relations of its component bones which the huge skull has undergone, and will show in the clearest manner to the least instructed visitor that the so-called fin or flipper of the whale is composed of all the same parts—shoulder, elbow, wrist, and fingers—as his own arm and hand. The hind limbs are entirely absent; but two bones are seen suspended at some distance from the spinal column, which represent the pelvic or hip bones of other animals. In some species of whales there are even traces of the thigh, knee-joint, and leg attached to this, and like it deeply buried within the body of the animal.

The cases placed on the floor of the hall around the skeleton of the whale illustrate general laws or points of interest in Natural History which do not come appropriately within the systematic collections of the departmental series.

One group, in a case near the entrance to the hall, shows the great variation to which a species may become subject under the influence of domestication, as illus-

From *A General Guide to the British Museum (Natural History), with Plans and Views of the Build-ing.* London: British Museum, 1893.

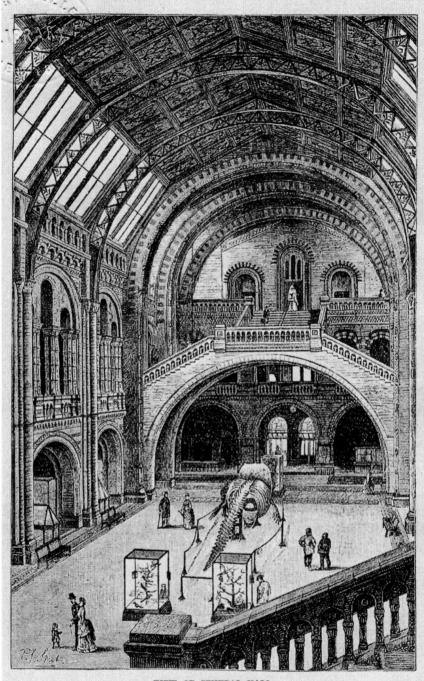

VIEW OF CENTRAL HALL.

FIGURE 5.1 "View of Central Hall," Museum of Natural History. *A General Guide to the British Museum (Natural History), with Plans and Views of the Building.* London: British Museum, 1893.

trated by choice examples of the best marked breeds of Pigeons, all of which have been derived by careful selection from the wild Rock Dove (*Columba livia*), specimens of which are shown at the top of the case.

A case placed on the left of this illustrates a remarkable instance of external variation in the two sexes and at different seasons, not under the influence of domestication. The birds in it all belong to one species, the Ruff (*Machetes pugnax*), of which the female is called Reeve, belonging to the Snipe family (*Scolopacidæ*). In the upper division of the case are shown the eggs, newly-hatched young, young males and females in the first autumn plumage, and old males and females in winter, when both sexes are exactly alike in colour, size only distinguishing them. The large group occupying the lower part of the case, consists of adult birds in the plumage they assume in the breeding time (May and June). In the female the only alteration from the winter state is a darker and richer coloration, but in the males there is a special growth of elongated feathers about the head and neck, constituting the "ruff," from which the bird derives its name. In addition to this peculiarity, another may be observed, which is rare among animals in a wild state (though so common among domesticated races), that of striking diversity of colour in different individuals. As many as twenty-three specimens are shown in the case, no two being entirely alike.

On the same side of the hall follow two cases which illustrate the adaptation of the colour of animals to their natural surroundings, by means of which they are rendered less conspicuous to their enemies or their prey. The first contains a specimen of a mountain or variable Hare (the common species of the North of Europe), a Stoat, and a Weasel, some Willow Grouse and Ptarmigan in their summer dress, obtained in the neighbourhood of Christiania in the month of July, showing the general harmony of their coloration at this season to that of the rocks and plants among which they live. The second case shows the same species of animals obtained from the same spot in mid-winter, when the ground was completely covered with snow. Such complete changes as those here shown only occur in latitudes and localities where the differences between the general external conditions in the different seasons are extreme, where the snow completely disappears in summer and remains continuously on the ground during the greater part of the winter. Even some of the species here shown do not habitually turn white in the less severe winters of their southern range, as the Stoat in England and the Hare in Ireland. In a few permanent inhabitants of still more northern regions, where the snow remains throughout the year, as the Polar Bear, Greenland Falcon, and Snowy Owl (of which a specimen is shown on the wing in the upper part of the winter case), the white colour is retained throughout the year. The whiteness of these animals must not be confounded with *albinism* (whiteness occurring accidentally in individuals normally of a different colour), illustrated in a case on the other side of the hall.

—◦❧ ❦◦—

The last group shows that two forms of Crows which appear quite distinct, and which, judged by their external characters, might be held to be different species, may in a state of nature unite, and produce offspring of a perfectly intermediate character. In the same case is also a series of Goldfinches, showing a complete gra-

dation between birds of different coloration, and which have naturally been held to be different species. Both these examples may by some naturalists be considered instances, not of crossing of distinct species, but of "dimorphism," or the occurrence of a single species in nature under two different outward garbs; but from whatever point of view they are regarded, they illustrate the difficulty, continually increasing as knowledge increases, of defining and limiting the meaning of the term "species," of such constant use in biology.

The bays or alcoves round the hall, five on each side, are devoted to the Introductory or Elementary Morphological Collection, designed to teach the most important points in the structure of the principal types of animal and plant life, and the terms used in describing them, all which should be known before the systematic portion of the collection can be studied with advantage. This has been called the "Index Museum," as it was thought at one time that it would form a sort of epitome or index of the main collections in the galleries; but the name does not exactly express what it has developed into. It is really more like the general introduction, which almost always precedes the systematic portion of treatises on any branch of natural history. This collection is at present far from complete; in fact, only in its infancy; and as nothing exactly like it has been exhibited in any public museum before, it will, as its formation goes on, be subject to much modification and improvement; but it is hoped that it may ultimately serve as a guide for the formation of educational biological museums elsewhere. The space being strictly limited, the number of illustrative specimens is necessarily restricted, probably to the advantage of the student, at all events in the earlier part of his career. In examining this collection the visitor should follow each case in the usual order of reading a book, from left to right, and should carefully study all the printed explanatory labels, to which the specimens are intended to serve as illustrations.

The bays on the west side (left-hand on entering the hall) are devoted to the Vertebrated Animals, or those possessing a "backbone." In Nos. I. and II. are shown the characters of the Mammalian modifications of this type. The wall-cases of No. I. are already nearly filled with specimens showing the bony framework (internal skeleton) of Mammals.

In the first case (south side of the recess) will be seen a complete skeleton of a good example of the class—a large monkey, with all the bones separated, laid out on a tablet, and with their names affixed to them. Below it is a skeleton of the same animal articulated, or with the bones in their natural relation to each other, and also named. By examining these two specimens a fair idea may be obtained of the general framework of the body of animals of this class. In other parts of the case are placed examples of modifications of the skeleton to suit different conditions of life.

1. Man, showing a skeleton adapted for the upright position.
2. A Bat, or flying mammal, in which the fore-limbs are converted into wings by the great elongation of the fingers, which support a web of skin stretched between them.
3. A Sloth, in which the ends of all the limbs are reduced to mere hooks, by which the creature hangs back-downwards

from the boughs of the trees among which it passes its entire existence.

4. The Baboon serves as an example of an animal walking on all four limbs in the "plantigrade" position, *i.e.*, with the whole of the palms of the hands and soles of the feet applied to the ground.

5. A small species of Antelope shows the characteristic form of a running animal, in which the limbs perform no office but that of supporting the body on the ground. It stands on the tips of the toes of its elongated slender feet.

6. A Porpoise, adapted solely for swimming in the water. The fore limbs are converted into flattened paddles, and the hind limbs are entirely absent, their function being performed by the tail. The rudimentary pelvic bones are preserved.

The rest of the case is occupied by details of the skull in some of its principal modifications. At the top are diagrams of the structure of bone and cartilage as shown by the microscope.

## Chapter Six

# PEDAGOGY: SOUTH KENSINGTON
# AND THE PROVINCES

While the British Museum and the National Gallery were the sites to which the imagination of a total centralized collection tended to return through most of the nineteenth century, the period saw the emergence of other important institutions established to satisfy the same goal. The South Kensington Museum, identified from the outset by its location far from the center of the city, manifested the museal aspirations of the era unconstrained by the limits of a traditional site, collection, or structure. Founded by the sponsors of the Great Exhibition with funds remaining from that venture, the institution was driven from the outset by clearly articulated pedagogic aims. However, while Henry Cole emphasizes his commitment to transparency and openness in the brief extract that opens this selection, the institution that later became the Victoria and Albert Museum was not likely to escape the threat of confusion and surfeit liable to afflict a national storehouse or treasury that came to include a number of quite distinct collections. As the four-part series from *Leisure Hour,* "The South Kensington Museum" (1859), demonstrates, the modern museum is as subject to becoming overwhelmingly heterogeneous as its more old-fashioned predecessors.

The author of "Provincial Museums," an article from *Chambers's Journal of Popular Science and Arts* (1866), advocates for a new rationalization of the typically incoherent local collections based on their use as sites for the exhibition and study of regional natural history, culture, and ethnography. Still, metropolitan institutions were to prove decisively important for the development of provincial museums, in particular through the emergence of centralized programs providing for the circulation of material from major London collections. This chapter concludes with a *Report on the System of Circulation of Art Objects on Loan from the South Kensington Museum* (1881), a document tracing the development of a national system of collection and display involving an ambitious technical and organizational infrastructure and a notable commitment of resources.

# Henry Cole

—◦❧ ❦◦—

## Extracts from an Introductory Address on the Functions of the Science and Art Department

It has been said that the contents of the Museum here are very heterogeneous, although Science or Art is the basis of all the collections. The remark is just. These collections come together simply because space was provided for their reception. For years they had been for the most part either packed away unseen, or were very inadequately exhibited, and the public deprived of the use of them. The architectural collections belonging to the Department for years were buried in the cellars of Somerset House, and were but most imperfectly shown at Marlborough House. The prints and drawings possessed by the Department had never been seen by the general public. The casts of the Architectural Museum are surely better displayed here than in Cannon Row. The union of these collections, and the addition of the models of St. Paul's and various classical buildings, betoken what an Architectural Museum may become, if the individuals and the State will act together. Every foreigner who has seen this commencement sees in it the germ of the finest Architectural Museum in Europe, if the public support the attempt. But for this iron shed, a Patent Museum might have remained a theory. The educational collections were packed away for three years unused, awaiting only house-room to show them. Since the Exhibition of 1851, the Commissioners had been compelled to store away the Trade collections which either are so attractive here, or have been usefully distributed to local museums. The Iron Museum is only to be regarded as a temporary refuge for destitute collections.

Besides proving the public value of these collections, the provision of space has signally demonstrated the willingness of the public to co-operate with the State when space is found. But even the present collections, crude and imperfect as they are, have sufficiently attracted public attention, to confirm their public utility; and it may be expected that the public will not grudge that proper house-room for their more systematic arrangement and development should be provided. It was prudent at least to try the experiment, which has been fully justified by success. Distinct buildings of a permanent and suitable character are wanted for the Patent Collection; for the products of the Animal Kingdom, which logically seems to be an appendix to the national collection of the animals in the British Museum; and for the collections of Education and of Art, as well architectural as pictorial, sculptural, and decorative. For each of these collections prudence would provide very ample space, as they must continue to grow as long as they exist. Models of patented inventions, specimens of

Henry Cole, "Extracts from an Introductory Address on the Functions of the Science and Art Department" (1857), *Fifty Years of Public Work of Sir Henry Cole, K.C.B.* Alan Summerly Cole and Henrietta Cole, eds. (London: G. Bell and Sons, 1884) 2:291–294 (excerpts).

animal produce, architectural casts, objects of ornamental art, and sculpture, cannot be packed as closely as books or prints in a library. They require to be well seen in order to make proper use of them; and it will here be a canon for future management that everything shall be seen and be made as intelligible as possible by descriptive labels. Other collections may attract the learned to explore them, but these will be arranged so clearly that they may woo the ignorant to examine them. This Museum will be like a book with its pages always open, and not shut. It already shows something like the intention which it is proposed to carry out. Although ample catalogues and guides are prepared and are preparing, it will not be necessary for the poor man to buy one, to understand what he is looking at.

Every facility is afforded to copy and study in the Museum.

It has been the aim to make the mode of admission as acceptable as possible to all classes of visitors. Unlike any other public museum, this is open every day, on three days and two evenings, which gives five separate times of admission, making in summer an aggregate of thirty hours weekly free to every one. On the other three days and one evening it is free to students whose studies would be prevented by crowds of visitors; but, on these occasions, the public is not turned away, as a fee of sixpence gives every one the right of admission as a student.

The working man comes to this Museum from his one or two dimly lighted, cheerless dwelling-rooms, in his fustian jacket, with his shirt collars a little trimmed up, accompanied by his threes, and fours, and fives of little fustian jackets, a wife, in her best bonnet, and a baby, of course, under her shawl. The looks of surprise and pleasure of the whole party when they first observe the brilliant lighting inside the Museum show what a new, acceptable, and wholesome excitement this evening entertainment affords to all of them. Perhaps the evening opening of Public Museums may furnish a powerful antidote to the gin palace.

But it is not only as a metropolitan institution that this Museum is to be looked at. Its destiny is rather to become the central storehouse or treasury of Science and Art for the use of the whole kingdom. As soon as arrangements are made, it is proposed that any object that can properly be circulated to localities, should be sent upon a demand being made by the local authorities. The principle is already fully at work, and its extension to meet the public wants depends altogether upon the means which the public may induce Parliament to furnish. It may be hoped by this principle of circulation to stimulate localities to establish museums and libraries for themselves, or at least to provide proper accommodation to receive specimens lent for exhibition.

An essential condition to enable this plan to be carried out satisfactorily is ample space, and fortunately this space is provided by the present site, which could not be obtained without enormous cost at any nearer point to the centre of London. Of course, any other spot, at Birmingham or Derby would serve equally well as a centre for radiation. But the present site has in addition the public advantages of having a larger resident population than any provincial town, and it may be borne in mind that half the population of the metropolis is made up of natives of the provinces.

The number of works of the highest art is limited, and it cannot be expected that every local gallery can possess many of them, but the mode of circulation alluded to would afford to every local gallery the qualification of having each some in turn.

# Anonymous

— ∘❧ ❦∘ —

## The South Kensington Museum

GREEN lanes! green lanes! how I regret to see you improved into fine streets, with big mansions all up and down. It *must* be, I suppose. The woodman's axe, little heeding my rural tastes, will sharply fall on the trunk of many a tall elm-tree, endeared to my memory by old association. London expands, and must still go on expanding. It is its fate and fortune so to do; and if former residence, with its train of old associations, has endeared to me the umbrageous network of paths leading from Brompton to Kensington in times that were, my perhaps too selfish self must not repine and grumble at the destruction of their sylvan beauty, wrought out for the public good. Old Brompton may be said to exist no more. It is New Kensington now. Big mansions stud the way where once grew tall elm-trees. Cabby points his knowing finger, and wags his saucy tongue, on the very spot where I remember well to have gone collecting wild-flowers in times that were; and a certain pretty villa, with its velvet lawns and gay flower-beds, that I well remember in the year 1842 coveting for my own, is now swept away, demolished to make room for an edifice—fantastic somewhat, but pretty in the main—to wit, the South Kensington Museum.

It is, in the widest sense, an educational establishment, and no person who goes through it with moderate attention will go through it in vain. Should you wish to learn what to eat, drink, and avoid, pay a visit to the South Kensington Museum. Should you desire to know the philosophy of china or crockery, from Samian vases or Etrurian coffins, down to Wedgwood, Parian, and encaustic tiles, a ramble through the museum will bring you *au courant*. Venetian mirrors may be your weakness, perhaps, or the tapestry of Gobelins; or, haply, antique Flemish wood carvings may be what your heart desires to linger upon. Well, there they are all—*there*, in the museum. The two Siamese kings awhile ago presented to her Majesty the Queen certain curious articles of luxury—a state-chair to sit upon, a golden canopy to loll under, and vestments of peculiar golden tissue, only made in Siam. Would you like to see them? Ay. Then go to the museum; for there they are, properly laid out, and labelled to please and instruct the visitor. Multifarious the contributions are—an *omnium gatherum*, reminding one of the cabinet of the virtuoso. I bethink myself of the cabinet of curiosities described by the poet Burns as appertaining to Captain Grose, of antiquarian renown, and fancy this must be like it.[1] Even in the matter of

Anonymous, "The South Kensington Museum" (4-part series) *Leisure Hour* 8 (1859), 215–264 (excerpts).

1. Captain Francis Grose (1731–1791): antiquary and friend of Robert Burns. See Burns, "On the Late Captain Grose's Peregrinations thro' Scotland Collecting the Antiquities of that Kingdom" (1789). [Ed.]

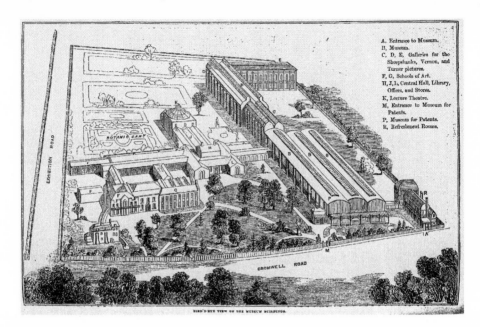

A. Entrance to Museum.
B, Museum.
C, D, E, Galleries for the Sheepshanks, Vernon, and Turner pictures.
F, G, Schools of Art.
H, J, I, Central Hall, Library, Offices, and Stores.
K, Lecture Theatre.
M, Entrance to Museum for Patents.
P, Museum for Patents.
R, Refreshment Rooms.

BOTANIC GARD

EXHIBITION ROAD

CROMWELL  ROAD

BIRD'S-EYE VIEW OF THE MUSEUM BUILDINGS.

FIGURE 6.1   "Bird's-Eye View," The South Kensington Museum. *Leisure Hour* 8 (1859).

house adornments, such as buhl and marqueterie, glass, ornamented metals, porcelain, carpets, and so forth, a long succession of pretty things meets the eye of the visitor. A lady might linger over them lovingly for hours, and sometimes, I fear, she would depart with notions of the elegant in art manufacture, sorely trying to her powers of endurance under temptation to the cash in her purse. A visitor, in short, to the South Kensington Museum may come away all the better for the visit—having enlightened his understanding on a vast number of useful matters.

But before asking you, my reader, to accompany me in an ideal ramble through the rooms and galleries, I must crave your patience while I describe very briefly the history and the purpose of the museum—very important matters to be clearly understood.

The origin of the institution can be set forth in few words. The close of the Great Exhibition in 1851 was attended with the pleasing result of surplus cash in the money-box. The question then arose, what was to become of it? Some advocated one thing, some another. There were many differences of opinion, as, indeed, usually happens when money has to be disposed of. Eventually the South Kensington Museum sprang out of that money, and sure I am no reasonable person will grieve at the result. The *ground*, at least, was bought with the money in the hands of the Commissioners, and a good investment the purchase has been. It is a noble estate, with soil, site, and aspect all that could be desired, and, from the proximity to Kensington Gardens, safe from being surrounded by buildings. The present structures and arrangements can only be regarded as provisional and temporary, until suitable permanent edifices can be erected. By successive additions to the buildings that were on the estate when bought, the structure has gradually assumed its present

form and dimensions. New offices were erected by the Board of Works; the wooden sheds used by the pupils of the Schools of Design were moved from Marlborough House; a commodious, if not elegant, iron structure was raised by the Commissioners of the Exhibition of 1851; and brick galleries have been since constructed for the reception of Mr. Sheepshanks' munificent gift of pictures and drawings. More recently, extensive new galleries have been added for the pictures from the Vernon and Turner collections.[2] There have also been erected refreshment rooms, storehouses, and various other structures, all of a temporary and economical kind, yet, in the internal fittings and arrangements, admirably adapted for every object in view. What if the buildings are not very symmetrical, and the business transacted in them of a miscellaneous character—the museum is in this respect a true offshoot of the British constitution itself, in its gradual and irregular growth, but its sure and practical usefulness.

The nominal *suzerain* of the establishment is the President of the Committee of the Privy Council on Education. The business of that important committee is two-fold, the primary division having reference to government aid of the education of the poor, and the secondary division is represented by the "Science and Art Department," the object of which is to diffuse among all classes of the community those principles of science and art which are calculated to advance the industrial interests of the country. At the South Kensington Museum this science and art department has its head-quarters, with corresponding schools of art in the provinces. The central training institute for artists, with its schools, lectures, models, and library, is here located, and good work it is now doing, the influence of which is felt throughout the kingdom, both by diffusing knowledge of art, and by encouraging rising talent—pupils being sent up from provincial schools as the reward of merit and industry, as tested by competitive examination.

Under the shelter of this Science and Art Department, sundry other institutions have found a temporary home. The Commissioners of Patents have transferred their collection of models and drawings to South Kensington, and a part of the museum has been assigned for their exhibition. The Architectural Museum, formerly in Cannon Row, has been removed to this place. The Institute of British Sculptors have contributed their collection, and other societies, as well as liberal individuals, have helped to enrich the museum. We hope yet to see a range of buildings worthy of the nation, erected on the South Kensington estate, rich in objects for exhibition, and furnished with every appliance for popular instruction. Although the annual display of paintings by the Royal Academy, or the exhibition of a National Gallery of pictures by old masters, may be elsewhere, it is here that there ought to be the People's Palace of Art, with its galleries, collections, schools, libraries, and all accompanying arrangements.

Already, even in the infancy of the museum, its popularity and usefulness are apparent. There are upwards of forty thousand visitors monthly on the free days of admission, and on the students' days a goodly number are also in attendance. The museum has not yet been open two years, and, when it is better known, it will

2. Sheepshanks, Turner, Vernon: see glossary. [Ed.]

be one of the most favourite places of resort. One thing will be admitted by every visitor, that there is no public institution in the kingdom where the convenience and comfort, as well as the amusement and instruction of the people, are more efficiently provided for. The directors and officials of all the departments are zealous and attentive, and the civilian staff is ably reinforced by a detachment of the Royal Engineers, whose useful services at the Exhibition of 1851 will be always remembered with satisfaction.

## Second Article

IN our former article we said that the South Kensington Museum was in its widest sense an educational establishment, which no one can visit without getting information on a vast number of useful matters. Strictly speaking, every part of a popular museum is "educational." A thinking being is, or ought to be, under process of education all life long. Wherever we go, or whatever we do, some stray notion may probably be gleaned, some previously unconsidered trifle of knowledge stored away, all which is education.

But there is a certain part of the South Kensington Museum more especially devoted to the purposes of education—in fact, to the art of teaching. We will, therefore, tell the reader how the aids and appliances of teaching are brought together in one special focus, so to speak, for the benefit of teachers, and parents, and all interested in the instruction of the young. This is the object of the educational department of the museum.

### The Educational Museum

These collections, occupying the central portion of the iron building, had their origin in an exhibition of books, models, and apparatus, at St. Martin's Hall, organized by a committee of the Society of Arts. Most of the articles exhibited were presented to the Society, and by it transferred to the Committee of Council on Education. Whatever the educational subject may be that the teacher desires to teach, or the learner to learn, (speaking within moderate compass,) the educational department of the South Kensington Museum illustrates the means of teaching and of learning. All the accredited books on every branch of knowledge, the utility of which has been tested in the best schools, are arranged for consultation, and duly entered in the well-arranged and copious catalogue. Not merely, too, are the books in question laid up as mere curiosities on a shelf, their titles only to be looked at, under proper but necessary regulations; they may be taken down and examined, notes may be made of their contents, and, being thus viewed comparatively, a far better general conclusion as to their advantage may be arrived at than any single examination of one book at a time would have made possible.

Then there are maps, diagrams, models, and apparatus; and object-lessons are also conspicuous. The curiosities, and luxuries even, of the schoolroom are not absent. If I want a piece of wood-work cunningly devised, that, by virtue of shifting it

this way or that, may become a chair, a table, or a writing-desk, there I see it; the maker of it duly indicated, so that I may supply myself with the like. If I wish to purchase chemical apparatus, but, being a tyro, hardly yet know what I want, or where or at what price my wants can be supplied, the apparatus cases will inform me. But my greatest commendation must be reserved for the object-cases, fitted up with natural productions and wrought materials. So far as it is desirable for people in general to know the origin and nature of the "common things" about which so much has been lately said and written, object-lessons are better able to convey that information than any mere book learning. To this conclusion seem to have arrived the happy groups of children I see there, about and around me, prying with eager eye, under the direction of governesses and tutors, into the varied and instructive treasures of the glass-cases.

Having thus explained the nature and objects of the educational part of the museum, one can find nothing more to write about it. If it were possible to indicate, by means of print and paper, the full value of the collection, there would be little need of the latter. Learners and teachers must proceed there and examine for themselves. In this they will be aided by the useful Guide (price one penny) published by authority, and sold within the door of the museum. The following extract from it will give an outline of the chief objects of interest in the educational department.

"In the first bay on the left, is a collection of models of existing school buildings, mostly contrived so as to show the interior arrangement of the rooms, desks, and fittings. Among those demanding especial attention are the Central School for boys, of the British and Foreign School Society, Borough Road; Homerton College Training Schools; First, Second, and Third Class-rooms of the Royal Naval Hospital Schools, Greenwich; the Norwich Diocesan Boys' School; and the beautiful model of Lord Granville's Schools at Shelton, Staffordshire. On the adjoining walls are numerous plans, sections, and elevations of normal schools of France and Germany; and in front are specimens of the desks, reading-stands, easels, and other school fittings, as used and recommended by most of the great metropolitan educational societies.

"General Education commences in the next recess. The greater portion of the library, which now numbers upwards of 8000 volumes, is arranged here. It contains the series of works published by the English book-trade, contributions from various schools and educational writers, and sets of works selected by continental nations for their governmental schools. Of these, about 400 volumes are from France, about the same number from Germany, about half as many from Denmark and Holland, a few from Malta, about 100 published by the Egyptian government, and presented by it to the Commissioners for the Exhibition of 1851, and a considerable number from the New York Board of Education. The books may be removed from the shelves, for examination or study, on students' days, (Wednesdays, Thursdays, and Fridays), on application to the attendants.

"Proceeding down the left-hand side of the museum, still occupied by General Education, the visitor reaches a series of small glass-cases containing examples of object-lessons, such as cotton, silk, and metals, showing the various processes of manufacture, sent by the Home and Colonial and British and Foreign School Societies and the Royal Military Asylum, Chelsea. Opposite these are the Kinder Garten

and other instructive toys. Next in order of classification comes the apparatus for teaching persons of deficient faculties. Among the books exhibited in this class will be found no fewer than eight different systems for teaching the blind to read. From the very few books published for the blind, it is much to be regretted that a uniform system of tangible typography is not adopted. The remaining portion of this recess is allotted to music and physical training.

"The visitor next reaches the collection of objects of household economy. The last recess on this side, together with the end wall and opposite recesses, are devoted to drawing and the fine arts.

"In the division of Natural History, Professor Henslow contributes a valuable collection of botanical specimens, a case illustrative of the physiology of fruits (exhibited at Paris in 1855), and a set of botanical diagrams prepared for the Department of Science and Art; Professor Tennant, a collection illustrative of mineralogy and geology; Mr. Sopwith, geological models; and Mr. Waterhouse Hawkins, models of extinct animals. The elementary collection of minerals, by Professor Krantz, is excellent, as are also the diagrams of Messrs. Day, and the geological and natural history diagrams of the Working Men's Educational Union.[3]

"Geography and Astronomy come next in order of arrangement, and form, perhaps, the most perfectly represented class in the Educational Museum. The large collection of maps and atlasses includes specimens from France, Germany, and America, and from most of the principal publishers of our own country. In front of the maps, surrounded by globes and astronomical diagrams, stands the Astronomer Royal's full-sized model of the transit circle of the Greenwich Observatory, and lower down more globes and orreries, by Newton and Son. On the wall is a fine map, drawn by E. Hughes, master of the Lower School at Greenwich.

"The astronomical diagrams of Messrs. Day, and those of the Working Men's Educational Union, are worthy of attention, the former for excellence of production, and the latter for clearness and cheapness. The two next recesses, with the glass-cases before them, contain physical and chemical apparatus and diagrams, principally from Newton, Horne and Thornthwaite, Elliot and Griffin.[4] The first exhibits microscopes in the recess, and the second a large collection of apparatus for galvanic, voltaic, and frictional electricity.

"The last division in the Educational Museum is allotted to Mechanics, including hydraulics, pneumatics, hydrostatics, etc., occupying the end wall and the glass-cases. There is also a large collection of French apparatus."

3. John Stevens Henslow (1796–1861): influential botanist, teacher, and friend of Charles Darwin. James Tennant (1808–1881): mineralogist and mineral and shell dealer and professor at King's college. Thomas Sopwith (1803–1879): surveyor and civil engineer. Benjamin Hawkins Waterhouse (1807–1889?): natural history artist and sculptor, responsible for life-size models of various extinct animals, fossil plants, and geological strata at the Crystal Palace at Sydenham. Adam August Krantz (1808–1872): founder of a distinguished company dealing in mineral specimens and models established in Freiberg, Germany in 1833. Messrs. Day: Day and Son, the most prominent lithographic firm of the period.

4. Newton and Son, Horne and Thornthwaite, Elliot and Griffin: makers of precision optician's instruments and equipment for scientific research and navigation.

## Museum of Animal Products, and Food Museum

IN the East Gallery, above the Educational Museum, will be recognised many articles which were displayed at the great Exhibition of 1851. The idea then was to obtain a general collection of all objects of commercial interest—a museum of the exports and imports of the world, where men of business might examine and test samples of the articles in which they traded, or respecting which any information was desired. To have museums of this kind in the city of London, and other centres of commerce, is still desirable. The Mineral products are to be seen in completeness at the Jermyn Street Museum, and Vegetable products at the Kew Museum, while the present collection is now confined to the useful applications of the products of the Animal Kingdom.

In the same gallery is a collection illustrating the history, varieties, and chemical composition of food, both animal and vegetable, with drinks also, and condiments. Explanatory labels are attached to all the specimens, for those who wish to study the details.

A glance at the cabinets wherein the series of life-supporters are so neatly laid out, and an attentive perusal of the explanatory placards affixed, will convey a very satisfactory general notion of the philosophy of eating and drinking. Things which animals take into their stomachs are either aliments or condiments. Either they suffer digestion, or they assist other things to digest. Digestible matters either contribute to supply the wear and tear of the body, or they serve as fuel to maintain a proper degree of animal heat. Speaking in a general way, digestible bodies rich in carbon are the combustibles, and those rich in nitrogen are the blood and tissue formers. In this department of the exhibition, the wanderer will probably be attracted by the appearance of a large heap of barley, about one and a half bushel. What is there to be seen in a bushel and a half of barley? The placard explains: gin and whisky, nay, at the present time, much brandy is manufactured out of grain, and for the most part, this grain is barley. Well, according to excise returns, each adult male in these islands consumes yearly about three gallons and four-ninths of ardent spirits; and assuming the latter to have been produced from barley, the corresponding and necessary amount of that grain would be about one bushel and a half—a quantity sufficient to feed a man for forty days. Only consider the quantity of wholesome bread it would have made! Consider, too, how much less drunkenness there would have been had ardent spirit remained undiscovered. "The fiery demon of drunkenness, in the form of ardent spirits," says an accompanying placard, "unknown to the ancients, was discovered by northern barbarians." This is not quite true. Northern barbarians were the first to use ardent spirits extensively, indeed; but alcohol (ardent spirit) was known to the Arabians.

Turning our eyes towards the next glass-case, an interesting lot of commercial starches meets our view. Starches belong to the series of combustibles or fat-formers. They yield nothing to the blood or muscle. Tapioca, sago, arrowroots of all species, are starches which have been subjected, more or less, to preliminary treatment. Contemplate the wide distribution of the material starch. Not only a constituent of all cereal grains, we find it in tubers, as the potato; in roots, the *Maranta arundinacea*, or true arrowroot, for example, deposited amidst the woody tissues; or in the pith of

plants, as evidenced by sago and tapioca. Whatever the variety of starch, it is always innocent. The tapioca tree, *Jatropha manihot*, is violently poisonous; but when the starch of it is extracted, well washed with water to remove vegetable juices, and subjected to a sort of baking process, it becomes a valuable human food. Truly speaking, tapioca, by subjection to the heating process adverted to, is partially transformed into gum. All starches thus treated undergo a similar change. The material called British gum, and largely employed in the calico-printing operation, is nothing else than baked potato starch. I believe British gum is employed to render postage stamps adhesive.

The compartment allotted to the display of malt and hops furnishes an opportunity for conveying, by means of a placard, some interesting information relative to beer, which liquid is nothing more than malt infusion, partly fermented and rendered somewhat bitter by the hop plant. Common beer, we are informed, holds no more than one per cent. of alcohol, stout about six per cent., and the very strongest ale about eight per cent. Considering what beer-drinkers we English are, we are, nevertheless, startled by the announcement of the placard, that about five hundred and fifty millions of gallons of beer are brewed in the British isles annually.

After examining the cases containing the varieties of articles of food, some of them curious enough, we turn to the clothes worn by the human race, and the materials of which they are formed. Well, observe, hanging against the wall, those pictures of sheep. The merino sheep is not a very pretty animal (to the uneducated eye at least), though its wool is incomparable. Many attempts have been made, though unsuccessfully, to naturalize merino sheep in England. They do not prosper; and even if they did, perhaps they would not suit the English taste. Wool is a very fine thing in its way, but so is mutton, in respect of which latter the merino sheep have little to boast about.

Now observe yonder specimens of wool, placed conveniently for our inspection; and further, do not omit to note these enlarged delineations of hair and wool filaments magnified. Observe well all these things; some curious information hangs upon them. How new and beautiful are the ideas which the microscope begets for us! What a host of things, hidden and mysterious, do not the magic lenses open to our view!

—◦❥ ❦◦—

## Article Third

THERE was a time when we English, instead of imagining our art designs for ourselves, complacently borrowed (without permission, be it understood) from our foreign neighbours. Judging from the creditable specimens of British design hung up for display in the Museum, let us hope such practices are abandoned for ever. To appropriate a design without permission is more than a meanness—it is a robbery. Looking at the freehand drawings and study-paintings executed by pupils in connection with our new schools of design, and exhibited at the north end of the Museum galleries, we see many encouraging proofs of the good that the schools are accomplishing. Some drawings from the round are models of truthfulness: so are some coloured delineations of landscapes and still-life. Being in this vein of artistic reverie, you doubtless expect, gentle friend, that we should next glide into the Sheepshanks gallery of pictures, critically examining, and no less critically describing the treasures

therein contained. No, not a bit of it. To describe a picture gallery is not at any time a small undertaking, much less when one has to view it with birds'-eye glances, so to speak, whilst skimming hastily over the treasures of a whole museum. We must give our attention, at present, to the large and miscellaneous collection known as "The Museum of Ornamental Art," chiefly contained in the northern hall, the north and west galleries on the ground-floor of the iron building, and in the rooms under the Sheepshanks gallery. But, before going downstairs, let us walk along the western gallery of the iron building, which is devoted to

## The Architectural Museum

The object of this department is to afford to the public, as well as to architects, artists, and art-workmen, the means of studying the architectural art of all countries and times—not as a mere archæological study, but with the practical view of improving the art-workmanship of the present day. Casts and specimens of all the different styles and schools of architecture are arranged and classified for study, as far as possible in chronological order. The casts illustrative of the history of Gothic art are numerous, and present a most instructive series. Other styles are also well represented. There is a rich exhibition of details, comprehending figures, animals, and foliage; mouldings, encaustic tiles, mural paintings, roof ornaments, rubbings of sepulchral brasses, stained glass, impressions from seals, and of all other objects of fine art connected with architecture. To casts and specimens are added, as opportunities offer, photographs, drawings, and engravings of architectural works; the photograph or engraving giving a view of the whole structure, the casts giving the detail. To these have been added models of buildings, conspicuous among which, and most interesting of all to the passing visitor, is the original model of St. Paul's Cathedral, as designed by Sir Christopher Wren.

## The Museum of Ornamental Art

We have now found our way down-stairs again, where as yet we have only examined the educational collections in the first compartment of the central hall of the iron building. Beyond this, and in the side galleries, there is a vast variety of interesting objects, which formerly used to be exhibited at Marlborough House as the Art Museum. Many additions have been since made to the collection, which includes specimens of carving in wood and ivory, terra-cotta work, glass painting, enamels, pottery and porcelain, glass, metal works, watches, jewellery, arms and armour, furniture, textile fabrics, etc.; also examples of ancient illumination, drawings, engravings, etc.

The Central Hall (north) is principally occupied by the larger objects formerly exhibited at Marlborough House, chiefly in the class of furniture. The copies from the frescoes of the loggia of Raffaelle, ought more properly to have followed in sequence with the rest of the specimens illustrative of mural decoration placed in the corridor; but the height of the pilasters would not allow of their being so placed. For the same reason the colossal statue of David, by Michael Angelo (plaster cast), has been unavoidably placed in the centre of this hall. This celebrated work was recently

moulded for the first time by the Tuscan government; and this cast (a present from the Grand Duke of Tuscany) will, for the first time, enable those who have not visited Italy to form a true conception of, perhaps, the most notable work in sculpture of the great Florentine artist. At the base of this cast is a small glass case, containing a collection of original models in wax and clay by the hand of Michael Angelo, being first thoughts or sketches for several of his most celebrated works: among them a small model in wax, about four inches high, is believed to be the first thought for the statue which towers above it. These models were purchased by Government three years ago, and have been already exhibited at Marlborough House.

—◦❥ ❧◦—

The east wing of the iron building, that which faces the visitor on his entrance, is called the Structure Gallery, being devoted to building materials of all kinds. A court is appropriated to specimens of ornamental art manufactures in various categories—especially rich Indian tissues, Chinese and Japanese porcelain and lacquered work, decorative arms, bronzes, damascene work, and oriental art generally. Another phase of the same art receives illustration from the gorgeous examples of Siamese workmanship lately brought over by the ambassadors of the King of Siam, and lent by the Queen to this Museum. In the same case is a sword sent by the King of Siam to Lord Palmerston, and by him presented to the Museum.

In the first of the north rooms under the Sheepshanks Gallery, are placed cases containing a series of enamels, a collection of Italian majolica, of Flemish stoneware, of Sèvres, Dresden, and other porcelain, and of Venetian and German glass. An altarpiece of Della Robbia ware, bas-reliefs and medallions of the same are placed on the walls; also a series of coloured photographs, representing some of the most important works of art in the Louvre and other French collections, such as Limoges enamels, crystal gold-mounted cups and vases, ivories, etc. A large chimney-piece, brought from Antwerp, with some of the moulded fire-bricks which formed its back, and a marble Italian fountain, are fixed against the walls. In the windows are specimens of stained glass, principally Dutch and Flemish, and a collection of framed drawings, executed by ancient artists of the school of Basle, merit especial attention; they are drawings or cartoons for heraldic window-glass, chiefly of the sixteenth century.

Behold yonder Venetian mirrors. Their peculiarity consists in having glass frames. Scrolls, volutes, and other ornamental forms, made of glass, being perforated, are screwed on. Upon the whole, gilt frames look more effective, but the Venetian glass frames must have been far more expensive. Perhaps the reader may not be aware of the fact that Venice was anciently celebrated for her manufactures in glass.

In the second room are cases of metal work, including jewellery, watches, armour, wrought-steel locks and keys, ecclesiastical and other goldsmiths' work;*

---

*Besides the permanent contents of the Art Museum, there are always on exhibition many valuable or curious specimens lent for a time by liberal private collectors. The kind example of the Queen has been well followed in this respect, and thus the Museum becomes the medium for obtaining for the people a view of art-treasures which would otherwise be hidden in the cabinets of the wealthy.

engravings of ornament, and examples of illumination from MSS. of the fourteenth and fifteenth centuries, are hung on the walls.

Wandering up and down the treasure store-house of pretty and rare things, avoiding system overmuch, yet obliged, by the very multitude of objects, to be in some degree systematic, we find ourselves among the ceramic curiosities. I am not much given to the use of hard names, and would adopt some more English word than the Greek *ceramic*, if I could lay my hand upon it. I cannot. Were I to say *crockery*, perhaps you would consider yourself warranted in excluding bricks and tiles, which would not at all answer my purpose. Well, we are amongst the crockery and ceramic ware. One of the many arts practised awhile by the medieval monks, was the manufacture of encaustic tiles. The product was very beautiful; several manufacturers essayed to revive it, but unsuccessfully, until the achievement of the late Mr. Herbert Minton, the result of which you see yonder.[5]

Hark! the gong strikes. We are summoned to depart. Don't tell me we have skipped hundreds of interesting things. I know it, and cannot help it. Art is long, and time is short, and paper has limits and so has patience, and so *ought* to have one's expectations and desires. Farewell, then, for to-day, to the South Kensington Museum.

## Fourth Article

THE southern portion of the iron building, or that nearest the road, is devoted to models, drawings, and descriptions of patented inventions. This department is under the separate management of the Commissioners of Patents, and being partitioned off from the rest of the exhibition, there is a distinct entrance in the centre of the Museum front.

### The Patent Museum

The object of the Commissioners in forming this Museum has been, first, to exhibit and illustrate the progress of inventions, such as that of the steam-engine, for the guidance of mechanicians and the instruction of the public; and, secondly, to open a library of all specifications and drawings of patents, from the earliest, in 1617, to the most recent entered under the new law.

The pleasure and advantage to be derived from the treasures here stored away, will vary according to the capacity of the observer for grouping and deduction. Without this quality, the Patent department will seem an uninteresting sort of place; with it, no one portion of the South Kensington Museum will perhaps confer an equal amount of satisfaction. It is a matter of no great interest, for example, that a mangle should be made with glass slabs for bearing planes working on glass rollers.

5. Herbert Minton (1793–1858): pottery manufacturer and pioneer of new ceramic materials, including Parian, majolica, and (in collaboration with Pugin) encaustic floor tiles. [Ed.]

Inasmuch as the smoothest possible surface is indicated for mangling purposes, glass would readily have suggested itself, and the man who first adopted glass for that purpose would seem to be no conjuror. True; but now reflect that until very lately the duty on glass would necessarily interfere with its application to this sort of mechanical purpose, and we come to view the glass mangle under quite another aspect. We come to speculate on the damage caused by fiscal regulations on materials of public utility. Filled with these reflections, the eye now wanders about and rests on a number of glass-made instruments with redoubled satisfaction. Yonder pump, for example, wherein a glass tube supplies the place of an ordinary leaden one, is worth thinking on. Occasionally a leaden pump cannot be employed for the pumping of certain kinds of water, without poisoning the latter. A glass-tubed pump may be used without danger; but ere the Chancellor of the Exchequer had been induced to drop the duty on glass, the drinker of such water must either have been poisoned, or he must have done without a pump.

Glancing next at the various screws, and models of screws, employed instead of paddle-wheels to effect propulsion of steam-vessels, there may not be much, if anything, to interest the mind, according to the opinion of a non-reflective observer. But when one comes to think that these little screws have not only changed the construction of every war ship, but have materially disturbed the relationship previously existing between the efficiency of maritime Powers, these screw models become interesting. I notice some which take two or three turns round: they were the first manufactured. I notice others which only take one turn round: they come next. I finally remark that marine screw-propellers now are hardly to be termed screws at all, except by courtesy; they are merely inclined vanes, very much like those of a windmill; and, what seems extraordinary, ships provided with these modern screw-no-screws go through the water all the better for the modification.

Some curious-looking pieces of fresh beef and mutton next challenge the wanderer's attention. The placard informs us they have been hanging there ever since January, 1858. Though in a glass case, they are nevertheless exposed to the air, and still remain quite sweet, and free from decomposition. To preserve fresh meat thus, has been made the subject of a patent, the principle of which is capable of easy comprehension. Putridity is nothing more nor less than a sort of fermentation; and it so happens that a certain gas—sulphurous acid gas—is potent to ward off fermentation. Accordingly, if fresh meat be exposed for a certain season to the agency of sulphurous acid gas, it is no longer prone to decomposition. Any method of preserving meat fresh for a long time together, is a great boon to the public. Salting is the ordinary method followed for the preservation of animal substances, as I need not inform the reader; but salting has its disadvantages. Persons who are restricted to salt provisions alone, for a long time together, soon discover that the agent adopted as a preservative of meat is by no means a preservative of health.

# Anonymous

— ◦❧ ☙◦ —

## Provincial Museums

THE formation of local museums has constantly been advocated by the highest scientific authorities; but notwithstanding all that has been written and said on the subject, there are as yet very few provincial towns in England which can boast of possessing a museum where the naturalist can study a complete series of specimens illustrating the geology and mineralogy of the surrounding district, or where the antiquary can see those relics of former ages which may at different times have been discovered in the neighbourhood.

Our provincial museums in general contain nothing but a heterogeneous mixture of curiosities, brought from all the four quarters of the globe; and if any specimens of local interest are comprised in the collection, they are either so much in the minority, or so intermixed with the miscellaneous productions of foreign lands, as to be rendered comparatively useless for purposes of reference.

The late Professor Edward Forbes, in one of his lectures, most admirably sketched the prevailing character of provincial museums.[1] He says: 'When a naturalist goes from one country into another, his first inquiry is for local collections. He is anxious to see authentic and full cabinets of the productions of the region he is visiting. He wishes, moreover, if possible, to study them apart—not mingled up with general or miscellaneous collections—and distinctly arranged with special reference to the region they illustrate. . . . In almost every town of any size or consequence, he finds a public museum; but how often does he find any part of that museum devoted to the illustration of the productions of the district? The very feature which of all others would give interest and value to the collection, which would render it most useful for teaching purposes, has in most instances been omitted, or so treated as to be altogether useless. Unfortunately, not a few country museums are little better than raree-shows. They contain an incongruous accumulation of things curious, or supposed to be curious, heaped together in disorderly piles, or neatly spread out with ingenious disregard of their relations. The only label attached to nine specimens out of ten is "Presented by Mr or Mrs So-and-so;" the object of the presentation having been, either to cherish a glow of generous self-satisfaction in the bosom of the donor, or to get rid—under the semblance of doing a good action—of rubbish that had once been prized, but latterly had stood in the way. Curiosities from the South Seas, relics worthless in themselves, deriving their interest from association with persons

Anonymous, "Provincial Museums," *Chamber's Journal of Popular Literature, Science, and Arts*, 36, 4th ser. 3 (1866): 218–222.

1. Edward Forbes (1815–1854): zoologist and paleontologist, lectured on natural history at King's College, the Museum of Practical Geology, and the University of Edinburgh. [Ed.]

or localities, a few badly-stuffed quadrupeds, rather more birds, a stuffed snake, a skinned alligator, part of an Egyptian mummy, Indian gods, a case or two of shells, the bivalves single, the univalves decorticated, a sea-urchin without its spines, a few common corals, the fruit of a double cocoa-nut, some mixed antiquities, partly local, partly Etruscan, partly Roman and Egyptian, and a case of minerals and fossils—such is the inventory and about the scientific order of their contents.'

Professor Forbes allowed, however, that several towns in England formed brilliant exceptions to this rule; and during the thirteen years which have elapsed since his lecture was published, it would be unjust to assert that no improvement has taken place.

Every provincial town ought to possess a collection of purely local specimens, and it is to the development of such museums that Professor Forbes looked, more than to anything else, for the future extension of intellectual pursuits throughout the land. Mechanics' clubs and scientific institutions are now so universal, that if the committee or council of each of these clubs were to set apart a small room in their building, or even fit up in their library or reading-room a glass-case for the reception of local specimens, such a collection would very quickly get formed; and not only would it serve to promote the study and love of science amongst the inhabitants of the district in which it is situated, but it would also most materially assist those geologists or antiquaries who may happen to be pursuing some special branch of inquiry, and may therefore be obliged to consult museums in different parts of the country, so as to enable them to compare the productions of one specific locality with those of another.

Thus, in the case of a geologist wishing to study the fossils of some particular district, it is often quite indispensable that he should have a local collection to refer to. The London museums (not excepting even the British Museum) cannot be expected to have a complete suit of specimens labelled and arranged, so as to illustrate the fossil remains, mineral wealth, and antiquarian treasures found in some given area; and if the chief town of the district is also deficient in this respect, by what means can the scientific visitor obtain that knowledge which it is necessary, and in many cases indispensable, for him to possess? He may indeed make the town his head-quarters, and thence take expeditions in different directions, and so endeavour, by traversing the country, to find out for himself as much as it is possible for him to do. But if—as it often happens—his time is limited, this is at the very best an unsatisfactory mode of proceeding; and a survey of this description can be neither a perfect nor exhaustive one.

If, on the other hand, a naturalist has a moderately good local museum to consult, he may, with the aid of a map, learn more in one hour, than by spending a fortnight in a succession of tedious, and perhaps expensive peregrinations, for in such a museum he would see specimens found by resident collectors, who have had the opportunity of noting the particulars of every discovery as soon as it is made, and who are able to watch carefully the progress and results of every fresh excavation, whether it be in quarries, tunnels, cuttings, drains, wells, or foundations for houses; and thus to accumulate, not only a large number of specimens, but also a quantity of valuable data, such as measurements of sections, drawings of contorted rocks, &c., which it would be impossible for any stranger to obtain for himself in a passing visit.

Suppose a tunnel for a railway is in course of formation. Whilst the work is in progress, a local collector has plenty of opportunities for taking measurements of the various strata through which it is cut, and will often find amongst the *débris* rare and valuable specimens. If these are preserved in a local museum, they become in a few years doubly valuable in the estimation of a geologist; for as soon as the tunnel is finished, and the débris carried away to form embankments, the place becomes inaccessible, and not another specimen can be obtained from that locality. The geologist will therefore regard those which are deposited in the museum with a double interest—first, on account of their intrinsic value for purposes of reference; and secondly, because they were found in a situation from which it is impossible that any more can be procured.

Another advantage of a local museum is, that it forms a safe depository, not only for photographs or drawings of neighbouring ruins, ancient camps, abbeys, stone crosses, &c., but also for certain kinds of portable antiquities, such as coins, weapons, seals, or pottery, found in the vicinity, which, if rare, choice, and in a good state of preservation, would otherwise get swallowed up in the omnivorous jaws of the British Museum; or, if less valuable, would probably find their way into the hands of individuals (not collectors), who would keep them for a short time as ornaments for the chimney-piece, only to consign them, when their novelty is gone, to the depths of the lumber-room.

In some places, the naturalist will find a private collector possessing a series of local specimens, arranged so as to make them of the greatest use in illustrating the productions of the neighbourhood; and thus in some degree he will be compensated for the loss of a public museum. In other places, he will find in operation the rival interests of both public and private collectors, each striving to outdo the other. Now, geological and mineralogical specimens are generally to be obtained in sufficient numbers to give both parties a chance of rendering their respective collections equally perfect—provided they use equal diligence in making their search; but when these emulative spirits come to deal with antiquarian relics, it becomes a serious question, to whose care unique specimens should be intrusted—which should carry off the spoil—the public museum, or the cabinet of the private collector.

If a local museum is to be established in a provincial town, or if one already existing is to be rearranged, it is most necessary, if the space is limited, to begin by making, at the very outset, a stringent rule not to accept any specimen unless it is found within a certain area or district, of which the town should be the centre. This area may be great or small according to circumstances, but for a town, a radius of from ten to fifteen miles will generally be found quite sufficient; or that for a collection in a city might be made co-extensive with the county of which it is the capital. In either case, the map published by the Ordnance Survey should be procured, and the exact limits of the district clearly laid down. This map, hung up in the museum, would not only serve the stranger as a guide to the geography of the neighbourhood, but would also shew at a glance the boundary-line, beyond which specimens cease to be regarded as local. If the space at command is unlimited, all specimens, local and non-local, may be received; but in order to make the collection of any real value, those which are found within the prescribed area should be placed distinctly apart from

all the others; they should be put in separate cases; they should be classed separately, and in every way treated as if they belonged to a different collection.

In the same manner, if an old museum is to be rearranged, it may not be possible, or even expedient, to make a clearance of all the non-local specimens, but the best and most satisfactory plan undoubtedly is to break up the existing arrangement, and begin *de novo*, putting together by themselves all those specimens which have been found in the neighbourhood. This apparently simple operation will, however, be found anything but an easy one, if the collection has hitherto been arranged according to a scientific system, and especially difficult if the specimens happen to be numbered with consecutive figures, for then this mode implies not only a complete rearrangement, but also the work of putting fresh numbers or labels to every individual specimen, besides making an amended catalogue. In such a case, the simplest thing to do is, to affix to each local specimen either a card or label bearing some conspicuous and distinctive mark to show its local origin. As an illustration of this mode of pointing out particular specimens, I may refer to the plan which is adopted in the public museum at Bern, where the arrangement of minerals is carried on in a continuous series of cases, extending from one end of the gallery to the other; and in these, minerals from all parts of the world are classified according to a scientific system, totally irrespective of their nationality. As a means, however, of calling especial attention to those specimens which have been found in Switzerland, a red cross, the emblem of the confederate states, is printed in a conspicuous position on their labels.

The other plan I have mentioned—namely, that of entirely separating the local from the non-local specimens, is best exemplified—though, of course, on a much larger scale—by the collection in the Ferdinandeum, or University Museum, at Innsbruck, where special rooms are set apart to contain all the natural productions of the Tyrol; and the rocks, minerals, and fossils of that most interesting district being arranged with special reference to the geology of the region they illustrate, can thus be studied without any interruption being caused by the miscellaneous collections with which the other parts of the building are occupied.[2]

2. Ferdinandeum: founded 1823. [Ed.]

# F. R. SANDFORD

—◦❧ ❦◦—

*Report on the System of Circulation of Art Objects on Loan
from the South Kensington Museum (1881)*

## Formation of Department

IN January 1852 the Lords of the Committee of the Privy Council for Trade de-
termined to create a Department of the Board of Trade, to be called the DEPARTMENT
OF PRACTICAL ART, to which should be entrusted the management of the Schools of
Design established in 1837 upon the recommendation of the Select Committee of the
House of Commons, appointed in 1835 to "inquire into the best means of extending
a knowledge of the arts, and of the principles of design among the people (especially
the manufacturing population) of the country."

Among the proposed objects of this Department was "the application of the
principles of technical art to the improvement of manufactures, together with
the establishment of museums by which all classes might be induced to investigate
those common principles of taste which may be traced in the works of excellence
of all ages."

## Opening of Museum

In furtherance of this object, THE MUSEUM OF ORNAMENTAL ART was opened
to the public on Monday 6th September 1852, in Marlborough House, Pall Mall,
which by permission of Her Majesty the Queen had been temporarily assigned for
the purposes of the Department. Here a suite of rooms was appropriated to the
reception and exhibition of a collection of examples of industrial art, purchased by
a Treasury grant of 5,000*l.*, from the exhibition of 1851; this collection was largely
supplemented by loans from Her Majesty the Queen and several other contribu-
tors, and with it were incorporated the articles of manufacture, casts, &c., which at
various times from 1838 onwards had been purchased for the use of the School of
Design at Somerset House. A library of books on art, prints, drawings, &c. occupied
other rooms.

In March 1853 the Department of Practical Art was merged in the newly created
DEPARTMENT OF SCIENCE AND ART, still, however, acting under the Board of Trade.

F. R. Sandford, *Report on the System of Circulation of Art Objects on Loan from the South Kensing-
ton Museum for Exhibition as Carried on by the Department from Its First Establishment to the
Present Time* (London: Science and Art Department of the Committee of Council on Education,
South Kensington, 1881).

## Removal of Museum to South Kensington

The Museum remained at Marlborough House till February 1857, when it was closed for the removal of the collection to a temporary iron building erected at the cost of Her Majesty's Commissioners for the Exhibition of 1851 on a site at Brompton, purchased by the Government from the Commissioners for the sum of 60,000*l.*, being a portion of the estate acquired by them out of the surplus proceeds of the Exhibition. This building was opened by the Queen, accompanied by the Prince Consort, on 22nd June 1857, under the name of THE SOUTH KENSINGTON MUSEUM.

Shortly before this removal the Department of Science and Art had by Order in Council been transferred from the Committee of Privy Council for Trade to the Committee of Council on Education.

## Art Circulation Established

In less than two years after the opening of the Museum at Marlborough House it was judged to have attained sufficient extension to admit of the carrying out of one of the principal objects of its formation, the circulation of specimens to the local schools of art in connection with the Science and Art Department;* accordingly the following circular was issued:—

BOARD OF TRADE, DEPARTMENT OF
SCIENCE AND ART.

August 1854.

*The Lords of the Committee of Privy Council for Trade are desirous that Local Schools of Art should derive all possible advantages from the Central Museum of Ornamental Art, and are prepared to afford assistance in enabling them to do so. Their Lordships are of opinion, that if articles belonging to the Central Museum were circulated among the schools of art, and publicly exhibited, the instruction given in the schools would be aided, the formation of local museums encouraged, the funds of the schools assisted, and the public taste generally improved.*

*With these views my Lords have directed that selections should be made of articles from each of the divisions of the Central Museum, comprising glass, lace, works in metal, ivory carvings, pottery, woven fabrics, &c.; and that they should be sent in rotation to local schools which make due*

---

*A system of circulation of objects from school to school had been in practice in the old Schools of Design some years before, but owing to defective organisation had been discontinued.

*application, and express their willingness to conform to the
following conditions:—*

*1. That adequate provision be made by the committee
of the local schools for exhibiting the collection, during a
limited period, to the students and the public, both in the
daytime and the evening.*

*2. That the committee of the school endeavour to add to
the exhibition by obtaining loans of specimens from the col-
lections of private individuals in the neighbourhood.*

*3. That the students of the schools be admitted free; but
that all other persons, not students, pay a moderate fee for
admission, which should be higher in the morning than the
evening. To enable artizans, and others employed in the day-
time, to share in the benefits to be derived from the collec-
tion, the fee on three evenings in the week should not exceed
one penny each person.*

*4. That any funds so raised should be applied, — 1st, to the
payment of the transport of the collection to the school, and
other expenses of the Exhibition; and 2nd, that the balance
be appropriated in the following proportions, namely; one
quarter to the masters' fee-fund; one-half to the purchase of
examples for a permanent museum, &c.; and one quarter to
the general fund of the school. Committees of schools desir-
ing to receive the collections are requested to make applica-
tion in the accompanying form.*

<div style="text-align: right;">

(Signed)  HENRY COLE.
LYON PLAYFAIR.[1]

</div>

*Marlborough House, 11th August 1854.*

# First Circulating Collection

A small but comprehensive collection of about 430 specimens, and 150 framed
drawings, photographs &c., was at once formed, and in February 1855 this was first
exhibited at Birmingham.

The Collection, which was enriched by several fine examples of Sèvres porcelain
lent by Her Majesty, was accompanied by an experienced officer of the depart-
ment, who remained in charge during the period of exhibition in each town. It was
contained in five glazed cases, so constructed as to fit together and form a stand,
occupying a ground space of 12 feet by 6 feet; the base being formed of square

---

1. Cole: see authors and speakers. Lyon Playfair, first Baron Playfair (1818–1898): politician, influen-
tial scientist, and education and civil service reformer. In 1853 Cole was appointed secretary of art
and Playfair secretary of science in the newly constituted Department of Science and Art. [Ed.]

boxes, in which the objects were packed when in transit. In addition to these cases, were seventy glazed frames, for the display of textile fabrics, lace, photographs, etc., which were furnished with stands, the whole being so contrived as to admit of ready packing. A carriage or truck constructed especially for the purpose, and adapted to travel on all railways, contained the collection and all appliances. A descriptive catalogue of the collection, with a brief historical account of each class of art manufacture was provided and sold for fourpence.

The efforts of the committees of the various local schools of art usually led to additional loans of art treasures from owners in the neighbourhood, and it was shortly found desirable to ensure the proper exhibition and safe custody of these by providing suitable cases, constructed on the same model as those designed for the circulating collection itself. This provision led to increased readiness on the part of owners of valuable objects to send them for exhibition, and numerous instances occurred of loans being permitted to be retained long beyond the period originally intended by the contributors, and to be taken with the collection from town to town.

At the close of 1859 the collection, which had been constantly in circulation for nearly five years, and had been exhibited in 26 of the principal towns in England, Scotland, and Ireland, was brought back to South Kensington in order that it might be re-organised on a more extended scale.

The following minute was passed with reference to its future management:

CIRCULATION OF OBJECTS OF ART
IN THE PROVINCES.

At South Kensington, the 29th day of March 1860.

*By the Right Honourable the Lords of the Committee of Her Majesty's most Honourable Privy Council on Education.*

*Read the Minute of the Lords of the Committee of Privy Council for Trade passed in August 1854, expressing their Lordships' desire that Local Schools of Art should derive all possible advantages from the Central Museum of Ornamental Art, and their willingness to afford assistance in enabling them to do so. Their Lordships were of opinion that if articles belonging to the Central Museum were circulated among the Schools of Art and publicly exhibited, the instruction given in the schools would be aided, the formation of local museums encouraged, the funds of the schools assisted, and the public taste generally improved; and with these views they directed that selections should be made of articles from each of the divisions of the Central Museum, comprising glass, lace, works in metal, ivory carvings, pottery, woven fabrics, &c., and sent in rotation to local schools which made due application, and expressed their willingness to conform to certain conditions. A travelling collection was accordingly organised, to which Her Majesty the Queen most liberally contributed valuable objects.*

*My Lords also read the report of the Superintendent of the Art Collections, from which it appears that the travelling collection has been sent to different parts in the United Kingdom, that it has been visited by 359,125 persons (of whom a large number were Art-students), and that it has realized in fees, which have been received by the local authorities, upwards of 8,352l. 18s. 1d. Although the most fragile articles, such as Sèvres porcelain and glass, have been transmitted at least 3,690 miles by railway, &c., and been packed and unpacked more than 60 times, no specimens have been broken or damaged.*

1. *This experiment having shown that the use of national property in works of art may be extended to all parts of the United Kingdom, and the National Collections of Art of the Science and Art Department having been greatly enlarged by the liberality of Parliament, my Lords consider that the system should be revised, enlarged, and made as self supporting as possible. In future, in consequence of the liberal gift of Mr. Sheepshanks, it will be possible to add pictures and engravings to the classes of objects to be circulated, and it will also be possible, in addition to the travelling collection already organised, to get together other special series, some of which may be specified as follows:—*

1. *Engravings of the English School.*
2. *Wood Engravings, Ancient and Modern.*
3. *Drawings and Engravings illustrative of Wall Decoration.*
4. *Illustrations of the History of Painted Glass.*
5. *Textile fabrics, Mediæval and Oriental.*
6. *Ancient and Modern Pottery.*
7. *Ancient and Modern Glass Wares.*
8. *Works in Metal.*
9. *Furniture and Carvings in Wood, illustrated in addition by Photographs and Drawings.*
10. *Water Colour Drawings and Sketches.*
11. *Oil Paintings by Ancient Masters.*
12. *Oil Paintings by Modern Masters.*
13. *Engravings and Etchings, Ancient and Modern.*
14. *Modern Continental Contemporary Art Manufactures.—Bronzes, Pottery, Jewellery, &c.*
15. *Reproductions of Works in Metal, Fictile Ivory, &c.*
16. *A Selection of the Publications of the Arundel Society.*
17. *British Museum Photographs.*
18. *Photographs of Raffaelle's Cartoons.*

19. *Photographs from Drawings by Ancient Masters.*
20. *Photographs of objects of Decorative Art, chiefly in Foreign Museums and Private Collections (several series).*
21. *Photographs of Paintings, Wall-Decoration, &c., and Drawings of the same.*
22. *Architectural Photographs and Drawings.*

2. *Hereafter the conditions under which the principal travelling collection will be circulated to Schools of Art, will be as follows:—*

3. *Adequate provision must be made by the committee of the local school for exhibiting the collection, during a limited period, to the students and the public, both in the day-time and the evening; such provision to be first approved by the Department.*

4. *The committee of the school must endeavour to add to the exhibition by obtaining loans of specimens from the collections of private individuals in the neighbourhood.*

5. *Artizans being students of the School of Art must be admitted free; but all other persons must pay a moderate fee for admission, which should be higher in the morning than the evening. To enable artizans, not students in the School of Art, and others employed in the day-time, to share in the benefits to be derived from the collection, the fee on two evenings in the week is not to exceed 1d. for each person.*

6. *The funds derived from the exhibition of objects must be charged with the following payments, which are to be made through the Department officer in charge.*

    *a. All expenses of the carriage of objects to the exhibition, from the last place of exhibition.*

    *b. One pound a day to be paid towards the expenses of the officer in charge, while employed in unpacking, arranging, and repacking the collection, and for each day's attendance while inspecting the collection, at such intervals as may appear to him necessary.*

    *c. Before final arrangements are made for sending the travelling collection to any School of Art, the officer in charge will visit the locality should it appear necessary, in order to consult with the committee of management of the school, and to ascertain the extent of the accommodation that can be provided for the exhibition. If required he will assist the local committee in obtaining loans of works of art from local proprietors, and*

> *generally give the benefit of his experience to the*
> *committee, so as to ensure, as far as may be pos-*
> *sible, a successful result. He must be ex-officio a*
> *member of the local committee of management.*
> d. *The remaining balance of the surplus will be at*
> *the disposal of the local committee.*
>
> 7. *Special collections (alluded to in clause 1) will be cir-*
> *culated from the Central Museum, subject to such of the*
> *above regulations only, as may be applicable in the respec-*
> *tive cases.*
>
> 8. *Committees of Schools desiring to receive the collec-*
> *tions are requested to make application on the accompany-*
> *ing form, and all communications, &c. must be addressed to*
> *the "Secretary," South Kensington Museum, London, W.*
>
> 9. *Exceptional applications from localities where no*
> *School of Art is established, can only be considered to a limited*
> *extent, and dealt with according to the merits of each case.*
>
> *By order of the Committee of Council on Education.*

In June 1860, a special Committee of the House of Commons was appointed to inquire and report concerning the South Kensington Museum. The following passage is taken from the Report of this committee:

> 5. *The objects have not been merely exhibited in the*
> *Metropolis, but a system of circulation first recommended*
> *by the Committee of 1836, has been matured, and very suc-*
> *cessfully carried into effect by means of a travelling museum,*
> *the exhibition of which offers many advantages to schools*
> *and museums in provincial towns.*
>
> *Her Majesty has been pleased to allow objects of great*
> *value and very fragile nature, such as Sèvres porcelain, to be*
> *circulated in this manner; and her example has been followed*
> *by many private gentlemen, benefactors to the Museum. It is*
> *remarkable that although the collection has travelled through*
> *the United Kingdom, and been packed and unpacked 56*
> *times, not a single article has been lost or broken.*

### Second Circulating Collection

The newly arranged and much enlarged Travelling Collection was again sent out in June 1860. It now comprised 600 examples of art manufactures, illustrating each of the classes in the South Kensington Museum, together with 300 framed drawings, photographs, &c. A new edition of the descriptive catalogue, with historical notes on the chief art industries, was prepared to accompany the collection, and to be on sale in each of the towns in which it should be exhibited. For the next three years the travelling collection continued to be sent from town to town.

## Extension of System of Circulation

By 1864 it was apparent that however valuable the travelling collection had been at first it had now done its work. It had been exhibited in all parts of the Kingdom for nearly 10 years, and a general desire began to be expressed by managers of provincial exhibitions for greater variety and novelty in the contributions from the Museum, and especially that the objects sent might be selected with special reference to the various industries of the localities in which the exhibitions were held; *e.g.*, that pottery might be more fully represented at Stoke-upon-Trent, metal work at Sheffield, and lace at Nottingham. In order to meet this desire the collection had already on various occasions been supplemented by other examples, and several special loan collections had from time to time been sent out for short periods, in accordance with Clause I. of the Minute of 29 March 1860.

A Select Committee of the House of Commons had been appointed early this year to inquire into the constitution and working, and into the success of the Schools of Art supported or assisted by the Government. In the Report of this Committee presented on the 8th July 1864, the following passages occur:—

> "There can be no doubt that the fine collection at South Kensington is calculated to raise the taste of the country, or, at all events, of those persons who are able to visit it; but it is equally certain that it is only a small proportion of the provincial public which has the opportunity of doing so, and it appears that the arrangements made for circulating portions of the collection to the provincial towns are as yet far from perfection. That the collection of works of Art, and the library attached to it, are not made as useful to the country schools as they might be, is due, perhaps, in part to the fact that the local committees are but imperfectly aware of the advantages which the Department offers them, but partly also to some defects in the arrangements of the Department itself. Mr. Cole suggests some relaxations of the conditions under which works of Art are lent to the provincial schools, which he thinks might induce the local committees to borrow them more freely than at present. He also throws out some valuable suggestions as to the formation of local museums, to be supported in great part by a system of circulating some of the works of Art belonging, not only to South Kensington, but also to the National Gallery, and the British Museum. These suggestions are well worthy of consideration."
>
> "Resolved that the collection of works of decorative Art at South Kensington be made more generally useful than at present throughout the country, especially in connexion with local museums."

Prior to the appointment of this Special Commitee the Lords of the Committee of Council on Education had determined that the extent of the Museum collections

admitted of still greater freedom in the selection of examples for loan, and on February 11, 1864, the following minute was passed:—

> *"All works exhibited in the Central Museum which can be lent and removed with safety are available for temporary exhibition to the public in Local Schools of Art for short periods."*

## System of Circulation in Force since 1864

From the date of this minute up to the present time the system of making a special collection of objects for each loan collection sent out from the Museum has been uninterruptedly followed. During the 17 years, 1864 to 1880 (both included). 258 collections have been sent out by the Department, many of them as loans to permanent museums. In most cases these collections have been largely supplemented by other loans drawn from the neighbourhood in which the exhibition was held. Sometimes, indeed, the Department contribution has been comparatively unimportant as compared with the extent and value of other loans, but even in these instances the example of arrangement and labelling, and the precautions for security, safe packing, &c., the result of long and varied experience, cannot have failed to be of service to the promoters of provincial exhibitions. Owners of works of industrial art, paintings, &c. are more ready to entrust their valuable possessions to a committee when they find that a Government Department has rendered substantial aid to the project, and thus proved its confidence in it.

## Extension of Loans to Corporation Museums, &c.

The rule requiring that all museums or other institutions must be connected with schools of art in order to be entitled to loans for exhibition having been found to exclude some institutions eminently deserving of such aid, the following Minute was passed on 17th June 1880:—

> *"In order to facilitate the circulation of suitable museum specimens for exhibition on deposit loan (for six months or one year) in the great centres of manufactures, application from corporation museums, either as such or in connexion with free libraries, are to be placed on the same footing as applications from schools of art, or museums in connexion with such schools. As usual each application is to be considered upon its own merits."*

## Other Contributions on Loan to Schools of Art, &c.

Since 1857 there has also been in operation a system of lending to the Schools of Art, in connexion with the Department, examples of oil paintings and water-colour

drawings suitable for copying, for the exclusive use of the students, and 764 such examples are now set apart and circulated. Thirty-two cases have also been prepared for the use of students in these schools, each containing a small selection of objects of art, such as electrotypes, pieces of figured damask, cut velvet, and other textile fabrics, stone-ware vases, etc., suitable for forming groups, from which studies in form and colour ("still life") may be painted. Besides these, numerous loans of art examples have constantly been made to the Schools of Art, not only for use in the instruction of the students, but also for exhibition for brief periods, generally one or two days only, at annual meetings of schools, prize distributions, and similar gatherings; 106 schools were thus aided in 1880.

The more costly books on art are also lent from the library of the museum to the provincial Schools of Art.

## Loans for Exhibition and for use in Schools of Art in 1880

In 1880 it appears that contributions of examples of industrial art to the number of 1,346, and of paintings, drawings, and other framed matter to the number of 1,286, have been lent to seven permanent museums for the full period of twelve months, while 1,929 objects and 1,975 paintings, drawings, &c., have been lent to twelve museums and other institutions for an average period of 51 days each, to which period must be added at least 14 days occupied in packing, unpacking, carriage, &c. The loans to Schools of Art during the year, for copying, and for exhibition for brief periods at annual meetings, &c., amount to 1,942 examples of industrial art, and 2,611 oil paintings, water-colour drawings, and other framed matter.

Hence 5,217 objects and 5,872 pictures, &c., in frames have been sent out from the parent Museum during the year.

## Demand for Loans, How Met

This great demand is met:

FIRSTLY, by such objects as readily admit of division. Pairs of ear-rings, of candlesticks, of vases, &c., are treated as two distinct objects when acquired, one example being thus readily available for circulation. Portions of textile fabrics, laces, &c., which admit of cutting without actual injury are taken for the same purpose.

SECONDLY, by selection from examples exhibited in the museum cases. This withdrawal is yearly practised to a great extent in consequence of the demand for variety and novelty in the annual contribution to the permanent provincial museums. In the gap thus caused labels are placed naming the towns to which the missing objects have been lent, and the frequency of these labels shows how thoroughly the minute of 11th February 1864 has been acted on.

THIRDLY, by reproductions by the electrotype and other processes, of original examples of gold and silversmith's work, &c., in the South Kensington Museum, and other collections, both public and private. Three electrotype copies are always made of each example, one to remain as a type piece, and to be exhibited in the museum,

the others for circulation. The system of electrotyping suitable examples, which was adopted in the earliest days of the art collection at Marlborough House, when copies of all the best examples of metal work in the museum were made expressly for loan to the Schools of Art, has of late years been greatly developed. At present the museum possesses copies of examples of metal work in gold, silver, and bronze, including the regalia in the Tower of London, the Royal plate at Windsor Castle, and the Knole Park collection of old English plate, which for all purposes of art study are little, if at all, inferior to the originals, and a list has been prepared of many other fine examples, English, and foreign, in various Imperial and Royal Treasuries, Continental museums, colleges, Inns of Court, and other public and private collections, for which permission to copy has already been granted, and which will be put in hand year by year as each annual parliamentary grant for the cost of reproductions becomes available.

Other modes of reproduction are by casts in "fictile ivory" (plaster saturated with wax) of ivory carvings. Of these the Department possesses an extensive series, representing not only all the best examples in the museum, but also many of the most important ancient and mediæval carvings in ivory in the public and private collections of Europe.

Coloured photographs are frequently made of enamels, tapestry, porcelain, and other examples of art workmanship, which do not admit of more direct imitation.

It will be readily seen that the advantage derived by a provincial museum from the system of annual loans is greater than would be conveyed by a money grant from the State; variety is secured, an important consideration where many of the visitors must be drawn from a fixed population, which, as the experience of many museums, both English and Continental, has shown, will not continue to be attracted by a permanent and unchanging exhibition, however good it may be. Authentic and well chosen examples of industrial art are shown which it would be difficult, if not impossible, to purchase at the present time, when the desire for such objects is so widely spread. The tendency to settle down into a mechanical routine, with little attention to dusting, cleaning, labelling, &c., which once characterised some of the smaller provincial museums is counteracted by the periodical call for renewal and re-arrangement, while the modes of displaying and labelling objects in the loan cases, serve as examples of the latest results of experience at the parent museum.

## Provision for Safe Transmission and Custody of Loans from the Museum

The vans now used by the South Kensington Museum for the conveyance of objects sent out on loan are constructed upon the principle of those first designed in 1866 for conveying to Paris the valuable loan collection of paintings and art treasures sent to the History of Labour Section of the Exhibition of 1867. As it was necessary that these vans should travel equally well by road, by rail, and by steamboat, without their being opened or the contents disturbed from the time of packing until they reached their destination, full details were first ascertained by an officer of the Department of the maximum dimensions allowed by the various railways,

English and Continental (including the heights of tunnels and arches), of the limits of weight by passenger train, the capacities of cranes for shipping and unshipping, and so on, and the vans were then constructed in accordance with these conditions. The delays, risks, and uncertainties of travel by goods train, which was at first the only mode available, were found to be so great that it was evidently indispensable that the vans should always be sent by passenger train, the more so as a museum officer must always accompany each. After considerable negotiation the various railway companies conceded this point, and have now generally agreed to a freight per van of sixpence a mile, besides the charge for weight.

Glazed cases are always provided by the Department in which all loans to provincial museums, &c. are exhibited, and every selection of objects for loan is made so as to fill one or more of these with due regard to appearance. They are of ebonised wood and plate glass, and while so nearly dust proof that they may be left closed for a year without the contents requiring cleaning they admit of being taken to pieces and packed flat for travelling. All are under two sets of locks, the keys being entrusted to no one but South Kensington Museum officers. Hence when a collection has been once arranged, either as a temporary loan or as a deposit loan for a year in one of the permanent museums, thus aided, the attendance of a Department officer with the key is necessary before a case can be opened. This regulation not only ensures greater safety of the objects, but also lessens the responsibility of the local authorities.

## Precautions against Fire

The art treasures of the South Kensington Museum are not insured against fire, either when at home or when on loan. The premiums charged for the insurance of such fragile objects would doubtless be very high, and the sum total would be a heavy permanent charge on the Department, while no money could possibly replace many of the objects. It has, therefore, been thought best to spend this money in guarding as far as possible against all risks. Within the museum all possible precautions are taken, and when the loan of a collection is applied for by a provincial institution, careful inquiries are made, and in any case of doubt an experienced museum officer is sent to report on the nature of the building in which the exhibition is to be held, and on the precautions against fire, before the loan is finally authorised by the Department.

## Catalogues and Handbooks

So long as the circulating collection was kept together, a descriptive catalogue, with brief historical notes on the chief divisions of Industrial Art comprised in it, was provided and sold at each place at which it was exhibited. The number of copies sold between February 1855 and June 1863 exceeded 35,000. When, however, a different collection was made for each exhibition, it became impossible to furnish a printed catalogue except in one or two important cases where the probable sale justified the

cost. Each object bears a descriptive label, and full particulars of the museum contributions are furnished to the managers of provincial exhibitions, who occasionally themselves undertake the publication of a comprehensive catalogue.

In order to supply the demand for some popular aid to an intelligent appreciation of the collections, both in the parent museum and on loan, the Lords of the Committee of Council on Education have caused a series of illustrated handbooks to be prepared by competent authors. One of these volumes, "The Industrial Arts" treats briefly of each of the chief divisions of the subject, and thus serves as a general introduction. Other volumes enter more fully into detail, each being confined to one subject only, as glass, majolica, bronzes, furniture, &c. Several others are in preparation. The volumes are published under official sanction by Messrs. Chapman and Hall (Limited), and are sold in all museums and institutions connected with the department at lower prices than those at which they are issued to the general public. The publishers undertake to send a supply for sale in each provincial exhibition to which the department contributes.

## Duplicates

As has already been stated it has been the practice to treat as two or more objects all examples acquired by the South Kensington Museum which occur in pairs or sets, such as candlesticks, firedogs, knives, spoons, vases, and many articles of personal jewellery, as bracelets, buckles, and earrings. Such might be considered as duplicates. Exact duplicates also frequently occur in pottery and glass vessels, ornamental tiles, &c. Besides these every museum will inevitably possess a large number of objects closely resembling each other, and to which the term duplicate may for all practical purposes of art instruction be applied, though it would, perhaps, be denied them by the connoisseur or the collector. Classified lists of all such objects as are practically duplicates have been prepared for official use, but it will not be thought necessary to include the lists in this Report when it is borne in mind that the supply of art objects for circulation does not depend in any degree on these alone, but is, in accordance with the Minute of 11th February 1864, drawn from "*all works exhibited in the central museum which can be lent and removed with safety.*"

## Summary

From what has been said it will be seen that the South Kensington Museum exists, not wholly, nor even chiefly, as an institution for the exclusive advantage of the dwellers in, and visitors to London, but that it is in truth also a great National Collection or store-house, formed and administered for the benefit of the whole kingdom. This has from the first been the intention of the official chiefs, both political and permanent, by whom it has been governed, and every development of the original scheme has tended to bring this principle more prominently forward. Nine permanent museums, and on an average ten other public exhibitions, are yearly aided, in addition to numerous and constant loans to the Schools of Art. No inconsiderable

proportion of the cost of the maintenance of the Museum is incurred in spreading a knowledge of the principles of design, as applicable to manufacture and decoration, by bringing the best examples before the eyes of dwellers in all parts of England, Scotland, and Ireland. It has, in the first instance, got together a vast collection of objects of art workmanship of all ages and countries, and has then led the way in devising the best modes of conveying, arranging, and displaying them with security. By its example it has inspired the owners of similar treasures with confidence, and has in consequence enlisted the voluntary and generous co-operation of very many who would otherwise have hesitated to incur the risk of lending their most valuable possessions, often cherished heir-looms, for the education of the art workman, and of the general community. It is believed that not fewer than 170,000 loans of examples of fine and industrial art have thus been made by private owners to the various Art Exhibitions with which the Department has been connected since 1854.

## Chapter Seven

# REFORM AND THE PSYCHOLOGY
# OF MUSEUM ATTENDANCE

While much of the discussion of the nature and structure of museums in the nineteenth century was produced in response to particular crises, perceived or real, this great period of museum development was bound to inspire more general responses to the institution. This chapter includes two representative instances of critical reflection on what had been attempted and what might yet be.

John Ruskin's "On the Present State of Modern Art, with Reference to the Advisable Arrangement of a National Gallery" (1867) attempts to distinguish some of the very elements earlier proponents of the museum had brought together in

FIGURE 7.1 "Holiday Time: British Museum." *Illustrated London News*, April 12, 1873.

order to make their claims for the value of rational amusement—that is education, entertainment, and wonder. William Stanley Jevons's "Use and Abuse of Museums" (1883), an important work of nineteenth-century museology by a noted economist, presciently begins with the fundamental question not of the content or form of display, but of the psychology of museum attendance. For all their differences, both writers recognize the challenges to individual attention presented by institutions of display. For both, proliferation and expansion call for drawing more effective distinctions among the categories of museums and among the aspirations of particular institutions.

## JOHN RUSKIN

—◦❧ ☙◦—

### On the Present State of Modern Art, with Reference to the Advisable Arrangement of a National Gallery

I pass next to the chief subject of our inquiry—the proper arrangement of public educational collections. Such institutions as they should be distinct from places of public amusement on the one hand, so they should be distinct from national museums on the other. I will read on this point a piece of a letter written to the *Times* last year:*—

"There is a confused notion in the existing public mind that the British Museum is partly a parish school, partly a circulating library, and partly a place for Christmas entertainments.

"It is none of the three, and I hope will never be made any of the three. But especially and most distinctly it is not a 'preparatory school,' nor even an 'academy for young gentlemen,' nor even a 'working men's college.' A national museum is one thing, a national place of education another; and the more sternly and unequivocally they are separated the better will each perform its office—the one of treasuring, and the other of teaching. I heartily wish that there were already, as one day there must be, large educational museums in every district of London freely open every day, and well lighted and warmed at night, with all furniture of comfort, and full aids for the use of their contents by all classes. But you might just as rationally send the British public to the Tower to study mineralogy upon the Crown jewels as make the unique pieces of a worthy national collection (such as, owing mainly to the exertions of its maligned officers, that of our British Museum has recently become)

John Ruskin, "On the Present State of Modern Art, with Reference to the Advisable Arrangement of a National Gallery" (1867), *The Complete Works of John Ruskin*, Library Edition, ed. E. T. Cook and Alexander Wedderburn (London: George Allen, 1903–1912), 19: 197–229 (excerpts).

*A letter from Ruskin himself in the *Times* of January 27, 1866.

the means of elementary public instruction. After men have learnt their science or their art, at least so far as to know a common and a rare example in either, a national museum is useful, and ought to be easily accessible to them; but until then unique or selected specimens in natural history are without interest to them, and the best art is useless as a blank wall."

This being so, there are three kinds of national collections which it is desirable should be arranged especially for educational purposes:—

1. Libraries.
2. Educational Museums of Natural History.
3. Educational Museums of Art.

First, of Libraries. The British Museum ought to contain no books except those of which copies are unique or rare. All others should be arranged in smaller public libraries for familiar use with excellent attached reading-rooms, and access to the Museum reading-room should be a matter of higher privilege.

One of the worst sources of [the corruption*] of the national temper and intellect is in the irrigation of it by foolish and evil writing overflowing. The Greek Parnassus was of living rock and its Helicon of living waters; but our Parnassus is like the Rossberg, of rolled pebbles and worn fragments, and by the weight of it squeezing out streams of slime. And the thing needing to be done is the selection by our Universities of a series of virtuous, vigorous, helpful, and beautiful examples of literature, not many, but clearly enough for any man's life, and the publication of them in a perfect form, and the founding of a public library in every important town, which should contain this series at least, and copies enough of these to supply all the readers, with reading-rooms attached, into which the entrance should be matter of some difficulty and honourable privilege, yet free on certain conditions to all.

Similarly, we require the selection by our Universities, and the purchase by Government, of a limited series of engravings and casts representing works of art of exclusive and high merits, such as in every respect might form and guide the mind of the student contemplating them; and these, so limited in numbers as to permit attention to be given to every one, and all to be well remembered as parts of a relatively collected whole, should form a small museum in connection with every such public library, and an explanatory catalogue be prepared for them stating whatever facts respecting each it was desirable for the student to know. Farther, every one of our principal cities ought to have a permanent gallery of art of which the function should be wholly educational, as distinguished from the historical and general purposes of the collections in the British Museum and National Gallery. And this should be done under the clear understanding that the utility of an educational collection depends not on its extent, but, first, on the absolute exclusion of all works of secondary merit or of trivial character (so that the full strength of trusting and faithful admiration might be given to whatever was exhibited); and, secondly, on the easy visibility and pleasantly decorous presentation of the works of art contained in them, and on the general comfort and habitableness of the rooms.

*[The words "of corruption" are here conjecturally inserted; there is a blank in the MS.]

(2.) Secondly, Educational Museums of Natural History. The Natural History Collection in the British Museum should be as complete as it can by any cost or research be made, but it should contain no inferior or duplicate specimens, and its arrangements should be calculated for scientific reference, not for exhibition. It should only be for the use of advanced students in every science. But the Educational collections of Natural History should be arranged so as to attract and reward inquiry; they should be disposed for exhibition with the utmost convenience and elegance, and elaborately catalogued, with references to the best farther description of each class of objects exhibited. Small libraries containing such books only, should be attached to the collections, with suites of reading-rooms; and while a certain part of the series of exhibited objects was permanent and not permitted to be handled, a sufficient number of inferior specimens replaceable from time to time should be kept in cabinets connected with the reading-rooms, and of these inferior specimens the curator should have the power of permitting quite free experimental use to such students as he might judge deserving of the trust.

(3.) Lastly, I come to Schools of Art. And here a quite new consideration introduces itself. In natural history your specimens can only be more or less instructive, they can never be the reverse of instructive. But specimens of art either lead or mislead; there is in these a positive good and a positive bad, and the first condition of your being able to establish a School of Art at all is that you should clearly know one from the other. There is this farther difference also, and a very essential one. While in natural history, if you exclude useless duplicates, you cannot for representation of varieties have too many specimens; in art, you can hardly have too few. The good a student gets from the examination of any work is most strictly proportioned to the strength of feeling and closeness of attention he gives to it, and the feeling will not come at first, nor perhaps for a long time. Your great object should be to fasten this, the student's attention, on the examples required for his help, and then not to distract it. He will get three times as much good from one piece looked at for half-an-hour, as from three looked at for ten minutes each. And, lastly, here is a third and no less vital distinction. In natural history, though good specimens of characteristic average quality are on the whole most useful, it is well occasionally to see the finest types of every species. But in art it is often injurious to see the highest kind until you are ready for them. Not indeed if, as in times of energetic art life, the highest be everywhere a common food: men then take of it, naturally, just as much or little as they like—that is to say, as much or little as they should; but when it is presented to them rarely, and they try to compel themselves into liking it or learning from it—being all the while wholly incapable of entering into its true qualities—it falsifies their whole nature and is mere poison. I could give you some curious personal experiences on this matter, but I must keep to the business in hand.

Our object, then, in the Educational Art Schools should be to arrange a series of specimens, all first-rate of their kind, but for the most part of a description intelligible to the ordinary student—drawings before engravings, for instance, and engraving before painting, and bold dramatic sculpture before refined ideal sculpture—keeping all the highest works of art without any exception in the National Gallery, and only allowing them to be copied or studied from as matter of high privilege.

Now to bring these conditions into practice. The first is that you should have no bad art visible anywhere.

This is the great mischief in the Kensington Collection. It is full of precious and instructive things, but they are surrounded by the vilest, and the very aspect of these, even if not chosen for imitation, prevents the qualities of the good ones from being felt. Who is to judge of relative merit, you will ask. Well, the point is simply this: if you cannot find among the upper and educated classes of England a small body of men so far informed on the subject of art as to agree what are its mainly desirable and what its undesirable qualities, you can have no art schools. You can only have a confused museum of objects acquired by chance, out of which the student must learn what he can discover by chance.

I do not think, however, that there would be any real difficulty in this. Once fix your principle, that no bad or even gravely deficient art is to be admitted into the educational collections, and you will easily by vote of committee be able to cleanse and purify them to a most wholesome and vivifying extent. And the thing I should like to see done is mainly this. Let a certain not extensive but carefully chosen series of casts from sculpture and coins, of photographs from architecture, drawings and natural objects, and of engravings of standard value, be fixed upon as the basis of the educational collection. Let this established series be carefully catalogued, described, and arranged in illustrative order, and let every town possessing an art school do what it can to obtain the nucleus of this appointed series of which each piece should be everywhere known by its unalterable number, so that in discussion and writing about art Number so-and-so of the school collection should be as recognised a piece as the numbered Sonata of a great composer. Farther, as in the natural history collections inferior specimens, so in these art collections duplicate copies of the prints, casts, and photographs should be kept for close examination and free use: many private persons would gladly contribute from their stores for such purpose when once they knew what was wanted; while reflectively the importance attached to the authoritative examples chosen for the main school collection, would make private persons interested and eager in the possession of the same, and would act strictly as a teacher in every household.

Then for crown to this established series, whatever was obtainable of good painting, sculpture, and decorative art ought to be exhibited in a beautiful and attractive way; but only what was good and beautiful. I would insist much on this principle of severe selection—one good piece of art is a school in itself; surround it by a dozen of bad ones, and it becomes useless.

And now, lastly, we come to the National Gallery or Museum of Art—the Treasury and Storehouse, not the school; respecting which the great law should be that while everything was perfectly accessible to the persons who really needed sight and use of it, nothing should be exhibited to the public confusedly and vainly merely for the sake of showing it was there, but that all the most precious possessions should be exhibited with every beautiful accompaniment and accessory that could either do them honour or prepare the temper of the spectator for their meaning. Your National Gallery must be a stately place—a true Palace of Art, pure in the style of

it indeed, and, as far as thought can reach, removed from grossness or excess of ornament, but not unsumptuous, especially precious in material and exquisite in workmanship, and having the places of all its chief possessions unalterably decided upon, so that they can be at once treated with right harmony of effect. Classification, in a National Gallery, should be boldly kept subordinate to the convenience of finding a thing where you expect it to be, and in a place which becomes it. I don't care what the connection of things is, so only that they be not kept for years in dark corridors or plank outhouses. Build beautiful rooms for what you have got, let the things take up their abode therein, and when you get anything else like them, build another room for that, and don't disturb what you have already.

Therefore, while a National Gallery should always be stately and lovely, it should not be limited by symmetries of plan. It should look, in a word, what it is—a gallery, capable of being extended without limit in any convenient direction; and as in any great metropolis it may be assumed that ground is valuable, a National Gallery may always advisably consist of three stories—the lowest for sculpture, the second for the libraries and prints, the third, lighted from above, and, where needful, laterally also, for the paintings, vases, gems, and coins. And these three stories might, in the external design, bear to each other somewhat the relations of the nave arches, triforium, and cloister of a cathedral; or, if the design were Italian, might be beautifully proportioned in any convenient dimensions. Design the walls or arches of such an elevation gracefully for two compartments, and you may prolong the same design for miles, if you need it, and find it more beautiful and impressive as it is extended. I should myself desire to see it built or inlaid with some beautifully coloured and fine stone—Cornish or Genoa serpentine, or any kind of grey or green marble, with string-courses of white marble and bearing shafts of porphyry—or else carved niches of white marble, containing statues; but it is of no use saying what would be desirable—for I know that it will never be done—nor saying where it should be built neither, for there it assuredly never will be built.

# W. STANLEY JEVONS

—◦❧ ❧◦—

## The Use and Abuse of Museums

IT is a remarkable fact that, although public Museums have existed in this country for more than a century and a quarter, and there are now a very great number of Museums of one sort or another, hardly anything has been written about their general principles of management and economy. In the English language, at least, there is apparently not a single treatise analysing the purposes and kinds of Museums, or describing systematically the modes of arrangement. In the course of this article I shall have occasion to refer to a certain number of lectures, addresses, or papers which have touched more or less expressly upon this subject; but these are all of a slight and brief character. The only work at all pretending to a systematic form with which I am acquainted is that upon "The Administrative Economy of the Fine Arts in England," by Mr. Edward Edwards, of the British Museum. But this book was printed as long ago as 1840, and has long been forgotten, if indeed it could ever have been said to be known. Moreover it is mostly concerned with the principles of management of art galleries, schools of art, and the like. Many of the ideas put forward by Edwards have since been successfully fathered by better-known men, and some of his suggestions, such as that of multiplying facsimiles of the best works of art, are only now approaching realisation.

It is true, indeed, that a great deal of inquiry has taken place from time to time about the British Museum, which forms the Alpha, if not the Omega, of this subject. Whatever has been written about Museums centres upon the great national institution in Bloomsbury. The Blue Book literature is abundant, but naturally unknown to the public.[1]

I do not propose in this article to boil down the voluminous contents of Blue Books, but, depending chiefly upon my own memory of many museums and exhibitions which I have visited from time to time, to endeavour to arrive at some conception of the purposes, or rather the many purposes, which should be set before us in creating public collections of the kind, and the means by which those purposes may be most readily attained. Although the subject has hardly received any attention as yet, I believe it is possible to show on psychological or other scientific grounds that much which has been done in the formation of Museums is fundamentally mistaken. In other cases it is more by good luck than good management that a favourable result has been attained. In any case a comparison of the purposes and achievements of Museums must be instructive.

W. Stanley Jevons, "The Use and Abuse of Museums" (1882), in Jevons, *Methods of Social Reform and Other Papers* (London: Macmillan, 1883), 53–81.

1. Blue Book: official publication of the British Parliament. [Ed.]

According to its etymology the name Museum means a temple or haunt of the Muses, and any place appropriated to the cultivation of learning, music, pictorial art, or science might be appropriately called a Museum. On the Continent they still use *Musée* in a rather wider sense than we in England use Museum; but it is remarkable that, although the art of delighting by sound has long been called emphatically *Music*, we never apply the name Museum to a Concert Hall. In this country we have specialised the word so much that we usually distinguish Museums from libraries, picture galleries and music halls, reserving the name for collections and displays of scientific specimens, or concrete artistic objects and curiosities of various kinds. As a library contains books which speak from the printed page, or the ancient inscribed parchment, so the Museum contains the books of Nature, and the sermons which are in stones. About the use and abuse of printed books there cannot arise much question. It may be assumed as a general rule that when a person reads a book, he understands it and draws some good from it. The labour of reading is a kind of labour test, and gives statistics to the effect that certain classes of books are used so many times in the year on the average; there is little need to go behind these facts. But it is somewhat otherwise with public Museums, because the advantage which an individual gets from the visit may vary from *nil* up to something extremely great. The degree of instruction derived is quite incapable of statistical determination. Not only is there great difference in degree, but there is vast difference also in the kind of benefit derived. Many go to a public Museum just as they take a walk, without thought or care as to what they are going to see; others have a vague idea that they will be instructed and civilised by seeing a multitude of novel and beautiful objects; a very small fraction of the total public go because they really understand the things displayed, and have got ideas about them to be verified, corrected, or extended. Unfortunately it is difficult to keep the relative values of these uses of a Museum distinct. There seems to be a prevalent idea that if the populace can only be got to walk about a great building filled with tall glass-cases, full of beautiful objects, especially when illuminated by the electric light, they will become civilised. At the South Kensington Art Museum they make a great point of setting up turnstiles to record the precise numbers of visitors, and they can tell you to a unit the exact amount of civilising effect produced in any day, week, month, or year. But these turnstiles hardly take account of the fact that the neighbouring wealthy residents are in the habit, on a wet day, of packing their children off in a cab to the so-called Brompton Boilers, in order that they may have a good run through the galleries.[2] To the far greater part of the people a large brilliantly lighted Museum is little or nothing more than a promenade, a bright kind of lounge, not nearly so instructive as the shops of Regent Street or Holborn. The well-known fact that the attendance at Museums is greatest on wet days is very instructive.

Not only is a very large collection of various objects ill-suited for educational purposes, but it is apt to create altogether erroneous ideas about the true method of education. The least consideration, indeed, ought to convince any sensible person

2. Brompton Boilers: popular nickname for the early buildings that housed the South Kensington Museum, said to look like steam boilers lying on their sides. [Ed.]

that to comprehend the purpose, construction, mode of use, and history of a single novel object or machine, would usually require from (say) half-an-hour up to several hours or days of careful study. A good lecturer can always make a lecture of an hour's duration out of anything falling within his range of subject. How then is it possible that persons glancing over some thousands of unfamiliar specimens in the British Museum or the South Kensington Courts, can acquire, in the moment devoted to each, the slightest comprehension of what they witness? To children especially the glancing at a great multitude of diverse things is not only useless but actually pernicious, because it tends to destroy that habit of concentration of attention, which is the first condition of mental acquisition. It is no uncommon thing to see troops of little schoolboys filing through the long galleries of a Museum. No more senseless employment could be imagined. They would be far better employed in flattening their noses for an hour or two against the grocer's shop window where there is a steam mill grinding coffee, or watching the very active bootmaker who professes to sole your boots while you wait.

A great deal has been said and written about the unities of the drama, and "canons" are said to have been laid down on the subject. It does not seem, however, to have occurred to the creators and managers of Museums, that so far as education is aimed at, a certain unity of effect is essential. There may be many specimens exhibited, but they ought to have that degree of relation that they may conduce to the same general mental impression. It is in this way, I believe, that the Thorwaldsen Museum at Copenhagen exercises a peculiarly impressive effect upon the multitudes of all classes of Danes and Swedes who visit it.[3] This Museum contains in a single building almost the whole works of this great sculptor, together with all the engravings and pictures having reference to the same. Very numerous though the statues and bas-reliefs are, there is naturally a unity of style in them, and the visitor as he progresses is gradually educated to an appreciation of the works. The only objects in the building tending towards incongruity of ideas are Thorwaldsen's own collection of antiquities and objects of art; but even these are placed apart, and if visited, they tend to elucidate the tastes and genius of the artist.

In somewhat the same way we may explain the ineffaceable effect which certain other foreign galleries produce upon the traveller, especially those of the Vatican. This is not due simply to the excellence of any particular works of art, for in the Louvre or the British Museum we may see antique sculpture of equal excellence. But in the principal Vatican galleries we are not distracted by objects belonging to every place and time. The genius of the classical age spreads around us, and we leave one manifestation of it but to drink in a deeper impression from the next.

I hardly know anything in this kingdom producing a like unity and depth of effect. No doubt the gallery in the British Museum appropriated to the Elgin and other Greek sculptures presents a striking unity of genius well calculated to impress the visitor, provided he can keep clear of the Assyrian bulls which are so close at hand, and the great variety of Egyptian and other antiquities which beset his path. It is in the Crystal Palace, however, that we find the most successful attempt to carry the

---

3. Thorvaldsen Museum: opened in Copenhagen in 1848 to display the work of the Danish neo-classical sculptor Bertel Thorvaldsen (1770–1844). [Ed.]

spectator back to a former stage of art.[4] The Pompeian House is the best possible Museum of Roman life and character. For a few minutes at least the visitor steps from the present; he shuts out the age of iron, and steam, and refreshment contractors, and the like, and learns to realise the past. As to the Alhambra Court, it is a matchless lesson in art and architecture.

Everybody must have felt again how pleasing and impressive is the Hampton Court Palace, with its gardens and appropriate collections of historical pictures. In the same way I would explain the peculiar charm attaching to the Museum of the Hôtel de Cluny, where the ancient buildings and traditions of the place harmonise entirely with its present contents and purposes.[5]

In Museums, as a general rule, we see things torn from their natural surroundings and associated with incongruous objects. In a great cathedral church we find indeed architectural fragments of many ages, and monuments of the most diverse styles. But they are in their places nevertheless, and mark and register the course of time. In a modern art Museum, on the contrary, the collection of the articles is accidental, and to realise the true meaning and beauty of an object the spectator must possess a previous knowledge of its historical bearings and a rare power of imagination, enabling him to restore it ideally to its place. Who, for instance, that sees some of the reproductions of the mosaics of Ravenna hanging high up on the walls of the Museum at South Kensington, can acquire therefrom the faintest idea of the mysterious power of those long lines of figures in the Church of St. Apollinaris? Although it is, no doubt, better to have such reproductions available, it is not well to cherish delusion. The persistent system of self-glorification long maintained by the managers of the South Kensington Museum seems actually to have been successful in persuading people that the mere possession and casual inspection of the contents of the South Kensington courts and galleries has created æsthetic and artistic tastes in a previously unæsthetic people. Such a fallacy does not stand a moment's serious examination. It is dispersed, for instance, by the single fact that the fine arts are in a decidedly low state in Italy, although the Italians have had access to the choicest works of art since the time of the Medicis. It might also be easily pointed out that the revival of true æsthetic taste in England, especially in the direction of architecture, began long before South Kensington was heard of. It is to men of genius, such as Pugin, and Barry, and Gilbert Scott, and to no Government officials, that we owe the restoration of true taste in England, only prevented for a short time, as I hope, by the present craze about the bastard Queen Anne style.[6]

4. Crystal Palace: not the structure that housed the Great Exhibition, but its successor, opened in Sydenham in 1854. It featured a set of courts furnished with casts and decorated to evoke particular periods of art, including the Pompeian House, which attempted to reproduce the home of a wealthy resident of Pompeii, and the Alhambra Court, the reproduction of a section of the famed palace in Granada. [Ed.]

5. Hampton Court: see glossary. Hotel Cluny: now the National Museum of the Middle Ages, opened as a museum in Paris in 1844. [Ed.]

6. Augustus Welby Pugin (1812–1852): architect, designer and champion of the Gothic style. Sir Charles Barry (1795–1860): architect of the Houses of Parliament. Sir George Gilbert Scott (1811–1878): architect inspired by Pugin in his support of the Gothic. Queen Anne: a picturesque and eclectic architectural style popular in the second half of the nineteenth century. [Ed.]

The worst possible conception of the mode of arranging Museums is exemplified at South Kensington, especially in those interminable exhibition galleries which the late Captain Fowke erected around the Horticultural Society's unfortunate gardens.[7] When I went, for instance, to see the admirable collection of early printed books, at the Caxton Loan Exhibition, I had to enter at the south-eastern entrance, and after successfully passing the turnstiles found myself in the midst of a perplexing multitude of blackboards, diagrams, abacuses, chairs and tables, models of all sorts of things, forming, I believe, the educational collections of the Science and Art Department. Having overcome tendencies to diverge into a dozen different lines of thought, I passed on only to find myself among certain ancient machines and complicated models which it was impossible not to pause at. Having torn myself away, however, I fell among an extensive series of naval models, with all kinds of diagrams and things relating to them. Here forgetfulness of the Caxton Exhibition seemed to fall upon all the visitors; a good quarter of an hour, and the best, because the freshest, quarter of an hour, was spent, if not wasted. But when at length it occurred to people that it was time to see that which they came to see, the only result was to fall from Scylla into Charybdis in the form of the late Mr. Frank Buckland's admirable Fishery Collection.[8] Now at the Norwich Fisheries Exhibition, and under various other circumstances, nothing can be better and more appropriate and interesting than the collection of fish-culture apparatus, the models of big salmon and the like. But anything less congruous to old Caxton editions cannot be imagined. As a matter of fact, I observed that nearly all the visitors succumbed to these fish, and for a time at least forgot altogether what they were come about. When at length the Loan Exhibition was reached, the already distracted spectator was ill fitted to cope with the very extensive series of objects which he wished seriously to inspect. In returning, moreover, he had again to run the gauntlet of the big fish, the complicated naval machines, and the educational apparatus. An afternoon thus spent leaves no good mental effect. To those who come merely to pass the time, it carries out this purpose; but the mental impression is that of a nightmare of incomprehensible machines, interminable stairs, suspicious policemen, turnstiles, and staring fish.

But I must go a step further and question altogether the wisdom of forming vast collections for popular educational purposes. No doubt the very vastness of the Paris and other International Exhibitions was in itself impressive and instructive, but speaking from full experience of the Paris as well as the London exhibitions, I question whether it was possible for any mind to carry away useful impressions of a multitude of objects so practically infinite. A few of the larger or more unique objects may be distinctly remembered, or a few specimens connected with the previous studies and pursuits of the spectator may have been inspected in a way to produce

7.  Francis Fowke (1823–1865): engineer and architect, principal designer of the South Kensington Museum complex. His responsibilities included the design of the Sheepshanks, Turner, and Vernon galleries and the conservatory, council chamber, and south arcade of the Royal Horticultural Society Gardens. [Ed.]

8.  Francis Trevelyan Buckland (1826–1880): pisciculturist, naturalist, and lecturer at the South Kensington Museum. His teaching collection expanded to form the basis of the International Fisheries Exhibition of 1883. [Ed.]

real information; but I feel sure the general mental state produced by such vast displays is one of perplexity and vagueness, together with some impression of sore feet and aching heads.

As regards children, at any rate, there can be no doubt that a few striking objects are far better than any number of more monotonous ones. At the Zoological Gardens, for instance, the lions, the elephants, the polar bears and especially the sea lions, are worth all the rest of the splendid collection put together. After the ordinary visitor, whether young or old, has become well interested in these, it has an obviously depressing and confusing effect to proceed through the long series of antelopes.

In this, as in so many other cases, the half is better than the whole. Much inferior as the Hamburg Zoological Gardens may be in the variety of the collection to that in the Regent's Park, I am inclined to prefer it as regards the striking manner in which the principal animals are displayed.

The evil effect of multiplicity of objects used to be most strikingly displayed in that immensely long gallery at the British Museum which held the main part of the zoological collections. The ordinary visitor, thoroughly well distracted by the room previously passed through, here almost always collapsed, and sauntered listlessly along the closely-packed ranks of birds, monkeys, and animals of every possible shape and clime. If the attention could be stimulated anew, this was done by a few cases containing beautiful birds grouped about nests in the manner of life. I can positively assert that these few cases were, for popular purposes, actually superior to the whole of the other vast collections in the room. The fact of course is that the contents of the British Museum have been brought together for the highest scientific ends, and it is a merely incidental purpose which they serve in affording a show for young or old people who have nothing else to do but wander through the store-rooms. The delectation of loungers and youngsters is no more the purpose of a great national Museum than the *raison d'être* of the Royal Mint is to instruct visitors in mechanical processes, or the final end of the House of Commons is to interest the occupants of the galleries.

I venture to submit that on psychological and educational grounds the arrangement of diverse collections in a long series of continuous galleries, worst exemplified at South Kensington, but also unfortunately to be found in the older galleries of the British Museum, is a complete mistake. Every collection ought to form a definite congruous whole, which can be visited, studied, and remembered with a certain unity of impression. If a great Museum like the British Museum contains many departments, there ought to be as many distinct buildings, each adapted to its special purpose, so as to exhibit a distinct and appropriate *coup d'œil*. Were a skilful modern artist, for instance, to construct a special building for the Greek sculptures of the Museum, how vastly would it assist in displaying their beauties.

On the whole I am inclined to think that the Museum of Economic Geology in Jermyn Street is one of the best models, combining strictly scientific purposes and arrangement with good popular effect.[9] The larger objects and more interesting groups and cases are brought forward in a conspicuous manner, and can be reached

---

9. Museum of Economic Geology: see glossary. [Ed.]

without passing through an interminable series of distracting specimens of less interest. The general disposal of the geological collections is such as to give some idea of their natural order and succession. At the same time the *coup d'œil* of the Museum is distinctly good, the light in the more essential parts is excellent, and the size and general approach to homogeneity of the collections is such as fully to occupy without exhausting the attention of the visitors.

After all, the best Museum is that which a person forms for himself. As with the books of a public library, so in the case of public Museums, the utility of each specimen is greatly multiplied with regard to the multitude of persons who may inspect it. But the utility of each inspection is vastly less than that which arises from the private possession of a suitable specimen which can be kept near at hand to be studied at any moment, handled, experimented and reflected upon. A few such specimens probed thoroughly, teach more than thousands glanced at through a glass-case. The whole British Museum accordingly will not teach a youth as much as he will learn by collecting a few fossils or a few minerals, *in situ* if possible, and taking them home to examine and read and think about. Where there is any aptitude for science, the beginning of such a collection is the beginning of a scientific education. The passion for collection runs into many extravagances and absurdities; but it is difficult to collect without gaining knowledge of more or less value, and with the young especially it is almost better to collect any kind of specimens than nothing. Even the postage-stamp collecting mania is not to be despised or wholly condemned. At any rate a stamp collector who arranges his specimens well and looks out their places of issue in an atlas, will learn more geography than all the dry text-books could teach him. But in the case of the natural sciences the habit of collecting is almost essential, and the private Museum is the key to the great public Museum. The youth who has a drawer full of a few score minerals at home which he has diligently conned, will be entranced with delight and interest when he can first visit the superb collection of the British Museum. He will naturally seek out the kinds of minerals previously known to him, and will be amazed at the variety, beauty, and size of the specimens displayed. His knowledge already having some little depth will be multiplied by the extent of the public collection. The same considerations will of course apply to palæontology, zoology, petrology, and all other branches of the classificatory sciences.

In all probability, indeed, botany is the best of all the natural sciences in the educational point of view, because the best Public Botanical Museum is in the fields and woods and mountains. In this case the specimens are available in every summer walk, and can be had without the slaughter attaching to zoology and entomology. Though the average Englishman of the present generation too often makes it the amusement and joy of his life to slaughter any living thing he comes across, surely our young ones should be brought up differently. Now botany affords in an easy and wholly unobjectionable way an unlimited variety of beautiful natural objects, the diagnosis and classification of which give a mental exercise of the most valuable possible kind. Botany, however, is less related to the subject of public Museums than other natural sciences, because it is quite clear that every botanical student should form his own herbarium, and the great public herbaria of Kew and Bloomsbury can be of little use, except to facilitate the researches of scientific botanists. The glass-houses of Kew, of the Botanical Gardens at Liverpool, Manchester, Edinburgh, and

elsewhere, must naturally delight a botanical student more than other people; but the great cost of maintaining an elaborate botanical garden renders it undesirable to attempt the work in many places. It is very desirable, however, that every local Museum should have an herbarium of the local plants, which, though kept under lock and key, should be rendered accessible to any person wishing to consult it for really botanical purposes. Such a public herbarium greatly encourages the private collector by the facility for verifying names and ascertaining deficiencies.

But whatever may be said against particular Museums and collections, there can be no doubt whatever that the increase in the number of Museums of some sort or other must be almost co-extensive with the progress of real popular education. The Museum represents that real instruction, that knowledge of things as they are which is obtained by the glance of the eye, and the touch of the fingers. The time ought to have arrived when the senseless verbal teaching formerly, and perhaps even yet, predominant in schools should be abandoned. A child should hardly be allowed to read about anything unless a specimen or model, or, at any rate, a picture of the thing can be placed before it. Words come thus to be, as they should be, the handles to ideas, instead of being empty sounds. I hope the time is not far distant when it will be considered essential for every school to contain a small Museum, or, more simply speaking, a large cupboard to contain a few models of geometrical forms, mechanical powers, together with cheap specimens of the commoner kinds of rocks, minerals, and almost any kinds of objects interesting to children. Mr. Tito Pagliardini has recently advocated the attaching of a rural scholastic Museum to every village Board-school,* but he quite overshoots the mark in recommending that every school should have a separate wing of the building filled with all the birds shot in the neighbourhood, or any miscellaneous objects which any people of the neighbourhood may present. Again, when he insists that "the walls of every school-room should be literally papered with maps, and the beautiful synoptic diagrams and tables of geology, natural history, botany, etc. . . . and copies of choice works of art to be found in that educational paradise, the South Kensington Museum," he just illustrates what ought *not* to be done. The papering of the walls of a school-room with all sorts of diverse and incongruous things is calculated only to confuse youthful minds and render them careless about the said diagrams, etc., when they become the subjects of a lesson. The walls of a school-room may well be rendered lively by a few good pictures or other pleasing objects, but it would be much better to stow away the diagrams and other things derived from "the Educational Paradise," until they are needed. A diagram thus brought out freshly and singly would be far more likely to attract the children's interest than if it had long been familiar and unheeded among a crowd of other incomprehensible diagrams. On the same ground I would rather have the small Museum enclosed in an opaque cupboard than constantly exposed to view.

Doubts may be entertained whether sufficient discrimination has always been observed as regards the classes of things exhibited in recently formed or recently proposed Museums. The so-called National Food Collection, originally formed at

* "Transactions" of the Social Science Association, Cheltenham, 1878, pp. 721–728.

South Kensington in 1859, is a case in point. It arose out of an attempt to represent the chemical compositions of different kinds of food, by means of small heaps of the constituent substances. It was an experiment, and a very proper experiment, in "visual teaching," the idea being that the poorer classes who know nothing of chemistry might learn by direct observation what kinds of food yield most nutriment. But, as a general rule, novel experiments may be expected to fail. I fancy that the result of this experiment is to show that such "visual teaching" is a mistake. On a little consideration it will be understood that in such collections the specimens have a totally different function to perform from that of true specimens. They are indicators of quantity and proportion, relations which may be better learned from diagrams, printed books, or oral instruction; whereas the purpose of a true Museum is to enable the student to see the things and realise sensually the qualities described in lessons or lectures; in short, to learn what cannot be learnt by words. As to the actual food itself, and its constituents, they are either so familiar as not to need any exhibition, or at any rate they need not be repeated over and over again as they are in this teaching collection. There is not space to argue the matter out at full length here; but it seems to me that in these food collections, now relegated to the Bethnal Green Museum, the line is wrongly drawn between oral or printed and visual teaching.[10] It is a further serious objection to such collections, if collections they can be called, that if developed to any great extent they would render Museums insufferably tedious. A well designed popular Museum should always attract and recreate and excite interest; the moral should be hidden, and the visitor should come and go with the least possible consciousness that he is being educated.

Another mistake which is made, or is likely to be made, is in forming vast collections of technical objects, the value and interest of which must rapidly pass away. We hear it frequently urged, for instance, that a great industrial country like England ought to have its great industrial Museum, where every phase of commercial and manufacturing processes should be visibly represented. There ought to be specimens of the new materials in all their qualities and kinds; the several stages of manufacture should be shown by corresponding samples; the machines being too large to be got into the Museum should be shown in the form of models or diagrams; the finished products, lastly, should be exhibited and their uses indicated. It is easy enough to sketch out vast collections of this sort, but it is a mere phantasm which, it is to be hoped, it will never be attempted to realise.

It is forgotten that if such a technical exhibition were to be so complete and minute as to afford every information to those engaged in each particular trade, it would be far vaster in aggregate extent than any Great International Exhibition yet held. If it were to be a permanent Museum, ten years would hardly elapse before its contents would become obsolete, owing to the progress of invention. Either, then, the Museum would have to be constantly expanded so as to contain the new alongside of the old, or else the new would have to push out the old. In the latter case the Museum would approximate to a shop, or at best to the periodic exhibitions of which we have so many, and which are of a different character and purpose from the

10. Bethnal Green Museum: see glossary. [Ed.]

permanent typical collections which we call Museums. The fact is, however, that the real technical exhibitions of the country are to be found in the shop windows and the factories; and when the newest phases of productive ingenuity may be readily examined in the reality of life, it is a waste of good money to establish great buildings and great staffs of officers to carry on what is, comparatively speaking, child's play. If anybody wants to see the newest notions of the day in the way of machinery, domestic utensils, tools, toys, and the infinite objects of ordinary use, he has only to saunter down Holborn from Bloomsbury to the Holborn Viaduct. He will there find an almost unbroken succession of remarkable shop-window exhibitions, with which no exhibition, even under the most distinguished patronage, can possibly compete.

From this point of view I think it is a happy thing that the Loan Exhibition of Scientific Instruments was dispersed and not converted into a permanent Museum, as some scientific men wished. The collection was indeed an admirable one, and every ten or fifteen years we might wish to see a like one. But the greater part of the contents could not have that finality and permanent interest demanding their perpetual exhibition. Each chemical or physical research needs its own peculiar apparatus, which ought to be sufficiently described, if successful, in the scientific record of the experiments. Were all the apparatus used to be treasured up at South Kensington, it could only produce additional bewilderment in those whose brains have been already scattered by the educational and other numerous collections of that locality. As to the principal instruments, such as microscopes, telescopes, dividing engines, cathetometers, thermometers, hygrometers, anemometers, and the like, they undergo such frequent modification and improvement, that the best forms would never be sought in a Museum, but in the shops of the principal manufacturers. No doubt, however, there are a few standard instruments employed in researches of especial importance which it would be well to preserve for ever.

The same considerations hardly apply to the Parkes Museum of Hygiene now open to the inspection of the public during certain hours at University College, London.[11] This may be regarded as the collection of samples of a most important kind of sanitary Institute. To allow such a Museum to grow to any great bulk, and to preserve all the obsolete forms of syphon traps, sinks and what not, would surely defeat its own purposes.

It is an interesting sign of the times that the holding of industrial exhibitions has of late years become itself a profitable branch of industry. Some years since the proprietors of the Pomona Gardens, a place of popular entertainment at Manchester, built a large exhibition hall and opened an exhibition of machinery, which quite eclipsed that shortly before brought together by a more public body. In the last few years the Agricultural Hall at Islington has been a scene of industrial exhibitions of a very interesting character, which, it is to be hoped, will dispel for ever the disgusting walking feats formerly carried on there. Each exhibition indeed is somewhat limited in extent, but it is quite as large and as various as a visitor can inspect during an afternoon, and the latest novelties of invention, but a few weeks old, may often be seen there.

---

11. Parkes Museum: founded in 1876 to commemorate the life and work of Edmund Alexander Parkes (1819–1876), pioneer of public health reforms. [Ed.]

Then, again, if anybody wants to learn how things are made, it can only be done by visiting the factories themselves and seeing the real work in progress. A busy factory is one of the very best kinds of educational Museums, and it is impossible to urge too strongly upon the proprietors of large works conveniently situated in or near large towns, the advantage which they confer upon the public by allowing inspection. I know several important works in Manchester and elsewhere where wise and liberal ideas have long prevailed in this way. The visitor, furnished with the least proper introduction is handed over at once to an intelligent guide, and shown round the regular course of the manufacture. On leaving, the visitors deposit about sixpence per head in a box to be devoted to the workmen's benefit society. The expense and interruption to work produced by systematic visiting in this way must be very slight, and must usually be more than repaid (though this, I am sure, is not the motive) by the advertisement of the goods. Proprietors of factories generally close their works to the public under the plea that they have all sorts of secret pro- cesses and arrangements which they cannot allow strangers and foreigners to learn; but in most cases this is absurd. If there is any real secret to be learned, there are hundreds of workmen in a busy factory through whom it can be learned. Of course, what applies to private factories, may be said still more strongly of Government works of all kinds. Entrance is already obtained pretty easily to the Royal Mint, the Dockyards, Woolwich Arsenal, etc. So great is the educational and recreational value of admission to such establishments, that the Government ought to insist upon the utmost possible freedom of admission for visitors consistent with the work being carried on. The manner in which the public were until lately admitted, or rather not admitted, to the Tower Museum, for instance, was highly absurd and objectionable. The Tower is just one of those natural historical Museums which, from the unity and appropriateness of its contents and surroundings, is calculated most strongly to impress the visitor. It is an almost unique and priceless historical possession. But it is impossible to imagine why entrance should be barred on most days of the week by a charge of 6d., while the costly Museums in other parts of the town are free. Not even students have to be considered; and nothing but free opening on every day of the week can be considered a satisfactory settlement.

A good deal has been said about the cellars of the British Museum, where there are supposed to be great quantities of duplicates or other valuable objects stowed away uselessly. I cannot profess to say, from my own knowledge, what there may or may not be in those cellars; but I have no hesitation in asserting that a great national Museum of research like that at Bloomsbury ought to have great cellars or other store-rooms filled with articles which, though unfitted for public exhibition, may be invaluable evidence in putting together the history of the world, both social and physical. If the views advocated above are correct, it distinctly injures the effect, for popular educational purposes, of fine specimens of art and science to crowd them up with an infinite number of inferior or less interesting objects; accordingly a great number of imperfect remains, fragments of statues and monuments, inferior copies, or approximate duplicates, should be stowed away. This both saves expense, pre- vents weariness and confusion of ideas to the public, and facilitates the studies of the scholar. In the same way by far the largest part of the biological collections should be packed in drawers, and only the more distinct and typical specimens exposed to

view. But then come a number of zealous, well-meaning men who urge that these drawers and cellars full of expensive articles ought to be offered to the provinces, so that fifty Museums might be filled out of what is unseen in one. Such suggestions, however, proceed upon an entire misapprehension of the purposes of a great collection, and of the way in which the mysteries of the past, the only key to the mysteries of the present, are being unfolded by the patient putting together of link and link.

Of course when two things are real duplicates, like two coins from the same dies, there will not usually be any motive for retaining both in a Museum; a curator will then, as a matter of course, arrange for an exchange of the duplicate with some other duplicate from another Museum. But there may be many things which might seem at first sight to be duplicates, but are not. In many cases the slighter the differences the more instructive these are. The great national herbarium, for instance, ought to contain the floras of all parts of the world, and a certain number of plants will appear to be identical, though coming from opposite sides of the globe. These coincident specimens are, however, the very clues to the former relations of floras, or to the currents, cataclysms, or other causes which can be supposed to explain otherwise inexplicable resemblances. The same is obviously true, *coeteris paribus*, of all the other biological collections.

It is also true, in a somewhat different manner, of historical objects. If, as the whole course of recent philosophy tends to prove, things grow in the social as in the physical world, then the causes of things can only be safely traced out by obtaining specimens of so many stages in the growth that there can be no doubt as to the relation of continuity. Some of the ancient British coins, for instance, bear designs which to all appearance are entirely inexplicable and meaningless. Careful study, however, consisting in the minute and skilful comparison of many series of specimens of coins, showed that these inexplicable designs were degraded copies of Byzantine or other earlier coinages. The point of the matter, however, is that no one would recognise the resemblance between the first original and the last degraded copy. We must have a series of intermediate copies, as necessary links in the induction. Now it is apparent that if these indispensable links being merely duplicates of each other, are dispersed to the provincial Museums of Manchester, Liverpool, Bristol, Newcastle and the rest, the study of their real import must be indefinitely retarded. Concentration and approximate reduplication of specimens is in fact the great method of biological and historical inquiry. This instance of the coins, too, is only a fair specimen of what holds of all the sciences referred to. The forms of architecture, the derivation of customs, the progress of inventions, the formation of languages, the establishment of institutions, all such branches of anthropological science can only be established by the comparison of chains of instances. A century ago etymology was a reproach to learning, being founded on mere guess-work as to the resemblance of words; now the etymology of a word is established by adducing the series of approximate duplicates which show, beyond the reach of doubt, how the word has come to be what it is. We can swear to its identity because we have followed it, so to say.

To distribute the supposed duplicates of the British Museum or of other great scientific collections would be simply to undo the work of a century's research, and to scatter to the points of the compass the groundwork of learning and history. Did we proceed in this country on autocratic principles, the opposite course would be that

most beneficial to human progress, namely, to empower the Librarians and Curators of the British Museum to seize whatever books, specimens, or other things they could find in any of the provinces suitable for the completion of the National Collections.

It is quite possible that a good deal might be done in the way of concentration and completion of scientific collections, but of course it must be done either by the legitimate process of sale and purchase, or by some systematic arrangement between curators. It is a matter exclusively of scientific detail, in which the men specially acquainted with each collection can alone form any opinion.

It is naturally a point of the highest importance to ascertain if possible the best constitution for the control of a Museum, and the best mode of organisation of the staff. Without undertaking to argue the matter here as fully as it would deserve, I venture to express the opinion that a Museum ought to be regarded as a place of learning and science, and not as a mere office or shop for the display of so many samples. It ought therefore to be controlled in the manner of a college, by a neutral and mixed board of men of science and of business. Such a council or board will retain in their own hands most questions relating to finance, the structure of the Museum, and what does not touch the professional and scientific work of the curators. They will appoint a chief curator or librarian, and in a case of a large Museum, the chiefs of the separate branches; but will probably leave to the chief curator the minor appointments. If a happy and successful choice is made as regards the curators, especially the chief, it will probably be found that the whole direction of the institution will centre in the latter, who will form the medium of communication between his colleagues the branch curators, and the board. All important matters involving the scientific organisation of the Museum will be discussed among the curators and reported to the board before the latter pass any final decision upon them. The advantages of such a constitution for the purposes in view are manifold.

It would be a difficult matter to classify the various kinds of Museums in a manner at all complete and natural. There are very many kinds of Museums, and the species shade into each other or overlap each other in the way most perplexing to the systematic classifier. Dr. Gunther[12] divided Museums into three classes,* but I am inclined to add three others, and we then obtain the six following principal classes:

     I. Standard National Museums.
     II. Popular Museums.
     III. Provincial Museums.
     IV. Special Museums.
     V. Educational Museums.
     VI. Private Museums.

*British Association, Swansea, 1880; report, p. 592.

12. Albert Charles Lewis Gotthilf Günther [*formerly* Albert Karl Ludwig Gotthilf] (1830–1914): German-born ichthyologist and keeper of zoology at the British Museum. Gunther would oversee the organization of the natural history collection for removal from the British Museum to the new Museum in South Kensington (1882–1883). [Ed.]

The Standard National Museum of Great Britain is, of course, the British Museum; and even in a very rich kingdom there can hardly be more than one really national collection. There may, indeed, be outlying portions of the national collection, such as the Museums and Herbarium at Kew, the Patent Office Museum, the India Museum, and other collections at South Kensington. The principal purpose of all such central collections must be the advancement of knowledge, and the preservation of specimens or works of art which hand down the history of the nation and the world. It can only be in a merely secondary way that such invaluable and costly Museums are opened for the amusement of casual sightseers and strollers. Properly speaking, there ought to be a series of Museums both in London and the larger towns, which I have specified in the second place as Popular Museums. These are best represented in London by the Bethnal Green Museum, and in the provinces by that admirable establishment, the Peel Park Museum at Salford.[13] Practically, indeed, it is impossible to separate the popular from the Provincial Museums; the latter is not wholly designed for popular use, and may have important scientific and historical collections, ill-suited for recreative and educational purposes. For reasons of economy, however, the popular and the scientific Museums are generally merged together, as at Peel Park and many other places. Of Provincial Museums I will, however, speak more fully below.

Special Museums form a very numerous but varied group, and include any narrow collection formed by an institution for particular purposes. The Monetary Museum at the Paris Mint is a good instance, and it is pleasant to notice that the nucleus of a similar Museum already exists at our Mint on Tower Hill, and is being arranged and improved. The superb Museum of the Royal College of Surgeons is a special one, if, indeed, it does not more properly belong to the class of Standard National collections. Among other special collections may be mentioned the Architectural Museum in Tufton Street, Westminster, the Museums of the several learned societies, of the Royal United Service Institution, and the Parkes Museum of Hygiene.[14]

Under the fifth class of Educational Museums we place those maintained by colleges and schools, for the illustration of lectures or the direct use of students. Every teaching institution ought to have some kind of Museum, and many already have extensive collections. University College has a large Museum of anatomical and pathological specimens in addition to other collections. Owens College has fortunately received the considerable Museum formerly maintained in Peter Street by the Natural History Society, but is in need of funds to erect a suitable building, so as to allow of the popular use of the Museum in accordance with the terms of the gift.[15] The universities of Edinburgh and St. Andrews possess great natural history collections,

---

13. Peel Park Museum: established 1850. [Ed.]

14. Monetary Museum, Paris: established 1827. Museum of the Royal College of Surgeons: see Hunter/Hunterian in glossary. Architectural Museum: established 1853. Its collection of casts and photographs was eventually moved to the Victoria and Albert Museum. The Royal United Service Institution: military museum founded 1830. [Ed.]

15. Owens College: the Manchester Natural History Society, located from 1835 on Peter Street, transferred in 1868 to Owens College (later the University of Manchester). The museum opened to the public in 1890. [Ed.]

which probably surpass the bounds of simply educational Museums, and assume an almost national importance. The same may be said of the Ashmolean Museum at Oxford and the Fitzwilliam Museum at Cambridge.[16] Under the fifth class must also be placed the minor teaching Museum already formed at Harrow, Clifton, and some other public schools, and the indefinitely numerous small collections, which will, I hope, be eventually found, as already explained, in all schools.

Of the sixth class of private Museums it is not necessary to say much. They are usually formed for special scientific purposes, and often become by bequest or purchase the foundation of the corresponding branches of the national collection.

So far as I am aware no complete and systematic information is anywhere to be found as to the number, kind, purposes, and regulations of the local Museums of the United Kingdom. But there are undoubtedly great numbers of Museums owned by local learned societies, by royal institutions, or even by private persons which are more or less open to the public.

But when the Free Library and Museum Acts come fully into operation it is to be hoped that every county town, and every town of, say, 20,000 inhabitants and upwards, will have its public Museum in addition to, but in no case in place of, its public library.[17] There ought to be a great many more libraries than Museums, and for pretty obvious reasons it would be better to concentrate the Museums than divide them up into a great number, which cannot maintain proper curators. Probably about one hundred efficiently maintained public Museums would suffice for the whole of England, and other local collections might often be usefully absorbed into the public Museums when established. It is very desirable, however, that in forming such county Museums, definite ideas should be entertained as to the purposes of the local collection and of the proper means to carry out such purposes.

Everybody knows what a heterogeneous and absurd jumble a local Museum too often is in the present day. Any awkward article which a person of the neighbourhood wanted to get rid of is handed over to the Museum and duly stuck up, labelled with the name of its donor. A Roman altar dug up in a neighbouring farm supports a helmet of one of Cromwell's soldiers; above hangs a glass-case full of butterflies, surmounted by poisoned arrows and javelins from the hill tribes of India. A large cork model of a Chinese temple blocks up one corner of the room, while other parts are obstructed by a brass gun of unknown history and no interest, a model of an old three-decker, an Egyptian mummy, and possibly the embalmed remains of some person who declined to be laid under the turf.* Elsewhere in the valuable collection will probably be found the cups which a great cricketer of the county won, a figure of a distinguished racehorse, the stuffed favourite pugdog of a lady benefactor, and

---

*As was formerly the case in the Natural History Museum, Peter Street, Manchester.

16. Edinburgh: the collection of the University Museum came to form the core holding of the city's Royal Museum (completed 1888). St. Andrew's: the collection developed by the St Andrew's Literary and Philosophical Society (founded 1838) was fully taken over by the University and formed the core of the Bell-Pettigrew Museum (founded 1912). Ashmolean: see glossary. Fitzwilliam: founded 1816. [Ed.]

17. Library and Museums Acts: legislation allowing for the establishment of free museums and public libraries funded from the rates. Museum Act, 1845; Library Act, 1850. [Ed.]

so forth. There is really no exaggeration in this fancy sketch of a county Museum, and it is far better to have such a Museum than none at all. Indeed, for children such a collection is not unsuitable, and is better than a large collection. But it is to be hoped that when local Museums are multiplied and improved, their contents may be so exchanged and selected and arranged, as to produce an orderly and sensible, if not a very scientific, result.

I venture to suggest that as a general rule a local Museum should consist of four principal departments; there may be one or two more, but there should not be many more nor many less. In the first place every local Museum should have its archæological department devoted to the preservation of any antique articles connected with the neighbourhood. Not only are valuable relics thus preserved, but they are preserved at the place where they have special significance, and may lead to special researches. Such relics will be of all ages, from the flint knives of the palæolithic age to the tinder-box which the town clerk's father used. We cannot help the mixture of times, which, after all, is not without its lessons. But then we must not mix up with such local relics those of other places and nations. These should be exchanged with some other collection to which they will be appropriate.

A second branch of the Museum should contain some representation of the local natural history, the rarer birds and insects, especially those which are likely to become extinct, the rocks and fossils of any formation for which the locality is celebrated, the local herbarium already referred to. It will not, however, be usually possible to attempt all the branches of the natural history, and the curator may properly develop disproportionately that branch in which he feels most interest and has most facilities, or which is less represented in neighbouring towns.

A third branch of the Museum may profitably contain almost any kind of collection which forms the special hobby or study of the curator, or of any local enthusiast who likes to make the public museum the depository of his treasures. Whether it be old china, or Japanese idols, or Australian boomerangs, or crystals of calcite, or old bank-notes, or church-door keys, or the fangs of serpents; it hardly matters what product of nature or industry be thus specially represented, provided that it be systematically, and, as far as possible, completely studied. Almost any such thorough collection will lead to new knowledge, and if the curator be an intelligent and scientific man he will be able to arrange and explain it so as to excite interest in his visitors. He will do this far more effectually if he be allowed liberty of choice in some portion of his collection, in respect to which he, so to speak, enjoys a certain endowment of research. In fact, unless the curator of a museum becomes an original student and collector in one or more branches, he is more a cabinet maker and head door-keeper to his institution than the man of science who should be a light to half the county.

The remaining fourth branch of the local Museum should be simply a blank space, available for the reception of occasional loan collections, either from the authorities of South Kensington, or from other local museums, from private collectors, or from the united loans of private owners. The idea of loan collections was perhaps not originated at South Kensington, but it has certainly been developed there in a degree previously unknown. It is doubtless capable of rendering the greatest possible services to Museum economy. The loan collection of Japanese art lately exhibited at Nottingham Castle, for instance, was beyond praise.

But surely this loan system can be worked without the intervention of Government officials. As soon as the curators of Museums become an organised body, *en rapport* with each other, it would be easy to arrange for exchanges of loan collections, and any very good and complete collection formed in one town as the special hobby of its curator, might be gradually circulated round the entire country, and thus vastly multiplied in utility. Thus the local Museum would practically operate as one vast divided Museum, although each curator with his superintending committee would maintain their perfect autonomy.

It is essential, however, to good Museum economy that wholly irrelevant and trifling articles, such as the local cricketers' cups, the stuffed pug-dogs, the models of three-deckers, etc., should be got rid of by exchange or donation. In a well-arranged Museum they serve only to produce distraction and ridicule.

There already exist some good models of what county or other local Museums may become. The Ipswich Museum, in which the late Professor Henslow had a leading part, is, I believe, a very good one, but I have not seen it. The Nottingham Castle Museum, due to a suggestion of Sir Henry Cole, is as yet rather dependent on South Kensington, but in any case it is a charming addition to the resources of the town, and must have very perceptibly brightened the lives of the Nottingham people.[18] There are a good many old castles which might surely be utilised in the same way.

I venture to suggest, in conclusion, that the best possible step which could now be taken to improve the Museums of the United Kingdom would be the constitution of a Museum Association on the lines of the well-known Librarians' Association. If the curators of all the public Museums would follow the example of other professional bodies, and put their heads together in a conference, they might evolve out of the existing chaos some unity of ideas and action. At any rate they would take the first important step of asserting their own existence. There have been enough of blue-books and royal commissions, and we have heard too much of what "my Lords" of the Council have got to say. Let the curators themselves now speak and act, and let them especially adopt as their motto—"Union, not centralisation."

18. Ipswich Museum: John Stevens Henslow (1796–1861), influential botanist, teacher, and friend of Charles Darwin, was closely involved with the development and management of the natural history collection of the Ipswich Museum (established 1847). Nottingham Castle Museum: a gutted shell until 1878, when it was restored as one of the first provincial museums of fine art. [Ed.]

# Chapter Eight

# FROM WONDERS TO SIGNS: ANTHROPOLOGY AND ARCHEOLOGY

While objects from the non-western world and from classical antiquity were featured in the very earliest museums and in their forerunners, the development of newly scientific approaches to archeology and anthropology was bound to profoundly affect the collection and display of such items. This chapter begins with an extract from David Murray's important study, *Museums: Their History and Their Use* (1904), addressing the turn to specialization and careful classification characteristic of the development of the institution in the second half of the century. In Murray's history, the emergence of archeological and anthropological museums marks a key transition from the cabinet of curiosities to the modern museum.

The move from the celebration of classical antiquity to its scientific study is related to the parallel shift from speculation about exotic curiosities to the emergence of anthropological approaches to the study of culture. The transition Murray describes is well demonstrated by the case of the Ashmolean Museum at Oxford, which, as John Henry Parker indicates in *The Ashmolean Museum: Its History, Present State, and Prospects* (1870), attempted to transform itself from a collection gathered with no system from various disparate sources into a modern scientific museum of archeology. Especially notable is Parker's emphasis on the role of photography in overcoming the limitations of the collection. The chapter also includes excerpts from an early catalogue of what became the anthropological collection of the Pitt-Rivers Museum in Oxford, a document important as much for the items it contains as for the principles of organization used to arrange them (1874). Objects that would have been at home in a cabinet of curiosities, such as skulls and native implements, are given a developmental gloss that demonstrates the important debt Pitt-Rivers owed to Darwin.

# David Murray

—◦❧ ❧◦—

## The Modern Museum

### Archaeological Museums

SIR WILLIAM FLOWER thinks, and probably with justice, that John Hunter is to be regarded as the founder of the modern museum, the distinguishing features of which are specialization and classification.[1] A museum has been described by Huxley as "a consultative library of objects"; and just as special libraries are required, so special museums have become a necessary aid in scientific research.[2] Instead of one museum embracing every subject, or at least many subjects, we have museums which are limited to one or to a few special subjects, as, for instance, museums of Natural History, museums of Geology and Mineralogy, Industrial, Commercial, Agricultural, Chemical, Educational and Military museums, museums of Archaeology, museums of Art and of Antiquities—Christian and secular—and sundry others.

Archaeology furnishes a good example of what is gained by careful and accurate classification, and the bringing together of objects for comparison. Archaeology has been called "the science of sepulchres." This is true, in a sense, for it is from the resting-places of the dead that we have recovered the greater portion of the material remains of prehistoric peoples which we now possess; and the recognition of the fact that interments afforded valuable aid in the elucidation of the past was one of the great steps in archaeological science. But while this is so, it is the museum which has made them intelligible. Whoever it may be that first spoke of the "three-age system," it was Christian Thomsen who first turned it to practical account, and it was the arrangement of the great museum of Copenhagen, according to this system, that created the science of Archaeology.[3] Prior to his time the museum was but a valley of dry bones; in his hands and by his genius these were made to live and to tell the story of the past. The co-relation of the various monuments of antiquity to one another and to the present time was sketched out by him in broad outline, and soon a host of observers all over the world arose to fill in the details. Immense progress has been made since the publication, in 1836, of Thomsen's classification; and the history of the past, the growth of culture and

From David Murray, *Museums: Their History and Their Use* (Glasgow: James MacLehose and Sons, 1904), 231–244 (excerpt).

1. Sir William Flower: see authors and speakers. John Hunter: see glossary. [Ed.]
2. Thomas Henry Huxley (1825–1895): biologist and science educator. [Ed.]
3. Christian Jurgensen Thomsen (1786–1865): Danish archeologist, first put into practice the three-age system (Stone Age, Bronze Age, and Iron Age) at the Danish National Museum. [Ed.]

the progress of civilization are now being investigated and recorded in every country on sound scientific lines.

—◦❯ ❮◦—

The names given to ages, periods, or epochs, are immaterial. What is of value and what is aimed at in every properly organized museum of archaeology is to discriminate and illustrate the stages of human culture, in other words to trace the growth and development of civilization.

A most useful feature of modern museums is the separation of objects into national and foreign, the latter being reserved as objects with which to compare, and by which to illustrate the former. Nothing has done more than this to place archaeological science upon a sound basis; and yet fifty years ago so little had this principle been thought of, that there was not a single room in the British Museum specially appropriated to British Antiquities, and even gifts of national antiquities were reluctantly received and sparingly acknowledged. The few that were preserved were mostly unclassed and practically unavailable for reference and comparison.

As we approach recent times archaeology shades into antiquities, and the archaeological collection grows into the historical. In every considerable museum therefore, the archaeological section is followed by an historical and is supplemented by an ethnographical, and in some cases by an anthropological, section.

One of the greatest museums of the day is the Germanic National Museum at Nuremberg, established in 1852 for the illustration of German historical research. It contains an enormous amount of material, much of it of the kind that was to be found in the museums of the seventeenth and eighteenth centuries;—stone implements and clay urns, Roman and other antiquities, carvings, glass and porcelain, ecclesiastical vessels and vestments, scientific apparatus, and all that used to pass under the name of artificial curiosities. These have, however, been arranged so as to tell the history of the German land and the German people, chapter by chapter, and subject by subject, from the earliest period down to the present; prehistoric, Roman and German. Objects illustrative of civil life and ecclesiastical life, war, agriculture, handicrafts and trade, art and science, are set out in order, so that the student has everything grouped before him and the mere passer-by can read and understand their import. The lesson of the museum is the importance of order and method. These are what give scientific value to the collection. It was the want of these that made the old museums comparatively worthless.

The recognition of the fact that the products of the lower forms of civilization of the present time materially assist in understanding the life, the thought and culture of prehistoric peoples, and of many of the manners and customs of our own day, was a great help to the progress of archaeology. The importance of this comparison seems to us to be obvious, but it was not grasped, or at least, was not acted upon until comparatively recent times.

—◦❯ ❮◦—

In his arrangement of the Copenhagen Museum Thomsen sorted out and arranged the ethnographical objects as a separate and independent collection, and took steps to provide material for this part of the museum from every available source.

After his death it was taken in hand by Worsaae, who modified and improved the system of arrangement, and the museum is still one of the foremost of its kind in Europe.[4] Similar collections have been organized at Christiania and Stockholm. In England we have the great collections of the British Museum; of the India Museum, and of the Ashmolean at Oxford; in Paris there is one in the Louvre and another in the Musée du Trocadéro;* besides the Musée Guimet founded at Lyons in 1879 by M. Émile Guimet, presented to the State and transferred to Paris in 1885, the leading object of which is to illustrate the history and practice of religion.

---

* Hamy, "Les origines du Musée d'Ethnographie" in *Revue d'Ethnographie*, viii., p. 305.

4. Jens Jacob Asmussen Worsaae (1821–1885): influential Danish archeologist and author, studied with Thomsen and succeeded him as curator of the Danish National Museum. [Ed.]

# JOHN HENRY PARKER

## *The Ashmolean Museum: Present State and Prospects*

The Museum is now a Museum of Archæology only. What is Archæology? It is *History in detail*, and the details are tenfold more interesting than the dry skeletons called School Histories. Details give life and interest to any subject. Archæology is also history taught by the eye, by shewing a series of tangible objects; and what we have once *seen* we can remember far better than anything of which we have only heard or read. This Museum must be made to illustrate the History of Architecture, and Sculpture, and Painting—or rather Drawing. Paintings require more space, and students of Painting must be referred to the Picture Galleries.

It is by comparing small remains in one place with more perfect remains of the same kind and of the same period in other places, that we learn to understand the smaller remains. To carry on this study formerly required the power of travelling far and wide; but the art of Photography enables us to pursue this study by our own fireside, and sometimes even better than we could do by travelling, because we can place the objects side by side, and not have to trust to memory or to drawings, which are not always to be depended on.

At first sight, indeed, it may appear absurd to say that in this small building the general History of Architecture can be illustrated. But this modern art of Photography enables us to do many things that were impossible before. The great work of Seroux d'Agincourt, the History of Architecture, Sculpture, and Painting, *from existing remains*, shews what may be done by a well-selected series of examples in chronological order, even though the drawings from which his plates are engraved, and often the engravings themselves are so bad as to deprive his great work of half its use.[1] For some years past I have been endeavouring to supply the place of these bad engravings by a series of Photographs arranged in chronological order, according to the plan and under the guidance of D'Agincourt's work. A large proportion of his examples are necessarily taken from ROME, for they could be found nowhere else; and I think I now have photographs of all his subjects that remain in Rome. For the first ten centuries of the Christian era, it would be in vain to try and find a connected series anywhere else.

From John Henry Parker, *The Ashmolean Museum: Its History, Present State, and Prospects.* A Lecture Delivered to the Oxford Architectural and Historical Society, November 2, 1870 (Oxford: np., 1870), 4–23 (excerpts).

1. Jean Baptiste Louis George Seroux D'Agincourt (1730–1814): French archeologist and historian, (posthumous) author of *Histoire de l'art par les monuments, depuis sa décadence au IVme siècle jusqu' à son renouvellement au XVIme* (1823). [Ed.]

In the present state of Europe, and at this season of the year, it would be rather difficult for the members of our Society to go and see these things with their own eyes; they must be content to trust to other people's eyes, and the large collection of engravings and drawings that are in the Society's Library, and which they will bear in mind that each member can have to his own fireside. Photographs are still better, when they can be obtained; in these, we do not have to trust to the eye or the hand of other people. A building shewn in a photograph is as well seen as on the spot, sometimes better, for the photographer is obliged to choose the right time of the day, when there is a good light upon the object, and sometimes details can only be seen when there is a good light upon them. I have frequently been obliged to have the same object taken two or three times, because the light had not been right at first. In the case of the remains of the House of Plautius Lateranus, of the time of Nero, which was incorporated in the city wall by Aurelian, and thus preserved, I had this done half-a-dozen times before I was satisfied that the old doors, windows, and the construction of the wall of a house of the first century, could be seen.

Of the two-thousand Photographs that I have been enabled to have prepared in Rome, there is now a set in this Museum. It is arranged for reference according to the numbers in the printed Catalogue, and, by means of the Index, any subject can be looked out in a few minutes; so that a student can at once have photographs of all the existing remains in Rome that illustrate the subject he wishes to study.

For SCULPTURE, we have Photographs of some of the principal statues in the Museums of Rome, including the busts of the Emperors, which are useful for the chronology and to shew the costume and the headdresses.

On the subject of Sculpture and Carving, we must not forget the carved ivory tablets, commonly called ivories, of which we have some good specimens in the Museum; these are of the thirteenth and fourteenth centuries. It would not be difficult to form a chronological series of them from the time of the early Roman Empire down to the sixteenth century, when Archæology ceases. The Consular Diptychs would form part of this series, and these are practically dated. The style of drawing, and the costumes, as well as the carving itself, are all useful for historical purposes. It will perhaps be worth while to have a set of Photographs made of them; but the excellent series of casts issued by the Arundel Society are generally accessible, and are as useful for Historical purposes as the originals would be.[2] They are so well made that it is often difficult to distinguish the casts from the originals.

The celebrated Arundel Marbles are now for the most part in the lower room of the Museum; they are more valuable for the Inscriptions than for the Sculptures. Some of the more important Greek inscriptions are still built into the walls of the room in the schools in which they were formerly kept.

For THE ART OF DRAWING, we have an excellent series for the first thousand years of the Christian era, in our Photographs, such as could not be obtained anywhere but in Rome. We begin with the Mosaics of the first century, such as the celebrated "Pliny's Doves," taken from the original, and several other mosaic pictures and pavements of that period, and of the two following centuries, which is

2. Arundel Society: founded in 1848 to disseminate art reproductions. [Ed.]

called "the time of the early Empire." We then go on with the mosaic pictures in the churches, beginning with S. Constantia, in the fourth century. These are merely for ornament, the culture of the Vine, &c. At S. Maria Maggiore, in the fifth century, is a remarkable series of Scripture subjects, the whole history of the Bible as understood at that time. I long despaired of getting these from nature, and I had them copied from Ciampini's great work on the subject; he has preserved some that are now destroyed, and his drawings will be useful to compare with the originals, if I do succeed in getting them, as I believe I now shall.[3] The last I heard was that the Dean and Chapter of the great Cathedral Church of S. Maria Maggiore had at length yielded to the importunity of my photographer, that the mosaics have been cleaned, and the Photographs are now in hand. Of the sixth century, we have the mosaic picture in the apse of SS. Cosmas and Damian, with the portrait of the Pope who was the donor. Of the eighth and ninth centuries, there are many mosaic pictures, executed by order of the Popes after the siege of Rome by the Lombards, when many of the churches and catacombs were almost destroyed.

Simultaneously with these mosaics, we have a series of fresco-paintings in the Catacombs. A few of these are of the second and third centuries; but these are not of religious subjects, they are merely for ornament, as in the Pagan tombs. A large proportion of these paintings were ordered by the same Popes as the mosaic pictures in the churches, and in both cases for the same object,—for the benefit of the numerous pilgrims who came to worship at the altars containing the relics of celebrated martyrs, or at their tombs. These mosaics and frescoes bring down the history of the art of drawing to the year 1000, and shew how low it had then fallen.

For the Medieval period, which in a certain sense may be said to begin after the year 1000, when the great revival of all the arts began, we have a large collection of mosaics, frescoes, altar decorations, and other objects, all well dated, generally by inscriptions recording the names of the donors. These begin with the fine series in the crypt of St. Clement's Church, which are of the eleventh century, and go on to the sixteenth and seventeenth.

On the subject of Painting, we must not forget the beautiful enamels with their brilliant colouring. The one contained in King Alfred's Jewel has been already mentioned. Of a later period we have another very remarkable example, the colours of which are so brilliant that it was described in the old Catalogue as made of hummingbirds' feathers, and ours is not the only catalogue in which the mistake has been made; the colours are as bright as if the work had been executed yesterday. The reliquaries, croziers and other church ornaments of the Middle Ages, are frequently enriched with enamels. The series of excellent chromo-lithographs of frescos and other early paintings published by the Arundel Society, should also be mentioned here. It will not be difficult to obtain a set of them, when we can find room for them; but we must not attempt to do everything at once.

For the present season, we must be content with Rome, for which the catalogue is ready. For the buildings before the Roman period, in Egypt, Palestine, and Greece, and for the series of Christian antiquities, and the mosaics at Ravenna, and the

---

3. Giovanni Ciampini, *De sacris aedificiis a Constantino Magno constructis* (1693). [Ed.]

Medieval period in England, France, and Germany, I must ask you to have patience for another season. I have made arrangements to procure the photographs; but the catalogue of them will take more time than I have been able to give to it this season, and I shall want the help of friends who are acquainted with those Eastern countries that I have not seen. We shall, in many cases, be able to accompany the photographs of buildings with works of art from the same places and of the same periods.

# Augustus Henry Lane Fox (Pitt-Rivers)

—◦❧ ❦◦—

## Catalogue of the Anthropological Collection Lent by Colonel Lane for Exhibition in the Bethnal Green Museum

## Preface to Parts I and II

As the first two parts of this Catalogue are to be published before the remaining portion is completed, it appears desirable to say a few words explanatory of the system upon which the collection has been arranged, reserving a more comprehensive introduction until the whole is finished. Most of the objects exhibited are such as may be found in many ethnological museums, and it is only in relation to their psychological and sociological bearings that I venture to think some improvement may be found to have been introduced into the method of exhibiting them.

The objects are arranged in sequence with a view to show, in so far as the very limited extent of this collection renders such demonstration practicable, the successive ideas by which the minds of men in a primitive condition of culture have progressed in the development of their arts from the simple to the complex, and from the homogeneous to the heterogeneous.

Evolution and development are terms which, it is now beginning to be admitted, are as applicable to the progress of humanity as to all other mundane affairs. Anthropology, according to the more usual acceptation of the term, deals with the whole history of human development, and may be divided into two main branches. The first relates to the constitution of man, in which we have to do with man as a member of the animal kingdom, his mental and physical faculties and peculiarities, the varieties of race, the influence of heredity and so forth. The second division may be classed under the head of culture, in which we deal with a new order of things, the origin of which was coeval with the first appearance of man upon the earth, no other animal being capable of self culture in the proper sense of the term. Up to this point the development of species has gone on in accordance with the laws of procreation and natural selection. Man being the last product of this order of things, becomes capable by means of his intellect of modifying external nature to his wants, and from henceforth we have to concern ourselves with a series of developments produced by art.

It is the province of anthropology to trace back the sequence of these developments to their sources. In the more restricted sense of the term anthropology, it appears to be applied by some to the first only of these two divisions of the subject, whilst the second, or that which I here term culture, has been recognised under the

Augustus Henry Lane Fox (Pitt-Rivers), *Catalogue of the Anthropological Collection Lent by Colonel Lane for Exhibition in the Bethnal Green Museum*. London: Science and Art Department of the Committee of Council on Education, South Kensington, 1874), xi–xvi, 1–3.

appellation of sociology or social science. It matters little which term is employed, provided we keep the two ideas distinct in our minds.

All the specimens in this collection, with the exception of those referred to in Part I. of this Catalogue, relate to the second division of the subject, viz., human culture.

Human ideas, as represented by the various products of human industry, are capable of classification into genera, species, and varieties in the same manner as the products of the vegetable and animal kingdoms, and in their development from the homogeneous to the heterogeneous they obey the same laws. If, therefore, we can obtain a sufficient number of objects to represent the succession of ideas, it will be found that they are capable of being arranged in museums upon a similar plan.

The classification of natural history specimens has long been a recognised necessity in the arrangement of every museum which professes to impart useful information. But ethnological specimens have not generally been thought capable of anything more than a geographical classification. This arises mainly from sociology not having until recently been recognised as a science, if, indeed, it can be said to be generally accepted as such at the present time. Travellers, as a rule, have not yet embraced the idea, and consequently the specimens in our museums, not having been systematically collected, cannot be scientifically arranged. They consist of miscellaneous objects brought home as reminiscences of travel or of such as have been most easily procured by sailors at the sea-ports. Unlike natural history specimens which have for years past been selected with a view to variety, affinity, and sequence, these ethnological *curiosities* have been selected without any regard to their history or psychology, and although they would be none the less valuable for having been selected without influence from the bias of preconceived theories, yet, not being supposed capable of any scientific interpretation, they have not been obtained in sufficient number or variety to make classification possible.

Since 1852 I have endeavoured to overcome this difficulty by selecting from amongst the commoner class of objects which have been brought to this country those which appeared to show connexion in form. Whenever missing links have been found they have been added to the collection, and the result has been to establish, however imperfectly, sequence in several series.

I had already accumulated a considerable number of objects upon this plan when I first became acquainted with the more extensive and valuable collection of Mr. Henry Christy, which, however, at that time was confined chiefly to pre-historic specimens, in which field of research he had himself contributed important discoveries; since then, and subsequently to his death, his collection has extended to objects illustrating the industry of modern savages.[1]

The utility of two collections embracing the same class of objects might not be very apparent were it not for the different method upon which the specimens have been collected and arranged. In the Christy Collection the primary arrangement is geographical, whereas I have from the first collected and arranged by form. The

---

1. Henry Christy (1810–1865): anthropologist particularly concerned with the study of prehistory. After his death, his archeological and ethnological collections were exhibited in a suite of rooms in Westminster until 1884, when they were moved to the British Museum. [Ed.]

result has been that different points of interest have been brought to light. Both systems have their advantages and disadvantages, by a geographical arrangement the general culture of each distinct race is made the prominent feature of the collection, and it is therefore more strictly ethnological, whereas in the arrangement which I have adopted the development of specific ideas, and their transmission from one people to another, is made more apparent, and it is therefore of greater sociological interest.

Acting upon the principle of reasoning from the known to the unknown I have commenced this catalogue with the specimens of the arts of existing savages, and have employed them as far as possible to illustrate the relics of primeval men, none of which, except those constructed of the more imperishable materials, such as flint and stone, have survived to our time. All the implements of primeval man that were of decomposable materials having disappeared, can be replaced only in imagination by studying those of his nearest congener, the modern savage.

To what extent the modern savage actually represents primeval man is one of those problems which anthropology is called upon to solve. That he does not truly represent him in all particulars we may be certain. Analogy would lead us to believe that he presents us with a traditional portrait of him rather than a photograph. The resemblance between the arts of modern savages and those of primeval men may be compared to that existing between recent and extinct species of animals. As we find amongst existing animals and plants species akin to what geology teaches us were primitive species, and as among existing species, we find the representatives of successive stages of geological species, so amongst the arts of existing savages we find forms which, being adapted to a low condition of culture, have survived from the earliest times, and also the representatives of many successive stages through which development has taken place in times past. As amongst existing animals and plants these survivals from different ages give us an outline picture of a succession of gradually improving species, but do not represent the true sequence by which improvement has been effected, so amongst the arts of existing people in all stages of civilisation we are able to trace a succession of ideas from the simple to the complex, but not the true order of development by which those more complex arrangements have been brought about. As amongst existing species of animals innumerable links are wanting to complete the continuity of structure, so amongst the arts of existing peoples there are great gaps which can only be filled by pre-historic arts. What the palæontologist does for zoology, the pre-historian does for anthropology. What the study of zoology does towards explaining the structures of extinct species, the study of existing savages does towards enabling us to realise the condition of primeval man.

This analogy holds good in the main, though there are points of difference which greatly complicate the human problem, and which cannot be entered into in this brief summary of the subject.

The importance of studying the material arts of savages and pre-historic men is evident, when it is considered that they afford us the most reliable evidence by which to trace their history and affinities. It has been said that language is the surest test of race. This is true of an advanced state of culture, in which language has attained persistency, and still more so where it has been committed to writing; but it is certainly not true of the lowest savages, amongst whom language changes so rapidly

that even neighbouring tribes are unable to understand one another; and if this is the case in respect to language, still more strongly does it apply to all ideas that are communicated by word of mouth. In endeavouring to trace back the history of the arts to their root forms we find that in proportion as the value of language and of the ideas conveyed by language diminishes, that of ideas embodied in material forms increases in stability and permanence. Whilst in the earliest phases of humanity the names for things change with every generation, if not more frequently, the things themselves are handed down unchanged from father to son and from tribe to tribe, and many of them have continued to our own time faithful records of the condition of the people by whom they were fabricated.

In concluding this preface I cannot do better than refer the reader to the recently published work of Mr. Herbert Spencer on the study of sociology, and more particularly to that portion of it which relates to the difficulties of social science arising from the automorphic interpretation of the works of people in a very different state of culture to our own.[2] To this cause must be attributed chiefly the difficulty which we experience in realising the very slow stages by which progress has been effected during the earliest periods of the human race.

## Note

The Collection to which this Catalogue relates occupies the whole of the South Basement of the Museum buildings. The series commences at the East End with the typical human skulls and hair of different races, and then proceeds with specimens of the culture of modern savages and barbarous races; these are arranged along the line of Screens and Walls on the South Side from East to West, and along the North Wall and in upright glass cases from West to East. After these the pre-historic series commences on the West, and runs along the line of desk cases from West to East.

Where necessary, arrows are painted on the Screens, indicating the sequence in which the objects thereon have been arranged.

## Catalogue, Part I

### Case 1, East Wall: Typical Human Skulls and Hair of Different Races

*Physical Anthropology being only cursorily treated in this collection, it has not been attempted to form a complete series of skulls. The best collection of skulls may be seen at the College of Surgeons, in Lincoln's Inn Fields, and in the collection of the Anthropological Institute, St. Martin's Place.[3]*

The following are examples of typical skulls of some of the principal races. It must, however, be understood that they only represent specimens of average forms.

---

2. Automorphism: the ascription of one's own characteristics to another, a coinage of Herbert Spencer in *The Study of Sociology* (1873). [Ed.]
3. College of Surgeons: see Hunterian in glossary. Anthropological Institute: founded 1871. [Ed.]

In nearly every race there are many varieties from the Dolichocephalic or long-headed to the Brachycephalic or short round-headed skull. Races have, however, for the most part characteristic forms, more especially aboriginal races in which the form of the skull is generally more uniform than that of more advanced races, which being the result of many crosses varies between greater extremes. Thus for example, the negro of Africa, the Papuan of New Guinea and the Melanisian Isles, the Australian, and most of the black races are dolichocephalic or long-headed people (*see* Professor Huxley's map of the principal varieties of mankind),[4] whilst the Mongols of Northern Asia are examples of the opposite extreme of Brachycephalic or short skulls. European nations vary more than these, but still retain characteristic differences; thus the Germans are, as a rule, a rounded-headed people, whilst the French and English, more particularly the latter are dolichocephalic. The cephalic index represents the form of skull in figures, being the proportion of the greatest breadth to greatest length in any individual specimen: the greatest length being taken at 100 the index represents the breadth of the widest part in proportion to this length. All skulls in which the index is over 80, are regarded as Brachycephalic or short-headed, whilst those which are under 80 are dolichocephalic or long-headed.

As regards the psychological peculiarities appertaining to the various forms of skulls, that question must be considered for the present in abeyance awaiting further research. The arbitrary rules of the phrenologists have not been confirmed, owing to the uncertain knowledge we possess of the internal organism of the brain, and whilst on the other hand it is admitted that, all other things being equal, size represents mental power, it is upon the whole the tendency of modern investigation to attach less value to the form of the skull as an absolute indication of racial and mental character than was formerly supposed.

1. SKULL of HUMAN FŒTUS.
2. CAST of a NEGRITIC SKULL. New Guinea. Cephalic index, 63. Example of an extremely dolichocephalic or long form of skull.
3. CAST of a TARTAR SKULL. Cephalic index, 99. Example of an extremely Brachycephalic or short form of skull.
4. CAST of NEANDERTHAL (ELBERFELD) SKULL. Found in a grotto in the valley of the Dussel near Elberfeld, Germany, in association with the bones of mammoth and cave bear. Extreme length, 8 inches: extreme breadth, 5.75.
5. CAST of ENGIS SKULL. Found in a cavern near Liége with the remains of elephant, rhinoceros, bear, hyena, &c. Index, 68.1.
6. SKULL. Typical Australian. Cephalic index, 69. The Australian skulls are remarkable for the prominence of the supraciliary ridges.

---

4. Thomas Henry Huxley, "On the Geographical Distribution of the Chief Modifications of Mankind," *The Journal of the Ethnological Society of London* (1870). [Ed.]

7. SKULL. Australian. Cephalic index, 69.
8. SKULL. Ethiopian. Index, 75. The negro skulls are remarkable for their prognathism or prominence of the jaws.
9. SKULL. Ethiopian. Index, 71.
10. SKULL. North American Indian chief. Index, 77. The square chin, prominent cheek bones, and marked features of the American Indian race are exemplified in this skull.
11. SKULL. Californian Indian. From the cemetery of the church of the old mission of San Carlos near Montery. Index, 81.
12. SKULL. Patagonian Indian. South America. Index, 79. An extremely thick massive skull, the prominent cheek bones and broad face of the Patagonian race is insufficiently represented in this specimen.
13. SKULL. New Zealander. Index, 72. An approach to the Australian type is observable in this skull.
14. SKULL. Chinese. Index, 82.
15. SKULL. Romano-British. Found by Col. A. Lane Fox with Roman remains 20 feet beneath the surface, in digging the foundations of a house in London Wall in 1866. Index, 70. A good typical specimen of the dolichocephalic British or Romano-British form.
16. SKULL. Anglo-Saxon. From the Saxon crypt at Thorpe Mallow, Northampton, 1840. Index, 78. A good example of the Brachycephalic Anglo-Saxon skull.
17. SKULL. Found by Col. A. Lane Fox in contact with a bronze socket knife or dagger (in this Collection) in a grave at Highdown Hill, Sussex, Oct. 12, 1867. Index, 70. Its connexion with the remains of the Bronze age is doubtful, and from its form improbable.
18. SKULL. Irish, of an extremely elongated form. Index, 65. Found several feet beneath the present burial ground of Cork Cathedral in digging the foundation of the new church, the elongation may be partly due to deformation subsequent to interment, the skull being extremely soft when found.
19. SKULL. Modern Irish, from Kilcrea Abbey, co. Cork, 1864. Index, 75. Probably adult female, and of a low order of intellect: the individual was living probably not more than a century ago.
20. SKULL. Probably that of a young female from Twyn-Capel, Holyhead Island. This skull is probably of the date of the chapel which surmounted the tumulus.
21. SKULL. Modern English. Index, 73.
22. SKULL. Modern English. Index, 78.

# Chapter Nine

## EXHIBITING INDIA

The relationship between museums and the British Empire was constant and varied. Important objects were acquired by trade, exploration, and—more rarely—by outright battle throughout the areas in which Britain had economic and political interests. In India itself museums were established as early as the Asiatic Society of Calcutta, founded in 1784, and they proliferated throughout the nineteenth century. While the history of museums in the empire—which ran parallel to developments in England but also diverged in important ways—is outside the scope of this volume, the uncertain fate of the *national* collection of Indian materials is one important cultural manifestation of the metamorphoses of imperial power in the period.

The East India Museum had opened in 1801 at the offices of the East India Company on Leadenhall Street, but as the state took over rule of India and the company dissolved, the collection became peripatetic. In 1853, control passed to the India Office, where the collection was administered by John Forbes Watson. In 1861, the museum reopened in incongruous quarters at Fife House, where it remained until 1869. By 1875 the material was becoming absorbed in the South Kensington Museum complex, and between 1879 and 1880 the collection was finally divided between the South Kensington and the British Museums.

The brief article from *Illustrated London News*, which opens this chapter, draws attention to the remarkable inappropriateness of viewing the splendid collection cramped into the domestic quarters of Fife House (1861). John Forbes Watson's *On the Measures Required for the Efficient Working of the India Museum and Library* (1874), an ambitious description of the reforms necessary to rationalize the national collection, makes clear the distance between the potential of the India Museum as a tool for empire and the collection's actual condition. While Watson draws on arguments for general culture and design improvement that had been established earlier in the century for the support of museums of Western art, he also emphasizes the centrality of the imperial project for British identity and power. Nevertheless, the unstable nature of the Indian Museum Watson proposes to reform—uncomfortably

poised between its roots in the East India Company and its current unsatisfactory situation in makeshift quarters—is characteristic of the ambiguous and uncertain place of the collection in the capital of the British Empire.

T. Holbein Hendly's article on "Indian Museums" (1913) makes particularly clear the manner in which the management and funding of an imperial museum will necessarily involve key contradictions in the cultural imagination of the role of empire. Who is the audience for such a museum? What form should it take? Who should pay for it? Questions that shaped museum debates throughout the nineteenth century return with a new poignancy and special urgency when the imagination of a subject nation is at stake. The extract from Hendley's extensive monograph is drawn from that work's appendix, which is a transcription of the proceedings of a 1909 deputation making a futile attempt to argue for the establishment of a major Indian museum based on holdings that had been turned over to the South Kensington Museum more than thirty years earlier.

## Anonymous
### The India Museum, Whitehall

THE collection of native products, and the specimens illustrative of the arts and industrial pursuits of the people of India, which for several years past had been on view at the old India House in Leadenhall-street, have been removed to Fife House, Whitehall. The building is not well adapted for the purposes of a museum, but it may serve as a temporary dépôt for the extensive collection of silks, jewels, metal wares, and other produce and manufactures which illustrate the wealth of our Indian empire. In the entrance-hall there are placed the marble statues of Wellington, Clive, Hastings, Coote, Wellesley, and the other military men and statesmen who have at one time or another distinguished themselves in the field or in the council of India. On the staircase are hung the valuable pictures which were formerly in the possession of the East India Company. The library formerly occupied by Lord Liverpool is now filled with the mineral products of India; the dining-room is stored with raw products and manufactures in jewellery and Japan wares; the drawing-room has been fitted up with much care, and in it are displayed the silk and jewelled dresses of the East, which present a most gorgeous appearance. A small room adjoining is filled with models of agricultural implements and of the various craft for navigating the seas and rivers of India. The large collection of models illustrating

Anonymous, *Illustrated London News*, August 3, 1861, 125–126.

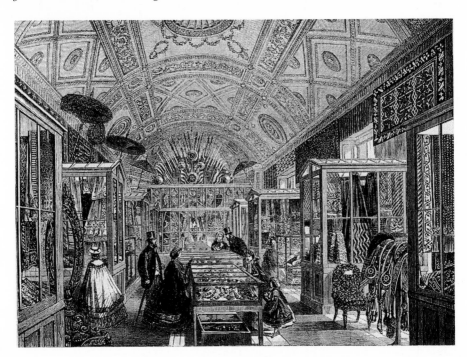

FIGURE 9.1 "The New India Museum." *Illustrated London News*, August 3, 1861.

the manners and customs of the people will be shown in a corridor adjoining. The six bedrooms on the upper floor are stored with birds, which have been most carefully classified and are arranged very ingeniously, so as to take advantage, in the best manner, of the unfavourable light which the small and inconvenient rooms afford. The kitchen of the establishment is filled with antelopes, stags, leopards, and other large stuffed animals. A fine collection of the Elliot marbles, consisting of slabs, cornices, panels, and other portions of the sculptures from the ruins of Amrawutti, are arranged in the grounds of Fife House.[1] These marbles have not yet been exhibited in this country, and they are remarkable for the extreme delicacy and minuteness of their finish. The subjects represented are connected with the worship of Buddha; and the marbles formed at one time portions of a magnificent temple, of which the ruins now alone remain to tell of the patient skill of its founders. A more interesting collection of sculpture does not exist, and many of them will bear favourable comparison with the Elgin marbles in beauty of design, while they greatly exceed them in point of finish and careful execution. The large collection of ethnological specimens, containing electrotype casts of the faces, feet, and hands of every tribe of Northern India, Cabul, and Thibet, in the completion of which the accomplished M. Schlagentweit lost his life, are arranged in the entrance-hall, together with many of those remarkable specimens of Indian sculpture which were formerly shown in

---

1. Elliot marbles: statues from Amaravati excavated in 1845 by Sir Walter Elliot (1803–1887), eventually displayed at the British Museum. [Ed.]

the sculpture gallery of the India House.[2] There is no branch of industry or of manu-factures, and scarcely any description of raw produce, which is not illustrated in this most interesting museum. Some very considerable inroads were made into the collection by the trustees of the British Museum, who were authorised to take any specimens they thought proper, and they availed themselves of the liberal offer to the extent of clearing off nearly all the specimens of natural history. The India Museum is open to the public on Mondays, Wednesdays, and Fridays.

2.  Adolf Schlagintweit (1829–1857): German explorer, commissioned by the East India Company to undertake an expedition along with his brothers in the Deccan Traps and the Himalayas. He was put to death by the amir of Kashgar. [Ed.]

# J. FORBES WATSON

—◦❧ ❧◦—

## On the Measures Required for the Efficient Working of the India Museum and Library

### Part I: Organization and Proposed Measures

#### Preliminary Remarks

THE promotion of the literature, arts, and sciences of India by England had its origin in the acquisition of the Province of Bengal. Policy required a knowledge of the laws and institutions of the country: its administration could not be conducted in an efficient manner without geographical knowledge, nor its commerce promoted without a knowledge of its products and their uses. When, under Warren Hastings, the Government of the Company's territories assumed a more regular shape, it was found necessary to make use to a great extent of the agencies left by the previous Governments, and to assimilate, in some measure, the collection of revenue and the administration of justice to the use and wont of the country.[1] This of necessity gave a powerful impulse to the study of its literature, which contained the authoritative exposition of the native organization. The study of Sanskrit, Persian, and Arabic thus assumed an urgent practical importance, and the first Indian statesmen were also the first Indian linguists. Under their auspices the new studies grew rapidly. It suffices to mention the names of Sir William Jones and of Colebrooke to call up the memory of the great achievements in Oriental research then accomplished, of the priceless literary treasures then for the first time disclosed to Europe, and of the surprising influence which all these new discoveries exercised on the stream of European thought.[2] A new epoch in the study of history, archæology, mythology, and of linguistic science began from that date, and since then the collection, investigation, and description of all Indian antiquities have gone on with unflagging zeal, whilst at the same time the exploration of the country in a geographical, scientific, and commercial sense has more than kept pace with the political establishment of England as the paramount power over the whole of the country. The necessity for having some permanent repository in which the rapidly accumulating literary, artistic, commercial, and scientific collections could be preserved and rendered permanently useful was very soon felt. In 1798 the Court of Directors of the Honourable East

J. Forbes Watson, *On the Measures Required for the Efficient Working of the India Museum and Library, with suggestions for the Foundation, in Connection with them, of an Indian Institute for Enquiry, Lecture, and Teaching* (London: Eyre and Spottiswoode, 1874), 1–28 (excerpts).

1. Warren Hastings (1732–1818): governor-general of Bengal (1772–1785). [Ed.]
2. Sir William Jones (1746–1794): orientalist and judge. Henry Thomas Colebrooke (1765–1837): administrator in India and scholar. [Ed.]

India Company passed a resolution to devote a portion of their house in Leaden-hall Street for the establishment of a Museum, and Mr. (afterwards Sir Charles) Wilkins thereupon submitted a plan for its organization.[3] In connexion with the Museum, a Library was also founded. This was to include Oriental manuscripts, coins, medals, &c., and such publications on Asiatic subjects as should be deemed useful for reference, including all works and maps published under the auspices of the Company. In 1800 Mr. Wilkins was appointed librarian, and charged with the foundation of the Museum. The Museum began, though slowly, to acquire a character suitable to its purpose. Dr. Horsfield, when its curator, as the successor of Sir Charles Wilkins, commenced the formation of the Natural History Collection, but the commercial representation of the productions of India in the Museum dates mainly from the Great Exhibition of 1851.[4] A considerable proportion of the articles then sent from India were available for this purpose, and formed under the skilled hands of Dr. Forbes Royle the Industrial Section of the Museum as it existed at the old East India House.[5] Further steps in the same direction, by initiating a systematic use of the Museum as an instrument for the promotion of the commercial relations between England and India, have been taken under the present Director of the Museum, the Reporter on the Products of India. On the breaking up of the East India Company, both the Museum and Library were in 1860 removed from Leadenhall Street, and temporarily accommodated,—the former in Fife House, and the latter in the offices of the late Board of Control in Cannon Row. Since 1869 both have been transferred to their present position in the new India Office. The collections which had accumulated from that time up to the period of the abolition of the Company in 1857 formed an admirable representation of the condition and past history of India. The Library, as regards its manuscript collections, stands foremost amongst all oriental collections; and the various Museum collections exhibited an admirable *epitome* of India,—illustrating the topography and history of the country; its people and their customs, manners, trades, and religions; its antiquities, agriculture, manu-factures, mineral resources, and natural history.

Since the removal from the old East India House, however, the condition of the Museum and Library collections has ever been unsatisfactory. The arrangements made for them had from the first the character of a makeshift, while the scantiness and in-convenience of the existing accommodation have in every way acted injuriously.

In the first place, not only has the growth of the collections been checked, but their preservation even has been endangered. The collections are to a considerable ex-tent the result of private donations. Many of them, thus obtained, it has been impos-sible to exhibit from insufficiency of space, and it has been necessary simply to store them. It is evident that the neglect thus shown to the fruits of long labours must often have been resented by the donors, and that this has discouraged many persons who otherwise would have taken a pride in helping to render the Museum in every way a complete representation of India. But not only have the collections not increased as they should have done,—they have to a certain extent deteriorated in value.

3. Sir Charles Wilkins (1749–1836): pioneering Sanskrit scholar and translator. [Ed.]
4. Thomas Horsfield (1773–1859): physician and naturalist. [Ed.]
5. John Forbes Royle (1798–1858): surgeon and naturalist. [Ed.]

Besides, it is obvious that the usefulness of a collection is not to be measured solely by the number of its specimens, that is, by its mere materials. It depends greatly upon the manner in which these resources are applied for the furtherance of the purposes of the institution; and upon the facilities given to scientific investigators and to the general public for making use of the accumulated materials for research and information; but the same causes which arrested the growth of the collections have also prevented their systematic utilization. The preparation of natural history catalogues—of the greatest use to the scientific world—had to be discontinued. Even with regard to such portions of the collections as were actually exhibited, the temporary nature of the arrangements, and the cramped and unsuitable space, have prevented the carrying out of any systematic classification, or the preparation of catalogues possessing a permanent value. The Library in certain respects is in even a worse position than the Museum. Like the Museum it is situated in the attics of a high building, badly ventilated, and exposed to excessive heat, dust, and soot, and every bit of space available for extensions has been all but filled up. Under existing conditions it is impossible to carry out a subject-matter arrangement, a point of vital importance for the proper utilization of the literary treasures contained in it.

Thus it has come to pass that the collections which Government held in trust for the fulfilment of a public purpose have been virtually placed under conditions in which this purpose either could not be carried out at all, or only could be carried out with a small amount of efficiency. Instead of keeping up a living institution, actively promoting the ends indicated by its founders, continuing its traditions, and answering the expectations of the public, little could be done beyond keeping the collections intact until some future opportunity would allow of a development of their latent capabilities. The repeated representations of the Asiatic and Zoological Societies, and of many individual investigators, foreign as well as English, who have been debarred from consulting collections which, though known to exist, were inaccessible, prove the injurious effect of this state of matters in so far as they attest the disappointment of those already acquainted with the value of the information which has thus been practically withheld. The more important effect on the general public, who are virtually shut out from the only popular source of information on Indian subjects which is accessible in this country, is not one which manifests itself in complaints, but which may nevertheless be traced in the prevailing ignorance of and want of interest in many Indian questions,—an ignorance and want of interest which a well-organized museum and library might have gone far to remove.

It must be remarked that this interruption in the activity of the Museum happened at a period when museums everywhere were entering upon a wider sphere of action: and when, instead of being institutions specially devoted to scientific investigation and the promotion of research, they had begun to be made use of as instruments for directly influencing the practical life of nations by spreading information on current economic, domestic, or social questions. The new direction given to the activity of museums was traced out for them by exhibitions. This practical tendency is becoming more and more apparent, and the opinion gains ground that many of the objects which were originally aimed at by exhibitions may be much better attained by more permanent and more systematically conducted institutions such as museums.

It is a tendency moreover which is entirely in accordance with the current of modern thought and practice throughout the whole field of its relations with external nature, and which is as perceptible in the case of research and discovery, as it is in the mode of imparting information to the public at large.

The characteristic of the modern methods in all these respects is to increase the direct contact with nature, and to develop the power of personal observation and the art of drawing correct inferences from the observed facts,—to acquire, in short, the power of using facts instead of cultivating a mere aptitude for receiving the impressions and ideas of others.

This method, which is the foundation of the whole of the natural sciences, and which has long guided all scientific investigations, has been extended to other fields. In general literature—scientific, historic, or artistic,—the same increased perception of, and desire for, reality becomes apparent. Proof of this is afforded not only by the extended use of pictorial and graphic illustration, but even by a marked change in the very style of literary composition. Thus in historical writing, the extraordinary development of biographical analysis and of descriptive power offers a substitute for reality by presenting its image re-constructed by imagination. The same spirit has vivified the whole system of education, and to its influence must be attributed the more and more extended use of "object-lessons" in primary education, and of laboratories and museums in the higher education.

It seems natural that the same method which already tends to prevail in education, *i.e.,* in the training and instruction of those preparing for practical life, should also be applied for communicating information to those who have already entered upon practical life, that is, to the active classes of the community.

At present, literature is the almost exclusive vehicle for this purpose, though the insufficiency of the merely literary method with regard to most of the objects on which popular information bears is recognised. It is here that museums step in, and by placing the example at the side of the explanation facilitate the acquirement of the instruction conveyed by both. It is the most telling manner in which information can be conveyed both to the popular and to the trained mind, imparting to knowledge that precision and vividness which no mere description can give. This is the direction already entered on by artistic and technical museums, intended to demonstrate, and make available to the public at large, applied art and applied science. The usefulness of such a course is apparent as regards commercial, economic, or any other questions of general interest, supplying to the discussion a firm basis in the shape of an actual representation of the subject involved in it. Some of the existing museums, as well as some of the past exhibitions, afford good indications of the proper methods to be used for all these purposes. Distinctly traceable and practically tangible results can thus be achieved through the instrumentality of museums, apart from their influence on general culture. A wide field of future progress lies before them, and rich and manifold results may be expected from increased efforts in this direction.

Throughout the management of the India Museum, the constantly expanding ideas as to the functions of museums in general, and as to their mode of action, have never been lost sight of; and advantage has been taken of every opportunity of making the resources of the Museum bear on issues of practical importance to India and to England, as far as it was possible to do so under the very unfavourable conditions

before referred to. The arrangement of the economical collections already effected at the Museum; the special and loan collections; and the lectures from time to time delivered, are examples of actual work in this direction. But the straitened space, and the straitened means in every way, which precluded the execution of any comprehensive scheme, are reasons why the work accomplished by the Museum should not be measured merely by the results which have thus far become apparent. The activity of the Museum since its removal from the old East India House has been to a great extent prospective, that is, tending towards the preparation of future means of action by maturing plans and elaborating methods for the better utilization of the collections, so as to be ready to put these plans into practice the moment the favourable opportunity arrived.

One important conclusion was arrived at during these preparatory studies, namely, that the majority of the conductors of museums are but imperfectly aware of the extraordinary power and wide applicability of the instrument placed in their hands. By tracing the principles of arrangement and the methods of action which have already led to the success of existing institutions, by supplementing these with suggestions derived from exhibitions or from other sources of information, and by combining the various suggestions and methods already practically tested, into one comprehensive scheme, an efficiency scarcely yet realized may be attained in the accomplishment of the various purposes of a museum, and this to a great extent merely by the proper handling of existing resources.

## Principles

Before attempting to describe the features of such a scheme, as applied to the proposed India Museum, it may be useful to give here an example of one kind of operation which might be very advantageously extended to almost all classes of objects. This example is afforded by the scheme sanctioned by the Secretary of State in Council, and to a great extent already carried out, for the extension of a knowledge of the textile manufactures of India.

This scheme consists in the preparation and distribution in this country and in India of identical sets of trade collections, embracing in the shape of actual specimens or of fac-simile illustrations, the whole range of the Indian textile fabrics, arranged according to their special uses and their mode of manufacture. The number of specimens contained in each of the sets already issued amounts to 700, and in the sets under preparation, and of which a considerable portion has already been distributed, to upwards of 1,400, for which a sum amounting to nearly 3,000l. has been subscribed by the chief seats of commerce in this country. Full information about each of the classes into which the collection is divided is supplied by the work on the "Textile Manufactures and Costumes of the People of India," which was issued some years ago, and which thus stands in the place of a catalogue *raisonné*.

The advantages of the plan followed in the preparation of these textile collections are very great. This plan is applicable to almost all classes of collections, and it has been made the basis of the proposals, now before Government, for the organization of trade museums throughout India. Its essence consists (1) in the

preparation of standard collections, illustrating some special point, and composed of well-selected typical specimens, systematically arranged and fully described, and (2) in the mechanical reproduction and multiplication of the collections so prepared. The effect of such a system on the practical influence of museums is similar to that produced by printing upon the usefulness of a manuscript. As many copies can be struck off as there are places in need of information, and thus the effort which produces the standard collection is rendered useful to the country at large, so that the influence of museums ceases to be local and becomes national.

This one example is sufficient to show, that in attempting to realize the probable effects which a well-organized India Museum may be expected to produce, there lies at the root of the question a conception of the functions of a museum which differs from that commonly entertained and acted on. This conception consists in considering the Museum not as a *mere store* of various more or less interesting or curious specimens, from which casual visitors, or even students are left to extract what information they may, but as a *machine* specially designed for the accomplishment of certain well-defined objects. It may be asserted that from the want of a clear insight into their purpose and possible uses, collections which might be made to illustrate questions of practical and scientific importance, remain mere assemblages of specimens, unconnected by any thread of purpose or meaning, and of little use to anyone but a few specialists who possess the knowledge and the time requisite for utilizing them.

Special fitness for special ends is the characteristic of every properly designed mechanism. Therefore, in organizing a museum, it is necessary to anticipate clearly and to take separately into account the various forms of usefulness which it can exercise, the various classes of people who will appeal to it for information, the special character of the information which will meet the wants of each class, and the mode of arrangement which will render that information most readily intelligible. Thus, although the general purpose of the Museum will remain the same throughout the whole field of its influence, special measures must be adopted to further each special object, and the efficiency of the institution as a whole will only be the sum of the special effects thus produced. The general purpose of an India Museum is apparent,—it is to supply accurate information with regard to all the features of India capable of being illustrated by its contents. In order to accomplish this function with efficiency—that is, in order to supply the maximum amount of information to the largest number of people in the shape most convenient for them—certain principles must be kept in view, which are indispensable conditions of success, and which might be called obvious if they were not too frequently ignored.

### Separate Representation of the Different Features of the Country

The first requirement of a museum arranged with a view to efficiency is *specialization of its contents*. The key to the kind of specialization required is afforded by the reflection that all the information supplied by a museum is more or less akin to direct personal experience. A museum, indeed, is intended in some measure to supply the place of personal observation or experience by exhibiting in a small compass the same material sources of information which may be gathered with trouble in the country

itself. Now it is obvious that if a merchant, a manufacturer, a scientific man, or an artist visit a country, each will look on it from a different point of view, and direct his attention to different objects, or if two or all of them are attracted by the same object, it will be as a rule by a different quality of it. The merchant will have the interests of commerce in view, and will study articles which, in the condition in which he can obtain them, are capable of immediate use, and have attained or may attain a place in the market of the world, and he will also study the various material wants and habits of the people which are a guide to him regarding the articles he can dispose of in the country. The manufacturer will with preference direct his attention to articles or products which, in order to fit them for use, require some further manipulation or transformation, and he will note the concurrence of the natural and economic conditions favourable for production. The scientific man, again, will be interested in all articles, useful or not, if they illustrate some natural order or species, or exemplify the working of some natural law; and the artist will be attracted by all objects natural or artificial, provided they suggest some artistic combination of form or colour, or illustrate some style of art or some original mode of its practical application. In the same manner, different features of the country and of the people will attract the attention of the statesman, the agriculturist, the engineer, the medical man, or the historian. As the general public which may be expected to resort to the Museum for information consists of such various classes of individuals, each having a special purpose in view, the usefulness of the Museum will depend on its success in presenting to each visitor the kind of articles and the kind of information which he himself would have sought out if he had had the opportunity of investigating the country itself. In none of the exhibitions which have taken place, nor in any of the existing museums, has this principle been systematically acted on, although it is one which would facilitate to an extraordinary extent the utilization of collections for practical purposes. The system here advocated leads to the division of the collections into groups, each illustrating the country from a special point of view, and each being as nearly as possible a complete picture without reference to other groups. It is in fact doing, once for all, the work which every visitor resorting to a museum for a special purpose has to perform for himself, but at such an expense of time and research as few can afford.

—◦❯ ❮◦—

## The Special Arrangement of Each Group

The second principle which must be kept in view is a corollary from the first. The specialization applies not only to the selection of the articles, but also to their arrangement. Each group will require its own *special method of arrangement,* derived from the leading idea which it is intended to represent, bringing out all the characteristic features in their most natural connexion, or in that connexion which is most familiar, and which approaches most nearly to the daily experience and the mental associations of the class for whose benefit the group is designed. The point here touched upon is one of vital importance, but it is even less attended to, and its advantages less recognised than are those resulting from the simple specialization of the collections. Most of the advantages of specialization, however, may be lost, if the collection is classified and arranged according to some inappropriate or merely empirical method.

A well-arranged museum should be articulate, should speak a language of its own, using for the purpose objects or their images instead of verbal designations, but always leading to obvious conclusions.

In like manner as the letters of the alphabet, if differently arranged, produce different words, or as the same words, if combined in a different order, express a different meaning, so the same set of specimens may be used for illustrating different features of the country, that is, the succession of the specimens will impart a view which will differ according to the variation in the principle of arrangement.

A consequence which deserves mentioning is the living and progressive character of a museum organized in this manner. The progressiveness will appear even in reference to those collections which will represent features of the country possessing a more or less permanent interest, since the mode of arrangement will have to be constantly improved as our knowledge of the country increases, and our ideas with regard to the utilization of its resources expand. But independently of this, new questions of economic, social, or historic importance may arise, and the Museum, faithful to its mission of assisting in the solution of current questions, will have to use its resources for the purpose of special representation of such new problems.

## The Importance of Supplying Full Information with the Specimens

A third condition of efficiency is that the Museum should show not merely the materials from which information can be derived but results. Collections specially selected and specially arranged, with reference to a special object, will go far in giving a direct representation of results, *i.e.*, of conclusions apparent without further inquiry or study. With regard to important branches of information, however, actual representation is impossible, and the actual articles must be supplemented by literary and statistical information, as also by pictorial or graphical illustration. This is the only way of bringing out the full significance of the collections, as the general public can never be expected to perform the work of inquirers. Besides, it is a true economy of force to render available to the public the results of past investigations. With regard to the knowledge of India, we have not so much to complain of any absolute want of information, as of the fact that its possession is restricted to a remarkably small number of persons, and that the sources from which information may be derived are exceedingly scattered, voluminous, and difficult of access, rendering any attempt to collect it almost hopeless on the part of a private individual. The Department of the Reporter on the Products of India has to a certain extent the mission of bringing to the notice of the practical classes, both of this country and of India, the information already available with regard to commercial products. The materials collected in the department occupy several thousand record-boxes, but the limited staff of the department has precluded any attempt at elaborating the information for the whole range of products on a systematic plan. Such a course would, however, vastly increase the usefulness of the department, and would materially diminish the work now imposed on it. The greatest portion of the inquiries addressed to the Reporter are of a nature which a well-arranged museum, exhibiting a condensed view of all the results referring to each product, would render unnecessary. In fact, one of the strongest arguments for such a connexion of the literary information with that

afforded by the specimens is the frequency with which similar inquiries recur, each of which must now be answered separately.

## Preparation and Reproduction of Typical Collections

In attempting to realize the amount of practical influence which a museum arranged on the foregoing principles may exert, two conclusions force themselves upon the mind. The first is that, after all, its influence will be limited to the comparatively small number of people who can personally visit and study it,—that it will to a great extent not be exercised on the country at large but on the fraction of the population which will be able to visit it in London. It may consequently be said that were the Museum ever so perfect some most important classes deeply concerned in India would find it practically inaccessible. For instance, as regards commercial interest in India, it cannot be doubted that places like Manchester, Bradford, and Glasgow may be quite as important or more so than London. If the Museum is capable of exercising a useful influence, why should its action be limited to a fraction of the community, and not extended to the country at large? The other conclusion is, that such a collection as the present India Museum presents, or rather would present, if all its resources could be displayed and developed, contains too great a multiplicity of objects to impart at first sight a clear notion of the leading features of India, except to those who have full time to study it. The picture is too large to be surveyed at once. For certain practical purposes a very much smaller collection, consisting of well-selected typical and strongly characteristic specimens fully described and illustrated, might be found in many respects more efficient. The difference is the same as that between information shut up in big folio volumes necessarily confined to large libraries, and that conveyed through the medium of current literature.

There still remains a question to be dealt with: granted that an institution consisting of the Museum, Library, and Institute here alluded to will be efficient in accomplishing the immediate purposes indicated—the promotion of investigation and the dissemination of information—are the practical advantages resulting from success in this effort worth attainment at the required cost?

This question will be best answered by considering the importance of such an institution under the following aspects:—

    (*a.*) The commercial usefulness of such an institution:
    (*b.*) Its educational influence:
    (*c.*) Its political advantages:
    (*d.*) The assistance it will render to Government in the carrying out of its policy with regard to science, art, and literature.

## Commercial Usefulness

One of the most obvious effects of such an institution would be its influence on the development of the commercial relations between England and India.

In considering this question, it is desirable to look forward to the time when trade museums giving a picture of all the economic resources of India will have been established throughout the principal seats of commerce in this country, as well as in those of India. If typical collections on the plan here advocated are once created, it is believed that their multiplication will be the result of support received from the public. The manner in which the chief seats of commerce in this country have subscribed for the reproduction of the textile collections justifies this expectation.

It is necessary, however, to guard against exaggerated notions as regards the possible effects of such museums.

It would be a delusive expectation to suppose that the information contained in the trade museums will as a rule be of immediate use to men of business without the trouble of special inquiry, though this will be the case as regards some portions of it. It must be remembered that the practical success of a mercantile enterprise is often dependent on the concurrence of such apparently trivial and singly unimportant conditions as general information cannot embrace.

But it would be as unreasonable to declare trade museums of no use because they cannot attain such direct and immediate ends as it would be to declare a topographical survey useless, because it cannot relieve the engineer of the necessity for making a special study and a special map for his railway, or to consider a geological survey superfluous because a special inquiry and preliminary experiments will be necessary for a mining enterprise. The use of the economic picture of the country given by the trade museum will be exactly of the same kind for all commercial operations as that of a topographical map, for operations dealing with the surface of the earth. It will show the general commercial character of every locality, point out where information is to be obtained, and indicate the nature of the materials which are to be expected. Special inquiries, whether on the part of the man of business or on that of some special Government department, which, because of their speciality, cannot embrace a large area, will have their field circumscribed, and be put upon the right track, and thus errors and losses will frequently be prevented.

The effect will therefore be,—

(a.) To economize skill by presenting, as it were, an industrial bird's eye view of the country, thus saving much preliminary inquiry, and allowing the skill to be directed at once to the right place.

(b.) To facilitate the acquirement of skill by giving the best existing information regarding every product in India,—information which it would take years to obtain by individual exertion,—and by referring on all general subjects to the best sources of information.

This twofold action will be of special importance now that, in consequence of the shortened communication with the East, *via* the Suez Canal, there goes out to India a yearly increasing number of European agents, who have no Indian experience,

and little time to spare for acquiring information in the tedious and imperfect manner in which at present it is alone possible for them to obtain it.[6]

The practical use of trade museums will therefore be twofold:—

(*a.*) They will be calculated to promote trade directly, by becoming instrumental in facilitating commercial transactions. This feature has been indicated and acknowledged as regards the collections of Indian textile manufactures which have been already issued by the Department of the Reporter on the Products of India or which are now in course of preparation. What applies to these collections applies equally to other collections, all of which, being as far as possible identical, will allow of easy reference from any place where one of the museums is established to all other places possessing a corresponding collection or museum.

(*b.*) The chief use of the trade museums will, however, be indirect. They will become useful by the information they will afford, that is, by the number of practical suggestions which men of business engaged in commerce, agriculture, or manufactures will derive from them.

There is one more point which should be here alluded to. The objection is now and then raised that it is not worth while to disseminate commercial information on India, as the great houses engaged in Indian trade already possess more information than any such scheme could afford them. In some respects this is no doubt frequently the case, but the information possessed by them usually refers mainly to the few staples in which they are interested. But even were it granted that the commercial information which will be afforded by the trade museums is already possessed by a few firms, it would be like arguing that books are unnecessary because there are some people who already possess the knowledge communicated by them. Commercial knowledge amounts under many circumstances to a virtual monopoly, and secures its possessors against competition. If the acquisition of this knowledge be facilitated, all the advantages derived from increased competition will follow. Experience shows that the increased competition alone, produced by railways, steam navigation routes, and telegraphs, put the leading firms on their mettle, and forced them to discard the tortuous system of middlemen, to enter into direct communication with the up-country producers, and to ascertain on the spot all the circumstances referring to their particular trade. But startling revelations still appear from time to time, showing how much remains to be done in the same direction. A well-conceived and well-executed scheme for rendering industrial information regarding India accessible to the commercial classes generally, might well be expected to contribute to a further development in that direction.

6. The Suez Canal linking the Mediterranean and the Red Sea opened to traffic in 1869. [Ed.]

## Educational Advantages

The use of a museum, and of typical collections like those here described for educational purposes, is very obvious. Thus the commercial and the manufacturing series of the collections afford an admirable groundwork for commercial and technical education, and the facility with which these collections can be multiplied renders their acquirement possible for educational institutions interested in India. Probably for such purposes it would be advisable to prepare special collections in a smaller compass than those destined for the practical use of trade. The matter possesses some importance for this country, but as regards India, the subject of technical education, and of a larger introduction of the natural sciences in general into the higher teaching, is a question of great importance. The chief defect of the present educational system in India is that it is founded almost entirely on book-work,—cram and examinations. This is true even as regards sciences, in which experiment and observation are the only efficient means of acquiring knowledge. Of recent years some steps have been taken to give to education in India a more practical tendency, as shown by the appointment of a few professors of natural sciences and practical arts. The Museum might afford help in two ways. In the first place the typical collections previously mentioned would be available for India, and facilitate the acquirement by the natives of an extended and accurate knowledge of their own country. In the second place the Museum would be well fitted and ought to be used for the purpose of arranging and transmitting to India typical collections referring to science in general, such as mineralogy, botany, mechanics, &c., without which it is hopeless to attempt a general introduction of the teaching of natural sciences or of technical arts.

The effects of the proposed Institute on the higher education of the natives of India who come to London and in training the candidates for the India Civil Service before they proceed to India have already been alluded to.

## Political Advantages

The political advantages which India may derive from a wide-spread knowledge of her condition and resources depend on the fact that the final policy of the Government of India is determined in this country by the action of Parliament, which is itself the expression of the political opinions of the English people. There can be no doubt therefore that it is of great importance that the interest in Indian matters should be kept alive, and that a knowledge of the characteristic features of the country and of its people should be extended as far as possible. At present the apathy of the English public, and even of Parliament, when any Indian question comes up for discussion, has become proverbial. This does not arise from any inherent want of sympathy with the many millions under English rule in India. The course of public opinion during the present famine distinctly proves that, in any question appealing directly to their minds and sympathies, the English people pronounces in an unmistakeable manner its anxiety for the welfare of India. The apathy prevailing with regard to most Indian questions is largely the result of ignorance. The mind, bewildered by the strangeness of everything referring to India, assailed from all sides by contradictory opinions, cannot develop an active feeling of political responsibility for the course

of the Indian policy of England, and cannot realize the good or bad effects of any given line of policy, the materials for forming an opinion on such a subject being so difficult of access.

For the last ten years official publications, such as the Moral and Material Progress Reports, have been issued with the direct intention of keeping Parliament and the public informed of the condition of India. But apart from the fact that Blue Books seldom enjoy a wide popularity, India is so different from this country that few people would be capable of realising from a mere literary representation its special characteristics.

And yet there are at the present time in England many important sections of the public warmly interested in certain special matters connected with India, and though, as a rule, unconnected with politics, they frequently aspire to political influence. The missionary and philanthropic interest, for example, has a considerable amount of public support, and has exercised considerable influence on India. Then there is the Manchester interest, based on the commercial connexion between a cotton producing and a cotton manufacturing country; the general interest which a large portion of the educated classes feel for India as the home of a refined taste and an harmonious art; and the interest felt by scientific and literary men in India as the cradle of modern linguistic science. There are besides the numerous old Indians, connected personally or through their families with India, and frequently continuing to take a warm interest in it. An institution therefore making information with regard to India of easy access would not have to create an interest, but would appeal at once to the sympathies of many. It would thus start under favourable auspices.

# LORD CURZON ET AL.

—◦❧ ❦◦—

## The Future Treatment of the Indian Collection at the Old South Kensington Museum (1909)

LORD CURZON said: Mr. Runciman, the important deputation which I have the honour to introduce to you to-day has come here to invite the reconsideration by His Majesty's Government of their alleged intention to distribute what is popularly known as the Indian Collection at South Kensington. The bodies and associations represented here to-day are of a very influential character. I have the honour myself to speak on behalf of The British Empire League, which naturally regards this matter from the Imperial standpoint, and also on behalf of the University of Oxford, which, in so far as it both trains a large number of Indian students and of Englishmen likely to play a prominent part in the future government of the Empire, has a vital concern in this question. Among the other bodies represented here are the Royal Asiatic Society, the East India Association, the Royal Anthropological Institute, and a committee of artists and experts who are specially interested in this matter. We could easily have added both to the number of representative bodies, delegates from whom appear here to-day, and also to the number of distinguished men who have attended this afternoon. The origin of the apprehension which has brought us here to-day is to be attributed to the report of a Committee which, as you know, sat last year. In the early part of 1898 a Departmental Committee appears to have been appointed to draw up a comprehensive scheme for the rearrangement of the products in the South Kensington Museum, in the interests, firstly, of those engaged in commercial production, and, secondly, for the due encouragement of art. When this report appeared in the course of last summer we learned that this Committee had reported in favour of classification by material for all the contents of the Victoria and Albert Museum. If I may be allowed to say so, I think that principle is sound and wise, and anything I shall say is not intended to contest its application over the general sphere of action with which you are concerned. But it appears to us that this Committee reported in favour of the application of that principle without thinking of the immense influence that it must necessarily have upon the fate of the Indian Collection. I have here the report of the Committee, and I am almost astonished to notice the slight and even perfunctory fashion in which the Indian Collection is referred to in it. Apart from the main recommendations with regard to India, so little was the Indian point of view appreciated that I even find a sentence on another page in which it is suggested in the most light-hearted way possible that it is a proper thing to group Indian and

From "Proceedings of the Deputation to Mr. Runciman, M.P., President of the Board of Education, on May 6th 1909, with reference to the future treatment of the Indian Collection at the old South Kensington Museum." In T. Holbein Hendley, "Indian Museums," *Journal of Indian Art and Industry* 16 (1914): 49–64 (excerpt).

Chinese woodwork together, as though there is the remotest resemblance or connection between those two forms of artistic production. Sir, the examples of Germany and Austria are quoted here as pertinent and forcible examples, but you will allow me to remind you that neither Germany nor Austria happens to have, or is likely to have, an Indian Empire, and the fact that we have differentiates the case of England and our collection from that of either country, and invalidates any analogy based on the practice of other countries. (Hear, hear.) Moreover, the Committee, while they provided for the separate existence of independent collections, notably the Jones Collection, which, we all know, did not appear to think that India was worthy of the treatment which it dealt out to Mr. Jones.[1] So soon as this announcement was made public protests were heard from many quarters. Many distinguished persons, some of them here to-day, wrote to the newspapers. Since then questions have been asked in Parliament. This deputation has been organised, and I think it cannot be denied that a large body of authoritative opinion has been aroused on the matter. I am sorry to say, sir—you will correct me if I am wrong—that the India Office was rather caught napping in the first place, and there are words in this report which lead me to infer that they accepted the recommendations of the Committee. But if that was so I believe there has been a change of attitude on their part. I understand the India Office generally are in sympathy with the views of this deputation, and I believe that in any discussion you may have upon the matter we shall receive the warm support of the distinguished statesman who presides over that Office at this moment. (Hear, hear.)

Now, sir, before I come to the reasons which induce us to ask you to-day to reconsider the alleged intention of the Government, may I briefly refer to the circumstances in which this collection came into being, and passed into your possession at all, because they materially affect the decision to be taken as to its future. The nucleus of the Indian Collection was to be found in the collection in the old East India House in Leadenhall Street in the City. That collection, I understand, was accumulated partly as the result of conquest and acquisition in India, partly by gifts from Indian potentates and distinguished persons, and largely by purchase. When the Government of India was taken over by the Crown this collection was not unnaturally transferred to the custody of the India Office, and I believe for many years it was accommodated, imperfectly accommodated, in a number of rather discreditable iron sheds in the space opposite the India Office, which in the future is to be occupied by some great public building. But whether it was well housed or badly housed, so important was it regarded that the India Office spent, be it remembered entirely from Indian revenues, a sum of about £10,000 a year upon the upkeep and augmentation of the collection. In 1879 there appears to have been what I cannot myself help regarding as a rather unfortunate, though it may have been a necessary, break-up of this collection. The geological and mineralogical products were sent to the museum in Jermyn Street, the vegetable products were sent to Kew, the antiquities, or the greater part of them, went to the British Museum, and the

---

1. John Jones (1799–1882): wealthy military uniform supplier, left his collection of eighteenth- and nineteenth-century fine and decorative arts and furniture to the South Kensington Museum with the condition that the collection be kept intact and not be distributed through the museum. [Ed.]

Art products went to what was then called South Kensington. But at the time this transfer was made the Secretary of State for India defined the object of the India Office in transferring the collection as being—and you will allow me to call your attention to these words—"the continued exhibition of the Indian Collection as a whole." Now, sir, at that time South Kensington, which thus became the possessor of this collection, had, I believe, a collection of some value and interest of its own, and it then proceeded to send out Sir Caspar Purdon Clarke to India, where, with his extraordinary knowledge of Indian art production and his great opportunities, he amassed a considerable portion of that collection with which we are familiar.[2] Since then I believe that your Department with the aid of grants made by the Government has materially added to that collection from time to time. Thus we are now confronted with the fact that this Indian Collection in the main belongs to two owners, if different branches of the British Government can be so differentiated. Part belongs to your department, and part to the Secretary of State, and I lay stress upon the fact that, to the best of my knowledge, the Secretary of State has never parted with his share of the ownership. On the contrary, in 1886, when a proposal was made by the Department to him that he should surrender finally the Indian contribution to the collection he replied that there was no present intention to recall it from South Kensington, but that he reserved the power to re-consider the matter if it was desirable in the interests of India.

Now, sir, what is the present position? I take it that all of us who are interested in this matter have adopted the preliminary step of going down and looking at the present position of this collection at South Kensington. I think our experience has probably been one to excite feelings of regret. This exhibition is now accommodated in two long galleries, erected for the exhibition of pictures and profoundly unsuited for the present purpose. It is badly arranged, not because of anybody's fault, but because of the structural difficulties of the site and place. You find, therefore, a jumble of objects—historical, antiquarian, artistic, economic, ethnographical, commercial and otherwise, grouped together almost in a medley of confusion. And, further, I understand that the galleries in which they are accommodated are likely to be required for other purposes in the future, and that even if you decide to leave them there for the moment the question of their future destination would not be thereby solved. May I say at once, speaking on behalf of myself and, I believe, for others here, that we are quite prepared to pay reasonable deference to the principle upon which your Committee has reported? If you think it desirable that in order to illustrate the progressive development of the arts in any particular department, say, in the making of textiles, tiles, or anything else, Indian exhibits should be taken and put alongside those of European or other countries, we think it should be quite possible to gratify that wish, without seriously impairing the quality or continuity of the Indian Collection, by selecting such duplicates or such objects of no very great value as may be

2. Sir Caspar Purdon Clarke (1846–1911): museum director and architect. After organizing the Indian collections at South Kensington in 1880, Clarke spent two years as special commissioner in India. He became keeper of the India Museum at South Kensington in 1883. [Ed.]

required for that purpose. But what we are here to-day to urge you respectfully to consider is that you should not break up the collection as a whole. (Cheers.)

This brief historical summary leads me to the main argument which we advance. It would be possible to cover a very wide field of reasoning on this matter, but I think I may condense the different points of view represented by all here in a few sentences. In the first place, there is what I may call the political and historical argument. Surely it is a supremely desirable thing that there should be in England, and of course in the Metropolis of this Empire, some visible presentation of the Indian Empire. We are too apt in England to think and to speak of India as if it were an afterthought, an accident, a casual accretion, instead of one of the foundation-stones of the British Empire. (Cheers.) Those of us who have had any connection with India, on the other hand, regard it as the greatest of our Imperial assets, one of the main sources both of national duty and of national glory. Is it not, then, desirable, if it be feasible, that there should be some place in England where three classes of people can go to learn something of India if they so desire? The first class is the Englishman, be he the stay-at-home Englishman or a traveller, like myself, who have often visited this collection before going to the East to learn something about the countries I was going to see. Ought there not to be some place where he can form an idea of the character and modes of life and thought, and of the artistic productions of India, which will give him not only the knowledge he may need at the moment, but some idea of the great capabilities of that country? Then the second class I refer to is the foreigner. Now, when the foreigner who never has any opportunity of going to India, or may not have it, comes to England, is it not natural that amongst the evidences of the resources and range of this great Empire he should expect to find in London something that refers to and illustrates India? I am fairly familiar, as no doubt you are, with the French Colonial Possessions. They are not comparable with our own in Asia. But go to the Louvre and see what they make of their relatively exiguous possessions in Asia. And is a Frenchman familiar with the exhibitions of his own country to come here and ask what we have to show for India and to be told that all the Indian objects have been dissipated to enable audiences to compare Indian musical instruments with European musical instruments or Indian tiles with Spanish tiles, or whatever the case may be? The third class is the Indian himself. Is it not a natural thing that the Indian, whether a Prince or a native student, when he comes to England should expect to find here some evidence of interest in his country and of the importance that is attached by Englishmen to things Indian? Then there are some of us here to whom the artistic argument appeals. I speak with some deference on the matter, and yet as a large collector of Indian objects I have very definite views. There has always seemed to me something about Indian art which not only is susceptible of, but demands independent treatment. (Hear, hear.) It has a character, what is popularly called an atmosphere, of its own. It starts from a different point of view from any other and represents different ideals. It aims at and reaches a different goal. It is extremely difficult, as any of us know who have collections, to break up our collections and put them in our drawing-rooms with other European objects, and what is true of the individual in that limited way is true of a national collection as a whole. Indian art is best seen when it is seen together and not when it is broken up and scattered in various directions. (Cheers.) Then there is the scientific

argument, upon which I will not enlarge, because I believe the point will be taken up by others, but I believe it to be the case that there are features in this collection which have a value in relation more particularly to the sciences of anthropology and ethnology which is hardly realised and which would be altogether sacrificed if this collection were broken up. Finally, sir, there is the argument which I would like to address to you as the head of the Education Department—viz., the educational argument. Is it not more important to the student generally to learn something about India as a whole than it is, while he is making a comparison of the products of individual groups, incidentally to learn the part that India may have played in the evolution of any particular material or design. He can learn the latter lesson, as it is, by going to the Indian Collection; but he can also learn much more, because while acquiring his lessons in art he is absorbing a lesson in citizenship which should be of the highest value. These are in summary the reasons which animate most of us who are addressing you.

You will naturally ask me, sir, at this stage, what is in our minds as to the future, what is the sort of plan we would like to see carried out supposing you are favourable to our main contention? I suppose our first inclination would be to ask that the Indian Collection should receive adequate accommodation in the new Victoria and Albert Museum about to be opened, that certain galleries or halls should be assigned to it there where it could be adequately shown. I think there are two reasons against that. I think the authorities are agreed in saying that they are quite unsuited for the purpose of accommodating the Indian Collection in its present form. And even if it could be placed there now, so great is the pressure on their space and so certain is it that the demands upon it will increase in future that all possibilities of expansion, which I have in mind the whole of the time, would have to be sacrificed if the collection were placed there. Well, if these facts are correctly stated, do they not point to a larger solution and to a bolder plan? I hope I shall not frighten you, sir, at a moment when there are considerable demands on His Majesty's Government, which, however, they are always informing us of their perfect readiness to meet, if I suggest that the moment is favourable to create an Indian Museum that shall really be worthy of the name. (Cheers.) The first thing to do would be to acquire a plot of land, and if I were in your counsel I believe I could indicate a not unsuitable site. Then, if that were purchased, a building should be erected upon it worthy of a real Indian Collection. It might be possible, if the building were raised, to collect again inside it many, at any rate, of the articles unfortunately dispersed nearly thirty years ago. I believe the British Museum, which is hopelessly overcrowded, would be glad to give back to us, though I have no authority to say so, some of the antiquities then handed over to them. It might also be that the economic section of the Imperial Institute might be absorbed under the same roof. Of course, I contemplate that any such museum, if created, should be under the control of your Department, and as a necessary sequel it should be under the authority of the distinguished official who presides over the Victoria and Albert Museum. I would not propose anything independent under separate management or control. Co-ordination and control on your part I regard as indispensable. In this way, if you were able to contemplate such a plan, might we not have a museum which, instead of being a jumble, an anachronism, and a reproach, would be a living and a growing thing, an organic factor in the scheme of develop-

ment of our Empire? Such a museum would have great capacities for expansion. It would be augmented by legacies from many of us who do not know what to do with our collections, seeing that other people appear to have a distrust and suspicion of them quite equal to the enthusiasm with which we regard them ourselves. It might provoke gifts from Indian potentates and other persons, and I believe if you are able to make an announcement of such a character or indicate sympathy with such an idea your words would be received with immense satisfaction in every part of India itself. (Cheers.) Only one other consideration. I have often urged the claims of India, and nowhere more strongly than when questions of money have been concerned. It seems to me we are almost habitually, in point of money, in debt to India. When the Imperial Institute was founded, rather more than twenty years ago, out of the £400,000 contributed for that object £236,000 was raised in this country, over £100,000 was contributed by India, and only £64,000 by the rest of the British Empire.[3] Now, I am not contending that India gained nothing from the Imperial Institute even as now arranged, but I do submit that with the Imperial Institute transferred to the Secretary of State for the Colonies, with half of the building already appropriated by London University, and the other half exclusively devoted to the exhibition of commercial and industrial products—I do submit that India has not obtained a return commensurate either to the degree and extent of her original contribution or to the ideas and expectations with which that contribution was made. If that be the case, I think we are in a position not only to do an act of generosity to India, but to repay a national debt to her on the present occasion. (Hear, hear.) I apologise for detaining you so long, but I hope I have now said enough to explain to you the ideas which are in our minds; and may I conclude by expressing the hope, firstly, that the Government will not agree to the dispersion of this collection; and, secondly, that you may, perhaps, be willing to consider favourably some scheme by which it may be resuscitated and reinvigorated and placed in future in a position where it may play, not merely an educational, but a national part in the life of our people? (Cheers.)

MR. (now SIR JOHN) REES, M.P., stated that when he brought the matter up in the House of Commons his object was to ensure that the collections should not be broken up, and it was evident that there was a strong feeling in favour of this view. Busy men in the City said, when he told them what he was going to do, "Go on and prosper, every one of us will back you up and be your clients," because men who want to go to an exhibition of this kind do not care about scientific cataloguing. They say, "I want to go to India. Where is it? And the next thing there it is close at hand."

SIR MANCHERJEE BHOWNAGGREE, in the course of his address, said: "The Englishman's pride in the British Indian possessions of the Empire is a legitimate one, and no less proud is the loyal Indian to think that the Englishman is proud of those possessions, and I think that such visual evidence of that pride and of the interest felt by Great Britain in His Majesty's Dominion of India is best given by such a comprehensive and unified collection as the Indian Collection is desired to be by this deputation. I think it would have a disastrous sentimental effect in India upon all

3. The Imperial Institute was established in 1887 for the purpose of carrying out research into the resources and raw materials of the empire. In 1899, the University of London took over half of its building to use for administrative offices. [Ed.]

classes . . . if it were known that the Imperial Government allowed this rich Indian Collection to be dispersed and practically destroyed." Sir Mancherjee referred to the fact that, under the impression that the collection was to be kept entire and united to some extent with the one in the Imperial Institute, he had himself presented a corridor to the latter.

MR. RUNCIMAN, in reply, said: My lords, ladies and gentlemen, I have in the first place to thank you for coming here to-day and giving me the benefit of your views and information, and I particularly thank those members of the deputation who have refreshed their memories recently as to the condition and extent of the location of the Indian Collections in London. My friend Mr. Rees puts his finger, as he often does in his humorous way, "on the spot" when he says that his City friends cannot at the present time go to any one collection of Indian objects and say, "There I find within four walls the representation of India." The fact is that the history of the present collection, as Lord Curzon describes it, is quite accurate. It grew up originally in the old days in the East India House in Leadenhall Street, and I think even then it was not gathered together as one collection. I believe it was located in three rooms in the old East India House. Then, after having passed, I believe, through Fife Street, much of it ultimately found its way to South Kensington, but at the present time the Indian objects are scattered over several museums. Bethnal Green has the food products, and it also houses the excellent collection which Lord Curzon has been good enough to lend to that end of London. The British Museum shares in the Art Collection, for it has much of the sculpture—I think nearly all the sculpture—originally in the Indian Collection. Kew has the botanical specimens, and curiously enough, the lacquer, or much of the lacquer; while our Science Museum has some of the scientific instruments and some interesting specimens of the old agricultural implements of India. And, last of all, South Kensington houses the artistic and ethnological objects. It must be quite clear to the deputation, therefore, that in pressing their view they are not pressing it against what they thought was the reactionary policy of my Department, but they are going a step forward and wish to see the mistakes of the past rectified and these collections brought together under one roof. (Hear, hear.) Well, the trouble that we have been in is that not only have we only a small site on which to work, but that the new Art Museum which will be opened in the course of the summer by His Majesty the King must of necessity be limited in extent.

The purpose of the Victoria and Albert Museum was really to illustrate the development and history of industrial arts. That was our main object, and in preparing the scheme of arrangement it became necessary, as we thought at the time, to distribute some of the artistic objects now to be found in South Kensington under the heading of various materials of which they formed a part, so that they could be given their true place in relation to other Western or Eastern Art. On one point I must disagree with Lord Curzon, though I feel it is rather a reckless thing to do at any time, and that is to say that I cannot agree with him altogether that Indian Art can or ought to be considered a thing apart by itself. The highest authorities on Indian Art inform me now that there is a growing feeling that Indian Art and the Renaissance in Europe are closely related and inter-related, and therefore I rather deprecate any

attempt which might be made to treat Indian Art as a thing entirely by itself. I hope it may be still possible to consider it in relation to Western Art. Our object, therefore, was to draw together the artistic articles which were under our control so that they could be put in their true relation to other objects from other parts of the world, but that could not be applied to the whole of the articles in the collection in South Kensington, for some of them are of very poor quality. I do not think they are worthy of a place in a public collection at all. I refer particularly to some of the textiles there to be found. The various articles now in that collection have come from many sources, but I wish to point out that my Department has been responsible for placing there some of the most beautiful things now to be found under that roof. The old India Collection was devoted very largely to arms and armour, jewellery, lapidaries' work (jade and crystal carvings), Mogul jewelled jade, models of looms, vehicles, etc. We have added enormously to the collection by acquiring in one form or another samples of architecture, wood-carving and inlay, stone-carving, pottery and tilework, glass, metalwork, carpets, ivories, paintings, illuminations, and between us we have added samples of textiles, including embroideries, enamels, lacquers, musical instruments, leather work, furniture, plaster casts, and gold and silversmiths' work. It may be thought that to represent truly the whole of the Indian Art, industry and life, all these objects should be kept together as a whole. I am considering, again in conjunction with my noble friend the Secretary of State for India, how far we can attain that object, but the difficulty of the Board in the fulfilment of the object is that we find we have no available site at the present time. We have no building worthy of a great collection of this kind. Anyone who has recently been at the long galleries where the Indian Collection is housed will be aware that they are not worthy of our Indian Empire. They are undignified, and I believe I am correct in saying they are not as safe as they might be. But of one thing I am quite sure, and that is, that you may rely upon it that the Government has no intention of doing anything which will cause misgivings either amongst those who have served this country in India, or who, like Sir Mancherjee Bhownaggree, represent in a peculiar sense the Indian people. (Hear, hear.) We at this Board, I think, hesitate, and rightly hesitate, as to the fitness of those who are now under the Board, and the Board itself, to have control of what must be purely and simply a representation of the Indian Empire. That is a matter, I think, which we must certainly consider among the many points which have been raised this afternoon, and others which will be raised in the India Office and in India itself. I can only tell you this, that all the information you have given to me to-day, along with other representations which have been made, will be fully considered, and if I for my part can do anything to further the main object of your representation, viz., that India should be represented under one roof as far as possible, that the various scattered collections should be brought together so that for the first time in the history of museums in this country the Indian Collection should be together as a whole, I will do whatever lies in my power. I qualify that only with one statement, which is that I hope you will agree with me that we should not isolate India even in regard to the arts and crafts. I hope India will certainly have her relation to Eastern and Western arts and crafts visualised, as well as the fact that we have been the controllers and creators of the Indian Empire. (Cheers.) India has laid a heavy toll on the best brains and the steadiest characters of our race, and we have every

reason to be proud of the work done by many of those in this room, and by no one more than Lord Curzon. (Cheers.) India deserves the best representation of her life and products that we can provide. In so far as we can embark on this larger scheme, I shall bring it under the consideration of my colleagues and I think you will leave this room with the assurance that nothing will be done by this Department which will be detrimental to the true interests either of the English in India or of Indians in England. (Cheers.)

# GLOSSARY OF FREQUENTLY CITED
# COLLECTORS AND COLLECTIONS

Note: museums and collections described in the text are generally omitted from this list.

**Angerstein**   The first paintings to enter the National Gallery belonged to the collection assembled at his home in Pall Mall by London businessman John Julius Angerstein (1735–1822). The works, acquired in 1824 when the House of Commons voted £57,000 for the purchase of thirty-eight pictures, were displayed at Angerstein's home until completion of the National Gallery building in Trafalgar Square in 1838.

**Assyrian**   Important works of art from ancient Mesopotamia, many excavated under the direction of Henry Austen Layard (1817–1894), were acquired by the British Museum in the late 1840s and 1850s. Popular enthusiasm for objects identified with Nineveh and Babylon was encouraged by Layard's own writings and by a widespread sense that the antiquities illustrated the truth of scripture.

**Banks**   An important naturalist and patron of science who accompanied Captain Cook on his voyage on the *Endeavour*, and in later life was instrumental in promoting numerous scientific endeavours—notably at Kew Garden—Sir Joseph Banks, baronet (1743–1820), formed and organized a collection that became the core of the British Museum's natural history division.

**Bethnal Green**   A branch of the South Kensington Museum originally constructed when the iron and glass buildings which had formed the first home of that museum were reerected in east London (1872), the permanent collection of the Bethnal Green Museum comprised the Food Museum, designed to teach the nature and sources of food, from chemical composition to natural occurrence. In its early years it was also the site of important and long-lasting temporary displays, notably of the Wallace collection and of the anthropological collection of Colonel Lane-Fox (Pitt-Rivers). Since 1974 it has been a Museum of Childhood.

**Beaumont**   Art patron, landscape painter, and friend of many contemporary artists and writers, notably Wordsworth, Sir George Howland Beaumont, seventh baronet (1753–1827), was a fervent supporter of the founding of a national gallery, to which end he offered an important set of canvasses to the nation with the proviso that the Angerstein collection should be purchased and a gallery established.

**Bourgeois, Francis**   See Dulwich.

341

**Cotton**    Sir Robert Bruce Cotton, first baronet (1571–1631), antiquary and politician, assembled an important collection of books and manuscripts acquired for the nation in 1710 and at the British Museum since its inception.

**Crystal Palace**    The original Crystal Palace housed the Great Exhibition from May to October 1851. A new version was constructed at Sydenham in 1854 and became well known for its period rooms furnished with casts of important works of art. A popular site, it went into decline toward the end of the century and was largely destroyed by fire in 1936.

**Dulwich**    Said to be the earliest purpose-built public art gallery in England, the Dulwich Picture Gallery opened in 1817 with a revolutionary design by Sir John Soane. The gallery was founded from the bequest of Sir Francis Bourgeois, who at his death in 1811 left his collection and the funds for a building to house it to Dulwich College. The collection was originally assembled by Bourgeois and his partner, Noël Desenfans, two successful London art dealers who had been commissioned to put together a suitable collection for the king of Poland. By the time they completed their labors, the political situation in Poland had changed, so they were left in possession of the works of art they had acquired. The museum includes a mausoleum containing the bodies of Bourgeois as well as of Desenfans and his wife.

**Elgin Marbles**    Thomas Bruce, seventh Earl of Elgin and eleventh Earl of Kincardine (1766–1841), entered the army in 1785, and starting in 1790 was sent on a variety of diplomatic missions. Appointed ambassador to the Ottoman Porte in 1799, Elgin used the position to study the remains of Greek art in the Turkish Empire. In 1801, he began to remove friezes and sculptured slabs from the Parthenon, which he shipped back to England between 1803 and 1812. Elgin's actions were controversial, but the Marbles, which were at first put on display in a shed next to his home, were widely (though not universally) admired. In 1816 the collection was purchased for the nation for 35,000 pounds and installed at the British Museum.

**Geology**    The Museum of Economic Geology, a collection of minerals, maps, and mining equipment made by Sir Henry De la Beche (1796–1855), director of the Geological Survey of Great Britain, opened in Craig's Court, Charing Cross in 1841. The museum, which also provided some student places for the study of mineralogy and metallurgy, was succeeded by the Museum of Practical Geology and the Government School of Mines Applied to the Arts, which opened in a purpose-designed building in Jermyn Street in 1851.

**Hampton Court Palace**    Built by Cardinal Wolsey in 1514 and presented by him to Henry VIII, the palace was first opened to the public by Queen Victoria in 1838. Its popular attractions include the Great Vine, planted in 1768, and the Maze, planted in about 1695. For connoisseurs and art students in the eighteenth and early nineteenth centuries, however, a principal reason to visit was the set of cartoons for tapestries by Raphael on display at the palace until 1864, when it was moved to the South Kensington Museum.

**Hunter/Hunterian**    Sir John Hunter (1728–1793), the pioneering pathologist, formed a large collection of anatomical specimens that was purchased by the government in 1799 and donated to the newly formed Royal College of Surgeons. It opened as a museum in

London in 1813. John Hunter's elder brother, William Hunter (1718–1783), physician, anatomist, and man-midwife, assembled a vast collection of anatomy preparations, coins, minerals, and curiosities brought back from Cook's voyages, as well as important collections of shells, corals, and insects. He left these, and his pictures and library, to Glasgow University, along with funds to build a museum, which was opened in 1807.

**Kew Gardens**   Popular name for the Royal Botanic Gardens, Kew, Surrey, England, founded in 1759 by Augusta of Saxe-Coburg (1719–1772), the mother of King George III, as a small garden and greatly expanded throughout the nineteenth century. It was passed to the nation by Queen Victoria in 1840. Sir William Hooker (1785–1865), the first official director of the Royal Botanic Gardens at Kew, opened the Museum of Economic Botany in 1847.

**Marlborough House**   The first home of the Department of Practical Art, which opened a Museum of Manufactures there in 1852 containing contemporary designs as well as older objects. In 1853 the Department of Practical Art became the Department of Science and Art, and the Museum of Manufactures was renamed the Museum of Ornamental Art.

**Nineveh**   See Assyrian.

**Orleans**   Louis-Philippe-Joseph, duc d'Orléans (1747–1793), a member of the Orleans branch of the royal family, sold his collection of important paintings in order to fund his political intrigues around the time of the French revolution. Display of the collection in London (1798–1799) by the English collectors and speculators who had acquired it was a momentous event in the history of the exhibition of art in England. Paintings from the collection entered a number of private hands, many subsequently finding their way to major public collections.

**Patent Museum**   The Patents Law Amendment Act of 1852 established, along with the Patent Office, the Patent Museum at South Kensington, a new institution to which inventors were invited to contribute models of their designs. The museum was absorbed by the Science Museum in 1884.

**Phigaleian Marbles**   Sculptures from the Temple of Apollo at Bassae, Greece, purchased by the British Museum in 1814, received in 1815.

**Sheepshanks Collection**   In 1857 John Sheepshanks (1787–1863), art collector and patron, donated his collection of principally British oil paintings to the South Kensington Museum.

**Sloane**   Sir Hans Sloane, baronet (1660–1753), physician and collector, assembled the collection that formed the core of the British Museum at its inception. His early collection developed in his travels as personal physician to the Duke of Albemarle, governor of Jamaica. On his return to London, he published on his discoveries and became closely involved with the Royal Society. To the material collected on his Jamaican voyage, he added collections of seeds, fruits, shells, and plants, as well as other curiosities, books, and manuscripts. His home became an important sight for connoisseurs and scientists visiting London. Sloane's will was carefully designed to keep together the collection and make it available for the nation. The material was ultimately acquired by Parliament

and—along with the Harleian and Cottonian collections of manuscripts—constituted the founding collection of the British Museum when it was established by act of Parliament on 7 June 1753.

**Somerset House**    In 1837 the Government School of Design was founded in Somerset House, London. With the establishment of the department of Practical Art in 1852, the department, including the Museum of Manufactures and the School of Design, moved into Marlborough House.

**Townley**    Charles Townley (1737–1805) began assembling his noted collection of antiquities during a voyage to Rome in the 1760s, where he bought from Piranesi and other Roman dealers, as well as the English dealer Thomas Jenkins. During a longer visit to Italy between 1771 and 1774 he acquired more works, including sculptures from Jenkins, Thomas Byres, and several Italian dealers, as well as from the painter and excavator Gavin Hamilton. Back in London, Townley continued to expand his collection. In 1791 he acquired a discobolous found in Hadrian's villa. His home, which was designed to set off his collection, became one of the sights of London. Visitors were freely admitted, sometimes guided by Townley himself, and he provided manuscript catalogues for consultation. The bulk of the collection entered the British Museum in 1808, but new knowledge of original works of ancient art, the Elgin Marbles in particular, soon overshadowed the kinds of much-restored largely Roman productions that the eighteenth century had taken for Greek.

**Tradescant**    Tradescant's Museum, or "Ark," was founded in Lambeth in the first half of the seventeenth century by John Tradescant the elder (d. 1638), an important gardener and collector, and further developed by his son, John Tradescant the younger (1608–1662). This collection, which could be visited for a small fee, included animals, insects, minerals, fruits, weapons, clothing and ornaments (including Chief Powhatan's feather cape), domestic utensils, coins, and medals, as well as exotic plants. The collection was acquired by Elias Ashmole (1617–1692) and formed the core of the Ashmolean Museum when it was eventually opened in a purpose-built museum in Oxford in 1683.

**Turner**    At his death, Joseph Mallord William Turner (1775–1851), the most important English painter of the nineteenth century, left an ambiguous will that resulted in a long legal struggle. At the resolution of the case in 1856, the National Gallery received a large number of works by the artist, including hundreds of paintings in various states of finish, and thousands of watercolors and drawings. A separate bequest had left two works to the gallery with the instructions that they be hung next to two Claudes from the Angerstein Collection. Constraints of space did not allow the display of the rest of what came to be known as the Turner bequest, so the collection found its way to the South Kensington Museum in 1858, where it was displayed along with the Vernon collection. Works from both collections were ultimately hung at the National Gallery once the departure of the Royal Academy to Burlington House opened up space in 1869.

**Vernon**    In 1847 Robert Vernon (1774–1849) left a set of paintings, largely by British artists, to the National Gallery. The collection was squeezed into the lower floor in 1848, but it was subsequently moved to Marlborough House in 1850, to South Kensington in 1859, and only found its way back to the National Gallery in 1876.

# AUTHORS AND SPEAKERS

**Althorp**   See Spencer, John Charles.

**Ashley**   See Shaftesbury, Anthony Ashley Cooper.

**Bankes, George (1787–1856)**   A Tory politician and lawyer, Bankes joined Parliament in 1816, where he served as the chair of the Elgin Marbles Committee. In 1852 he held the office of judge-advocate-general and was sworn a privy councilor.

**Bateman, Henry Mayo (1887–1970)**   After training at the Westminster School of Art and the Goldsmith's Institute at New Cross, Bateman became an acclaimed and popular caricaturist, first for the *Tattler* and then *Punch*.

**Best, William Draper, first Baron Wynford (1767–1845)**   Judge and politician, Best became serjeant-at-law in 1799 and entered Parliament in 1802. He was a noted opponent of the Reform Bill.

**Bhownaggree, Sir Mancherjee Merwanjee (1851–1933)**   Born in Bombay and trained as a lawyer in England, Bhownaggree was called to the bar in 1885. He was elected Conservative MP for Bethnal Green in 1895. In 1916 Bhownaggree published a pamphlet, *Verdict of India*, countering German allegations about British rule in India and declaring the loyalty of Indians to the imperial war effort.

**Bicknell, W. I.**   Author of *The Natural History of the Sacred Scriptures and Guide to General Zoology* (1851).

**Brougham, Henry Peter, first Baron Brougham and Vaux (1778–1868)**   In 1802 Brougham helped to launch the *Edinburgh Review*, a publication he dominated for decades. He was called to the Scottish bar and then the English bar in 1808. In Parliament he was an effective voice against slavery. Brougham was the moving force behind the establishment of the Society for the Diffusion of Useful Knowledge in 1826. In 1830 he became lord chancellor, and was subsequently deeply involved in passing the Reform Bill.

**Bullock, William (c. 1780–1849?)**   After working as a jeweler and goldsmith, Bullock opened a museum, first in Sheffield in the early 1790s and then in Liverpool around 1795, containing works of art, armor, objects of natural history, and curiosities acquired from Richard Green's Lichfield Museum and Sir Ashton Lever's collection. In 1809 Bullock moved to London, where his collection, eventually known as the London Museum, became extremely popular, especially after taking up residence in the Egyptian Hall, erected to house it in Piccadilly in 1812. The contents of the museum were sold at auction in 1819,

and in 1822 Bullock made his way to Mexico, only recently independent from Spain. On his return, he put on display many valuable antiquities and reproduction of antiquities from that nation. Bullock ultimately sold this collection, in part to the British Museum, and continued his travels in the Americas. In later life he became involved in promoting migration to the United States. Aside from several editions of his museum catalogue, Bullock published *Six Months' Residence and Travels in Mexico* (1824) and *Sketch of a Journey through the Western States of North America* (1827), among other works.

**Cole, Sir Henry (1808–1882)**    Cole was trained as a clerk, but studied watercolor painting and exhibited sketches at the Royal Academy. He advanced rapidly through a series of government posts in the 1830s and 1840s, becoming a member of the Society of Arts in 1846, and being elected first to its council and then its chair. Cole was appointed to the executive committee of the Great Exhibition in 1849. In 1853 he founded what came to be known as the South Kensington Museum (eventually the Victoria and Albert).

**Croker, John Wilson (1780–1857)**    Born in Ireland, Croker was a member of Parliament from 1807 to 1832 and secretary of the Admiralty from 1810 to 1830. For many years an important contributor on literary and historical subjects to the *Quarterly Review*, his most notorious piece is probably his virulent attack (1818) on Keats's *Endymion*. He also produced an important edition of Boswell's *Life of Johnson* (1831).

**Curwen, John Christian (1756–1828)**    Curwen was an active parliamentarian who supported Catholic emancipation, parliamentary reform, and the repeal of the Corn Laws. In 1805 he inaugurated the Workington Agricultural Society, which was deeply influential on local agriculture in the first half of the nineteenth century.

**Curzon, George Nathaniel, Marquess Curzon of Kedleston (1859–1925)**    Politician, traveler, and eventually viceroy of India (1899–1905), Curzon was active in the protection and restoration of Indian antiquities, including the restoration of the Taj Mahal. In England, he became president of the National League for Opposing Women's Suffrage, president of the Royal Geographical Society, and a trustee of the National Gallery. (He was also an important figure in the Royal Society for the Protection of Birds.) Curzon promoted an influential scheme to exempt owners from death duties on their houses and paintings, provided their collections were kept intact and made available to the public.

**Duncannon**    See Ponsonby, John William.

**Eastlake, Sir Charles Lock (1793–1865)**    An important figure in the Victorian art world as painter, author, and curator, Eastlake studied drawing with Samuel Prout and attended Charterhouse. He was elected to the Royal Academy in 1830 and served as its president (1850–1865) and as first director of the National Gallery (1855–1865).

**Eastlake, Lady Elizabeth (1809–1893)**    Journalist, critic, writer on art, and translator, Eastlake wrote travel memoirs and was a frequent contributor to the *Quarterly Review*. Her translations included Passavant's *Tour of a German Artist in England* (1836), Kugler's *Handbook of the History of Painting* (1851), and Waagen's *Treasures of Art in Great Britain* (1854).

**Elcho**    See Wemyss, Francis Wemyss Charteris Douglas.

**Ellis, Sir Henry** (1777–1869)   Ellis first worked as an assistant at the Bodleian Library at Oxford starting in 1798. Two years later he joined the staff of the British Museum, where, in 1806, he was named keeper of printed books. In 1814 Ellis was appointed secretary to the trustees of the British Museum, and in 1828 principal librarian. He also became senior secretary of the Society of Antiquaries in 1814, a position he held for forty years. He wrote biographies of early fellows of the society, published a catalogue of its manuscripts (1816), and made many contributions to its journal, *Archaeologia*.

**Ewart, William** (1798–1869)   Politician, social reformer, and man of letters, during his forty years in the House of Commons Ewart was a strong advocate of working-class access to public museums and galleries. In 1836 he submitted a report to Parliament on the connections between arts and manufactures that led to the creation of the Schools of Design at Somerset House the following year. In 1850 he successfully promoted a bill establishing free public libraries throughout England. Ewart was also instrumental in the legalization of the standard system of weights and measures.

**Fitzwilliam, Charles William Wentworth, Viscount Milton, third Earl Fitzwilliam** (1786–1857)   Fitzwilliam (known as Viscount Milton when he entered Parliament) made his maiden speech in favor of the abolition of the slave trade in 1807. He called for an inquiry into the Peterloo massacre, favored the repeal of the Corn Laws, and argued against the purchase of the Elgin marbles. He coedited the *Correspondence of Edmund Burke* (1844).

**Flaxman, John** (1755–1826)   Britain's preeminent neoclassical sculptor, Flaxman was born to a maker and seller of plaster casts in York and raised in his father's shop. He joined the Royal Academy Schools in 1770 and in 1775 was employed as a designer by Wedgwood. In 1787 Flaxman and his wife traveled to Rome, where they stayed for seven years before returning to London. Elected a full member of the Royal Academy in 1800, he became the academy's first professor of sculpture in 1810. A friend of William Blake, Flaxman's European influence was principally due to the widespread reproduction of his important illustrations to the *Iliad* and *Odyssey*.

**Flower, Sir William** (1831–1899)   A comparative anatomist, Flower became curator of the Hunterian Museum of the Royal College of Surgeons in 1861. In 1884 he became director of the Natural History Department of the British Museum. His publications include *Essays on Museums* (1893).

**Grant, John Peter** (1774–1848)   After a couple of failed attempts Grant won a parliamentary seat from the rotten borough of Great Grimsby, Lincolnshire. He continued in Parliament until 1826, when (under serious financial duress) he secured an Indian judgeship in Bombay. He resigned that position in 1830 after a dispute with the governor of the city. He died at sea on his voyage home in 1848.

**Gray, John Edward** (1800–1875)   Despite his lack of a formal education, Gray became an influential zoologist and curator at the British Museum, particularly concerned to expand and catalogue the natural history collection. Gray was elected a fellow of the Royal Society in 1832, and in 1840 he was appointed keeper of the zoological department at the British Museum He was also involved with prison and debt reform, as well as with improving the care of the mentally ill.

**Gregory, Sir William Henry (1816–1892)**   Gregory was known in Parliament for his advocacy of state funding for the arts. Chair of a House of Commons inquiry into the British Museum (1860), he supported the opening of public museums on Sundays and the development of the South Kensington Museum. Appointed trustee of the National Gallery in 1860, he was closely involved with growth of the collection. Gregory became governor of Ceylon in 1872, a position he held until 1876. A life-long friend of Anthony Trollope, late in life he married Isabella Augusta Persse (subsequently, Lady Augusta Gregory), and the two established a salon frequented by many important literary figures.

**Hammersley, Hugh (1774–1840)**   Banker and politician, Hammersley represented Helston, Cornwall, 1812–1818.

**Hawkins, Edward (1780–1867)**   Appointed keeper in the British Museum's department of antiquities in 1826, Hawkins oversaw a period of extraordinary growth. Two notable developments during his term were the acquisition of Henry Layard's finds of Assyrian and Babylonian material and the establishment of a collection of prehistoric, Roman, and medieval artifacts from western Europe. Hawkins's principal scholarly contribution was in the field of numismatics, including *Silver Coins of England* (1841), the standard manual on English coinage for almost a century.

**Hazlitt, William (1778–1830)**   Son of a Unitarian minister, Hazlitt attended Hackney College until he abandoned his studies in an unsuccessful attempt to become a portrait painter. From 1814 to 1830 he wrote essays on a wide range of subjects for the *Edinburgh Review*, the *London Magazine*, and other journals. He was concerned with the fine arts throughout his career, but his major sustained contribution to their study was his *Sketches of the Principle Picture-Galleries in England* (1824). His well-known *Spirit of the Age* was published in 1825. Other essay collections include *Table Talk* (1821) and *Plain Speaker* (1826).

**Hendley, Thomas Holbein (1847–1917)**   A surgeon in the Indian Medical Service, Hendley eventually became colonel and Companion of the Order of the Indian Empire. He served as honorary secretary of the Jaipur Museum (1880–1898). In 1913 he published an extensive monograph on Indian museums for the *Journal of Indian Art and Industry*. His other published works include *Rulers of India, and Chiefs of Rajputana* (1897) and *Indian Jewellery* (1909).

**Hume, Sir Abraham, second baronet (1749–1838)**   Hume entered Parliament in 1774, but his main interest was collecting art and precious stones and minerals. Elected a member of the Royal Society in 1775, he was also a founder of the Geological Society. An amateur painter, Hume owned a large collection of paintings including works by Bellini, Titian, Rembrandt, Van Dyck, and others.

**Jameson, Anna (1794–1860)**   After coming to public attention with the anonymous publication of *The Diary of an Ennyuée* (1826), a fictionalized account of her brief stay in Italy and travels in Europe, Anna Jameson became known for her works on women, literary topics, and the fine arts, including her two-volume account of the public and private galleries of London (1842). Her *Sacred and Legendary Art* was published in four parts between 1848 and 1860.

**Jevons, William Stanley (1835–1882)**   The son of an iron merchant in Liverpool, Jevons went to University College, London as a student of assaying and meteorology but turned to logic and mathematics and made his mark as an important logician and economist. In his final years, Jevons published papers on the introduction of an international currency and financial approaches to social problems.

**Knight, Richard Payne (1751–1824)**   Connoisseur, classicist, and theorist of the picturesque, Knight was born in Herefordshire and educated at home, taking many trips to Italy throughout his childhood. In 1774 he inherited the Downton Castle property, which he redesigned in the picturesque style. He was in Parliament from 1780 to 1806. In 1786 Knight published the scandalous *Account of the Remains of the Worship of Priapus*, and in 1816 he again courted controversy when he resisted the purchase of the Elgin Marbles. Knight was an important member of the Society of Diletantti, for which group he edited *Specimens of Ancient Sculpture* (1809). Other works include the didactic poem, *The Landscape* (1794) and *An Analytical Inquiry into the Principles of Taste* (1805), as well as studies of the Greek alphabet and Homer.

**Long, Charles, first Baron Farnborough (1760–1838)**   A friend and supporter of William Pitt, Long became a member of Parliament in 1789. A respected connoisseur, Long was a staunch supporter of the purchase of the Elgin Marbles and of the establishment of the National Gallery. He also served as an advisor to George IV on the commissioning of art works. On his death in 1838, he left to the National Gallery a collection of paintings including works by Rubens, Vandyck, Canaletto, and others.

**Milton**   See Fitzwilliam, Charles William Wentworth.

**Moore, Peter (1753–1828)**   After working in various capacities for the East India Company, Moore returned to England in 1785 and began a political career that would last over thirty years. A committed Whig, he was a strong supporter of workers' rights and the abolition of the slave trade. A close friend of Sheridan, Moore was also involved in the affairs of Drury Lane Theatre.

**Morrison, James (1789–1857)**   A self-educated man, Morrison made his fortune in the drapery business. He first entered Parliament in 1830, where he focused on railway reform. Morrison had a sizable library and was an avid collector of paintings by Italian and Dutch masters and contemporary English artists.

**Murray, David (1842–1928)**   Solicitor, antiquarian, and man of letters, David Murray was at various times fellow and vice president of the Society of Antiquaries of Scotland, president of the Glasgow Archaeological Society, president of the Royal Philosophical Society of Glasgow, and president of the Glasgow Bibliographical Society. He produced important works in all his areas of interest, including *Museums, Their History and Their Use* (1904) and *An Archaeological Survey of the United Kingdom* (1906).

**Newport, Sir John (1756–1843)**   Newport's political career began with his election to Parliament in 1803. Later he was appointed chancellor of the Irish exchequer in the Grenville ministry. A spokesman for political and financial reform, Newport also supported Catholic relief.

**Nollekens, Joseph** (1737–1823)   Nollekens, the most successful portrait sculptor of his day, had many ties to the world of literature and drama. He lived in Rome from 1760 to 1770, where he made a sizable fortune from the collection, restoration, and resale of antiques. In 1772 he became a full member of the Royal Academy.

**Oldfield, Edmund** (1816–1902)   Following a stint as fellow and librarian at Worcester College, Oxford, Oldfield joined the British Museum in 1848 as a first-class assistant in the newly formed Department of Coins and Medals. He resigned from the museum in 1861 and later wrote for archeological journals. A friend of John Ruskin, he also served as secretary to Sir Henry Layard when the latter was first commissioner of works (1868–1869).

**Owen, Richard** (1804–1892)   Owen's apprenticeship to a surgeon and apothecary led to his fascination with anatomy, a topic he pursued at the University of Edinburgh and later as a member of the Royal College of Surgeons. In 1827 Owen was made assistant curator at the Hunterian Museum at the college, the formal beginning of a long association that included his 1836 appointment as Hunterian Professor of Comparative Anatomy. Owen's scientific reputation grew rapidly and brought him in touch with important men of science and letters, including Darwin, Carlyle, Turner, Tennyson, and Dickens. Owen was a member of the preliminary committee of organization for the Great Exhibition of 1851. In 1856 the British Museum formed for him the post of superintendent of natural history, in which capacity he served until 1883. He was the driving force behind the creation of the Museum of Natural History, which finally opened in 1881. A difficult man, Owen's reputation in his later years was also hurt by his virulent response to Darwinian ideas.

**Panizzi, Antonio** (1797–1879)   Panizzi was born in Brescello in the Duchy of Modena. He studied law at the University of Parma, where he apparently also became involved in the movement for Italian unification. Panizzi arrived in London in 1823, fleeing arrest for his revolutionary activity. Through the support of Henry Brougham, Panizzi was appointed as extra assistant librarian in the department of printed books at the British Museum, the beginning of an extraordinary rise that culminated in 1856, when he became head of the museum. Panizzi presided over the rapid growth of the collections, as well as over such design developments as the construction of the new reading room and book stacks.

**Parker, John Henry** (1806–1884)   Parker succeeded his uncle as a bookseller and publisher at Oxford in 1832, where he became an important publisher of works of the Tractarian movement. He studied architecture in his spare time and published several works between 1836 and 1884, including *Study of Gothic Architecture* (1849). He served as vice president of the Oxford Architectural Society and founded the British Archeological Society of Rome, for which he produced *A Catalogue of 3,300 Historical Photographs of Antiquities in Rome and Italy* (1867–79; rev. 1883). In 1870 he was appointed keeper of the Ashmolean Museum, a position he had endowed the previous year.

**Peel, Sir Robert, second baronet** (1788–1850)   Peel entered politics at the age of twenty-one as MP for the Irish rotten borough of Cashel City, Tipperary. Although he had resisted Catholic rights in Ireland throughout his political career, he was forced to support the Catholic Emancipation Act in 1829, the same year he began to reform

England's police force as home secretary. By 1834 Peel rose to be prime minister, but he was forced to resign in 1835, not to regain his post until 1841. After the potato blight of 1845, Peel repealed the Corn Laws, removing duties on imported corn. However, this gesture was unpopular even within his own party, and he was forced to resign a second time in 1846. Peel assembled a notable collection of Dutch and Flemish paintings, which he displayed in a specially commissioned gallery in his London home. Many of his canvasses were purchased for the National Gallery in 1871.

**Pitt-Rivers, Augustus Henry Lane Fox (1827–1900)**   Born Augustus Henry Lane Fox, Pitt-Rivers assumed his last names upon inheriting the estates of his cousin in 1880. After his education at Sandhurst, Pitt-Rivers embarked on a military career that culminated in the rank of lieutenant-general in 1882. Pitt-Rivers participated in the development of several new models of rifle, an experience that played a part in his understanding of tool adaptations and archeology. Much influenced by Darwin, Pitt-Rivers was a noted collector of objects of anthropological interest as well as a pioneering archeologist in his own right. He became inspector of ancient monuments under the Ancient Monuments Act of 1882 and was involved in founding two novel museums, the one which was given his name at Oxford, and which opened in 1884 following his typological organization, and the Farnham Museum, a pioneering popular archeological-ethnographic institution founded in 1885.

**Ponsonby, John William, Viscount (later Baron) Duncannon and fourth Earl of Bessborough (1781–1847)**   Known as Duncannon until 1844, Ponsonby served on the committee that drew up the Reform Bill in 1831. He was also responsible for an important public parks program and deeply involved in the development of the new houses of Parliament.

**Rees, Sir John David (1854–1922)**   During his long years in the Indian Civil Service (1875–1901) Rees held many important positions, including British resident in Travancore and Cochin. He was also the government translator in Persian, Tamil, Telugu, and Hindustani and a fellow of the University of Madras. Rees authored several books and articles on India. He entered Parliament in 1906.

**Ridley-Colborne, Nicholas William, first Baron Colborne (1779–1854)**   A Whig who served in Parliament from 1804–1837 with only a brief intermission, Ridley-Colborne was best known for his strong support of the arts. He was a director of the British Institution, a member of the Fine Arts Commission, and a trustee of the National Gallery.

**Runciman, Walter, Baron Runciman of Shoreston (1870–1949)**   Son of a shipping magnate, Runciman was educated at Trinity College, Cambridge, and served in Parliament, with two interruptions, from 1899 to 1937. He held a number of governmental administrative positions, including the presidency of the Board of Trade (1914–16, 1931–37). In 1938 he served as a mediator between the Czech government and the Sudetenland Germans.

**Ruskin, John (1819–1900)**   The most important English art critic of the nineteenth century and among the most influential social critics of his day, Ruskin began his career with an impassioned defense of J. M. W. Turner as a painter of landscapes. Principal

works of this prolific author, whose interests ranged from geology to Greek mythology, include *Modern Painters* (1834–1856), *Seven Lamps of Architecture* (1849), and *Stones of Venice* (1851–1853). *The Political Economy of Art* (1857) was a response to the Art Treasures Exhibition in Manchester, but throughout his career Ruskin addressed questions of display, collection, restoration, and art education. Notable late works include the series of letters to the working men of England he entitled *Fors Clavigera* (1871–78) and the autobiographical *Praeterita* (1885–89).

**Sandford, Francis Richard John, Baron Sandford (1824–1893).**  Born in Glasgow and educated there and at Oxford, Sandford had a long and distinguished career in the Education Department.

**Shaftesbury, Anthony Ashley Cooper, seventh Earl of (1801–1885)**  A philanthropist and politician, Shaftesbury was first elected to Parliament in 1826, where he became a leader of the movement for factory reform.

**Shelley, Sir John Villiers, seventh baronet (1808–1867)**  A Liberal who favored vote by ballot and extension of the suffrage to all rate payers, Shelley was elected to Parliament in 1852, where he represented Westminster until 1865.

**Sibthorp, Charles de Laet Waldo (1783–1855)**  After a military career including service in the Napoleonic wars, Sibthorp was elected member of Parliament for Lincoln in 1826. He soon developed his reputation as the most reactionary member of Parliament of his day. Among his notable stands: he opposed Catholic Emancipation, the repeal of the Corn Laws, the Reform Act of 1832, and the Great Exhibition of 1851.

**Spencer, John Charles, viscount Althorp and third Earl of (1782–1845)**  Spencer entered Parliament in 1804. He became leader in the lower house in 1830, and later both leader of the House of Commons and chancellor of the exchequer. He led the fight to pass the Reform Bill of 1832.

**Spring Rice, Thomas, first Baron Monteagle of Brandon (1790–1866)**  Spring Rice entered Parliament in 1820. He became secretary of the treasury in 1830 and secretary of state for war and the colonies in 1834. He served as chancellor of the exchequer in 1835–1839. Spring Rice wrote for the *Edinburgh Review* and was a trustee of the National Gallery as well as a member of the senate of the University of London and of the Queen's University in Ireland.

**Thwaites, George Saunders (1778–1866)**  After an extensive military career, Thwaites became assistant keeper of the National Gallery and secretary to the trustees.

**Uwins, Thomas (1782–1857)**  Uwins was apprenticed in 1797 to the engraver Benjamin Smith, and the following year entered the Royal Academy Schools. In 1845 he was appointed surveyor of pictures to Queen Victoria, and he completed the first catalogue raisonné of the royal collection six years later. Following Eastlake, he served as keeper of the National Gallery from to 1847 to 1855.

**Waagen, Gustav Friedrich (1794–1868)**  The son of a painter in Hamburg, Waagen spent time with the community of German artists in Rome before enlisting in the army in 1813 to fight Napoleon. He studied in the Musée Napoleon before its contents were repatriated at the end of hostilities, and at the universities of Heidelberg and Breslau. In

1823 Waagen moved to Berlin to assist in the creation of the new Royal Gallery, where he eventually became director. Waagen traveled extensively, surveying the art of many European countries, and was particularly influential in shaping the reception of Northern Renaissance art. In 1833 Waagen published his essays on Rubens, which were translated by Anna Jameson. His two most influential works in the English context were *Works of Art and Artists in England* (1838) and *Treasures of Art in Great Britain*, translated by Elizabeth Eastlake (London, 1854 and 1857). Waagen was a recognized authority in the British art world. Not only did his work bring new attention to the wealth of art objects in private collections, but his career and ideas helped shape both the emergence of art history as an academic field and the diffusion of modern concepts of display.

**Warburton, Henry (1784–1858)** A philosophical radical, Warburton became a fellow of the Royal Society in 1809 and was a member of the Political Economy Club from its foundation in 1821. He was a leading supporter of the foundation of London University. Elected as member of Parliament for Bridport, Dorset, in 1826, Warburton was active in the reform of bankruptcy, the repeal of stamp duty on newspapers, the introduction of the penny post, and the campaigns of the Anti-Corn Law League.

**Ward, John William, Viscount Ednam and Ward and Earl of Dudley (1781–1833)** A politician whose early parliamentary career was financed by his father, owner of extensive coal mines in Worcestershire and Staffordshire, Ward supported Catholic relief and advocated the acquisition of the Elgin marbles.

**Watson, John Forbes (1827–1892)** Watson was born and educated in Aberdeen, where he also trained as a doctor. He was assigned to the Bombay army medical service in 1850 and began a study on the nutritional value of the Indian diet in 1855. In 1858 he was made the director of the India Museum. Watson represented India at the international exhibitions in London (1862), Paris (1867), and Vienna (1873).

**Wemyss, Francis Wemyss Charteris Douglas, eighth Earl of (1818–1914)** Lord of the treasury (1852–55) and a promoter of the volunteer movement and of the National Rifle Association in later life, Wemyss, known as Lord Elcho while he was lord of the treasury, was also an accomplished amateur artist. In 1856 he played an important role in preventing the removal of the National Gallery to Kensington Gore.

**Westmacott, Sir Richard (1775–1856)** Westmacott was born in London and studied at the Accademia di San Luca in Rome. He was elected an associate member of the Royal Academy and succeeded John Flaxman as professor of sculpture at the Royal Academy in 1827. Among his well-known works are the Waterloo Vase and Achilles. Following his testimony on the acquisition of the Elgin Marbles in 1816, he served as an unofficial advisor to the British Museum.

**Wildsmith, John Peter,** Attendant, National Gallery from 1824 to at least 1841.

**Wynn, Charles Watkin Williams (1775–1850)** Wynn entered Parliament as representative of the borough of Old Sarum in 1797. He had a long career in Parliament including a brief period as secretary at war. Wynn was known for his scholarly interest in antiquities. He was a lifelong friend of the poet Robert Southey, for whom he secured a pension.

# SUGGESTIONS FOR FURTHER READING

Nineteenth-century material is listed in chronological order. For reasons of space, parliamentary papers have been omitted.

## Introduction

Alexander, Edward P. *Museums in Motion: An Introduction to the History and Function of Museums*. Nashville, Tennessee: AASLH Press, 1979.

Altick, Richard D. *The Shows of London*. Cambridge: Harvard University Press, 1978.

Bann, Stephen. *Romanticism and the Rise of History*. New York: Twayne Publishers, 1995.

Bazin, Germain. *The Museum Age*. New York: Universal, 1967.

Bennett, Tony. *The Birth of the Museum: History, Theory and Politics*. London: Routledge, 1995.

Carbonell, Bettina Messias. *Museum Studies: An Anthology of Contexts*. Oxford: Blackwell, 2003.

Crimp, Douglas. *On the Museum's Ruins*. Cambridge, Massachusetts and London: MIT Press, 1993.

Duncan, Carol, and Alan Wallach. "The Universal Survey Museum." *Art History* 3 (1980), 448–69.

Findlen. Paula. *Possessing Nature: Museums, Collecting and Scientific Culture in Early Modern Italy*. Berkeley: University of California Press, 1994.

Fisher, Philip. *Making and Effacing Art: Modern American Art in a Culture of Museums* New York: Oxford University Press, 1991.

Hakell, Francis. *The Ephemeral Museum: Old Master Paintings and the Rise of the Art Exhibition*. New Haven: Yale University Press, 2000.

————. *Rediscoveries in Art: Some Aspects of Taste, Fashion, and Collecting in England and France*. Oxford: Phaidon, 1976.

Haskell, Francis, and Nicholas Penny. *Taste and the Antique: The Lure of Classical Sculpture, 1500–1990*. New Haven: Yale University Press, 1981.

Huyssen, Andreas. *Twilight Memories: Marking Time in a Culture of Amnesia*. New York: Routledge, 1995.

Impey, Oliver, and Arthur MacGregor. *The Origins of Museums: The Cabinet of Curiosities in Sixteenth- and Seventeenth-Century Europe*. Oxford: Oxford University Press, 1985.

Malraux, Andre. *The Voices of Silence*. Garden City, New York: Doubleday, 1953.

McClellan, Andrew. *Inventing the Louvre: Art, Politics, and the Origins of the Modern Museum in Eighteenth-Century Paris*. New York: Cambridge University Press, 1994.

McShinte, Kynaston. *The Museum as Muse*. New York: Museum of Modern Art, 1999.

Molfino, Alessandra, and Mottola Molfino. *Il Libro dei Musei*. Turin: Umberto Allemandi, 1991.

Pearce, Susan. *Museums and Their Development: The European Tradition, 1700–1900*. London: Routledge, 1999.

Pomian, Krzysztof. *Collectors and Curiosities: Paris and Venice, 1500–1800*. Cambridge: Polity Press, 1990.

Sherman, Daniel J., and Irit Rogoff, eds. *Museum Culture: Histories, Discourses, Spectacles*. Minneapolis: University of Minnesota Press, 1994.

Siegel, Jonah. *Desire and Excess: The Nineteenth-Century Culture of Art*. Princeton: Princeton University Press, 2000.

# Private Collections

## Nineteenth-Century Sources

Anonymous, "An Account of the Prince and Princess of Wales Visiting Sir Hans Sloane." *Gentleman's Magazine* 18 (1748).

Buchanan, William. *Memoirs of Painting, with a Chronological History of the Importation of Pictures by the Great Masters into England since the French Revolution*. London: R. Ackermann, 1824.

Anonymous. "London Museums of the Seventeenth Century." *Chamber's Edinburgh Journal*, n.s. 15 (1851).

Eastlake, Sir Charles. *Hints on Household Taste*. London: Longmans, Green, 1868.

Loftie, William John. *A Plea for Art in the House*. London: Macmillan, 1876.

Nesbitt, Alexander. "Art Collections." *Quarterly Review* 150 (1880).

Michaelis, Adolf. *Ancient Marbles in Great Britain*. Cambridge: Cambridge University Press, 1882.

Deane, Ethel. *Byways of Collecting*. London: Cassell, 1908.

Conway, Sir W. Martin. *The Sport of Collecting*. London: T. Fisher Unwin, 1914.

## Modern Sources

Aguirre, Robert D. *Informal Empire: Mexico and Central America in Victorian Culture*. Minneapolis: University of Minnesota Press, 2005.

Elsner, John, and Roger Cardinal, eds. *The Cultures of Collecting*. Cambridge: Harvard University Press, 1994.

Hermann, Frank. *The English as Collectors*. New York: Norton, 1972.

Pearce, Susan M. *On Collecting: An Investigation into Collecting in the European Tradition*. New York: Routledge, 1995.

Pears, Iain. *The Discovery of Painting: The Growth of Interest in the Arts in England 1680–1768*. New Haven: Yale University Press, 1988.

Reitlinger, Gerald. *The Economics of Taste: The Rise and Fall of the Picture Market, 1760–1960*. New York: Holt, Rinehart and Winston, 1961.

Taylor, Francis Henry. *The Taste of Angels: A History of Art Collecting from Rameses to Napoleon*. Boston: Little, Brown, 1948.

## Toward a Public Art Collection

### Nineteenth-Century Sources

Powlett, Edmund. *General Contents of the British Museum: With Remarks Serving as a Directory in Viewing That Noble Cabinet.* London: R. and J. Dodsley, 1761.
Alexander Thomson, *Letters on the British Museum.* London: J. Dodsley, 1767.
Rymsdyk, Jan van. *Museum Britannicum, Being an Exhibition of a Great Variety of Antiquities and Natural Curiosities.* London: J. Moore, 1778.
Hazlitt, William. "The Elgin Marbles." *The London Magazine*, February 1822.
Cockerell, Charles Robert. *Description of Ancient Marbles in the British Museum.* London: British Museum, 1830.

### Modern Sources

Caygill, Marjorie. *The Story of the British Museum*, 2nd ed. London: British Museum, 1992.
Cook, B. F. *The Townley Marbles.* London: British Museum, 1985.
Crook, J. Mourdant. *The British Museum.* London: Allen Lane, 1972.
Holt, Elizabeth Gilmore. *The Triumph of Art for the Public: The Emerging Role of Exhibitions and Critics.* Garden City, New York: Anchor Press/Doubleday, 1979.
Miller, Edward. *That Noble Cabinet: A History of the British Museum.* Athens: Ohio University Press, 1974.

## The Public in the Museum

### Nineteenth-Century Sources

Ruskin, John. *The Opening of the Crystal Palace Considered in Some of Its Relations to the Prospects of Art.* London: Smith, Elder, 1854.
Boutell, Charles. "The Crystal Palace: A Teacher from Ancient and Early Art." *Art Journal* (1857).

### Modern Sources

Bailkin, Jordanna. *The Culture of Property: The Crisis of Liberalism in Modern Britain.* Chicago: Chicago University Press, 2004.
Black, Barbara, *On Exhibit: Victorians and Their Museums.* Charlottesville and London: University Press of Virginia, 2000.
Gidal, Eric. *Poetic Exhibitions: Romantic Aesthetics and the Pleasures of the British Museum.* Lewisburg, Pennsylvania: Bucknell University Press, 2001.
Kavanagh, Gaynor. *Museums and the First World War: A Social History.* London and New York: Leicester University Press, 1994.

## Art and the National Gallery

### Nineteenth-Century Sources

Edwards, Edward. *The Fine Arts in England; Their State and Prospects Considered Relatively to National Education.* London: Saunders and Otley, 1840.

Eastlake, Charles. "The National Gallery: Arrangement of Picture Galleries Generally."
    *The Builder* (1845), pp. 282–84.
Holmes, John. "The British Museum," *Quarterly Review* 88 (1850–51).
Ruskin, John. "The National Gallery" (1852). *Complete Works of John Ruskin*, Library
    Edition, ed. E. T. Cook and Alexander Wedderburn. London: George Allen, 1903–
    1912, 12:411–14.
Pulszky, Francis. "On the Progress and Decay of Art and on the Arrangement of a Na-
    tional Museum." *The Museum of Classical Antiquities* 5 (1852).
Anonymous. "The Proposed New National Galleries and Museums." *Fraser's Magazine
    for Town and Country* 47 (1853).

### Modern Sources

Barlow, Paul, and Colin Trodd, eds. *Governing Cultures: Art Institutions in Victorian
    London.* Aldershot: Ashgate, 2000.
Haskell, Francis. *The Ephemeral Museum: Old Master Paintings and the Rise of the Art
    Exhibition.* New Haven and London: Yale University Press, 2000.
———. *Rediscoveries in Art: Some Aspects of Taste, Fashion and Collecting in England
    and France.* Oxford: Phaidon, 1976.
Holt, Elizabeth Gilmore. *The Art of All Nations, 1850–73, The Emerging Role of Exhibi-
    tions and Critics.* Princeton: Princeton University Press, 1982.
———. *The Expanding World of Art, 1874–1902.* New Haven: Yale University Press,
    1988.
———. *The Triumph of Art for the Public, 1785–1848: The Emerging Role of Exhibi-
    tions and Critics.* Garden City, New York: Anchor Press/Doubleday, 1979.
Robertson, David. *Sir Charles Eastlake and the Victorian Art World.* Princeton: Prince-
    ton University Press, 1978.
Whitehead, Christopher. *The Public Art Museum in Nineteenth-Century Britain: The
    Development of the National Gallery.* Aldershot: Ashgate, 2005.

## Natural History and the British Museum

### Nineteenth-Century Sources

Dickens, Charles. "Owen's Museum." *All the Year Round* 8 (1862).
Teacher, John H. *The Anatomical and Pathological Preparations of Dr. William Hunter in
    the Hunterian Museum.* Glasgow: J. MacLehose & Sons, 1900.

### Modern Sources

Stearn, William T. *The Natural History Museum at South Kensington: A History of the
    British Museum (Natural History), 1753–1980.* London: Heinemann, 1981.
Yanni, Carla. *Nature's Museums: Victorian Science and the Architecture of Display.* Lon-
    don: Athlone Press, 1999.

## South Kensington and the Provinces

### Nineteenth-Century Sources

Conway, Moncure D. "The South Kensington Museum." *Harper's New Monthly Maga-
    zine* 51 (1875).

Cole, Sir Henry. *Fifty Years of Public Works of Sir Henry Cole, K.C.B., Accounted for in His Deeds, Speeches and Writings.* London: George Bell and Sons, 1884.

## Modern Sources

Auerbach, Jeffrey. *The Great Exhibition of 1851: A Nation on Display.* New Haven: Yale University Press, 1999.
Baker, Malcolm, and Brenda Richardson, eds. *A Grand Design: The Art of the Victoria and Albert Museum.* Baltimore: Harry Abrams, 1997.
Burton, Anthony. *Vision and Accident: The Story of the Victoria and Albert Museum.* London: V&A Publications, 1999.
Cocks, Anna Somers. *The Victoria and Albert Museum: The Making of the Collection.* Leicester: Windward, 1980.
Physick, John. *The Victoria and Albert Museum: The History of Its Building.* London: V&A, 1982.

# Reform and the Psychology of Museum Attendance

## Nineteenth-Century Sources

Ruskin, John. *The Political Economy of Art.* London: Smith, Elder, 1857.
Greenwood, Thomas. *Museums and Art Galleries.* London: Simpkin Marshall, 1888.
Flower, William. *Essays on Museums.* London: Macmillan, 1893.

## Modern Sources

Bourdieu, Pierre, and Alain Darbel. *The Love of Art: European Art Museums and Their Public.* Trans. Caroline Beattie and Nick Merriman. Oxford: Polity, 1991.
McClellan, Andrew, ed. *Art and its Publics: Museum Studies at the Millennium.* London: Blackwell, 2003.

# Anthropology and Archeology

## Nineteenth-Century Sources

Michaelis, Adolf. *Ancient Marbles in Great Britain.* Trans. C.A.M. Fennell. Cambridge: Cambridge University Press, 1882.
Pitt-Rivers, Augustus Henry Lane-Fox. *The Evolution of Culture and Other Essays.* Oxford: Clarendon Press, 1909.

## Modern Sources

Clifford, James. "On Collecting Art and Culture," in *The Predicament of Culture: Twentieth-Century Ethnography, Literature, and Art.* Cambridge: Harvard University Press, 1988.

Gosden, Chris. *Anthropology and Archaeology: A Changing Relationship.* London: Routledge, 1999.

Jenkins, Ian. *Archaeologists and Aesthetes: In the Sculpture Galleries of the British Museum 1800–1939.* London: British Museum Press, 1992.

Karp, Ivan, and Steven D. Lavine, ed. *Exhibiting Cultures: The Poetics and Politics of Museum Display.* Washington, D.C.: Smithsonian Institution Press, 1992.

Ovenell, R. F. *The Ashmolean Museum, 1683–1894.* Oxford: Clarendon: 1986.

Pearce, Susan M. *Museums and the Appropriation of Culture.* Atlantic Highlands, New Jersey: Athlone Press, 1994.

## Exhibiting India

### *Nineteenth-Century Sources*

Gordon, Peter. *The Oriental Repository at India House.* London: Murray, 1835.

South Kensington Museum. *Catalogue of the Objects of Indian Art Exhibited in the South Kensington Museum.* London: Chapman and Hall, 1874.

### *Modern Sources*

Barringer, Tim. *Colonialism and the Object: Empire, Material Culture and the Museum.* London: Verso, 1998.

Desmond, Raymond. *The India Museum, 1801–1879.* London: Her Majesty's Stationery Office, 1982.

Richards, Thomas. *The Imperial Archive: Knowledge and the Fantasy of Empire.* London: Verso, 1993.

# INDEX

acalephes, floating, 233
accessibility, 213, 226–27, 245
  books, 229-30, 250, 251, 279
  information, India example of, 320,
    330, 334,
  location and, 140, 144–46, 156, 193,
    223, 227, 229
acidity, statues damaged by, 177
acquisition, 6, 9–10, 73, 219
  India collection, 332
Acts of Parliament, 96, 124, 224, 228, 297
adaptation, animal, 241
admission, 83, 90, 110, 111. *See also* days
  of admission; hours of operation;
  Sundays
  artists, 126, 127–29, 226
  barred, 210, 293
  of children, 82, 90, 95, 100, 121–22,
    126, 209–10
  fees for, 78, 83, 86–87, 116–17, 246
  foreign galleries/museums, 86, 126
  free, 91, 117, 249
  King's Library, 67, 69, 110, 111
  permission for, rooms requiring, 215, 219
  ticket of, 215
  unrestricted, 210
Africa, 20, 21
Age of the Museum, 3–4, 7
d' Agincourt, Seroux, 304, 304*n*1
Albert (prince), 204. *See also* Victoria and
  Albert Museum
alcohol (ardent spirit), 246, 253
alehouse. *See* public-houses
Alexandria, "museum" application in, 64
Alhambra Court (South Kensington
  Museum), 246, 247, 248, 248f, 286
Althorp. *See* Spencer, John Charles
Amrawutti, (Amaravati), 316
amusement, 278
anatomists, 239
Angerstein, John Julius, 14, 34–36,
  73–74, 341

animals, 19–20, 21, 22–25, 216
  adaptation of, 241
  marine, display/preservation of, 233
  mollusks, classification of, 216
  Roman use of, zoology not
    furthered by, 232
  stuffed, 14, 259–60
Anne (queen), 30*n*10
"Ante-Bellum Tragedy" (Bateman), 82
anthropology, 8, 308–13, 335
  art and, 308, 310
  ideas classified by, 309
antiquities, 70–71, 216. *See also* curiosities;
  archaeology, objects
  Assyrian, 114, 147, 152, 169–70, 176,
    295, 341
  British, 302
  British Museum expansion of, 152
  civilization illustrated by, 152
  Egyptian, 13–14, 22–25, 32, 109, 110,
    147, 152, 154, 158, 219
  Indian, 318
  keeper of, 106, 168–72
  library for, 181–82
  Mexican, 152, 216
  prices of, 46–48
  works of art v., 144
Apollo, 3
Apollo Belvedere, 41, 41*n*3, 43
apparatus, 127, 250, 251–52, 287,
  292, 302
  chemical, 251, 252
  fish-culture, 287
Arabs, 253
archaeology, 192, 301–3, 304–7
  art education and, 192, 195
  division of collection, 153, 155, 172
  history revealed through, 304, 305
  medieval specimens of, 152–53, 306
  study of, 184
  value of, 172
  as visual history, 304

Paris Mint, 296, 296n14
Parker, John Henry, 300, 304–7, 350
Parkes Museum of Hygiene, 292, 292n11, 296
Parliament
    Acts of, 96, 124, 224, 228, 297
    art and manufacturing, report on, 85–89
    British Museum founded by, 221–22
    building control by, recommended, 203–4
    Department of Board of Trade of, 263, 264–65
    Department of Practical Art, 263
    Elgin marbles debate by, 39–60
    funding/grants by, 60, 62, 200, 211–12, 224, 263, 271
    India viewed by, 329–30
    National Gallery debate of 60–63
    New Houses of, 218
    public interest in art report by, 81
    vote of, 59
Parthenon marbles. See Elgin marbles
"A Party of Working Men at the National Gallery" (The Graphic), 79f
passports, 126
The Patent Museum, 245–46, 257–58, 343
Pausinias, 218
Peel Park Museum, 296n13
Peel, Robert, 6, 38, 62, 203, 296n13, 350–51
Pembroke, 27n2
The Penny Magazine, 38, 68n3, 71, 122–23
periodization 45, 163, 167, 188, 197, 205, 207, 302
periods
    combining, 205
    missing, pictures needed for, 211
    Napoleonic, 5, 6, 38
    painting, 167, 205, 207
Perugino, Pietro, 205, 212
Peruvians, 216
Phidias, 43n6, 46, 180
Phigaleian marbles, 218, 218n3, 343
Phigalian Saloon, 218
photographs, 265, 267
    archaeology advanced by, 304–5
    of architecture, 255, 281, 304–5
    coloured, 273
    of loaned objects, 273
    of paintings, 195
picture(s). See also drawing(s)
    arrangement of, 204–7
    Blenheim Palace, 30–32
    bluish coating on, 208
    catalogues, 210–11
    Charles I collection of, 72

Christian, Pagan sculpture displayed with, 166, 188, 197
classification of, 93
copying, 78, 101, 106, 107, 127–33, 195
damage to, 78, 174, 189
display methods for, 153–54, 162, 183–84, 187, 189–90, 202–3, 204–7
drawings and, 162–63
dusting, 209
fake, 76
glass over, 188, 189
hanging of, 207–8
ideal floor for, 282
large, 189–90, 202–3
lighting for, 32, 201, 203
mosaic, 306
National Gallery, 74–75, 166, 211, 212
numbering of, 210
number of, in various galleries, 30, 77–78
overcrowding of, 77–78
periods of, dividing display into, 167, 205, 207
preservation of, 208–9
prints v. original, 35
private collections of, 26–30
purchase of, 88, 198, 211–12
relocation of, 209
restoration of, 209
rooms for, 202–3
sales of, 26, 29, 30, 72, 74, 128, 131
small, 189–90, 202, 203
space between, 208
tarnishing of, 209
third floor for, 282
vandalism/damage to, 29
visitor interest in, 91
picture-galleries, 34–36, 194
Pio-Clementino (Vatican), 6, 44, 44n8
Pitt-Rivers, Augustus Henry Lane Fox, 300, 308–13, 351
Pitt-Rivers Museum, 300
"Plan for a Museum of Antiquities in an Open Situation" (Oldfield), 151f
plaster casts. See casts
plastic art, 157
plunder, 5, 6
Plutarch, 46
polar bear, 22, 241
police, 92, 116, 119
politics
    division of collection/Orleans gallery, 29–30
    Elgin marbles, 6, 158
    India collection serving Indian, 329–30
polypes, preservation of, 233